TRADEMARKS
ON GREEK VASES

A. W. Johnston

ISBN 0 85668 123 7

OMNIBUS ADIUTORIBUS

Published by Aris & Phillips Ltd, Teddington House, Warminster, Wiltshire, England.

Printed in England by Biddles Ltd, Guildford, Surrey.

CONTENTS

List of Plates iv
Introduction v
Abbreviations vii

Chapter 1. The Origin and Growth of Use of Commercial Marks 1
 2. Physical Aspects of the Marks 4
 3. The Material from Greece 8
 4. Provenances 12
 5. Script, Dialect and Vocabulary 22
 6. Numerals 27
 7. Vase Names and Prices 32
 8. Marks and Vases 36
 9. Isolated and Double Marks 39
 10. Painters and Vases 43
 11. Trademarks, Trade and the Economy 48

Appendix 1. Provenance charts 54
 2. Painters and marks 56
 3. Marks on other artefacts 57

Notes to chapters 1-11 58

Addenda 66

The Catalogue
 Introduction 67
 Addenda 70
 Catalogue 71
 Commentary on the Catalogue 185
 Notes to Catalogue 239

Indexes
 Museum Index 253
 Greek Index 267
 Index of ancient authors cited 267
 General Index 268

Figures

Plates

List of plates

1	10A,4.	Munich, Antikensammlungen 1701
2	35A,1.	Louvre E707
3	15A,9.	Louvre E868
4	6B,6.	Louvre E858
5	6A,3.	The Brooklyn Museum, acc. no. 09.5, Gift of R.B. Woodward
6	24B,11.	London B260
7	11B,11.	Warsaw 142451
8	5D,22.	Louvre Cpl0701
9	19B,7.	Oxford, Ashmolean Museum 1910.804
10a-b	21B,1.	London B518
11a-b	1D,1.	Munich, Antikensammlungen 1703
12	15E,9.	Louvre E804
13	9E,107.	The Brooklyn Museum, acc. no. 03.8, Gift of R.B. Woodward
14	9E,74.	Adria (21,5); photo author
15	1F,4.	Budapest 50.154
16	3E,26.	Chiusi P543; photo author
17	18B,1.	Munich, Antikensammlungen 1681
18	1E,3.	London B160
19	5E,21.	Leiden PC33
20	1D,5.	Vatican 418
21	4D,1.	Rome, Villa Giulia; photo author
22	4D,3.	Rome, Villa Giulia; photo author
23a-b	8E,42.	London B325
24	9E,5.	Louvre Cpl0635
25	6D,7.	Adria (21,25); photo author
26	21F,2.	Warsaw 142290
27	23E,15a.	The Greek Museum, University of Newcastle-upon-Tyne 105
28	2F,47.	London B225
29	Corinthian 4.	Louvre E570
30	East Greek 58.	London 1888.6-1.769
31	East Greek 61.	London 1888.6-1.772
32a-b	21E,5.	London B262
33	19F,10.	Louvre G356
34	8E,47.	London B314
35a-b	Corinthian 56.	Syracuse, from Akrai
36a-b	Corinthian 46.	Louvre E630
37	Corinthian 13.	London 1867.5-8.892
38	Corinthian 17.	London o.c. 316
39	East Greek 56.	London 1888.6-1.767
40a-b	Corinthian 66.	Taranto 20766
41	East Greek 51.	London 1888.6-1.419
42	East Greek 55.	London 1888.6-1.766
43	East Greek 227.	London 1965.9-30.678
44a-b	East Greek 110.	Syracuse 24691
45	East Greek 228.	London 1965.9-30.679

All the photographs were supplied by the museums concerned, except where stated, and are published by courtesy of their several administrative bodies.

In eight instances untouched photographs (a) are accompanied by copies on which a dipinto has been inked in (b).

INTRODUCTION

'The pen is mightier than the sword' is a suitable motto for any book, but is particularly suited here. In the first place, a version chalked on an Oxford wall, with a minor alteration of word division, will provide the only touch of humour herein, will serve to illustrate the rather loose modern usage of the term 'graffito', and places the origin of this book as a doctoral thesis. Secondly, it can introduce the commercial theme, set in a period of Greek history in which warfare was endemic and institutionalised. Finally, it hints at the two alternative types of inscription with which we will be dealing, the pen- or brush-made dipinto and the graffito gouged out by the point, though in only one case would a sword be a candidate (Pl. 33).

The subject matter needs no full introduction from the present author since it was admirably outlined in his own introduction by R. Hackl, in the work that this book is designed to supplement (hardly replace), 'Merkantile Inschriften auf Attischen Vasen', in the volume of essays dedicated to A. Furtwängler's memory, *Münchener Archäologische Studien*. Hackl singles out the type of ceramic inscription that we shall encompass and gives a concise account of work on the subject in the years before 1909. My debt to Hackl's work will be very apparent; I retread much of the same ground simply because he so accurately pinpointed the basic questions which we should ask of the material. With more evidence at hand I feel able to give some more positive answers and to explore more deeply, and in some cases more widely, than did Hackl. It is by intention that I do not examine further aspects which some may consider missing here, in particular more general aspects of archaic trade, especially its historical perspective. 'Commercial' marks on vases forming part of that trade are one of the more objective sources of evidence for the purposefulness and organisation of such trading activities and I leave them largely to speak for themselves.

Study of trademarks has not been dormant between 1909 and the 1970s. In response to Hackl's paper Burrows and Ure wrote thoughtfully about the graffiti found in their excavations at Rhitsona in *JHS* 29 (1909), and it was not long before Beazley began his series of articles 'Inscriptions on vases', where more often than not he included some typically lucid comments on underfoot graffiti; his awareness of their significance can be tacitly understood from his acid remarks in *JHS* 51 (1931) 122 and from the full record of marks which he kept; they are now in the Beazley archive in Oxford.

Perhaps the most fruitful advances arose from the disagreements between D. A. Amyx and J. H. Jongkees in a series of articles, culminating in a clear victory for the former over the question of vase prices; see *Hesperia* 25 (1956) 287ff in the latest instance. However, in my turn I have come to question a few of his conclusions. The importance of having the right answers in this matter can be judged from the fact that we have precious little other evidence for prices - 'the cost of living' - in fifth century Athens, if we set aside the building of temples and expenses of warfare.

Beazley's last published article, *AK* 10 (1967) 136ff, paid due attention to the graffito under the chous by the Eretria painter in Basel; T. B. L. Webster too in one of his last works reviewed our topic with some typically challenging ideas, but with perhaps too little attention to detail for many to be convincing. Graffiti have duly been noted in *CVA*, often with useful comment appended, as well as in such recent ceramic monographs as B. Philippaki, *The Attic Stamnos*, H. Mommsen-Scharmer, *Der Affecter* and R-M. Becker, *Formen Attischer Peliken*. I have previously published a survey of the subject in *Greece and Rome* 21 (1974) 138ff, as well as a number of articles *AJA, BICS, BSA, PdP* and *ZPE*.

This work comprises a catalogue of marks designed to include all those that appear more than once on decorated Attic vases (for the partial exclusion of Attic glazed vases see p. 8), as well as complete lists of those on vases of other fabrics. A commentary on the several types of mark discusses their interpretation, script and distribution, as well as relevant aspects of the vases on which they are cut. The introductory chapters 'Aspects of Trademarks' deal with broader topics, bringing together the results obtained in the catalogue and commentary.

I have no doubt that in places my argument is too rigorous for the casual nature of the material, but I have thought

it best to err in this direction rather than to omit mentioning conclusions to which the straight line leads. New finds will certainly overthrow some more detailed points, but I hope that the broad outlines are now secure. Last minute inclusions have indeed necessitated minor corrigenda (e.g. 24E, 10 has opened Euphronios' account as an employer of 'regular' trademarks), and the addenda may well see others.

My original thesis was submitted in 1972; like many of its fellows it has undergone major surgery before publication, not only because of new finds and publications, but to remove blemishes and infelicities of all kinds. The most recent material of which I have been able to take full cognizance is that published, or rather available to me in mid-summer 1978. Some later material has been taken in but not fully digested (e.g. *Himera* ii, *Graffiti Antichnayo Chersonesa*).

My coverage of material cannot claim to be complete; while it goes far beyond the range of published evidence, I have only harvested the trademarks of a proportion of the world's unpublished Greek vases, concentrating in particular on collections in Cyprus, France, Great Britain and Northern Ireland, Greece, the Irish Republic and Italy. Since 1967 I have been assisted in my quest by a very large number of colleagues in these and other countries, and to their tolerance and generosity I dedicate these results. I am therefore pleased to record here my thanks to the following for their some-time assistance:

Many members, past and present, of the Dept. of Greek and Roman antiquities, British Museum; R. J. Charleston (Victoria and Albert Museum); S. Bon, R. Burgess, Ch. Ede, F. Nicholson (London); P. Stilwell (Harrow School); L. V. Grinsell (Bristol); A. Brown, H. W. Catling, M. J. Vickers (Oxford); R. M. Cook, R. V. Nicholls (Cambridge); Sir R. Mackworth-Young (Windsor); J. Ruffle (Birmingham); Lady Bromley-Davenport (Capesthorne Hall); I. Wolfenden, M. Warhurst (Liverpool); A. J. N. W. Prag (Manchester); J. Horsley (Newcastle); R. Oddy, H. V. Whitehouse (Edinburgh); J. Scott (Glasgow); R. D. Lockhart (Aberdeen); L. Flanagan (Belfast). J. Rafterey (Dublin). P. Devambez, A. Kaufmann, F. Villard, A. Waiblinger (Louvre); I. Aghion (Bibliothèque Nationale); S. Nikitine (Compiègne); E. Chirol (Rouen). A. E. Prescott (Ampurias); M. Picazo (Barcelona). J. Balty (Brussels); T. Hackens (Louvain). M. F. Jongkees-Vos, C. Kern (Leiden). P. A. Hansen, T. Melander, F. Johansen (Copenhagen). Ch. Scheffer, M-L. Winblat (Stockholm). E. Olshausen (Tübingen); D. Metzler (Karlsruhe); K. Deppert (Frankfort); H. Mommsen, N. Kunisch (Charlottenberg, Berlin); G. Beckel (Würzburg); B-A. Follmann, D. Ahrens (Munich). H. Steiner (Gotha); E. Kluwe (Jena). R. Noll, W. Oberleitner (Vienna). B. Ruszczyc (Warsaw); M. L. Bernhard (Cracow). M. Lazarov (Varna). J. Szilagyi (Budapest). K. S. Gorbunova (Leningrad). E. Arslan, B. M. Scarfi (Milan); E. Mangani (Venice); S. Patitucci-Uggeri (Ferrara); R. Pincelli (Bologna); P. Bocci, M. Martelli-Cristofani (Florence); A. E. Feruglio (Perugia); L. Fabbrini, A. Morandi, M. Moretti, M. Torelli (Rome); F. Roncalli (Vatican); A. de Franciscis, P. Pozzi (Naples); B. d'Agostino, V. Panebianco (Salerno), F. G. Venosta (Capua); F. G. Lo Porto, G. Andreassi (Taranto); P. Pelagatti (Syracuse); E. de Miro, G. Fiorentini (Agrigento); V. Tusa (Palermo). O. Alexandri, M. Brouskari, U. Knigge, B. Philippaki, T. L. Shear Jr, E. Vanderpool, F. Willemsen (Athens), Ch. Koukouli (Kavalla), C. K. Williams (Corinth); W. Gauer (Olympia); G. Papathanasopoulos (Sparta); I. Zervoudaki (Rhodes). H. A. Cahn, Chr. Leon, M. Schmidt (Basel); Chr. Dunant (Geneva); H. Jucker (Bern); H. Braun (Cologny). N. Firatlı (Istanbul). V. Karageorghis, I. Nikolaou (Nicosia). J. R. Green, J-P. Descouedres (Sydney); I. D. McPhee, A. D. Trendall (Bundoora). M. Hind (Dunedin). R. S. Bianchi, D. von Bothmer, J. V. Noble (New York); A. Herrmann, C. Harward (Boston); S. H. Auth (Newark); D. K. Hill (Baltimore); C. Boulter (Cincinnatti); L. Berge (Chicago); W. H. Peck (Detroit), K. B. Gates (Portland); R. M. Riefstahl (Toledo); W. Osmun, P. Packard (Los Angeles); J. Frel (Malibu). J. W. Hayes (Toronto).

For further assistance and discussion I am grateful to D. A. Amyx, J. Boardman, P. A. Cartledge, M. Cristofani, G. E. M. de Ste. Croix, L. H. Jeffery, D. C. Kurtz, C. M. Robertson, J. B. Salmon, B. B. Shefton, B. A. Sparkes. The second, fifth and sixth guided my steps as examiners and supervisor at Oxford and I owe them a considerable debt.

Periods of study abroad were only possible through the generous financial support of: the Craven Fund, Oxford University; Merton College, Oxford; the Faculty of Arts, University College London; the Central Research Fund, University of London. An award from the Small Grants Research Fund of the British Academy lightened the load of photographic expenses.

ABBREVIATIONS

I have in general followed Beazley's usage, but recapitulate the details here. See also the introductory remarks to individual entries in the Museum Index.

AA	Archäologischer Anzeiger
AAA	Athens Annals of Archaeology
ABL	C. H. E. Haspels, Attic Black-figure Lekythoi (Paris, 1936).
ABV	J. D. Beazley, Attic Black-figure Vase-painters (Oxford, 1956).
ADelt	Ἀρχαιολογικὸν Δελτίον
AE	Ἀρχαιολογικὴ Ἐφημερίς
AEA	Archivo Español di Arqueología
Agora	The Athenian Agora; results of excavations conducted by the American School of Classical Studies at Athens
AK	Antike Kunst
AJA	American Journal of Archaeology
AM	Mitteilungen des Deutschen Archäologischen Instituts, Athenische Ab.
Amazons	D. von Bothmer, Amazons in Greek Art (Oxford, 1957)
Annali	Annali dell'Instituto di Corrispondenza Archeologica
Ann. Arch. Arab. Syr.	Annales Archéologiques Arabes Syriennes
Ant. Cl.	L'Antiquité Classique
Arch. Class.	Archeologia Classica
Arch. Rep.	Archaeological Reports
Ars A. A.	Ars Antiqua A. G. (Luzern), Auktion
ARV	J. D. Beazley, Attic Red-figure Vase-painters (2nd ed., Oxford 1963)
ASA	Annuario della Scuola Archeologica di Atene
ASMG	Atti e Memorie della Società Magna Grecia
ASV MM	Attische Schwarzfigurige Vasen, Münzen und Medaillen A.G., Basel 1964.
Auktion	Münzen und Medaillen A.G., Basel, Auktion
AV	Ed. Gerhard, Auserlesene Griechische Vasenbilder (Berlin, 1840-58).
BABesch	Bulletin Antike Beschaving
Beazley Gifts	Select Exhibition of Sir John and Lady Beazley's Gifts to the Ashmolean Museum, 1912-1966 (Oxford, 1967)
BCH	Bulletin de Correspondance Hellènique
Bechtel	F. Bechtel, Die griechischen Dialekte (Berlin, 1921-4)
BIAB	Bulletin de l'Institut Archéologique Bulgare
BICS	Bulletin of the Institute of Classical Studies, London
Bloesch, AKS	H. Bloesch, Antike Kunst in der Schweiz (Zurich, 1943)
BMC	British Museum Catalogue (of Vases, unless otherwise stated)
BMFA	Bulletin of the Museum of Fine Arts, Boston.
BMM	Bulletin of Metropolitan Museum, New York.
Brommer	F. Brommer, Vasenlisten zur Griechischen Heldensage (3rd ed., Marburg, 1973)
BSA	Annual of the British School at Athens
BSR	Papers of the British School at Rome
Bull. Inst.	Bullettino dell'Instituto di Corrispondenza Archeologica
Cal. St. Class. Ant.	California Studies in Classical Archaeology
CB	L. D. Caskey and J. D. Beazley, Attic Vase Paintings in the Museum of Fine Art, Boston (Oxford and Boston, 1931-1963)
CIE	Corpus Inscriptionum Etruscarum
CIG	A. Boeckh, Corpus Inscriptionum Graecarum (1828-1877)
CII	Corpus Inscriptionum Italicarum
CRAI	Comptes rendus de l'Académie des Inscriptions et Belles-Lettres
CVA	Corpus Vasorum Antiquorum
Ergon	Το Ἔργον τῆς ἐν Ἀθήναις Ἀρχαιολογικῆς Ἑταιρείας
Forman	C. H. Smith, The Forman Collection (Sotheby, 19/6/1899)
Fowler and Wolfe	M. Fowler and R. G. Wolfe, Materials for the Study of the Etruscan Language (Madison, 1965)
FR	A. Furtwängler and K. Reichold, Griechische Vasenmalerei (Munich 1904-1932)

G & R	*Greece and Rome*	*Quad. V.G.*	*Quaderni di Villa Giulia, Rome*
Gardner	P. Gardner, *Catalogue of Greek Vases in the Ashmolean Museum* (Oxford 1893)	*RA*	*Revue Archéologique*
		Raubitschek, *DAA*	A. E. Raubitschek, *Dedications from the Athenian Akropolis* (Cambridge, Mass, 1949)
GGA	*Göttingische Gelehrte Anzeigen*		
Hackl	R. Hackl, 'Merkantile Inschriften auf Attischen Vasen', *Münchener Archäologische Studien dem Andenken Adolf Furtwänglers gewidmet*, 1-106 (Munich 1909)	*RE*	Pauly-Wissowa-Kroll, *Real-Encyclopädie der klassischen Altertumswissenschaft* (1894-)
		Rec.Art.Mus.	*Record of the Art Museum, Princeton University*
Hope Heirlooms	*The Hope Heirlooms; Irish Purchases now on view in the Central Court of the National Museum, Dublin* (Dublin, 1917)	*REG*	*Revue d'Etudes grecques*
		Rev.Phil.	*Revue Philologique*
		Rend.Linc.	*Rendiconti della Accademia dei Lincei; Classe di scienzi morali etc.*
HSCP	*Harvard Studies in Classical Philology*		
IG	*Inscriptiones Graecae*		
IM	*Mitteilungen des Deutschen Archäologischen Instituts, Istanbuler Abteilung*	*RG*	J. D. Beazley and F. Magi, *La Raccolta Benedetto Guglielmi nel Museo Gregoriano Etrusco* (Vatican, 1939)
Int. J. Naut. Arch.	*International Journal of Nautical Archaeology*	Richter and Hall	G. M. A. Richter and L. F. Hall, *Red-figured Athenian Vases in the Metropolitan Museum of Art* (New Haven, 1936)
JdI	*Jahrbuch des Deutschen Archäologischen Instituts*		
JHS	*Journal of Hellenic Studies*	*Riv.Fil.*	*Rivista di Filologia*
JPGMus.J	*J. Paul Getty Museum Journal*	*Riv.Stor.Ant.*	*Rivista Storica dell'Antichità*
Kirchner, *PA*	J. Kirchner, *Prosopographia Attica* (Berlin, 1901)	*Riv.St.Lig.*	*Rivista di Studi Liguri*
		RM	*Mitteilungen des Deutschen Archäologischen Instituts, Römische Abteilung*
LSAG	L. H. Jeffery, *The Local Scripts of Archaic Greece* (Oxford, 1961)		
		SCE	*The Swedish Cyprus Expedition*
Mat.Res.	*Materialy i Issledevaniya po Arkheologii SSSR*	*Schw.Münzbl.*	*Schweizer Münzblatter*
MEFR	*Mélanges de l'Ecole Française de Rome*	*SEG*	*Supplementum Epigraphicum Graecum*
Micali	G. Micali, *Storia degli antichi populi Italiani* (3rd ed, Florence 1849)	*SNG*	*Sylloge Nummorum Graecorum*
		SNR	*Schweizische Numismatische Rundschau*
MJbBK	*Münchner Jahrbuch Bildender Kunst*	*Sov.Arch.*	*Sovietskaya Archeologiya*
ML	*Monumenti Antichi, pubblicati per cura della Reale Accademia dei Lincei*	Spencer-Churchill	*Exhibition of Antiquities and Coins purchased from the Collection of the late Capt. E. G. Spencer-Churchill, Ashmolean Museum, Oxford, 1965.*
MM	*Mitteilungen des Deutschen Archäologischen Instituts, Madrider Abteilung*		
		Stamnos	B. Philippaki, *The Attic Stamnos* (Oxford, 1967)
Mus.Greg.	*Museum Gregorianum Etruscum* (Rome, 1842)	*St.Etr.*	*Studi Etruschi*
		Stud.Class.	*Studii Clasice*
NC	H.G.G. Payne, *Necrocorinthia* (Oxford, 1931); catalogue numbers.	Thumb-Kieckers	A. Thumb, *Handbuch der griechischen Dialekte* I (2nd ed, Ed. E. Kieckers, Heidelburg, 1932)
NSc	*Notizie degli Scavi di Antichità*		
Ol. Ber.	*Bericht uber die Ausgrabungen in Olympia* (1937 -)	*TLE*	M. Pallottino, *Testimonia Linguae Etruscae* (Florence, 1954)
Ol. Forsch.	*Olympische Forschungen* (1944 -)	*VDI*	*Vestnik Drevneii Istorii*
Paral	J. D. Beazley, *Paralipomena to ABV and ARV* (Oxford, 1971)	*Vente (Drouot)*	*Vente à l'Hôtel Drouot*
Payne	see *NC;* page numbers.	Villard	F. Villard, *La Céramique grecque de Marseilles* (Paris, 1960)
PdP	*Parola del Passato*		
Pottier	E. Pottier, *Vases Antiques du Louvre* (Paris 1887-1922)	Zannoni	A. Zannoni, *Gli Scavi della Certosa di Bologna* (Bologna, 1876)
Proc.Roy.Ir.Ac.	*Proceedings of the Royal Irish Academy*	*ZPE*	*Zeitschrift für Papyrologie und Epigraphik*

CHAPTER 1
THE ORIGINS AND GROWTH OF USE OF COMMERCIAL MARKS

A good number of Mycenaean vases, found largely in Cyprus and the Near East, have painted marks under the foot, and there can be little doubt that they have a commercial significance.[1] Superficially they have much in common with marks of the Iron Age - dipinti under the foot of exported vases, forming small groups. A proportion of them appear to be non-syllabic (equivalent to later non-alphabetic marks?), while others may well be abbreviations of personal names. There is, however, little firm ground on which to base any thorough interpretations of this material.

In certain aspects of material and spiritual culture an unbroken, if tenuous tradition survived the centuries after the demise of Mycenaean power, but there can be no possibility that techniques of vase-exporting formed part of that tradition, nor that the signs which we find on Late Helladic vases survived in any repertoire of trademarks or the like to be brought back into use more than three hundred years later. Such signs that appear on both Helladic and Hellenic vases belong to the very basic repertoire of decorative ornament, such as the swastika or asterisk; otherwise their appearance must be pure coincidence, e.g. marks similar to type 11E found on vases from Cyprus, and earlier on Kea.

The alphabet was adopted by some Greeks around the middle of the eighth century, and its use spread haltingly throughout Greece, Italy and Asia Minor. The earliest material that we possess is in the form of graffito inscriptions on vases, very many of them simple owner's marks of the type 'I belong to X'. Recent excavations at Pithekoussai on Ischia have also yielded large numbers of more abbreviated marks, alphabetic and otherwise, which we could regard as forerunners of later trade marks on decorated vases.[2] One mark, on an amphora of c. 730 BC, is of particular note, since it is accompanied by an Aramaic graffito, two pictorial doodles and an apparent numerical mark; it consists of two letters only, *phi iota,* but the first is of course one of the letters added by the Greeks to the Phoenician series, and the *iota* is straightened, perhaps the earliest example in Greek, not the crooked form of Phoenicia and the equally early Greek inscription on the oinochoe from the Dipylon cemetery at Athens.[3] Φι . . . is presumably the beginning of a personal name, as it is on a good number of later vases. The exact significance of such marks is hard to establish; indeed there may have been more than one purpose in inscribing them. Most no doubt indicate ownership, but as most of these amphorae were imports into Pithekoussai, it is open to consider that the owners may have been the traders who brought them and displayed them on the strand there. They may have wished to reclaim them when their contents were purchased and removed; such reuse is something of an unknown quantity, even if it is clear that large numbers of amphorae at this period remained at their destination to be used as burial urns.

Such marking of amphorae continued into the seventh and sixth century. A sequence is most clearly seen in the case of the Attic 'SOS' oil amphora, widely exported throughout the Mediterranean from c. 730 to 570 BC. A good proportion (but by no means all) bear graffiti on the shoulder or neck, ranging from full owner's marks to single letters or non-alphabetic shapes. There are very few cases of any mark appearing more than once. None of them is obviously commercial; some may be numerical, but proof is lacking. However, as with the Pithekoussai amphorae (which include SOS) there is presumably some trading transaction bound up with the inscribing of many of the marks, the great majority of which are probably in Attic script.[4]

Staying in the same field we may note some Chian wine amphorae of the seventh century bearing graffiti from the excavations at Old Smyrna.[5] The marks are scarcely instructive; some of the single letter marks may indicate in choes the capacity of the jars, but this is not solid enough evidence for us to assume the existence of the Ionic numeral system at this time, though it is a probable conjecture. With the evidence available it is not possible to compare SOS and Chian usage of graffiti. The Smyrna material shows at least that the use of graffiti for marking large and small vases was well established there in the seventh century.

The use of the underside of vases for decoration also became fairly widespread in the eighth and seventh centuries, most regularly on the Attic Geometric pyxis and Protocorinthian conical oenochoe, but also sporadically on other vases.[6] One late seventh century usage comes particularly close to the more casual application of trademarks on this part of the vase, at Vroulia on Rhodes, where neat spirals appear in the shallow cone of the underside of several cups;[7] Kinch suggested that these were potters' marks, but perhaps they are rather a simplification or reminiscence of earlier decorative patterns in this position. Whatever their interpretation, they do lead easily on to the use of this part of the vase for commercial dipinti, especially red marks which have something in common with painted decoration, even if applied after firing.

Most of our earliest trademarks are red dipinti and alphabetic; they therefore are no direct descendants of the decorative underfoot features just mentioned or the alphabetic graffiti found on storage amphorae on neck or

shoulder. We·need not perhaps search for more direct antecedents for the trademarks; SOS amphorae were given graffiti because they showed up best on the glazed surface, and it is possible that Chiot (or other) amphora types may have carried more dipinti in this early period than our present evidence suggests (although even on unglazed amphorae at Pithekoussai graffiti seem to have been the rule). In the present state of our knowledge the earliest red dipinti occur on Corinthian 1 and 2, followed late in the century by East Greek examples. It may be that the use of red was first adopted on stone inscriptions, which are rare before the second half of the seventh century.[8] The appearance of red marks on Attic vases in the sixth century may have been due to Corinthian influence.

It is hard to deny an international flavour in the spread of the use of commercial marks. The range of amphora types from Pithekoussai with marks is wide, and the Attic SOS, complete with graffiti, travelled to very many ports in the seventh century; at the end of the century traders from Corinth and East Greece began putting abbreviated marks under the feet of a proportion of the vases with which they were dealing, but for the most part used red pigment, presumably because it was more readily visible than graffito marks and they were aware of painted decoration in any case on this part of the vase. This step coincided with the foundation of the trading post at Naukratis, c. 620-610. The purpose of these marks was probably not the same as that of marks on amphorae, for now the vases themselves, not the contents, were the objects of trade; a mark could have had only a chronologically quite restricted use.

Compared with later sixth century Attic black-figure, few Corinthian and East Greek vases are marked, but the figures are much the same if we look at pre-550 Attic production.[9] In this period Athens was not only absorbing Corinthian influence and perhaps craftsmen, but she was also looking to the same markets, especially in the West. Finley has suggested that Corinthians were transporting Attic vases, without any thought of competition,[10] but I doubt whether this was the case; no marks on Attic vases of the period, or later, are plausibly in Corinthian script, and even ignoring alphabetic differences, there is no overlap in the repertoire of marks used (see p. 235). The early Attic marks are generally·an undistinguished lot, mostly single letters, though there are a number of reasonably long, three-letter dipinti, all different.[11] The script of these marks may be Attic, though signs like Ionic *gamma* and *lambda* do appear; however, there is again no overlap with marks on East Greek vases, save for the ubiquitous X; only later do some marks with an apparent East Greek pedigree come to be used on Attic vases (p. 236-7). The more obvious non-alphabetic shapes, such as X, swastika, asterisk and pentagram seem to have been common property, while others are more unusual, thought up perhaps by illiterate traders as truly individual marks. Impression of marks from a stamp or gem is unknown on decorated vases and rare on plain ware in the archaic period.[12] A few marks are likely to be pictographic - certainly 36A and 9D, probably some others, but *in toto* they cannot amount to any appreciable proportion.[13]

We find both the oldest and the greatest bulk of ligatures in the Greek world among trademarks, before they become common on coins of the classical period. It is tempting to suggest that the concept was introduced by traders, along with a broad range of complex non-alphabetic marks.[14]

Ligatures are rare before c. 550. There is no certain case of one on SOS amphorae. It should of course be stressed that many abbreviations cannot be satisfactorily or obviously ligatured, which may have impeded the spread of their use. The earliest assured examples seem to be on Chiot vases, an amphora handle from Smyrna and chalices from Naukratis, though they are rare;[15] marks of type 19B are frequent on East Greek vases, but it is not necessarily a ligature (p. 236). Probably closely contemporary with the chalices are the Middle Corinthian vases, 42, 45 and 46, with 105 rather later. These are perhaps the only possible ligatured marks on Corinthian vases, while others on East Greek pieces are mostly later than 550; perhaps only *Tocra* 652 and *Tanis* ii pl 32,3 are earlier. Later are East Greek 75, 87, 91 and 110 and probably the amphora handles *Naukratis* i 397a, 419 and 420. The major feature of all the early East Greek ligatures is that they are simple letters with only one added stroke, involving *alpha, epsilon* or *eta* with *lambda* or *upsilon.* The Corinthian ligatures are more complex, though simpler forms appear cut on the blocks of the Diolkos and perhaps dating to the early sixth century.[16]

The first ligatures on Attic vases are of types 4D, 10E and 17E. 17E, 22 and 25 are earlier than the middle of the century; 4D conveniently (or deliberately?) conceals the inter-state difficulties of recognising names in Her - - - -. After this, ligatures are a regular feature of trademarks, though they do not find widespread use in Greece otherwise; for example, they are relatively scarce among the graffiti on vase feet from the Akropolis, where unligatured versions are as likely to be used, and from the Athenian Agora only *Agora* xxi F14, F15, F27, F45-6, F48?, F52, F69 and F73 date to before 450.[17] At Naukratis also we find abbreviations which could be ligatured but are not;[18] however, this material (certainly the Chiot) is earlier than that from the Akropolis or Agora. In Greece most ligatures are later than c. 525, and appear sporadically from state to state; I know of none from Sparta, Rhitsona or Olynthos, few from Olympia and Rhodes and one each from Delphi and the Argive Heraion. They are more common at Corinth and on Delos and Cyprus.[19] The *delta-alpha* ligature on vases from the sanctuary of Aphaea on Aegina are probably earlier than 480.[20] In the Greek material common ligatures are the varieties of type 2B, 4D, 9E and 10E. Ligatured *mu-epsilon* within a word is found at three different sites in the fifth century.[21]

We may note some unusual and complex ligatures, though it may well be that the most recherché lie hidden behind their own obscurity. Of unusual form are the 'internal' ligatures of *alpha* or *epsilon* with *rho* (3E, v and 9E, xi); that of four-bar *sigma* with *iota* is at best confusing (7D, iv). The most complex ligature is probably 9E, 118, though other members of 9E are far from simple, notably sub-group xiii. Palermo 1820, neck amphora by Psiax (*ABV* 292, 4), has what may be a ligature of four-bar *sigma* and *eta* (Fig. 14e) and a monogram of MET is found on an unpublished small kylix foot from Adria (Ce 30).

Addendum The Use of Ligatures.

It may be thought that while personal abbreviations would tend towards ligatured forms, abbreviated vase names would not be so treated. Does the evidence support such a case? The generalisation does in fact hold for the most part, but there are some exceptions. Most noteworthy is type 2F, which has a clear vase-name connotation, though I argue that it does not refer to any one particular vase shape. Elsewhere the interpretation is not so secure; 5E, 6E and 12E may be ligatures and may have a non-personal meaning, but neither is proven. Some marks consisting of *lambda* and *epsilon* in ligature are found in direct relationship with numerals and could be vase names (16E, 8-9 - perhaps not *lambda* - , 17E, 37 and 21E, 44); also Ragusa 23004 (p. 60, n. 26). Since it is unlikely that both ligatured marks on 9E, 71-73 are personal abbreviations, we may assume a vase-name meaning for the *alpha-rho* on them. 9E, 73a confirms both these usages.

To confound the issue a little there seem to be cases of ligatured marks without vase-name significance being accompanied by numerals, including perhaps 16E, 8-9 mentioned above. However, they are few, and even fewer are groups of such marks: 5D, 2-4, 1B, 7, 7B, 6, 11F, 29 and Gela, Navarra 11 (p. 28); on 7B, 6 the numerals seem to be in another hand. [22]

The last four are from Sicily or Magna Graecia, and vases from Sicily also figure prominently among those with unligatured personal abbreviations closely related to numerals: 18B, 12 from Lipara and Gela 10597 (p. 60, n. 26); 9E, 124 from Ruvo has an AP1 with a possible adjectival force, while it is not easy to discern on what the numerals depend on 9E, 98 from Gela. 21A, 101 and 104 are clearly distinct from the rest of the type, but have nothing in common between themselves save the proximity of numerals. The unity of the mark 17B, 4 is not certain. Elsewhere, a single letter with no obvious vase-name meaning may introduce numerals: *alpha* on 18C, 59 and 63, 6D, 7 and 24F, 2; *mu* on 13B, 5-7, 28; *beta* on 6B, 15. [23]

In sum, occurrences of ligatured vase-name abbreviations are rare, or at least doubtful, beyond type 2F, while not many more examples of personal monograms or ligatures in direct relationship with numerals can be found.

CHAPTER 2
PHYSICAL ASPECTS OF THE MARKS

Dipinti

Painted marks occur only under the foot of decorated vases, with the exception of Chiot 68-9. I am inclined to think that four types of paint were used:

1. 'Added' red, as used in black-figure decoration. 21A, 29 is the sole example.
2. A non-lustrous black pigment. See 21A, 28, and I suggest that 9B, 20 and 5B, 6 may be similar. It is possible that any or all of them may be in glaze, which has been absorbed by the unpolished underside of the foot.
3. Glaze, used especially during the period 515-500, but never more frequently than
4. Matt red paint, often quite vivid when well preserved.

Glaze marks tend to make up small groups, some of which have close connections with red or graffito versions (16B, 9E, 10E). Isolated marks are rare, subsidiary list 2, 25, 33-36 in red-figure, and on black-figure 17B, 1 and three on vases by the Amasis painter, which may yet prove to be related: New York 56.171.10 (*CVA* 3, 6), Rome, Guglielmi (subsidiary list 6, 2) and Castle Ashby (12A, 4). If the pigment of the last two is glaze, rather than a matt black, these four are the earliest such marks on Attic vases, though Corinthian 4 is much older, rather isolated as a glaze mark c. 600 BC. I do not know the type of pigment used for the later Corinthian 63 and 87. No proof is needed that glaze marks were applied before the firing of the vase, but it is pleasing to note that the Etruscan graffito on 21A, 24 cuts clean across the mark.

There is a certain variety to the hue of the red dipinti and it is possible that more than one chemical pigment was used; certainly the two dipinti of 1E, 5 and 9 are different shades of red, and they are so close together on the foot that the explanation cannot lie in different circumstances of preservation. It is probable that the normal substance was a red ochre, though handbooks of ancient technology have mooted other possibilities.[1]

Preservation is of key importance in assessing and studying the use of red dipinti. I note in subsidiary list 5 a hundred and thirty-seven vases (with further red-figures examples in list 2) on which only traces of red can now be seen, ranging from the faintest washed out smear to substantial remnants either of the original mark or of later run-lines. As many of these marks are on earlier Attic pieces we can estimate that a substantial body of evidence is no longer available to us in this area. It is usually possible to distinguish between remains of dipinti and 'miltos' used decoratively, smeared under the feet of smaller vases, mainly in the fifth century and later.

Many factors must have contributed to the damage caused to red dipinti. Enough are fresh enough still to suggest that they generally suffered little before the vase was deposited in the tomb, where no doubt dampness in the soil and other debris did its work; some marks still legible are streaky and washed out in appearance, a decomposition consistent with slow erosive action. On other occasions only the ghost of the mark is left on the clay surface, often a darkish brown not easily distinguished from stains left by roots and the like. The typical appearance of a poorly preserved mark is a few faint patches, generally on the navel, and a thicker deposit washed into the angle of foot and navel; care should be taken to assess whether paint here is in its original position or not.

If this substance is 'miltos' one cannot but feel that the Greek sailor must have spent more of his time painting than voyaging. The resistance of the marks to alcohol varies, though I think all would eventually yield to it;[2] here I deliberately echo Pottier's words in *CVA Louvre* 9, 66, where they are used in connection with a black mark (21A, 28). It was found safe to use acid to clean the vases with dipinti found at Tocra. So it would appear that lengthy exposure to a solvent is necessary to effect removal, though one suspects from the scoured feet of many early Attic black-figure vases that not all marks have been lost through natural causes.

While it is impossible to estimate the number of dipinti now lost, it is important to remember this hidden statistic. As well as those that have disappeared for ever there are a certain number lying beneath an accretion of dirt or calcite, in theory perhaps still recoverable.

It is of some moment to establish whether red dipinti were applied before or after firing. Amyx published a Corinthian oenochoe (41) with what he took to be a pre-firing mark, and I add another in the same category.[3] Noble states categorically that all dipinti were applied before firing.[4] Yet the two vases just mentioned are the only

substantial evidence for that viewpoint. Other Corinthian marks (33, 55 and 59) are very clearly painted over the glaze rings under the foot, almost certainly after firing. There are further arguments to show that red dipinti were normally applied after firing.

In particular some dipinti seem to have been applied over graffiti which in turn are post-firing. Unfortunately the number of examples is not large and in many cases the faintness of the dipinto or overlying dirt make it impossible to judge the order of application. Even where red does overlie a graffito line caution is necessary, as this could have been caused by later leeching out of the dipinto; similarly where a line appears to cut through a dipinto mark it is possible that the red paint may have been washed out only down the line of the incision.[5] One must therefore concentrate on dipinti in substantially their original condition. The best, perhaps the only cast-iron example of a good thickness of paint overlying a graffito is on Oxford 1910.804 (Pl. 9; 9E, 62); even here the edges of the dipinto are rather worn.

Also we have a number of dipinti which appear to be Etruscan, painted on Attic vases (p. 238). Such marks could not have been applied in the pottery unless Etruscans actually visited Athens or a Greek worker was using Etruscan letters to facilitate handling at the other end of the trade route; neither theory has much to recommend it, though the former is not beyond credibility; some of the Etruscan marks, graffiti rather than dipinti, seem to have a commercial significance, and one mid-fifth century sherd has an Etruscan vase inscription. [6]

Red dipinti are also often found on wine amphorae and other containers; the neck or shoulder of the vase is normally used. Some of these may have been owners' marks, but most no doubt had some commercial significance. As the growth in the use of marks on plain and decorated vases seems to have been largely contemporary we may accept a similar significance for dipinti on decorated vases.[7]

Dipinti are also found on less coarse vases from Greece (as well as on architectural blocks and the like - see Appendix 3). Most are in glaze and the largest category is of bespoke dedicatory inscriptions, on various parts of the vase, including the underside; e.g. see p. 250 n. 2 for material from Sparta, including a public measuring pot of a type well known from Olympia and Athens. Some more puzzling dipinti are known from the last two sites: Agora P10001 is the lid of a plain non-Attic vase with a dingy grey V-shaped mark by the handle; three dipinti on vases from the Kerameikos are known to me: glaze *delta* under the foot of a late fifth century squat lekythos, EPI under the foot of a b.g. Corinthian type skyphos and X in white under a largish echinus-shaped foot, roughly glazed inside. From Olympia, apart from the public measures, I know of five dipinti: one red and one glaze published in *Ol. Forsch.* v 152-7, 26 and 88; three glaze marks on fifth century cups of local manufacture, EVE (*Ol. Forsch.* viii 31), AI and ΓEO.[8]

Throughout the period of use of dipinti there is little resort to cursive lettering; two exceptions, 24B, 12 and 4E, 1, are very likely of Etruscan origin. In some cases we even see letters from the mason's book being painted, notably some of the *omicrons* of type 17A and what I take to be an *omicron* on a neck-amphora of c. 540 in Orvieto (*St.Etr.* 30 (1962) 82). However, the *sigma* of type 1E is often sinuous.[9]

Graffiti

Incised lettering on vases was the earliest form of writing adopted by the Greeks in the Iron Age and therefore it is no surprise that this method of marking vases for commercial purposes eventually prevailed; yet during the first half of the sixth century graffiti are rather conspicuous by their absence, except in the case of material from Naukratis.

It has occasionally been argued that graffiti were cut before the firing of the vase.[10] Hackl did not accept this, taking as his example Berlin 2188 (6F, 1) which Furtwängler had stated was inscribed with the clay still leather-hard. The excellent photograph of the mark in Kirchner, *Imagines Inscriptionum Atticarum*[2] pl. 11 makes clear the torn edges of the incised lines, indicating that the work was done after firing, since a pre-firing incision would have straight, clean edges and, if the lines were any width, slight ridges of clay to either side. [11] I am not convinced that any trademark shows signs of pre-firing application. Care was sometimes taken, so that the end product was not always as ragged as Berlin 2188; the person who cut the tomb numbers on the vases from Biliotti's excavations at Kamiros in the British Museum did careful work, but not, I fancy, before firing. Much the same goes for Etruscan graffiti of good quality, rare though they are.

A variety of tools must have been employed for incision work, though one can go no further than saying that they were of varying sharpness and width; occasionally sub-groups of marks can be distinguished by criteria of incision; cutting-compasses were also employed, if rarely. See type 21A in particular.

Graffiti appear in a number of places other than under the foot, unlike dipinti. Here it is extremely difficult to make a decision as to whether a given mark, say on the shoulder of a decorated vase, has a commercial significance; in subsidiary list 1 I have gathered together those pieces which could be thought of as such, though I argue that only a proportion belong to the category. The total (even if we include non-figured vases) [12] is paltry compared with the two thousand five hundred or so underfoot marks; this fact suggests that some enquiry be made into the reasons for this small number of disfiguring marks. In the following discussion the numbers refer to the entries in subsidiary list 1.

One mark was definitely repeated under the lid which belonged to the vase, 40; we cannot tell whether any others on vases once lidded may have had the same purpose. The use of underfoot marks partly or wholly for such a

purpose is reviewed under type 3F; it would seem that the practice was not particularly widespread, and it can be further noted that isolated lids do not often have marks.[13] Many of the marks are non-alphabetic and so could have been applied in Greece or Etruria, although there are cases where we can be more confident of the place of application (e.g. 3F and 24B, 14 respectively). On 40 there is already a 'regular' trademark of type 1B under the foot.

A number of the marks are relatively inconspicuous, including those on the handle and some on the shoulder in the vicinity of the handle, 22, 26 and 29; others, such as 3, 4, 13, 21, 30, 31 and 32 are very ill-positioned.[14] The former category includes some pieces with an underfoot mark repeated on the body of the vase and there can be little doubt that these (37-39) are trademarks; we may suspect that the second group had a more ostentatious purpose - advertisements of ownership or dedication. To the last category belong the most monumental inscriptions ever cut on vases, dedications on prize Panathenaic amphorae found at Isthmia, Sparta, Olympia and other sites.[15] None of the four prize amphorae included in the list (9, 25, 27, 28) have such marks; they could all be numerical and to that extent, but no further, have some connection with the only underfoot marks found on prize Panathenaics discussed under type 4F. Such exclusive marking of prize vases (and not a very large proportion of them) clearly sets them aside from the regular marketing system of other big vases. It is almost certain that all of the marks on them belong to a second phase in the life of the vases.

As well as 37-39, 6, 15, 16 and 48 have an underfoot mark repeated, unobtrusively save on 16, elsewhere on the body. 6 is of interest as having the underfoot glaze dipinto repeated graffito and post-firing.

A good proportion of the remaining marks are on quite early black-figure vases (1-4, 12-14, 20-23, 30-33, 36, 48). These graffiti are readily visible at a cursory glance. Only 12, 13, 20, 22, 23, 32 and 48 have known provenances, but Etruria is the likely find-spot of at least 1-3, 21, 30 and 31; on the other hand the marks on 2, 12, 20, 21, 23, 30-3 and 48 (and probably others) are Greek. In these circumstances 30 and 31 could well be a mercantile pair. 1, 3, 12 and 32 could possibly be owner's marks,[16] but this is hardly likely for 4, which has two abbreviated words on the lip in what appears to be Attic script.[17] HI suggests some kind of dedicatory formula, though it would be surprising on a tolerably preserved large vase; the fact that three other pieces have H or HI cut on top of the lip (5, 7 and 10) may tempt us to see a single motivation, but the pieces are very different in shape, date and provenance. 7 from an Etrurian site has Greek HI, perhaps in this case a trademark.

33 may be an owner's mark, cut on an inconspicuous part of the body, while 36 could be a mercantile mark (see p. 191); it is well cut and does not detract from the appearance of the piece. 32 is odd in being upside down and it is intriguing to guess at the circumstances of its cutting, but a wide range of possibilities is open.

Of the marks dating to after c. 530, 18 I take to be an owner's mark, the provenance of the piece being unknown; 24 too could be an owner's inscription, if ancient; certainly if it were commercial and contemporary with the manufacture of the piece the tailed *rho* would be unusual. 26 is completely isolated from other material and is presumably another owner's mark. Little can be said of the single letter marks 35, 46 and 52, apart from noting the rare position of the latter. 49 also occurs in an odd position, parallelled to my knowledge only by an Eretrian lekanis, Reading 56.8.8., of unknown provenance; Mrs. Ure took the mark to be commercial,[18] but I think this unlikely, since such a large area of the vase was available and more suitable for such marking. We could at a stretch believe that the Gorgon on 49 was branded with a *koppa,* but no such explanation is available for the Reading mark.

17, 45 and 52 may well have been inscribed by Greek owners at their Rhodian and Cypriot destinations. 19 and 44 have different marks on foot and body, and in the case of 19 the mark on the neck is particularly ugly; neither underfoot mark belongs to a known commercial type, and as the provenances of the vases are unknown, the possibility remains open that each vase has two Greek owners' inscriptions.

23 has a version of the *lambda-epsilon* mark, type 17E; it is Greek and probably commercial, but the precise form of the mark is not readily parallelled, 17E, 45 being perhaps closest.

The stamnos 29 has an obviously numerical mark; 10,900 is the interpretation offered in the auction catalogue, but this seems unlikely. One assumes that there was some definite purpose behind the defacing of the vase, which is likely to have been found in Etruria. I would suggest that ten χ(όες) and nine h(εμικοτύλαι) is what was intended; a rough calculation of the capacity of the vase gives only a slightly higher figure than this.[19] Liquid measurement is indicated, since no suitable dry measure begins with *chi.* The very fact that the vase was filled and marked, probably for sale, is unusual; it is a rare form of stamnos, close to plain ware examples and so perhaps regarded as more utilitarian than other decorated pieces, but it can hardly have been intended primarily as a functional vessel. Philippaki (xxi) stresses the rarity of decorated stamnoi in Greece; therefore it may be acceptable to conclude that not only is this type of graffito unusual but also the transaction that lay behind it. One proviso is worth adding; if a decorated vase had to be used for storage, a stamnos would be much easier to stow on board ship than a decorated amphora. The popularity of the stamnos in the fifth century may not have been unaffected by such utilitarian considerations.

41 too seems to have a numerical mark, judging from the two unit strokes. The script admits of a Greek or Etruscan origin, though the tidy lettering points rather to the former. In the light of 29 we may think of 'nine choes and two (kotylai)', in a mixture of Ionic numerals and unit strokes, but this can scarcely be the only possible interpretation, and we have now passed from coarse ware via the semi-fine 29 to the incontrovertibly decorative 41.[20]

Numeral strokes also appear on 43 and 51. The full reading of 51 is uncertain, but there is a possibility that the mark may be of type 9F, a late member, although there are no other cups in that type. There is a case for including 43 in the same type; it terminates with two sets of three unit strokes, analogous to some type 9F marks, with

which the vase is contemporary (though not from a workshop represented in the type). The reading of the first part is difficult; read left to right it yields Attic *gamma* or Ionic *lambda* followed by two *nus* and a completely inscrutable sign or pair of signs. To obtain NV the mark has to read 'upside-down' when the desired letters appear at the end, with perhaps an original but defective attempt at the letters in the centre; this is all far from assured.[21]

In sum, marks other than under the foot are rare on decorated vases and only a proportion of those that could be taken as commercial are likely to be so. Several belong to the earliest period of use of graffiti for trademarks on Attic vases. Numerals appear relatively often, especially on Panathenaic prize amphorae and stamnoi.

Hackl (57) expressed the opinion that at least in the fifth century the navel of the foot was reserved for the cutting of monograms. Such a distinction holds for the most part, but see for example 10F, 7 and 23 for cases of vase-name marks cut on the navel. Within a single type, however, one usually finds consistency in application of the mark so that a doubtful case could be rejected if it were not on the appropriate part of the foot. Confining the question to marks on the foot proper, we cannot press such arguments too closely, although the great majority of marks, where their alignment can be confidently assessed, are cut parallel to the edge of the foot, or approximately so. Some types whose direction is not immediately apparent from the lettering presented become more recognisable by the application of this rule of thumb. A number of dipinti straddle foot and navel, but the technique of incision makes this a less attractive procedure; small parts of a graffito can spill over on to the navel, and in a very few cases (type 37A and part of 21A) the distinction is ignored completely.

It is easier to spot a second hand in graffiti than dipinti, but this means little in absolute terms; there can be no such precision as in formal inscriptions. Only occasionally can we isolate different phases of the inscribing of several marks on a single vase, but even so such observations can give precious clues about the commercial history of the vase; see in particular type 2F.

CHAPTER 3
THE MATERIAL FROM GREECE

Large numbers of vases found in Greece bear abbreviations and monograms akin to those on vases exported to Etruria. Clearly these cannot be ignored, but we shall see that they have little direct relevance to trademarks; therefore I have not felt it necessary to give here a full coverage of that material, though in excerpting it I hope not to have omitted any pieces that could be considered in any way pertinent.

The major differences between the two sets of material is that from Greece we have precious few large vases with marks (see subsidiary list 3),[1] and none of them has a mark which belongs to any commercial group of graffiti or dipinti. Conversely, small exported vases are less likely to be marked (chapter 8), and rarely belong to the major types. Such a basic difference in the material encourages us to believe that the marks on exported vases have a commercial meaning; most of them are clearly not Etruscan and so were applied by Greeks, but those Greeks did not mark vases destined for local consumption in the same way. At the same time the difference does make it more difficult to correlate the two sets of marks simply because of the lack of directly comparable material; this is not wholly true, fortunately, and we can often find an abbreviation used in a commercial context also employed on small vases from Greece of much the same period, and we can also point to a few cases of groups of such marks which demonstrate that this method of multiple identification was not unknown in the homeland, even if it is not yet found in any clear commercial context.

These groups of graffiti are all close groups, not merely collections of vases fortuitously bearing the same mark:

1. As type 7B. Vases marked as the property of the city and found in the neighbourhood of the Tholos in the Agora; mostly c.470-440. *Agora* xxi, 51 group Fa.
2. As type 7B. Spear-butts from the Akropolis, similarly designated; before 480? *AAA* 9 (1977) 87-9.
3. As type 18B. On a number of vases of the early fifth century, mostly type B cups; the small neat lettering is particularly distinctive: Agora P6630, 7056, 7057, 7097, 7107, 7827, 8550-5, 10844, 15993, Corinth CP 6714, Aegina, Furtwängler, *Aegina* 386.
4. As type 22B. Mugs and skyphoi of the fourth century, Agora P8599, 8614, 8618-9.
5. ⊗ PA. Various vases from the Agora, 520-480; *Agora* xxi F33ff. One is a pelike (F35) with the mark retrograde on the neck.
6. ⟩⟨ . A complex monogram on pieces from the Corinthia; the shape varies a little, but they are probably a single group: *Corinth* xiii, *The North Cemetery,* tomb 326, 3 (skyphos) and 5 (cup); Corinth CP 37.379, skyphos,[2] cf. *AJA* 41 (1937) 547; *Perachora* ii 400, 152 (skyphos).

The first two groups are of public property, but 4, 5 and 6 are more likely to be owners' marks. We may have reservations about 6; the chronological spread seems wide and it is not easy to accept that the two earliest pieces, found in a grave, could have belonged to the same person as the latest, found in a well of a later period. There is a possibility that 3 is a trademark in view of the examples from Aegina and Corinth, but we can exclude any connection with type 18B, where there are no such small neat graffiti.

These are by no means all the graffito groups on vases with a Greek provenance, but a representative selection from Athens and Corinth. Other groups, such as those from Boeotian, Rhodian and Cypriot tombs are very likely to be owners' marks, while there are more that are dedicatory, from the Akropolis of Athens and of Sparta, from the Kabirion and Samothrace.[3] None of these groups is demonstrably earlier than c. 520.

Parallels for the form of many trademarks are also found in the Greek material. The examples listed below are nearly all on small vases and are rarely contemporary with any of the close groups in the respective commercial type.

4A	Akropolis 447	Stemless cup
	Kerameikos	Rouletted bowl, c. 375?
	Perachora ii 400, 143	Salt-cellar, 500-450
	Samothrace 2 ii, 21	Three possible examples
17A	Agora P3809	Oenochoe, on neck
	Agora P18857	Skyphos
	Kerameikos	Bowl, fourth century
	Olynthus v 904	One-handler, fourth century

20A	Agora P12448	Pithos, marked on shoulder, sixth century
	Akropolis 414	Type C cup
	Halai	Cup, *Hesperia* 9 (1940) 497, 3
21A	*Agora* xii 564 (P1181)	Cup-skyphos, c. 520, retrograde with Σ
	Agora P12448	Small bowl, on outside wall
	Agora	*Hesperia* 5 (1936) 352, two pieces noted
	Akropolis 469	Bowl, retrograde
	Corinth CP2143	Skyphos 480-70, *Hesperia* 37 (1968) 358
	Al Mina, Oxford 1956.468	Stamped bowl, late fifth century
1B	Akropolis 387	Type C cup
	Délos xvii 203	Stemless cup
2B, i-ii	Agora P8844-5	Olpai
	Agora P10285	Salt cellar, on wall, *Hesperia* 32 (1963) 133
	Marion, Cyprus	Askos, 450-400, Myres 1914.
2B, iv	Agora P9035	Cup
	Agora P138	Foot, twice (once retrograde)
	Agora P23371	Dipinto on amphora neck, 520-480
	Kerameikos	Bowl, late fifth century
	Boeotia	Cup, 500-450; *CVA Geneva* 1 pl. 26, 11
2B, vi	see 2B, 46, add:	
	Agora P24177	Semi-glazed krater
	Eleusis '17'	Corinthian type skyphos, 450-425
	Aegina, Furtwängler 382	Cup
	Labraunda II i pl 5, 22	Salt cellar, early fifth century, on wall
2B, vii	*Thorikos* ii 35 fig 23	Olpe, 550-525, on neck
	Athens	Skyphos, *AE* 1958 94
3B, i	Agora P19183	Fragment, by handle
7B	see group 1 above	
	Akropolis 394	Type C cup
	Akropolis 453	Skyphos? not in ligature
	Akropolis 454	Bowl
	Akropolis 478	Salt-cellar
	Kerameikos	Bolsal, 450-400, on floor
	Thorikos ii 56 figs 68-9	Vicup, 475-450
	Olynthus v 1059	Plate, 400-350; not in ligature, with ΔΔΔ
9B	Agora P606	Bowl
	Agora P2315	One-handler, 450-25
	Agora P5941	Bowl, on floor
	Agora P7979	Bowl, fourth century
	Agora P23029	On outer edge of a foot
	Agora P25542	Skyphos
	Agora P27882	Skyphos, the mark not wholly preserved
	Akropolis 421	Type C cup
	Akropolis 457	Stemless cup, with *kappa* in the ligature
	Akropolis 474	Small bowl, with X
	Aegina, Furtwängler 388	Cup
	Olympia Forsch. v 155 46a	Amphora, 450-400, by handle
	ibid 46b	Oenochoe, 450-400, on shoulder
	ibid 46c	One-handler, 450-400
	ibid 46d	One-handler, 450-400
	ibid 50	Skyphos, 450-400
	Lindos i 2849	Bowl
11B, iv	Agora P1350	Dish, 490-85
	Agora P18841	Skyphos, 425-400
14B	Agora P5812	Handleless bowl
	Agora P5938	Foot
	Agora P15110	Skyphos
	Akropolis 458	Bowl
17B, i	add to 6:	
	Agora P5450	Olpe, c. 450 (cross-bar slopes up to right)
	Kerameikos	Mug, c. 435, *AA* 1972 602
	Athens 2514 (H461)	Cup
17B, iii	Agora P2780	Shoulder of unglazed vase, 485-80
17B, iv	Akropolis 296	Perhaps incomplete
	Olynthus v 888	Cup, fourth century; also EΠΙ
17B, v	*Agora* xii F27 (P6173)	Cup; twice, in ligatured form
18B	See group 3 above; add:	
	Akropolis 415bis	Cup
	Corinth CP442	Foot, late fifth century; tailed *phi*
22B	See group 4 above; add:	
	S.1. 3, 16	
	Lindos i 2808	Cup
23B	Akropolis 418	Type C cup
	Olympia Forsch v 155, 67	Oenochoe, 450-400, on shoulder
	Olympia	On shoulder of large red-glazed vase
5D, ii	Agora P17804	Neck of amphora, 525-500
	Thasos	*BCH* 89 (1965) 854; tailed *rho*
	Greece?	Guttus, c. 350, with ΔΔΔ; *MM February 1972* (list 331), 520
7D, iv	Agora P14558	Bowl, fourth century
	Samothrace 2 ii 239	Bowl, not in ligature
3E, iv	*Agora* xii 578 (P24584)	Cup-skyphos, early fifth century
6E	Corinth CP64-213	Dipinto on plain amphora neck, with a sign resembling an uptilted shallow *omega*
9E	See also on Cyprus, p. 19-20	
9E, iv	Agora P19166	Semi-glazed krater, 520-480; the cross-bar slopes down to the right

9E, vii	Akropolis 425	Type C cup; cross-bar slopes up to the right
9E, viii	Akropolis 426	Stemless cup
	Akropolis 477	Salt-cellar or pyxis
	Délos xvi 147	Stemless cup
	Xanthos iv 414	Skyphos, ?later fifth century
9E, xii	*Agora* xxi F219 (P3788)	Handle of cup; ARI
	Agora P23372	Dipinto on amphora neck, 520-480; AR
	Eleusis '24'	Bowl, 500-475, perhaps incomplete; ARI
9E, xiii	Ampurias	Bolsal?, 450-425; cf. *XIV Congreso Nacional di Arqueologia* 831-2.
9E, xv	Akropolis 424	Type C cup, AP
10E	Common; to 10E, 11 add:	
	Agora xii 126 (P18804)	Oenochoe handle, 425-400
	Agora P5705	Bowl
	Agora P9479	Cup, 500-450, ligatured; *Hesperia* suppl. 5 142, fig 69, 34
	Agora 15167-8	Mugs
	Kerameikos	Shoulder of oenochoe, ligatured
	Corinth CP441	Bowl, MEI
	Corinth CP2143	= s.1. 3, 9
	Corinth KP1376	Attic type skyphos, 500-450
	The Argive Heraeum ii pl 69, 25	Ligatured
	Olympia Forsch. v 155, 59	One-handler 450-400
	Greece	British School at Athens G9; bowl, fourth century, ligatured
	See also *JHS* 98 (1978) 218-9.	
13E	Agora P16444	Fragment of body of amphora, c. 425
	Agora P17534	Knob of pyxis lid, 450-400
15E	Akropolis 366	Cup, perhaps incomplete
	Akropolis 408	Type C cup
	Akropolis 409	Cup
20E	Delos	Cup foot, Mykonos museum
23E, iv	Kerameikos	Skyphos, late fifth century; also B
23E, v	Abdera	Fragment of foot, Kavalla museum
1F, vii	Kerameikos	Dipinto on fragment of wine amphora
2F	Agora P24269	Cup, c. 500
10F	Agora P12985	Foot
11F, i	Agora P98	Bowl
	Agora P2639	Cup, c. 485
	Délos xvi 197	Pyxis
11F, iv	Corinth	Foot from sanctuary of Demeter and Kore; also ME
13F	Agora P881	Bowl
	Agora P16044	Closed vase, on wall
	Agora xxi F123 (P21220)	Stemless cup, 425-400; with *epsilon* (?)
20F	Agora P20335	Pyxis
	Agora P21401	Oenochoe, twice, in ligature; *Hesperia* 25 (1956) 13.

No detailed comment is needed on these marks; the great majority are isolated examples of owners' names, demonstrating that the use of such abbreviations was current in Greece during roughly the same period that they were used as trademarks. The absence of various trademarks from the Greek material does not of course prove that they are non-Greek, but together with alphabetic and other arguments may suggest a non-Athenian origin for some commercial graffiti. On the other hand, we note that the commonest marks are of types in section B, indicating that we may well expect a proportion of owners' marks on decorated vases with Greek-speaking provenances among those types. It must remain extremely doubtful whether any of the marks refer to persons using similar trademarks; in many cases there is no close chronological link, while in others the range of names that would require the relevant abbreviation is so wide that even if the vases were contemporary the odds would be high against a single point of reference.

Some individual notes:

20A. The range of possible supplements is perhaps small enough for us to consider whether the first two entries may refer to the same man as in the mercantile type; if so, he dealt in coarse as well as fine ware and was probably Athenian, but proof is lacking.[4]

17B, i. The date is rather later than the main commercial group. The slope of the cross-bar is not that normal at Athens, but of itself this cannot rule out an Athenian hand.

22B. See p. 199 with n. 2.

23B. See p. 237.

5D, ii. The first entry points up the question whether the ligature can stand for Attic h$e\rho$, with long or short *epsilon,* though the piece probably has a non-Attic origin.

6E. While this mark seems even more enigmatic than its counterparts in type 6E, it may go some way to supporting an interpretation other than a personal name. I would not care to hazard the date or origin of the piece.

10E. See *JHS* l.c. for the ligatures within words. It is possible that the unusual number of marks on the shoulder of oenochoai or similar jugs may refer to something other than personal names (cf. *Agora* xii 62); however, it does seem that the shoulder of larger undecorated or glazed vases was preferred to the foot as the place to put one's mark (*Agora* xxi 29).

13E. Here only one stroke is added to the basic *(h)eta*; the date would allow the interpretation Ἡγ . . . at Athens.

23E, iv. Again, at this date the letter could be taken as Ionic *lambda* at Athens.

10F and 13F. None of these pieces can have the specialised significance of some of their commercial
counterparts.

11F, iii. There may be a possibility that this mark has a commercial significance, a parallel for 11F, 13,
though neither are easily interpreted.

We may note a few marks that do not find parallels in the Greek material: e.g. 25A, 24B, 5C, 1D, 1E, 3E, 5E, 8E, 11E, 12E, 14E, 22E, 9F, most non-alphabetic marks and most vase names. Some of these marks may be Etruscan - see the commentary on 25A, 24B and 8E. Others could be abbreviations of words that we would not expect to find in other than mercantile contexts, e.g. 1D and 9F. 11E, 12E and perhaps 5C are based on a triangular *delta* and so cannot be Etruscan; yet the fact that they do not appear outside a commercial context suggests that they have some peculiar significance therein. 1E and 22E must also be Greek, but the origin of their inscribers is difficult to pin down. The Greek material gives few clues as to the origin of 25A, 24B and 14E; 25A and 14E are without parallel in Greece and Etruria beyond the mercantile groups, while 24B is not a common trademark and no groups are formed by it.

The use of abbreviated graffiti on vases in Greece adequately supports the argument that many of our commercial marks were applied at source; in this respect the substantial qualitative difference between the kinds of vases marked matters little. There still remains however a large body of trademarks which do not appear in other contexts, where we may have hoped to glean some information about their place of origin.

CHAPTER 4
PROVENANCES

Etruria

An overwhelming proportion of all trademarks on Attic vases are found on pieces with Etrurian provenances; see the tables in Appendix 1. In general terms, extremely few commercial links between these vases and those found elsewhere can be demonstrated for the sixth century, while during the fifth similar marks appear increasingly frequently on vases found in Campania and to a lesser extent Sicily. Such links I discuss more fully under the other area headings below.

Vulci is pre-eminent among the Etruscan sites. Where close groups can be isolated it is normal that the majority of pieces with a known provenance will be from Vulci. Therefore I note here those groups where there is what might be termed an even distribution of marks over a range of Etrurian sites ('even' when we take into consideration the proportionately smaller total of Attic vases from those other sites) and those groups in which Vulci plays a minor role, or none at all.

Most of the marks with a more even distribution belong to the period 540-510: 4A, 20A, 21A, 1D, 9D (a few Cerveteri), 1E, 9E, iv, 21E, i-ii (but mostly Vulci). The Antimenes group figures prominently among the vases, as does the Affecter and the Lysippides and Euphiletos painters. Mostly a little later are 3E, ii-iii and 17E, i-iii (the latter mainly Vulci). Apart from the vase-name mark 20F, only 18C of fifth century marks includes good numbers from Vulci, with a wide range of other provenances.

A similar pattern is seen in those groups where Vulci takes a second place to another Etruscan or non-Etruscan site. Before c. 515 Tarquinia provides a good portion of the Antimenean 16A, i and 37A, together with the small group 11A. Cerveteri is prominent in 4D and 3E, i, while Orvieto has a small sub-group of 33A to itself. Around the turn of the century Tarquinia is represented in 9A and in minor sub-groups of 22B and 22E; Cerveteri has 26B, i and is prominent, together with Campanian sites, in 12E; 6A includes a wide range of provenances. After 480, Campanian sites are well represented in the vase-name types 8F, 9F, 10F and 21F, and also 2C, while Cerveteri is frequent enough in 2B,ii and 5C.

In the fifth century the marks do little more than reflect the general trend to a wider dispersal of exports of Attic vases, as will be further demonstrated below; there is extremely little evidence for discrimination among Etrurian destinations on the part of individual traders. However, in the sixth century we may discern some more deliberate choices. Tarquinia in particular seems to have been the main, though not the only target of some traders, and we can distinguish between those whose marked vases appear almost wholly at Vulci and those with a broader range of destinations, while noting that concentration on Vulci is largely a post-515 phenomenon (17A, 25A and 11F, i being exceptions). Cerveteri has rather unusually in view of its ready accessibility thrown up few 'specialists'; most noticeable is the Nikosthenic 3E, i.

It is not easy to judge from this evidence much about the distribution of Attic vases in the hinterland of Etruria, in particular the Orvieto region; here the poor publication of much of the material from Orvieto itself hampers full discussion. Where Orvieto appears as a provenance within a group of marks we usually find other Etrurian sites, and one would hesitate long before prescribing an unlikely journey via Vulci for those pieces with marks which appear otherwise only at Vulci (33A, 14B, 8C). Orvieto is prominent in type 9E, iv, where there also appears a vase from Bologna, which I argue below was imported via Etruria; I would not press any one particular explanation for this pattern, but would stress its peculiarity.

Other sites that appear sporadically in the catalogue are Arezzo (24E, 9), Chiusi (in several 'main-line' groups - 17A, 21A, 9D, 3E, 2F), Bolsena (2F, 53), Falerii, Nepi (21E, 4 and 7D, 7), Perugia (18B, 7), Narce (15C, 8), Populonia (21F, 13) and Veii (8D, 20). The overall picture from these mainly inland sites is very sketchy and as yet commercial marks are of little help in tracking down lines of trade routes.

Northern Italy

The extent and pattern of Attic imports into this area has been treated more than once of late.[1] At Bologna material appears c. 525 and steadily increases, while some rather earlier pieces are known from Adria. Spina imports

little or nothing before 500, but vases continue to arrive in large numbers after the trade to Adria and Bologna declined in the period 450-425.

Adria

Owing to the fragmentary nature of the material it is not realistic to try to separate BF from RF or glazed vases, nor to give many close dates.

Most of the marks are on the feet of kylikes or stemless cups, immediately distinguishing the material from any other body of marks from Etruria and North Italy. As it is highly likely that there were Greeks living at Adria,[2] we may consider such marks as owners' mongrams, akin to the Etruscan marks on so many RF cups, or to the Akropolis material. Such an interpretation could be extended to the groups of marks that are found, in types 10B, 19E and 11F. Certainly they have few apparent connections with marks from other sites; there is the usual quota of *alpha-rho* marks, one of which is quite close to 9E, 71 and 72, all being accompanied by numerals and all probably from cup-skyphoi or the like. Other numerical marks must have had some commercial significance, 16A, 20, 6D, 7, 14 and 15 and a mark including 'arrow' *delta* and '*gamma*' five, 13B, 28. 9B, 19 causes a little difficulty; the EV mark is in the same hand as 9B, 18 and the two vases are closely similar. Yet there is a second graffito on the vase, probably a ligature of *epsilon* and *pi*, a ligature which appears on three other fragments from Adria, two Attic type skyphoi (19,19 and Ce 69, unpublished) and a stemless cup, Ce 82, unpublished, on a bowl from Spina, *St.Etr.* 46 (1978) 311, 35 and on one glazed vase from Rhodes, a standed bowl, Rhodes 12153 (*BSA* 70 (1975) 160, 90); all are to be dated around the middle of the fifth century. We can assume that both sets of marks on the Adria vases are owners' inscriptions, or that one has a commercial significance, perhaps the neater and smaller ligature that is also found at Spina and on Rhodes. The second graffito on 2B, 42 seems to refer to the dedication of the piece in a sanctuary, after having been marked by an owner or possibly trader. Of the two pieces with a ligature of HEN (?) one is a lamp (21,12), and it is therefore most likely that the marks are an owner's inscription in a non-psilotic dialect.

The script seems varied; the aspirate is frequent, there is probably a three-bar *sigma* on 7D, 20 and a non-Ionic numeral system on 13B, 28; but 'Ionic' *lambda* may be involved in 6D, 14 and 15, while 14E, 14 and 11F, 23, 26 and 27 have a markedly 'Boeotian' *alpha;* the *alpha* with a cross-bar sloping up to the right is more common than other forms. Much of this range is covered by the Aeginetan alphabet, which Colonna has distinguished in several longer graffiti from Adria.[3] If we accept its presence in the shorter marks we would probably have both owner's and commercial marks from Adria in that script.

Black-figure; Spina

Marks appear on most types of black-figure vases found at Spina, mainly oenochoai and lekythoi; see *CVA Ferrara* 2. The pattern of export and of marking is not parallel to that at Bologna, nor as far as we can tell at Adria. There are five groups of marks which account for just over half the marks known to me: 1B, 18-19, 3D, 10-13, *CVA* 2 13 and 29 with KE, *CVA* 2 28 and 30 with *sigma upsilon* (?) - three vases, and three unpublished hydriai by the Painter of half-palmettes with *zeta,* or *heta,* and an additional detached stroke.

9E, 87 provides the only possible link with marks from elsewhere; see on that type. This one example scarcely indicates similar trading methods on the Etrurian and Adriatic runs. As vases with the same mark come from different tombs, it is not perhaps very likely that they are local owner's marks, of Greeks living and dying at Spina, although it remains possible that some isolated marks may be such.

The alphabet is apparently less unitary than that found at Adria. The same 'Boeotian' *alpha* appears, again in company with *kappa,* on 1B, 18 and 19. Tailed *rho* on 9E, 87 may be Attic, while 'Ionic' *lambda* - not necessarily used by an Ionian - is found on 3D, 10-13 and an unpublished oenochoe from tomb 16d. The most likely interpretation of one of the recurring marks mentioned above involves a four-bar *sigma.*

Black-figure; Bologna

With one exception the thirteen marked vases from Bologna have no obvious connection with any from elsewhere; some are included in the catalogue, but are apart from any close groups in their types, as is the only pair of marks, 13B, 1 and 2.[4] The erosion of the surface of many vases from the cemeteries of Bologna and Spina could have entirely removed any red dipinti.

The one exception is 9E, 22, which has the same mark as other bilinguals by the Andokides/Lysippides painter from Etruria, which in turn are connected with other members of 9E with the same provenance. It must have been exported in the same manner as these, and reached Bologna via Etruria, in contrast to the rest of the black-figure vases with marks from northern sites. The fact that several relevant members of type 9E were found at Orvieto points strongly to the original home of the owner of the Bologna bilingual. [4a]

Most of the marks could or must be Greek and so should have some commercial significance. The alphabet is unexceptional, with crossed *theta* (12B, 7) and tailed *rho* (14F, 8), the latter not at home in Ionia at this period.

Red-figure; Spina and Bologna

Not quite half the twenty-four marked vases from Bologna known to me are in the catalogue. Four unpublished pieces do not find a place there: an obscured graffito on Bologna 198, a *kappa* on 322, a four-bar *sigma* on an un-numbered glazed oenochoe of 475-450 and a krater foot of the same period with a non-alphabetic mark.

Less than twenty marked vases from Spina have been published; 9B, 25, 9E, 73a and 25F, 10 are the only ones in the catalogue. Four further pieces are in Milan: 12B, 8, 18C, 69 and 80 and Milan A1806 (*CVA* pl. 10) with Λ on the navel. I have learned of thirteen other marked vases from McPhee and from Beazley's notes, six of them in the catalogue: 16B, 36, 18C, 40 and 80, 5D, 15, 9E, 110 and 17E, 49.[5] It is difficult to estimate how many more vases from the Spina necropolis may be marked, but I would suggest that a far smaller proportion of vases sent to Spina (and Bologna) were marked than those from the rest of Italy.

Type 18C is represented at both sites, but only one other mark so recurs, type 17E, vi; however, the example from Spina, 17E, 49 is later than the group from Bologna, and to judge from Beazley's transcript it is on the foot, not the navel as the Bologna marks.

No non-Greek marks occur on the Bologna vases, although some of the simple letters and signs are ambiguous. It may therefore be that many of them have a commercial meaning, yet less than half are in the catalogue and only one group is found. However, there are marks which may appear to have connections with pieces from elsewhere. Bologna 153 has some puzzling features which I discuss under types 6A, 9E and 12F; the monogram may connect it with pieces of Dourian inspiration, but the mark is not identical with, and the vase is far grander than 9E, 122 and 123; most of the other vases with a KAΔI mark are later and from different workshops, and do not have the additional EIII. Similarly, Bologna 162 (1F, 8) cannot be connected by both spelling of the mark and the workshop with any other in the type. Bologna 174 (H199) seems to have some connection with type 6C; it is on a large vase and chronologically of the same period, but the shape of the mark is not quite the same, and there is no accompanying *nu* as in the rest of the type. Bologna 190 and 250 are isolated within their respective types, 10F and 6D. Spina T612 yielded a bell-krater by the Meleager painter (*ARV* 1411, 32) with the mark *pi iota*, akin to other numerical marks on late fifth century kraters; see type 14F, n. 1. 16B, 36, a skyphos of the early fourth century from T597, also has a numerical mark, ΔIII, with a separate Π; this is akin to the skyphoi 16B, 34-35 and equivalent to the marks on 8F, 14, from Histria. Further batch marks are found on glazed bowls, 9E, 72a and *St.Etr.* 46 (1978) 312, 36 and 314, 41.

The diagnostic lettering of the script points away from Ionia. An Ionian would have used *eta* on Bologna 162, and the owner's mark from Spina, *St.Etr.* l.c. 302,18 has no *omega; heta* is also found on two occasions, ibid. 295,9 and 320,51. Uggeri considers that the mark three-bar *sigma upsilon* found on five Spina pieces is Greek rather than Etruscan, but I do not feel quite so confident about their inscribers (ibid, 304). Some letters that would not be wholly at home in Athens at the relevant period are also found: four-bar *sigma* on Bologna 206 and the unnumbered oenochoe, Ionic *lambda* on Bologna 162 and 17E, 46-48 and the *gamma* of 9B, 25.

In sum, apart from the marks of type 18C, there is only one certain link between the marks on vases from northern Italy and those from elsewhere, 9E, 22, while there are a few more doubtful candidates, e.g. 9E, 87 and the ligature of *epsilon* and *pi* (p. 13 above). There are groups of marks from all three sites, but they scarcely impinge on each other. The bulk of the marks are isolated, though apparently in Greek script, and probably more than one Greek script is evidenced.

Campania

Black-figure

The character and extent of exports of Attic black-figure vases to the three main centres, Cumae, Capua and Nola, is very uniform; in *ABV* we find roughly the same number of attributed vases from each site, spread throughout the period, more thickly at the beginning and end. Many Corinthian vases reached Nola, some marked, and it may be in this context that we should put the one known early Attic marked vase from Campania, 13A, 1. The uniformity in numbers of vases from the three sites is matched by similar numbers of marked pieces; I know of 12 on Attic vases from Nola, 13 from Cumae (mostly in the Raccolta Cumana at Naples) and 17 from Capua. Most of these vases are later than c.515; exceptions are 13A, 1, 20A, 35, 41A, 1 and 10E, 3. The first and third of these are severally related to vases without provenance (the first less closely to another from Taranto); the last may be connected with pieces from Vulci and Tarquinia; the second is an integral member of the largely Etrurian 20A.

About a half of the later pieces are included in the catalogue; there vases from Nola are connected by their marks to pieces with an Etrurian provenance in types 21A, 21B, 9E, xiii (largely with RF vases), 12E and 9F (also with RF vases) and with material from Taranto in 9E, ix. Capua is so related with Etruria in types 12E and 21E, also in type 5D, ii if the reported provenance is correct; the piece 9E, 70 has no sure connection with others in the sub-group. Cumae has Etruscan connections in types 5A, iii and 3E, iii and is related to vases with no known provenance in 40A and 9B. Connections further south are likely with Agrigento (6A). The one marked BF vase from Caudium (6D, 1) is not surely to be connected with any others in the type.

The other site to have produced marked BF vases, all late, is Suessola; three of the five which I have noted are in the catalogue: 8D, 43 is of little interest, 9E, 73 may well be connected with the Nolan and Tarentine pieces in its

sub-group, and 10F, 4 has company as a mark from many sites, while as a vase it is nearer to the piece from Aleria than any other in the type.[6]

Marks rarely recur on vases from Campania; 9E, 71 and 73, 12E, 2 and 3 and 21E, 40 and 48 are the only secure examples. This suggests that Campania at this period was not the particular goal of any exporter - a point seen also in the very distribution map of BF vases. That vases from Campania and Etruria occasionally have the same mark is good evidence that those marks were applied in Athens before the vases left port. There is very little that appears Etruscan or non-Greek in the forty or so marks on vases from this area.[7] There seems to be nothing diagnostic in the alphabet of those marks not included in the catalogue.

Red-figure

I know of somewhat more than one hundred and fifty red-figure vases with graffiti, mainly from the three sites isolated above, others from Naples, Suessola, Vico Equense, S. Agata de' Goti, Caudium and Ischia, as well as 'Campania'. Most date after 480 and are fairly evenly distributed over the ensuing seventy years. A few are earlier: 7D, 10, 1F, 14 and 15, 12C, 1 and 2 and Mannheim Cg 11 (*ARV* 201, 64).

About ninety-five of the vases are in the catalogue, the majority belonging to close mercantile groups, some of which include pieces from Etruria: 17B, 6C, 17C, 7D, 9F, 20F. This situation is not that of the black-figure pieces, but here rather we have varying ratios of vases of Etrurian and Campanian provenance within those groups. Again the trend in exports, concentrating more and more on Campania, is reflected in the marks. There are, moreover, a number of vases belonging to types not certainly attested outside Campania: 2C (RF vases), 3C, 1F, viii and ix, 11F, iii, 17F and 18F. It may be thought that some of the vase-name marks could have been cut on the vases in, say, Cumae, but there are enough vase-name types represented by vases from Etruria only, or with mixed Etrurian and Campanian provenances, to make the suggestion difficult to uphold; in types 8F and 21F Sicily, Apulia and more remote areas are included.

There seem few anomalies in the distribution pattern of the marks among the several Campanian sites. The number of smaller vases from Suessola (black- and red-figure and glazed) with numerical marks is noticeable;[8] on a larger vase we find one of the rare assuredly non-Greek marks on Attic ware from the area, CN on Naples 4862, by the painter of the Florence stamnoi; the same mark is found on London E319, a neck-amphora by the Briseis painter from Nola.[9]

South Italy

Black-figure

I have noted occasional dipinti on Corinthian vases from Taranto, Metaponto, Crotone and Paestum; we may expect further to come to light in more extensive excavations. As for Attic vases, few cemeteries have yet yielded large numbers of complete vases - Taranto, Lokri and Fratte are the most noticeable exceptions, none of which are well published as regards trademarks.

I have noted six marks on those vases from Fratte which I have been able to examine. [10] 19B, 2 is possibly connected with a vase from Orvieto, and 12E, 13 can be associated with material from Etruria and Campania. This suggests that the Fratte necropolis was served with Attic vases imported via a Campanian port.

The single marked piece that I know of from Lokri (8D, 14) is scarcely illuminating. On the other hand, I have found some thirty marks on Attic black-figure from Taranto, mostly unpublished, representing a good proportion of the total of imports, especially of larger vases. The pattern of marking that emerges is in striking contrast with that in Etruria or Campania. Fifteen of the marked vases are amphorae, hydriai or kraters, and nine of them are earlier than c. 530; [11] all of the latter have dipinti, 13A, 3 with the mark graffito as well. As far as the remains allow one to judge, none of the dipinti are alike, though two have possible connections with vases from elsewhere, 13A, 3 and 5D, 1. Of the later pieces, 7D, 3 finds a parallel from Gela.

The script of the marks is not uniform: 5D, 1 may be Ionic, but 7D, 3 has three-bar *sigma* and Taranto 52127, a neck-amphora of c. 545 has a dipinto which certainly ends in Attic *lambda;* 13A, 3 could be variously interpreted. [12]

There are ten marks on lekythoi, ranging in date from 510 to near 480, and seven on cups and skyphoi;[13] among these marks we find one repeated, albeit the common ligature of *mu* and *epsilon;* there may be a close commercial group here, of additional interest in that it seems related to a piece from Campania (9E, 71). A connection with Gela is seen in type 22E. Such marking of small vases is rare in an Etrurian context, a little more widespread in Campania and relatively frequent in Taranto and Sicily. Of course a larger proportion of Attic vases from the latter areas are small, but this does not explain away the infrequency of marks on smaller vases from Etruria. Again, there seems to be no single alphabetic range: Ionic *eta* and *sigma* on 13E, 1 and 19F, 16 respectively and possibly local *koppa* on 16A, 25.

The overall picture is untidy, with few groups of marks and mixed alphabets; a number of the marks are no doubt owner's inscriptions, though this is unlikely in the case of the dipinti and impossible for the few numerical marks. This overall picture is akin to that from North Italy and Sicily, in contrast to the often neat grouping of Etrurian material. Taranto does stand apart in the comparative wealth of early marked Attic vases, and certainly a greater percentage of early amphorae bears marks than in Etruria (though here I suspect that the Etrurian survival rate for dipinti is poorer).

Red-figure

The material is limited to less than twenty marked vases, from Taranto, Ruvo and single representatives from Numana, Altamura, Egnatia, Conversano, Valenzano and the Basilicata region. We may add three members of type 18C in Bari with no known provenance, and a glazed vase from Reggio with an interesting batch inscription.[14]

Setting aside 11B, 19 we find a curious uniformity about the Tarentine material. There are five vases, four of which have four short vertical strokes, once preceded by a small circle, and the fifth has three horizontal lines followed by an arc, akin to a half-obol sign.[15] Yet despite this apparent similarity, the marks are of various sizes, the vases of various shapes and the dates range from c. 470-440. It would be dangerous to take them all as price marks, giving roughly similar prices for vases of varying size and quality; it is likely that the arc is a half-obol sign and that the calyx-krater by the Christie painter may have cost three-and-a-half obols, but at the same time the circle on Taranto 4544 is not happily interpreted as 'obol' since the resulting price of four obols would seem rather high for a lekythos, even one 41.8 cm. tall.[16]

There is little duplication among the remaining marks, those of type 18C excepted. The piece from Altamura, as well as one from Ruvo, belongs to type 8F in company with pieces from a number of other areas, though they share no other features with them as vases. 16B, 18 from Egnatia is connected with vases from Campania and of no known provenance, but there is no parallel known to me for the mark on London F54 from the Basilicata. The remaining pieces from Ruvo are an owl skyphos (5F, 6) and two late glazed vases with vases names (Ruvo 537 and 812), Naples 3105 (9E, 75) and Leningrad St.1491;[17] the Naples vase is closely paired with 9E, 76 of no known provenance. This is the earliest red-figure vase from the area with a mark; the rest fall within the period 470-440 or the fourth century. The pieces from Numana and Valenzano are early in this sequence: Bari 2799 is a black-glazed column-krater from Valenzano of c. 470, with traces of a red dipinto, *pi* followed by at least an arc; it is the only dipinto on a fifth century vase from the area. The Numana vase (22F, 5) does not tie in closely with any of the rest, but the Attic script reminds one of 1F, 2 and 3, the first from Syracuse. The script of these pieces is otherwise unremarkable, non-Ionic *heta* possibly on 11B, 19.

Sicily

Black-figure

I know of somewhat more than sixty marked black-figure vases from Sicily, about two-thirds of them from Gela, a small number from each of Agrigento, Selinus, Syracuse, Kamarina and Megara Hyblaea, and singletons from Centuripe, Lipari and Montagna di Marzo.[18] About a half of these are in the catalogue. There are also marks on Corinthian vases from most of these sites.

The vases can be split into two more or less equal parts, larger and smaller pieces, the latter mainly lekythoi and skyphoi. Most of the larger vases belong to the period 530-490 - contrast Taranto; earlier are Syracuse 11889 (subsidiary list 1, 12), Syracuse 21054 (*BSA* 70 (1975) 165) and Agrigento R145, a column-krater of c. 540 with red traces. Nine of the marks are dipinto, all of them different, and none, as far as the remains allow judgement, with parallels outside Sicily; we may note in particular the Leagros group neck-amphora from Gela, Syracuse 21957, that has a dipinto unconnected with any marks found on the vases of the group found in Etruria.[19] Among the graffiti there are some groups, the most obvious being 2B, 44 and 45; this could be considered a Geloan owner's mark, since although 2B, 43 has a similar mark and is from another site, it is earlier than the pair from Gela. A connection with vases from outside Sicily is afforded by the group 7D, 2-4, and a connection could perhaps be argued for 9E, 43.

About half the smaller marked vases are also in the catalogue, most of them lekythoi, popular exports to the island. As with the larger vases we have one group and one piece connected with other areas: despite the difference in format of the mark 9E, 69 and 119 should be connected, and 22E, 3 seems close to 22E, 4 from Taranto. The glaze mark on 5A, 1 from Gela must have been applied at Athens, but we do not know the provenance of its companion 5A, 2. Another dipinto, 15B, 6, has no close company, nor can one judge how closely related 17E, 32 may be to the rest of the type. For 21A, 95 and 1B, 7 see the respective commentaries; the price graffito on the latter is similar in format to that on Gela Navarra 11.[20] On both these vases we may note the use of normal acrophonic *pi* in the numerals.[21]

With such a disparate collection of marks it would be dangerous to talk of similarities or differences in the pattern of marking at various sites; full publication of the cemeteries of Kamarina, Gela, Selinus and Megara Hyblaea is needed before such a task can be attempted. The alphabet of the material at hand shows little Ionic influence; three-bar *sigma* is the rule, and could be Attic or local, while Attic *lambda*, not the local or Ionic form is found on two pieces from Gela, 15A, 6 and Syracuse 21953 (*ML* 17 484).[21a] Ionic *lambda* is probably to be read on 17E, 32, not a local mark, one would have thought. The triangular *delta* on 7B, 2 would have been unusual at Gela in the late sixth century,[22] and the one tailed *rho* on 20F, 1 could be local; *heta* appears only once, on 10B, 5, the letter may be *heta* or *eta* on 5D, 13, perhaps a local Geloan mark.

Red-figure

Again, of the eighty or so marks which I have noted on red-figured and contemporary glazed vases from Sicily, more than half are from Gela; fourteen are from Kamarina, but no other site has produced more than seven. Forty-eight of the total are in the catalogue, comprising both large and small pieces, though the latter comprise only lekythoi and small oenochoai; there are but a handful of cups and skyphoi in the total. [23] Two of the marks are dipinto, subsidiary list 2, 16 and 21. The range of dates is 480 to 425, with some later pieces from Lipara; 23E, 17 and 14F, 11 may be earlier than 480, as is Syracuse 19867, a lekythos of c. 490 from Gela with *phi.*

The proportion of groups and of connections with vases from beyond Sicily is greater than in black-figure. Type 18C is represented at Syracuse, Kamarina and Agrigento, but not to my knowledge at Gela; the genesis of the mark can be seen in the pieces from Kamarina, two with triple strokes, one with double. [24] Two pieces also have important price graffiti (18C, 59 and 63; see p. 34).

Groups of vases from Gela can be found in types 13B, 32A, 11C, 3E (together with vases of unknown provenance) and 16E, perhaps connected with a vase said to be from Capua. It is difficult to assess the position of 9E, 49, 50 and 97, both as regards each other and the rest of the sub-groups concerned. Apart from the possible connection with Capua in type 16E, vases from Gela are closely associated with others from Etruria and Campania in type 5C and from Campania in type 7D.

A vase from Syracuse is clearly related to others from Etruria, Campania and Apulia in type 16B, and with one of unknown provenance in 1F. The connection of 2B, 32 and 33 from Kamarina and Syracuse with the rest of the sub-group seems less close, and there is no good reason to believe that 21F, 10 was handled by the same trader as any other vase in the type. 16B, 33 from Syracuse has a format similar to that of 24F, 2 from Gela, and both vases are Polygnotan.

The alphabet of the marks is varied. 1F, 2 is purely Attic; elsewhere three-bar *sigma* is rare, probable on 33A, 20 and certain on London 1863.7 - 28.451, glazed lekythos of c. 480 from Gela (before *mu*) and 19F, 14 (which has another mark, a ligature probably involving four-bar *sigma* and *iota,* in what may be a 'mercantile' Attic script); its first two marks are best taken as those of local owner(s). The only possible trace of lunate *delta* is in 3E, 39 and 41-2; both normal and 'arrow' forms of *delta* are found as a numeral, and they are found together on Gela 10597 (below n. 26) as letter and numeral respectively. *Heta* is used on 11B, 23 and 21F, 10, while its value is uncertain on 5D,14; *eta* is found on 1F, 6, of the later fifth century. Ionic *lambda* occurs on 17E, 18 and 37; on the former a presumably non-Ionic and perhaps local tailed *rho* appears as well. *Omega* and blue *xi* are not unexpected on the late 24F, 2, though perhaps Attic rather than Geloan; the related 16B, 33 also has blue *chi.* Blue *xi* rarely appears in trademarks, but we do find it on a problem vase, Syracuse 53237, column-krater by the Agrigento painter, from Megara Hyblaea, later than the destruction of the city by Gelon in 483/2. [25] The mark, AOΞ, is inscrutable, perhaps too cryptic for a reference to ὀξύβαφα; sadly, the *xi* can tell us little about the origins of the inscriber; perhaps the graffito was cut at Athens rather than Megara. The 'red' *chi* of 32A, 21-2 and 9E, 98 is regular for Gela.

There is an increasing representation of 'main-line' trademarks on vases from Sicily from c. 490 onward, a trend similar to that seen in Campania, but not in northern Italy (save for type 18C). The proportion of price graffiti on vases of Sicilian provenance is noteworthy, especially if we do not take into consideration those on vases with no provenance; there are also a number of vases with other numerical marks, some of which may indicate prices. [26] The alphabet used suggests that some marks are Attic and others Sicilian, but certainty is rarely possible; a number of Ionic letters are found, but not necessarily cut by Ionians. Very little of the local Sicilian scripts can be discerned.

Corsica

A number of marks are found on Attic vases from the cemetery of Aleria. I have discussed these in some detail elsewhere, [27] and merely summarise my conclusions here.

The marked pieces belong to the fifth century, and there is no clear evidence that any belonged to Greeks living locally at Aleria. While a number of the marks have no obvious connection with those from elsewhere, others clearly fit into the Etrurian/Campanian range, especially in types 9F and 10F, and perhaps 7B and 19B.

France and Spain

I know of no marks on Corinthian or decorated Ionian vases from the Western Mediterranean. Iberian and Phoenician marks are found on Attic vases, as well as an increasingly significant number of Greek graffiti. [28] Those from the Languedoc and Catalonia have recently been gathered together by Jully, and to these are to be added a few from the Massiliote area, Massilia itself, Antibes and the Camargue. [29] The marks appear predominantly on cups and lekythoi, which in turn formed the bulk of Attic exports to the area. A very high proportion of the Greek marks give every appearance of being simple owner's inscriptions, being largely in Ionic script, when any diagnostic letters are found, although few belong to the period before c. 450 when such diagnosis would be significant for the origin of the inscribers. We may note the ligature at the beginning of what might originally have been a complete name on 2B, 23.

A few marks do stand out from this category. Several have numerals, indicating batches of vases, and they come from a range of sites. [30] Two from Ampurias are of particular significance: an early fifth century BF lekythos,

much commented on by previous writers, has three-bar *sigma* followed by three 'arrow' *deltas;* [31] attempts to interpret this as an Iberian mark seem unnecessary and so far unconvincing, but taken as a Greek numerical mark, it falls in well with types such as 9F and 10F, which include similar vases. True, the *sigma* is not readily explicable, and only one other lekythos (Palermo 1891, p. 29) is so marked, but the form of *sigma* is such as we find on 10F, 25 and is non-Ionic, while there are a number of minor BF vases in those types. The second piece is 8F, 12 which not only demonstrates how we should interpret the other more or less contemporary batch marks found in the area, but itself records the largest batch of figured vases known to me; in this context one cannot but recall the wreck off Majorca carrying numbers of late decrepit red-figured cups, presumably bound for Spain. [32]

Two marks on vases from sites further south in Spain should be noted also. The SOS amphora, seemingly of non-Attic origin, from Toscanos, with what is probably a Greek graffito on the shoulder, [33] and the foot of an Attic RF krater from Almeria, 18C, 52, whose Phoenician graffito seems to reflect Greek methods of marketing. [34]

The Greek mainland

The material from Greece was discussed in the previous chapter. I conclude that there is evidence for one or perhaps two groups of marks with a commercial significance, but that few other trademarks can be discerned among the numerous owner's inscriptions. On the other hand, the various types of trademark can often be parallelled in owner's marks from Greece. My judgements are based on consideration of material, published and unpublished, from Athens, Thorikos, Eleusis, Corinth, Aegina, Argos, Sparta, Olympia, Delphi, Perachora, Halieis, Thebes, Halae, Rhitsona, Olynthos, Neapolis, Thasos, Abdera, Samothrace, Delos and Thera.

Commercial marks are found on coarse storage amphorae from Greece - not a subject that I will take up here; many such marks are in some sense numerical, but we should note the relative scarcity of numerical marks on glazed or decorated vases. From the Agora area there are very few: *Hesperia* 25 (1956) 13 (Agora P21401), *Hesperia* suppl. 5 34, no. 25, a kantharos of 400-350 with a batch mark, and Agora P28531, salt-cellar, with a batch mark for 800. A few pieces, mostly of the fourth century, from the Kerameikos have batch marks, including a foot of a bolsal with a price of five drachmae for 60 pieces. A not readily datable glazed shoulder sherd from Sparta with a mark of capacity helps swell this meagre total. [35] It is only at Olynthos that a good number of such marks have been found: the scale of excavations, especially in the habitation area, may perhaps account for this. Among the numerical marks (presumably indicating batches of vases including the marked piece) we find 14F, 19. [36]

The Black Sea

Marked East Greek vases are known from Histria and Taman: the former have some point of contact with material from elsewhere (p. 237). Very few marks on Attic figured vases have been published; I know of only one black-figure vase, 5A, 7, from Taman, which could be related to other pieces from Vulci. Marked red-figure vases seem confined to 33A, 21, 5D, 16, 8F, 13, 8F, 14 (presumably figured), 22F, 2, Leningrad St. 1807 and St. 2173, and Varna II. 1450 (*BIAB* 27 (1964) 112); the earliest is of the late fifth century and Tolstoi dated 5D, 6 to the third. [37] The pattern is consistent with that of Attic exports save for the lack of fifth century marks. None of the pieces seem to be connected with others in their types, although 22F, 2 could be taken with 22F, 1 of unknown provenance; Leningrad St. 1807 is not one of the bell-kraters by the Kadmos painter with lengthy price marks of type 14F. On the other hand the two marks of type 8F demonstrate some sort of connection with vases from a wide range of other sites, although there is no need to assume that the marks were cut by a single person or that the vases come from a single workshop or were traded by one merchant.

A good number of glazed vases with marks have been found at sites around the Black Sea, [38] the earliest still of the sixth century. Among the longer graffiti are dedications, owner's marks, an abecedarium and various festive remarks. Although Tolstoi and others have attempted to place a commercial interpretation on some of the lesser marks there is little to warrant the idea. There are some numerical marks, in particular from Apollonia and Chersonesos (together with 8F, 13 and 14), but these seem to be regular batch marks, as we have noted elsewhere, and cannot readily bear the fuller meanings put upon them. [39] One mark from Apollonia may include a drachma sign, as does one from Chersonesos. [40]

The majority of the shorter marks are no doubt owner's marks, with a range similar to that from other areas (e.g. marks similar to types 22A, 8B, 9B, 15B, 18B, 9C, 5D, 7D, 9E and 10E). As in the Greek mainland these marks are rarely of the same period as their commercial counterparts, and they appear for the most part on smaller drinking vessels. Common abbreviations, such as 9E and 10E appear at more than one site, but no mark is found in any numbers in any single place. [41]

Most of the marks are in Ionic script, but there are a few points to note. Tolstoi 56 is given a three-bar *sigma*, but as the vase is said to be of fourth century date one suspects a false reading or defective cutting. Crossed *theta* appears twice (Tolstoi 77 and *St. Class.* l.c. 1, of roughly 500 and 400 respectively); on the former it is combined with an *alpha* of markedly Aeginetan shape (see p. 242, n. 7). Tailed *rho* is more common in the area than in Ionia itself. At Apollonia we find unexpected examples of the aspirate. [42]

In sum, the Ionic script is fully in accordance with an interpretation as owner's marks, and there are few marks on glazed vases which have any clear commercial purpose. A few rather loose links with other areas can be found in

the case of some marks on decorated vases, but closer ties are only to be found in the dipinti on East Greek products.

Asia Minor

The record of marked figured vases from this area, excluding the off-shore islands, is very thin; Corinthian 72 is from Elaious in the north, 22B, 1 from Xanthos in the south. We must also recognise that the total number of intact Attic vases from the area is small. The few published graffiti on glazed vases from Troy, 'Larissa', Miletus, Smyrna and Labraunda contain little of interest, save the precious identification of the first site and acrophonic numerals on a sherd from Miletus. [43] S.1. 2, 26 from Smyrna is probably an owner's mark, while 26F, 14 provides the closest link with material from elsewhere, even though it consists merely of a use of the batch formula with a price, introduced by T1(MH).

Rhodes

I have dealt with the marks on vases with a Rhodian provenance in *BSA* 70 (1975) 145-167 and merely summarise the results here.

There are several marks on Laconian and Corinthian vases which probably have a mercantile significance, and of these Corinthian 28 is close to a piece from Nola. Others are owner's inscriptions, as are those on vases of East Greek origin with no clear exception.

Of the thirty-six marked black-figure vases twenty-one are red dipinti. One is a full owner's inscription (l.c. no. 48), and it is possible that some of the abbreviated dipinti should be similarly interpreted, though I rather think that the majority are trademarks; none however are closely connected with marks on vases from other areas, and only one small close group can be isolated, 7F, 1 and 2. There is one inscrutable numerical mark, l.c. no. 38. The overall pattern of marking is similar to that found on vases from Etruria, commercial dipinti on larger vases and likely owner's marks on smaller ones, with few exceptions in each category.

The twenty marked red-figure vases include one member of type 18C and 24F, 1, a vase-name mark with affinity to, if no personal connection with others in the type. A number of askoi may have trademarks rather than owner's inscriptions; see below.[44] 9C, 1 and 2 are cut by the same hand and are on very similar vases; as the pieces come from different tombs, there is a nice balance of argument whether the mark is commercial or personal.

The bulk of the marks on glazed vases are likely to be owner's inscriptions; two pyxides have potter's tally marks under foot and lid (p. 38) and one of the few numerical marks appears to be in Attic script (l.c. no. 136, kylix). The scarcity of tally marks such as are found in other peripheral areas may be due to the fact that little of the Rhodian material is of the fourth century (or latest fifth) when batch marks are most frequently found on smaller glazed vases.

Cyprus and Al Mina

A large number of Late Helladic vases with 'commercial' dipinti have been found in Cyprus (see p. 1). Among decorated or glazed vases of the Iron Age I know only one of non-Attic origin with a possible trademark, Nicosia C950, an East Greek cup fragment with a mark of type 23E, iv on the floor - very likely an owner's mark. Marks are also rare on Attic figured vases; three on black-figure vases seem to have no relation to other marks, 13B, 18 and 14B, 18 and a perhaps syllabic mark on Salamis 5341, a lekanis by the Polos painter. [45] The red-figure list is also short, comprising 25F, 21 in syllabic script, and some pieces from Marion, a cup, 16B, 9 and several askoi. [46] The figured askoi cannot be separated from glazed pieces, some with the same mark of type 9E, xv, and there are a good number of other glazed vases, mainly from Marion, to be added to these. I have noted about thirty such pieces not included in Myres' catalogue or later publications. [47]

The marks on these pieces are of value because of the potential light they could throw on the question of the introduction and spread of the use of alphabetic script in the island during the second half of the fifth century, to which many of them belong. Much depends on whether the alphabetic marks are to be taken as trademarks, perhaps applied at Athens, or local owners' inscriptions. This is not the place for a full treatment of the question, but I will attempt to outline and illustrate the questions to be faced.

Some of the marks are obviously numerical; to those mentioned in *BSA* l.c. 167 n. 54 may be added Nicosia C532, a stamped bowl, with a batch mark, forty-five and C969, a bowl with six stroke before a drachma sign and an *alpha* above; *alpha* followed by a drachma sign is found on C883, red-figured askos and 1950 vii-31/4, stamped dish. Subsidiary list 4, 13 is a further example of a potter's tally mark on a pyxis. As noted above, some of the askoi have marks of type 9E, xv, which can be parallelled on Rhodes; marks akin to type 19B also appear on askoi from both areas, though here neither the shape of the mark nor the date of the vases is noticeably close. Marks of this general character are relatively frequent, however, on East Greek vases, and I suggest that the slight variations in shape may not be significant (p. 236); the same could apply to these rather later Attic vases, with perhaps Ionic trademarks. On two askoi and one stamped bowl which have such a mark we also find a graffito in syllabic script; of these, Myres 1926 (C578) has the same syllabic inscription as an askos fragment C947, but it is not known whether the two

pieces could have come from the same tomb. If we take the mark of type 19B as a ligature of *lambda* and *upsilon,* it is worth noting that those letters appear unligatured on two further vases, in company with different syllabic marks, C594, stamped bowl from Sphageion tomb 26, and 1961 ii-2/8, one-handler, and once alone, C574, stamped bowl from Sphageion tomb 14 (the same tomb - ?the same burial - as C883 above). Of the few other pieces with both alphabetic and syllabic marks we may note C688, bolsal with ME and, a little apart, syllabic *ma* closely followed by 'arrow' *delta iota.* Among the partly reconstructible tomb groups we may note Sphageion tomb 26/1 which includes five pieces with a mark of type 9E, viii (Myres 1934, 1935, 1712, 1792 and 1793 - the first two (C535 and C462) with other marks, probably syllabic) and one with a mark of type 18B (C558, Myres 1912, one-handler).

The complexity of the problem will be apparent from this survey, but it would be unwise to pass judgement on the matter of interpretation without a full publication of the material. It would appear that some of the marks in question are trademarks, but I doubt whether this applies to more than half the alphabetic marks, and to strengthen the case of local owner's marks in alphabetic script we can point to a small number of longer graffiti on similar small vases; they have none of the characteristics of trademarks. [48]

We may note the glazed vases with marks found on board the Kyrenia ship, even though it is highly likely that they are owner's inscriptions, cut by one Eup - - before the ship's final voyage. [49]

14F, 17, a bell-krater from Al Mina has a certain connection with others in the type, from other areas, though as elsewhere the link does not extend as far as a common monogram or personal abbreviation. The same applies to a red-figure pyxis lid of c. 400 from Apamea, marked AⱵᴦΔ on the underside; we may ponder its relationship to the Cypriot pieces with AⱵ mentioned above. There is a strong suggestion that a price of a drachma for fifteen pieces is being quoted, presumably at Athens; the resulting unit price is not elegant, but does seem in line with the practice of quoting prices based on so many tens (here fives) per drachma, which I have suggested for other price marks of the same period. [50]

A number of feet of open glazed vases from Al Mina now in Oxford have marks. Several are batch marks 45, 35 and at least 30 (1956.503, 467 and 500 respectively); they are fourth century stamped and rouletted bowls or plates, rather later than most of the Cypriot material just discussed. Two other pieces may be noted: 1956.498, a similar foot, fragmentary, with an 'arrow' *delta,* and 1956.468, from a stamped bowl of the later fifth century, with Ϩο, as type 21A.

Egypt

Marks of a probable or assured commercial nature are common on East Greek vases from Naukratis and Tell Defenneh; other sites have yielded very few marked pieces earlier than c.300. [51] Figured vases do not seem to have marks, 9B, 20 excepted, though the fragmentary nature of the material does not encourage confidence in such an observation. A large number of the marks published in *Naukratis* are on Attic glazed ware: 373, 376-383, 468, 494-614, 654, 685-7, 697a, 866, 870. [52] Some marked pieces in the series London 1965.9-30 are also Attic and very probably are from Naukratis. The overall impression is that most of these marks are owner's inscriptions, ranging in date from the middle of the sixth century into the fourth. Few marks are repeated and there are no large groups. The occasional numerical mark should have some commercial significance, as elsewhere: *Naukratis* 551 and 866 have simple numerals and 1965.9-30.579 an 'arrow' *delta* followed by an ill-preserved letter; longer is 1965.9-30.876 with ⱵΔΔΔ Δ and ΔΔᴦ (a later fifth century glazed bowl). This may indicate a price of one drachma for forty such vases, but this interpretation does not account for the other numeral. [53]

9B, 20 has no clear association with others in the type; Hackl mentions some of the other pieces, [54] and one can add a few further parallels to marks in the catalogue (569, 586), but most of these are common abbreviations. They include the inevitable examples of types 9E and 10E. 373 and 569 both have marks of type 11E; we cannot rule out a connection with the trademark, but if we bear in mind the ramifications and combinations of the latter, we must conclude that the Naukratis marks are unlikely to have the same individual significance. 872, with ΛEK I have not seen; it could perhaps be an abbreviation of a vase name.

Nearly all the marks could or must be in Ionic script; an exception worth noting is 504 (which I have not traced) where three-bar *sigma* is found apparently along with *heta,* 'arrow' *delta* and drachma signs.

Cyrenaica

Dipinti are found on some East Greek pieces from Tocra, but I know of only one Attic figured vase earlier than the fourth century that has a mark, Louvre M7, hydria by the Syracuse painter (*ARV* 520, 38) with a ligature, *epsilon* and another letter. Three fourth century pieces are in the catalogue, 8F, 3, 24F, 8 and 25F, 8. We have seen that 8F has a wide distribution; the meaning of the mark on 8F, 3 is presumably the same as in the rest of the type. 24F, 8 finds an odd parallel in a piece from Leontini given in *NSc* 1955 336, fig. 49, 9, but apparently not mentioned in the text; it is likely to be an abbreviation of ἔμπορος or a related word, though its significance is by no means thereby clarified. [55] The explicit batch lists on 25F, 8 encourages us to think that more obscure numerical marks may be similarly interpreted; we have already noted above that such batch notation lasts well into the fourth century, longer than the usage of personal trademarks.

This material can be supplemented by marks on some glazed vases from Euhesperides once stored in the Ashmolean from the excavations of C. N. Johns and B. Wilson. I noted sixteen graffiti (and one red dipinto, ⱵΡⱵ

on an amphora neck), all on open glazed vases; several were not fully preserved. Two may be singled out since they denote batches, one of 42 (but the beginning lost) on a bowl, perhaps not Attic, of the later fourth century, the other of 28, employing 'arrow' *delta* and *'gamma'* five, on an Attic glazed skyphos of Corinthian type, of the second half of the fifth century. Of two inscribed vases in the British Museum from Benghazi, one is a red-figured askos of the late fifth century, G39, with the mark KΛE. the other is a lekanis of c. 450-425, glazed, with lid and has a batch mark ΔIIII (1866.4-15.19).

CHAPTER 5
SCRIPT, DIALECT AND VOCABULARY

The question most often asked of our marks in general works on Greek trading practices is 'who applied them?'.[1] The assumption is made that the script of the marks betrays the nationality of the inscriber and therefore of the trader or middleman. Ionians are often given particular prominence. This assumption is not wholly acceptable, but at the same time we must attempt to determine the hands responsible for the marks as best we can, and this I do throughout the commentary on the individual types.

It is a dangerous procedure to distinguish 'nationalities' from minor variations in the lettering of short graffiti of a fairly casual nature; on the other hand consistency in such variations should serve as reliable evidence of the origin of the inscriber, with the proviso that one man could perhaps have habitually used letter forms atypical of the preference of his fellow citizens.

First I discuss the alphabets of the marks, treating them letter by letter and omitting those of no diagnostic value; then I shall treat other linguistic matters and finally summarise the conclusions reached in the commentary on the scripts of the individual types.

Alpha. As in formal inscriptions, there is a trend towards a horizontal cross-bar. Among our marks there are few exaggerated forms; the 'Boeotian' form with one angled upright is found occasionally in a context which does not appear Etruscan, esp. 1B, 18 and 19 from Spina. I attempt to isolate trends within types in the slope of the cross-bar since the direction can be of help in determining a particular script; only with large samples, or strong additional evidence is it safe to draw definite conclusions; I approach that in type 1D, and feel that the consistent slope of the cross-bar up to the right in the kernel of 9E, iv does not support the idea of an Athenian hand at work.

Beta. Apart from Corinthian 27 and 28 there is no assured occurrence of unusual forms; but see East Greek 234 (p. 237).

Gamma. See *Lambda.*

Delta. Most deviant forms appear as numerals; see p. 27ff. It is possible that some pieces with Sicilian provenance in type 3E incorporate lunate *delta.*

(H)eta. Our marks reflect the increasing rarity of the letter, whether used as aspirate or vowel, in its closed form as the sixth century progresses; it is largely confined to 10A, i-ii, some of which may be Etruscan, although one is dipinto; also on London B144, Panathenaic amphora by the Swing painter (Fig. 14b).

The earliest occurrence of the open form on Attic vases is the problematic pair 5D, 21-2; after 550 we find it in types 10B, 1E, 4D and 5D and the value of the letter in these types is respectively aspirate, vowel, numeral and undetermined. Among the graffiti from the Agora there seems to be no assured use of the letter as a vowel before c. 470.[2]

Theta. Both in Athens and Ionia crossed *theta* is in use till c. 480, though the dotted form coexists with it for some time.[3] For the Etruscan usage see p. 242 n. 3. Crossed *theta* is common in marks, see types 12B, 1D and 1F, 2 and 3; it is found in an Ionic mark of c. 505, 2F, 32. Some of the later examples of the letter in type 12B can hardly be alphabetic, and one is tempted to include the pyxis, subsidiary list 4, 12 with them. Dotted *theta* appears where expected in other fifth century marks, but also earlier on 5A, 12 and 15F, 2.

Lambda and **gamma.** 'Attic' *lambda* is not rare in sixth century marks, but often one suspects an Etruscan origin; see on types 14A, 15A and 15E. 15E, 9 and 10 appear to be Greek, but are in some sense freaks. More assured instances of the letter in a Greek inscription seem confined to 15E, 8, 1F, 1-3, Syracuse 21953 (*ML* 17, 484, from Gela) and Taranto 52127 (p. 15); in 1F, 2-3 the script is certainly Attic, in the others probably so.

It is not always possible to decide whether isolated letters, or even some accompanied ones, are Ionic *lambda,* Attic *gamma* or perhaps *upsilon.* Ionic *lambda* is securely identified in types 17E, 1F, 2F and 10F, in regular use therefore before the end of the sixth century. As the letter is not found in the Agora graffiti before the second quarter of the fifth century,[4] it is unlikely that the marks were cut by an Attic hand, but see type 10F for some reservations. It is not clear whether the *lambda* of type 21E is Attic or Ionic, probably the former. I take the Λ of 23E, 10 (at least) to be Aeginetan.

Attic *gamma* is not surely found, though see p. 189 for the glaze dipinto on 19A, 1. Ionic *gamma* appears among the Ionic numerals of type 2F and becomes common in the fifth century, though never in association with other letters that one would take as Attic. The *'gamma'* sign for five appears in inscriptions in Attic script, though there is no indication that the sign ever had any alphabetic connections (see p. 29-30).

Xi. · The only form that can be isolated is the Ionic Ξ. After the puzzling 15E, 9, we find it in the clearly Ionic 2F, 51 and on 14F, 14 which has no other diagnostic letters. Three vases by the Berlin painter or his circle present the form, 10F, 22-4, and I argue in the commentary that this part of the graffiti on those vases is later than the ON mark which is in Attic script. Other instances of Ξ are 9B, 23 and 24, and Syracuse 53237 from Megara Hyblaea (see p. 17). There are further instances of the letter wholly isolated.[5]

Koppa. It appears as a numeral in type 4F, but also as a letter on 16A, 24, 13F, 8 and 9 and the cup-skyphos in Biel, *Auktion* 14, 60. The first of these four may be of Tarantine origin, the rest cannot be pinpointed.

Sampi. The letter seems to be used in the graffito on Cambridge 1937.8, oenochoe by the Athena painter (*ABV* 526, 1), where it is followed by EI. The form of the letter is clear, even if the sequence of letters is highly implausible.[6]

Rho. For a full discussion of the early history of the tailed form see on type 3E. In the sixth century we frequently find the stemless form of the letter, a form which is used widely in Greece, though I doubt whether it can be Ionic since it is not found among our assuredly Ionic marks.

Sigma. There is one example of *san,* Corinthian 63, and it is also worth noting a second possible case on New York 26.60.20, a neck-amphora by the Painter of London B235, from Vulci (*CVA* 4 52); the mark is so similar to the legend on some early coins of Posidonia that one is tempted to see a direct connection between the two.[7] If it exists, the vase graffito is presumably in some sense secondary, and if it is ancient it was presumably cut somewhere on its journey from Athens to Vulci.

Four-bar *sigma* occurs often in trademarks, but never accompanied by letters that are clearly Attic, though 21A, 102 is said to come from Athens. The form occurs sporadically in Attic vase-inscriptions, and elsewhere, of all periods, sometimes in company with Attic letters.[8] Before 450 we have examples in types 21A (disassociated from the three-bar examples), 22A, 7D, 2F, 4F, 20F and also as an isolated letter.[9] Conversely, three-bar *sigma* is found where expected on 1F, 2 and 3, and occurs frequently on sixth century vases, though not ranging widely beyond the large groups 20A and 21A (some Aeginetan?) with 26A and part of 7D. It is not common after 475-450; of non-Etruscan marks 7D, 19 and 22F, 5 are the latest examples in the catalogue. Type 1E is more difficult to explain; the three-bar form is very unlikely to be Ionic, although accompanied by *eta,* since its latest usages in Ionia are probably not later than 570.[10] In type 2F we also find some apparently three-bar *sigmas,* which I hesitatingly explain as countermarks.

Chi. The form usually found is X. Probable exceptions are the Ψ on three vases from Gela, 31A, 21 and 22 and 9E, 98, where we seem to have a local *chi.* The appearance of X as *chi* on 7F, 1, from Kamiros led me to think that it is an Attic or Ionic trademark, not an owner's dipinto.[11]

Omega. The letter is not common; there are two main groups, 22A, which is clearly Ionic, and certain vases of type 10F with part-Attic, part-Ionic marks (see **xi** above). Type 29A, with subsidiary list 1, 36, seems based on an *omega* and we can add Tarquinia RC7045 (type 23A, n. 1) and a few more doubtful isolated pieces.[12] 22A, 1, 3 and 4 and the Tarquinia vase have an *omega* cut by means of straight lines with the side strokes slanting upward, if at all; the rest have a more rounded shape and the slant of the strokes varies, downward on 22A, 5, 29A, 2 and 10F, 23, upward on 22A, 2 and 7 and subsidiary list, 1, 36, more or less horizontal on the rest. When the letter appears later in the fifth century (e.g. 22F, 3 and 24F, 5) it is usually rounded with horizontal side strokes.

Three examples are known to me of *omega* in inscriptions from the Agora before c. 470, one in an abecedarium, another rendering the genitive singular ending of an o-stem noun.[13] The same usage is found in the vase inscriptions on 17E, 3, of the Leagros group, together with a 'correct' *omega* and an Attic *lambda.* Was the vase-painter influenced by the Ionians who dealt with so many of the vases made in the workshop, one of whom later cut an Ionic *lambda* under the foot of this very vase?

Ionic lettering is clearly more frequent in the century 550-450 in commercial graffiti than in casual graffiti and other inscriptions from Athens. Much is probably the work of Ionian visitors to the Kerameikos, since Ionic and Attic letters do not seem to mix, but as so many marks have no diagnostic letters, it is not possible to be sure of the percentage of Ionic and Attic marks, nor to be confident about possible borrowings of Ionic letters by Athenians.

Therefore it remains a valid, if not proven hypothesis that the presence of Ionian traders in the Kerameikos could have influenced the development of the Attic alphabet in the late sixth and early fifth centuries.

Direction of script

Often we cannot be sure which way a mark is to be read. In a very few instances we find a preponderance of retrograde marks in a given type, and even here it is probable that the marks may be Etruscan, especially in types 14A and 15E. More than one retrograde mark is found in the following types:

14A Several examples, but some are likely to be Etruscan; discounting 13, they are all early, before 540.

20A It is not always easy to judge the direction of the more fragmented examples; there are perhaps eight possible candidates out of 88, with a date range 525-510.

21A The mark is reversible, but there are a few reversed *sigmas*.

1B There are three retrograde marks: 22 is early, 23 is probably a local Syracusan mark of c. 520-515 and 24 is of the mid fifth century; it must be a Greek mark, but is an isolated retrograde inscription at this date, although we should remember that it is in ligature.

10B The trio from Adria are retrograde, assuming that *alpha (h)eta* is an impossible combination. The interpretation of 16 is not fully assured.

15C The ductus of the marks suggests that 1, 4, 5, 8 and 9 at least are retrograde, again unusual for the date in question, though they could be Etruscan.

1D Three of the marks are retrograde out of twenty-three of the period c.525-510.

3D There are likely to be retrograde marks here.

3E A form of ligature which could be termed retrograde was in use throughout.

6E Taking the basis of the mark as a *pi,* we find five retrograde examples, of the period 515-500.

9E Apart from the 'internal' ligature of sub-group xi, the following are retrograde: 40, 58-61, 90, 93 and 99. The last three are outnumbered by related orthograde versions in the same sub-groups, 60 is not surely Greek and 58 and 59 have the mark in close association with an Etruscan graffito. 40 and 61 stand more alone.

15E Some of the retrograde marks are probably Etruscan, though most are early enough to cause no surprise in a Greek context.

17E Ignoring possible retrograde ligatures in sub-group iv, 13 is the only assured retrograde example.[14] Unfortunately we cannot assess where it was cut; Taras would be a likely candidate at the time in question, c. 440.

21E It is not possible to say which form of the ligature is to be termed retrograde, but examples of the mark where the *epsilon* is attached to the right strut of the sign read as ✓ outweigh those where the left strut is used by 32 to 8, as far as my knowledge of the material admits of statistics.

2F There are three retrograde examples of the ligature, 7, 11 and 29. I should also mention the mark HΛ which appears on two unrelated vases, 9B, 13 and Villa Giulia 14215, neck-amphora, near the Matsch painter (s.l. 2, 9a); the letters can be interpreted in several ways, but λη(κυ...) would be the most reasonable were it not for the retrograde direction. If such a reading is rejected, hυ(δρία) should also be discounted, especially as the vases are not hydriai; 9B, 13 then becomes one of the more inscrutable of double Greek marks (see below Chapter 9).

11F Another trio from Adria, probably in local script, with a red-figure cup of no known provenance. The *kappa* inside the neck of 4 appears retrograde, but was no doubt incised with the vase upside down.

17F 1 was probably cut retrograde for quasi-aesthetic reasons, to balance the other numerical part of the mark.

22F 9 is perhaps our latest retrograde mark, and was probably cut in Athens.

In addition, numerals are occasionally cut retrograde with reference to the mark which they qualify; the drachma sign also appears retrograde, e.g. 14F, 17 and Harrow 50 (p. 195).

Few marks on non-Attic vases are long enough for us to determine their direction. Corinthian 4, 59 and 60 are retrograde. We might have expected a larger number of such marks in the first half of the sixth century.

With the pieces from Adria and probable Etruscan marks removed we are left with a small number of retrograde marks. Few types have more than the occasional example and there seems little warrant to allot those types to a particular area of Greece on that account; we should be particularly careful with ligatures, and we may note the three retrograde ligatures in type 2F, an Ionian mark, from a supposedly progressive area of the epigraphical Greek world. Some retrograde marks are early enough to have been cut anywhere without seeming unusual, though there are the late oddities 1B, 24, 17E, 13 and 22F, 9. The marks of type 6E may be numerical; they are the latest marks to appear retrograde in any noteworthy proportion.[15]

Punctuation

Punctuation in marks first appears regularly on vases of the Leagros group, but there appear to be two slightly earlier instances in dipinti on vases from the Antimenean circle, in both cases probably separating numerals

from the rest of the mark, on 3D, 7 and Munich 1557, neck-amphora by the painter of Boulogne 441 (4A, 10). They have double-dot punctuation, as do perhaps the earliest of the 'Leagran' pieces, the red-figured vases of type 2F, vii C. On the black-figure Leagran vases of types 8A and 2F the double dash is normal; the dashes slope down to the right except on the pair 2F, 47 and 48. The bracket also appears on a red-figured vase of the period, 2F, 50, and occasionally later, though in certain cases it can also be used as a numeral, fifty (p. 29). The dashes also appear later, e.g. 22F, 4 and 25F, 5, though now they slope up to the right. We may note that at no time is punctuation the rule and even one piece in type 2F (32) does without it.

Various forms of double dot, dash and circle are found on pieces of type 14F, while a double chevron is used on 9E, 98 and is reported on another skyphos, 25F, 1. Triple dashes appear once, on 14F, 18; Beazley gives double crosses for 22F, 5. Apart from the bracket, single element punctuation is confined to 6F, 2.

Care was taken not to confuse punctuation with letters or numerals. [16] The types of punctuation used do not reflect the range found in any one area of Greece; in many cases the punctuated marks are in Ionic script, but 22F, 5 and 14F, 1-5 are Attic exceptions. The bracket is used with Ionic letters (2F, 50) and with Attic (9F, 51 and perhaps Altenburg 279, column-krater by Myson, *ARV* 241, 67); 10F, 25 is more surely Attic, but there I am convinced that the bracket sign is numerical.

We may note the complete absence of punctuation in the vase-name marks on vases of the Polygnotan group. One reason for this may be that numerals appear rarely among them and in nearly every case known to me punctuation serves to isolate numerals; type 8A is the only possible exception and even there a numerical explanation cannot be ruled out.

Orthography

Informal, even more than formal, inscriptions are likely to contain errors of spelling, and our marks are no exception. I have noted four examples of the omission of a letter in a vase name, 14F, 4 and 16, 21F, 10 and 12, and two in an adjective, 12F, 3 and 24F, 2. We may be tempted to call the *omega* in the first syllable of 24F, 3 and 5 a spelling error, but it would be an unhappy description during the period when the Ionic script was being adopted at Athens, implying that there was a 'correct' system. The evidence merely suggests a certain ambiguity in some Athenians minds about the length of the vowel, sufficient for the employment of the newly learnt letter.

Letters have been corrected in 15F, 1 and 2. There seems to be something of an affectation in the unassimilated *nu* before the *mu* in 19F, 10. I argue a case for haplography on Villa Giulia 50624 (p. 27). Other errors and oddities may be lurking behind some of the more mysterious marks.

Dialect

There are two cases of metathesis: type 1D, which I suggest is of Doric origin, and 7F, 7, where it is more obviously Ionic. We should note, however, that metathesis of the aspirate does not occur where we might have expected it in other Ionic marks where XV is used as an abbreviation of χύτρια or the like (2F, 32-7, 51).

Also in 7F, 7, if my reading is correct, we find a form of the diminutive of κύαθος in - ειον which has only recently found a near contemporary parallel, datable to 413-2 (*Hesperia* 32 (1963) 155 1.10). The same diminutive may appear in 15F, 2, where the termination is - εα; the spelling with *epsilon* would be normal if the diphthong was a secondary formation, which could be argued; on the other hand, if one takes it as a primary diphthong, there are few parallels for the rendering of EI as *epsilon* in Ionic. [17] The secondary diphthong in MEZΩ on 6F,1 could be Attic or Ionic, but the script of the mark points to Ionia, as does the contraction of the termination -ονα to *omega.* [18] Other interesting case endings are the plural terminations of - ης adjectives in type 24F, q.v.

Psilosis is most noticeably found in type 21F, along with aspirated examples; for our purposes psilosis must be of Ionian origin, though this was by no means the only area of Greece to dispense with the aspirate. A possible instance of etacism is found on 3D, 16; I note other possible examples in the commentary thereon.

Terse commercial notes allow little play for dialect forms. The Sicilian Doric graffito, 1F, 6, I have fully treated in *ZPE* 12 (1973) 295-9, and a possibly South Italian mark in *PdP* 30 (1975) 362-5. Types 1D and 23E provide further possible Doricisms. Ionic lettering is frequent, dialect forms much rarer.

Vocabulary

The greatest contribution of these marks is in the realm of vase-names; they are discussed in the commentary and in chapter 7. Nonetheless, some marks which seem to have such a meaning cannot be satisfactorily interpreted, especially 24E and 9F.

We find the earliest attested use of ἔνο (Sicilian Doric for ἔνεστι) in 1F, 6 and ἐνθήματα in 14F, 6. The reading is uncertain, but ἄτιμα on 7F, 8 should perhaps be interpreted as 'cheap', not a common meaning of the word.

Type 4F, 1-3 amply support Herodotus' testimony that ἀρύστηρ was used as a liquid measure in Ionia. The colloquial usage of σπάθη as a vase-name can now be taken back into the fifth century (type 18F). Ἰχθύα can hardly be the 'pot, perhaps for pickled fish' which Liddell and Scott suggest, and room should be made in the same lexicon for our ὀξύβαφον, of fairly frequent occurrence. There seems to be considerable confusion over the length of the first vowel in λήκυθος, λέκανις and related words; I attempt to sort out the situation in the commentary on type 1F.

I append my thoughts on the origin of the inscribers of the various types about which anything significant can be said.

1A-3A	Probably Etruscan.
8A	Perhaps Ionic in view of the punctuation and possible numeral.
10A	The horizontal shape has parallels in East Greece, while the upright type should be in a non-psilotic dialect.
12A	Depends on the value of the *(h)eta.*
14A	Some Etruscan, others probably Attic.
19A	The black-figure pair at least Attic.
20A	Not Ionic, probably Attic.
21A	The glaze marks should be Attic, others may be Aeginetan.
22A	Ionic
25A	Not Ionic.
26A	Not Ionic.
29A	The basic *omega* indicates an Ionian origin.
33A	Mixed; if any are ligatures with three-bar *sigma* they are probably Attic.
2B	The glaze dipinti Attic; sub-group iii probably Ionic.
4B	The glaze marks Attic.
10B	Not Ionic because of the aspirate.
16B	The glaze marks Attic.
21B	Most are likely to be Attic in view of the script of the accompanying mark on 6 and 7.
24B	Varied, with some problematic pieces.
14C	Possibly Etruscan.
15C	Some perhaps Etruscan.
18C	Inscribed at Athens.
1D	Aeginetan?
3D	The dipinti possibly Aeginetan (see p. 204).
4D	Ionic.
5D	Depends largely on the value of the *(h)eta.*
7D	Some Etruscan; most of the others probably Attic, progressing from three- to four-bar *sigma,* but Ionic and Sicilian examples are probably present.
8D	The glaze pieces Attic, as presumably the related red dipinto.
1E	Cycladic? or an otherwise poorly attested Ionic script?
3E	Sub-group iii may be Attic.
4E	Etruscan
8E	A puzzle; not Attic if we take due regard of Rhodian 97.
9E	The glaze marks Attic; most of sub-group iv seems neither Ionic or Attic to judge from the letter forms; sub-group xii probably Attic.
10E	The glaze marks Attic, taking with them others in the type.
12E	Ionic in view of the accompanying numerals.
14E	Does not seem Attic or Ionic, perhaps Etruscan.
15E	Some Attic, some Etruscan and two oddities.
17E	The main sub-groups Ionic.
21E	Perhaps mostly Attic.
22E	Some not Attic in view of the shape of the *alpha.*
23E	Some Aeginetan.
1F	Varied, Attic, Ionic, Sicilian and South Italian; perhaps hybrids also.
2F	Ionic
3F	Ionic?
4F	Ionic
5-6F	Mostly Ionic
7F	7 is Ionic.
9F	The accompanying numerals point away from Ionia, but the Λ *lambda* does not encourage one to think of an Attic origin.
10F	Much the same, but with some more certain Attic members.
13F	Various.
14F	1-5 Attic, taking 12 and 15-18 with them; 10 and 11 (in part) could be Attic. 9 and 13-14 Ionic.
17F	1 is Attic, 2 Ionic, the rest undetermined.
19F	The earlier pieces Ionic.
21F	The aspirated examples presumably Attic, the rest Ionic.
22F	4 is Ionic, 5 Attic, the rest too late for distinctions to be made.
24F	The dialect of some may be Attic.

Further remarks on individual pieces will be found in the commentary. For the classification of all glaze marks as Attic see type 19A with n. 1.

CHAPTER 6
NUMERALS

It is no surprise that numerals are of frequent occurrence in trademarks. This body of material is of considerable importance since it provides the earliest good evidence for the use of various numeral systems. The origins and early history of these systems has not been given due attention; in his basic articles Tod was more concerned with local differences revealed on the whole by much later material. Lang has published useful comparative material from the Agora and Graham and myself have probed into the history of three systems, Euboean, Ionic and South Italian.[1]

Ionic numerals

One of the major difficulties of treating this system is isolating instances of its use. Obviously a single letter on its own could be regarded as alphabetic or numerical, though it is highly likely to be the former, especially when it can be found on several related vases, e.g. the *betas* of type 6B, 1-3. Therefore we can only safely consider the small proportion of those marks that could *possibly* be Ionic numerals where a numerical interpretation is vouchsafed by the presence of additional marks which would lead one to expect a numeral, or by a collocation of letters such as could only reasonably be explained as an Ionic numeral.

The earliest examples of the system that can be found using these criteria turn up in unusual circumstances. First comes Corinthian 47, datable to c. 575; I give my reasons for interpreting the mark as σύμ(μικτα) in *BSA* 68 (1973) 186-7. The dipinto is in Ionic script, proof enough that the system is correctly named despite the previous lack of evidence for its early use.[2] I discuss the next Ionic numerals, on 4D, 1-3, in the commentary on that type, withdrawing my earlier opinion that they may have been applied in Etruria. Early in the fifth century an Ionic numeral, IB, appears under the foot of an Attic cup found at Gravisca, and most likely inscribed there.[3]

There are fairly plentiful examples of the system in the last dozen or so years of the sixth century and they continue down to 480-475, at which point it disappears.[4] All these examples are associated with other marks in Ionic script, confirming the range of use of the system. Most of the examples are in type 2F, vii where the vase-name formulae put the interpretation beyond doubt, as do the separate tallies noted on some of the pieces. Next come the marked prize Panathenaic amphorae of type 4F, though we cannot be sure how long after manufacture they were marked; here the combination of the letters, together with the accompanying ἀρύστηρ suggests the interpretation. Combinations of letters also betray the numerical significance of some marks accompanying type 12E in the early fifth century, and finally the vase names and letter combinations on 6F, 1 and 25F, 5 signal the last appearance of the system, still in the company of Ionic lettering.

It is in a sense not a pure coincidence that these Ionic marks are found on Attic and Corinthian vases, but rather an indication of the widespread Ionian participation in Greek international trade in the period 575-475; the marks were not applied in Miletus or Samos, but at Athens, even in the Etruscan ports or the supposedly monopolistic Corinthian harbour of Lechaion. The demise of the system will be due partly to the decline of Ionia after the revolt of 499-4, partly by the emergence of Athens as the leading power in the Aegean in the 470s.

Acrophonic systems

There are several varieties of the acrophonic system that emerge by the end of the sixth century. One stands rather apart and does not in fact obviously deserve the title 'acrophonic' at all; the others are truly acrophonic, using the initial letters of πέντε, δέκα, ἕκατον, though they vary because different forms of these letters were in use at this time. As far as concerns our material, the relevant variant is in the *delta* of δέκα; I discuss the mark on Villa Giulia 50624 fully in *PdP* 30 (1975) 362-5, concluding that it is the work of a South Italian; the vase is of the late sixth century and can be presumed to be of Etrurian or Campanian provenance. A further possible refinement of this particular form of the system is that the plain lunate *delta* may be confined to Sicily, while a stroke is added across it in South Italy.[5] However the small amount of material, its comparative dating and the need or not to distinguish alphabetic from numerical *delta* should all be kept in mind.

The variety of the system that appears most frequently in later years employs a plain equilateral *delta* for ten and a *pi* with an added stroke or *delta* for fifty. Commercial graffiti account for most of its early uses; the sole examples before c.450 known to me elsewhere are on the lead loan tablets from Corcyra, published by Calligas in *BSA* 66 (1971) 79 ff. On them we should note the lack of a sign for fifty and five, as well as the spelling out in full of many of the numerals, a procedure found also, for example, in the silver inventory list from the Artemisium at Ephesos (*LSAG* 344, 53, mid-sixth century), early Cretan law fragments, mason's marks on the late archaic temple of Aphaea on Aegina (Furtwängler, *Aegina* 369) and the assembly marks on the terracotta revetments from Calydon (*LSAG* 227, 4, c.600-575); in literary texts it would seem that all numerals were written out in full till an advanced date.[6] Herodian reports that Solon's law code employed the system for denoting the fines to be exacted, but as neither coins nor the system are otherwise attested so early, we must assume that if the report has any truth in it it refers to a later publication of the laws.

If we exclude examples of simple *pi* or *delta*, and ⌐⌐ and ᐃᛁ also, except where the context strongly suggests a numeral, there is very little to be placed in the sixth century. It is feasible that a graffito on an Attic SOS amphora of the first quarter of the century has a numerical ᐃ, but there is no persuasive argument in favour, while a numerical mark of probably Eastern Mediterranean origin is cut on the amphora that bears our earliest Greek inscription of all, found in the necropolis of Pithekoussai.[7] Perhaps the earliest Corfu tablets belong before 500; to these we can add two pieces from Sicily, exhibiting only the *pi*, 1B, 7 and Gela, Navarra 11 (*CVA* 3 6; *ZPE* 17 (1975) 154). 17B, 4 probably belongs to the years before 515 and very obviously employs the system, with a batch mark, 49; regrettably there is no clue as to the point of reference - I would assume accompanying small vases. 14F, 14 of c.500 has ᐃᛁ associated with O⨯, suggesting perhaps a tally of oxybapha, but in that case it would be an unparallelled case of acrophonics associated with what appears to be an Ionic inscription. Earlier is a neck-amphora, *Auktion* 16 104, 14A, 12, on which four strokes follow the sequence *alpha, upsilon* (?), *delta*; the transcript does not enable a judgement to be made on whether the *delta* is numerical. Finally, Laconian 9 has an apparent numerical mark on the shoulder, beginning with a *delta* but including at least one X; it dates some way back into the sixth century, but again we cannot be sure what sort of numeral system is employed. Chiot 55 and East Greek 221 both have a mark resembling three joined *deltas*, similar to runs of *deltas* found on glazed vases of the later fifth and fourth centuries, but on 221 the central '*delta*' does not touch the ground line and on 55 the end strokes are clearly vertical and there is also a further stroke below the complex (Pl. 42).

This system does not appear in frequent use in the first half of the fifth century either. It is possible to list all examples, and it is a very mixed collection:

7B, 6; 9E, 71, 72 and 74, from various sites; 17E, 18, from Agrigento; 1F, 1-3 (2 from Syracuse); s.l. 1, 29.

Naples Sp. 353, bolsal, from Suessola (fig. 14s).

Cab. Med. 244, prize Panathenaic amphora, from Vulci (p. 223-4).

Ragusa, neck-amphora, c. 460, from Kamarina (p. 60, n. 26).

London 1864.10-7.1704, cup, from Kamiros; *BSA* 70 (1975) 162, 136.

Agora P8856, *Agora* xii 1715, 520-490.

Agora P14973, *Hesperia* 25 (1956) 22, 100.

Agora P5165, ibid. 18, 74.

Agora P5979, ibid. 21, 88, early fifth century.

Agora xxi 22, E1-3.

To which can be added some pieces not closely datable from available evidence, but perhaps of this period:

9E, 124 and 5F, 6, from Ruvo.

Halle, skyphos (H610)

Ragusa 23004, glazed cup from Kamarina (p. 60, n. 26).

London 1866.4-15.19, lekanis from Euhesperides (p. 21).

1B, 8, from Taranto is a further possible and early example.

The types of vases marked, their provenances and the context of the numerals are very mixed. In several cases lists of vases seem to be the point of reference, elsewhere an indication of capacity (Cab. Med. 244, *Agora* xxi E1 and s.l. 1, 29). In two cases the system used is 'defective', lacking *pi* on 17E, 18 and without signs for fifty and a hundred on Cab. Med. 244. The expected H for one hundred appears on 1F, 1 and 3, 8F, 12, the Reggio vase, p. 60 n. 14 and Agora P28531, a salt cellar with a batch mark, 800 (p. 18).

There are a few pointers to the origin of the inscribers. The lettering of 1F, 1-3 strongly suggests an Attic hand, though the crossed *theta* is late for Athens; the only alternative would seem to be Euboea or a Euboean colony and that seems an unlikely explanation. London 1864.10-7.1704 would also seem to be Attic with its three-bar *sigma*, and there is no need to deny an Attic inscriber of the Agora marks. For the rest there is little diagnostic evidence; however, I believe that a lunate *delta* would have been used in Sicily in the Dorian colonies, which would rule out a local origin for a number of the marks, though not necessarily prove that the inscriber was Attic. 17E, 18 is particularly problematic, with only a reported provenance of Agrigento; the alphabetic marks are in two hands and the numerals seem dependent on the ΛE, which is not Attic; we would not expect the acrophonic system in an Ionic inscription, and it would seem best to think of a non-Ionic state using Λ *lambda*, or of a 'mixed' alphabet.

The vases from Campanian sites and Ruvo were presumably not marked locally but by an Athenian or other Greek trader, and the same must apply to the Panathenaic prize vase from Vulci; I argue (p. 224) that it is a capacity

mark. The lack of a sign for fifty and a hundred need not mean that none existed in the system being used, but that the *deltas* were inscribed cumulatively, although this does involve an extremely awkward procedure of filling and inscribing. I am not confident of any close link with the albeit otherwise closely related prize Panathenaics, 4F, 1-3, with capacity marks using Ionic numerals.

The system was obviously used in Attica in the first half of the fifth century, and amply attested after that in inscriptions. Few of the marks discussed could not have been cut at Athens; 17E, 18 is the most likely exception; however, there is no reason to attempt to force all the marks on to Athenian hands.

The third variety of the system is that in which an 'arrow' *delta* and '*gamma*' five is employed; this is used more frequently in the early period and in a much more regular manner, so much so that a good proportion of the list of examples before c. 450 can be organised into a series of close groups.

1. 5A, 16 and 17.
2. 6D, 8 and 10.
3. 10F, 1, 3-7, 17, 21-25.
4. 9F, 29, 32a, 35, 51.
5. Leiden K94/1.10, neck-amphora, near Red-line painter (*CVA* 1 pl. 53, 4).
 Manchester IIIh 48, neck-amphora, painter of Manchester satyr (Fig. 14k). From South Italy.
 London B489, oenochoe, Daybreak painter (*ABL* 13). Dipinto, three *deltas*.
6. Others
 21A, 101 and 104; 13B, 28; 6D, 17; 7F, 8.
 Gerona, lekythos, black-figure (p. 17 with n. 31).
 Gela 10597, oenochoe, black-glazed, 475-450 (p. 60 n. 26).
 Bologna PU318, lekythos, red-figured, 480-470, with ʌ‖.
 Palermo 1891, black-figured lekythos (? = *ABV* 385, 30, Acheloos painter), Fig. 14*l*.
 From La Monedière, Jully, *La Céramique attique de la Monedière* 196, 20, cup foot, c. 500.
 Malibu 73.AE.23, lekythos, c. 480. See p. 99 and fig. 14r.
 New York GR 580, pelike, Argos painter (*ARV* 289, 14).
 New York 41.162.127, skyphos, 500-450, *CVA Gallatin* 105.
 Oxford 1956.482, stemless cup, 500-450, from Al Mina. *Delta*.
 London 1859.2-11.71, type C cup, glazed. *Delta*.
 From Satrianum, tomb 7, 43, cup, c. 450, R. Ross Holloway, *Satrianum* 52-3; see also K. M. Phillips, *AJA* 75 (1971) 451.
Some more doubtful cases
 Xanthos iv 398, foot fragment, c. 550-525. *Delta*?
 Thasos vii, 120, 8, skyphos.
 Lindos i 2832, skyphos. ʌ‖ and ʌⱺ.
 Agora P16499, foot of bowl; *delta*, preceded by a part-preserved sign.
 Agora P17900, large skyphos; graffito broken off before ʌſ.
Some not readily datable either side of 450
 Agora P9177, *Hesperia* 25 (1956) 16, 69.
 Berlin 2599, skyphos, bought in Naples = 25F, 1.
 Munich 6498, from Cumae = 16F, 1.
 London 1965.9-30.579, from Naukratis, foot of glazed vase; *delta* with traces of a following letter.
 ex-Barone = 12F, 4.
 CIG 8345i = 8F, 16.
Later material
 6D, 18, 9E, 66, 73a and 98, 17E, 21, 14F, 1 and 2, s.l. 3, 15.
 New York 08.258.21, calyx-krater, Nekyia painter (*ARV* 1086, 1).
 Nicosia C688, bolsal (p. 20).
 Bochum S522, hydria, black-glazed, 450-425; N. Kunisch, *Antiken der Sammlung Funcke* no. 113.
 Oxford 1956.498, rouletted bowl, from Al Mina (p. 20).
 From Euhesperides, skyphos, 450-400 (p. 20). Fig. 14m.
 From Chersonesos, skyphos, c. 400, Solomonik, *Graff. Ant. Chers.* 1770.

The system is rarely found in stone inscriptions, only in a monetary context in inscriptions of Hermione, Kerkyra and perhaps Andania, all of the fourth century or later,[8] whereas only one of the ceramic examples seems later than 400, the rouletted bowl from Al Mina, which has the simple arrow sign; this sign need not necessarily be numerical, and similar doubts apply to a number of the examples listed above: the vertical joins the top angle on the Xanthos and the Bochum marks; neither of these need be numerical, nor should the obvious reading Ἡλι... be denied for the Thasos sherd. 6D, 18 with a joined vertical remains difficult and New York GR580 cannot be readily interpreted either. The Naukratis graffito is unfortunately incomplete.

The earlier examples demonstrate that the arrow sign originally belonged in a system using ſ for five; the sign for fifty is found on 10F, 3 and 23, and perhaps 6D, 17, and consists of the symbol for five with an added stroke. On 6D, 8 and 10 the sign for fifty is derived from *pi*; this is curious as otherwise *pi* does not appear with arrow

delta until c. 410 (14F, 1 and 2; I do not think it appears on 10F, 17 - see the commentary); that '61' should appear on two vases of discrepant dates is a further oddity, and I wonder whether the simple numerical interpretation can be correct.[9] The bracket sign on 9F, 51 is large enough to be considered punctuation rather than 50; a batch of 72 kraters would be surprising; the bracket on 6D, 17 is a problem, as there seems to be a *pi*-based fifty also.

The *'gamma'* five appears without an arrow *delta* on some pieces of type 10F, but they clearly belong here, and should take Bologna PU318 with them. In two cases we find the *'gamma'* upside down, 10F, 6 and 25, and perhaps the arrow *delta* was cut upside down to the introductory mark on 9F, 32a.

Normal alphabetic *delta* appears together with arrow *delta* on 12F, 4, 14F, 1-2, 16F, 1, Gela 10597 and in the secondary graffiti on 10F, 22-4.

The origin of the inscribers is no easier to find than with the normal *delta*. I have suggested that group 1 may be Aeginetan,[10] group 2 is unhelpful and group 5 is dependent on 3 and 4; of the etcetera of the early period two are accompanied by four-bar *sigma*, one by three-bar, while the intriguing 7F, 8 may involve Doric dialect with 'blue' *chi*. With regard to groups 3 and 4, I note that the Ionic letters on 10F, 22-4 are not an integral part of the numerical mark (p. 226), but the Ionic *lambda* sometimes associated with marks of both type 9F and 10F should give us pause. 10F 25 points to an Attic hand with its *lambda* and *sigma*, and if we are to interpret ON consistently as ὠνητός or the like (see the commentary) we must take all the graffiti as non-Ionic because of the lack of *omega*. The lack of evidence for the use of acrophonic numerals in Ionia is a further argument of weight, despite the fact that a form of *delta* similar to the arrow shape is found in alphabetic inscriptions on Samos.[11] The tailed *rho* on 10F, 17 also points away from Ionia. Later, 14F, 1-2 were cut at Athens and 9E, 98 probably at Gela since the third letter is more likely 'red' *chi* than *psi*. Without a date for 25F, 1 we cannot properly judge its Ionic letters. The material from the Athenian Agora is more restricted than that using normal *delta*, though examples do exist; a *'gamma'* five seems to be used on Agora P17900.[11a]

In sum, the system was certainly known in Athens in the fifth century, and on Aegina perhaps earlier. Many of our commercial uses could be Attic, but they do not appear to be exclusively so. The system is used with some consistency in the early period, more frequently than the version with normal *delta* with which it seems to have little in common, beyond the doubtful *pi*-based mark for fifty on 6D, 7 and 9.

The system does not appear to be truly acrophonic; the *'gamma'* is an Etruscan form of *pi*, but not an abbreviation of an Etruscan word for five, nor is the arrow any Etruscan form of numeral.[12] The upright form of the mark was normal, but not necessarily 'correct', as the two upturned examples demonstrate. The sign was given an added stroke to indicate fifty, which suggests in turn that a single stroke was given an added tick to denote five. The arrow form is not explained in any such way; if it is a derived form of *delta* we must assume a mixed origin for the system, part acrophonic, part tally. The lack of a sign for five on 10F, 17 does not necessarily show the precedence of the arrow *delta* in this system, since the seven unit strokes may well have been part of a running tally; in any case the vase is later than many of the pieces in type 10F with which it is closely associated; the *gamma* sign must have been in the inscriber's repertoire.

The uses of the acrophonic system in financial accounting are well known from fifth century Athenian inscriptions; commercial graffiti add little of significance. The drachma and half-obol signs are mentioned in the commentary on type 26F; there is a certain variety in usage and we should note in particular the apparent abbreviation ΔΡ for drachma on 16F, 1 and the use of a horizontal stroke for an obol on 14F, 15 and for a quarter-obol on 10F, 25; there is no assured example of the use of O to indicate an obol, although its half, C, is found indicating a half-obol, or possibly a quarter-obol.[13] The mark on the stamnos, subsidiary list 1, 29, is discussed on p. 6; it gives an early example of the acrophonic system applied to capacity, with the initial letter of the unit, in this case the chous, being combined with the relevant numeral; on the same piece the *(h)eta* may stand for ἡμικοτύλη.

Other systems

The simplest way of denoting a number is to inscribe the requisite number of single strokes, a running tally. This method of notation appears early on Attic vases, at about the same time as the Ionic system is found (note 4D, 1 especially). On two vases by the Swing painter we find six strokes cut (p. 207), as on a neck-amphora of the Botkin class (*Auktion* 51, 123); seven strokes are found on 9E, 33 (in another hand?) of c. 525 and on Geneva 5761, a hydria near the Lysippides painter (*CVA* 2 pl. 60, 1). Early members of type 5D have a lesser number of strokes. On one of the vases by the Swing painter, London B185, three dots in column follow the strokes, suggesting fractions of a unit and therefore ruling out the simplest explanation as a tally of accompanying vases; neither of the two alternative explanations, price and capacity, can command much support.[14] The concentration on the numbers six and seven (with eight in type 4D) may point to the second of these alternatives.

The method of 'tying' unit strokes into bundles by means of a horizontal appears only sporadically; it is not found on the above pieces or on the non-prize Panathenaic amphorae in Liverpool with strokes on the shoulder.[15] On Naples, Spinelli 2086, a glazed stemless cup of the later fifth century, a horizontal binds nine verticals; on London MS catalogue 1927 and 1929, non-Attic glazed bowls, there are three and four strokes so bound. It would seem that the same mark as on the latter is found on the pyxis lid, Agora P9809 (*Hesperia* 25 (1956) 18, n. 77); this mark is post-firing, but those on the lid and box, subsidiary list 4, 15 are pre-firing and do not match (fig. 14cc). A related mark may be that on Bologna 153 (fig. 8h), where a horizontal runs across the top of four strokes. Some

vases by the Ethiop painter should also be considered: Cab.Med. 393 has an unpublished mark (*ARV* 665, 1), a vertical followed by three horizontals and three verticals, some kind of regular numerical mark; on the other hand Copenhagen 148 (*ARV* 665, 10) and Boston 01.18 (*ARV* 666, 13) have marks consisting of a long horizontal sprouting a number of short verticals, six in each case, though on the Copenhagen piece they spring from a single central point, on the Boston Nolan from individual points. Another mark on the Copenhagen vase, 24B, 7, may not be unconnected with the numeral - it would appear to be Greek in view of the *omicron.*

A more intriguing system centres on type 3D. As many of the dipinti here are poorly preserved our evidence is not of the best at the outset, but it is clear that a mark similar to Ionic *lambda* was used in conjunction with unit strokes and dots. Two members of type 2D are stylistically close to vases of this group and have numerical marks involving *pi*, but of this *pi* there is no trace in type 3D. The reconstruction of this system must depend largely on the interpretation of the '*gamma*' sign on 3D, 5 and 7; the former unfortunately is lost, but if we choose to take the sign as five, the '*lambda*' should be ten. Alternatively we may take it as a smudged unit stroke or poorly formed '*lambda*'; in either case it would remain possible to read the numerals the other way up, not a '*lambda*' but a '*upsilon*'. The reading now assured for 7 virtually disposes of that possibility, although it by no means eases the '*lambda*' and '*gamma*' problem. Here one further dipinto, also associated with a mark of type 1D, may assist; on 1D, 5 there is a red X (Pl. 20), and I am encouraged by the association with 1D to take this too as a numeral, surely ten; in this case the '*lambda*' and '*gamma*' must be equated (the two forms are also found for five in the semi-acrophonic system discussed above) and taken as five. We may note that this is an early system, coming before our first true acrophonics.

There is clearly a close relationship with Etruscan numerals here, and perhaps with the Chalcidian system as suggested by Graham. [16] It is well worth considering whether the vagaries of transmission may have resulted in '*lambda*' and '*upsilon*' varieties of five being adopted in Etruria and Rome from a Greek source. However, we should not forget the connection with *pi* in type 2D, which may dissuade us from taking the type 3D dipinti as Etruscan; also the use of X to indicate ten seems rather wider still. There are a good number of numerical entries in type 8D, and it can hardly be that all are Etruscan; 8D, 66, one of our earliest marked Attic vases, from Taranto, can scarcely have been given its numerical mark by an Etruscan, though whether it was applied at Athens or Taras is not readily decided. The letter X seems to be used for ten also at Gela, on architectural terracottas of the sixth century. [17]

In certain instances the X may stand for 'χοῦς', but this can hardly be the case with the Taras cup. 8D, 68 is particularly instructive; six unit strokes follow the X, proving that it does not represent five, but either ten or a non-numerical concept; here no sign for five is used. The three dots following the strokes are likely to be fractions, as on the vase discussed above, by the Swing painter. If the mark were monetary, there seems no explanation for the X; taken as ten it would give a price of at least sixteen obols, surprisingly high for a vase and scarcely to be adopted on such slight grounds. If capacity is being noted, six choes and three kotylai would be an acceptable figure were we not dealing with a hydria, not a container that would be used for any commodity likely to be tallied in such a manner.

In sum, on at least one occasion numerical X was not cut by an Etruscan, and on at least one occasion it is not accompanied by '*lambda*' five. There would seem to be therefore a variety of systems employing X as ten in the later sixth century and even earlier. There is precious little in our evidence to suggest any connection with Euboea or its colonies; the only numerical marks that have connections with those colonies are 16F, 1 with 'arrow' *delta*, s.l. 1,27 with 0 perhaps used for ten and a glazed piece from Reggio with 'regular' acrophonics (p. 16); however, all these are of the fifth century or later.

Perhaps the dipinti of type 3D are Etruscan, but it may be considered unusual in that case that the marks appear on such a limited, and to an extent, stylistically related group of vases; the retrograde direction of the dipinti suggests Etruria, but there are also a proportion of retrograde examples of the accompanying Greek graffito of type 1D. As regards the significance of the numerals, we run up against the same problems as above; the apparently high number quoted on 3D, 5 only makes the matter more difficult.

No signs for larger numbers in these X-based systems appear in our marks. At Olynthos the related system uses a figure-of-eight sign for one hundred (although in our trademarks it is the hour-glass, not the figure-of-eight that appears in Greek contexts); as the Olynthos system is not acrophonic it cannot be that the sign is a rounded off *heta,* but perhaps it is connected with a further sign that can be used to signify ten, a simple circle. It appears on s.l. 1, 27, mentioned above, and on Taranto 4544 (p. 16) accompanied by four strokes. [18] Somewhat earlier we find the use of a horizontal line for ten on 2F, 32 and 33; the usage is borrowed from the Near East and also appears on Cyprus. [19] I am tempted to see an Etruscan use of it in the unpublished graffito under Florence 4007, oenochoe by the Niobid painter (*ARV* 607, 85); ∨〉= on the navel could perhaps be interpreted as twenty culiχna (kylikes). [20]

Two pieces that I know of only through Beazley's notes employ a sign similar to an Etruscan *gamma* in a numerical position. On an early BF hydria, Jena 189, six strokes precede the sign, while on Dresden 325, a pelike by the Orchard painter (*ARV* 526, 53) four strokes follow it; as the marks are reversible, their direction cannot be ascertained from Beazley's facsimiles. It is perhaps unlikely that the sign has the same significance on the two pieces; if it has an alphabetic origin it cannot be Attic, and if it is numerical the six strokes on the Jena vase show that it cannot represent five, at least on that piece. The possibility that it may be an angled half-obol sign cannot be fully ruled out for the Dresden vase. [21]

Such is the incomplete but intriguing body of evidence provided by trademarks for the extent of numeral systems in Greece (and Etruria) in the sixth and fifth centuries. While much remains obscure, it is clear that some systems are rather older than has been previously recognised, and that initially a range of systems was tried out, many of which were not adopted on any large scale thereafter.

CHAPTER 7
VASE NAMES AND PRICES

In this chapter I shall deal only with Greek vase names and these only within the framework of trademarks; recent work elsewhere covers very adequately the broader range of Greek names and the evidence for Etruscan usage.[1]

It has been generally accepted that certain names found in the graffiti refer to the vases actually inscribed, but there is some uncertainty whether many more are to be applied to the inscribed or other vases, a factor which limits the amount of positive identifications that can be made; we may call this the self-referent problem. I believe that we can be somewhat more positive here than has previously been considered. On the other hand we must be ready to admit that usage was not so tight that a single name referred only to one given shape rather than to a range of related vases.

The vase-names that are undisputed are *krater* (either Corinthian - column-krater, or Milesian - bell-krater) and *hydria,* which are identified by marks on vases of those shapes,[2] and *oenochoe,* inscribed on vases of different shape. Adjectives that should cause no dispute are λεῖα, μακρά, μέλανα, παχέα and ῥαβδωτά; to these we may add ποι (κίλα) and γλαῦ(κες), though the precise nature of the latter can be argued.

Vase names for which we cannot find a suitable identification are *aryster, lepastis, lydion, myrtote, oxis, pellinion, skaphis* and *tryblion.* None of these appear to be self-referent (see the respective commentaries) and most appear in batch and/or price inscriptions on larger vases. We can be reasonably confident that the *oxis, pellinion* and *tryblion* were smaller or small glazed bowls.

Some further self-referent names can be listed. *Spathe* is applied to the slim fifth century neck-amphora. *Kadiskos,* or variants, is confined to the pelike and Nolan amphora (save that one piece, 26F, 21, with a self-referent *krater* mark, also has a non-self-referent *kadi-).*[3] *Stamnos* and *stamnion* also are confined to the pelike and amphora, according to size.*Chytris* appears only on stamnoi and may be a restricted usage. Finally, three vases, all probably lekanides, are marked with what we may assume to be a self-referent ἰχθύα.

A few single marks may also be self-referent. An owl skyphos has KV (5F, 5), presumably an abbreviation of κύλιξ, and there is ample evidence to support the identification (p. 224), although Athenaeus and the lexicographers give us a generous range of other vase-names in κυ-. The γλαυ on another owl skyphos is obviously self-referent, and among the other adjectives in type 25F it is reasonable to think those stating size or variety of vase are self-referent since it would be difficult to understand any other noun than one applicable to the inscribed vase; λεῖα, μακρά and ῥαβδωτά offer no difficulty, though the price of the μέλανα and the size of the μεγάλαι are not fully in keeping with what might be expected. Of the other small vases with vase-name marks, the two cups 7F, 1 and 2 cannot be properly judged, 14F, 19 is probably not self-referent, 14F, 21 may be and 13F, 11 and 12 remain undetermined.

Some of the marks on larger vases which appear not to be self-referent can be explained. κύλικες and χόες can be identified to a certain extent, and I suggest in the respective commentaries identifications for κυάθεια,κωθώνια and ὀξύβαφα. As noted above, others must remain as yet uncertain within the range 'relatively small cup or bowl', the general term in the trade for them being ἐνθήματα. For the rest, we have various forms of *lambda-epsilon* and *lambda-eta* marks together with a few fuller names indicating lekythoi of various sizes (especially 14F, 15) as well as lekanides. EM may possibly represent a non-self-referent ἐμβάφιον.

Vases of a particularly striking shape or use, such as the hydria, krater and owl skyphos, could have one definite name, but the bulk of the comparatively amorphous mass of containers or drinking vessels shared a pool of stock names such as κύλιξ and κάδος, although no doubt particular names could stick to a single shape. Trademarks may tell us that there are limits to the range of some of these names, but that limit may only be that of the evidence available.[4] Certainly, there are examples of one shape being described by two or more names - pelike, amphora and skyphos, perhaps lekanis and oenochoe also.[5]

While Greek usage could tolerate such duplication, it is more useful for us to have a single word for each vase shape. In some respects current usage does need some adjustment; one wonders whether we would still be calling the bell-krater 'oxyphaphon' if an eminent nineteenth century scholar had devoted a successful monograph to the type under that title. We apply 'kothon' and 'stamnos' wrongly, and 'ichthya' is a handy colloquial term for the lekanis.

Perhaps we would find difficulty in tracing an alternative for 'stamnos', although 'chytris' is available, at least for a decorated vase.[6] On the other hand, we reserve 'kyathos' and 'kotyle' for distinct shapes, while ancient usage was broader.[7]

Our marks yield little evidence about possible regional variations. The Attic 'lekythos' denoted the Doric 'aryballos', although on 1F, 6 Doric 'lakythion' is used for what we may take to be the squat lekythos. 'Aryster' as a measure may be confined to Ionic usage (see on type 4F), and it is possible that 'myrtote' is an Ionian coining for some Attic vase shape. However, the long association between Athenian and Ionian traders in Athens and the Peiraeus must have resulted in the adoption of a great deal of common nomenclature.

Prices

This topic was dealt with in some detail by Amyx, *Hesperia* 27 (1958) 275-307, and I have dealt with some aspects elsewhere.[8] Here I summarise those arguments, as well as those put forward in the commentary below. In the lists of prices appended here I would like to think that all the entries are assured interpretations, but it cannot be denied that the degree of certainty attached to individual entries does vary, necessarily so in view of the varied nature of the evidence.

	- 480	480-430	430 -
belly amphora	5 (10F, 24) 7 (10F, 21)		
neck-amphora			6 (18F, 1)
Nolan amphora		2 (16E, 8) 1½ (16E, 9; glazed) ?3½ (13B, 7) ?3 (6B, 15)	
pelike			7 (14F, 15) ?½ (26F, 1)
hydria	7 (10F, 23) ?4 (10F, 17)	18 (18C, 63; 21F, 8) 12 (21F, 7 and 10)	
oenochoe			½ (8F, 11)
column-krater		10 (24F, 2) ?3 (7B, 6)	
bell-krater		9 (18C, 59; glazed)	3 (26F, 21) 4 (14F, 6) 4 (14F, 1-4) 4½ (14F, 5)
lekythos	?2/3 (Gela, p. 28)		½ (14F, 15)
lekythion			3/50 (14F, 15) 2/3 (1F, 6)
lekythis		1/11 and 1/12 (1F, 2-3)	
skyphos	?6/5 (1B, 7)	?¼ approx. (fig 14p)	½ (16B, 34) ?1 (16B, 35)
sky - - -	¾ (10F, 25)		
guttus			1/10 (*Agora* xxi E13)
askos			2/5 (Apamea, p. 20)
ichthya (fishplate)		?2 approx. (16F, 1)	
ly - - -			½ approx. (6F, 2)
skaphis		?3 (22F, 5)	
bolsal			½ (Kerameikos, p.18)
		13/23 (fig 14s)	
melan		1 (25F, 4)	
oxis			3/22 (14F, 15) 3/20 (14F, 3-4) 1/6 (14F, 5)
oxybaphon			1/13 (14F, 15) 1/20 (14F, 4) 3/50 (14F, 3)
pellinion			3/8 (14F, 5)
bathy			7/20 (14F, 1-2)
enthemata			7 (14F, 6) 6 (6F, 2) ?3 (*AJA* 82 (1978) 226)
Table of prices given in trademarks; all prices in obols			

In all cases save 6B, 15 and 16E, 8 the graffito involves either the word τιμή (or an abbreviation) or a monetary term or sign (drachma, half-obol or τριτήμορον - 1F, 6).

For most of the early prices see the commentary on type 10F, and for the rest *ZPE* 17 (1975) 155. The two assured prices for Nolan amphorae are linked by the mark of type 16E; one has a clear half-obol sign and I feel confident that a price is quoted on both. For the reading of 13B, 7 see the commentary; I merely suggest that the strokes on 6B, 15 may have a price significance. The price on 26F, 1 would seem to me to be for a batch of similar slight pelikai, but I retain a question-mark.[9] The hydria price, 21F, 10 seems far more assured than Amyx' words suggest (l.c. 296 with n. 33), especially in view of the comparanda now available in 18C, 59 and 63 and 24F, 2. The prices for skyphoi need some explanation; the quarter-obol price for owl skyphoi has to retain a question-mark as part of the graffito (HΛII) remains unexplained; the rest of the mark indicates a price of one drachma for twenty-six pieces since the format of the graffito is somewhat akin to 16B, 34 and 35, where I feel far more confident of the interpretation. On these two the *pi* should stand for ποικίλ(α) on the analogy of 16B, 36 and 8F, 13 and 14 whose marks are similarly structured, albeit without a price; the rest of the mark will then be the batch size and the price. The prices for askoi and bolsals are similarly reached by dividing an apparent batch figure into a price indicated by a drachma sign; for the *ichthyai* a different form of price notation is used (see on type 16F). The entries for *ly - - -*, *enthemata* and the smaller pieces accompanying the kraters of type 14F are all fully discussed by myself in *AJA* l.c., if not already by Amyx.

There are some graffiti including drachma signs that do not appear in the above list; in particular we may note 11C, 1, where a single drachma sign accompanies a ligature; it is possible that the marked vase did cost a drachma, to whomsoever; it is a large and careful red-figure lekythos, some 40 cm. high, belonging to the years soon after 480.[10] The slightly earlier 7F, 8, *may* have cost five obols (see the commentary).

I have not included in the table any of the prices seen by Amyx and earlier scholars in the double Ionic numerals on some pieces of type 2F and on 22F, 4 and 25F, 5. There is no substantial reason to assume that one of the numbers on each is to be understood as obols (or drachmae or any other monetary unit); in the case of 2F, 52 I have noted that the sum of the two figures following the ΛΗKV is a figure similar to batches of ΛΗKV on other vases in the type, and I therefore argue that we are dealing with a batch split in two parts. Whatever the reason for the division of a batch we can observe that it does occur elsewhere.[11] So I prefer to see split batches in all these cases involving Ionic numerals. There is little to support the arguments advanced that the mark of type 3F indicates a price; see the commentary.

Three prices culled from other sources are of varying value. Aristophanes tells us of a one-obol lekythos in *Ranae* 1236 and Kephisophon threatened to extort a drachma from anybody who might break his cup, which Vanderpool has demonstrated to have been a skyphos.[12] A price of two obols for a type B amphora of about 540 has been argued from the vase inscription on the ex Hearst amphora New York 56.171.13, but not only is the relevance of the inscription to the vase questionable, but we may well doubt whether the obol coin was in existence at the time.[13]

The significance of the prices that have come to light or been made more probable in the light of new evidence since Amyx' review is that many refer to vases of known type and dimensions, unlike many of the secure prices for uncertain shapes in type 14F, the backbone of previous lists. One particularly valuable result is that we can clearly see the premium paid for figured vases from the pairs of marks, 16E, 8 and 9 and 18C, 59 and 63, one each on a figured and glazed vase; more cautiously we can add the cheaper owl skyphoi listed on Würzburg 610 (fig. 14q). In many cases we cannot say whether we are dealing with figured, glazed or patterned vases (especially lekythia etc.), though I would assume that the accompanying pieces on 14F, 1-5 were glazed.

Caution is necessary in trying to extract further conclusions from this body of material. Webster has devoted several pages to the subject of vase prices and well demonstrated the dangers of making hasty generalisations from insecure evidence and doubtful assumptions. It will be clear from my table that I cannot agree with a good proportion of his alleged prices, especially those of the early period, and his statement that 'prices were generally rising during this period' (i.e. 540-440) is not, I believe, founded on any concrete evidence.[14] His attempts to sort out 'retail' and 'wholesale' prices are certainly more laudable, but again I feel little conviction in his results.

The problem of where the prices were asked, or paid, can in some respects be cleared up. The marks of type 14F were applied in Athens, as the spelling on 1-5 and the overincision on 15 show; the similarity of format of the price inscriptions on 6F, 2, 14F, 6 and 18F, 1 strongly suggests that they too were inscribed at Athens. The fact that at least one of the pieces with a price inscription in type 10F was found in Etruria must indicate that the monetary transaction took place elsewhere, and the script of 10F, 25 supports the most obvious candidate, Athens. The script of the *lekythides* price marks, 1F, 2-3 is highly likely to be Attic, and one could hazard that the *mu* on 13B, 7 refers to the same person as that on the *lekythides* pair. The script of 22F, 5 also seems Attic. There is little such formal evidence to prove the origin of many of the rest of the price marks. I have outlined the difficulty of interpreting the history of 24F, 2 in the commentary; it has a price introduced by an *alpha*, as 18C, 59 and 63 (and possibly the Apamea askos?), but also on the same foot a batch of kraters is mentioned, and it is not easy to see how the isolated price and the batch are to be accommodated. The aspirate in the related price mark, 21F, 10, helps little, although as we seem to have hydria prices quoted on vases both with and without the aspirate it may be preferable to place the marks in Athens rather than the Sicilian provenance of some of the relevant vases.

Only two vases are marked with prices that were certainly asked at markets beyond Athens, 1F, 6 in Sicily and 26F, 21 presumably on Cyprus. However, even if the price was asked or paid there, we cannot satisfactorily judge what unit of currency is indicated, and this renders the information far less useful.[15]

Webster based his opinion on prices asked and prices paid on the striking difference between two- and three-drachma hydriai and four-obol bell-kraters, and regarded the hydriai graffiti, with their different format, as advertisements, not notes of transaction that had already taken place. The first argument is of course specious and is now blurred by the discovery of a ten-obol krater belonging to the first category and a seven-obol pelike to the latter (24F, 2 and 14F, 15). On the second point there is little more that can be said; some of the price marks involving ΠΟΙ give every appearance of notes of transactions, e.g. the batches on 8F, 11-15; the ΠΟΙ is an insurance against glazed vases getting mixed up deliberately or otherwise with the lot. Such an argument need not of course necessarily apply to the hydriai, and we must, on Webster's line of reasoning, add 18C, 59 and 63 and 24F, 2 to the list of asking prices, since they are similarly 'high'. In sum, I am not convinced that we can suitably interpret these prices, but there is perhaps a slight balance of argument in favour of taking them as prices paid, or likely to be paid for the marked vases.

What then can we say of the fifth century cost of living? From the viewpoint of the consumer, I think we can gain a fair idea of what he might expect to pay for a range of vase types, glazed and decorated. I would consider the two- and three-drachma products of c.440 comparable with the 3½ to 7 obol vases of late in the century, taking into account the size, difficulties of potting and numbers of figures on the individual vases.

Kraters were more easily potted than hydriai, and bell-kraters more simply than column-kraters. The average height of the kraters of type 14F is 31.5 cm., and all have four figures on side A and three himation figures on the reverse; it must be very likely that the other kraters in the batches were similar. The pelike, 14F, 15, is 37 cm and has an extra figure on side A; it is also more carefully painted, but we cannot be so confident of the nature of its companions in the batch. The earlier vases are all larger: 24F, 2, 42 cm. high, with four figures in all, for ten obols; 21F, 7, a hydria, 41 cm high with five figures, for twelve obols; 21F, 8, a hydria 47 cm high with six figures and a chariot, for 18 obols; 18C, 63, a hydria 48 cm. high with two rows of figures for 18 obols. So in every case (save 21F, 7 which is slightly smaller than 24F, 2 - though needing more careful potting) a higher price is charged for vases which have more figures and are taller. The difference of a whole drachma between 21F, 7 and its contemporaries is striking; it is indeed a lesser piece, but perhaps not to our eyes 33% less. Not much earlier, smaller Nolan amphorae with two figures instead of the six or more on the hydriai cost only a sixth or fifth of their price, while early in the century more substantial amphorae and hydriai commanded prices akin to those of perhaps slighter vases one hundred years later. [16] From these considerations it is not easy to draw conclusions about fluctuations in price. We may provisionally put a slight rise after the middle of the fifth century, with the caveat that this involves taking the prices for hydriai and related pieces as those actually paid, in Athens. The possibility of comparing prices of lekythoi and skyphoi throughout the century is unfortunately complicated by the fact that we cannot be sure of the interpretation of the early lekythos and skyphos examples (nor of where the prices were asked) and the identity of the early ϟκν is not known. Of the other skyphos prices, one, if accepted, is for small owl skyphoi and suitably cheap, while the late pair are for rather similar vases; one price appears to be twice the other. [17] There are good grounds for taking the *lakythia* of 1F, 6 as considerably more expensive than equivalent vases bought at Athens; we may compare the price of 2/3 obol with the ½ obol Athenian tariff for 'proper' lekythoi or 3/50 obol for probably similar lekythia (14F, 15).

So we have isolated some evidence for price increases for figures, or additional figures on vases, for higher prices asked at the other end of the trade routes and perhaps some increase in prices generally after 450, falling again by c.420-415. After the latter date we may note that the prices reached for the secondhand Panathenaic amphorae in the auction of the effects of the Hermokopidai are comparable to some prices for new vases with which we have been dealing. [18]

What can we say from the potter's or painter's viewpoint? Jongkees was worried that at the prices which we can now see were clearly asked (or paid) the workshop staff could not make a living. While we now have an idea of what was being paid for a range of vases, and in certain cases for the more intricate potting and painting involved, we have little idea of the overheads of any establishments and can only guess at rates of production. [19] Therefore it is not easy to judge how many potters may have grown wealthy in their profession; better to point to some of the elaborate dedications made by potters on the Akropolis in the later sixth century. However, taking Jongkees' own example, the 'unrealistic' 'obol' price for oxybapha, we can see that to make a drachma a day each employee would have to produce about 120 pieces. Jongkees' suggestion of a drachma is high, based on the piecework rates paid to skilled men on the Akropolis, and we may assume that a high proportion of those in a pottery workshop were slaves who only had to produce enough to cover their subsistence. However, we may cancel out this factor by placing against it the unknown figure for overheads - basically the raw material, clay and fuel for the kiln. [20] The oxybaphon was clearly a small handleless bowl, and it would not be impossible for a man to produce one hundred of these in a day from start to finish, although in fact we must talk of man-hours in any realistic calculation of this kind. The equation reached from the price lists of type 14F is that one krater demanded the same number of man-hours as about eighty oxybapha; perhaps it was at this point that the Greek workshop owner thought of a 'good day's work' rather than at the higher figure of 120 oxybapha. At any rate, our range of prices for the late fifth century can give us a good idea of the relative amount of time expended on individual vase shapes and their decoration - not only kraters and oxybapha, but pelikai, oenochoai, skyphoi and lekythoi as well.

CHAPTER 8
MARKS AND VASES

The majority of marked vases belonging to close groups are larger pieces, amphorae and hydriai in particular in the realm of black-figure and in addition a range of newly introduced shapes, kraters, stamnoi, pelikai, in red-figure. The fact that many close groups contain a mixture of these vase shapes demonstrates that they were treated solely as objects of trade and that the amphorae were not employed as containers.[1]

The amphora types include the Panathenaic shape; non-prize vases appear in several types,[2] but prize vases never; a few prize vases do bear marks and the most interesting of them are discussed in the commentary on type 4F. This distinction is a very strong indication that in general vases were exported directly from Athens, and that prize vases were a necessary exception (see further p. 40-1 below).

About a half of the marked non-prize amphorae have 'main-line' marks: this percentage is lower than for neck-amphorae or hydriai, but higher than for the type A amphora; of the forty BF examples of the last with marks which I have noted only a little more than a quarter have 'main-line' marks, though five have only red traces and another five have Etruscan graffiti. A very similar pattern applies to the forty-five marked BF kraters known to me, with a larger percentage of red traces and probably local Greek owner's marks. Only one is a calyx-krater (20A, 83) and four volute-kraters (13B, 2, 7D, 3, s.l.6 115a and Taranto 20336, *ASMG* 8 (1967) 54). None of the marks seem self-referent; the only vase names found are the presumed *lakythia* or the like of 21A, 62 and Villa Giulia 50624 (p. 27). Marks are as rare on RF volute-kraters, confined to 9E, 91 and perhaps 85 and Ferrara T436 (s.l. 1, 42). Eighteen marked RF calyx-kraters amount to no considerable number and all save 10F, 25 and London E458 (*ARV* 239, 16) are to be dated after 460. Psykters are as rarely marked as their accompanying kraters; an early version, Rhodes 12200, has an inscrutable mark (*BSA* 70 (1975) 152, 36), a glazed psykter has X under foot and lid (8D, 63) and I know of three RF pieces, 12C, 3, 7D, 9 and Louvre G58 (p. 239, n. 4).

Not all the vases of the shapes already mentioned are large; the small neck-amphora played a considerable part in later sixth and early fifth century exports and a number bear marks, though the percentage of marked vases is well below that of their larger brothers. Groups of small neck-amphorae can be found in types 4B, 12B, 21B, 11E and 20E; some of these groups are isolated, others are in contact with a range of larger vases. One or more small neck-amphora can be found associated with larger pieces in types 6A, 7D, 9D, 8E, 9F and 10F; in the latter case a number of other small vases are also involved.

We should also stress that although a smaller proportion of kraters etc. are marked they are represented in the major groups, suggesting that at least some of them were marketed in the same way as the staple neck-amphorae etc; if this was the case with the Antimenean 20A, 83 and Leagran 2F, 32 and 33, to give but three examples, there seems little reason to think that other type A amphorae and calyx-kraters were treated in some special way by those concerned with their selling and transport.[3]

Turning to generally smaller vases, we should first note the proportion of larger and smaller pieces sent to particular destinations; for example, there are many more larger Attic vases from Etruria than skyphoi or lekythoi, but far fewer from Rhodes or Gela. However, even when such a distribution pattern is taken into account, it will only cause minor modifications in the picture that emerges of the very sporadic use of trademarks on smaller vases. The relatively few ('relatively' being an important qualification) small vases of Athenian manufacture from Etruria have few marks in turn, which suggests some difference in their mercantile treatment from their larger companions. The scarcity of large marked vases from beyond Italy, especially in the sixth century, makes it difficult to apply the argument elsewhere, although I think this can be done in the case of Rhodes, where completely different patterns emerge.[4]

Some oenochoai bridge the gap between large and small vases and so we may begin there; most of the marked examples are of moderate size, not large examples of type I or the smaller versions of the chous. Of over a hundred marked black-figure oenochoai a good proportion appear in the catalogue, and while some are not closely connected with others in their types, many are, and they suggest that the oenochoe was a regular recipient of 'main-line' marks. Types in which oenochoai are intimately involved are: 20A, 21A, 11B, 12B, 9D, 3E, 5E, 8E, 9E, xii-xiii, 11E, 12E, 14E, 9F and perhaps 18B and 5D; they form a good proportion of 12E. Oenochoai in type 2F may be closely related to the central members of the type. We find small close groups of oenochoai by themselves in types 33A, 1B, 12B

and 9D. With the exception of those in type 13B, all the pieces so far mentioned are likely to have had an Etruscan provenance.

Despite the above links, oenochoai must still be regarded as peripheral to the main large types, such as 20A, 21A, 9E and 2F. Very few of the marks involve numerals or vase-names.

The other small closed vase to consider is the lekythos, of which I know about eighty marked BF examples. Four only have a definite Etrurian provenance, while thirty-five are from Taranto, Cumae and Sicily. None of the Etrurian pieces has connections with any mercantile type, although 12E, 13 from Fratte should not be entirely over-looked in this context. Nor can the pieces from Sicily in types 5D, 8E, 9E and 20E convincingly be associated with the larger vases from Etruria therein.[5] The same applies to the pieces without provenance in types 16A, 2B, 9B and 10B. There appear to be groups of lekythoi standing by themselves in types 5A (one piece with no provenance), 1B (Spina), 9E (Gela) and 22E (Gela and Taranto); probably 15B as well. In no case is it absolutely clear whether the marks are commercial or local owner's inscriptions save the glaze dipinti of type 5A. A price is quoted on one piece (Gela Navarra 11), and numerals denoting batches on 6D, 17, Palermo 1891 (p. 29) and a piece from Ampurias (p. 17-8); in the last three cases we can connect the marketing system with that employed on a range of vase shapes represented in types 9F and 10F.

It would seem that black-figured closed vases become more remote from the major trademarks the smaller they become. Does this apply also to red-figure? I know of fifty red-figured and contemporary glazed oenochoai and just over that number of lekythoi bearing marks (excluding in both cases vases from Greece itself). The proportion of oenochoai belonging to close groups of mainly larger vases, or of possibly being so related, is much as with black-figure, and the same applies to those forming small groups, of a commercial or personal nature, on their own account. Oenochoai appear with larger vases in types 13B, 3C, 15C, 7D, 11E and 9F, the range of dates being wide; more isolated groups of oenochoai are in types 32A and 9E, of personal and commercial significance respectively. A chous and a mug attract the ποικίλος tag in the later fifth century (8F, 2 and 11). Later, 25F, 8 is the master vase of a very large batch; numerals appear earlier on Gela 10597 (p. 29), Taranto 52235 (p. 60, n. 26) and perhaps 6D, 18, as well as 8F, 11.[6]

With regard to the lekythoi, only in two types can a case be argued for a close connection between them and larger vases, 7D and 20F. A connection could be considered in types 11C and 10F, and 9E, 49 and 50 could be linked with others in the type. An isolated sub-group of 3E includes lekythoi, one of which appears also in a smaller sub-group of 6B. As with black-figure, many of the marked red-figure lekythoi are from Magna Graecia and Sicily - over a third of the total, including most of those with a known provenance. Many are of the late archaic and early classical period, the work of the Berlin and Pan painters, Hermonax, and their associates and followers. Numerals are relatively frequent, of several kinds, some perhaps, one certainly (p. 34) a price inscription.[7]

Cups and skyphoi, with mongrel shapes, account for virtually all the marked black-figure small open vases. A kyathos, 12B, 15, is related to larger vases in the type, also from Vulci, while a mastos and a pyxis (3E, 52 and 8D, 24) have no certain associates.

I know of nearly seventy marked black-figured drinking vases. The majority of the cups are later pieces; there are two Siana cups and a few Little-masters, but these amount to a very insignificant proportion of total output when compared with contemporary amphorae.[8] Some later pieces do have links with larger vases, notably in types 1D, 6F and 10F, which are certainly or probably from Etruscan sites (including Suessola), as earlier pieces in type 21A. Some isolated red dipinti on cups from Italy should also be regarded as commercial.[9] A pair of commercial dipinti, 7F, 1-2, stem from Rhodes, as another pair of graffiti, 9C, 1-2, perhaps owner's marks, but see *BSA* 70 (1975) 166. Batch marks appear on 10F, 1 and 4, from Suessola, and 1B, 8 and 7D, 66 from Taranto.

There is little remarkable about the fifteen marked skyphoi; Tarquinia 637 has red traces, 1B, 7 from Centuripe has a price inscription, and two members of type 10F are skyphoi, both with batch marks. The handful of cup-skyphoi includes the connected trio 9E, 71-3, from Nola, Taranto and Suessola; 74 from Adria is certainly of a related shape, and we would seem to have here a trade in smaller vases (batch numbers are included), not connected on present evidence with major lines to Etruria.

Black-figure drinking vases are on the whole treated differently from larger pots; connections between them are sporadic and closest in type 10F. The proportion of marked pieces is extremely low, early or late.

Red-figured cups are marked far more frequently, but the great majority of these marks are Etruscan, applied by jealous owners. We must therefore assume that those marks on cups which cannot be readily identified as Greek or Etruscan are more likely to be the latter. It is therefore very difficult to give a figure to the number of RF cups with possible commercial marks; perhaps sixty would be a fair estimate, an extremely small figure compared with the total output.[10] Only one I would consider the mark of a dealer who also marked large vases, 8E, 29; a few have vase-name marks to be found on larger vases too, 8F and 9F, and there are two longer, and later, vase-name graffiti, 25F, 3 and 26F, 14. Batch numbers appear on the three last, Ragusa 23004 (p. 60) and Frankfort VF 425.[11] Isolated groups of cups with trademarks may exist, for example in types 4B, 10B, 14C and among the pieces with *lambda* graffito (type 13A, n. 4).[12]

Among the marked skyphoi (about thirty excluding material from Adria) there are none that connect closely with larger vases in any type, though in type 10B there are two skyphoi and a cup belonging to a close group of the late archaic period. There are however a good proportion of pieces with batch marks, notably the five with ΓΟΙ and Γ marks, 16B, 34-36 and 8F, 13-14; also 21A, 104, 7B, 9, 9E, 98 and 124, 5F, 6 25F,1 and 4, New York 06.1021.174

(*ARV* 1172, 21) and 41.162.127 (*CVA Gallatin* 105), and Naples Sp. 453 (fig. 14p). The size of many of the batches is between sixteen and twenty. The medium of 25F, 4, red dipinto, is noteworthy.

Of seven marked RF kantharoi three have vase-name graffiti without numerals, Ruvo 537 and 892 (H603 and 604) and 11F, 28.[13] Two glazed lekanides have names with numerals and are also connected by a monogram, 3B, 4 and 5; another pair is 8B, 13 and 14, while 17E, 21 is the master-vase of a batch of twelve. Probably commercial marks are found on a number of askoi from Cyprus and Rhodes (see p. 19); 24B, 8 stands apart from them on present evidence.

Most marks on pyxides were applied before firing in order to assure the correct partnership of lid and box after the load was extracted from the kiln.[14] Marking was usually done using a sequence of the letters of the alphabet, including *sampi* - subsidiary list, 4, 26; when all the letters had been used a new sequence was begun using an extra mark; these extra marks were of varying character, a single line (s.l. 4, 17), an Ionic *gamma* (14), C (6a, 10, fig. 14aa), almost a *rho* (4, 29, 30), like an Arabic 2 (6), or as an old crossed *theta* (12); the letters could be repeated (26); the interpretation of 13 and 22 is not so certain. On 15 we find a misplacement of the lid, since it has six strokes to the box's four. A detailed study of the profiles is needed before one can judge whether we have more than one piece from any single firing; 4, 29 and 30 must be candidates, but there seem few others, and therefore we may claim that it is highly unlikely that as much as one twenty-fifth of the original production of *marked* pyxides survives.

The few remaining marked RF plates, dishes, head-vases, cup-skyphoi and the like require no comment; black-glazed versions of these shapes with marks, often batch numerals, are found at a number of Mediterranean sites (see ch. 4 passim).

The marks on red-figured and glazed smaller vases are perhaps more remote from the major trademarks than their black-figure counterparts; but the difference is not great since in neither case are smaller pots treated in a 'fully commerical' manner. Good numbers of red-figured and glazed vases have batch marks which reflect the same system of marking as with contemporary larger pieces, especially those in types 8 - 10 F, where late black-figure pieces are already represented. Again as with black-figure, we must take into consideration the very large number of unmarked pieces. Obviously traders had reason not to write on the undersides of kylikes, which were meant to be seen, but since small vases as a whole bear far fewer marks, one must assume that they were not marked merely because they were smaller, whatever their artistic quality. The same is true of Laconian and Chalcidian, and to a certain extent Corinthian vases, although a good number of larger aryballoi and plain pyxides have dipinti; a number of them were sent to Sicily, from where a large proportion of smaller marked Attic vases come. The opposite is the case with Rhodian and 'Rhodian' vases; see p. 235.

The most reasonable explanation of the dearth of marks on smaller Attic vases must be that such vases sheltered under the commercial umbrella of larger master vases with which they were dispatched; the lists of batches in type 14F prove this procedure for the later fifth century. An alternative explanation which no doubt is also valid to some extent would be that smaller vases were often taken on board as cargo fillers without their being parts of specific orders or having to be specifically reserved by traders.

CHAPTER 9
ISOLATED AND DOUBLE MARKS.

I examine here the significance of marks that only appear once and those cases where more than one mark appears on a single foot, not of course mutually exclusive categories. While companions may well in future be found for marks that now appear isolated, it is also probable that new singletons will turn up.

The questions to be answered are these: if the trade in Attic vases to Etruria was direct, what could have been the purpose of a Greek graffito which has no known parallel on a vase found in Etruria? and how are we to explain the appearance of two or more Greek marks on any one foot?

The number of isolated marks is large. Some are included in the catalogue fortuitously because they happen to be the same as others which form a close group; I do not argue here the criteria for judging a close group (see p. 43), but it is self-evident for our purposes here that chronological disparity is sufficient to make a mark isolated. Then there are totally isolated marks; it is not easy to give precise figures, but even if we are strict in our selection of likely Greek marks of personal significance, the number remains substantial.

We can be strict in the following ways: by taking as many marks as possible, alphabetic or otherwise, as Etruscan; by interpreting others as vase-name abbreviations or the like; by considering that dipinti may be incomplete, or could be paralleled in other well worn examples; by thinking of others as jokes, sports and the like.

It is not feasible to go into detail over every isolated mark, and so I merely consider the record of three workshops, Antimenean, Leagran and Polygnotan. The relevant statistics are given in Appendix 2 and further aspects of them discussed below p. 45ff; here I restrict my comment to the isolated marks noted in column 5 of the tables. The percentage of isolated marks in other workshops is not strikingly different from the range offered by these three.

In the Antimenean group one hundred and eleven marks belong to close groups while nineteen are more isolated, with three further such marks appearing together with more regular ones. Excluding the output of the Acheloos painter and his followers in the Leagran statistics (except in so far as the painter's works are included in the main body of the attributions to the group in *ABV*), one hundred and five vases have associable marks, seventeen are isolated, again with three accompanied isolated marks. Forty-three Polygnotan marks are of close groups and eleven apart; some more unusual marks appear on vases with type 18C graffiti. One basic reason for the higher proportion of isolated marks could be that more vases were being sent to Greek destinations, and therefore may bear Greek owner's inscriptions.

Plain numerical marks I have not counted as isolated since they clearly have a commercial meaning of some kind; in any case there are only three such in the groups under survey. Also plain X or X with numerals is excluded; there are enough Antimenean vases with the mark to suggest a close group. Some of the graffiti may relate more closely to others than may appear on the surface, and these are difficult to categorise; if we take them as associable with other marks we will in certain cases be positing small commercial groups.[1] Of the vases from Etruria about a dozen have marks which seem Etruscan rather than Greek (if we include non-alphabetic marks as well), and there are a few more that could just be Etruscan; non-alphabetic marks are found on Etruscan vases and therefore I consider it possible that they may be Etruscan when found on Greek pots.[2]

Some Greek marks remain unaccounted for. Isolated *mu* appears on one Antimenean and one Leagran piece (13B, 13-14), just conceivably to be taken together. Some other Antimenean marks are more inscrutable: EI reported on Villa Giulia 762, *lambda* on London B198 (?numerical), *sigma* (plus a dipinto) on the Rothschild hydria *ABV* 268, 30 - possibly a further abbreviation of type 20A or 21A?; *phi* on London B223 and perhaps *kappa lambda* on Berlin 1835; two, perhaps non-alphabetic, marks accompanied by numerals on 21A, 74 and Berkeley 8.3851 (or could the latter be a garbled 20A?). Seven or so Leagran marks seem to be Greek and wholly isolated: *alpha* on Munich SL459, *delta* on Louvre F253 (numerical?), *(h)eta* on Berlin 1857 - possibly a misreported mark of type 2F, *lambda* on Würzburg 212, 9E, 62, 23F, 5 and the dipinto on Syracuse 21957 (p. 16). Also 17A, 18 has no close links with the rest of the type and maintains the different range of marks found on vases from North Italy at this period. The mark on Agrigento R136 (Fig 14j) may be alphabetic; the vase is Leagran, but not in *ABV*.

A similar number of Polygnotan pieces have apparently isolated Greek marks: *(h)eta* on Bologna 176, ?*rho* (twice) on Tarquinia RC4197, *tau* on 18C, 13, HE on Boston 00.346 (10A, 10), IN on Leningrad P211 (15B, 16) and a complex ligature preceded by three unit strokes on Ferrara T411; 17E, 13 may belong to some close group, but its

retrograde direction is unusual; it could be an abbreviation of a vase name however. 16B, 33 also gives us the name of a dealer, Archi - - , who is not surely attested in other marks.

In the three groups therefore there are some fifteen marks that are puzzling; although they amount to a small proportion of the total it would be pleasant if we could find an explanation for them. There can only be two possibilities, if indeed they are Greek marks: either they are Greek owner's marks and the vases were sent to Etruria secondhand, or they are trademarks and indicate that there were a relatively large number of casual traders - shippers or middlemen - dealing with vases.[3] This would apply in particular to the Adriatic trade, also to that with Sicily, though the possibility of Greek owner's marks makes it difficult to be dogmatic in that direction.

The question of double marks is relevant to these possibilities and should be examined first; the problem will become even more pointed if we find not one but two isolated marks on a vase sent to Etruria. In the following considerations I exclude those pieces which have one Greek and one clearly Etruscan mark.

Section E is devoted to types which are gregarious or contain sub-groups that are gregarious; type 18C is also regularly accompanied, by a large variety of marks. A straightforward explanation for double marks can be given when one is a personal abbreviation and the other a vase name abbreviation or numeral (or both), and many examples can be found in Section F. I hope to interpret marks as vase names from a variety of considerations, but never in order to avoid admitting two personal abbreviations on a single vase.

A large number of vases, mostly black-figure, have a graffito and retain traces of a red dipinto; we may well wonder whether the dipinto was of the same shape as the graffito. Preserved dipinti demonstrate that the possibility is roughly equal of its being the same or of being different; there are many more in each category than Hackl knew,[4] and the numbers of each are much the same when we subtract those dipinti that regularly accompany a different graffito (3D, 1E, 9E, iii). We might also consider in this respect vases on which the graffito is repeated.

Excluding regular pairings and vases with only red traces, I know of about sixty black-figure and forty red-figure vases with two marks that could be Greek. Six of the black-figure pieces involve gregarious marks with unusual companions: 5E, 19, 8E, 53-6, 13E, 27. In three other apparently similar instances, 11B, 11, 8E, 57 and 5E, 22 the accompanier is probably of vase-name type (see the commentaries). In a few cases the accompanying mark may be numerical: 21A, 83 - which would be a very early acrophonic numeral, and 6D, 2 - not only early, but also repeated, graffito and dipinto. The dipinto on 4A, 10 may also be part numerical (see the commentary).[5]

Many of the 'second' marks could be Etruscan, either because of the letter forms or ductus, or because they are non-alphabetic and therefore not necessarily Greek; in any case, non-alphabetic marks can be interpreted in various ways and they need not be personal insignia - that on 21A, 74 introduces unit strokes. Other non-alphabetic marks are: 5A, 6, 25A, 9, 34A,1 19B, 6, 21B, 11 - 12, 23B, 1, 24B, 6, 26B, 3, 8D, 13, 5E, 25, 17E, 42?, Louvre E810 (p. 202) and two non-alphabetic marks on the Pioneer group pelike recently acquired by Boston.[6] Marks that could be Etruscan are: 1A, 5, 14A, 4, 15A, 5 and 9, 25A, 7, 15B, 14, 15C, 1 and one of the three on 3E, 54 (Fig. 7a). A corollary of accepting them as Etruscan is that some types, or parts of types then become Etruscan, especially 15A and 25A. Elsewhere part or all of the marks could have been inscribed by Greeks at the final destination of the vase: 17E, 36 from Rhodes, 6B, 14 from Kamarina, 22E, 4 from Taranto and perhaps 6B, 7-8 from Gela.

Perhaps not all the above should be so explained and some should be added to the thirty or so unexplained pieces that remain. Considering that these figures belong to the whole range of marks on figured vases, and not just to the three groups selected for the discussion of isolated marks above, this is an extremely small percentage; as a number of them are without known provenance it remains possible that they may bear Greek owner's marks from their destination. Some of these pieces are discussed further in the commentary.[7]

We may now return to the question posed earlier, whether single isolated marks demonstrate a second-hand trade or rather a number of casual traders.

I can find no good evidence to support the idea of a sizable second-hand trade from Athens to Etruria or elsewhere in painted pots. Some vases did have more than one owner, but assured examples are perhaps confined to Exekias' dinos (*ABV* 146, 20) which reached Cerveteri via a Sicyonian (not an Athenian) and the special cases of the prize Panathenaic amphorae. Elsewhere it is argued that a proportion of finer vases were specially commissioned for Greek ownership, or that *kalos* and other inscriptions were meant to be admired, not dismissed straightway from the Agora; and we have just gleaned a meagre harvest of marks which could perhaps be considered as Athenian owner's marks, either standing alone or accompanied by presumably later commercial graffiti.

There are several models that could be propounded to support a second-hand theory: vases were only marked for export, and after a period of use in Attica; vases were marked after such use, but could also acquire owner's marks earlier; vases were inscribed with trademarks when made for local customers, and they could then be given their owner's marks also, or further marked when exported. There are substantial arguments against each of these models, though of varying weight. If vases were marked only after a period of use in Athens, it is most unusual that marks appear so frequently on groups of vases related by workshop, and of course glaze marks, related in several types to graffiti of the same form, cannot be explained on this theory. It may be attractive to explain them as potential Athenian owner's marks, since in certain circumstances they are obliterated by later marks (especially type 10E); in this case I find it disturbing that to date no vases of related type with related marks have come to light in Athens; were they all exported second-hand? We also find marks in Ionic script obliterated in type 2F and they are of clear commercial significance. If trademarks are secondary why do no Panathenaic prize amphorae bear marks of the same types as other shapes? What could never be proved or disproved in this area is whether vases may have

been used temporarily at Athens while awaiting shipment, already ear-marked for a given trader by a glaze dipinto or post-firing mark.[8]

The lack of marks on vases found in Greece also vitiates the theory that sees marks as applicable to local Athenian transactions; moreover, if the marks refer merely to Athenian buyers and temporary owners, why do we not find a more general spread of such marks when those vases were eventually exported? No BF vases from Rhodes, and probably no RF either, bear marks associable with those on pieces from Etruria, be those vases from related workshops or not.

There are subsidiary points that could be made. Many vases with καλός names belong to groups which exported a large percentage of their output to Etruria and include close groups of marks. Two pieces praising Leagros with the graffito ΛΕ may be tempting, but four others have glaze and graffito ΑΡ (9E, 7 and 48) and red and graffito ΜΕ (10E, 28 and 27), while glaze ΑΡ also appears on 9E, 9 with Νίκων καλός. Hiketes is καλός on 21A, 22 with glaze ʃο. Vases singled out by Webster in his book as special commissions bear a number of graffiti of varied types, though it perhaps should be noted that many pieces that we recognise as of outstanding skill and achievement are unmarked.[9] On the other hand special lines were produced for specific markets, especially Etruria; dealers seem to have treated the Nikosthenic amphorae in just the same way as other products; in type 21A and 3E the amphorae are accompanied by other, apparently contemporary pieces of regular shape.

I have stated here a rather general position, arguing against any large scale second-hand trade with Etruria. In detail there are no doubt many further points that should be made. Some, but I would say not many, exceptional pieces may have been special orders for an Athenian rather than foreign client; some pieces may have been sold off to dealers by indigent Attic owners, but they would most likely be vases from workshops other than those whose record shows them to be basically exporters, vases of the same general type as remained in Attica and have since been found there. Our isolated and double marks may just reflect such transactions. Yet it is worth noting that those traders or dealers whose names are preserved in more than very abbreviated form on vases are not known from more than two pieces (Simon, 19A); Ἀρχι .. on 16B, 33 cannot be securely identified in any other mark of type 9E, and Achenatos on 24F, 2 is certainly a singleton; all these men were involved in commercial transactions and so we may at least seriously consider that those indicated in our other isolated marks were similarly involved. [9a] One consideration that may seem to oppose such a conclusion is that vases sent to Bologna and Spina, prime export markets in the fifth century, bear rather few and very heterogeneous marks; we could plausibly compare them with the few isolated or double Greek marks on vases reaching Etruria and suggest that the marks are of Athenian owners. My preference would be to regard them as commercial marks, but the balance of the argument is very even.

Some further explanation is needed of the regularly paired marks. The very regularity of such pairings points to a commercial significance of the marks, since owner's inscriptions would be more casually related to any others. [10] If we omit pairings in which one member is clearly a numeral or abbreviated vase name (e.g. 1D with 3D or 2F with 3F and others), the following are the most regular: 1E with 2E and 33A, 3E with 4E, 5E with 6E or 9F, various combinations of 8E to 14E, 9E with 16E and 21E, 12E with ΕVΞ, 14E with 2F, 18E with 17E and 19E, 21E with 22E, 23E with 5A, 17B with 25B, 6C with nu.

No single explanation covers all these examples. In some a vase-name interpretation for one member is probable (cf. 9F with 5E); 23E in certain contexts can be a vase-name abbreviation and is accompanied by numerals when with a mark of type 5A; 2F may be a vase name when with 14E; 12E can also be followed by numerals, though it appears alone with ΕVΞ. 3E and 4E seem to provide a link between Greek and Etruscan traders. In some of the pairings one member is non-alphabetic and of doubtful significance; 2E with 1E, 25B with 17B and 6C with nu. In the first two cases the marks are in different hands, in the last the mark is probably unitary. While complete explanations may be lacking, the above pairings do not appear to present us with two Greek personal abbreviations.

Six cases remain to be considered, three of them involving *lambda-epsilon* abbreviations. I suggest in the commentary on 1F that a vase-name interpretation of these marks is generally unacceptable because they are so often unaccompanied and rarely with numerals; such marks are accompanied by numerals and also other marks in four cases (17E, 16-18 and 21E, 44), by simple numerals in three cases (16E, 8 and 9 - in neither is the *lambda* assured - and 17E, 37) and by other non-numerical, non-Etruscan marks in twenty-four cases (16E, 1, 6, 10 and 12; 17E, 11 14, 19, 20, 41, 42, 44 and 49; 20E, 9-13; 21E, 14, 45, 46, 54, 59, 60 and 61); this amounts to thirty-one of the one hundred and forty marks in those types. Eleven of the exceptions are on vases later than 490, where we can also put the pairings of 18E with 17E, 19E and 9F, iv of undoubted vase-name significance.

Of the remaining twenty earlier marks, we may take three as an abbreviation of a vase-name (17E, 16 - 17 and probably 18), five do not certainly have *lambda* in the ligature and also seem to have a numerical context (20E, 9 - 13), one is trivial (21E, 14) and a hard core of eleven remains; of these, one has an uncertain reading (21E, 54), two are with otherwise regularly accompanied marks (16E, 1, a problem piece, [11] and 17E, 14) and the rest belong to pairings listed above, with 9E and 22E.[12]

One other 'regular' pair is more isolated, 3E with 6B; the mark of type 3E seems to be the more normal on the vases concerned, with the *beta* something of an intruder. Such meagre evidence makes a satisfactory explanation impossible.

The two remaining sets are 5E with 6E and 8E-14E, both Leagran at heart. Neither 5E nor 6E can be suitably interpreted, but it is probable that at least one is not a personal abbreviation; as 5E appears with 9F, it may be that 6E is some kind of vase-name mark, but again certainty is impossible. The 8E to 14E complex is fully discussed in

the commentary on 10E and succeeding types. 9E and 10E never appear together and are presumably personal abbreviations, the only such in the group of marks; they are alternatives, since both appear as glaze and red dipinti; possibly 13E is another personal abbreviation - at any rate it does not appear with 9E or 10E. 12E has some numerical connotation, which may be imported back to 11E; 11E was inscribed later than 9E and 10E (overincisions, glaze dipinti); 8E and 13E are often accompanied by a form of countermark. The whole issue is bedevilled by the difficulty of interpreting 8E, or even of asserting whether it is Greek or Etruscan.

Overall, it is apparent that very rarely do two Greek personal abbreviations appear on a single vase, whether just once or as a more regular pairing. Such pairings usually contain one member that has a numerical or vase-name significance (if both are of Greek origin). We must envisage traders having their own monogram placed on the vase together with, or followed by a further indication of the character of the consignment. Such a procedure is characteristic of the Leagran workshop, though not originating there. [13]

Some further comment on unmarked vases. The ratio of unmarked to marked vases varies from period to period, workshop to workshop, though the possibility of wholly worn dipinti, especially on earlier amphorae, may distort the statistics. Very few small vases are marked (see above ch. 8); for larger vases see the tables in Appendix 2. Unmarked vases pose none of the problems afforded by doubly marked ones; it is risky to draw any substantial conclusions from the fact that even in the most organised of workshops a substantial minority of larger pieces were dispatched, even to Etruria, without being marked. The memory of potter or trader may have substituted for a mark, or the required information may have been indicated by some other means, such as a separate label. [14] There may have been no necessity to mark a vase taken more or less from the kiln to the ship, without waiting long in the pottery either before or after firing and without having other pieces in a batch with it. Very special commissions could have identified themselves to all concerned. In later years unmarked pieces could have belonged to batches - one of the sets of kraters and the like mentioned in such marks as 9F, 51 and 14F, 1 - 6. Did a trader want to choose or was he able to choose better painted and fired pieces? or was he satisfied with any five kraters? Pre-firing glaze marks may suggest that the workshop may have had some hold over its clientèle, who may have had to accept the vases even if they were not fired as well as could have been wished; we may note that glaze marks were used mainly during the period of greatest popularity of Attic ware, and were placed mainly on stock products.

CHAPTER 10
PAINTERS AND MARKS

A cursory glance at the catalogue will show that there is often a close relationship between painters of vases and the marks on their respective products. Here I examine the nature of that relationship, in particular with regard to chronology.[1] First we must examine more closely what constitutes a group or close group of marks in order that we can see whether the evidence that they afford can be fully independent of other chronological and stylistic (in the broadest sense) considerations and so can be meaningfully used in relation to them.

The majority of marks indicate either a person's name, a vase name or an adjective descriptive of or qualifying vases, or a numeral. We have seen that marks of the latter types can occur on vases which are closely related by style and date; examples are type 2F, vii and the vase-name abbreviations on a range of Polygnotan vases. Yet it would be rash to suggest that the use of a vase name or adjective was strictly confined to one period, even less one workshop within that period. Rather, certain forms of combination, abbreviation and inscribing are the hallmarks of close groups among marks of this type. It is highly unusual to find a given pair of particular marks on vases which clearly belong to different periods, which may encourage us to conclude that such pairings and other distinctive mannerisms appear on vases which should be closely contemporary.

How closely? This is one of the most important questions to be faced in a study of trademarks. Any attempt at an answer must also involve marks indicating personal names; in this category it is clear that the same abbreviation can be found on vases of widely disparate shape, size, provenance and date. Several occur sporadically throughout the period under consideration, including most of those in section B and some in E. It is impossible to look at a mark and say 'Attic, 505 BC'; the vase itself must also be considered. Once this is done however, it is remarkable how often a mere glance at the vase is sufficient for us to be able to say just that, with perhaps the significant alteration to '510-500'. There are even some marks that are so distinctive that even without any consideration of the vase, other than it being the prerequisite of having the mark, we can be confident that the vases on which the mark appears must be closely contemporary. This is what I term a close group par excellence: e.g. 8A, 18A, 23A, 26A, 1D, 1E, 5E. Elsewhere we can find groups of graffiti with unusual characteristics or of glaze dipinti, even though the actual abbreviation need not be exclusive to those groups; these too can be called 'close groups', such as 21A, v and vi, 4B, i, 9E, iii, xi and xiii, 21E, vi. In these cases too no close look at the vase is needed to establish the contemporaneity of the marks. Then there are combinations of marks; in particular when more than two marks recur on a group of vases we can accept them as contemporary - the 8E to 13E complex in particular. With two marks the conclusion is less compelling, but when one of them has an unusual form or combination of letters, some degree of close relationship should be accepted, e.g. 6E with 5E, 16E with 9E, 21E with 22E and 16B with 20F.

In all these cases we would be justified in thinking of the vases as contemporary with reference to the marks alone.[2] I originally selected the examples without consciously thinking of the vases on which the marks occurred; when we do turn to the vases it is clear that in each case stylistic and other criteria confirm the argument drawn from the marks.

Other marks appear reasonably individual, but not wholly so: 9A, 16A, 20A, 22A, 3C, 5C, some forms of 9E, and 17E. Here it would be rash to assume that the marked vases form contemporary groups; inspection of the vases indeed reveals many such groups, but there are also vases that stand apart in most cases, even if the marks are distinguished by slight differences in the form or by different hands.

There remain the marks that are fairly common abbreviations or signs. These too can contain groups of vases which are stylistically close, and for this reason we may speak of 'close groups' here also.

The term therefore can be used to describe groups picked out according to various criteria.

We may now return to the question 'how closely contemporary?'. Does the appearance of a particular mark, or set of marks, on a close group of vases mean that they were all sent from the Kerameikos in a single batch, or should they be spread over a number of years? An answer will have a significant bearing on the problems concerning the organisation, extent and importance of the pottery trade at Athens. I set out the possibilities here and pursue the matter in the next chapter.

A merchant could have traded for a substantial period - that must be granted; therefore his monogram could have been put on vases made up to a generation apart.[3] Over such a long career one man would have handled many

vases, and even if he were a general merchant (most likely) and only a proportion of the vases were marked (probable), a number of them would be likely to have survived till today. It must be an acceptable hypothesis that large close groups contain vases made over a period of years, smaller ones vases made in one or two, or not many more.[4] Here no account is taken of relative productivity over the years or among workshops. I argue, for example, that the Leagros workshop had some relatively sophisticated marketing techniques, which implies, though it does not entail, that the workshop itself was highly organised and therefore highly productive. So the large number of vases emerging from this establishment or establishments need not be spread over as many years as those, say, of the Pan painter.

Trademarks may help us judge the period of time over which a sequence of vases was made, but the process has its limitations, and will rarely give much more help than considerations of shape, *kalos* names, style etc. The evidence of marks is at any rate independent of these considerations. Where we have a very close group of marks, style may seem to be a less persuasive argument for proving contemporaneity. I touch on the use of marks to establish absolute dating in the next chapter, but anticipate to the extent of saying that any conclusions will be highly speculative.

A given type or close group in a type is often confined to vases from a single workshop or a set of contemporary workshops. This goes a little further than saying that the pieces are merely contemporary, and it is well worth analysing the evidence for close groups within the output of individual workshops, or groups including sets of vases from more than one workshop. On the assumption argued above that such close groups should embrace vases that are more or less contemporary (depending on the size of the group), we can then say that the vases in question, whether from one or more workshops, should also be contemporary.

I confine my considerations to Attic vases, but even so it will not be possible to examine every possible case of possible contemporaneity (however much a desideratum this may be; I hope at least that I present the evidence for any further discussion along these lines); I select rather a number of painters and workshops and examine their mercantile record and possible interrelationships. The latter are also pointed out in the commentary.

Some individual marks already listed above form very close groups on their own account and at the same time are confined to vases of a single workshop; 8A is the most striking but there are others, among them the earliest close groups on Attic vases, in the Lydan workshop. The red dipinti of type 24A, though consisting of a single letter, are distinctive and all on Lydan vases; other groups of dipinti, less obviously close, can be found on Lydan products in types 13A, 15A and perhaps 14B. Other small groups of early Attic dipinti are in types 9E, i and 6B, i. Earlier than this, the Tyrrhenian group has a very patchy mercantile record, vitiated by numbers of worn dipinti; 8D, 5 and 6 are the only dipinto pair, supplemented by the curious graffiti 5D, 21-22.

In the following generation further close groups are confined to vases of Group E, in types 25A and 1E. The dipinti of 17A include similar vases, but their relationship with other members of the type, including horse-head amphorae and a Lydan vase, is not clear. The horse-heads must be contemporary with each other, and there is good reason to take the Lydan vase with them.[5]

I have detected little chronological stratification in the marks on vases of Group E. No stylistic coherence appears in any of the sets of vases in types 17A, 25A and 1E; in the last two types vases by hands distinguishable from the residue of the group can be found. Some of the vases in 17A are closely related stylistically, e.g. the three broad neck-amphorae (6-8), and the Kassel and London amphorae (9-10); yet Lullies associates the latter pair closely with Louvre F32 and 55, which have marks of type 22A.[6] There seems little stylistic coherence in this last type.

The work of Exekias himself is remarkable for the lack of graffiti and dipinti; including the lid of Vatican 344, I have found only three.[7] Euphronios too rather lacks marks, though his works are often fragmentary, without feet. Masterpieces on the whole are rarely marked, or at least do not have marks belonging to large close groups.[8] This fact may lead us to think that such vases were recognised as something special *ab initio,* particular commissions or the subject of individual haggling between traders. Many pieces of the Amasis painter may be thought to belong to such a category; few mercantile groups can be found among the marks on his vases, examples being 5D, 2, 4 and 6 and perhaps a trio of black *alphas* (p. 4).[9] There is little connection through trademarks between Exekias and the Amasis painter or with their contemporaries.[10]

Close groups become relatively more frequent, to the exclusion of more isolated marks, in the years after 535. The neck-amphorae of Nikosthenes were made specifically for the Etruscan market; Er - - (or Her - -) and So - - marked twenty-five of them in all, and they bear no other assured trademark (type 3E, n. 1). So - - is likely to have been the Aeginetan Sostratos, whose vase-trading activities I have discussed in *PdP* 27 (1972) 416 ff; he also bought from the Affecter, another 'Etruscan' specialist. Er - - also handled pieces by the Swing painter, probably closely contemporary with the Nikosthenics (3E, 17-20).

The Affecter has five marks that appear more than once (21A, 23A, 33A, 11B and 9E) and ten others.[11] Marks of type 33A and 11B are on stylistically earlier vases, those of type 21A are more spread (with the early piece 21A, 30 a key vase in the dating of the type - see the commentary), and 9E appears only on later pieces; it is clear that the same Ar - - - patronised the Affecter and the Lysippides painter, whose marked pieces would be contemporary, a link strengthened by the special neck-amphora, *ABV* 242,35. Yet, even if we restrict its compass, this group of type 9E is large, and exact contemporaneity cannot be proved.

While this same sub-group of 9E leads into red-figure through the bilinguals of the Lysippides painter, the bulk of 'commercial' black-figure was still to be produced. In the period c.530-510 Smi - - and So - - were active, as well

as Ar - -. Our dating of better black-figure of this period is heavily dependent on stylistic considerations, which may lead to persuasive conclusions within workshops but are not so easy to apply between workshops; vase shapes and *kalos* names assist, but only to a point, and so where potting or style may allow a five-year leeway, or more, similarity of marks may help us to identify contemporary pieces - though not absolutely dated. [12]

Relations between black- and red-figure groups are of some interest. Ar - - we have just noted; his mark appears on work by the Lysippides/Andokides painter, Smikros and perhaps Euthymides and the Pezzino group, while the Ar - - of the internal ligature (9E, xi) may be the same man, marking work by the Nikoxenos painter and the Berlin painter in his earliest years: these two at any rate must be close contemporaries, and of the same years must be the black-figure hydria in Leiden, 9E, 77. The hydria by the Carpenter painter, 9E, 84, poses more of a problem since its second mark belongs rather with the later work of the Berlin painter.

The danger of making vases with the same, not uncommon, mark contemporary can be seen in type 1B. The marks may suggest a link between the Andokidean or Antimenean pieces and those by or near the painter of Munich 1519, but style points to the large spread covered by the series. In view of the frequent enough occurrence of the mark, such a conclusion need cause no surprise. More secure links between vases of the two techniques are to be found in type 2F; in the commentary I note the slight differences in the marks on the RF vases of sub-group vii, which support a marginally earlier date for the pieces, suggested also by the shape of the hydriai. The *kalos* name Leagros and the general appearance of the complex graffiti still keeps them fairly close. If the controlled and generally efficient (save 11E, 48) Leagran marketing system was first worked out with red-figure vases, we could add one further facet to the 'Pioneer' label.

Bloesch has demonstrated the close relationship of these BF and RF schools or workshops, but the vases which he allots to individual potters do not bear the same marks; rather it is the painters, not only in the Leagran workshop, that seem to have 'their own' marks. [13] However, the phenomenon is the more striking in the Leagros group, especially in the case of 11E, 48 with its 'wrong' mark erased and replaced by the 'right' one for the group concerned. The red-figure counterparts of the Leagros group do not fall so readily into painter-orientated commercial groups; Smikros has no certain commercial tie with the group, Euphronios is tied in with the group through 24E, 10, though his other work lacks marks (discounting the Etruscan graffito on *ARV* no.12), Hypsis has one mark of type 2F and Phintias three such marks, plus one of type 7D (2F, 35 has however a monogram that may be related to type 5E). Euthymides' work presents a complete jumble: 2F, 50, with unusual punctuation, 8E, 31 on the other side of the Leagran fence, 9E, 47 possibly linked with the Lysippides/Andokides painter and five other marks with no clear propensity for any black-figure group. [14] A further Leagran problem is posed by 9E, 10 and 85; the glaze mark connects this foot with the work of Painter A, while the graffito is reminiscent of the 'internal' ligature of the early Berlin Painter, to one of whose works it may belong; there may be some justification here for making Painter A and the Berlin painter just contemporary at one point, no doubt c.505. [15] See Addenda, p. 70.

Other isolated instances suggest chronological links between BF and RF. Perhaps more than isolated are the occurrences of type 21B on the BF vases of the Diosphos painter and the RF ones of the Kleophrades and Syriskos painters. The pelike of the Eucharides painter in type 7F is connected by its monogram with some patterned and red-figure kraters, and by the particular structure of its vase-name marks (perhaps a less compelling argument) to red-figure vases by the Tyszkiewicz and Copenhagen painters in types 1F and 19F. Both the latter vases have the monogram 9E, xiii, which is the hallmark of the Syriskos and Copenhagen painters, as well as occurring on some black-figure vases, including a Panathenaic amphora of the group of Vatican G23 and an oenochoe of the Athena painter. The life of the monogram need not have been particularly short, but it does afford some useful chronological links. Another connection of the Athena painter with red-figure is *via* Spina tomb 867 which contained an oenochoe by him with a mark of type 9E, xii and a vase of the Berlin painter, who uses the same mark early in his career.

Vases from the workshop of the Athena painter appear in type 12E, a mark in use for some length of time - though again we may note work by the Berlin painter and a trio by his pupil the Providence painter.

Some other types contain both black- and red-figure vases which can have no close chronological connection, e.g. 22A, 9F and 10F, the latter two being probably adjectival abbreviations current over a good span of years.

In sum, later black-figure, so much of which was exported to Etruria, often with marks, had little commercial contact with contemporary red-figure; we may conclude either that the black-figure pieces are earlier than the period of considerable increase in the production of larger red-figured pots, usually placed around 500 BC, or that the respective workshops were physically distinct and so orders tended not to be mingled. The truth is likely to lie well in the middle ground of the alternatives. To a certain extent the same alternatives can be applied to the later BF workshops themselves; there is a strong tendency for marks to be confined to vases of particular schools - was this because the workshops were chronologically consecutive or topographically apart? A sure answer can perhaps only emerge from a deeper study of the later black-figure neck-amphora in particular, but I put forward the evidence of the marks here.

The two major workshops, Antimenean and Leagran, were certainly not contemporary. The latter is to a certain extent fixed by Leagros himself, though he is not so firmly anchored as we would like. [16] The Antimenes painter is obviously earlier, though not absolutely dated by any solid evidence, and the work of his school could overlap with Leagran work of c. 515-510. There are some instances of the same mark appearing on vases of each school.

The Antimenes painter is well represented in types 16A, 20A, 21A, 37A, 1D and 21E. The vases in type 21E are mostly of the painter's early years, but the use of the 'Antimenean' form of the mark, i and ii, continues later

and includes some Leagran pieces, although there is a separate 'Leagran' form of the mark as well, in sub-group vi. [17]
21A is more often on later Antimenean vases and also appears on rather more Leagran pieces; yet the mark had a
long life, first occurring in the mid 530s. Other painters associated with the Antimenes painter in these types are the
Lysippides painter, Euphiletos painter and Painter of Cambridge 51 (20A), Painter N, the Affecter, Priam and
Madrid painters (21A), the Euphiletos painter (1D) and the Long-nose painter (16A and 21E).

Typically Leagran marks are 1A, 5E, 6E, 8E, 9E, iii, 10E, 11E, 17E, 21E, vi, 24E and 2F. These are very rarely
found on Antimenean vases; one piece from the workshop appears in each of the major sub-groups of 17E and two
in 8E. An apparent close link between the two shops is in type 32A, 11 - 14, but the readings are uncertain, the
Leagran pieces peripheral and the marks probably Etruscan (treasured by a collector of these new stamnoi?). Other
users of these 'Leagran' marks are the Rycroft painter (8E and 11E) and the Group of Munich 1501 (1A and 2F);
neither have connections with the Antimenes group elsewhere in their record of trade-marks. We cannot surely
connect the glaze marks of 9E, iii with the rest of the type, nor do we know the relationship of the Leagran members
of 17E with the later red-figure and vase-name examples.

Both groups make sporadic use of 9D and 13E, the former in use over a good period of time, the latter a
speciality of the Priam painter. 11F has some Antimenean tendency and there are three pieces in 4A; both marks
appear chronologically fairly restricted. In other types with representation of the two groups (separately or together)
there is no such restriction or clear grouping, e.g. 5A, 13B, 18B.

Black-figure vases with marks therefore tend to belong to painter-oriented groups, especially after c.530. Most
of the vases are amphorae and hydriai and the proportion of marked to unmarked pieces is high. In red-figure we
have noted already some relations with BF workshops and seen a tendency for individual marks to appear on the
work of a broader range of painters. If the marks were of the same significance on BF and RF vases, we should con-
clude that there was more workshop sharing by RF painters, a conclusion borne out by much evidence of a different
character, e.g. potters' signatures, particular vase shapes, 'shared' vases.

The limiting condition at the beginning of the last sentence should not be overlooked; it is not always possible
to be confident that marks were applied early in the career of the vase, within or near the workshop, and so not all
statements about inter-workshop relationships drawn from the evidence of marks need be of equal validity. On red-
figure vases we also have an increasing number of vase-name marks, which need not be confined to a restricted period
of use in one place - although they sometimes do seem limited in some such way. Types 9F and 10F are examples;
several vases in type 10F are stylistically contemporary, but though the simple mark appears on the work of several
painters, no two painters share the more complex forms. Single painter groups are found in type 9F, but the apparent
nature of the mark and the spread of dates do not lead us to conclude that those painters are necessarily connected
by workshop. In type 18C we can obviously draw no such conclusions, but merely observe that some workshops
use the notation more frequently than others.

There are however personal abbreviations on RF vases that do give us close groups and interrelationships.
Overall, increasingly fewer vases are marked; we may note the exception of the type C amphorae of the Flying-Angel
painter (type 17B). The mark appears in a similar form on a late piece by the Berlin painter and others by the
Tyszkiewicz and Syleus painters, and all of these probably belong to one short period. A rather earlier vase by the
Tyszkiewicz painter appears among those of the Copenhagen and Syriskos painters in 9E, xiii, a mark already
mentioned in this chapter with regard to its black-figure connections.

The group of glaze dipinti on vases by the Birth of Athena painter (2B) is also striking and we can fairly connect
with them the red mark on a piece by Hermonax. Dipinti are not common on RF vases (subsidiary list 2); a group
seems to centre on vases by the Kleophrades, Tyszkiewicz, Harrow and Geras painters, but since full readings cannot
be given for a number of them it may be hazardous to speculate that the vases are closely contemporary. Hermonax
is associated with the Briseis and Oionokles painters in a sub-group of 3E, and with various painters in 15C, a mark
that may not have been applied in the workshop. The Kleophrades painter is accompanied by the Syriskos painter
in 21B.

Neither the Berlin nor the Kleophrades painter shows consistency in their marks. Vases by the latter bear a
bewildering variety of marks with few duplications (9B?, 21B, 12C and perhaps the dipinti): near the painter is the
apparently isolated pair, 9E, 75 and 76. The Berlin painter is more interesting; we have already looked at the
difficulties raised by 9E, 10 and the two varieties of 9E that appear on his early work. Still on his earlier work we
find four instances of 10F, not a personal mark, although on one piece and on two others associated with him we
find the possibly personal ΞΔΩ. His stamnoi are frequently marked, with the unusual long-footed pair standing by
themselves, 22B, 6-7. Philippaki noted (p. 39) that his stamnos London E444 is related in shape to one in Orvieto by
the Painter of the Yale lekythos, and both have the same mark (8C, 2-3); this group however looks less compact with
the addition of the Basel and Vatican vases, 1 and 4. On the Berlin painter's later work 7D occurs relatively often,
bringing his work into association with that of Hermonax and the Pan and Charmides painters: these pieces should be
closely contemporary.

Further close groups of the late archaic period can be found in types 18E and 2B. In the former a certain
development in the combinations used can be seen within the Syleus sequence, accompanied by the Tyszkiewicz
painter; in the latter the stamnoi of the Dokimasia and Hephaisteion painters are closely linked.

There is no mark that seems to connect late archaic and early classical painters, e.g. the Berlin painter with
the Achilles or Villa Giulia painter. This may indicate that marks were only current for short periods at this time,

but there are some marks that do seem to cover a broader range of RF vases without forming recognisable groups - 8B, 9B and 17C, while 5C embraces two awkwardly juxtaposed sets of vases.

Few close groups are found around and after the middle of the fifth century, and those centre mainly on the Polygnotan school, 16E, 19B, 17F, 20F and 21F. The school has a near monopoly of vase-name marks at this period, a charmed circle broken perhaps only by the Niobid painter in type 18F. A more mixed bag is found in type 6C, with a fairly broad time spread; we find the Achilles painter intruding into Polygnotan territory in types 13C and 16B, where the Phiale painter is also represented; the abbreviation is however of an adjective and crops up again at a much later period. Repetition of marks is not as yet attested for the Achilles or Phiale painters, nor for the Villa Giulia and Niobid painters (save 6C, 1-2), though isolated vase-name marks are to be found on both the latter. Little distinctive appears in the Mannerist group either; one pair by the Pig painter (10F, 15-16) and occasional vase-name marks on pieces by the Leningrad and Agrigento painters. In such surroundings the three or more examples of 9F on vases by the Chicago, Comacchio and Alkimachos painters stand out, but see the caveat on 9F entered above.

Later in the century very few vases are marked and there seems to be only one close group not of a vase-name nature, 12B, 8-11. 18C still appears and vase-name marks continue into the fourth century, notably in types 8F, 14F and 24F. The use of marks seems to dwindle gradually between 450 and 400 rather than suffer any sudden decline, such as is sometimes posited for the Attic vase trade as a whole after the battle of Cumae in 474 or after the outbreak of the Peloponnesian War. [18]

Scarcely two score of Attic figured vases made after c. 415 are marked, and about two-thirds of these have some vase-name significance. [19] While far fewer vases were made in Athens during the years 410-380 than in the corresponding period a century before, trademarks have diminished considerably more; with such limited material it is naturally unrealistic to suppose that we can talk of relationships between workshops based on marks.

CHAPTER 11
TRADEMARKS, TRADE AND THE ECONOMY

Hackl had no doubts that our marks had some commercial significance, and I feel that it is hardly necessary to offer formal proof. Vase names, batches and prices speak for themselves, even those whose interpretation remains elusive, such as 9F and perhaps 1D. There is left a substantial body of personal name abbreviations, to which I have applied the adjective 'commercial' or 'mercantile' without having fully justified the terms; we have seen that most of them are acceptable abbreviations of Greek names, such as are found as owners' marks on pots from Greece, though a few could still be abbreviations of vase names. For the bulk of them the only explanations available are as traders', potters' or owners' inscriptions, and there are a number of reasons why the last two possibilities cannot be generally accepted.

We know the names of relatively few potters and painters, but where evidence is available there is no correlation between the names and the marks on their vases (Amasis, Exekias, Psiax, Andokides, Phintias, Euthymides, Polygnotos). Four possible exceptions should be noted, though two are trivial.[1] It is not beyond the bounds of possibility that type 20A may refer to the vase-painter Smikros, but names in Smi - - are not unusual, and in any case it could not be that the name would then be any form of signature. Similarly the two examples of 3E, iv on vases by Hermonax should not be disassociated from the other vases in the sub-group, by other painters. More plausibly, there are the *ly - -* abbreviations on vases by, or connected with, Lydos and a mark that could be interpreted as *kappa lambda* associated with the Kleophrades painter; there are substantial objections to the latter interpretation (see the commentary on 12C), although a case could still be made with regard to Lydos. Beazley suggested a connection (*JHS* 59 (1939) 305); it might even be argued that he used, or had used, both Attic and Ionic *lambda.* In this case we should not rule out completely the possibility that the Lydian marked vases from his workshop; he may even have been his own exporter.[2]

The question of owners' marks has been treated at various points. Some marks listed in the catalogue may be Etruscan owners' inscriptions, but there are not likely to be many of these. Greek marks on vases with a non-Greek provenance are most unlikely to indicate one-time Greek owners (see p. 41). Similar marks on vases from Greek-speaking (or -spelling) areas could be those of local owners, though there are various reasons for taking the majority of them as commercial marks.[3]

So most marks are in some way commercial; one, type 36A, suggests by its shape, an anchor, the occupation of its inscriber(s).[4] Hackl concluded that most marks, of whatever kind, were the work of traders visiting the pottery and placing orders, sometimes choosing a 'master' vase for the selected batch. The solution is overconcise, but has much to recommend it.

Dipinti and graffiti were usually applied after the vase was fired, but they may be related closely to pre-firing glaze dipinti, and they can refer to events taking place inside the pottery; some other less easily interpretable marks were obliterated at a later stage and so must have had a limited useful life, presumably early in the history of the vase. Most of these observations are drawn from the record of marks on vases of the Leagros group, but we may legitimately extend the analogy at least to other near contemporary BF and RF groups with Greek marks. The possibly Etruscan 8E was at any rate applied at a later stage, and so were some other marks - those overincised on others (though some of them still seem to belong within the pottery or Athens) and occasional non-Attic and Etruscan marks such as 1F, 6, 26F, 21, and type 4E.

We cannot therefore assume that all marks were applied in the Kerameikos. Glaze dipinti, Attic dialect and to a certain extent Greek script anchor many of them there, and in these cases we can accept an explanation along the lines proposed by Hackl, taking due note of his remarks about the inscrutability of much of the material. The most informative of the types is 2F, with its ramifications, and here we can reconstruct something of the commercial history of the vases, though much remains speculation. In this type no hint of the dispatch of services of tableware to Etruria can be seen, nor are such services found in later vase-name marks, with the possible exception of ladles accompanying stamnoi.[5] The vases in the batches listed in 2F, vii cannot now be traced; they may not have reached Etruria, but in any case could not have been used together with the master vase as a complete service (and in the case of ΛΗ and ΛΗΚV not at all). The fact that graffiti do not list services does not exclude their export of course, but certainly in the later sixth century much of the black-figure production at Athens seems to have been aimed directly at Etruscan tomb-furnishing.[6]

We may never be able to reconstruct the precise mechanics of the buying and selling of such vases at Athens, nor say how the system changed, if at all, with the increase in the everyday use of coined money. Many marks are in Ionic or other non-Attic scripts and it is generally accepted that they are the work of foreign traders visiting the Kerameikos; it should not be overlooked, however, that non-Athenian letters appear sporadically in vase inscriptions of all periods, increasingly so after 500, and it is highly likely that some foreigners - whether metic or slave - worked in the Kerameikos, though little can be conclusively proved. We may cite the numerous potters and painters with foreign names, from Lydos and Brygos to Sikelos. There would still be a solid Athenian base,[7] and we have noted that all glaze dipinti, with one doubtful exception, are in Attic script. Such dipinti and other trademarks in apparently Attic script could be considered the work of Athenian traders, but this conclusion does not follow, since they could all have been applied by Athenian potters or vase-painters for dealers of any origin. Trademarks therefore do not allow us to say whether Athenians traded their own vases at any time.

Such Athenian participation cannot be completely ruled out. Solon and Themistokles are historical figures who are said to have had an interest in overseas ventures, and by the mid-fifth century Athens seems to have developed interests in Sicily - not unconnected, I would have thought, with the considerable increase in vase exports to the island and to Campania after 480. Much earlier, there is a possibility that SOS oil amphorae could have been shipped by Athenians.[8] We might compare the record of marks at Corinth, though the analogy should not be pressed; Corinthian vases bear dipinti largely in Corinthian script, with an occasional exception, and we can be reasonably certain that the Corinthians sailed westward themselves.[9]

Even the longer marks are of little assistance in helping us reconstruct the system of trade involved. Several crucial questions can only be tentatively answered - was there a distinction between overseas trade and local retail markets? were the prices marked on vases those asked or those paid? how and when were batches assembled and why were they noted on a master vase? The wholly different character of the marks on vases exported to the West (until the later fifth century) does suggest some distinction between pots intended for that market and those for local use or export elsewhere, though it is hard to discern the nature of such a division.[10] The inscrutable character of many marks, especially the single-letter abbreviations of vase-names and the like (*kappa, pi, sigma*) suggests that they were meant for the eyes of initiated merchants rather than the average Athenian. We might posit that there already existed some kind of Δεῖγμα in Athens or the Peiraeus for overseas trade, but the glaze dipinti take much of the force out of such an argument, at least for the pre-480 period.[11] Much of the trading, whether ordering or haggling, was done in the Kerameikos itself.

One possible interpretation of personal abbreviations would put a slightly different complexion on such a picture, namely that they represent the recipient of the vases at an emporion like Gravisca; the marks would have been applied in Athens in order that the pieces would be recognised at the other end of the route. I doubt whether this is the correct interpretation in the majority of cases because we would then expect most marks to be in Attic script, and in any case such a system still demands contact between the person whose mark was applied and the Kerameikos through some third party who presumably travelled from Athens to the west, with the vases or independently.[11a]

We know the names of very few traders. Sakon, Simon and Achenatos (24F, 2, however interpreted) are given in full, and I resurrect Sostratos. Archi - - (16B, 33) and Mnesi - - (21B, 6-7) are longer than most, while ἀλλιω on 18C, 72 could be the start of a name also. None of these fuller names appears more than twice. One seems to be Sicilian, Sostratos was Aeginetan and the rest are of no fixed origin, though Simon could be Attic, appearing in a glaze dipinto. Hackl (p. 93) mentions the possibility of Etruscan participation in this trade; positive evidence beyond vase graffiti is virtually limited to the Etruscan vase-inscription on a cup from the Penthesilea workshop, *ARV* 969, 66. Finds of Etruscan material in Greece amount to little and can all be thought of as mementos of the West brought home to curious friends by Greek sailors.[12] It is instructive to note where these homes are, since we find there some evidence for the origin of these sailors; on such grounds Samos, Rhodes, Corinth and Athens are all possible centres for traders dealing with Etruria.

Merchant marks may give some clue as to Etruscan involvement. A few types seem Etruscan rather than Greek and do not appear to be owner's marks. The frequent pairing of Greek type 3E with Etruscan 4E and other Etruscan marks seems to point to some 'organised' trading link in the later sixth century. As there must have been some involvement of Etruscan dealers in the ports of Etruria this conclusion need cause no surprise. Possible joint experimentation between Greeks and Etruscan in numeral systems may also indicate a certain amount of professional haggling in Etruscan ports, and a couple of marks on Attic vases seem to list batches of vases, in Etruscan (p. 21). The evidence which we have does not allow us to take the Etruscans to sea, although one may have reservations about the particularly enigmatic 8E, curiously confined to one branch of the Leagros group *if* it is the mark of an Etruscan dealer based at home.

The presence of Sostratos at Gravisca, the port of Tarquinia is doubly significant in that it demonstrates that traders from mainland Greece worked through to Etruria and that such traders were not exclusively Ionian. The nature of the transactions carried out in such emporia may have varied from generation to generation, but in the period with which we are concerned they must have been non-monetary; the virtual absence of Greek coins in Etruria and the lack of Etruscan minting prove the point.[13] After 480 we do find a number of vases with Sicilian provenances inscribed with price marks; although Athenian coins are found in the island from a quite early date, and all the colonies used a standard compatible with, or the same as that of Athens, we have no clear evidence that these prices

refer to purchases made in the island rather than at Athens (until c. 420 with 1F, 6). Some of the earliest assured price marks are on vases of type 10F and were almost certainly relevant only in Athens and I argue that in the case of 10F, 25 we must presuppose the exchange of coins, in particular the quarter obol, in the transactions. Earlier, in the sixth century, it is more reasonable to assume that commodity exchange, including perhaps non-coined silver, supported the flourishing vase trade of Athens and before her Corinth. How Attic potters were remunerated on this system is far from clear and it would be largely idle to speculate on the matter; presumably traders, Ionians in particular, judging from literary sources, would have been able to offer workshops in the Kerameikos a range of goods by exchange. [14]

The use of 'countermarks' seems fairly widespread, but especially prevalent in the Leagran area; however it does not seem to extend into the fifth century. The added strokes, ticks and zig-zags accompanying marks of type 8E, 10E, 11E, 13E, 14E, and 2F are the clearest examples, and I suggest possible ones elsewhere. Yet it appears that they were not later additions but an integral part of the mark, which is usually otherwise alphabetic; therefore they are not countermarks *sensu stricto* but some form of control or notation of unfathomable import.

Vase names accompanied by numerals usually refer to the inscribed pot or to a batch of similar pieces, with or without further vases and batches, though not of such a character as could be termed 'services'. The earliest batch is that noted on Corinthian 47 of the mid-sixth century and such mixed batches appear sporadically in the ensuing century and a half. The batches sent out with the hydriai and amphorae of type 2F, vii were of various sizes and covered a wide range of vase shapes, but the system of marketing was clearly organised and such 'packaging' a regular feature. Certainly by the later fifth century, and possibly much earlier, the accompanying vases in a consignment were simply known as ἐνθήματα.

Numerals without any accompanying vase name sometimes refer to batches (most clearly seen in types 9F and 10F). Such batches need not necessarily include the marked vase, but they presumably do in the case of the many small glazed vases found throughout the Mediterranean, largely of the later fifth and fourth centuries. The large order on 25F, 8 is a scaled up version of such batch numbers, which can be substantial (8F, 12 and p. 28); for larger vases batch sizes are rarely noticeably large; 9F, 51 with a mention of twenty-three column-kraters stands out.

Plain vase names without numerals are much rarer, though there are a number of self-referent examples in types 18F, 19F and 21F, associable with similar marks accompanied by numerals and prices, and the same applies to some isolated vase names that are not self-referent (e.g. 17F, 22F, 1 and 9). The information that a master vase was accompanied by vases of a specific type would be useful, but it is not so easy to suggest why a hydria for example should be marked with its name. The implication is that the information would be of use when the vase was not entirely visible, presumably packaged for transit. [15] The designation ποι(κίλος) would also be useful in such a context.

A few isolated numerals are less easy to interpret. Some may indicate batches and/or prices without our being confident of such an interpretation. I have puzzled over a handful of others that may have indications of capacity (p. 207), though the fact that they include hydriai does not encourage the view that the marks indicate the contents of the vase, let alone in transit. The rare assured capacity marks are all in some way special cases, 4F, 1-3 and subsidiary list 1, 29; Panathenaic prize amphorae were originally filled with oil (and designed accordingly) and the relatively frequent appearance of numerical graffiti on them suggests that some of them continued to fill that function during their later careers. In this light the question sometimes posed whether decorated vases were sent to the West full of oil or wine remains unanswered. Opinions have been voiced on either side without solid evidence being offered. [16] On the whole merchant marks support Vallet's strong arguments against such commodity export. If we assume that hydriai were not used as containers (they would of course have been extremely difficult to seal) we can argue that because hydriai were exported in large numbers along with amphorae of all types and were marked in just the same way, it would be curious if the amphorae were full and the hydriai not. In the fifth century amphorae tend to be smaller and we often find kraters appearing in close groups with them. The lack of any significant numbers of marks that could refer to contents is also important. [17] Here the record of marks on prize Panathenaics stands out against that of other decorated vases; there is no hint that neck-amphorae and the like took over the role of the SOS oil jar when the latter ceased production around 570. As Vallet points out, Athens was supplying the crockery, Etruria could provide her own oil. Earlier in the sixth century Corinth had sent few large closed vases to Etruria; when Athens took over from Corinth as supplier to Etruria the larger proportion of amphorae dispatched was probably the result of a pattern of production already established at home. [18]

The importance of the vase industry to Athens is not a subject that can be dealt with from consideration of graffiti and dipinti alone. It is a matter that has exercised a number of minds of late, and will probably continue to do so. [19] The debate was sparked off by R. M. Cook's thought-provoking article, *JdI* 74 (1959) 114ff. Of later writers Klüwe accepts Cook's calculations and assesses that between one twentieth and one twenty-fifth of the working population in Athens (to use an extremely vague term) was employed in the vase trade; Stahler believes that more men were employed and Müller implicitly suggests that they were slaves. I would accept that Cook's figures cannot be far from the mark, though he does neglect the productive black-glaze side of the industry. Any argument on this subject must largely depend on one's assessment of what proportion of vases are extant today; R. M. Cook tried to apply arguments which by-passed this factor, arguments based on the rate of survival of prize Panathenaics (a rate not likely to be consistent with that of less special vases) and the known production rate of painters. Little comment has been added since concerning his conclusion that in our present state of knowledge each painter on

average produced three vases a year. Are these three the tip of an iceberg or a fair proportion of the output of decorated vases? The same problem is involved in our assessment of close groups of marked vases, i.e. over how many years should they be spread?

The size of some of the batches noted underfoot does rather suggest that no large proportion of vases has yet been recovered. We have just treated the twenty-three column-kraters of 9F, 51; the six column-kraters of 24F, 6 are also significant since the vase is late for a column-krater as it is, without our having to look for five companions. [20] 8F, 12 is also worth another mention for the bulk export of decorated vases; no doubt the one hundred and fifty pieces noted were simple RF vases, but nonetheless present a sizable consignment, probably from one workshop, which surely was used to dispatching such numbers of pieces. The only known wreck carrying Attic figured pottery was taking similar slight pieces to Spain at a rather later date. [21] There is the danger of circular argument, however; the lower the percentage of survivals that we postulate the smaller the percentage of vases with such batch marks also. [22]

Because of this basic uncertainty we cannot gain any true impression of the scale of operation of any of our 'main-line' traders. Not only do we have an unknown proportion of marked vases extant, but also dipinti have been lost and a not insignificant number of larger vases and most smaller ones were not marked at all. I have argued (p. 41) that a number of traders dealt only in a minor way with Attic vases. We would probably be right in assuming that vases in any case would form only a part of any cargo, sometimes a very insignificant part. [23] It remains true, however, that international trade did seek out these vases and that Athens was the major producer of fine ware in the Mediterranean for a century and a half; luxury trade though it was (yet with modest prices compared with those of the bronzesmith) it was the livelihood of a significant proportion of the population. While we should not ignore the less clear or unheard claims of the Corinthian metal-workers and Milesian weavers, the dangers of using pottery as an index of economic conditions in general terms should not blind us to the obvious importance of vase production in Athens. [24]

I fear that no neat picture of the mechanics and development of the vase trade emerges from my study, but nonetheless some progress has been made and it is time to draw together the threads.

The placing of trademarks on decorated vases, mainly to denote the name of a shipper, was a practice that arose in Ionia and Corinth in the years before 600 BC. Only exported ware was so marked; in Ionia it was smaller vases that were most frequently marked. There is no very obvious explanation for the appearance of the phenomenon at this period; I have outlined the prehistory of the practice and suggested that such commercial techniques would have been fostered in corporate communities such as Naukratis and earlier Pithekoussai. The evidence points to the middle-men in the process being indicated by the marks, but we cannot be sure of their nationality when the mark is in the script of the producing state; hence Corinthians need not have exported all the pieces with Corinthian *epsilon* or *digamma,* and a few Corinthian vases with Ionic marks show that there was no monopoly in the handling of the ware.

Attic vases began to take over the market from Corinthian around the years 580-60. There are no assured Corinthian letters in the marks on Attic vases of this period and so there is no positive evidence that Attic vases ever travelled in Corinthian ships; when evidence becomes more plentiful we can be sure of this conclusion. Who then did carry them? In the sixth century and some way into the fifth Ionians (Samians possibly to the fore) and Aeginetans were involved, and we cannot rule out Athenians or perhaps Euboeans. There is no evidence to tell us whether the same Ionians could have carried both Corinthian and Attic ware. The fall of Ionia to the Persians around 540 has no apparent effect on the role of Ionians as shippers. [25]

Trademarks only contribute in a negative way to the problem of the route of Attic exports to the west, via the Isthmus or around Malea. Nothing suggests transport across the Diolkos, and the lack of Corinthian marks on Attic vases is at least suggestive of the conclusion that they were not reshipped from Lechaion. However, the question should be dependent on weightier evidence, if and when it is forthcoming. [26] Marks on Laconian vases are not sufficiently diagnostic for us to hazard anything about their route of export.

Once clear of Greece the cargoes probably stayed aboard till Etruria was reached (or later, Sicily, Campania or the Po delta). Marks cannot contribute to the question whether portage across the toe of Italy ever took place, but the likelihood of large clay vases being transported up valley and down dale for upward of twenty miles is minimal. [27] At least down to the latest sixth century there seems to have been little stopping-off to sell vases en route to Etruria; we would have expected more 'main-line' marks on pieces found in Campania and Sicily had this occurred (p. 14-15). Some small overlap suggests that ships occasionally called in at the Bay of Naples and the local Etruscan settlements, but not elsewhere; if they did, the local traders were not allowed to buy up the pots, intended for richer pockets to the north. It is possible that some marks were intended merely to ensure delivery to the requisite person in a Greek emporion in Etruria. [28] In the fifth century there seems to have been a change; marks are spread over a wider range of provenances, suggesting a more piecemeal retailing of pottery, facilitated no doubt by the greater availability of coined silver for individual transactions. Whether vases with the same mark found, say, in Etruria and Campania were part of a single consignment out of the Peiraeus cannot be determined. Trade with the Adriatic, to Spina, Adria and Bologna, increased, but there is little sign that it was in the same hands as that to the west coast of Italy, or as highly organised.

Only towards the end of the fifth century do vases found in the eastern Mediterranean begin to be marked in a similar manner. The route to Etruria was clearly the most profitable and the most frequented; yet vases of quality from Athens reached Rhodes, Naukratis and elsewhere throughout the period under discussion. Possibly Athenians

themselves carried on some of this trade and had little need for marks, [29] but such an argument does not account for the different range of marks found on vases from Rhodes. The lack of 'main-line' marks on vase feet from the sanctuary at Gravisca could be used as evidence that marked vases were intended from the outset for a specific, Etruscan, market. [30]

The proportion of non-Athenians shipping Attic vases in the later sixth century was probably high. Ionians evolved a certain sophistication in their marketing technique and the appearance of 'proto-acrophonic' numerals in association with possibly Aeginetan graffiti (type 1D) suggests a similarly brisk trade. The variety of early numeral systems should dispel previous dogmatism on the introduction of Ionic and acrophonic systems.

The increasing influence of Ionians on the Kerameikos eventually led to the changes in the Attic alphabet of the fifth century; this trend started well before the inception of the Delian league, though its formation no doubt accelerated the change. There were presumably some men of Ionian origin at work in the potteries, but not enough to account for our marks in Ionic script. That should not lead us to ignore the role of metics entirely in explaining the variety of scripts displayed by our marks. In a few instances it must be considered whether in the commercial sphere scripts could merge or develop along separate lines (7D, 1E, 1F?).

It is not possible to be certain how many Aeginetan marks there may be, but those I consider under that heading are all of the later sixth century. Perhaps the deterioration of political relationships between Athens and Aegina may have put an end to Aeginetan participation in the vase trade, but there are many imponderables in such an argument. [31] There is nothing in the record of Ionic marks to suggest historical events and influences, and the difficulties of isolating the scripts of individual cities greatly hampers any such search. Hackl believed that Ionians no longer figured among exporters after 479, but proof is lacking; many marks of the following years do not have diagnostic letters, and where Ionic letters are found we could take them either as Attic or Ionic. It is therefore by no means simple to isolate Ionians at this date, and it remains the case that Attic marks do not necessarily indicate Athenian traders.

In the fifth century the use of marks becomes less frequent, personal abbreviations in particular. Somewhat surprisingly vase-name and price marks tend to either extreme - single letters or fully spelt out words, though retaining a modicum of 'regular' abbreviations. The longer marks could be tokens of a more open marketing system, but it is not easy to discern a clear divide between them and single letter abbreviations, which can occur on similar vases. If such an open system did exist it is difficult to explain why marked vases do not appear in Athens or continental Greece. Is the virtual lack of glaze marks in the fifth century an indication that there were no longer merchants ready to snap up vases in the Kerameikos as soon as they were painted and that workshop owners had to take their wares down to the Peiraeus and advertise them in the Deigma to less enthusiastic traders? Some situation like that would account for the apparent prevalence of marks in the Attic script in the fifth century and the demise of personal abbreviations.

Most of the prices quoted in graffiti were asked or paid in the Kerameikos; there is some indication that prices at the other end of the trade routes were significantly higher, but the material available is slight. We can say nothing of whether Attic exports suffered by the competition of local Italian products in this respect. On the assumption that the prices otherwise were those paid in Athens, we see that there was little fluctuation from one end of the fifth century to the other, and that prices were suitably scaled according to the size, complexity and decoration of the piece. There is no evidence that prices expressed in drachmae, obols or whatever were any part of the marking system in the massive sixth century trade to Etruria.

If the overall picture that emerges from these considerations is less than clear it should be remembered that the results that have been obtained often depend on the identification of local scripts in material drastically abbreviated, and indeed in only the most manageable part of the total amount of material. There remain the single marks, Etruscan marks, multiple, overincised and inexplicable marks - enough to remind us that ceramic footnotes often do not elucidate but complicate questions concerning Greek trade by their very variety and sometimes inscrutability. Overgeneralisation is therefore likely to mislead. We see very clearly from a study of the subject that we cannot think in terms of mass production, but rather of the relationships between individual potters and traders, relationships which can become highly organised, but were by no means necessarily so, even at the point of greatest demand. In the fourth and succeeding centuries there is no phenomenon to compare with our marks, save the occasional numerical graffito and more owners' marks. Only when what could be termed true mass production appears in the Gaulish sigillata workshops are vase feet used once more for such sordid commercial purposes, and even then there is nothing to suggest that those purposes were in any way similar to those of the Greek traders of the sixth and fifth centuries.

Postscript

New finds of graffiti and dipinti will expand our knowledge of the subject and will almost certainly invalidate some of the arguments advanced in this book, although I would like to believe that much of the ground-lines and a good proportion of the more specific points will remain intact. I would envisage further discoveries of price graffiti, or the elucidation of already known numerical marks as prices through the appearance of more clearly interpretable marks of a similar character. Such marks may be found particularly on smaller vases - I think especially of lekythoi and skyphoi from Sicily and Campania.

The isolation of further 'nationalities' among traders will be a more difficult task; possibly excavations of archaic levels in Ionic cities may afford clues, or further finds of emporia in Etruria to compare with Gravisca.

Individual studies of vase-painters and workshops should make more use of graffiti than I have done in chapter 10 where some possibilities only were outlined.

Whatever future work may be carried out on this subject and related topics, it is to be hoped that some of the more speculative vase prices will disappear from the handbooks on the classical Greek economy, and that a more rigorous approach will be made to the concept of close groups, and that when a given mark appears on the Akropolis or at sites like Xanthos or Segesta it will not be uncritically associated with commercial marks on pottery from Etruria.

APPENDIX 1

Provenance charts

These two charts include only those Attic vases which find a place in the main catalogue; some total figures will be found in chapter 6. Black-glazed vases have been divided at around 500 BC and allocated to BF and RF charts respectively. Gravisca is subsumed under Tarquinia.

Key to column headings:

1	Neck-amphorae, including Nolan amphorae and the like	9	Lekythoi	
2	One-piece amphorae, including Panathenaics and unknown 'amphorae'	10	Skyphoi	
3	Hydriai	11	BF Cup-skyphoi	RF Askoi
4	Oenochoai	12	Lids	Plates
5	Kraters of all types	13	Feet	Lekanides
6	Stamnoi	14	Other	Other
7	Pelikai	15	Unknown	Feet and unknown
8	Cups, including stemless cups	16	Totals	

BF

	1	2	3	4	5	6	7	8	9	10	11	12	13	14	15	16
Vulci	215	63	104	29	2	5	-	6	3	-	-	1	1	1	3	433
Tarquinia	59	18	2	4	-	-	-	2	-	-	-	-	1	-	-	86
Cerveteri	31	8	2	6	1	-	4	3	-	-	-	-	1	-	-	56
Orvieto	7	3	4	-	-	-	-	-	-	-	-	-	-	-	13	27
Bolsena	1	1	-	-	-	-	-	-	-	-	-	-	-	-	-	2
Chiusi	3	3	-	-	-	-	-	-	-	-	-	-	-	-	-	6
Nepi	2	-	-	-	-	-	-	-	-	-	-	-	-	-	-	2
Bologna	3	1	-	1	2	-	-	-	-	-	-	-	-	-	-	7
Spina	-	-	-	7	1	-	-	-	2	-	-	-	-	-	-	10
Nola	2	2	-	5	-	-	-	-	-	-	1	-	-	-	-	10
Capua	3	5	3	-	-	-	1	-	-	-	-	-	-	-	-	12
Cumae	2	2	1	1	-	-	1	-	1	-	-	-	-	-	-	8
Suessola	-	-	-	1	-	-	-	1	-	-	-	-	-	-	-	2
Fratte	-	1	-	-	-	-	-	-	1	-	-	-	-	-	-	2
Taranto	2	1	-	-	1	-	-	3	4	1	1	-	-	-	-	13
Gela	6	-	-	1	1	-	-	-	11	-	-	-	-	-	-	19
Syracuse	-	-	-	-	1	-	-	-	1	-	-	-	-	-	-	2
Ialysos	-	2	-	-	-	-	-	-	-	-	-	-	-	-	-	2
Kamiros	2	1	-	-	-	-	-	4	-	-	.	-	-	-	-	7
'Rhodes'	2	-	-	-	-	-	-	1	-	-	-	-	-	-	-	3
Others	7	3	1	6	2	-	-	5	2	4	-	-	-	1	1	32
Unknown	367	106	93	47	15	6	4	12	18	2	-	8	12	3	5	698
Total	714	220	210	108	26	11	10	37	43	7	2	9	15	5	22	1439

RF

	1	2	3	4	5	6	7	8	9	10	11	12	13	14	15	16
Vulci	7	12	19	6	2	22	3	6	1	-	-	1	-	1	1	81
Tarquinia	1	-	-	-	2	1	3	1	-	1	-	-	-	-	-	9
Cerveteri	1	4	-	1	1	4	7	7	-	-	-	-	-	-	2	27
Orvieto	1	-	-	-	-	3	1	-	-	-	-	-	-	1	-	6
Chiusi	1	-	-	-	3	-	1	1	-	-	-	-	-	-	-	6
Falerii	-	-	1	-	4	1	1	-	-	-	-	-	-	-	-	7
Bologna	-	-	-	-	8	2	1	-	-	-	-	-	-	-	-	11
Spina	-	-	-	1	8	-	-	-	-	1	-	-	-	-	-	10
Nola	24	1	4	4	1	2	5	1	1	1	-	1	1	-	1	47
Capua	7	3	5	-	1	5	3	1	-	-	-	-	-	-	-	25
Cumae	-	-	-	1	8	-	-	2	-	-	-	-	1	-	-	12
Naples	1	-	-	-	2	-	1	-	-	-	-	-	-	-	-	4
Suessora	1	-	-	-	1	-	1	1	-	1	-	-	-	-	-	5
S. Agata de'Goti	-	-	-	-	2	2	-	-	-	-	-	-	-	-	-	4
Vico Equense	-	-	-	-	1	-	-	-	1	-	-	-	-	-	-	2
Ruvo	-	-	-	1	-	-	-	-	-	2	-	-	-	2	-	5
South Italy	3	-	2	-	2	-	1	-	-	1	-	-	-	-	-	9
Aleria	-	-	-	-	2	-	-	2	-	-	-	-	-	-	-	4
Adria	-	-	-	-	-	-	-	29	-	4	-	-	-	1	3	37
Gela	8	-	-	3	2	-	6	-	8	1	-	-	-	-	-	28
Kamarina	-	-	2	-	6	-	1	-	-	-	-	-	-	-	-	9
Syracuse	-	-	-	-	1	-	1	-	-	-	-	-	-	-	-	2
Agrigento	-	-	1	-	1	-	-	-	-	-	-	-	-	-	-	2
Lipara	-	-	-	-	-	-	-	2	-	-	-	-	-	-	1	3
Cyrenaica	-	-	2	1	-	-	-	-	-	-	-	-	-	1	-	4
Kamiros	-	-	1	-	-	-	2	-	-	-	-	-	-	-	-	3
'Rhodes'	-	-	1	-	1	-	1	-	-	-	-	-	-	-	-	3
Other	2	1	2	6	9	1	7	5	2	2	1	1	-	1	1	41
Unknown	58	17	44	16	79	40	45	20	13	9	4	1	3	3	2	354
Total	115	38	84	40	147	83	91	76	28	23	5	4	5	10	11	760

The other entries in each list are made up of single examples of the following shapes (save the first listed):

BF Neck-amphora: Agrigento (2), Bomarzo, Fratte, Apulia? and Sicily. Panathenaic: Lokri. Type B amphora: Megara Hyblaea, Marion. Hydria: Toscanella. Oenochoe: Rome, Perugia, Adria, Apulia, Taman and Attica. Column-krater: Montagna di Marzo and Xanthos. Cup: Caudium, Suessola, Monte Sannace, Marseilles and Cyprus. Lekythos: Selinus and Naukratis. Skyphos: Aleria, Lipara, Centuripe and Greece. Lekanis: Arezzo. Kyathos: Vulci. Psykter: unknown.

RF Nolan amphora: Sicily and Corinth. Type B amphora: Agrigento. Hydria: Populonia. Mug-oenochoe: Taranto. Krater: Almeria, Altamura, Catania, Caudium, Conversano, Narce, Numana, Odessos and Al Mina. Stamnos: Todi. Pelike: Bomarzo, Serignano, Egnatia, Akrai, Athens, Kerch and the Crimea. Cup: Populonia, the Camargue, Athens, Marion and Asia Minor. Lekythos: Selinus and Sicily. Skyphos: Histria, Chersonesos. Askos: Cyprus. Plate: Olynthos. Pyxis: Naukratis. Unknown: Ampurias.

APPENDIX 2
Painters and marks

The chart below is based on entries in *ABV, ARV* and *Paralipomena.* Not all the figures can be said to be absolutely precise; for example, I have omitted obviously non-commercial Etruscan marks, but keep some that may be commercial; then there are marks on the boundary of 4 and 5 that can only be allotted subjectively; varying quality of publication may mean that some vases included in 2 but not in 3 may yet have a mark.

1 Vases in *ABV* or *ARV* and *Paralipomena* attributed to the painter.
2 The larger vases of 1 (amphorae, hydriai, kraters, stamnoi, pelikai and oinochoai) which a) have non-Greek provenances, b) are adequately published or known to me personally, and c) have an intact and clean foot.
3 Those of 2 with marks.
4 Those of 3 that have 'main-line' marks.
5 Those of 3 with other marks.
6 Those of 3 with traces only of dipinti or obscured graffiti.

	1	2	3	4	5	6
The Tyrrhenian group	184	107	18	3	4	11
Princeton painter	32	17	6	2?	3	1
Painter N	88	43	25	24	1?	-
Group E	82	51	33	26	5	2
Priam/AD painter	45	35	21	16	3	2
Antimenes painter	158	97	63	53	4	6
Manner of Antimenes painter	68	40	22	18	2	2
Related to Antimenes painter	31	23	13	10	3	-
Group of Toronto 305	21	17	12	6	5	1
Near Group of Toronto 305	11	7	3	1	2	-
Group of Bologna 33	4	1	-	-	-	-
Group of Compiègne 988	7	3	2	1	1	-
Eye-siren group	16	12	8	7	1?	-
Group of Bologna 16	3	3	1	1	-	-
Group of Würzburg 199	34	26	13	11	1	1
Group of Würzburg 179	2	2	1	1	-	-
Painter of Boulogne 441	3	2	2	2	-	-
Alkmene painter	2	1	1	1?	-	-
Leagros group:						
Painter S	10	9	9	9	-	-
Painter A	8	8	8	8	-	-
Group of Vatican 424	9	8	6	6	-	-
Simos group	4	4	4	4	-	-
Chiusi painter	11	3	2	2	-	-
Group of Würzburg 210	11	9	6	4	2	-
Antiope group I	20	15	9	6	3	-
Painter of Oxford 569	4	2	1	1	-	-
Group of London B338	3	3	2	2	-	-
Unallotted	260	116	81	63	12	6
Andokides painter	16	10	8	6	-	-
Euphronios	24	6	2	1	1	-
Euthymides	21	12	8	5	2	1
Kleophrades painter	112	40	18	8	7	3
Berlin painter	279	109	37	29	7	1
Tyszkiewicz painter	97	35	17	12	5	-
Polygnotos	71	36	17	14	3	-
Painters associated with him	171	75	14	13	1	-
Group of Polygnotos, other	179	61	16	10	6	-
Kleophon painter	71	17	7	6	1	-
Kadmos painter	38	17	3	2	1	-

APPENDIX 3

Marks on other artefacts

This is not an exhaustive study of marks and abbreviations on objects other than pottery, but rather an attempt to place commercial marks on vases into a wider framework. In the archaic period and down to c.450 (I exclude consideration of later material here) we find marks of an abbreviated nature most frequently on coins, bronze vases and architectural members.

Coins need trouble us little. Abbreviations cut in the die begin to be used much later than on vases or on stone; in the early period they are all simple, usually the name of the issuing state (see H. Cahn, *Knidos* 71-2) or more rarely of a 'magistrate', notably at Abdera (May, *The Coinage of Abdera* 44-5). Only later do they begin to proliferate. Ligatures are extremely rare before c. 450 (see also p. 58): a pseudo-ligature on early Sybarite fractions (W. Schwabacher, *Gnomon* 43 (1971) 726), ligatures indicating value on Kolophonian fractions of the early fifth century (Kraay, *SNR* 42 (1962-3) 5ff) and an enigmatic, but seemingly alphabetic mark on a silver cake ingot from the Ras Shamra hoard (Schaeffer, *Mélanges Dussaud* 485-6). Some late archaic graffiti on coins are noted on type 20A, n. 2; one could consider them being the abbreviated names of dedicators, did not the find context point away from their being part of a sanctuary dump. On some early coins of southern Asia Minor we find symbols such as the ankh and whirling triskelos (J. Boardman, *Iran* 8 (1970) 25 - with later material); Boardman also discusses there the use of such devices on Achaemenid seals and coins and points to the poverty of marks on Greek gems. He sees eastern influence in the branding of horses with simple marks (add to his bibliography *AA* 1969 74 n. 14, *AJA* 75 (1971) pl 74, fig 9 and *AJA* 76 (1972) 1 n. 3 and 3 n.11). Such marks are rarely found as commercial marks.

As well as horses, another perishable commodity that was often marked with a single sign was shield-facings; see M. Guarducci, *Epigrafia Greca* i 399-400.

We might have expected bronze vases to have similar commercial marks under their feet to those on clay pots. Yet graffiti would have been a little more difficult to cut and dipinti would not have long survived. The poor state of preservation (and sometimes publication) of much of the material should also be borne in mind. On present evidence there is little to suggest that bronze vases were so marked. Athens had no considerable school of bronze-exporters, but Corinth, the most widely recognised centre of manu-facture of bronze vessels, did have a tradition of marking exported pottery.

The following list is no doubt incomplete, but I think that the conclusion can still be drawn that affinities with the pot trade were not close.

1 The Vix krater. Single letters for facilitating the assembly of the figures on the neck; probably three such series, one at least probably in Laconian script.
2 Baltimore, Walters Art Gallery, hydria (Diehl, *Die Hydria* B39a). A sixth century hydria with a fifth century dedication in Arcadian script; somewhere in between a note of capacity cut pointillé on the rim, involving what in any case must be an early use of combining acrophonic numeral and initial letter (here *mu,* for mina) in one sign. The shape of the *mu* suggests a fifth century date.
3 Istanbul, Diehl, o. c. B123. Fifth century kalpis; apparent monogram on the mouth. See 7.
4 Louvre 2674-75, Diehl o.c. B150. Fifth century kalpis; simple cross on the foot which Diehl takes as an assembly mark.
5 Athens NM 7123, Lolling, *Katalogos* CXXV, De Ridder, *Catalogue des Bronzes trouvés sur l'Acropole d'Athènes* 121. ΝΑ on the rim of a bowl; De Ridder suggests an abbreviation of ἀνέθηκεν, implausibly.
6 Athens NM 7130 and 7156, Lolling o.c. CXXVIII, De Ridder o.c. 201 and 203. Marks on the handles of two phialai or the like. Lolling suggests they are a pair, but the hands are different and the mark not surely the same.
7 Thessalonike, *ADelt* 24 (1969) A 3, n. 6. Kalpis, 550-500; ligature of *delta* and *epsilon* under the foot. It is suggested l.c. that 3 has a similar mark.
8 From Ugento, from an early fifth century tomb, a somewhat earlier oenochoe; N under foot. Lo Porto, *ASMG* 11-12 (1970-1) 108-9.
9. Silver mug from Stara Zagora, Oxford 1948. 104. ΣKV under foot; see p. 230 and *BICS* 25 (1978) 79.

We may add the single letters or marks on bronze siren protomes, *OLForsch.* vi 92, A22 and A23, of the seventh century. The early date is noteworthy, but it is not certain that the marks belong to the original assembly of the relevant cauldron(s).

Far more frequent in the archaic period are masons' marks or similar architectural aids, ranging from full inscriptions (as the earliest examples of such marks on the early sixth century temple at Kalydon, *LSAG* Aetolia 4) to single signs or letters. Lists and discussions can be found in Barbaro, *Klearchos* 33-34 (1967) 100, Martin, *Manuel d'Architecture Grecque* i 222-231, Montuoro-Bianco, *Heraion alla Foce del Sele* i 30, Moreno, *Rend.Linc.* 1963 201-229, Neutsch, *Herakleia-studien* 162 and Orlandos, *Les Materiaux de Construction* ii 84-87.

The majority of the earlier marks denote the place of a member, using a letter or cipher. They can be graffito or dipinto; for the latter see Martin, o.c. 226 n. 1, *Olympia* ii 194, Guarducci, *Epigrafia Greca* i 113, Orsi, *ML* 29 449-450, Kienast l.c. p. 62, n. 3, Peppa-Delmousou, *Charisterion eis An. Orlandos* iv 371, Travlos, *A Pictorial Dictionary of Ancient Athens* 208 (compare in the latter case the method of marking type D pyxides - p. 38). Some of these references are to much worn or now lost red dipinti on marble; they may lead us to a greater conviction that many similar dipinti on vases are now lost.

A number of these series of marks belong to the sixth century. Most important are perhaps those at Posidonia (Guarducci o.c.) and at Olympia (Sikyonian treasury) where the local alphabets are very fully preserved, and at Samos (Kienast), Caulonia (Orsi), Gela and Syracuse (Moreno) which provide early numerical systems to place beside the evidence of commercial graffiti. Ionic numerals used at Saint-Blaise belong to a period when the system is not well attested, the late fifth or early fourth century (Rolland, *Fouilles de Saint-Blaise* 92-97). Among individual letters and signs of note are a *koppa* reported at Taranto (Weuillumier, *Tarente* 242 n. 2), an hour-glass sign at Phana, Chios (*ADelt* 1 (1915) 83) and a double-axe at Policoro. As on coins there is little evidence for the use of ligatures; see p. 2 (Diolkos), Wiegand, *Die Poros-Architektur der Akropolis zu Athen* 181 fig. 189, a ligature of type 5A on a piece of 550-500, Neutsch l.c. a), and Peppa-Delmousou l.c. 383-4. The marks on the terracotta pipes, Travlos l.c., are in a semi-cursive script.

Architectural aides-mémoire appear at least as early as commercial graffiti, share the usage of graffiti and dipinti and regularly employ abbreviations, despite the greater space available.

Abbreviations, largely of names, appear on a variety of other objects in the archaic period, e.g. stelai (*PdP* 23 (1968) 433-6), revetments (*Himera* i 346), bronze plaques (for the period, the tribal abbreviation on the Francavilla plaque, Guarducci, *Epigrafia Greca* i 110 fig. 14; compare the horoi of the first half of the fifth century from Corinth, Stroud, *Cal.St.Class.Ant.* 1 (1968) 233-242), and the bronze sauroter from Croton, *Arch.Rep.* 1976-7 61 fig 25.

NOTES TO CHAPTERS 1 TO 11

Chapter 1

1. The fullest lists of such marks are in Stubbings, *Mycenaean Pottery from the Levant* 45ff; add material in *CVA Cyprus* 1 and 2, *Kadmos* 5 (1966) 142 and 147, Raison, *Les Vases à Inscriptions Peintes* (Incunabula Greca 19) 214 n. 12, and *Proc. Roy. Ir. Ac.* 73 (1973) C 346,62 and 417,801. Judicious remarks on pre-and post-firing dipinti, Daniel, *AJA* 45 (1941) 265-6. For marks on earlier vases from Kea, Caskey, *Kadmos* 9 (1970) 107ff; from Tiryns, Döhl, *Kadmos* 17 (1978) 115ff.
2. The publication of some of these is forthcoming in *ML*, while the early amphora, and a companion, are already discussed by Buchner, *PdP* 33 (1978) 130ff. See also *BSA* 73 (1978) 115-6, 131.
3. For epigraphic treatments of the Dipylon oenochoe see *LSAG* 68, Guarducci, *Arch. Class.* 16 (1964) 134-6, M. Langdon, *AJA* 79 (1975) 139-40, Annibaldis and Vox, *Glotta* 54 (1976) 223-8.
4. *BSA* 73 (1978) 103ff, q.v. for more detailed discussion of the types of graffito found on the amphorae.
5. Jeffery, *BSA* 59 (1964) 40ff, 5-11.
6. A good cross-section of decorated undersides of Geometric vases can be found in *CVA Heidelburg* 3: pl 105 and 111, 3, Attic pyxides; pl 114, 2 and 5, Attic(?) kalathos; 118, Boeotian pyxis, 119, 1-3, Boeotian pyxis, with further references in the text; 119, 5-7, Boeotian cup; 122, 3 Cycladic(?) pyxis. Protocorinthian conical oenochoai: a full figured scene, Kraiker, *Aigina; die Vasen des 10 bis 7 Jahrhunderts* 267, pl 19; horses, *Arch. Rep.* 1970-1 64, fig 2; others, *Perachora* i pl 123, 9 and 10, unpublished material from Isthmia. Argive cup, Courbin, *La Céramique géometrique de l'Argolide* 311 and pl 76. Samian cup of later seventh century, *Samos* v 213.
7. Kinch, *Vroulia* 170.
8. All are concerned with sacral and related regulations, the earliest perhaps from Crete, *LSAG* 310-1; probably still in the seventh century the texts from Tiryns, Verdelis, Jameson and Papachristodoulou, *Arch. Eph.* 1975 150ff. No red paint is said to have been preserved on any of these texts, but the use of the word ποικιλάζειν in Crete by c.500 to indicate the inscribing and colouring of letters suggests that it was a well established custom (Jeffery and Morpurgo, *Kadmos* 9 (1970) 118ff; their interpretation preferable to that of Beattie, *Kadmos* 14 (1975) 26-31).
9. Taking into account smaller Attic vases we find that the total percentage marked during the period is extremely small; cf. p. 36.
10. M. Finley, *A History of Sicily* 34.
11 The latter listed in *BSA* 75 (1970) 157 n. 31.
12 A single seal impression is found on an Attic SOS amphora, *Excavations in the Necropolis of Salamis* ii 275; a linear stamp is found rather earlier on the handle of a plain Corinthian amphora, *Hesperia* 45 (1976) 101-2. The use of impressed marks on storage jars, in a rather simpler form, reappears in the sixth century (Massiliote wine-jars, *Gallia* 16 (1958) 426), and the amphora stamp is not generally adopted till the fourth century, although earlier tile stamps are known. On the lack of use of seal impressions in Greece see Boardman, *Greek Gems and Finger Rings* 112-3 and 235-8.
13. See also on 25B, 2; a mark very close in shape to a caduceus is cut on Syracuse 21150, a Nolan amphora by the Persephone painter from Gela, Fig. 14x.
14. An early, but not securely dated example of a ligature within a word occurs on a gravestone from Thera, *LSAG* 319. Ligatures, as distinct from abbreviations, are rare on coins before the later fifth century; an ingot from Ras Shamra dating to the end of the sixth century appears to have one (Schaeffer, *Mélanges Dussaud* 485-6). Of about the same period is a monogram of *san* and *upsilon* on Sybarite fractional coinage (Kraay, *Schw. Münzbl.* 7 (1957) 74-6) and perhaps a little later the ligature of *tau* and *epsilon* on fractional issues of Kolophon (Kraay, *SNR* 42 (1962-3) 5, 1-30).
15. Chiot 58 (pl. 30) and perhaps 65; amphora, *BSA* 59 (1964) 40, 11.
16. *AM* 73 (1958) 143. We cannot be sure whether the marks are contemporary with the building of the Diolkos, c. 600.
17. Examples from the Akropolis: type 1B, 7B and 9E cited on p. 9-10; add 428, kylix and three not accurately rendered in *Akropolis* ii: 357, mark of type 6D, i *under* the *kalos* graffito; 457, cup-skyphos, E⋎; 490, handle of mug with ligature probably of *kappa* and tailed *rho*.
18. E.G. MV, East Greek 184; AΓ?, East Greek 196; ΔA, *Naukratis* i 441.
19. *Délos* xxi 63-4; *The Argive Heraeum* ii pl 69; most of the marks from Corinth and all those from Delphi unpublished; for Cyprus see p. 19; Rhodes, *BSA* 70 (1975) 145ff; Olympia, *Ol. Forsch.* v 150ff.
20. Furtwängler, *Aegina* 466, 367ff; Burrows and Ure, *JHS* 29 (1909) 340 n. 12; *AAA* 9 (1977) 88.
21. *JHS* 98 (1978) 218. See pp. 8ff. for the marks from Greece.
22. I assume here that some of the more perplexing marks, such as 9F, cannot be personal abbreviations. It is not always easy to assess whether two marks were cut by the same hand, nor need close proximity of two marks on a foot necessarily indicate that their interpretation is inter-dependent.
23. There are no other groups of marks of this nature, unless we take 1D as such.

Chapter 2

1. An only partly successful examination of Corinthian 61 suggested that the mark was painted in red ochre (iron oxide), *BSA* 70 (1975) 148 n. 6. Red lead and cinnabar have also been suggested; see, for example, Forbes, *Studies in Ancient Technology* iii 206-14, Singer, *History of Technology* ii 361, Rosenfeld, *The inorganic raw materials of antiquity* 183-4 and Noble, *The Technique of Attic Pottery* 68. The last two substances have been found in the Agora, *Hesperia* 14 (1945) 152 and all three at the temple of Aphaea on Aegina, with ochre and cinnabar used as paint (*Berliner Beiträge zur Archäometrie* 2 (1977) 67).

2. Some marks which I have cleaned with alcohol have remained stable, others have begun to smear. For the loss of red on stone inscriptions see Vanderpool, *AJA* 81 (1977) 553-4.

3. *BSA* 68 (1973) 187; here Corinthian 13.

4. l.c. in n. 1 above.

5. Corinthian 31 is a salutory example, see *BSA* 70 (1975) 149, there no. 4.

6. Etruscan marks, see p. 251; red-figure sherd, *ARV* 969, 66.

7. I do not in this study attempt to deal with marks on storage amphorae in any detail; the material is very varied and much of it not readily datable, even if published in the first place; in this context reference could also be made to the quotation from Lambrino cited on p. 250 n. 5.

8. I have not been able to discover whether a glazed kantharos from Rhitsona had a red mark, *Black-glazed Pottery from Rhitsona* pl 1, grave 49, 308.

9. Similar painted *sigmas*, if such they be, are found on drainage pipes of the sixth century from the Agora, J. Travlos, *A Pictorial Dictionary of Ancient Athens* 208.

10. E.g., Shefton, *Arch. Rep.* 1969-70 60-1 and Birchall *apud* Webster, *Potter and Patron in Classical Athens* 275 n. 2 (with nice misprint); also Amyx, *Hesperia* 27 (1958) 295 n. 31. The graffito mentioned by Webster is no different in appearance from many another. I have not seen the vase in Newcastle published by Shefton, but it could be that the decorative miltos on the base has washed over the incised lines.

11. Light ridges are clearly seen and felt on the type D pyxides with pre-firing graffiti (subsidiary list 4). For other obviously pre-firing graffiti see *AM* 28 (1903) Beil. 23, 5 and 54 (1929) 30. Much depends on how dry the clay was before the mark was cut. The fineness of the incision in black-figure work is such that ridges are rarely thrown up.

12. Such as SOS amphorae and some material, mainly oenochoai, from Greece (p. 10); also Laconian 7 and 9. The aesthetic value of such marks is also reviewed by Burrows and Ure, *JHS* 29 (1909) 340.

13. A large lid in the Vatican with a large *kappa* cut underneath has now been paired with the type A amphora by Exekias, Vatican 344, which has no underfoot mark, as far as the worn surface allows one to judge; the *kappa* is more likely to be Greek than Etruscan. London 1965.8-16.12 is a lid with Etruscan *ta*; it probably belongs with E439, which has no such mark. The lid and foot of Rhodes 13467 also have different marks (*BSA* 70 (1975) 152, 42).

14. The letters in the chariot scene on the shoulder of 21 may be thought to refer to the action (cf. the owl-hoots cut on the early red-figure amphora, *AJA* 31 (1927) 348); I read the first letter as *phi* rather than the *theta* of the auction catalogue.

15. See Metaxa and Frel, *AAA* 5 (1972) 246-7, and *BSA* 70 (1975) 162 n. 43. One dedicatory inscription is in equally fine chiselled letters, on the top of the lip of a late archaic red-figure volute-krater from Naukratis, *BSA* 5 (1898-9) 56, 107.

16. For 12 see *ZPE* l.c., where I suggest that it may have been cut by a Chalcidian at Megara Hyblaea, if it is not Attic.

17. At the date in question open *heta* accompanied by ∧ or ∆ could only be Attic or Cycladic; the reported provenance, Attica, adds confirmation.

18. *BICS* 12 (1965) 22ff.

19. Without exact measurements one cannot be sure of the validity of the reckoning; I calculated two-thirds of the capacity of the cylinder formed by the estimated maximum diameter and the height less the estimated height of the foot, i.e. 2/3 (40 x 42 x Π) cc = 35.3 litres or approx. 128 kotylai (of the capacity established by Lang, *Agora* x 44ff).

20. The mixture of numerals is not happy; apparent parallels on amphorae published by Lang, *Hesperia* 25 (1956) 5-6 consist of running tallies summed up in Ionic numerals. Additionally, Philippart gives the first letter as O, not ⊙ as Philippaki.

21. The manner in which the unit strokes tail off shows that they were cut from the top of the handle, if inscribed orthograde.

Chapter 3

1. Two oddities may be mentioned: Robinson published a graffito on a neck-amphora by the Antimenes painter from Athens (*CVA Robinson* 1 pl 28), but the reading of the word is *νέος*, a common way of denoting a plaster foot. Athens 561 (Collignon 743) has a graffito, four-bar *sigma*, but it does not have a Greek provenance, being the gift of the King of Naples.

2. The shape of this mark is half-way between the two pieces from the North Cemetery, the top part similar to a *kappa*, as tomb 326, 5, the bottom a *beta* as 326, 3. I feel that the marks must be taken together, but cannot explain the discrepancies. The two North Cemetery graffiti are in different hands.

3. A good range of owner's marks are found on the canteens from the workshop of Pheidias at Olympia, *Ol. Forsch.* v 152-5. For Rhodes and Cyprus see p. 19-20. Athenian Akropolis: Graef and Langlotz, *Die Antiken Vasen von der Akropolis zu Athen* ii 1303ff and 1368ff (here cited by their numbers as inscriptions); Spartan Akropolis, p. 250, n. 2; Kabirion, Wolters, *Das Kabirionheiligtum bei Theben* 68-9; *Samothrace* 2 ii 47-60.

4. For further examples see type 20A, n. 2; on balance, the equation made between the trader denoted in type 20A and the abbreviation on Akropolis 414 seems overhasty (Starr, *The Economic and Social Growth of Early Greece* 74).

Chapter 4

1. Mansuelli, *Spina e l'Etruria Padana* 66-73; *Mostra dell'Etruria Padana e la città di Spina* i 430-42, ii 154-206; G. Colonna, *Riv. Stor. Ant.* 4 (1974) 1ff.

2. Colonna l.c.; L. Braccesi, *Grecità Adriatica* (2nd ed., 1977) 128ff.

3. Colonna l.c. 9.

4. There are two marks not included by Pellegrini, *Vasi greci dipinti delle necropoli Felsinee*: red traces on 7 and a graffito on 5 approximating to *iota* and Attic *lambda*.

4a. The vase was not associated with any others in the grave, *NSc* 1879 63.

5. The published marks not in the catalogue are: T411, bell-krater by Polygnotos (*NSc* 1927 182; *ARV* 1029, 21); T436, volute-krater by the Painter of Bologna 228 (s.l. 1, 42) and T456, glazed skyphos (*NSc* 1927 188); we may add the pair of type 2 oenochoai with the name *Ξάνθιππος*, *Spina* ii T709, pll 97-8. Further marks from Beazley's notes: T44, col-kr, by the Painter of Munich 2335, *kappa*; T266, bell-kr, *phi* and three strokes; T604, pelike by the Hasselmann painter, *alpha*; column-krater by the 'Niko. p.' with ⚶; s.l. 2, 38.

6. The other pieces are: Naples Sp. 257, olpe related to the Dot-ivy group (*ABV* 449, 9) with a large *mu*-shaped sign over the foot and Sp. 296, neck-amphora by the Red-line painter (*ABV* 710, 24 bis) with a partly obscured graffito.

7. A five-stroke *mu* appears on a neck-amphora from Capua of unspecified date, *Vente Drouot 11/5/1903* 58.

8. In addition to 9E, 73 and 10F, 4 in the catalogue we should note: Naples Sp. 353, glazed bolsal of c.450 (Fig. 14s); Sp. 453,

St. Valentin class skyphos, 450 or later (Fig 14p); Sp. 2086, glazed stemless cup of later fifth century with nine unit strokes linked by a horizontal (p. 30).

9. The abbreviation is attested elsewhere; see *CVA Hannover* 1 50.

10. I have examined only a small proportion of the total; marked pieces not in the catalogue are: Salerno 142+ a fourth digit, n-a of c. 510, graffito E*I*; 1658, pelike of the class of the Red-line painter's pelikai a graffito noted only through the glass, an unnumbered column-krater s.l. 5,107, and an unnumbered n-a of c. 530 with perhaps X (8D, 70).

11. The five later pieces are: two volute-kraters, Lo Porto, *ASMG* 8 (1967) 52 and 54; 4B, 9; Taranto 11809, hy, c.515, with red *delta* and other strokes; Bari 3083, hy, Priam painter (*ABV* 334, 4) with a complex red dipinto on the navel.

12. See *BSA* 70 (1975) 151 n. 14 for Taranto 4320, whose mark may be red H∧, though the first letter is poorly preserved.

13. Four of the cups and skyphoi are published in *ASMG* l.c. (n. 11 above); the others are 1B, 8, 19F, 16 and Taranto 51663, a Siana cup with red *digamma*.

14. Reggio 1463c, described as a 'vasetto', marked with acrophonic numerals for 285, our largest batch notation outside Athens; *NSc* 1892 486 and De Franciscis, *Stato e Società in Locri Epizefiri* 65, n. 5.

15. With four strokes: Taranto 52235, oen, Washing painter (*ARV* 1132, 180), Taranto 52318, lek, c. 470 and Taranto 106912, pel, Orpheus painter (*ARV* 1104, 14); with added circle, Taranto 4544, lek, c. 470; with horizontals and C mark, Taranto 4625, cal-kr, Christie painter (*ARV* 1047, 3).

16. See further p. 35 for lekythos prices. An alternative would be to regard the circle as indicating ten, see p. 31.

17. The published reading of Leningrad St. 1491 looks suspect; perhaps the intention was *alpha rho upsilon,* a combination which may appear on the Naples vase, though there a vase-name interpretation cannot be entertained (as it can be on 8F, 7).

18. The latter trio are 1B, 7, 18B, 12 and 10B, 5 respectively. For a possible mark on a neck-amphora from Heloros see *ML* 47 239.

19. *ML* 17 490 fig. 349; I read the mark as *rho sigma epsilon,* with the last two letters joined by a leftward extension of the top hasta of the *epsilon.*

20. See *ZPE* l.c. in catalogue; I would interpret the prices as five and nine pieces respectively for a drachma, though I would not place too much confidence on such an interpretation.

21. One further numerical mark may be noted, four unit strokes on Syracuse 18418, lekythos by the Edinburgh painter from Kamarina.

21a. Although we should not overlook the sporadic use of 'Chalcidian' or Attic *lambda* in local Geloan inscriptions, Guarducci, *Ep. Gr.* i 250.

22. For the Geloan alphabet see Guarducci l.c. and *LSAG* 262-4 and 272-4.

23. I do not include in any of these totals any of the graffiti from Segesta, in the latest instance, V. Tusa, ΚΩΚΑΛΟΣ 21 (1975) 214-25, nor did *Himera* ii come to hand early enough for the material there to be fully assimilated.

24. *BSA* 70 (1975) 160.

25. Follmann, *Die Panmaler* 23.

26. Some numerical marks not in the catalogue: Gela 9255, Nolan, 440-30, with two sets of three strokes; Gela 10597, glazed oenochoe, 475-50, with E Δ ⋏⋏; Himera ii 696, 248, glazed skyphos, 450-400, Ν; Ragusa, unnumbered neck-amphora, c.460, Δ‖; Ragusa 23004, glazed stemless cup, ⌐ ΔΔ‖ E ; Syracuse, unnumbered hydria from Kamarina, c. 430, with four strokes followed by a partly preserved letter, probably *heta*; Louvre G347, col-kr, Walters painter (*ARV* 279), from Agrigento, with *heta* followed by five strokes.

27. *BICS* 25 (1978) 80-2 and 84 n. 9.

28. Iberian graffiti: Almagro, *Las Inscripciones Ampuritanas*; Malaquer de Motes, *Epigrafia Prelatina Iberica* 113 and 115. I am indebted to Miss A.E. Prescott for much information about other marks, Iberian and Greek, on material from Ampurias.

29. Jully, *Dialogues d'Histoire Ancienne* 1976 53-70, with full bibliography. Marseilles: Villard, *La Céramique Grecque de Marseilles* 27-9; Antibes: *Gallia* 18 (1960) 318ff; Olbia: *Riv. St. Lig.* 34 (1968) 242; Camargue: 5D, 20.

30. Jully l.c. no 74ff; one of the Antibes sherds has ΔΔΔ. Other unpublished pieces from Ampurias have: ΔΔΔΔΠ and ΔΔΔ; ΔΠ‖‖ and φ; Π‖‖. ΔΔΔ also on a fourth (?) century glazed vase from the Alicante area, *AEA* 23 (1950) 26 and fig. 11.

31. See Jully nos 74-75 for earlier bibliography; his discussion of the 'arrow' *delta* is, however, rather patchy (see p. 29ff. below). Most unusual is the spelling out in full of the number ninety on a cup foot from Ullastret, M. Picazo, *Las Cerámicas Áticas de Ullastret* 61, 167bis; the Π following the numeral may perhaps stand for ποικίλα rather than πέντε - the piece would then be a foil for the rather earlier 8F, 12.

32. *Riv.St.Lig.* 38 (1972) 300ff; it is not easy to decide from the versions given there whether the marks on some of the glazed pieces are Greek or Phoenician. This cargo sufficiently discredits Langlotz's theory that cups of this type may have actually been made in Spain (*Gymnasium* 84 (1977) 432).

33. *MM* 11 (1970) 102ff; *BSA* 73 (1978) 131.

34. *BICS* 25 (1978) 82-83.

35. Woodward, *BSA* 30 (1929-30) 248 fig 4, 5 and Guarducci, *Ep. Gr.* i 449; curiously, neither believe that sense was intended. The vase was large, the date I could not judge. See also Cartledge, *JHS* 98 (1978) 31-2.

36. See *BICS* l.c. 79-80 for marks from North Greece. We may add in this context mention of storage pithoi with indications of capacity from Olynthos, Seuthopolis, Callatis and elsewhere; see, e.g. Graham, *Phoenix* 23 (1969) 347ff, Toncheva, *BCH* 82 (1958) 479-80, D. Dimitrov and M. Čičikova, *The Thracian City of Seuthopolis* 22-3 (κοτύλη erroneously for χοῦς); ibid. fig 61 for a late fourth century batch mark and perhaps an example of type 9E, xiii, incomplete.

37. Leningrad St. 2173, pelike of Group G from Pantikapaion (*ARV* 1463, 23) has a large *epsilon* (Ian McPhee tells me). Tolstoi, *Grecheskie Graffiti.*

38. See especially Tolstoi l.c. Add: Minns, *Greeks and Scythians* 361; von Stern, *Philologus* 72 (1913) 547; *Mat. Res.* 50 69-71 and 103 46; Gorgippa: *VDI* 1968 1 139; Chersonesos: Belov, *Otchet o Raskopkach v Chersonese 1935-6* 229, *VDI* 1970 3 73-80 and 1976 3 137-8, and especially Solomonik, *Graffiti Antichnoyo Chersonesa* (which reached me too late for the material to be fully digested here); Levi, *Olbia* 136 and 164; Histria: *Stud.Class.* 7 (1965) 273-86; Apollonia: *Izvest.Burgas* 2 (1965) 11ff, esp. 38 and *Apollonia* nos 552, 555, 556, 573, 598 and 620. A glazed vase from Pantikapaion, *CVA Mainz RGZM* 1 92. A further pithos rim from the Crimea, *AZ* 1857 75*.

39. e.g. Tolstoi 1, 2, 3 and 8; *Stud.Class.* l.c. 18.

40. Apollonia, *Izvest. Burgas* l.c. 40, 135; Chersonesos, Solomonik l.c. 548 (I assume 20 for 1 drachma, not 20 drachmai, as Solomonik).

41. Although exception should be made for some Chersonesos groups, which appear to be close groups and not random collections of similar marks on disparate vases; e.g. the ligature *theta epsilon,* Solomonik 914-922.

42. *Izvest. Burgas* l.c. 28, 48 and 52. Other non-Ionic graffiti are found in the area: Aeolic dialect at Histria (*Stud. Class.* l.c. 9); Aeginetan or Rhodian script at Olbia (Vinogradov, *Sov. Arch.* 1971 2 232ff); a non-Ionic spelling at Chersonesos, Tolstoi no 122.

43. Miletos, *IM* 22 (1972) 80-1, pl 24, 4, possibly local fourth century bowl; *Troy* iv index s.v. graffito; *Larissa* iii 183-4; *Labraunda* II i 47-8; Smyrna, *BSA* 53-4 (1958-9) 179-80 and 59 (1964) 39ff; Chios, *BSA* 49 (1954) 147. Seven marked bowls or the like from Ephesos, dating from the late fifth to the third century, add little (London 1874.2-5.171 to 177).

44. Add to the list in *BSA* l.c. the askos from Kamiros in the London market cited at the end of n. 4, p. 239.

45. *Salamine de Chypre* iv 52.

46. Askoi: Hackl 362-4, 369-76, Myres 1901, *SCE* ii tomb 406, 6 and *Vente Drouot 28/5/1887* 405; unpublished, Nicosia C869 (tomb 231) with IT, C883 (Sphageion tomb 14) with AI- and Harrow School 100, Fig 14u.

47. I do not give full details here; not included in this count are vases with syllabic graffiti only (though those with both syllabic and alphabetic marks are). Myres omits illustrations of 1915-1920. Other glazed vases with marks: *SCE* ii, various, *SCE* iii pl 83, 11; Hermann, *Gräberfelder von Marion* 32; *Vente Drouot 28/5/1887* 147; *BCH* 85 (1961) 284 and 95 (1971) 691-2.

48. Rather longer alphabetic marks: TETTA, Beazley, *AJA* 58 (1954) 322; ΓΑΝΝΑϹ(?), Nicosia C592, bowl, inscribed on floor, and separately 'arrow' *delta* with three (?) unit strokes; MENEO, Nicosia C807, ribbed mug from Sphageion tomb 8.

49. *Expedition* 11, 2 (1968) 55-8.

50. *AJA* 82 (1978) 223. The drachma sign on the vases from Cyprus could theoretically be interpreted as syllabic *ta*, but it is so closely connected with the *alpha* that I do not think it can be a serious possibility. The Apamea pyxis, *Apamée de Syrie, Bilan des recherches archéologiques, 1965-1968* 47.

51. We may note the glazed vases from Abydos, Herbert, *Greek and Latin Inscriptions in the Brooklyn Museum* nos 2-4.

52. I have not seen 475-493 (save 486, which is a Corinthian skyphos), nor many of the sequences 494-614, 691-697 and 864-873.

53. A further price mark of interest, perhaps not directly relevant here, is on the sherd 1965.9-30.747, from a plain closed vase of the late sixth or early fifth century (Fig. 14h); the letters seem to follow the contours of the break, but the second line is not complete; ? a label. The type of drachma indicated by the signs cannot readily be guessed; the piece may be Attic. ΔΙΙΙ is found on a stemmed bowl from Abusir, c. 300, Watzinger, *Griechische Holzsarkophage* 10.

54. *Naukratis* i 368, 373, 375, 477, 479, 501, 511, 542, 546, 560, *Naukratis* ii 870 and 872; of these 375 is an East Greek bowl and 368 a non-Attic handle; all the rest which I have seen are feet of Attic vases.

55. One may also think of the ἐμπόριον in the Peiraeus, a rather poorly attested mart for overseas trade; see Judeich, *Topographie von Athen*[2] 446 and for a clearer statement of the separate existence of the ἐμπόριον the regulations in the currency decree promulgated around the time of manufacture of 8, *Hesperia* 43 (1974) 158 lines 21 and 41, and 183.

Chapter 5

1. E.g. R. M. Cook, *JdI* 74 (1959) 116, Heichelheim, *An Ancient Economic History* ii 41 and Boardman, *The Greeks Overseas* 211-2. For a survey of opinions, and one of his own, G. Vallet, *Rhégion et Zancle* 192 n. 2.

2. The letter may be used in a complex ligature of the early fifth century, as a vowel, *Agora* xxi F15 and in a possibly non-Attic mark of the early fifth century, ibid. F53; it also appears in ligature with *rho* on Agora P2735, c. 485-0.

3. Dotted *theta* first appears in Athens around the middle of the sixth century, in Ionia shortly after (*LSAG* 66 and 325).

4. Examples of this period are *Agora* xxi C15, C20, D39, F59 and F74, in addition to the wholly Ionic mark F56. Earlier instances are B2 (with Σ), C7 (in two hands, one using Attic, the other Ionic *lambda*), C13 and D27, all of the late sixth or early fifth century.

5. Two other not wholly explicable instances of the letter may be noted, on a Corinthian glazed vase from Sparta, *BSA* 45 (1950) 297, 53, and under the foot of an Attic small glazed vase from Ampurias (London collection), where the preserved letters are ΞΥΝ and the lower part of a vertical, with little room for more; the piece seems to be of the late fifth century.

6. We should note its appearance in the fifth century at Athens on a pyxis lid, s.l. 3, 26 and at Himera, *Himera* ii 695, 230.

7. The rhomboid *omicron* is particularly noteworthy in this respect; it is found on coins of the early period of spread flans, e.g. *SNG American Numismatic Society* 506, 616-8; *BMC Italy* Posidonia 9, 11 and 12; Brett, *Catalogue of Greek Coins, Boston* 123.

8. Although they are few and far between in the later sixth and early fifth century, as a perusal of *Agora* xxi will show. Some examples in vase inscriptions of the period are on the Leagran vase 2F, 53, on Louvre F287 (one four-bar form among the remaining three-bar *sigmas*), in the incised inscriptions on Munich 2302, and note the plaques by Skythes from the Akropolis, *ABV* 353. Douris uses the form more often (*ARV* 427), but also the typically Attic genitive in -ω on the aryballos, *ARV* 447, 274.

9. Most of those listed in type 19F, n. 2 are later than 450.

10. For late three-bar *sigmas* in Ionia see type 20A, n. 2.

11. *BSA* 70 (1975) 156.

12. I am not convinced that an *omega* is used in type 23A and so exclude the type from consideration here. Nor am I sure whether the letter should be read on two stamnoi, Louvre G182bis, by the Syleus painter (*ARV* 251,29) and Louvre G188 by the Painter of the Florence stamnoi (*ARV* 508, 1), from Nola and Vulci respectively.

13. Abecedarium: *Agora* xxi A3; genitive in -ω: *Hesperia* suppl. 7 159, 114 (also Raubitschek, *Dedications from the Athenian Akropolis* 113); the third piece is in wholly Ionic script, *Agora* xxi F72.

14. Florence 3935, skyphos of the later fifth century (*CVA* 2 62) may be a parallel, and we may compare another skyphos, Würzburg 610, of after 450 (Fig 14q), see type 25F, n. 3.

15. The later retrograde marks could well be rare aberrations by left-handed writers, cf. *LSAG* 47.

16. For one difficult exception see the commentary on 6D, 17, p. 206.

17. Cases of the secondary diphthong written as EI are equally rare in Ionia and Attica; from Naukratis (*LSAG* Miletus 28) there are no more than seven instances of ΕΙΜΙ in the whole body of material; for Attica see *BSA* 73 (1978) 129 n. 31.

18. Smyth, *The Greek Dialects: Ionic* § 552.

Chapter 6

1. M. N. Tod, *BSA* 18 (1911-12) 98ff, 28 (1926-7) 141ff, 37 (1936-7) 236ff and 45 (1950) 126ff; M. Lang, *Hesperia* 25 (1956) 1ff; J. W. Graham, *Phoenix* 23 (1969) 347-58; Johnston, *BSA* 68 (1973) 186-8, *PdP* 30 (1975) 360-6.

2. The term Milesian is often used, but I prefer the more neutral Ionic. The existence of the system before c. 575 causes little alphabetic difficulty; the total rejection of *san* in Ionia and the adoption of *sampi* would be pushed back a little, on the assumption that the substitution was not made after the genesis of the numeral system. See *LSAG* 327.

3. Another important series of Ionic numerals is found in the red dipinti on the walls of the tunnel of Eupalinos on Samos; the letters measure the length of the tunnel, are contemporary with its execution and include figures for hundreds. See H. J. Kienast, *Architectura* 7 (1977) 112.

4. The evidence for its use in Athens is tenuous; see M. Lang, *Hesperia* 26 (1957) 271 n. 2 and *Agora* xxi 59-60, and also *JHS* 98 (1978) 218. We should carefully distinguish the full numeral system from uses of the letters of the alphabet *seriatim* as labels etc. A *possible* Cretan use of the fifth century, J. N. Coldstream, *The Demeter Sanctuary at Knossos* 133. Mid-fourth century usage on silver vessels from Vergina, M. Andronikos, *AAA* 10(1977)72.

5. Examples of the system from Sicily known to me use only a simple lunate *delta,* on an unpublished bronze weight in a private collection (two *deltas* = two drachmai),on two associated fourth century sherds from Heraklea Minoa (p. 248 n. 5) and perhaps in the symbols on some terracotta revetments from Syracuse of the later sixth century (Moreno, *Rend. Linc.* 1963 206 fig. 3).

6. I claim no expertise in this matter, but we may profitably note that in a third century A.D. papyrus of Thucydides i the controversial numeral at the beginning of ch. 103 is written out in full (A. Bulow-Jacobsen, *BICS* 22 (1975) 74).

7. *PdP* 33 (1978) 130ff, esp. 148 (Garbini).

8. Tod, *BSA* 18 (1911-12) 105, 107 and 113.

9. My current view is therefore less dogmatic than that expressed in *PdP* 30 (1975) 365-6. For *'gamma'* five see also *BICS* 25 (1978) 81.

10. *PdP* 27 (1972) 418-9.

11. A glazed bowl of the fourth century from Miletus has graffiti including acrophonic numerals and is said to be of possibly Milesian manufacture (*IM* 22 (1972) 80-1); the numerals incised on the rim of a pithos (undated) from Balaklava are more problematic (see p. 60 n. 38) since the vase was no doubt inscribed locally in this area of strong Milesian influence. For the dotted *delta* as a letter see *BSA* 70 (1975) 163 n. 45; in a difficult, but apparently non-numerical Ionic graffito under an Attic skyphos foot from Gravisca (72/20095) a *delta* has more of an 'arrow' shape.

11a. We must therefore modify the statement of S. Dow, *AJA* 56 (1952) 21 that, Γ has no place in the Attic acrophonic system.

12. None of the names for numbers on the famous Etruscan dice begins with a *pi*, M. Pallottino, *The Etruscans* 292, 95.

13. The O on the two vases mentioned above, p. 31, is unlikely to indicate 'obol'. For the half- or quarter-obol sign see *AJA* 82 (1978) 223. The origins of the drachma sign are obscure, it may merely be an obol stroke with an added line; certainly the theory advanced by H. I. Bell, *Studies Presented to David Robinson* ii 425, cannot be seriously entertained, depending as it does on developed cursive writing.

14. Dots are used in a numerical context on some pieces of type 7D and on 13A, 6 also. For some pieces from the Agora employing unit strokes see Lang, *Hesperia* 27 (1958) 1-17, where dots and dashes too are found. Dots also on the amphora handle, *Naukratis* i 393. The brevity of many of these marks does not assist us in interpreting them and on the whole I have ignored them in my account of the early numeral systems.

15. *AJA* 63 (1959) 165; I have not seen the piece.

16. Graham l.c. p. 61, n. 1. An entertaining but scarcely credible theory of the origin of the Roman system is put forward by B. W. Minshall, *Didaskalos* 5 (1976) 262ff.

17. Moreno, *Rend. Linc.* 1963 207.

18. The 8 would then be a 'super-ten', just as it is found rarely as a 'super-omicron' or *omega* (*LSAG* 147). This origin for the sign may be preferable to that suggested by Graham l.c., that it is a substitution for *phi*, under Lydian influence, in the sequence of the final letters of the alphabet employed at Olynthos (and elsewhere) for numerals. Lack of evidence for any sign employed for five also hampers Graham's argument; in the system using *'gamma'* five we saw that the origin was very likely a unit stroke with an added tick, such as may have given rise to a form ∧ or V later. In the admittedly later Seuthopolis pithos graffiti the use of E, Ψ and ⊓ for 100, 50 and 5 seems very eclectic (p. 60 n. 36). A squared off O seems to be used in a numerical context in a graffito on a sixth century cup of Ionian origin found at Sybaris, *NSc* 1969 suppl. 3 261, 156. A solid disc of glaze as a 'divider' (?) on some Geloan and Syracusan revetments, Moreno l.c. 206-7.

19. O. Masson, *Les Inscriptions Syllabiques Chypriotes* 80.

20. For culixna see Colonna, *Arch. Class.* 25-6 (1973-4) 136-9; more regular Etruscan numerals are found in the batch mark on an Attic RF krater from Poggio Sommavilla (*AJA* 43 (1939) 253 n. 1 and Colonna l.c. 137, 3).

21. Beazley's reading of the mark on Munich 2363 (*ARV* 853, 1, from Capua) gives this sign, but the *CVA* version adds a vestigial third stroke to make a three-bar *sigma*, and I list it as 7D, 19.

Chapter 7

1. Greek vase names: Sparkes and Talcott, *Agora* xii 3ff; further details on names inscribed on vases, M. Lazzarini, *Arch. Class.* 25-6 (1973-4) 341ff; Johnston, *ZPE* 12 (1973) 265-9, *AJA* 82 (1978) 222ff. Etruscan vase names: Colonna, *Arch. Class.* 25-6 (1973-4) 132ff.

2. The hydria has always been the most readily identifiable vase; it is therefore curious that the earliest 'illustrated' uses refer to amphorae: the pot dropped in Achilles' pursuit of Troilos on the François vase and the ὑδρίη μετρίη of about the same date found in a bothros at Gravisca, *PdP* 32 (1977) 400-1.

3. The *kadi* - mentioned on 12F, 1 are not certainly self-referent, see the commentary.

4. For example it is possible that some day a stamnos will come to light with a self-referent *kados* mark.

5. The pelike and amphora are both termed κάδισκος and στάμνιον (or the like); the skyphos can be γλαυ - - , κυ - - and perhaps σκυ- -, the lekanis ἰχθύα as well as λεκα - -, and the oenochoe, in addition to its own name may be termed χοῦς, and just possibly ἀρύστηρ or κύαθος.

6. χύτραι has a much wider application: αἱ χύτραι is a colloquial expression for the Kerameikos, and the χύτροι was a name of one day of the Anthesteria festival - the name-vase of which has not been positively identified.

7. Both of course were measures of capacity as well as vase names; no doubt the name was applied to a range of vases of the appropriate size. κοτύλη or - ος is used of cups and kantharoi, Lazzarini l.c. 357-60.

8. Especially *ZPE* 12 (1973) 267-8, *Greece and Rome* 21 (1974) 147-50 and *AJA* 82 (1978) 222ff. The false interpretations of Jongkees, corrected by Amyx, are followed by Vallet and Villard, *Etudes Archéologiques* 211-212. See also T. B. L. Webster, *Potter and Patron in Classical Athens* 273ff; it will become clear that I cannot agree with the bulk of his arguments. The syntheses in Starr, *The Economic and Social Growth of Early Greece, 800-500 BC* 72-5 and *RE* Suppl. XV 666 (I. Scheibler) are similarly ill-founded.

9. I would raise it just above the 'footnote level' assigned by Amyx l.c. 299; the price would be as of the oenochoai listed on 8F, 11, which is a larger (21 cm against 12 cm high) and rather more careful piece, although both have three figures in the scene.

10. The price would be compatible with that suggested for Taranto 4544 (p. 16). Other apparent drachma signs are found on two askoi and a bowl from Marion, see p. 19. Their interpretation is not clear; the price may refer to an unspecified batch, for on all three occasions it is accompanied by an *alpha,* as on the askos from Apamea, p. 20, where a batch number is given. A drachma sign plus batch number is also found on the Halle skyphos cited on p. 28. Add *Agora* xxi E13, quoting a price of one drachma for 60 glazed gutti; I feel far less certain about the interpretation of ibid E8 as a price, which is used by Webster o.c. 274. The possible price interpretation of type 20F should also be remembered. I hope that I have not overlooked other examples of the drachma sign or marks involving Tι which are not readily interpreted as prices for the marked vase or batch.

11. See *AJA* 82 (1978) 225 n. 27 and the final paragraph of the commentary on type 6F.

12. E. Vanderpool, *Hesperia* 36 (1969) 187ff.

13. See von Bothmer, *CVA Metropolitan Museum* 3 8 for bibliography. Little of substance has been added since, but see Webster o.c. 274-5. The graffito on the vase is not without interest, нм with presumably Ionic *eta*; probably not ἡμιδράχμη. At c. 540 we are in the infancy of coinage on the Greek mainland.

14. Webster o.c. 277. I am not aware of any evidence beyond the vases at issue which suggests increased prices; in sum, extremely few prices are known at all before the mid-fifth century, and most of those are for building materials - or tribute.

15. Assuming that the graffito was cut for other Cypriot eyes, and purses, the Persian standard was likely to have been intended, since it was in general use on the island (*BMC Greek Coins* 24 xxii-iii); the unit would most naturally be the siglos and the price not three obols but the Attic equivalent of just short of four drachmae, a considerable mark-up on prices in Athens, within the range of the price of *lakythia* in Sicily. For a possible interpretation of 1B, 7 as a local price see the commentary.

16. 10F, 17, hydria, 37 cm high with three figures, for 4 obols?; 10F, 21, belly amphora, 52 cm high with two figures, for 7 obols (but the foot not surely belonging); 10F, 23, hydria, 39 cm high with three figures, for seven obols; 10F, 24, belly amphora, c. 55 cm high with two figures, for five obols. There are more inconsistencies here (even ignoring the problematic foot), but in very general terms there is compatibility with much later pieces.

17. Würzburg owl skyphos (?¼ obol), 9.4 cm; 16B, 34 (½ obol) 13 cm, with four figures; 16B, 35 (one obol), 18 cm, four figures. The last two are approximately contemporary, but the second of them is better painted. Another owl skyphos, 5F, 6, notes a batch of 24, ? for a drachma unstated.

18. From 2.4 to 3.7 obols (Amyx, *Hesperia* 27 (1958) 178).

19. Jongkees, *Mnemosyne* 1951 261. The manning levels in scenes on vases were perhaps largely dictated by the size of field available to the painter; the best illustration remains that on a vase from the most commercially organised workshop, on the Leagran hydria Munich 1717 (Noble, *The Techniques of Painted Attic Pottery* fig 73). For production rates we have none of the type of evidence available to the investigator of Gaulish sigillata workshops, the kilns themselves and the graffito tallies of production; for the latter see R. Marichal, *CRAI* 1971 188ff and J. Salomonson, *BABesch* 46 (1971) 180-1; *Gallia* 36 (1978) 393.

20. Potters were in stable employment, unlike the masons engaged on the Akropolis. The Treasurers of Athens had to pay for clay for the moulds used for the Promachos statue (*SEG* x 243, esp. l. 64), but it is not known whether potters had this obligation, nor can we be sure of the material used for the firing of the kiln; in recent periods branches and brushwood were the normal fuel (F. R. Matson, *Classics and the Classical Tradition* (Essays presented to Robert E. Dengler) 136).

Chapter 8

1. This argument is not capable of formal proof, but I find it difficult to envisage that in a close group which includes kraters the amphorae could have been exported full of oil or whatever.

2. e.g. 16A, 20A, 21A, 8E, 11E, 12E, 9F, 13F.

3. Herein is bound up the larger problem of special commissions; the type A amphora and calyx-krater were the vehicles for the best work of a number of painters, and here, if anywhere, we might spot pieces commissioned in the Kerameikos - the burden of much of Webster's book. If such pieces bear regular trademarks, such an explanation is seriously weakened; see further p. 41.

4. *BSA* 70 (1975) 152-60.

5. For 8E, 60 see *ZPE* l.c. in catalogue.

6. A chous in Milan (*CVA* pl 14, A1805) with about fifteen close-set, very worn lines can be added.

7. Only a few of the numbers are high; 9E, 66, 20F, 2, Bologna PU318 (p. 29) and Malibu 73.AE.23 (ibid) run from seven to fifteen. The rest are all from two to four, which strongly suggests that they may represent the price of the vase in obols; the size and quality of the pieces is generally high: 11B, 23, 7D, 34 and 36, 11F, 29, Taranto 4544 and 52318 (p. 60), Naples Stg. 253 (*ARV* 645, 1), Basel BS404 (*AM* 83 (1968) 200) and Swiss private collection (*AK* 19 (1976) 74).

8. Siana cups: 8D, 66 and Taranto 51663 (red *digamma*); little-master cups: 21A, 28 and Milan A126, band-cup, c. 525, with MI.

9. The foot ex Louvre F54 has an archaic red *epsilon,* F130 has red traces (s.l. 5, 62) and Tarquinia 576, c. 540, has retrograde *digamma.*

10. There are large numbers of black-glazed cups from various sites with marks (Athens, Adria, Himera, Chersonesos, Cyprus etc); Adria and other sites have yielded fragmentary feet which may have belonged to figured or glazed cups. A bowl (?) from Reggio has a large batch mark (p. 60). The great majority of these marks were undoubtedly owner's inscriptions.

11. *CVA* 2 35.

12. Some cups with non-alphabetic marks may be connected with other vases in types 20B, 22B and 17C.

13. I would take the mark on the latter, KAP, as an abbreviation of καρχήσιον; the vase is a sessile kantharos, and the mark therefore supports Iris Love's attribution of the name to this shape, though she did not use this evidence in her article, *Essays in Memory of Karl Lehmann* 204-222. Yet a further KAP graffito should be noted, on the neck of a canonical kantharos of the late fourth or early third century from Alexandria, Brescia, *La Necropoli di Sciatbi* 65, 168 and pl 54, 109.

14. See *Agora* xii 178. Another method of ensuring the fit of box and lid seems to have been to note the decorative feature on the lid beneath its matching box; a pyxis box from Berezan is inscribed ὗς, the animal on the lid, *AA* 1904 106. See also S. R. Roberts, *The Attic Pyxis* 55.

Chapter 9

1. Examples of this type of mark: from the Antimenean workshop, London B340 (*ABV* 267, 9) with ⊕AN, which appears retrograde on Florence 3861, a black-glazed neck-amphora of about the same date; Tarquinia RC1871 (5A, 4) and Louvre F244 (18B, 2). From the Leagran workshop: Munich 1700 (*ABV* 362, 27) with an obscured graffito, perhaps as 12B, ii, and New York 49.11.1 (2B, 1). From the Polygnotan shop: Boston 00.346 (10A, 10) and Naples 3232 (5F, 4). Although some of these are in the catalogue, they do not obviously connect with other vases in their respective types.

2. See for example *BSR* n.s. 24 (1969) 10.

3. See above p. 40-41 for the lack of any significant second-hand trade from Athens.

4. Graffito and dipinto the same: 13A, 3, 20A, 16 (= 15B, 5) and ?5, 30A, 3, 33A, 11, 3B, 1, 6B, 6, 5D, 2, 6D, 2, 3E, 26 and 10E, 28. Graffito and dipinto similar: 7C, 1?, 18E, 2, 21E, 2, 5, 21, 26 and 63. Graffito and dipinto different (listed by graffito unless otherwise stated): 5A, 6, 10A, 9, 13A, 3, 8B, 4 (dipinto), 13B, 4 and 6D, 2 (as well as above). Combinations in which one mark may be Etruscan: 11A, 3?, 14A, 2 and 9, 15A, 9, 17B, 21, 26B, 3, 3E, 26, 5E, 25, 15E, 10. Combinations in which one mark is non-alphabetic or numerical: 4A, 10, 24A, 4, 29A, 3?, 8B, 5, 23B, 1, 1D, 14 and 19, 9E, 62, 17E, 42 and s.l. 2, 26. Cases with X: 8D, 13 and 54.

5. Three feet from Adria have a mark of type 6D with further letters; it is not clear in how many cases the mark is numerical.

6. In this and the following list the catalogue entries cited are not always to the mark considered non-alphabetic or Etruscan. The Boston pelike: C. M. Robertson, *The Burlington Magazine* 1977 78ff with n.2; a parallel that has come to light is on Palermo 1820, interestingly by another Pioneer, Psiax; the two marks are differently orientated on the foot (Fig 14e).

7. I hope a complete list (of figured vases) is: 10A, 9, 13A, 4 (probably not numerical), 19A, 1 (a unitary mark), 21A, 26 (Etruscan or numercial?) and 90 (perhaps accompanied by a vase-name mark, as 13A, 4), 29A, 3 (numerical?), 1B, 1, 3B, 3 (vase name with numeral?), 7B, 3, 8B, 4 and 8 (the former with perhaps Etruscan *alpha*, the latter from Greece), 9B, 13, 13B, 4 (the dipinto *pi* possibly numerical), 15B, 3, 17B, 26, 11C, 3, 6D, 14, 9E, 64, 66-7, 71-2, 84, 87 and 112 (see the commentary for most of these), 21E, 14 (*tau* or merely scratches?), 11F, 20 (one mark probably a vase name), 19F, 17 (one mark connected with numerals).

8. The marks of type 9E and 10E on Leagran vases (including glaze examples) are never unaccompanied by marks applied later; had they no connection with these later commercial marks such a coincidence would be most surprising. The overincision on 5E, 21 is a further proof of workshop based commercial transactions.

9. For remarks on καλός names and special commissions see E. T. Vermeule, *BMFA* 63 (1965) 50 (Leagros), Webster o.c. passim, C. G. Starr, *The Economic and Social Growth of Early Greece* 72-5. I do not see how the *kalos* names on white-ground funerary lekythoi are any more relevant to their usage than those on vases found in Etruria were to their purchasers. For lack of marks on 'prestige' vases see p. 41.

9a. Similarly there are a number of potters and painters known from only one signed, or even attributed work; one, Mnesiades, is also known from a dedication on the Akropolis, *ABV* 314.

10. I have been unable to detect any regular pairings of marks on glazed vases from Athens and other sites; Lang suggests a numerical interpretation for some single letters on pieces from the Agora which also bear a second graffito (*Agora* xxi 27-8), but I feel that this is an unnecessary complication and does not take into consideration the very large number of similar feet marked *only* with a single letter and not included in the volume.

11. The mark may be an early form of type 13E, also found accompanying 8E, but the possibility is not so strong that it should affect our interpretation of 13E.

12. After the *lambda-epsilon* set of graffiti, type 9E presents the most awkward doublets; I argue below (p. 221 with n.10) that both marks *can* have a vase-name significance, but when they appear together (9E, 53, 77 and 81-3) I cannot see that either *should* be so interpreted.

13. The combination of 1E with 33A or 2E is earlier, as some of those involving 8E.

14. Perhaps a separate tag made from a sherd, such as *Agora* xxi 16ff, though none of these has any obvious relevance to vase exports; see also p. 61 n. 53.

Chapter 10

1. This aspect of trademarks has been treated in any extensive manner only by Philippaki in *The Attic Stamnos* and Mommsen in *Der Affecter*. Coincidences have been noted elsewhere without any substantial conclusions being drawn.

2. We must accept the possibility of an occasional 'rogue' piece, especially a foot wrongly attached to a given vase.

3. On the assumptions, discussed elsewhere, that the marks are more or less contemporary with manufacture, and that they do refer to traders.

4. Some vases made as pairs have the same mark, e.g. 2B, 4 and 5, 32A, 21 and 22; see Jongkees-Vos, *Talanta* 1 (1969) 12-14, and also *Agora* xii 13, n. 19. 21F, 13 seems to refer to the companion vase found with it in a grave at Populonia.

5. *BSA* 70 (1975) 158, n. 33.

6. *AK* 7 (1964) 85; see also Boardman, *CVA Oxford* 3 1-2.

7. The lid p. 59 n. 13. Dublin 1921.97 (327) has a graffito, repeated, approximating to *iota pi*, the latter with verticals of equal length; Louvre F206 has red traces. The foot of Vatican 344 is very worn.

8. E.g. of the larger vases illustrated in Arias-Hirmer-Shefton, *A History of Greek Vase-painting* thirteen are known to me to have marks, and some of these are lesser pieces (20A, 81, 21A, 37, 1C, 1 and 1D, 15). We may add the namepiece of the Pan painter to such a list (7D, 29). Some famous vases have 'main-line' marks: 1B, 11 and 9E, 23 by the Andokides painter, 2F, 50 by Euthymides and 18C, 11 by the Phiale painter (though a by-form of the mark); others are less canonical: 16C, 1 by Smikros, 31A, 4 by Euthymides, 20E, 15 by the Achilles painter; or unparalleled: Würzburg 241 by the Phrynos painter (dipinto remains consistent with a mark of type 20E).

9. Von Bothmer, *AK* 3 (1960) 76ff suggests that the three are not far apart chronologically, belonging to the painter's middle period, as do the pieces in type 5D - the shorter abbreviation, 5D, 6, being on perhaps the earliest vase.

10. The Amasis painter is perhaps connected with the Painter of Berlin 1686 in type 5D and with others in type 29A.

11. Published marks collected by Mommsen, *Der Affecter* nos 12, 15, 79 and 80; add Munich 1439 (her 105) with red traces, *CVA* 7 40; I noted red traces under Louvre F27, Munich 1441, London B153 and Munich 8772 (5, 106, 107 and 26 respectively), while a glazed neck-amphora from his workshop, Naples Stg. unnumbered, has red ς, plausibly an abbreviation of ςο.

12. It is sometimes overlooked how many later black-figure amphorae were not attributed by Beazley; some of our types are entirely made up of unattributed BF vases. Neglect of such material (as well as lekythoi and oenochoai) vitiates the statistical argument put forward by Starr, o.c. 217, n. 49.

13. Bloesch, *JHS* 71 (1951) 29-39; arranging the vases under the headings of his potters produces a complete jumble of marks.

14. 31A, 4, 2B, 12, 26B, 7, 2D, 8 and Frankfort VF (*ARV* 28, 13) with at least *alpha* (B).

15. See also *Greece and Rome* 21 (1974) 145.

16. Robinson and Fluck, *Greek Love-names* 132ff urge due caution about dating all vases with a *kalos* name to the prime of that youth; yet, although the tag stuck to Leagros for a long time, its first appearance should not be earlier than 515 or a little after, if we are disposed to accept the evidence of the eighth letter of 'Themistokles' about the contemporaneity of the two men. For relations between the Antimenean and Leagran workshop see *ABV* 391. Von Bothmer advances an intriguing case for dating the Euphronios krater in New York to 514 or shortly after (*AA* 1976 494).

17. Here I follow the broad lines laid down by Beazley for dating the works of the Antimenes painter, *JHS* 47 (1927) 63-92, esp. 80.

18. Hackl himself, on erroneous epigraphical grounds, stressed the effects that the battle of Himera may have had (p. 93).

19. The following pieces can be placed with some confidence after 415-10: Meidias painter: 18C, 78; in his manner, 21F, 14. Nikias painter: 18C, 47, 81-2, Suessola painter, 24F, 5. Meleager painter: 18C, 46 and Ferrara T612 (type 14F, n. 1). Telos painter: 18C, 84 and Louvre G522 with a mark on the navel approximating to a single stroke with serifs (B). Erbach painter, 18C, 49. Painter of the Oxford Grypomachy (and related): 3B, 3, 18C, 85 and Oxford 1960. 1289 (*epsilon*). York-reverse group: 18C, 53 and London F54 (p. 16). Group G: 33A, 21, s.l. 7, 16 and Leningrad St. 2173 (p. 60 n. 37). Various other painters: 18C, 50, 51 and 54, 8F, 3, 14F, 16 and 22F, 2. Unattributed vases include 16B, 34-36, 14F, 6, 22F, 10, 24F, 8, Milan A1806 (p. 14), Ferrara T1210 (bell-krater, 350-40, |ζ|), Moscow 1089 (pelike, c. 340, mark akin to type 11C); the last two I know of through McPhee. There are also some pyxides in s.l. 4, and askoi, including 24B, 8.

Chapter 11

1. See also *BSA* 68 (1973) 189 n. 27, critical of Webster, *Potter and Patron in Classical Athens* 279-80; his group 2 is not 'SA' but AR (9E, xii), and neither 2 nor 3 have any claim at all to be potter's marks.

2. Not wholly irrelevant to this issue is the vase inscription on a BF kyathos from Vulci in the Villa Giulia, Canciani and Neumann, *AK* 21 (1978) 17ff; a painter's signature of Lydos is followed by ΔΟΛΟΣΟΝ and more than a dozen further letters. The writer seems to be a slave, δοῦλος ὤν, but it is not clear if he is telling the truth, and unlikely that he is the known Lydos, since the style is not his, unless of a feeble old age c. 525.

3. I suggest criteria for assessing whether marks are of local owners or of commercial significance in *BSA* 70 (1975) 146-7.

4. Some caution is needed in accepting such a conclusion since the anchor is also a common shield blazon on sixth century vases, where the nautical connexion is far from clear; but we may also consider the ship graffito, 25B, 2.

5. Hackl (p. 97) thought of services à propos of marks of type 2F. For ladles see p. 229. For some notations of true services (of Roman silver) see *Germania* 11 (1928) 51-2.

6. To what extent Greek vases were used by Etruscans before deposition in the tomb is a large question not strictly relevant here. Repairs to vases were frequent and sometimes elaborate, e.g. *St.Etr.* 34 (1966) 19 fig. 9 and *AJA* 76 (1972) 9-11. Some amphorae and kraters must have been put to use (see Vallet, *Hommages à Grenier* 1558 and n. 2); repairs could have been watertight (Pottier, *RA* 1904 i 50). Many repairs were no doubt made in Greek emporia after a rough passage, as well as by Vulciot bronzesmiths; it is probable that even repaired vases could fetch a worthwhile price. At Spina it has been noted that the more pretentious vases are often of earlier date than their lesser tomb companions (Robertson, *Gnomon* 39 (1967) 821), and such discrepancies are also found in Campanian tombs, see Corbett, *JHS* 80 (1960) 60.

7. We may compare the non-Athenian element in marble-working. In some signatures we find fully Ionic script, others have occasional non-Attic letters; see Raubitschek, *DAA* 447-8. Endoios' record includes three signed bases in Attic script but with four-bar *sigma* (*AM* 84 (1969) 59, 1-3) and a similar form of alphabet is found in Philergos' signature on the base for the Samian Leanax (ibid. pl. 36 - c.520 BC); see also B. S. Ridgway, *The Archaic Style in Greek Sculpture* 287ff.

8. *BSA* 73 (1978) 129. Solon: Arist. *Ath.Pol.* 11, 1. Themistokles: Podlecki, *The Life of Themistokles* 21. Segesta: Meiggs and Lewis, *Greek Historical Inscriptions* 37 and more recently, Bradeen and McGregor, *Studies in fifth century Attic Epigraphy* 75-9 and Wick, *JHS* 95 (1975) 186ff. My own opinion, after autopsy, on the crucial letters of the archon's name is to follow Bradeen and McGregor in a *non liquet*.

9. There are no Attic parallels for the physical evidence for Corinthians in the West: e.g. the attempted abecedarium in Corinthian script on a locally made Cumaean oenochoe, *LSAG* 130, 2, the grave stele from Selinus, ΚΩΚΑΛΟΣ 9 (1963) 145, a dedication in Corinthian script on a Corinthian vase from Satyrion, near Taranto (to be published), and the exile Demaratus, Pliny *HN* xxxv 152.

10. Vallet, *Rhégion et Zancle* 185 puzzled over a similar discrepancy regarding his argument over the role of Syracuse (see below); this difficulty was of his own creation however, while mine appears more real.

11. For the Deigma see *AJA* 82 (1978) 224 n. 21, and on the Emporion (where the Deigma was presumably situated) p. 61 n. 55 above.

11a. A recently recovered graffito from Gravisca appears to be a dedication of a vase by a person whose slave had broken ?another (the verb κατάξας is used); the same verb occurs in a puzzling graffito from Cepi in the Crimea, *Actes xii Congr. Int. Et. Class.* 618 (550-500 BC).

12. Langlotz's arguments for production of a range of 'Attic' vases in the West came too late to be fully assimilated in respect of trademarks (*Gymnasium* 84 (1977) 423-37). Marks do not give any direct support to any of his examples, for which he adduces largely stylistic reasons for a western origin; see p. 60 n. 32 and also note that the chequer-patterned kraters which he would see made in the West are closely tied in with 'straight' red-figure production in type 7F. The publication of the Metaponto kiln material and further clay analyses must be awaited before further judgement can be given. For bucchero in the Greek world see J. MacIntosh, *Hesperia* 43 (1974) 34ff, esp. n. 2; add kantharoi from Kition (unpublished) and Ras-el-Basit (*Ann. Arch. Arab. Syr.* 23 (1973) 27) and oenochoai from Naukratis (in the British Museum, lip fragments, not to be confused with the kantharoi reported elsewhere and ascribed by Vallet to Aeolis, *Hommages à Grenier* iii 1626).

13. Vallet, *Rhégion et Zancle* 196.

14. From such transactions at Athens (whether before the dispatch of the vases or on the return of the trader with his cargo from the west) would have arisen the problems eventually eased by the setting-up of the Deigma and the institution of officials and regulations to control many aspects of trade; the Phaselis decree of c. 460 (Meiggs and Lewis 51), concerned with contracts, affords our first insight into the technical workings of Athenian trade.

15. See *Greece and Rome* 21 (1974) 143, where I feel that I overstate the case against access to vase feet during transit.

16. In support of such use: Pottier, *RA* 1904 i 47-50, Kluwe, *Die Griechische Vase*, (*Wissenschaftliche Zeitschrift der Universität Rostock* 16 (1967)) 470; against: French, *The Growth of the Athenian Economy* 43, Vallet, *Hommages à Grenier* iii 1557-8.

17. See p. 207 and 224.

18. The neck-amphora was in production at Athens throughout the seventh and early sixth century. They were presumably easier to transport than kraters, although this did not stop increasing numbers of Attic bell- and calyx-kraters being exported in the fifth and fourth centuries.

19. See for example, Vallet in *La Circolazione della Moneta Ateniense in Sicilia e in Magna Grecia* 225, Kluwe, l.c., Stahler, *Eine Unbekannte Pelike des Eucharidesmalers* 67-8, W. Müller, *Keramik des Altertums* (Jena) 17-18, Starr, *The Economic and Social Growth of Early Greece, 800-500 BC* 69, 85-6 etc.

20. The latest column-kraters in *ARV* are those by the Suessola painter (1345, 7-9) and by the Meleager painter (1409, 2-8). All the latter are from Spina, surely not the provenance of 24F, 6. To my knowledge, none of the eleven pieces are as heavy and squat as the Dublin vase.

21. See p. 60 n. 32.

22. We cannot avail ourselves of the statistical probabilities open to the numismatist concerning the survival of dies and the likely total production; Raven, *Essays in Greek Coinage presented to Stanley Robinson* 41ff.

23. The ship wrecked in the early fourth century off Porticello in the Straits of Messina carried such a mixed cargo, *Archaeology* 24 (1971) 118ff.

24. French o.c. 50 gives a balanced view of Athenian exports, placing vases behind coined silver but still high in the list. In the sixth century silver would have certainly been far less significant.

25. Rather, expulsion from Ionia increased Ionian participation in trade, although the Samians, not seriously affected by the event, probably took a leading role; see M. Torelli, *PdP* 32 (1977) 450-1. The discovery of the emporion at Gravisca has thrown much new light on the Ionians in the west, and must throw considerable doubt on the elaborate theory developed by Vallet involving transhipment of vases at the Straits of Messina (and the explanation of Ionic trademarks as the work of metics) - *Rhégion et Zancle* 188-9 and (with Villard) *PdP* 21 (1966) 166-190. The distribution pattern of Attic and other 'surplus' coinages may only have a passing relevance to the vase trade.

26. The Diolkos is published by Verdelis, *AM* 73 (1958) 140ff; see also *BSA* 68 (1973) 185, n. 14.

27. On an alternative note, Vallet, *Rhégion et Zancle* 184-6 and Villard, *Hommages à Grenier* iii 1634 consider that Etruscans obtained their Greek vases from Sicily in the early sixth century, a system no longer current later in the century. We must agree with the second point, whatever doubts the first raises.

28. See p. 49 with n. 11a.

29. As suggested by French o.c. 48-9.

30. Though there are marks not fully of 'main-line' character on pieces from the site, e.g. 14E, 13 and 22E, 5; in addition, the dedicated vases are mainly small, open vases, not the amphorae particularly favoured by the Tarquinians.

31. See p. 242 n. 8.

Addenda

Appendix 1, p.54. Add Pescia Romana to the list of Etrurian provenances: 20A,37 and Florence 70995, n-a, Lydos (*BSA* 70 (1975) 157, n.31); Cristofani, *Atti del X Convegno di Studi Etruschi e Italici* 239.

p.58, note 1. For marks on Mycenaean vases see now Döhl, *Kadmos* 18 (1979) 47ff.

p.60, note 31. The Ullastret fragment would appear to be from a figured vase; the *pi* could then well be an abbreviation of ποικίλος . I thank Marina Picazo for supplying a photograph.

THE CATALOGUE

Following Hackl, I base the main part of my catalogue on groups of Attic BF and RF vases bearing the same or similar marks; these groups I call 'types'. Therefore I do not include here all marks on Attic figured or glazed vases of such a nature as could or should be described as commercial in the very broadest sense. Nonetheless a large proportion of more isolated marks that are of interest are treated at some point in my text, and I devote special attention to them in Chapter 9.

In certain areas all known marks have been listed, e.g. on non-Attic vases and dipinto on Attic RF vases. It would have been cumbersome to include all marks on BF and RF pieces, let alone the myriad single letters on glazed pots found in Greece which could possibly be argued to have a commercial significance (though they are almost certainly owners' marks). These latter marks have no close connection with those on exported figured vases, as will become apparent, but for the sake of completeness I do include in the catalogue the occasional figured vase with a Greek provenance if it bears a mark that occurs elsewhere. The very rarity of these entries (see subsidiary list 3) justifies of itself the label 'commercial' or 'mercantile' applied to those marks found on exported ware.

My catalogue is considerably larger than Hackl's. Not all the additional material was unknown to him and it is worth noting why it is now included. Among the Attic vases most additions have been made as the result of the subsequent appearance of groups where Hackl only knew of one or two examples. He did not think it worth including marks consisting of a single letter, but they sometimes do form meaningful groups, though it will also be seen that any single letter (and a number of longer abbreviations) can also occur on vases which have no chronological or stylistic association with any of the closer groups so formed. Again for the sake of completeness, all the decorated vases with a given mark are included under that heading despite such remoteness from closer groups.

Repetition of marks is something of a rarity on non-Attic vases, and no substantial types emerge. Therefore I have arranged those parts of the catalogue merely on chronological and/or topographical criteria.

The main Attic part of the catalogue I have split, not without hesitation, into six sections, A–F, each one covering types of a different general nature. A completely undifferentiated catalogue would have been unhelpful, and the long life-span of many forms of abbreviation would have made any purely chronological ordering extremely difficult. So the system which I have adopted is close to that used by Hackl; I would, however, stress its flexibility. Hackl based his catalogue on a chronological ordering of types within a number of different categories of mark — dipinti and simple and more complex graffiti. I have preferred to devote two sections, A and C, to types which appear very largely on BF and RF vases respectively, reserving B for types where both kinds of vase are found; in sections A–C the marks are normally simple and unaccompanied. The ordering of the types is alphabetic, with non-alphabetic marks at the end of each section. All vases in section C are RF unless otherwise stated.

Different criteria come into operation for sections D–F. Section F comprises those types which can be interpreted *prima facie* as being abbreviations of vase names or adjectives describing vases, or indeed are full vase names or adjectives. Section D includes those types which are either of themselves numerical or regularly appear with numerals, but are not otherwise normally accompanied (excluding those types eligible for section F). In section E are to be found those types which regularly appear together with other, non-numerical marks; the entries of such a nature may comprise a whole type or only part of one type, the rest being basically section A, B or C material. Here again types eligible for section F are excluded, despite having a 'gregarious' nature. The ordering of the types in sections E and F is influenced by the desirability of juxtaposing closely related or similar types, such as 1E with 2E and the various *lambda-epsilon* and *lambda-eta* marks and their satellites, 15E to 3F.

I insist on the flexibility of this system because a type like 3E or 11F is basically A or B material, with just a few members showing definite signs of 'gregariousness' or of being a vase-name abbreviation. Some of the

attributions to sections D—F are based on interpretations that may be questioned, though I hope here to have erred on the side of caution, for example by putting 9D, 18E, 19E and 24E where they are and not in section F. 3F merely follows in the steps of its immediate predecessor without any qualifications of its own for section F. Such anomalies will of course occur where more than one set of criteria determine classification.

Explanation of entries

Within the catalogue all marks are to be taken as graffito unless otherwise stated, and all dipinti as red. The ordering of entries within sub-groups is roughly chronological.

Catalogue numbers followed by an asterisk denote that the mark is not published elsewhere, or is wrongly or defectively published in earlier publications.

The second column contains the location and museum number of the vase; most abbreviations to be found here are those employed by Beazley in *ABV, ARV* and *Paralipomena,* and for the most part I use the same inventory or catalogue numbers. Otherwise a note will be found at the head of the relevant entry in the Museum Index. An asterisk (*) before the citation of a vase in Munich denotes that it is no longer extant.

The third column denotes the shape of the vase. The abbreviations used are based on those in Brommer, *Vasenliste zur griechischen Heldensage.* Type A, B or C refers to amphorae. An asterisk (*) before Panath denotes a prize Panathenaic amphora. I do not distinguish between types of hydriai, oenochoai or cup.

The fourth column gives the provenance of the vase, if known. I omit 'Etruria' or 'Italy' as being meaningless within the scope of this enquiry, but do include 'Campania' and 'S Italy'. S. Agata denotes S. Agata de' Goti.

Column five gives any attribution of the vase, or failing that its date. The attributions are those of Beazley in *ABV, ARV* or *Paralipomena,* or of Haspels in *ABL,* except where names are added in brackets after the entry, indicating an attribution by that person unconfirmed by Beazley. Occasionally I use a loose adjective, e.g. Antimenean, which cannot be mistaken for a definite attribution. The dates of unattributed vases are generally given in rather precise terms. This has been done to absolve c. from constant use and it should always be tacitly understood; where c. is used the implication is that the date is more doubtful than in most cases.

In column six I give the most relevant publications of the vase, in particular of the mark. All *unbracketed* entries will lead directly, or via *ABV, ARV* or *Paralipomena* to a publication of the mark, and in the vast majority of cases the vase also. Where the vase is attributed the references will normally be to one of Beazley's works, but in some cases a more recent definitive publication is at hand, especially volumes of *CVA* published since *Paralipomena.* Where the reference is *bracketed* it will only lead to a publication of the vase, not the graffito; in most cases bracketed references are for vases in collections where the best catalogue for the purposes of the marks is unillustrated (Berlin, Leningrad, London, Munich, Naples — see the Museum Index); here the marks can be readily found in those catalogues. H followed by a numeral indicates the number of the vase in Hackl's catalogue. (B) indicates that I know of the mark only from Beazley's MS notes in Oxford.

The seventh column contains comment on the mark itself — its position on the foot, its direction, any repetition of it and sometimes a rough facsimile of it (I would stress 'rough' — entries here are not intended to be accurate, nor could they be). Here also is any reference to the figures and plates.

In the final column I put information on any other marks on the same foot (or in some cases elsewhere on the vase). These take either the form of cross-references to other entries for the same vase in the catalogue, or rough facsimiles of other marks.

Although each entry is that of a mark and not of a vase, which may command as many as five separate entries, I often do refer to entries as of vases in order to avoid tedious repetition of the formula '16 is on a vase which . . . '.

I refer, wrongly, to Etruscan letters by Greek names.

There are some important comments in the introduction to the figures (p. 271) on the notation used and the partial omission of some of the marks therein.

Erroneous entries in Hackl's catalogue

Apart from minor variations in readings, the following should be noted. Where I do not comment a note will be found in the catalogue under the entry given.

Hackl 20 = 17A, 14
 51 = 21A, 4
 104 The dipinto is 18B, 3
 178 Hackl's note belongs with 177
 214 = 23E, 13
 231 = 9D, 4; there is no mark as Hackl gives.
 266 is a doublet of 252
 289 The mark is of Hackl's type a, not b.
 297 The mark is of Hackl's type a, not b.
 300 = 1D, 3. The number is wrong.
 339 = 9E, 34; Hackl has the wrong number

347 is omitted in view of the reading given in CB iii 7.
384 see 10B, 19.
390 is a ligature of *delta* and *eta* (*CVA* 8 10)
400 = 2F, 12
446 Langlotz gives only an *epsilon* (382)
559 = 2F, 9

p. 59, London B475 = 5A, 6
p. 62, c = 10A, 7; Hackl has a wrong reading
p. 69, London E179; the foot is broken, part lost,
and worn. Hackl's reading is certainly wrong. Perhaps
it is HPA with 'Boeotian' *alpha.*

Addenda

5A,10a*	Liverpool 1977-114-13	hy	520-10		(*Arch.Rep.*1977-8 85-6)	twice	8E,55a
20A,37a*	Liverpool 1977-114-10	n-a	Antimenes painter		(*Paral* 120,93ter)		
20A,75a*	ex London market	type B	c.510		(*Sotheby 4/12/1978* 133,2)	no *iota*	
33A,3a	German market	n-a	Group E (Robertson)		see below	navel	
33A,25a	where?	oen	Capua?		*RM* 8 (1893) 336		
3E,16a*	Athens, Kanellopoulos	n-a	Painter N		(*AAA* 9 (1976) 146)		
8E,9a	Boston 62.1185	hy	Chiusi painter		*CVA* 2 27		
8E,55a*	Liverpool 1977-114-13	hy	520-10		(*Arch.Rep.*1977-8 85-6)		5A,10a
8E,56a	Boston 61.195	hy	Priam painter (AD)		*CVA* 2 24		10F,1a
9E,29a	Boston 28.46	hy	manner of Lysippides p.		*CVA* 2 22		
9E,98a*	Chiusi	kr foot	undetermined				
12E,32	Berlin 1962.82	pel	Pan painter		Becker, o.c.(below) no. 192		
10F,1a	Boston 61.195	hy	Priam painter (AD)		*CVA* 2 24		8E,56a
10F,7a	Orvieto?	col-kr	late sixth century		*NSc* 1910 36	sub-group ii	
s.l.5 59a	Louvre F27	type B	(Mommsen no. 5)				
East Greek 112a	Gela?	*NSc* 1960 150					

33A,3a is published in *Kunst der Antike* (Galerie Neuendorf 22 Nov - 20 Dec 1978) no. 5. 10F,7a is from near Orvieto.

13A, note 4. Add London E62 cup, Makron (*ARV* 471,194).

12B. A further perplexing crossed *theta* is on St. Louis WU3271, Nolan, Hermonax (*ARV* 488,77); the reading is ⊗ | Ξ , suggesting a price of 1¾ obols.

9D A simpler version of the mark, 𐤍 , is cut on the foot of a glazed Attic type C cup of the early fifth century (Louvre, Campana unnumbered), together with an unusual ligature, ⑨| .

9E,10 D. von Bothmer and A. Pasquier have discovered that this foot belongs to the calyx-krater by Euphronios, Louvre G103. This fact renders obsolete some of my observations and throws interesting new light on the commercial attachments of the painter.

16E. A possible candidate for the type is Boston 89.562, hy, 530-25 (*CVA* 2 17-18).

2F, note 8. The Histria jug now published as *Histria* iv 688.

p. 251, South Italian, note 1. Add a further pyxis, perhaps Sicilian, with black B on the lid. *NSc* 1969 suppl. 2 76.

A good number of pelikai with marks are included in R-M. Becker, *Formen Attischer Peliken*; I note in particular (quoting her catalogue numbers):

17 (18E,4). A further, non-alphabetic mark could perhaps be connected with those on 18E,6 and 7.

18 (Bonn 75, Painter of the Munich Amphora). The second mark may be of type 12C.

30 (7F,3). The version of the mark on the navel suggests that it may not belong here, but other marks of this type are also carelessly cut.

98 (5F,1).

123 (Dresden 293). Four unit strokes; a price?

288 (23E,4). This version of the mark looks like a batch number, 230, perhaps introduced by ΛA, but I hesitate now to include it in type 23E.

345 (17B,10). The incompleteness of the mark is overlooked.

SECTION A

Type 1A ![alpha symbol]

BF

1	Capua 145	n-a	Capua	Group of Munich 1501	*Paral* 153,7		
2	London B272	n-a	Vulci	Group of Munich 1501	(*ABV* 341,1)		
3	Leiden PC52	n-a	Vulci	Group of Munich 1501	*CVA* 1 pl. 52,10		
4	ex Rome, Hercle	hy	Vulci	Leagros group (Johnston)	*St.Etr.* 34 (1966) 320-1		1OE,30
5	Cab.Med. 232	n-a	Vulci	near p. of Munich 1519	*ABV* 395,9		KE
6	Munich 1527	n-a	Vulci	Nikoxenos painter	(*ABV* 392,5)	Fig.1b	8A,5
7	London B238	n-a	Vulci	Nikoxenos painter	(*ABV* 392,9)	Fig.1a	8A,10
8	Brussels R346	hy		520-10	*CVA* 2 7		

3, 8 and the published version of 1 do not have the additional tick on the right leg of the *alpha*.
The slope of the cross-bar of the *alpha* is up to the right on 2,3,4 and 5, down on 6 and 7, horizontal
on 8, unknown on 1 (stolen from museum).

An associated shape

RF

9	London 1929.5-13.2	stam		Geras painter	(*ARV* 287,26); *Stamnos* fig.15		
10	Syracuse 21186	lek	Gela	Achilles painter	*ARV* 993,80; *ML* 17 321		

Type 2A ![alpha symbol]

BF

1	Frankfort KH WM03	n-a		Three-line group	*Paral* 140,9bis
2	Vienna 3602(229)	n-a		525-500	
3	V.G. 50747(M499)	n-a		520-10	

Type 3A ![alpha symbol]

i) Retrograde, with |

BF

1	Munich 1729	hy	Vulci	Manner of Acheloos p.	(*ABV* 386,16)	Fig.1i	9E,58
2	Würzburg 323	hy	Vulci	near Acheloos painter	*ABV* 387		9E,59

ii) Orthograde, with V or a tick-shaped sign

BF

3*	Florence	n-a		510	Fig.1c
4	Conservatori 89	oen		500	*CVA* 1 15
5*	Louvre F405	hy		Painter of London B352	(*Paral* 154) Fig.1d

3 is a small vase: A, Dionysos and satyr; B, maenad and satyr.

iii) Alone

RF

6	Louvre G65	pel		Smikros	*ARV* 21,5	Fig.1e 5B,2

Type 4A ![alpha symbol]

i) Alone, BF

1	London B234	n-a	Vulci	Psiax	(*ABV* 292,3)	
2	Orvieto Faina 70	hy	Orvieto	Manner of Lysippides p.	(*ABV* 261,39); H97	
3	Vatican 357	type B	Vulci	near P. of Vatican G43	*ABV* 264	
4	Louvre F222	n-a	Vulci	Class of Cambridge 49	*ABV* 316,4; H96	
5*	Tarquinia 649	type B	Tarquinia	530-25		Fig.1f
6	Berlin, private	hy		530-25	Antiken aus Berliner Privatbesitz 216	
7	Tarquinia 636	n-a	Tarquinia	530-25	H93	Fig.1g
8	Würzburg 180	n-a	Vulci	520	H95	
9	Würzburg 179	n-a		Group of Würzburg 179	*ABV* 290,1; H94	

| 10 | Munich 1557 | n-a | Vulci | P. of Boulogne 441 | CVA 8 50; H92 | Red $\int:\bigcap$ navel |

| 11 | Munich 1505 | n-a | Vulci | P. of Boulogne 441 | CVA 8 51; H90 |
| 12 | Munich 1535 | n-a | Vulci | Pasikles painter | CVA 8 59; H91 |

The slope of the 'cross-bar' is irregular with no preponderance in any one direction.

ii) Similar marks on RF and b.g. vases

13*	Munich 2371	col-kr	S. Italy	Early mannerist	(ARV 584,22)	Fig. 1h
14	Louvre G231	pel		Painter of Louvre G231	ARV 581,4	
15	Cracow Arch.3598	kanth	Rijanovka b.g.		CVA 59	
16	London o.c. C100	saucer	Cyrenaica b.g.			

Type 5A and

i) The first mark; glaze dipinto. BF

| 1 | Oxford 1890.27 | lek | Gela | Edinburgh painter | Gardner 17; (ABL 216,2) |
| 2* | London market | lek | | 510-500 | (Sotheby 1/7/69 99) |

ii) The same, graffito

BF
3*	V.G. 50487(469)	type B		540-30		Fig.1l
4*	Tarquinia RC1871	n-a	Tarquinia	Antimenes painter	(ABV 270,64)	large
5	Tarquinia RC3870	n-a	Tarquinia	510	St.Etr. 36 (1968) 244	
6	London B475	oen	Vulci	510-500	(ABV 382,3); Hackl p.59	
7	Leningrad	oen	Taman	510-500	AA 1914 221-2	
8*	ex Holford	type B			(B)	
	b.g.					
9	Adria (21,11)	bowl	Adria			

Hackl erroneously included 6 in his list of vases bearing the same mark graffito and dipinto; the circular dipinto seems to have been painted over the graffito.

iii) The same, with an additional circular graffito

BF
10	Naples RC220	pel	Cumae	510		navel	
11	Munich 1713	hy	Vulci	520-10	(AV pl. 142)	Fig.1k	8E,56
12	Oxford 1879.152	cup	Kamiros	Painter of Oxford 237	BSA 70 (1975)153,66		

iv) The second mark, alone

BF
13*	Louvre Cp10710	oen		510		
14*	Florence	foot		(small closed vase)		Fig.1m
	b.g.					
15	Adria (21,10)	bowl	Adria			

v) The second mark, accompanied

BF
| 16 | Louvre F258bis | n-a | | 505 | PdP 27(1972)418 fig.3 | 23E,5 |
| 17 | Würzburg 217 | n-a | Vulci | Group of Munich 1501 | Paral 153 | 23E,6 |

vi)

RF
| 18 | Bologna 199 | col-kr | Bologna | Naples painter | (ARV 1096,2) |

vii) The following should be placed somewhere here

BF
| 19 | Mus. Etruscum 1700 | oen | Vulci |

Type 6A EΓΙ

i) Alone. BF

1	Würzburg 225	n-a	Vulci	Manner of Red-line p.	*ABV* 605,2	retrograde
2	New York 06.1021.n-a 59			Manner of Red-line p.	*CVA* 4 58	
3	Brooklyn 09.5	type B	Capua	510-500	*Vente 11/5/1903* 53	Pl. 5
4	ex Paris market	type B			*Vente 11/5/1903* 55	
5*	New York, Bothmer	n-a	Agrigento			

On 3 the *epsilon* seems to have been cut upside down.

ii) With other marks. RF

6	Bologna 153	type A	Bologna	470-60	Fig.8h	9E,64; 12F,1

Type 7A €

BF

1	Louvre F294	hy		Lysippides painter	*ABV* 256,8	Fig.2a
2*	London B211	n-a	Chiusi	Lysippides painter	(*ABV* 256,14)	Fig.2b

Type 8A EVᴧᴧᴦEV

BF

1	Orvieto Faina 124	n-a		Nikoxenos painter	*ABV* 392,1; H311		
2	Berlin 1844	n-a	Vulci	Nikoxenos painter	(*ABV* 392,2); H309		
3	Gotha 32	n-a	Tarquinia	Nikoxenos painter	*CVA* 1 42		
4	Louvre F247	n-a		Nikoxenos painter	*ABV* 392,4	Fig.1j	
5	Munich 1527	n-a	Vulci	Nikoxenos painter	(*ABV* 392,5); H308	Fig.1b	1A,6
6	San Simeon 9907	n-a		Nikoxenos painter	*ABV* 392,6; H312		
7	Brussels A200	n-a		Nikoxenos painter	*ABV* 392,7		
8	Mainz inv. 73	n-a	Vulci	Nikoxenos painter	*Paral* 172,7bis		
9	Würzburg 211	n-a		Nikoxenos painter	*ABV* 392,8		
10	London B238	n-a	Vulci	Nikoxenos painter	(*ABV* 392,9); H310	Fig.1a	1A,7
11	Munich 1546	n-a	Vulci	Nikoxenos painter	(*ABV* 392,10)		
12	Legon, University	n-a		Nikoxenos painter	*ABV* 392,12		
13	ex Rome, Hercle	n-a	Vulci	520-500	*St.Etr.* 34 (1966) 321		

The cross-bars of the *alpha* are horizontal. Odd lines in the publication of 4 are due to a misunder-
standing of the punctuation marks, and the same probably applies to the published version of 6. As
only the foot of 13 is illustrated in the publication it cannot be closely dated, let alone attributed
with confidence.

Type 9A Ⴕ

BF

1*	Villa Giulia 15535	n-a		520	(*CVA* 1 pl.4,1)
2	Brussels, Mignot 9	n-a		520	
3*	Boulogne 21	n-a		520-10	Fig.2c
4	Tarquinia 642	n-a	Tarquinia	510-500	*St.Etr.* 36 (1968) 238
5	Tarquinia 670	n-a	Tarquinia	510-500	*St.Etr.* ibid.
6*	Vatican 383 b.g.	n-a		510	
7	Tarquinia 661	n-a	Tarquinia	520-500	*St.Etr.* ibid.

2 is not published accurately in the *Catalogue*. For *St.Etr.* ibid. no 8 (Tarquinia 652) see 21E,11.

Type 10A HE

i) Closed *heta*, unligatured

BF

1	Louvre Cp10655	hy		Taleides painter	*Paral* 72,6	s.l. 1,1
2	Tarquinia RC3030	type B	**Tarquinia**	near Group E	(*ABV* 138,3); *St.Etr.* ibid.	

| 3 | Toronto 322 | lek | | Class of Athens 581 | ABV 494,115 |

ii) Closed *heta*, ligatured

BF, dipinto

4*	Munich 1701	hy	Vulci	Euphiletos painter	(ABV 324,27)	Pl. 1a-b
	graffito					
5*	Tarquinia 678	n-a	Tarquinia 510-500		(CVA 1 pl.5,1)	Fig.2d
6*	Tarquinia RC1082	n-a	Tarquinia 500		(CVA 1 pl.6)	Fig.2e

4 was probably more extensive originally.

iii) Open *heta*, unligatured

BF, dipinto

7	Louvre F3	type B		Painter of Berlin 1686	ABV 297,12; Hackl p.62	
8	Zurich 11	n-a	Tarquinia	Conservatori painter	CVA 1 20	
	graffito					
9*	Munich 1553	n-a	Vulci	525	CVA 8 18	6B,9
	RF					
10	Boston 00.346	bell-kr	Vico Equense	Lykaon painter	(ARV 1045,7); CB ii 83	

The graffito of 9 is not fully published in *CVA*.

iv) As iii, but the *epsilon* has four bars.

BF

| 11 | Toronto 304 | n-a | Tarquinia | Manner of Lysippides p. | ABV 259,21; *Paral* 114 | |

For further marks of a similar character see 11B,iv.

Type 11A Dipinto

This is the shape as preserved on 1, where the leftmost line disappears under a label. On 2 this line is not found, although the mark is very worn; I could not determine whether the rightmost stroke of 1 also appears on 2.

BF

| 1* | Tarquinia RC7205 | type B | Tarquinia | Swing painter | (ABV 306,44) | |
| 2* | Tarquinia RC2449 | type B | Tarquinia | 530 | (CVA 2 pl.24,1 and 4) | |

Probably associated

| 3* | Baltimore 48.2127 | type B | | Swing painter | (Paral 134,33bis) | graffito |

Type 12A IH

BF, dipinto

1*	Detroit 24.127	type B		Swing painter	(ABV 305,18)	
	graffito					
2	Boston 99.522	hy		c.530	H77; CVA 2 18	29A,3

Type 13A Dipinto Λ

BF

1*	Naples 2734	type B	Nola	Painter of Louvre F6	(ABV 126,50)	large
2*	London 1951. 1-21.2	type B		Painter of Louvre F6	(ABV 126,49)	
3*	Taranto 20256	n-a	Taranto	550		navel, see below
4	Castle Ashby	n-a		Amasis painter	(ABV 152,23); CVA 5	glaze? 23F,4
5*	Florence 3845	n-a	Vulci	Eye-siren group	(Paral 125,7bis)	1D,14
6	London B362	col-kr	Vulci	520-10		
7	vacat					
8	London o.c.639	oen	Vulci	c.500		
	RF					
9	London E728	askos		Veii painter	(ARV 906,118);BMC	glaze
10	Adria B452 (22,14)	sky	Adria			

On 3 the same mark is applied graffito and dipinto, superimposed, but in what order it is not clear.
On 6 the mark is preceded by two columns of triple dots.

Type 14A ᴠA

 i) Orthograde

 BF, dipinto
1* London B301 hy Vulci Alkmene painter (*ABV* 282,3) 3D,6
 graffito
2 Conservatori 15 n-a Circle of Lydos *Paral* 47,7 16A,15
3 Conservatori 55 n-a Painter of Vatican 309 *Paral* 50 Traces
4 Cracow 1083 col- Vulci? 530-20 *CVA* 9 21A,71
 kr

 b.g.
5 Villa Giulia cup Vulci *St.Etr.* 25 (1959)
 525

 RF
6 Naples RC171 col- Cumae c.460 navel other
 kr marks

5 has other, Etruscan marks, *tu* and *m*.

 ii) Retrograde

 BF
7 London B50 hy Painter of Vatican 309 (*ABV* 120,2)
8 Amsterdam 3374 n-a Painter of Vatican 309 *ABV* 121,12 traces
9 Munich 1446 n-a Vulci Manner of Lydos *CVA* 7 29 24A,3
10 Conservatori 47 type B Group E *Paral* 55,19
11 Florence 3830 hy 550-40 *CVA* 5 4
12 ex Swiss market n-a 520-10 *Auktion* 16 104 see below

The reading given in the publication of 12 makes a simple interpretation as *la* unlikely. Here the
cross-bar of the *alpha* slopes down to the right, while that of the other retrograde examples goes in
the opposite direction. In the orthograde marks the cross-bar slopes down to the right, save for
5 (up), and 4 (unknown to me).

Type 15A ᴠV and ᴧV

 i) ᴠV

 BF, dipinto
1 *Munich 1367 type B Vulci Painter of Louvre F6 *ABV* 127,61; H26
2 Munich 1368 type B Vulci Painter of Louvre F6 *ABV* 127,51; H27
3 Vatican 314 type B Painter of Louvre F6 *ABV* 125,39
4* Naples 127875 hy 530-20
 graffito
5 Würzburg 169 n-a Lydan (Trendall) retrograde
6* London 1863.7- n-a Gela Painter of Würzburg (*ABV* 591,2)
 28.443 234
7 Tarquinia 656 n-a Tarquinia 510-500 *St.Etr.* 36 (1968)
 238
8 Madrid 10903 n-a 510 *CVA* 1 6

 ii) ᴧV

 BF, dipinto
9 Louvre E868 n-a Lydos *ABV* 110,30 Pl. 3 see below
 graffito
10 London B212 n-a Vulci Princeton painter (*ABV* 297,1)

The additional graffito on 9 is not as published by Pottier; it is like a *mu* with a short first stroke
See type 6F for further examples of the abbreviation.

Type 16A ᴦV and the like

 i) ᴦV

 BF
1* Tarquinia RC1816 type B Tarquinia 535-25 navel

2*	Tarquinia RC5577	n-a	Tarquinia	recalls Lysippides p.	(*Paral* 116,4bis)	
3	Harrow 26	n-a	Vulci	Antimenes painter	(*ABV* 272,94); *G & R* 21 (1974) 151,4	
4*	Tarquinia RC1635	n-a	Tarquinia	Antimenes painter	(*ABV* 270,65)	
5	Munich 1548	n-a	Vulci	Antimenes painter	*CVA* 8 43	
6	Munich 1480	n-a	Vulci	Group of Würzburg 199	*CVA* 8 64	
7	Brussels R300	n-a	? Cerveteri	Group of Würzburg 199	(*ABV* 288,9)	
8	New York 41.162. 190	n-a		Group of Würzburg 199	*CVA* 4 26	
9*	Aberdeen 683	n-a		Group of Würzburg 199?	(*ABV* 289); (B)	
10*	Tarquinia RC1983	n-a	Tarquinia	Antimenean		Fig.2f
11	Munich 1480A	n-a	Tarquinia	Long-nose painter	*CVA* 8 33	
12	Vatican 378	Panath		520		
13	Los Angeles 50.8.19	n-a		510-500	*Hesperia* 24 (1955) 23	

| | RF | | | | | |
| 14 | Stockholm 2105 | stam | | Danae painter | (*ARV* 1075,3); *Stamnos* fig.17 | |

The reading of 7 in *CVA* is erroneous; the horizontal projects somewhat to the left. The following very likely had a similar mark, now worn:

| | BF, dipinto | | | | | |
| 15* | Conservatori 15 | n-a | | Circle of Lydos | *Paral* 47,7 | 14A,2 |

ii) Variations on the theme of i

	BF, dipinto					
16	Louvre AM1008	type B	Rhodes	540	*BSA* 70 (1975) 153,50	
	graffito					
17*	Palermo 1902	lek		Phanyllis painter	(*ABL* 200,31)	
18*	Dublin 1917.36	lek		Edinburgh p. (Shefton)		Fig.2i
19*	Tarquinia RC7480	n-a	Tarquinia	525-500		Fig.2h
	undetermined	foot				
20	Adria (21,24)	cup	Adria	500-475		⫼

The reading of 16 is not assured, see *BSA* l.c. The second vertical of the *pi* on 18 and 20 is short. 17 appears more like a ligature of *pi* and stemmed *upsilon*.

iii) ⎍⎺⏋

	BF					
21	Vatican 422	hy	Vulci	Leagros group	*ABV* 363,45	
22	London B338	hy	Vulci	Leagros group	(*ABV* 366,72)	
23	Louvre F250	n-a		510	*CVA* 4 28	
24	Berlin 1903	hy	Vulci	510	(*AV* pl. 252)	
25	Taranto 20348	cup	Taranto	Leafless group (Lo Porto)	*ASMG* 8 (1967) 63	⌀
	undetermined					
26	Villa Giulia	foot	Cerveteri	c.500	*NSc* 1937 423,72	

The second vertical of the *pi* is short except on 24 and 26

Type 17A �⎤Ɒ and ⎤O

It is normally possible to distinguish between the two, but in one case (5) judgment must be reserved.

i) ⎤Ɒ

	BF, dipinto					
1	Munich 1361	type B	Vulci	Horse-head	(*CVA* 1 pl.4,1); H15a	
2	Munich 1362	type B	Vulci	Horse-head	*CVA* 1 8; H15	retrograde
3	Erlangen M930	type B	Vulci	Horse-head	H15b	
4	Munich 1381	type B	Vulci	Towry White painter	*ABV* 142,5; H16	

Hackl doubted whether the paint used for 2 was the normal red; it is unlikely that any other pigment should have been used for a dipinto on an Attic vase of this period.

ii) Uncertain whether the second letter is *omicron* or *rho* (or *delta*?)

BF, dipinto

5	*Munich 1400	type B	Circle of Lydos	*CVA* 1,23; H17

iii) ⌐O , the letters adjacent

BF, dipinto

6	Munich 1471	n-a	Vulci	Group E	*CVA* 7 50
7	Oxford 1965.135	n-a		Group E	*CVA* 3 1
8	New York 56.171. 18	n-a		Group E	(*CVA* 4 14)

Enough of 8 is preserved to guarantee the reading.

iv) As iii, but the letters on opposite sides of the foot

BF, dipinto

9	Kassel T674a	type B Vulci	Group E (Lullies)	*CVA* 1 44
10	London B163	type B Vulci	Group E	(*ABV* 134,28)
11*	Chiusi 1806	type B Chiusi	Group E	(*ABV* 135,32)
12*	ex London market	type B	Group E	(*ABV* 135,46); *Christie 30/4/1975* 60

v) o⌐

BF, dipinto

13	Würzburg 248	type B Vulci	Group E	*ABV* 134,18; H19	
14	Louvre F9	hy		550-40	(*CVA* 6 42); H20

According to Pottier the latter had *iota delta*; the supposed *delta* has no point at its apex and there remain definite traces of a second vertical which I take to be that of a *pi*; Pottier indicates it by shading in his facsimile.

vi) ⌐O , graffito

RF

15	Adolfseck 42	pel	Group of Vienna 895	*ARV* 285,1
16	Vienna 895	pel	Group of Vienna 895	*ARV* 285,2
17	Basel market	sky	470-60	(*Sotheby 1/12/1969* 105)

On the first two the *omicron* is appended to the second vertical of the *pi*.

vii) o⌐ , graffito

BF

18*	Bologna 52	col-kr Bologna	Leagros group	(*ABV* 376,231)	Fig.2g

Pellegrini's publication is understandably defective as the *omicron* is obscured by two thick strips of plaster.

Type 18A PO|

BF

1	Oxford 1879.161	hy	Vulci	related to Antimenes p.	*CVA* 3 23
2	London B229	n-a	Vulci	520-10	(*CVA* 4 pl.56,3)
3	Bristol H801	hy	Vulci?	515-10	*G & R* 21 (1974) 151,5; Clairmont pl.23

Type 19A ϟIMON

BF, glaze dipinto

1	Hannover 1964.9	n-a		P. of Würzburg 199 (Follmann)	*CVA* 1 23	Twice, with ΛAB

graffito

2	Munich 1686	hy	Vulci	520-15		
3	Cleveland 24.197	col-kr		500	*CVA* 1 18	s.l. 1,18

On 3 the name is in the genitive, on the neck.

Type 20A ЅMΙ

I have arranged the sub-groups of this type in descending order of similarity to the basic form. Hackl noted that some examples not bearing a very close resemblance to the original abbreviation must nevertheless be taken as members of the type.　All vases are BF, except, apparently, 15.

i) A clear unligatured form

1	Würzburg 173	Panath	Vulci	530	H252		
2	Tarquinia 664	type B	Tarquinia	530-25	H251		
3	Munich 1502	n-a	Vulci	related to Lysippides p.	CVA 8 20; H257		
4*	Florence	n-a		Class of Perugia 124	(ABV 318,3)	Fig.2j	
5	Munich 1514	n-a	Vulci	Antimenes painter	CVA 8 40; H254		traces
6	Louvre F202	n-a	Vulci	Antimenes painter	ABV 274,119; H270		
7	New York 56.171.27	stam		related to Antimenes p.	(Paral 123,21); Stamnos fig.10		
8	Brussels R278	n-a		c.520	CVA 2 8		
9*	Belfast (1313)	n-a		520-15	(Sotheby 12/6/1967 134)	Fig.2m	
10*	Cab.Med. 215	type B		Painter of Würzburg 173	(ABV 327,2)		
11	Cambridge 51	n-a	Vulci	Painter of Cambridge 51	ABV 340,1	Fig.2k	8E,55
12	Erlangen	n-a	Vulci	520-10	CVA Munich 8 29; H259		
13	London B227	n-a	Vulci	Group of London B265	(Paral 142,2); H268		
14	Bonn inv. 39	n-a	Bomarzo	510-500	AA 1935 443 and 450; H280		
15	Mus. Etruscum 332	oen	Vulci				

2 and 15 are retrograde save for the *sigma*;　the *sigma* of 4 is retrograde, the rest orthograde. One of the bars of the *sigma* of 8 is not given in *CVA*.　9 should have been entered in sub-group ii.

ii) The *sigma* merges with the first stroke of the *mu*.

16*	Boulogne 575	n-a		535-30			15B,5
17	Compiègne 1055	hy	Vulci	530	CVA 5		
18	Würzburg 208	n-a	Vulci	near Lysippides painter	H263		
19	Munich SL458	n-a		Manner of Lysippides painter	CVA 7 62		3D,3
20	Manchester IIIh 50	hy		Manner of Andokides p. (Webster)	G & R 21 (1974) 151,3		
21	Copenhagen 4759	n-a		Psiax	ABV 293,6		
22*	Tarquinia RC3455	n-a	Tarquinia	530-20			
23	Vatican 382	n-a	Vulci	530-20	H275		
24	Vatican 420	hy	Vulci	530-20			
25	Leiden PC29	n-a	Vulci	530-20	CVA 1 pl. 53,2		
26*	London B312	hy	Vulci	525-20	(CVA 6 pl. 79,1)	Fig.2l	
27	Würzburg 339	oen		Class of Vatican 433	ABV 424,2; H287		
28	Toledo 55.225	n-a		Antimenes p.(Bothmer)	CVA 1 39		traces
29	Naples Stg.186	n-a		Antimenes painter	(ABV 270,51); H271		
30	Louvre F219	n-a	Vulci	Antimenes painter	ABV 270,59		
31*	Brussels R291	n-a		Antimenes painter	(ABV 270,52); (B)	Fig.2r	
32	Hannover 752	n-a		Antimenes painter (Follmann)	CVA 1 22		
33*	Copenhagen NyC 2653	n-a		Antimenes painter	(ABV 269,37)		
34	Küsnacht, Hirschmann	hy		Antimenes painter	(Paral 119,20bis)		
35	Zurich 8	type B	Capua	Antimenes painter	CVA 1 19		
36	Gotha 28	n-a	Cerveteri	Manner of Antimenes p.	CVA 1 44		
37*	Florence 70998	n-a		Manner of Antimenes p.	(ABV 278,37)	Fig.2p	
38	Florence 3856	n-a		near Antimenes painter	(ABV 278,30); H277		
39	Würzburg 189	n-a	Vulci	Eye-siren group	ABV 286,5; H262		
40	Vatican 388	n-a		Group of Toronto 305	ABV 283,9; H276		
41	London B264	n-a	Vulci	Group of Würzburg 199	ABV 288,19; H267		
42*	Louvre unnum.	hy		Antimenean		Fig.2n	
43	Würzburg 220	n-a	Vulci	Pasikles painter	ABV 328,1; H261		
44	Würzburg 200	n-a		Long-nose painter	ABV 327,2; H264		

45	Vatican G16	n-a	Vulci	Painter of Cambridge 51	ABV 340,3	
46	Compiègne 975	n-a	Vulci	Priam painter	ABV 331,13	Fig.2s
47*	Basel 1945.95	n-a		520		
48	Leiden PC48	hy	Vulci	520-10	CVA 1 pl.52,2	
49	Boston 25.220	type B		520-10	CVA 1 8	
50	Munich 1545	n-a	Vulci	520-10	CVA 8 85; H255	
51	Tarquinia 646	n-a	Tarquinia	515	(CVA 2 pl.39,1) H279	
52	Berlin 1893	hy		515	(AV pl.253); H282	
53	Naples 2501	n-a		515	H272	
54	Munich 1492	n-a	Vulci	515-10	CVA 8 73; H256	
55	London B240	n-a		510-500	(CVA 4 pl.58,4);H269	
56	Munich 1537	n-a	Vulci	510-500	CVA 8 60; H258	
57	Orvieto	foot	Orvieto		Annali 1877 pl.L,21	
58	Orvieto	foot	Orvieto		Annali 1877 pl.L,22	

The following are retrograde: 18, 23, 36, 38 and 57. In no case is the *sigma* retrograde to the rest of the mark. Wear on the foot of 22 has erased the top and bottom of the *mu*. The *CVA* publication of 46 is inexact.

iii) Similar to ii, but with slight variations or abnormalities

59	Vatican 391	n-a	Vulci	520-10	H274	
60	London B300	hy	Vulci	Euphiletos painter	(ABV 324,39); H285	
61	Cab.Med. 254	hy	Toscanella	Euphiletos painter	ABV 324,38	navel
62	Boston 22.404	n-a		Antimenes painter	CVA 1 32	
63	Vatican G17	n-a	Vulci	Eye-siren group	ABV 286,2	
64	Munich 1509	n-a	Vulci	Group of Bologna 16	CVA 8 69; H253	
65	Munich 1540	n-a		510	CVA 8 87	
65a*	ex London market	type B		c.510	(Sotheby 4/12/78 133,2)	

59, 61 and 65a have no *iota*. 60 has an extra stroke on the *mu*. The two-stroke *sigma* of 63 may be a defective reading. The fact that 60 and 61 are by the same painter suggests that these variations are of little significance.

iv) Marks of the form 𝄢V// or 𝄢V\ or similar

66	Louvre F56	type B		540-30	CVA 4 pl.29,1	
67*	Copenhagen Th. 72	n-a		Euphiletos painter	(ABV 322,14)	
68	Toronto 296	hy	Orvieto?	Manner of Antimenes p.	ABV 277,10	
69	Berlin 1894	hy	Vulci	Manner of Antimenes p.	(ABV 277,14)	
70	Oxford 1965.104	n-a		Painter of Cambridge 51	CVA 3 4	
71	Boston 23.210	n-a		Painter of Cambridge 51	CVA 1 35	
72	Windsor, HM The Queen	n-a		Painter of Cambridge 51	(Paral 152,5)	Fig.2v
73*	Boulogne 69	n-a	Vulci	Long-nose painter	(ABV 328,8)	Fig.2q
74	Tarquinia RC3222	n-a	Tarquinia	520-10	H278	Fig.2w
75	Naples 2505	n-a		515	H273	Fig.2u
76*	Naples 126050	n-a		510		Fig.2t
77	Berlin 1892	hy	Vulci		H281	
78	*Munich 1503	n-a	Vulci		H260	

v) The exact shape unknown

| 79 | *Munich 1687 | hy | Vulci | | H284 | Twice |

vi) Various others probably or possibly related

80*	Boulogne 564	type B		alien foot		Fig.2x
81	London B302	hy	Vulci	Manner of Lysippides painter	(ABV 261,40); H286	
82	Würzburg 188	n-a		Antimenes painter	ABV 269,44	
83	New York 56.171.20	n-a	Vulci	Antimenes painter	CVA 4 22	
84	Brussels R310	cal-kr		related to Antimenes painter	ABV 281,17	
85	Turin 4101	n-a	Vulci	520-10	CVA 2 4	

86*	Copenhagen Th. 74	hy	Vulci	Rycroft painter	(*ABV* 337,28)
87	Cape Town HW1	n-a		Red-line painter	Boardman and Pope no 2
88	Louvre F234	n-a		Diosphos painter	*ABL* 240,160
89	Erlangen I635	n-a foot			H288

For the published examples reference should be made to those publications for the particulars of each piece. 86 has, repeated, a *sigma* followed by an apparent upside-down *mu* with short first and last strokes. 81, 83 and 89 certainly belong to the type despite their peculiarities. The published readings of 82 and 85 may be faulty; for an attribution of the latter see von Bothmer, *AJA* 74 (1970) 114. 84 has the order $IM ; see the commentary. 80, 87 and 88 are only possible candidates; the lines of 88 are thin and spidery and in an unusual position for this mark. I owe the opinion about the pertinence of the foot of 80 to Elke Olshausen. A facsimile of 89 is to be found in Grünhagen's catalogue.

Type 21A $ O

The sub-groups are based mainly on medium of dipinti and manner of incision. All vases are BF save 26, 100 and 102-4.

i) Red dipinto

1*	V.G. 50499 (M476)	n-a			520-15
2*	New York, Noble	oen	Vulci	Painter of Villa Giulia M482	(*Paral* 297)
3*	Jena 184	n-a			510-500
4	Munich 'J1259'	n-a			H51

1 is a large mark. 3 has only two certain bars to the *sigma*. Munich J1259 is 1505, which has a different mark; Hackl seems to have seen a red dipinto in the Munich collection and I retain the entry.

ii) Glaze dipinto

5	Munich 1530	n-a	Vulci	Manner of Antimenes p.	(*ABV* 278,27); H52	
6	Adolfseck 4	n-a		related to Antimenes painter	*Paral* 123,12ter	
7	Florence 3839	n-a		related to Antimenes painter	(*Paral* 123,12⁵); H55	34A,1
8*	Tarquinia 673	n-a	Tarquinia		520-10	
9	Tarquinia RC2406	n-a	Tarquinia		520-10 H59	
10*	London market	n-a			520-10 *Sotheby* 10.7.79 300	
11	Bonn inv. 38	n-a	Vulci		520 *AA* 1935 432 and 449; H54	
12	Beaune	stam		Beaune painter	(*ABV* 344,4); *Stamnos* fig 11	
13	Greenwich, Bareiss	stam		Beaune painter	*Gnomon* 39 (1967) 817	
14	Cab.Med. 252	stam	Vulci	Beaune painter	*ABV* 344,1	s.l. 1,6
15	Los Angeles 50.8.2	stam		Michigan painter	*ABV* 343,1; H66; *Stamnos* fig 10	
16	Würzburg 328	stam	Vulci?	Michigan painter	*ABV* 343,2; H63	
17	Vatican 414	stam	Vulci	Michigan painter	*ABV* 343,3; H64	
18	Villa Giulia M496	n-a		Michigan painter	*ABV* 344,10	
19	Tarquinia RC5994	n-a	Tarquinia	Michigan painter	(*ABV* 344,11); H58	
20	Milan, Lerici	n-a	Cerveteri	Michigan painter	*Paral* 157,11bis	
21	*Munich 1617	n-a	Vulci	Bompas group	(*ABV* 485,10); H53	
22	Louvre F283	Panath		510-500	*CVA* 5 4; H62	
23	Orvieto Faina 80	n-a	Orvieto	510-500	(*AM* 53 (1938) 109); H61	
24*	Louvre F397	n-a			510-500	
24a	Tarquinia RC5660	n-a	Tarquinia		510 H57	
25	Where?	amphora	Bolsena		*RM* 1 (1886) 22	
26	London E261	type B	Vulci	Diogenes painter	(*ARV* 248,2); *BMC*; H67	⋀

I do not know the size of the marks on 21, 23 and 25; the rest are small and neatly painted, though 15 is more untidy. I take 26 as glaze, though its present appearance is rather matt; I must withdraw my comment on its graffito (*PdP* 27 (1972) 423, addendum), since it is as published in *BMC*. 10 has: A, three hoplites; B, four hoplites. For the lid published in *CVA* with 14 see 3F,1.

iii) As ii, but large

| 27 | Florence | n-a | Orvieto | 520-10 | H57; *Bull.Inst.* 1882 |
| | | | | | 235 |

iv) Other non-glaze dipinti

| 28 | Louvre F72 | cup | Vulci | 530 | *CVA* 9 66 |
| 29 | Tarquinia 657 | n-a | Tarquinia | 510-500 | H60 |

28 would seem to be genuine despite the statement in *CVA* that the mark eventually yielded to alcohol. As Hackl notes, 29 is in added red.

v) Graffito, small and deeply incised

30	Bologna PU189	type B		Affecter	Mommsen no 3; H223
31	Oxford 509	n-a		Affecter	Mommsen no 38; H224
32	Florence 3863	n-a		Affecter	Mommsen no 44; H221
33	Boston 99.516	n-a		Affecter	Mommsen no 54; H222
34	Binghamton 1968.	type C		Affecter	Mommsen no 68
	124				
35	Greenwich 21	type C		Affecter	Mommsen no 83
36	Compiègne 979	n-a		Affecter	Mommsen no 86
37	Tarquinia RC6847	type A	Tarquinia	P. of Tarquinia RC6847	(*ABV* 338,1); H225 Fig.2bb
38*	Louvre	amphora			(*AJA* 80 (1976) 43) Fig.2dd
		foot			

On 33 and 35 the *sigma*, or the whole mark, is retrograde. Mommsen gives no *phi* on 35, as recorded in *Ars.A.A.* iv 128.

vi) Extremely faint graffiti

39	Louvre F100	n-a	Cerveteri?	Painter N	*ABV* 216,2
40*	Louvre F108	n-a		Painter N	*ABV* 220,30
41	Brussels R389	n-a		Painter N	*ABV* 219,19
42	Providence 23.	n-a	Cerveteri	Painter N	*ABV* 220,34
	303				
43	Malmaison inv.	n-a	Cerveteri	Painter N	*Paral* 105,22bis
	297				
44	Malmaison inv.	n-a	Cerveteri	Painter N	*Paral* 105,34bis
	298				
45	Villa Giulia	n-a	Cerveteri	Painter N	*ABV* 221,42
	20747				
46	Villa Giulia	n-a	Cerveteri	Painter N	
47*	London B296	n-a		Painter N	(*ABV* 219,18)

Two Nikosthenic amphorae with the mark are cited in *NSc* 1937 424,78; I have not traced the second, 46. I include 41-4 and 46 on the strength of the painter relationship without having seen the marks. A vase that may belong here is reported to have a lightly cut graffito, consistent with our mark as far as it goes:

| 48 | Berlin 1895 | hy | Vulci | Antimenes painter | (*ABV* 268,31) |

vii) Graffito, with a compass-drawn *omicron*

49	London B336	hy	Vulci	Antimenes painter	(*ABV* 266,3)	navel
50*	Boulogne 95	n-a		Manner of Antimenes p.	(*ABV* 278,28)	O on navel
51	Munich 1695	hy	Vulci	Manner of Antimenes p.	(*ABV* 276,5); H240	twice
52	Dublin 1921.91	n-a		Antimenean	*G & R* 21(1974)	Fig.2z
					151,1	
53	Würzburg 304	hy	Vulci	525	H242	
54*	Tarquinia RC3300	n-a	Tarquinia	Painter of Oxford 213	(*Paral* 152,4)	Fig.2aa
55	Naples Stg.30	hy		Priam painter	*ABV* 333,26	Fig.2y
55a*	Chiusi 1794	type A	Chiusi	Priam painter	(*ABV* 330,1)	Fig.2cc
56	Tarquinia RC6975	n-a	Tarquinia	510-500	H236a	O on navel

To judge from the facsimiles in Langlotz the following belong here also:

57	Würzburg 320	hy	Vulci	Antimenes painter	*ABV* 267,18
58	Würzburg 307	hy	Vulci	Manner of Antimenes p.	*ABV* 276,4; H241
59	Würzburg 190	n-a	Vulci	Group of Würzburg 199	*ABV* 287,4

49 is not given an *omicron* in the old catalogue, but it is included in *CIG* 8035; the reason for the omission would be that the letter was mistaken for a wheel-mark, as it lies close to, but not exactly on the centre of the navel (as 56). When an *omicron* was cut on 55 the compass slipped and a second attempt was made, closer to the already inscribed *sigma*.

viii) A large graffito, on the navel

60	Villa Giulia	n-a	Cerveteri	Painter of Cambridge 51	*ML* 42 863-4	
61	Munich 1725	hy	Vulci	recalls Acheloos painter	(*ABV* 387)	
62	Cambridge Cl. Arch. 472	col-kr		c.510	*PdP* 27 (1972) 417	23E,10
63	Dublin UCD-101	n-a		c.500		Fig.2ee

The attribution of 60 is in the typescript *Paralipomena* in Oxford. 62 is illustrated in *Sotheby 23/3/1967* 157. Although sub-groups v-viii are not mutually exclusive there is little overlap; 49 and 55a could have been placed in viii, and perhaps some of the less well published marks below would cloud the issue.

ix) Unremarkable or unknown

64	Tarquinia 675	n-a	Tarquinia	540-30	(*CVA* 2 pl 39,3); H237	retrograde
65*	Cambridge 1952.2	hy		Ready painter	(*ABV* 130,2)	
66	Munich 2030	cup	Vulci	535-30	(*Amazons* pl 35,5)	
67	Munich 2078	cup	Vulci		H228	X
68	Berlin 1808	cup	Vulci			
69	Cambridge(Mass.), Friedländer	hy		530	*HSCP* 74 (1970) 46	
70	Cracow 836	n-a		530	*CVA* 9	
71	Cracow 1083	col-kr	Vulci?	530-25	*CVA* 9	14A,4
72	London B232	n-a	Vulci	Antimenes painter	(*ABV* 270,57); H234	
73	Munich 1722	hy	Vulci	Antimenes painter	(*ABV* 269,33); H239	
74	Adolfseck 3	n-a		Manner of Antimenes p.	*Paral* 122,34bis	١١‏٢س
75	Munich 1689	hy	Vulci	related to Antimenes painter	(*ABV* 280,5); H238	
76	London B303	hy	Vulci	Class of Munich 2418	(*ABV* 342,2); H245	retrograde
77	Munich 2418	hy	Vulci	early bilingual	*ARV* 12,7	٢٥ς
78	Berlin 1862	n-a	Nola	Three-line group	(*Paral* 141,11); H232	
79	Berlin 1935	oen		near Group of Vatican G47	(*ABV* 431,10); H229	
80	V.G. 50434(M480)	n-a		520		
81	Warsaw 142452	n-a		520	*CVA Goluchow* 15	
81a	London B230	n-a	Vulci	520	(*CVA* 4 pl 56,2)	
82*	Tarquinia RC5164	n-a	Tarquinia	520		
83	Louvre F242	n-a		515	*CVA* 4 27	16B,8
84	Munich 1552	n-a	Vulci	515	H230	over red traces
85	Louvre F292	hy		515	*CVA* 6 50; H244	
86	ex Rothschild	hy		near Priam painter	(*ABV* 333,2); (B)	
87	Hamburg 1917.477	hy		Class of Hamburg 1917.477	*CVA* 1 37	
88	Würzburg 313	hy	Vulci	Madrid painter	*ABV* 329,3; H243	
89	*Munich 1534	n-a	Vulci	recalled Madrid painter	(*ABV* 330,2)	
90	Tarquinia RC1803	n-a	Tarquinia	Leagros group	(*ABV* 372,170); H236b	23F,5
91	Geneva market	n-a		Leagros group (who?)	see below	
92	Vatican G25	n-a	Vulci	near Edinburgh painter	*ABV* 479,6	
93	Orvieto Faina 50	type B	Orvieto	c.510	*Annali* 1877 pl. L,14	
94	London B180	type B	Vulci	510-500	(*CVA* 3 pl.45,3)	
95	Gela, Navarra 116	lek	Gela	near Gela painter	*CVA* 3 6	
96	*Munich 1633	n-a			H232	
97	Cat. Campana 469	?			H226	
98	Orvieto	foot	Orvieto		*Annali* 1877 pl. L,15	retrograde
99	Villa Giulia RF	n-a	Cerveteri	550-500		
100	Leningrad St. 2193	pel	Crimea	Fourth century		

85 has the third stroke to the *sigma*, but it is largely covered by plaster. 91 is published in *Antiquités, une Introduction* (Galerie Faustus) no 51. Hackl has a wrong number for 96, and I assume that the correct one is J1362 (1633). H227 (Leiden PC55) is 8E,61; H231 (Munich 1690) is 9D,4 only. Two amphorae with the mark are cited in *NSc* 1937 424,79; 60 is one and I add 99 as the other, although I have not traced it.

 x) ΟΣ

BF							
101*	Munich 1664	n-a		Late sixth century		Fig.3a	
	RF						
102	Oxford, Miss.	pel	Athens?	Myson	*ARV* 238,7	navel	8B,8

 xi) ΣΟ
 glaze dipinto

103	London o.c.1233	bowl	b.g.	
	RF, graffito			
104	Vienna 589	sky		*CVA* 1 36

104 is accompanied by acrophonic numerals for 18.

Type 22A ⟨Ω⟩

BF					
1	Lausanne, private	hy		Swing painter	*Paral* 135,98bis
2	Erlangen 8	type B	Vulci	Swing painter	(*ABV* 305,8); H248; Grünhagen 37
3	Compiègne 981	n-a	Vulci	Swing painter?	(*ABV* 310)
4	Villa Giulia	hy	Cerveteri 535		*ML* 42 871 Fig.3c
5	Oxford 1879.162	n-a		Group of Munich 1501	*CVA* 3 6; H249
	RF				
6	Rouen inv. 538	hy	Vulci	Kleophrades painter	(*ARV* 188,68);H250 Fig.3b
	b.g.				
7	Villa Giulia	?	Cerveteri 550-500		*NSc* 1937 425,85

The *CVA* reading of 3 is erroneous, as is that of 1 in *Auktion* 18 93. 7 may not belong here; the second letter resembles a side-long *omega*.

Type 23A √Λ⟨Ε⟩

BF					
1	Erlangen I385	n-a		Affecter	Mommsen no 46
2	London B150	type C		Affecter	Mommsen no 62
3	Parma C1	type C		Affecter	Mommsen no 69
4	New York, Blos	n-a		Affecter	Mommsen no 74
5*	Cerveteri M.A. T561	type B	Cerveteri	Affecter	(Mommsen no 129) Fig.3d

5 appears to be the 'pelike', *St.Etr.* 33 (1965) 504; the Etruscan interpretation offered there is unconvincing.

Type 24A Dipinto Τ

BF						
1*	Naples 2714	type B	Tarquinia	Painter of Louvre F6	(*ABV* 125,35)	
2*	Leiden 1954/12.1	n-a		Painter of Louvre F6	(*Paral* 51,85)	
3	Munich 1446	n-a	Vulci	Painter of Louvre F6	*CVA* 7 29; H7	14A,9
4	Louvre E810	n-a		Painter of Vatican 309	*ABV* 121,14; see below	
5	Munich 1445	n-a	Vulci	Painter of Vatican 309	*CVA* 7 30; H8	

Pottier gives an incomplete reading of 4; the head of the *tau* is on the foot while the stem runs on to the navel where there is a repeated graffito.

Type 25A

BF
1	Compiègne 1050	type B Vulci	550-40	CVA 4	
2	Zurich, Ros	type B	550-40	Bloesch, AKS 162	
3	Würzburg 245	type B Vulci	Group E	ABV 133,1; H219	
4	Würzburg 244	type B Vulci	Group E	ABV 135,36; H220	
5	Louvre F55	type B	Group E	ABV 133,4	Fig.3e
6	Würzburg 251	type B	Group E	ABV 135,35; H218	
7	Richmond, Va.	type B	Group E	Paral 56,42bis	red E
8	Louvre F32	type B	Group E	ABV 135,43	
9*	Vatican 354	type B	related to Towry White (ABV 142) painter		Fig.3f
10	Louvre F248	n-a	510	CVA 4 28	12B,6

Albizzati's photograph of 9 is misleading. 10 may not belong here; it lacks the lower stroke of the second sign and is retrograde.

Type 26A

BF
1	London B224	n-a	Vulci	Toulouse painter	(Paral 141,4)
2	Würzburg 218	n-a		Class of Cambridge 49	ABV 316,2
3	Toronto 633	type A		Euphiletos painter	ABV 323,23
4	Louvre Cpl2279	col-kr		520	CVA 12 134
5*	Trieste 1406	n-a		520	

For the date of 4 see Beazley, JHS 81 (1961) 222. 5 has A, Herakles and Amazon (not in Brommer, Vasenlisten³); B, Dionysos, maenads and satyr.

Type 27A

BF
1	Hannover 1965.30	hy	Antimenes painter (Follmann)	CVA 1 30	
2	Louvre F52	hy	Eye-siren group	ABV 287,14	
3	Villa Giulia M500	n-a	520-10		
4*	Louvre Cpl0609	n-a	510		Fig.3g
5	V.G. 50495(M531)	oen	510-500		

Type 28A

BF
1	Berlin 1891	hy	Antimenes painter	(ABV 267,10)
2	Toledo 56.70	hy	Antimenes painter	CVA 1 39
3	ex Swiss market	hy	Group of Antimenes p.	Auktion 40 66
4	Hillsborough 5528	hy	530-20	Raubitschek 10

Type 29A

BF
1	Munich 1383	type B Vulci	Amasis painter	ABV 150,7; H75	
2	Louvre F99	n-a	related to BMN painter	ABV 228; H76	
3	Boston 99.522	hy	530	H77; CVA 2 18	12A,2

Type 30A

BF
1	Erlangen M35	n-a	Vulci	510-500	H111	
2	Würzburg 197	n-a		510-500	H112	
3	Vatican 387	n-a	Vulci	510-500	H113	see below
4	Munich 1542	n-a			H110	

There is also a red dipinto on 3, consisting of at least an arc, and probably repeating the graffito.

Type 31A þ

BF
1	Boston 01.8035	n-a	Orvieto	520-510		CVA 1 28
2	Bologna 17	n-a	Bologna	510		
3	Naples	n-a				H108

RF
4	Munich 2307	type A	Vulci	Euthymides		ARV 26,1; H109 navel

I have not been able to identify or locate 3 in Naples; Hackl suggests that the mark is horizontal, not vertical as on 1-2. 4 can be read in either direction. I am not convinced that the similar marks on H114-5 have any· mercantile meaning and do not include them in the catalogue.

Type 32A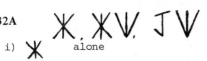

i) ✕ alone

BF
1*	Tarquinia RC1748	n-a	Tarquinia	Swing painter	(ABV 308,64)		
2	Munich 1473	n-a		540	CVA 7 52; H82		traces
3	London B251	n-a	Vulci	Painter of London B145	ABV 139,2		
4	Vatican 345	type A	Vulci	535		navel	⌐⌐
5	Munich 1461	Panath	Vulci	525	H83		
6*	Louvre Cp10599	n-a		520-10		Fig.3h	14B,13

RF
7	Syracuse 21138	col-kr	Gela	Chairippos painter	ARV 236,8

ii) ✕V

BF
8	Munich 2148	cup	Vulci	550-40	H85
9	Mus. Etruscum 247	amphora	Vulci		H86a
10	Berlin 1840	n-a		c.550, Etruscan	H86

I have not seen 10, but give the Museum's attribution.

iii) ⅃V

BF
11	Leiden PC43a	stam	Vulci	Group of Toronto 305	CVA 1 pl.52,6	
12	Naples Stg.175	stam		Group of Würzburg 199	ABV 289,25	Fig.3n
13	New York 96.18.51	stam	Vulci	Painter of Louvre F314	(ABV 388,5); Stamnos fig. 10	
14	Vatican 415	stam	Vulci	Painter of Louvre F314	(ABV 388,3)	see below
15	Vatican 421	hy	Vulci	510		
16	Mus. Etruscum 82	amph-ora?	Vulci			17E,15
17	Mus. Etruscum 84	amph-ora?	Vulci			

Von Bothmer notes that Philippaki's transcription of 13 is incorrect (Gnomon 39 (1967) 816). I saw no mark on 14 other than the kappa on the navel; therefore I do not know what to make of the strange cursive signs given in Albizzati's facsimile. It is possible that 16 and 17 are from the same tomb and that the mark is of type 11E,ii or iii (which is definitely not the case with 11, 12 and 15).

iv) ≠V

BF
18	*Munich 1645	n-a	Vulci	Uprooter class	(ABV 589,1); H87		
19	Naples 2787	n-a		near Group of Munich 1501	(Paral 153); H89	Fig.3i	11B,9
20	*Munich 1646	n-a			H88		

19 does not present exactly the specified mark as Heydemann's facsimile is not fully correct.

v) V

RF
21	Boston 13.191	oen	Gela	Chicago painter	(ARV 631,39)
22	Boston 13.197	oen	Gela	Chicago painter	(ARV 631,37)

The graffiti are noted by Bloesch in *Gestalt und Geschichte* (Festschrift K. Schefold) 88. I have omitted obviously Etruscan marks.

Type 33A ♀ and the like

 i) ♀

 BF, dipinto

1	Munich 1384	type B Vulci	Manner of Princeton p.	*ABV* 299,2		
2*	V.G. 50490 (M459)	n-a	imitates p. of Louvre F6	*ABV* 129		
3	Munich 1396	type B Vulci	Group E	*ABV* 135,39		1E,9
4*	Orvieto 299 graffito	type A Orvieto	near Group E	(*ABV* 138,6)		
5	Louvre E678	col-kr	Painter of Louvre F6	*Paral* 51,29	navel	
6	London B174	type B Vulci	Painter of London B174	(*ABV* 141,1); H73; BMC	thrice	
7	Naples 2498	n-a	Painter of London B174	*ABV* 141,5; H72	twice	
8	Florence 92167	type B Orvieto	Affecter	Mommsen no 14	twice, and under lid	
9	Bonn inv. 42	lid	Affecter	Mommsen no 116	twice	
10*	Louvre F201	n-a	Antimenes painter	(*ABV* 274,120)		

The additional line which Villard gives in *CVA* for 5 did not seem to me to be an original part of the mark.

 ii) ᴏᴴ

 BF, dipinto and graffito

11	Munich 1706	hy	Vulci	510	Hackl p.59 and pl. 2

 graffito

12	Orvieto	foot	Orvieto		*Annali* 1877 pl. L,17
13	Orvieto	?	Orvieto		*Annali* 1877 pl. L,18

 iii) ♉

 BF

14	Vatican G49	oen		Painter of Vatican G49	*ABV* 535,25
15	Munich 1791	oen	Vulci	Painter of Vatican G49	(*ABV* 536,29)

 iv) Various similar marks

 BF, dipinto

16	Munich 1415	type B Vulci		related to Leagros group (Lullies)	*CVA* 1 31

 graffito

17	Louvre F220	n-a		520-15	*CVA* 4 23
18	Conservatori 31	oen	Spina	520-10	*CVA* 1 14
19*	Copenhagen Th. 62	oen		Class of Vatican G47	(*ABV* 431,7)

 RF

20	Boston 01.8079	lek	Gela	Pan painter	*ARV* 557,114
21	Leningrad St. 1863	pel	Pantikapaion	Group G	(*ARV* 1464,63)

15, 19 and 20 are similar to ii but lack the final stroke. The rest are a mixed bunch. 18 is very worn.

 v) ᴏᴧ , not quite as ii

 BF

22	Vatican 431	hy		Rycroft painter	*ABV* 337,29	navel 8E,4
23	Basel BS412	Panath		Eucharides painter (who?)		Fig.3p 8D,73

The two are not cut by the same hand.

vi)

BF

| 24 | Louvre F338 | oen | Vulci | Painter of Vatican G49 *ABV* 536,35 |
| 25 | ex Hall, Tynemouth | oen | | (B) |

24 has merely a single short stroke attached to the right 'leg'.

Type 34A

	BF						
1*	Florence 3839	n-a		related to Antimenes painter	(*Paral* 123,12[5])	Fig.3k	21A,7
2*	Tarquinia 676	n-a	Tarquinia	520-15	(*CVA* 1 pl. 5,2)	Fig.3j	
3*	Louvre Cp10694	n-a		520-10		Fig.3l	
4*	Louvre F358	lek		c.500	(*AJA* 54 (1950) 314-6)	Fig.3m	

Type 35A

	BF, dipinto					
1	Louvre E707	n-a	Etruria	c.550	ΣΤΗΛΗ (Festschrift Kontoleon) 100	Pl. 2
2	Louvre E708	n-a		c.550		
3*	V.G. 50735 (M463)	n-a		BMN painter	(*ABV* 226,5)	
4*	Tarquinia 622	n-a	Tarquinia	535-30		

On all four vases the stem of the mark starts on the navel. The shape of 1 is closer to type 36A, but as the two Louvre vases are obviously a commercial pair I keep them together; Pottier's reading as *phi* is certainly wrong (*Catalogue* (1896) 541). I join Schauenburg (ΣΤΗΛΗ l.c.) in pronouncing 'non liquet' over the origin of the two; they are not from any orthodox Attic workshop. There are also apparently meaningless scratches on the foot of 4.

Type 36A

	BF				
1	Christchurch 42	type B	Group E	*CVA* 1 6	navel
2	Christchurch 43	type B	P. of Vatican mourner	*CVA* 1 6-7	navel
3*	Vatican, Astarita 45	n-a	Swing painter	(*ABV* 697,73bis)	Fig.3q
4*	Louvre	oen foot?			Fig.3r

Type 37A A large mark over the whole foot, usually approximating to the form

	BF				
1*	Tarquinia 662	n-a	Tarquinia	Antimenes painter	(*ABV* 269,42)
2*	Tarquinia RC976	n-a	Tarquinia	Antimenes painter	(*ABV* 269,45)
3*	Boulogne 422	n-a		Antimenes painter	(*ABV* 270,62)
4*	Tarquinia RC6991	n-a	Tarquinia	Antimenes painter	(*ABV* 271,72)
5*	Tarquinia 630	n-a	Tarquinia	Antimenes painter	(*ABV* 271,76)
6*	Tarquinia RC3015	n-a	Tarquinia	Antimenes painter	(*ABV* 272,101)
7*	Louvre CA4702	n-a		515	
8*	Würzburg 219	n-a		520-10	
9*	Tarquinia 605	n-a	Tarquinia	510	traces
10*	Louvre Cp966	lid		(on F35, but not belonging)	

8 is made up of four, not three lines.

Type 38A

BF

1	Erlangen M80	n-a	Vulci	525-20	*CVA Munich* 8 83; H5O1	
2*	Aberdeen 684	n-a		Manner of Antimenes p.	(*ABV* 278,29)	
3	Hillsborough 5517	hy		near Euphiletos p.(R.)	Raubitschek 6	
4*	Würzburg 314	hy	Vulci	near Priam painter	(*ABV* 334,2)	large

Type 39A

BF, dipinto

1	Munich 1410	type A	Vulci	Painter of Munich 1410	*ABV* 311,1; H9
2	Munich 1411	type A	Vulci	Painter of Munich 1410	*ABV* 311,2; H1O
3	New York 98.8.14	n-a		Painter of Munich 1410	*CVA* 4 17

RF, graffito

4	Duke University N.C.	lek		Berlin painter	*Paral* 345,194ter

Type 40A

BF

1	Naples RC199	n-a	Cumae	Group of Würzburg 199	(*ABV* 288,18)	
2	V.G. 50409 (M5O2)	n-a		510-500		navel

2 appears to be a faultily drawn attempt at the shape.

Type 41A Dipinto

BF

1*	Naples 86399 (RC219)	type B	Cumae	530	
2	New York O6. 1O21.88	n-a		Group of Toronto 305	*CVA* 4 25

SECTION B

Type 1B

i) Unremarkable

BF

1	Paris, Nearchos	col-kr		Ready painter	*Paral* 53		6B,4
2	Compiègne 988	n-a	Vulci	Group of Compiègne 988	*ABV* 285,4		8E,54
3	Munich 1519	n-a	Vulci	Painter of Munich 1519	(*ABV* 394,4); H325		
4	Munich 1564	n-a	Vulci	near p. of Munich 1519	(*ABV* 394,3); H324		
5	Vatican 398	n-a	Vulci	near p. of Munich 1519	*ABV* 395,7; H327		
6	Vologna 75	oen	Bologna	520-500			
7	Syracuse 52263	sky	Centuripe	Theseus painter	*ABV* 520,20; *ZPE* 17 (1975) 155	⊢∏	
8*	Taranto 20198	cup	Taranto	510-500		∏ǁ	
9	Lenningrad St.62	type B			H328		
10	*Munich 1629	n-a	Vulci		H326		

RF

11	Berlin 2159	type A	Vulci	Andokides painter	(*ARV* 3,1); H331	twice
12	Louvre F2O3	type A		Andokides painter	*ARV* 4,13; H332	twice
13	Leningrad P2O	pel		Smikros	(*ARV* 21,4)	
14*	Madrid 11O1O	bell-kr		Villa Giulia painter	(*ARV* 619,19); (B)	
15	Basel market	pel		Painter of Louvre G539	(*Paral* 482,1bis); *MM Sonderliste N* 4	
16	Orvieto Faina 23 b.g.	cup	Orvieto?		H333	
17*	Gela 27305	lek	Gela	c.470		

The cross-bar of the *alpha* slopes up to the right on 2-6 and 11-15, down on 7, and is horizontal on 8 and 17. 5 masquerades as Vatican 399 in some places.

 ii) With a pronounced 'Boeotian' *alpha*

BF
18	Ferrara 16290	lek	Spina	c.490	*CVA* 2 33
19	Ferrara 16291	lek	Spina	c.490	*CVA* 2 34

They are from tombs 1096 and 227 respectively. The cross-bar of the *alpha* slopes up to the right.

 iii) With an associated mark, as Fig.3t

BF
20*	London 1911.4- 12.1	oen	Class of Louvre F348	(*ABV* 428,2)	Fig.3t
21	Louvre F348	oen	Class of Louvre F348	*ABV* 428,1	

The cross-bar slopes down to the right.

 iv) Retrograde

BF, dipinto
22*	Würzburg 242	type B Vulci	550		mostly on navel

graffito
23	Syracuse 23257	col-kr Syracuse	520-15	*NSc* 1903 328-9	

RF
24	Munich 2322	n-a	Vulci	Nausicaa painter	*ARV* 1683

The cross-bar slopes up to the right on 22 and 23, down to the right on 24.

Type 2B A⋀ AN and AM

 When these abbreviations are ligatured it is not always easy to distinguish between them and so I put them under a single heading.

 i) A⋀ , unligatured

BF
1	New York 49.11.1 pel	Acheloos painter	*ABV* 384,19

It may belong to sub-group ii, but the letters are printed separately in *JHS* 71 (1951) 40.

 ii) A⋀

RF, red dipinto
2	Vatican 16526	stam	Vulci	Hermonax	(*ARV* 484,21)

glaze dipinto
3	Villa Giulia 20845	stam	Cerveteri	Birth of Athena painter	*ARV* 495,6
4	Villa Giulia 20846	pel	Cerveteri	Birth of Athena painter	*ARV* 495,2
5	Villa Giulia 20847	pel	Cerveteri	Birth of Athena painter	*ARV* 495,3
6	London E410	pel	Vulci	Birth of Athena painter	(*ARV* 494,1)
7	Swiss private coll.	pel		Birth of Athena painter	*ARV* 495,4
8	ex Swiss market	pel		Birth of Athena painter	*Paral* 380,5bis

graffito
9	London E177	hy	Vulci	Altamura painter	(*ARV* 594,56)
10	ex Rome market	n-a		Naples painter	*ARV* 1099,48

2 is not as published by Philippaki fig. 13. 4 and 5 are published as having , but the mark is the same as on the rest. The publication of 7 has M, but is perfunctory and this mark was probably intended. 8 is not graffito, as stated in the auction catalogue. The cross-bar of the *alpha* slopes consistently down to the right.

 iii) ⋀ (11, 16 and 17), ⋀ (12) and ⋀ (13-15, the circle with a central dot on 14)

BF

| 11 | Rhodes 13064 | hy | Kamiros | Class of Red-line p.'s kalpides | BSA 70 (1975) 152, 39 | | |

RF

12	Louvre G44	type A	Vulci	Euthymides	ARV 27,3	Fig.3s	
13	Vatican 17852	stam	Vulci	Aegistheus painter	(ARV 505,16); Stamnos fig.12		
14	Berlin 2188	stam	Vulci	Hephaisteion painter	ARV 298,1; H592		6F,1;22F,4
15	Oxford 1965.121	stam		Dokimasia painter	ARV 414,34; Stamnos fig.13		25F,5
16*	V.G. 50646 (M682)	col-kr		Painter of London E489	(ARV 546,8)		

b.g.

| 17 | Oxford 1918.28 | cup | | 475-50 | CVA 1 40 | | |

The cross-bar of the *alpha* slopes down to the right on 12 and 16.

iv) **A⁄** (which can be resolved as **AN** or **AV**)

BF

18*	Villa Giulia	type A	Cerveteri	Priam painter	(Paral 146,8ter)	Fig.3v	traces
19	Naples RC214	lek	Cumae	515-10		Fig.3u	
20*	Palermo 1895	lek		c.500	(Brommer 51,29)		
21	Villa Giulia 20842	n-a	Cerveteri	late	ML 42 286		
22	Leningrad St.73	lek	Vulci	early fifth century			

b.g.

| 23 | Marseilles | cup | Marseilles | 525-500 | Villard 27 | | |

RF

24	Louvre G46	type A		Nikoxenos painter	ARV 220,3		
25	ex Swiss market	cup		Brygos painter (Cahn)	MM Sonderliste N 76		Etruscan graffiti
26	Copenhagen 3882	lek		close to Two-row p.	ARV 727,(5)		
27	Louvre G188bis	stam		alien foot	(Stamnos 81)		↳↳
28	Cambridge 1937. 26	pel		Aegistheus painter	ARV 506,21		
29	London 1921. 7-10.2	hy		Group of Polygnotos	ARV 1060,138		8F,8;21F,7
30	Harvard 1959. 187	Nolan		Group of Polygnotos	(ARV 1059,126)	Fig.3y	11F,17
31	Naples Stg.270	Nolan	Capua	Painter of Munich 2335	(ARV 1161,1)		11F,20
32	Syracuse 22886	bell-kr	Kamarina	Eupolis painter	ARV 1073,3		18C,3
33*	Syracuse 42527	pel	Syracuse	Orpheus painter	(ARV 1104,12)		
34	Palermo undetermined	lek	Selinus	late	ML 32 341		
35*	Tarquinia Gr.II 21804	oen foot?	Gravisca	c.450			
36	Adria (20,31)	cup foot	Adria				
37	Adria (20,32)	cup foot	Adria				
38	Adria (20,34)	cup foot?	Adria				K

18 is defectively published in *Quad.V.G.* 1 (no page numbers). 23 is included to demonstrate the possibilities of expanding the abbreviation. A version of 30 is given in *The Frederick M. Watkins Collection* no 29. The cross-bar slopes down to the right on 19, 21, 24 and 28, up to the right on 20, 22, 27 and 30.

v) Similar, retrograde

BF

| 39 | Tarquinia RC5165 | type B | Tarquinia | Rycroft painter | (ABV 336,8) | Fig.12a | 1F,7 |
| 40 | Munich 1416 | type A | Vulci | Leagros group | **A**BV 367,90 | | to right ✓ |

RF

| 41 | Florence undetermined | cup | Populonia | | ML 34 399 | | |
| 42 | Adria (21,1) | cup foot | Adria | | | | |

Is 39 *CII suppl.* ii 377? The cross-bar slopes up to the right on 42, down on 40 and 41. There is a second graffito on 42, not noted by Schoene; I read it as ι]ερά (*ZPE* 34(1979) 277).

vi) **AN**, not in ligature

	BF						
43*	Syracuse 7731	type B	Megara Hyblaea	530-20			
44	Oxford 210a	n-a	Gela	510	CVA 3 10		
45*	London B233	n-a	Gela	510-500			
46	Amsterdam 3303	sky	Greece	c.500	ABV 581,15	s.l. 3,5	
	undetermined						
47	Adria (21,26)	cup foot	Adria	c.450			6D,14

The cross-bar slopes down to the right on 43-5.

vii) **AN**, in ligature, variously joined

	BF				
48	Ferrara 16351	oen	Spina	Class of Copenhagen 68	CVA 2 16
	RF				
49	Munich 2346	pel	S.Italy	Pig painter	ARV 565,32bis

On 48 the cross-bar slopes down to the right, on 49 up.

viii) Some oddities which probably belong here

	BF					
50	Tübingen 717 (D61)	oen	Attica	Painter of Vatican G49	ABV 535,5	s.l. 3,4
	RF					
51	Louvre G138	cup		Triptolemos painter	ARV 365,61; Pottier	
	b.g.					
52	Adria (20,30)	cup	Adria			

50 makes little sense the other way up, and finds its most natural place here; I gave a fictitious number for it in *BSA* 70 (1975) 157, no.29. 52 may be a ligature of **MA**.

Type 3B **AΓ**

i) A simple ligature

	BF, graffito and dipinto					
1	Vatican 359	n-a	Vulci	near Towry White p.	ABV 142	
	RF, graffito					
2	Berlin 2521	cup	Vulci	Mykonos painter	CVA 2 39	
2a	Edinburgh 1877.29	hy		Polygnotos	(ARV 1032,59)	18C,14a; 4F, 5; 21F,4
3*	Naples 967	bell-kr	S.Agata	Painter of Oxford Grypomachy	(ARV 1428,5)	see below
	b.g.					
4	Munich 6498	lekan-is	Cumae	c.450	H601a	16F,1
5	ex Pourtales	lekan-is			H601	16F,2

It is not easy to interpret 1; *CII* 2188 explains as retrograde ARICA, but the very close association of the final two letters would then be a little perplexing. If we seek an explanation more in terms of other marks, some combination of **AΓ** with retrograde **API** may suit, though it means splitting an apparently unitary mark. 3 has two other marks, K and **ΔI**. Autopsy has shown that my reading of 2a (*Greece and Rome* 21 (1974) 151,12) is incomplete.

ii) A ligature with the *pi* sprouting from the top of the *alpha*

	RF				
6	London E201	hy	Vulci	Kleophrades painter	(ARV 189,77)
7	Leningrad St. 1217	lid		late	
	undetermined				
8	Adria (21,2)	cup foot	Adria	c.450	

I use Beazley's reading of 6.

iii) Not in ligature

RF

9	Louvre G519	bell-kr		400-390	CVA 5 6	with II

Type 4B AT

i) Dipinto

BF, glaze

1	*Munich 1597	n-a	Vulci	Red-line painter	(ABV 601,21); H49
2	*Munich 1593	n-a	Vulci	Red-line painter	(ABV 602,30); H48
3	*Munich 1607	n-a	Vulci	Red-line painter	(ABV 603,45); H50
4	Mannheim Cg 40	n-a	Vulci	Red-line painter	ABV 603,51
5*	Basel Z363	n-a		Red-line painter	(?Paral 301,24bis)
6*	Florence	foot	Vulci?		
	red				
7	New York 98.8.15	n-a		Painter of Toronto 313	CVA 4 53

5 is not as described by Beazley in *Paralipomena*, but Dr. Schmidt tells me that there is no other Züst vase which fits that description. 6 is among the Campana fragments and is from a small closed vase.

ii) Various

BF

8	Vulci 64217	type B	Vulci	550-40	Quad.V.G. 3 28-30	
9*	Taranto 4360	type B	Taranto	Bucci painter	(ABV 315,4)	Fig.3w
	RF					
10	Vienna 2698	cup	Cerveteri	Makron	ARV 471,193	see below
11	Louvre G124	cup		Douris	ARV 436,110	
12	Orvieto Faina 103	cup	Orvieto?	Painter of Faina 103	ARV 951,4; H490	
13	Orvieto	n-a	Orvieto	c.450	H489	
14	London E771	pyxis	Naukratis	c.400	BMC; H491	s.l. 4,2
15	Villa Giulia	cup foot	Cerveteri		NSc 1937 419,41	
	undetermined					
16	Adria (20,33)	sky	Adria			ligatured

10 is a complex, obscured graffito, but AT may be separate from the other pair of marks. The cross-bar is horizontal save on 9, 11 and 14 where it slopes down to the right.

Type 5B

BF

1	Louvre F259	n-a		Leagros group	ABV 375,210	
	RF					
2	Louvre G65	pel		Smikros	ARV 21,5	Fig.1e 3A,6
	undetermined					
3*	Louvre	foot		ex E732		Fig.3x

None of these are worn ligatures of *alpha* and *rho*. 3 has another graffito.

Type 6B B

Some similar marks are included under type 7D; the reasons for the respective allocations can be found in the commentary.

i) Alone, dipinto

BF

1	Zurich 9	hy	Tarquinia	Zurich painter	CVA 1 17	
2*	V.G. 50697 (M436)	hy		Zurich painter	ABV 92,2	navel
3	Louvre F45	hy		Zurich painter	ABV 92,3	navel
4	Paris, Nearchos	col-kr		Ready painter	Paral 53	1B,1
5*	Louvre F233	n-a		c.520	(CVA 4 pl.45,1)	

The position of 1 is not clear from the text of *CVA*. 5 is painted lengthwise on the narrow sloping inner face of the foot.

 ii) Dipinto and graffito, with an additional mark

BF

6	Louvre E858	n-a		560	(*CVA* 1 pl.6,1)	Pl. 4

Pottier does not give the full dipinto.

 iii) With ⫤

RF

7*	Syracuse 17250	Nolan	Gela	Briseis painter	(*ARV* 410,57)	Fig.3z	3E,41
8	Syracuse 21196	lek	Gela	Oionokles painter	*ML* 17 456; *ARV* 649,43		3E,42

 iv) B|

BF, dipinto

9	Munich 1553	n-a	Vulci	c.525	*CVA* 8 18		10A,9

RF, graffito

10	Turin 4126	col-kr	Vulci	Agrigento painter	*CVA* 2 5		24B,6
11	ex London market	lek		Bowdoin painter	*Paral* 406,126bis		

 v) Various

BF

12*	Louvre Cp10352	cup		Group of Courting cups (*Paral* 82,9)			

RF

13	Vatican 16566	type B	Vulci	Diogenes painter	*ARV* 248,3		17C,2
14*	Syracuse 24009	col-kr	Kamarina	Boreas painter	(*ARV* 538,26)	Fig.4a	19F,14
15*	New York, Noble	Nolan	Gela	Dresden painter	(*ARV* 655,3)	Fig.3aa	
16	Gela Navarra 116/B	pel	Gela	Hasselmann painter	*CVA* 3 14		

12 has plain *beta*. As can be seen from Fig. 4a the B on 14 is not simple.

Type 7B ⟂E

BF

1	Louvre F205	type A		530	*CVA* 3 14	
2*	Gela	lek	Gela	510-500		

RF

3	Oxford 1891.323	lek	Vico Equense	470	*CVA* 1 32	after N
4*	New York, Noble	pel		Class of Pan p.'s small pelikai	*Paral* 389	
5*	Basel Z348	col-kr		Leningrad painter	(*ARV* 567,9)	
6	Munich 2379	col-kr		Painter of Bologna 228	(*ARV* 512,10); H469	⌐⊢⊢⎮⎮
7	Aleria 1954	kr foot	Aleria	c.450	*BICS* 25 (1978) 81	
8	Paris, Rodin 1052	bell- kr		Barclay painter?	*ARV* 1068,1	
9	Naples? undetermined	sky			H471	varia
10	Adria (21,28)	cup foot	Adria		H470	11F,11

Type 8B Δ|

 i) Retrograde

BF, dipinto

1	Louvre F60	n-a	Vulci	Swing painter	*ABV* 308,74; H22	navel
2	Louvre F31	type B		Witt painter	*ABV* 313,1; H21	navel
3	Louvre F48	hy		540-30	*CVA* 6 46	

There is a small dot after the *delta* on 2. As Pottier's facsimile shows, 3 is not completely preserved. For H2O see 17A,14.

ii) Orthograde

	BF, dipinto					
4*	Louvre E825	n-a		570-60	(*CVA* 2 pl.9,3)	s.1.6,1
	b.g. dipinto					
5	Rhodes 13467	n-a	Kamiros	c.510	*BSA* 70 (1975) 152,42	
	graffito, BF					
6	*Munich 1805	oen	Vulci			
	RF					
7*	ex Segregakis	col-kr		Manner of Göttingen p.	(*ARV* 235,9); (B)	
8	Oxford, Miss.	pel	Athens?	Myson	*ARV* 238,7	21A,102
9	Zurich 418	Nolan		Berlin painter	*CVA* 1 31	
10*	ex Rome market	hy		Harrow painter	(*ARV* 276,71 or 72); (B)	
11	ex Goluchow 34	n-a		Oionokles painter	*ARV* 646,10	
12	Frankfort KH	lek		P. of Paris Gigantomachy	(*ARV* 423,120); (B)	
	b.g.					
13*	Naples	lekan-is		475-50		
14*	London, V & A	lekan-is		475-50		
15	Ferrara 22073	bowl	Spina	450-400?	*St.Etr.* 46 (1978) 312	numerals

5 also has a large *psi*-shaped graffito over the whole foot. The first letter of 6 is not fully triangular.

Type 9B EV

i) Mostly plain

	BF, dipinto					
1	Leningrad St.35	type B		Lydan		with ❙
	graffito					
2	Oxford 1965.119	hy		Manner of Lysippides painter	*CVA* 3 23	
3*	Milan, Lerici B.116/1	n-a	Cerveteri	510		
4	Naples Stg.118	lek		Theseus painter	*ABL* 251,56; H464	
5	Hamburg 1917.987	hy		510-500	*CVA* 1 38	
6	Vatican 430	hy	Vulci	510-500		
7	Vatican G20	n-a	Vulci	510-500		
8*	Louvre F356	lek		510-500		Fig.4c
	RF					
9*	Basel, Borowski V67.33	col-kr		Göttingen painter (who?)		1F,1 (q.v.)
10	Malibu	n-a		Kleophrades painter (Frel?)	see below	
11	Louvre G55	stam	Tarquinia	Kleophrades painter	*ARV* 187,58; H468	
12	Louvre G354	col-kr		Flying-angel painter	*ARV* 281,35	
13	Basel BS451	stam		Triptolemos painter (Schmidt)	see below	
14	New York GR585	sky	S.Italy	Pan painter	*ARV* 559,150	
15*	Tarquinia 682	col-kr	Tarquinia	Early mannerist	(*ARV* 583,1)	
16	Munich 2407	stam	Vulci	Harrow painter	*ARV* 1641	
17	Dublin 1920.316	hy		450		Fig.3bb
	undetermined					
18	Adria (21,8)	cup foot	Adria			
19	Adria (20,1)	cup foot	Adria			⅌

10 is mentioned in *Greek Vases in the J. Paul Getty Museum, 1/1/77 to 3/4/77* 35. 13 is published by Schmidt, *Festschrift Jantzen* 141ff and with a proper, but defective facsimile by Isler-Kerenyi, *Stamnoi* 48. Notable for medium and provenance:

BF, black, non-glaze dipinto
20 London 1910. lek Naukratis *Naukratis* i 654
 2-22.248 foot

I assume that the vase was figured since it was repaired in antiquity; perhaps RF as likely as BF.

 ii) With $

BF
21 Capua 153 type B Capua 510 *CVA* 2 4 Fig.4b
22 Warsaw 142322 type B 510-500 *CVA Goluchow* 15

One cannot tell from the *CVA* publication of 22 whether the vases are by the same hand; they are
certainly very similar.

 iii) With ⲕ and a mark of type 12E

RF
23 Providence n-a Vulci Providence painter *ARV* 635,1 12E,24
 15.005
24 Vatican 16572 n-a Vulci Providence painter *ARV* 635,2 12E,25

 iv) With Γ

25 Ferrara T281 sky Spina c.470 (St Valentin *NSc* 1927 163
 class)
 v) With stemmed *upsilon*

BF
26 London B29 lek 540 *ABL* 29 s.l. 1,33
RF
27 Vienna 1073 hy P. of Berlin hydria *CVA* 3 38
28 Cambridge 1937. pel 440-30 *CVA* 2 63
 25
29 Leningrad P229 pel Washing p. EVKPA
 (Peredolskaya)
30* Boulogne 667 Nolan Ethiop painter (*ARV* 666,15) Fig.3cc
 b.g.
31 Villa Giulia foot Cerveteri *NSc* 1937 416,24
 48897

Type 10B

Throughout, the cross-bar of the *alpha* slopes to a greater or lesser degree up to the right.

 i) In ligature

BF, dipinto
1* Florence 3826 type B 530-20 navel
 graffito
2* London 1928. type B Swing painter (*ABV* 306,38)
 1-17.1
3 Munich 1567 n-a Bareiss painter (von *CVA* 8 16; H377
 Bothmer)
4* Bristol H802 n-a 530-25 (*AJA* 60 (1956) Fig.4d
 pl.113)
5* Syracuse col-kr Montagno c.510
 di Marzo
6* Palermo 1926 lek c.500 (*ABL* 50, 1133) Fig.4e
RF
7 Naples 3373 n-a Naples 480-70 H379 before E
8 New York GR597 cup Capua Penthesilea painter *ARV* 888,151
undetermined
9 Adria (21,16) cup Adria 525-500 H382
b.g.
10 Adria (21,14) sky Adria H380
11 Adria (21,15) bowl? Adria H381
12 Naples cup Cumae *ML* 22 459

Much of the foot of 7 is now plaster and I saw no E, but it may have been lost. The shape of the following mark is not known to me, but it may well belong here:

	BF				
13	Orvieto Faina 79	Panath Orvieto			H378

ii) Similar, but with a more markedly Etruscan *alpha*

	BF				
14	Leningrad St.43	oen			3E,48
	RF				
15	Brussels R307	Nolan	Berlin painter	*ARV* 203,94	

One may doubt whether an *alpha* was intended at all on 14.

iii) As i, retrograde

	RF				
16	Aleria 1903 undetermined	cup	Aleria	Circle of Antiphon p.	
17	Adria (21,17)	cup foot	Adria	500–475	H383
18	Adria (21,19)	cup foot	Adria		H383
19	Adria (21,18)	cup foot	Adria	500–475	H384

If 16 has a cross-bar it is extremely defective. I assume a misprint in Hackl over 19 ('pl. 21,16' for 'pl. 21,18'). Hackl also seems to connect 18 with the fragment Bc 12, but the *CVA* publication (pl. 39,7) does not support him.

Type 11B ⊓╫ and the like

i) ⫛

	BF				
1	Louvre F20	n-a		Affecter	Mommsen no 23; H80
2	Florence 3862	n-a		Affecter	Mommsen no 74; H78
3	London B152	n-a	Vulci	Affecter	Mommsen no 76; H81
4	Swiss market	n-a		Affecter	Mommsen no 77
5	Boston 99.517	n-a	Vulci?	Affecter	Mommsen no 78; H79
6	Villa Giulia 15537	lid		Affecter	Mommsen no 117

ii) ⊓╫

	BF					
7*	Louvre F1	type B		P. of Tarquinia RC3984	(*Paral* 132,3)	Fig.4j
8*	Basel 1921.356	type B		c.540	see below	
9*	Naples 2787	n-a		near p. of Munich 1501	(*Paral* 153)	Fig.3i 32A,19

8 is given to the same hand as 7 by Descouedres; the mark lacks the top horizontal. The vase has a normal foot, but 7 has the graffito cut on a narrow inner moulding.

iii) Similar marks

	BF					
10	Würzburg 198	n-a	Vulci	near Painter N	(*ABV* 224,1)	
11	Warsaw 142451	cup		c.510	(*CVA Goluchow* 16) Pl. 7	1OF,1
12	Frankfort VF 344	Panath		Painter of Oxford 218b	*Paral* 150,3	
	RF					
13	Louvre G142	cup	Chiusi?	Makron	*ARV* 471,198	
14	Louvre G247	sky	Nola	480	Pottier	

The basis of 10 is a closed *heta*; Langlotz' facsimile is incomplete. As Pl. 7 demonstrates, the *CVA* reading of 11 is misleading; better is de Witte, *Description des collections d'antiquités conservées a l'Hôtel Lambert* no 23.

iv) H̵E

BF
15	Würzburg 257	type B		520	H385	
16*	London B249	n-a	Vulci	510	(*CVA* 4 pl.61,1)	Fig.4f
17*	Capua 149	oen	Capua	Workshop of Athena painter IV	(*ABV* 527,12)	Fig.4g

RF
18	New York 29.131.4	sky		Brygos painter	*ARV* 381,176	
19	Taranto 4550 undetermined	mug	Taranto	Syriskos painter	(*ARV* 263,53)	Fig.4i
20	Adria (21,20)	cup foot	Adria		H388	

v) Similar, accompanied

BF
21	Louvre F221	n-a		520-10	*CVA* 4 24	Fig.4h	
22	Berlin 2081	cup-sky	Nola	Manner of Haimon p.	*ABV* 567,635		9E,71

RF
| 23 | Gela, Navarra 68 | lek | Gela | c.470 | *CVA* 3 5 | with ‖ |

21 is not easy to read; I agree with Pottier on the intended sign, and regard the lower part of the added vertical on the *epsilon* as accidental or foreign to the original mark; however it is included in Fig.4h. The similarity of 22 to Taranto 20328 (9E,72) is discussed in the commentary, p. 213. Furtwängler's reading could be inaccurate and the mark may be *mu-epsilon*, as on the Taranto vase.

vi) Similar to iv, with a very short left vertical

RF
24	Louvre G180	stam	Vulci	Siren painter	*ARV* 289,2; *Stamnos* fig.15
25	London E440	stam	Vulci	Siren painter	(*ARV* 289,1); *Stamnos* fig.15

Note the comma-shaped mark in the vicinity of the main graffito on both vases.

vii) Possibly related

RF
26	New York 08.258.58	cal-kr	Cerveteri?	Kleophrades painter	*ARV* 185,36
27	Aleria 2100	cup	Aleria	475-50	

Type 12B *Theta*

i) Crossed, alone

BF, dipinto
1	Geneva MF153	n-a		Painter of Akropolis 606	*CVA* 2 pl.52,1-4		
1a	Rhodes 10616	type B	Ialysos	550	*BSA* 70 (1975) 152,34		
2	London B181	type B	Vulci	Painter of Nicosia olpe	(*Paral* 196,8ter)		
3*	Tarquinia RC1330	type B	Tarquinia	540-30		navel	
4	Rhodes 10604	type B	Ialysos	530-20	*BSA* 70 (1975) 152, 33		
5*	Louvre F328	oen		510			
6*	Louvre F248 graffito	n-a		510	(*CVA* 4 28)	navel	25A,10
7	Bologna 20	n-a	Bologna	520-10			

RF
| 8* | Milan A1605 | bell-kr | Spina | c.430 | (*CVA* pl.9,1-3) | Fig.4l |

9	Madrid 11075	bell-kr		Pothos painter	ARV 1189,10	
10	Louvre G503	bell-kr		Kadmos painter	ARV 1185,18	18C,42; 14F,2; 26F,3
11	Boston 03.821	n-a	Suessola	Kadmos painter	(ARV 1186,29); CB iii 83	18F,1

8 is an untidy mark, rather a cross and circle. Beazley also connects Vienna 732 (18C,76), which has *phi* and unit strokes (*AJA* 45 (1941) 598).

ii) Crossed, with ʁ or a similar mark

BF

12*	Louvre F383	n-a		Red-line painter	(*Paral* 300,3)	Fig.4k
13	Würzburg 207	n-a		Acheloos painter	ABV 383,14	
14*	Florence 3857	n-a		near Acheloos p.	(ABV 372,165)	
15	London B467	kyath-os	Vulci	Caylos painter	(ABV 648,229)	
16	Leningrad St. 136	oen	Vulci			
17	Leningrad St. 140	oen	Nola?			

Stephani does not give a cross in the *theta* of 17. Possibly related, but with a tidier additional mark:

b.g.
| 18 | Halle Univ. 256 | cup | Nola? | c.500 | | |

It is published by Bielefeld, *Die Antiken-Sammlung des archäologischen Instituts der Universität Halle* 60 and pl 11,2.

iii) Dotted

undetermined
| 19 | Adria (20,5) | cup foot | Adria | | | |

b.g.
| 20 | Adria (20,3) | cup | Adria | | | |

Type 13B Μ

I give some close groups first, then the remaining material

i) BF

| 1 | Bologna 39 | n-a | Bologna | 510 | | |
| 2* | Bologna 59 | vol-kr | Bologna | 510-500 | | |

ii) BF

| 3* | Louvre F333 | oen | | Gela painter | (ABL 215,202) | Fig.4m,
navel | |
| 4* | Louvre F344 | oen | | Gela painter | (ABL 214,194) | navel | 16B,3 |

The intended reading is probably ϟ . There are other lines on the navel of 4, but not in the same hand; they are probably random furrows.

iii) RF

5	Syracuse 21834	pel	Gela	Syracuse painter	Paral 383,32	1F,2
6	Riehen, Granacher	hy		Syracuse painter	Paral 383,35	1F,3
7*	London market (Ede)	Nolan		Providence p. (Robertson)	Coins and Antiquities cat. 54 AN574	Fig.4bb

iv) RF

| 8 | Leningrad P216 | oen | | Shuvalov painter | (ARV 1207,30) |
| 9* | Dunedin F54.80 | oen | | Shuvalov painter | (ARV 1206,6) |

I take 9 (J.K. Anderson, *Greek Vases in the Otago Museum* pll. 10-11) to be the vase mentioned in Beazley's notes as 'Cast. oen. Shuvalov p.'

v) The remainder

BF, dipinto

10	Louvre E830	n-a		Tyrrhenian group	ABV 102,105	navel
11	Würzburg 240	type B	Vulci	Circle of Lydos	ABV 117,25	
	graffito					
12	Bareiss 20	n-a		Affecter	Mommsen no 79	
13	Naples 2466	type A		related to Antimenes painter	(ABV 281,14)	red stripe
14	Berlin 1861	n-a	Vulci	Leagros group, Antiope group I	(ABV 371,149)	
15	Naples RC192	hy	Cumae	Eucharides painter	(ABV 397,35)	
16	Oxford 1879.163	n-a		500-490	CVA 3 10	
17	Berlin 1880	n-a				
18	ex Paris market	type B	Marion		Vente Drouot 1887 90	
19*	Rouen	oen		late		

RF, dipinto

20*	Naples 126062	n-a		Harrow Painter	(ARV 273,16)	
21	Würzburg 518	stam	Vulci	P. of the Yale lekythos	ARV 652,7; Stamnos fig.13	8D,54
	graffito					
22	Riehen, Kuhn	mug		P. of Berlin 2268	ARV 158,68	
23	Louvre G53	hy	Vulci	Tyszkiewicz painter	ARV 294,64	
24	Stockholm	col-kr		Matsch painter	ARV 284,5	
25	London, Embiricos	lek		Eucharides p.? (Robertson)	Auktion 26 134	
26*	Munich 2333	Nolan		Painter of Altenburg 273	(ARV 1194,1); (B)	
27*	Tübingen E105	bell-kr	Cumae?	430-20	(B)	18C,39

undetermined

| 28 | Adria (21,22) | stem-less | Adria | | | ⋀⋀‖ |

b.g.

| 29 | Rhodes 10790 | pel | Ialysos | 480-60 | BSA 70 (1975) 162,144 | |

From the brief description supplied by the museum 19 does not seem to be one of the vases mentioned by Philippart, *Ant.Cl.* 1 (1932) 244. A similar mark was reported on Malibu 73.AE.23 (Robertson, *JPGMusJ* ii 57-60), but a facsimile supplied by Dr. Frel gives an additional stroke, making it a numerical mark (Fig.14r). Schoene's reading of 28 is slightly inaccurate; the final two signs are simple unit strokes. The letter is cut on an unspecified number of East Greek and other vases found at Paestum, *AA* 1956 397 and *Archaeology* 9 (1956) 31-2.

vi) With an additional mark, ⋁ or a tick

RF

| 30* | Syracuse 33503 | Nolan | Gela | Syracuse painter | (ARV 519,20) | |

b.g.

| 31* | Gela 640 | oen | Gela | 475-50 | | Fig.4aa |

undetermined

| 32 | Gela | lek foot | Gela | | NSc 1956 334 | |

30 is very similar to 32, though the size of the latter is not reported; 30 and 31 are both very small marks.

Type 14B N

The shape and alignment of most of these marks rules out a reading as three-bar *sigma*. Some marks that probably should be so read are placed in sub-group v.

i) Early BF vases

dipinto

1*	Orvieto, Faina 45	col-kr Orvieto	Painter of Louvre F6	(*ABV* 125,27)		
2*	V.G. 50527 (M266)	type B	540		navel	
3*	Boulogne 88	type B	Group E	(*ABV* 134,26)	navel	traces

graffito

4	Conservatori 77	n-a	Painter of Louvre F6	*Paral* 51,8	retrograde	
5	Villa Giulia 24994	n-a	Painter of Vatican 309	*ABV* 121,6		traces
6*	V.G. 50683 (M430)	hy	Lydos	(*ABV* 108,14)		
7	Cambridge 59	type B	Princeton painter	*ABV* 298,10	retrograde	
8	Germany, private	type B	560-550	*Auktion* 26 93		к
9	ex Rome, Hercle	n-a Vulci	560	*St.Etr.* 34 (1966) 320		

The last stroke on 1 is not simple.

ii) A later group of BF neck-amphorae

10	Louvre F239	n-a	Painter of Munich 1519	*ABV* 394,7
11	Vienna 3601	n-a Cerveteri	Painter of Munich 1519	*ABV* 394,8
12	V.G. 50387 (M489)	n-a	near P. of Munich 1519	(*ABV* 394,1)

It is not easy to judge from Masner's facsimile whether 11 (his 227) also has EE on the foot, or whether the letters belong to another vase.

iii) Others

BF, dipinto

13*	Louvre Cp10599	n-a	520-10		
14	Syracuse 21926	n-a Gela	520-10	*ML* 17 471	navel

graffito

15	Copenhagen NyC 3385	cup	530	*Festschrift Jantzen* 125ff	
16	ex Swiss market	oen	Kuhn class	*Paral* 144,6	
17	ex Swiss market	oen	Guide-line class	*ASV, MM* no 12	
18	Nicosia C650	cup Cyprus	c.520 (stemless)	Myres 1554	
19	Naples RC229	oen Cumae			

RF

20	Louvre G420	bell-kr	Phiale painter	*ARV* 1018,72	18C,10
21	Vienna	n-a		(B)	

The publication of 14 in *ML* is not quite exact.

iv) RF, dipinto

22*	Villa Giulia 47836	n-a Cerveteri	Kleophrades painter	(*ARV* 184,18)	retrograde
23*	Sarasota	n-a	Harrow painter	(*ARV* 272,9); (B)	
24	ex Swiss market	lek	Circle of Phiale p.	*Auktion* 34 170	

Beazley read *mu* on 22; see the commentary.

v) Shape and alignment support the reading *sigma*

RF

25	Vienna 3691	cup Cerveteri	Epidromos painter	*ARV* 118,8	
26	Bologna 244	col-kr Bologna	Alkimachos painter	(*ARV* 531,40)	18C,8
27	Villa Giulia 47121	cup Cerveteri		*NSc* 1937 417,26	

undetermined

28	Adria (20,19)	cup Adria foot	

vi) In shape near a *nu*, but clearly not intended to be a simple *nu*

BF
29*	Boulogne 13	n-a	Michigan painter	(*Paral* 157,9⁷)	Fig.4n
30*	Boulogne 85	n-a	Michigan painter	(*Paral* 157,9⁶)	Fig.4p

Type 15B N| and |N

It is usually possible to distinguish between these two forms since the *nu* is rarely reversible (by upturning) but retains an archaic form.

i) N|

BF, dipinto
1	Bonn inv. 11	n-a		Painter of London B76	*ABV* 86,7; H31	
2*	Tarquinia 624	type B	Tarquinia	Princeton painter	(*Paral* 130,15bis)	
3	Orvieto, Faina	type B	Orvieto?		H32	red DΓV
4	London B31	lek		Painter of London B31	*ABV* 452,1	
5*	Boulogne 575	n-a		535-30		20A,16
6	Syracuse 20958	lek	Gela	Wraith painter	*BSA* 70 (1975) 165 (B)	black
7*	ex-Peek graffito	hy				black
8	Palermo, Mormino 304	lek	Selinus	520-10	*CVA* 1 1	
9	Oxford, Miss.	n-a		Painter of Würzburg 314	*Paral* 147,1	
10	London B523	oen	Vulci	Guide-line class	(*ABV* 532,4)	
11	Oxford 249	lek	Gela		Gardner pl. 8	Fig.4q

RF
12	Gela, Navarra	pel	Gela	Pig painter	*CVA* 3 9
13	Vienna 696	n-a		Achilles painter	*ARV* 988,10

6 is probably not glaze.

ii) |N

BF
14	Germany, private	col-kr		School of Lydos	*Auktion* 40 61	⊞
15*	London B282	n-a	Sicily	Red-line painter	(*ABV* 602,27)	Fig.4r

RF
16	Leningrad P211	cal-kr		Kleophon painter	(*ARV* 1144,14)

iii) Indistinguishable whether N| or |N

BF
17	Würzburg 351	oen		Painter of Würzburg 351	*ABV* 436,1; H145	8E,38
18	*Munich 1772	oen		Class of Vatican G47	(*Paral* 185); (H175)	
19	Palermo 1825	lek		Group of arming lekythoi	*ABL* 201,11	

RF
20	Berlin 2274	cup	Chiusi	c.500	
21	Palermo	lek	Lipara	c.400	*Lipara* ii pl. n,7

Hackl includes 18 in his group XIX, my type 14E, but Jahn (85) gives the reading N| .

Type 16B *Pi*

i) Dipinto

BF, glaze
1*	Tarquinia 680	n-a	Tarquinia	Group of Toronto 305	(*Paral* 124,2bis)
2*	Aberdeen	n-a		520-10	

red
3*	Louvre F344	oen		Gela painter	(*ABL* 214,194)	13B,4

RF, red
4	Cab.Med. 852	askos		Curtius painter	*BSA* 70 (1975) 159 n.36; (B)

ii) Graffito, alone

	BF						
5*	Tarquinia 626	type B	Tarquinia	540-30			navel
6	Louvre F295	hy		Manner of Lysippides painter	ABV 260,31		
7	Munich 1744	oen		c.520			
8	Louvre F242	n-a		510-500	CVA 4 27		21A,83
	RF						
9	Nicosia C654	cup	Marion	connected to Chelis group			
10	Louvre G179	hy		500	CVA 6 41		
11	Copenhagen 5	hy	Capua?	P. of the Yale oenochoe	ARV 503,24		
12	ex Goluchow 28	n-a		near Ethiop painter	ARV 666,1		
13	Oxford 1879.166	cup		manner of Euaion painter	ARV 799,9		
14	London E142	sky	Nola	Agathon painter	(ARV 978,7); BMC		
15	London market	pel		Manner of Sabouroff p.	ARV 852,6		
16*	Edinburgh 1872. 23.10	Nolan		Dwarf painter	(ARV 1011,12)		
17*	Cambridge 1955.9	Nolan		Dwarf painter	(ARV 1011,8)		
18	Naples 3183	pel	Egnatia	Polygnotos	(ARV 1032,57)		
19*	Mt. Holyoke 1929 BS II4	Nolan		Polygnotos	(ARV 1031,44); (B)		
20*	Waiblingen	Nolan		Polygnotos	(ARV 1031,50); (B)		
21	Berlin 2345	Nolan		Polygnotos	(ARV 1031,42)		
22	Vienna 1065	bell-kr		Pothos painter	CVA 3 43		18C,44
23	New York 41. 162.137	cup		Marlay painter	ARV 1279,45		
24	Leningrad St. 1694	plate					

For 9 see Beazley, *Some Attic vases in the Cyprus Museum* 38.

iii) After K

	RF						
25	Berlin 2332	Nolan	Nola	Achilles painter	ARV 988,20		
26	London E380	pel	Vulci	Barclay painter	(ARV 1067,4)		

iv) With TP or TP|

	RF						
27	New York 06. 1021.187	bell-kr		Polydektes painter	ARV 1069,1		20F,6
28	Leningrad P210 b.g.?	stam		Kleophon painter	(ARV 1143,3); H492		20F,9
29	ex Barone	plate?	Nola		CIG 8346 l		20F,13

See also 32

v) With various other marks

	Patterned						
30	Naples RC2	col-kr	Cumae	c.500		Fig.6f	3D,15; 1F, 14; 7F.4
	RF						
31	Louvre G436	Nolan		Phiale painter	ARV 1015,1; H612		8F,10; 11F,16
32	Louvre G491	bell-kr		Polygnotos	ARV 1029,26	Fig.4z	3D,17; 20F,3
33	Syracuse	bell-kr	Syracuse	Christie painter	(ARV 1049,44)	Fig.4s	18C,22
34*	Malibu	sky		400-380	(Sotheby 24/4/67 175)		�haⅡ
35	Brunswick	sky		400-380	CVA 34		Δ hⅠⅠⅠⅠ
36*	Ferrara T597	sky	Spina	390-370			ΔΡⅠ

Type 17B

i) Unligatured ΓΑ

BF, glaze dipinto

1	New York 06. 1021.29	n-a		560-50	CVA 4 11		
	graffito						
2	Hannover 1962. 78	type B	Montalto?	Group E	CVA 1 21		
3	Tarquinia RC6147	n-a	Tarquinia	520	H456		
4*	Palermo 1908	n-a		520-10	(Brommer 145,29)	Fig.5a	numerals
5	Verona 18 Ce	n-a		near Edinburgh p. (Riccioni)	CVA 3		
6*	Belfast (1318)	cup	Boeotia?	late sixth century		Fig.4u	

RF

7	Vatican 17841	stam	Vulci	Berlin painter	ARV 208,148; H460; Stamnos fig.12		
8	Leningrad P52	type C		Flying-angel painter	(ARV 279,1); H459		
9	Petit Palais 307	type C	Capua	Flying-angel painter	ARV 279,2		
10*	Villa Giulia	type C	Cerveteri	Flying-angel painter	(ARV 279,3)	Fig.4v	
11*	Villa Giulia	type C	Cerveteri	Flying-angel painter	(ARV 279,4)	Fig.4x	
12	Louvre G212	type C		Flying-angel painter	ARV 279,5; H457b		
13	Leningrad P51	type C		Flying-angel painter	(ARV 279,6)		
14	Vienna 3724	type C	Cerveteri	Flying-angel painter	ARV 280,9		
15	Louvre G220	type C		Flying-angel painter	ARV 280,11		
16	Milan, Scala 416	type C		Tyszkiewicz painter	(ARV 292,33); CB iii 17		
17	Leningrad P59	n-a		Tyszkiewicz painter	(ARV 292,36); H457		
18	Louvre G223	pel		Syleus painter	ARV 250,16		

On 10, 15 and 17 the two letters touch but hardly form a ligature. The mark is on the navel of at least 9, 11, 12, 14, 15 and 18. 11 is not fully preserved, but the full mark can scarcely be doubted. The cross-bar of the *alpha* is mostly level; on 7 and 18 it slopes up to the right. Type C amphorae by the Flying-angel painter without this mark are Boston 98.882 (19B,5), Brussels A2483-5 (foot lost) and Munich 8726.

ii) As i, with a mark of type 25B

RF

19	Cab.Med. 390	pel	Vulci	Syleus painter	ARV 250,13		25B,5
20*	Florence PD538	stam		Syleus painter	(ARV 251,31)	Fig.4t	25B,7

The cross-bar slopes up to the right. One cannot tell from de Ridder's copy whether our mark is on the navel of 19; it is so on 20.

iii) Ligatured

BF

21	vacat						
22	Vienna	lek		fifth century?	H462		

iv) ΓΑΝ

BF

23*	Florence 72732	pel		505-495	(RA 1926 288 fig.4)	Fig.4w	
24	Leningrad St.21	type B			H230		

v) ΓΑΛ

BF

25	Hamburg 1917. 472	n-a	Vulci	Antimenean	CVA 1 26		W
26	London B179	type B	Vulci	520-10	(CVA 3 pl.32,2); H323		Ligature

27	London B219	n-a	Vulci	Leagros group	(*ABV* 370,125)	⌐
28	Munich 1550	n-a	Vulci	510		
29	St. Louis, Mylonas	n-a	Vulci	510-500	*Auktion* 11 327; H322	see below
30	*Munich 1624	n-a	Vulci		H321	

The cross-bar of the *alpha* slopes up to the right except on 25 and 28. The number of 29 appears as 328 in the plates of the *Auktion* catalogue; also the reading given there differs from that of Hackl - both have an additional K, but Hackl gives this form of the main mark, the catalogue a form as iv.

Type 18B ⑪|

	BF, dipinto						
1	Munich 1681	hy	Vulci	Lydos	(*ABV* 108,12); Hackl p.62	Pl. 17	
2	Louvre F244	n-a		Group of Toronto 305	*Paral* 124,2[6]		
3	Florence 3838	n-a		510-500	(H104)	Fig.4y	26B,3
4*	Florence 3821 graffito	oen		510-500			5E,25
5	Karlsruhe B31	oen	Nola	Gela painter	*ABV* 473		
6	London 1899. 2-18.67	lek		Edinburgh painter	*ABL* 216,1		
7*	London market	oen	Perugia	500-490, white ground			
8*	V.G. Castellani	oen		490			
9	Compiègne 1009	oen	Vulci	near Athena painter	*ABV* 529,54		
	RF						
10	Leningrad P35	col-kr		Myson	(*ARV* 240,43)		
11	London E473	col-kr		Pan painter	(*ARV* 551,11)		
12	Leningrad P125	Nolan	Capua	Nikon painter?	*Paral* 514	with K	
13	Palermo	lek	Lipara	Circle of Icarus p.	*Lipara* ii pl n,4	with ΔΔ	
14	Cambridge 1890.4 b.g.	askos	Cyprus	c.400	*CVA* 2 38	s.l. 1,45	
15*	Naples RC245	oen	Cumae		(B)		

There are two oddities about 1: the *iota* has a protuberance at the base, suggesting that the original letter may have been a *lambda*; and between the letters, joining the *phi* right, below, is the clear 'ghost' of a *psi*-shaped mark, out of alignment with the other two letters. I know of nothing else quite like it. 3 was reported to have only *theta* by Hackl, but though faint, *phi iota* is clear enough. The scene on 7 is a hoplite bearing down on another. 8 is an unnumbered vase with a wretched maenad-on-bull scene. Beazley's attribution of 13 is quoted in *Lipara* l.c.

Type 19B ⋈⋈ etc

i) ⋀⋀

	BF						
1*	Orvieto 273	n-a	Orvieto	near Euphiletos p.	(*ABV* 325)	over whole foot	
2*	Salerno 1152	type B	Fratte	Priam painter	(*ABV* 331,8)	navel, large	
	RF						
3	Aleria 1768	col-kr	Aleria	Leningrad painter	(*Paral* 391,23bis)		25F,6

ii) ⋈⋈

	BF?						
4*	Florence	foot	Vulci?				
	RF						
5	Boston 98.882	type C	Capua	Flying-angel painter	*Paral* 354,7; H195		ΓΛVΧΝ
6	Oxford 1966.853	pel		c.440	*Beazley Gifts* 313		
6a*	Monash University	pel		Nausicaa painter (Boardman)		with I	

4 is from a small closed vase among the Campana fragments.

iii) Tending to the shape

BF, dipinto

7	Oxford 1910.804 graffito	n-a		Leagros group	*CVA* 3 9	Pl. 9	9E,62
8	Toledo 23.3123	n-a		Swing painter (Bothmer)	*CVA* 1 39		
9	Harvard 60.315	n-a	Vulci	510–500	*AJA* 60 (1956) 12		

RF

| 10 | Munich 2343 | n-a | | Alkimachos painter | *ARV* 513,27; H194 | | +ll:l |
| 11 | Altenburg 284 | pel | Nola | 450–40 | *CVA* 2 pl.47,7 | | |

iv)

BF

12	Vatican 338	n-a	Vulci	Affecter	Mommsen no 80		
13*	Palermo 1917	n-a		520–10	(Brommer 47,26)	Fig.5c	after A

RF

14*	Florence 4010	n-a		Epimedes painter	(*ARV* 1044,4)		
15	London market	n-a		Epimedes painter	*ARV* 1044,5		
16	New York 06. 1021.116	n-a		Lykaon painter	*ARV* 1044,1		
17	Naples 3089	stam	S.Agata	Group of Polygnotos	(*ARV* 1050,4)	Fig.5b	18C,63a

The reading of 17 in Heydemann is incorrect; the mark is followed by a single stroke. A similar mark is given in *CVA* for Madrid 10913 (*ARV* 1054,51), but Beazley read the mark as *kappa*.

Type 20B

BF

1	Naples RC 204	type B	Cumae	near p. of London B495	(*Paral* 190)	large
2	Mus. Etruscum 83	n-a	Vulci			

RF

| 3 | London E44 | cup | Vulci | Onesimos | (*ARV* 318,2) | |
| 4 | London E274 | n-a | Vulci | Niobid painter | (*ARV* 604,53) | |

Heydemann's version of 1 is erroneous. 2 may not belong here; reference should be made to the facsimile in *Museum Etruscum*.

Type 21B and the like

i)

BF, dipinto

1*	London B518 graffito	oen	Vulci	Briachos class	(*ABV* 432,3)	Pl. 10a-b
2	Berlin 1837	n-a	Nola	Diosphos painter	(*ABL* 238,121)	
3	Cracow 1253	n-a		Diosphos painter	*ABL* 238,126	
4	Louvre F386	n-a	Vulci?	Diosphos painter	(*ABL* 238,131); Pottier	
5	Leningrad St.74	type B		Diosphos painter (Gorbunova)		

RF

| 6 | Munich 2427 | hy | Vulci | Kleophrades painter | *AK* 1 (1958) 7; *ARV* 1632 | MNESI |
| 7 | Basel, Wilhelm | hy | | Kleophrades painter | *AK* ibid.; *ARV* 189,73 | MNESI |

1 is incompletely rendered in o.c. 653.

ii)

BF

8	Laon 37971	hy	Capua	520–10	*CVA* 1 10

RF

| 9 | Kassel T682 | stam | Vulci | Circle of Polygnotos | *CVA* 1 55 |

iii) Various shapes

RF

10	Berlin 2164	Panath	alien foot		
11	London E168	hy	Syriskos painter	(*ARV* 263,43)	
12*	Trieste S423	hy	Syriskos painter	(*ARV* 263,45)	Fig.5d

Type 22B Swastikas and akin

i) Anti-clockwise swastika

BF, dipinto

1	Istanbul	col-kr	Xanthos	Manner of Sophilos (Metzger)	*Xanthos* iv no 193	
2	London 1863. 4-30.3 graffito	n-a	Kamiros	c.525, b.g.	*BSA* 70 (1975) 153,54	
3	Tarquinia 679	n-a	Tarquinia 515-10		(*CVA* 1 pl.12,2); H116	see below
4	Tarquinia RC3302	n-a	Tarquinia 520-10		H117	

Metzger does not decide whether 1 is red or poorly fired glaze. There are other marks on 3, attempts at a charicature and one finished version (see cover design).

ii) Defective examples

BF

5	London B228	n-a	Vulci	Leagros group, Gr. of London B228	(*ABV* 370,122)	

RF

6	Louvre G192	stam	Vulci	Berlin painter	*ARV* 208,160; *Stamnos* fig 16; H118a	
7	Munich 8738	stam		Berlin painter	(*ARV* 1633)	Fig.5e
8	Munich 2476	lek			H118	

The shape of 6-8 is the same, probably not intended to be a swastika. 6 and 7 seem to have been cut by the same hand, using a very broad point.

iii) Clockwise swastika, with added dots

BF, dipinto

9	Conservatori?	n-a		520-500?	*RM* 38-9 (1923-4) 84

Type 23B Pentalpha

BF

1	Oxford 208	n-a	Cerveteri	Lysippides painter	*CVA* 3 penult. fig.; (*ABV* 256,15)	traces

RF

2	Villa Giulia 15708	cup		Sabouroff painter	*ARV* 839,35	other graffiti

Type 24B ⧖ and ⧗

i) ⧖

BF

1*	ex London market	n-a		Group E (Johnston)	*Sotheby 1/7/1969* 100	lengthwise
2*	Louvre Cp12263	col-kr		Painter of Bologna 48	(*Paral* 155,1)	Fig.5g
3	Villa Giulia 47934	n-a	Cerveteri	510-500	*ML* 42 561-2	after A
4	Leningrad St.266	col-kr		Ionic		
5	Mus. Etruscum 172	oen	Vulci			lengthwise before ✔

RF

6	Turin 4126	col-kr	Vulci	Agrigento painter	CVA 2 5	lengthwise 6B,10
7	Copenhagen 148	pel	Nola	Ethiop painter	ARV 665,10	with O
8*	Perugia 123	askos		c.400		Fig.5f
	b.g.					
9	Taranto 20347	cup	Taranto	late sixth century	ASMG 8 (1967) 65	
10	Naples	cup		(stemless)	(B)	

The attribution of 4 is given to me by the museum.

ii) KOX , dipinto, BF

| 11 | London B260 | n-a | Vulci | 550-40 | (CVA 4 pl.64,2) | Pl. 6 | 13F,7 |

iii) ⧖

BF, dipinto

12	Munich 1490	n-a	Vulci?	520	CVA 8 23	
	graffito					
13	Vatican G22	n-a	Vulci	Painter of Munich 1519	ABV 393,1	NⱯ
14	Vatican G34	lid	Vulci	belonging to G22?		
15	Genoa 1169	n-a	Capua?	510-500	CVA 1 4	
16	Cab.Med. 251	stam		500-490	CVA 2 57	see below

12 is a cursive figure-of-eight version. 16 has the sign following Ɩ , with the same collocation, or something like it, repeated.

Type 25B Ⱶ

The first four only approximate to this shape

	BF						
1	London B214	n-a	Vulci	Group E	(ABV 141)	navel	traces
2	London B235	n-a	Vulci	P. of London B235	(Paral 152,1)	Fig.5h	
3	New York 1974.	n-a		520	CVA 4 54		
	11.1						
4	Berlin 1867	n-a		Leagros group	(ABV 371,149);H106		
	RF						
5	Cab.Med. 390	pel	Vulci	Syleus painter	ARV 250,13; H107		17B,19
6	Toledo 56.58	stam		Syleus painter	CVA 1 40; (ARV 251, 30)		
7*	Florence PD538	stam		Syleus painter	(ARV 251,31)	Fig.4t	17B,20

2 and 3 have similar marks. 6 is incompletely given in CVA, according to the text.

Type 26B ⋀⋀ and ᛘ

i) ⋀⋀

	BF						
1	Berlin 1713	n-a	Cerveteri	Botkin class	(ABV 169,5); H70		
2	Berlin 1714	n-a	Cerveteri	Botkin class	(ABV 169,6); H71		
3	Florence 3838	n-a		510-500	H104	Fig.4y	18B,3

Hackl wrongly gives a mark of sub-group ii for 3.

ii) ᛘ

	BF					
4	Boston 89.258	n-a	Tarquinia?	520	CVA 1 37; H105	
5*	Birmingham 1611.	n-a		Group of Toronto 305	(Paral 125,5ter)	
	85					
6	Warsaw 147864	cup		510-500	CVA 1 23	
	RF					
7	Warsaw 142332	n-a		Euthymides	ARV 27,8	
8	Laon 371023	Nolan	Nola?	Pan painter	ARV 553,33	

5 has the splayed outer strokes of sub-group i.

SECTION C

Type 1C

1	Brussels A134	stam	Vulci	Polygnotos	*ARV* 1027,1;	
					Stamnos fig. 17	
2	London 98.7-15.1	stam		Christie painter	(*ARV* 1048,35);	18C,21
					Stamnos fig. 17	

Type 2C

	BF				
1	Compiègne 1032	oen	Vulci	Athena painter	*ABV* 527,13
	RF				
2	New York 18.74.1	stam	Capua	Deepdene painter	*ARV* 498,2
3*	Capua 209	pel	Capua	Painter of London E356	(*ARV* 778,6); (B)
4	Altenburg 285	pel	Nola	Painter of London E356	*ARV* 778,9

Type 3C A⊙

1	Oxford 1885.659	stam		P. of the Yale oenochoe	*ARV* 501,1; H487
2	London E446	stam	Capua	P. of the Yale oenochoe	(*ARV* 502,4); H486
3	Louvre G368	bell-kr		P. of the Yale oenochoe	*ARV* 502,10
4	Florence 4025	oen		Orchard painter	(*ARV* 527,73); H488
5	Leningrad St.2168	pel			

2 has been published as AO, but the dot of the *theta* is clearly visible.

Type 4C

| 1 | Naples 3097 | Nolan | Nola | Triptolemos painter | (*ARV* 362,17) |
| 2 | Louvre G137 | n-a | | Dutuit painter | *ARV* 307,6 |

Type 5C

1	Naples Stg.249	n-a		Eucharides painter	(*ARV* 226,6)
2	Louvre G202	n-a		Eucharides painter	*ARV* 226,4
3	London E279	n-a		Eucharides painter	(*ARV* 226,1)
4	London E278	n-a	Vulci	Eucharides painter	(*ARV* 226,2)
5	Vienna 3729	stam	Cerveteri	Argos painter	*ARV* 288,1
6	Louvre G413	stam	Cerveteri	Hermonax	*ARV* 484,22

Type 6C

i) With N

1	Oxford 524	stam	Gela	Villa Giulia painter	*ARV* 620,30	
2	Villa Giulia 983	stam	Falerii	Villa Giulia painter	(*ARV* 621,33)	
3	Naples 3093	Nolan	Nola	Achilles painter	(*ARV* 988,17)	
4	Naples 126055	hy		Persephone painter	(*ARV* 1013,13)	Fig.5k
5	Warsaw 142337	n-a		P. of Louvre symposium	*ARV* 1070,3	
6	Cab.Med. 447	hy		Class of London E195	*ARV* 1076,5; H201	
7	London E195	hy		Class of London E195	(*ARV* 1077,1); *JHS* 51 (1931) 122	
8	Vienna 608	n-a		P. of Louvre Centauromachy	*ARV* 1093,93; H200	

9	Leningrad P201	hy		P. of Louvre Centauromachy	(*ARV* 1094,99)	
10	Castle Ashby	Nolan		P. of Leningrad 702	(*ARV* 1193,2); *CVA* 27	
	b.g.					
11	Naples 3500	bell- kr		450-425	(*BCH* 35 (1911) pl 9,1)	Fig.5j

The *nu* is on the left save on 2 and 5. For 11 see also Beazley, *CVA Oxford* 2 vii and 108-9. I am not convinced that Bologna 174 (H199; *ARV* 593,43) has this mark and so omit it.

ii) Alone

	b.g.				
12	Villa Giulia 45750	amphora	Cerveteri	'Fine VII'	*NSc* 1937 413,5
	other				
13	Adria (22,3)	cup	Adria	'di creta grisastra'	

Type 7C

	BF					
1*	Civitacastellana 814	col-kr	Falerii	520-10	(*CVA Villa Giulia* 2 11)	Fig.5i traces
	RF					
2*	Villa Giulia 1342	col-kr	Falerii	Göttingen painter	(*ARV* 234,6); (B)	
3	Leningrad P32	col-kr		close to Göttingen p.	(*ARV* 236,3)	

Type 8C ╪

	BF						
1*	Basel Z365	oen		c.510		twice	
	RF						
2*	Vatican 16548	hy	Vulci	Carpenter painter	(*ARV* 179,3)	Fig.5l	9E,84
3	London E444	stam	Vulci	Berlin Painter	(*ARV* 208,149); *Stamnos* fig.12		
4	Orvieto 1044	stam	Orvieto	P. of the Yale lekythos	*ARV* 657,1		

Type 9C ╪,Ɛ and ⱪ

i) ⱷ

	Six's technique				
1	London B697	cup	Kamiros	510-500	*BSA* 70 (1975) 158, 80; *BMC*
2	London B698	cup	Kamiros	510-500	*BSA* ibid. 73
	b.g.				
3	Naples	cup	Cumae		*ML* 22 459

A similar mark is given in *Museum Gregorianum* for Vatican 16568 (hydria by the Berlin painter) but the version is incorrect (corrected in Fig.14f). One of the marks on New York 06.1021.69 (4D,5) may be a sidelong version.

ii) Ɛ

4	New York 17.230. 13	lek		Achilles painter	*ARV* 994,105		
5	Oxford 1914.733	n-a		Group of Polygnotos	*ARV* 1058,120		
6	V.G. 50431 (M695)	cal-kr		Polydektes painter	(*ARV* 1069,3)		

iii) ⱪ

7	Belfast 58.13	cal-kr	Catania	Altamura painter	*ARV* 591,19	Fig.5n	
8*	Agrigento C1539	col-kr	Agrigento	Painter of London E489	(*ARV* 548,40)	Fig.5m	18C,7

Type 10C

1*	ex San Simeon	Nolan		Durham painter	(*ARV* 1193,1); (B)
2*	Madrid 11113	Nolan		Durham painter	(*ARV* 1193,2); (B)

Type 11C

1*	Syracuse 20966	lek	Gela	480-70		Fig.5x	
2*	Palermo V745	Nolan	Gela	Alkimachos painter	(*ARV* 530,14); (B)		
3*	Florence 4015	hy		450-40		Fig.5p	16E,11
4	Basel market	lek		Phiale painter (Cahn)	*MM Sonderliste N 34*	Fig.5w	20F,2

Type 12C

1	Louvre G201	Nolan	Nola	Berlin painter	*ARV* 201,63	
2	Oxford, Miss.	Panath	Capua	Nikoxenos painter	*ARV* 221,6	
3	Compiègne 1068	psyk	Vulci	Kleophrades painter	*ARV* 188,66	Fig.5r
4	Copenhagen 149	pel		Kleophrades painter	*ARV* 184,27	
5	London market	Nolan		Circle of Geras p. (Cahn)	*MM Sonderliste N 2*; *Sotheby 3/12/1973* 155	Fig.5q
6*	Vatican 17855	n-a		Syriskos painter	(*ARV* 261,23)	
7	Leningrad St. 1681	pel		Painter of Brussels A2482	(*ARV* 255,2)	
8	Villa Giulia 46940	pel	Cerveteri		*NSc* 1937 420,43	

On all save 2 (unknown) there is an additional stroke across or near one of the diagonals; 3,5 and 7 are 'retrograde'.

Type 13C Σ K O

1	London E331	Nolan	Nola	Achilles painter	(*ARV* 989,31); *BMC*; H496	
2	Naples 3211	pel		Group of Polygnotos	(*ARV* 1059,134); H497	18C,16

Type 14C AT⟨

1	Boston 95.32	cup	Cerveteri	Pamphaios, potter	(*ARV* 128,19); H448
2	Boston 95.35	cup		Poseidon painter	(*ARV* 136,2); H449
3	Boston 13.82	cup		Actorione painter	(*ARV* 137,2); H450

See Hoppin, *A Handbook of Red-figured Vases* ii 282 for the omission of H451.

Type 15C X E

1*	Vatican 17909	col-kr		Agrigento painter	(*ARV* 576,35)	☰ ⊕	
2	Glasgow 1883.32a	pel	Bomarzo	Hermonax	(*ARV* 485,30); see below	Fig.5t	
3*	Los Angeles 50.8.35	pel		Hermonax	(*ARV* 485,31)	Fig.5s	
4*	Tarquinia	pel	Tarquinia	c.450		Fig.5v	
5	Louvre G415	stam		P. of Louvre symposium	*ARV* 1070,2	twice	18C,28
6	Jena 355	hy		Painter of London E489	(*ARV* 548,55); *RM* 38-9 (1923-4) 95 n.3		
7	Villa Giulia	oen		Mannheim painter	*ARV* 1065,2; *RM* ibid. 84 fig.8b		
8*	Civitacastellana 5386	col-kr	Narce	Duomo painter	(*ARV* 1118,22)	Fig.5u	
9	Louvre G548	pel		Owen class	*ARV* 1220,3		

2 is *Catalogue of the Beugnot Collection* no 67. 4 is a small vase: serving girl with, A, mirror, B,
casket. There is another vague graffito on 7. The *epsilon* has an extra stroke on 9; it may be
accidental, but should be related to:

| 10 | V.G. 50444 | pel | | Owen class | | *(ARV* 1220,2) |
| | (M701) |

Type 16C

1	Brussels A717	stam		Smikros	*(ARV* 20,1); H502	Fig.6a
2	London E438	stam	Todi	Smikros	*(ARV* 20,3); *BMC;*	
					H503	

Previous published readings of 1 are faulty (see von Bothmer, *Gnomon* 39 (1967) 816). The lines
joining the two 'loops' seem accidental.

Type 17C

1*	Louvre CA2582	n-a		490-80		Fig.5y	
2	Vatican 16566	type B	Vulci	Diogenes painter	*ARV* 248,3; H197	navel	6B,13
3	Berlin 2478	lek	Nola	Bowdoin painter	*(ARV* 688,231);		
					H196		
4	Louvre G331	cup		Telephos painter	*(ARV* 819,42)`;		
					H198a		
5	Oxford 296	hy		Washing painter	*ARV* 1131,156;		
					H198		
6	Boston 06.2447	Nolan		Achilles painter	*ARV* 989,26		
	undetermined						
7	Villa Giulia	cup	Cerveteri	450-400	*NSc* 1937 426,93	with K	
		foot					

The reading of 2 in *Museum Gregorianum* ii pl 56,1 is completely erroneous and is followed in *CIG* 7389.

Type 18C Feet crossed by a simple line or lines

i) Three parallel strokes on either side of the foot, not continuous across the navel

1	Syracuse 22785	col-kr	Kamarina	Florence painter	*ML* 14 794;
	or 58				*ARV* 544,54
2	Syracuse 26564	col-kr	Kamarina	460-50	*BSA* 70 (1975)
					160 n.40

ii) Similar with double lines

| 3 | Syracuse 22886 | bell- | Kamarina | Eupolis painter | *(ARV* 1073,3); | 2B,32 |
| | | kr | | | *BSA* l.c. |

iii) Similar with single strokes

4*	Louvre Cp10751	col-kr		Florence painter	*(ARV* 541,2)		
5*	Bologna PU284	col-kr		Florence painter	*(ARV* 542,35)	Fig.7k	3E,49
6*	Ferrara T912	col-kr	Spina	Painter of London	*(ARV* 548,38); (B)		
				E489			
7*	Agrigento C1539	col-kr	Agrigento	Painter of London	*(ARV* 548,40)	Fig.5m	9C,8
				E489			
8*	Bologna 244	col-kr	Bologna	Alkimachos painter	*(ARV* 531,40)	14B,26	
8a*	Chicago 1911.456	hy		Leningrad painter	*(ARV* 572,88)		
9	Florence 73140	pel	Orvieto	Early mannerist	*(ARV* 586,51);		
					Hackl p.68		
10	Louvre G420	bell-		Phiale painter	*ARV* 1018,72	14B,20	
		kr					
11*	Vatican 16586	cal-kr		Phiale painter	*(ARV* 1017,54)		
12	Warsaw 142465	stam		Phiale painter	*(ARV* 1019,82);		
					Stamnos fig. 17		

13*	ex Rome market	cal-kr		Polygnotos	(ARV 1030,31); (B)		T
14	Oxford 1916.68	stam		Polygnotos	ARV 1028,6		9E,95
14a*	Edinburgh 1877. 29	hy		Polygnotos	G & R 21 (1974) 151,12		3B,2a; 4F,5; 21F,4
15*	Bari 1397	bell-kr		Group of Polygnotos	(ARV 1053,44)		
16*	Naples 3211	pel		Group of Polygnotos	(ARV 1059,134)		12C,2
17*	Bari 3196	hy		Group of Polygnotos	(ARV 1061,155)		17E,13
17a*	Perugia 81	stam		Group of Polygnotos	(ARV 1050,3)		
18*	Vatican 15531	stam	Vulci	Midas painter	(ARV 1035,1)		
19	London E453	stam	Vulci	Peleus painter	(ARV 1039,8); Stamnos fig. 17		
20	London E170	hy	Capua	Coghill painter	(ARV 1042,2)	Fig.13h	17F,4; 21F,5
21	London 1898. 7-15.1	stam		Christie painter	(ARV 1048,35); Stamnos fig. 17		1C,2
22*	Syracuse	bell-kr	Syracuse	Christie painter	(ARV 1049,44)	Fig.4s	16B,33
23	Vienna 1152	hy		Close to Christie p.	CVA 3 39		21F,6
24	Louvre G417	stam		Menelaos painter	(ARV 1077,2); Stamnos fig. 17		
25	Cambridge 1928.8	stam		Kleophon painter	(ARV 1142,5); Stamnos fig. 17		
26	Munich 2414	stam		Kleophon painter	ARV 1143,6		20F,10
27	Amsterdam 8212	stam		Kleophon p.(Gualandi)	BABesch 45 (1970) 51		⋈
28	Louvre G415	stam		P. of Louvre symposium	ARV 1070,2		15C,5
29	Munich 2410	stam	Vulci	P. of Louvre symposium	(ARV 1069,1); Stamnos fig. 16		
30*	Naples	bell-kr		450-40	(B)		
30a*	Edinburgh 1953. 22	hy		440			
31	Naples '1346'	stam		c.450-40	(B)		
32	New York 21.88.3	stam		Thomson painter?	(ARV 1072); Gnomon 39 (1967) 818		
32a*	Civitacastellana 5427	col-kr	Falerii	Ariana painter	(ARV 1101,3)		
33*	Louvre K343	col-kr		Duomo painter	(ARV 1117,7)		IO
34*	Bari 6251	col-kr		Duomo painter	(ARV 1118,14)		
35	Naples RC125	col-kr	Cumae	Hephaistos painter	(ARV 1115,21)		19F,12
36*	Milan A1814	col-kr	Spina	Hephaistos painter	(ARV 1115,25)		Φ, navel
37*	Oxford 1937.983	cal-kr	Spina?	Dinos painter	(ARV 1153,13)		
38*	Bologna 322	bell-kr	Bologna	Painter of Bologna 322	(ARV 1170,10)		K
39*	Tübingen E105	bell-kr	Cumae?	430-20	(B)		13B,27
40*	Ferrara T770	bell-kr	Spina	c.420	(B)		17E,49
41*	Naples Sp.2081	bell-kr	Suessola	420			see below
42	Louvre G503	bell-kr		Kadmos painter	ARV 1185,18		12B,10; 14F,2; 26F,3
43	Vienna 869	bell-kr		Kadmos painter	CVA 3 20		14F,1; 26F,2
44	Vienna 1065	bell-kr		Pothos painter	CVA 3 43		16B,22
45	London E504	bell-kr		Pothos painter	(ARV 1190,25)		14F,4
46	Dublin 1880.507	col-kr		Meleager painter	(ARV 1411,38)	Fig.13j	22F,6; 24F,6
47	Naples 151600	pel	Naples	Nikias p.(Johannowsky)	AJA 82 (1978) 222		14F,15; 19F,3; 26F,12
48	Salerno,Caudium T227	bell-kr	Caudium	c.400	AJA ibid 224-5		14F,6; 23F,3
49	Naples 2847	bell-kr	S. Agata	Erbach painter	AJA ibid 225		6F,2; 23F,7; 26F,13

50*	Naples 3245 (81572)	bell-kr		Painter of Naples 3245	(ARV 1438,1)		
51*	Vatican 9098	bell-kr		Painter of Louvre G521	(ARV 1441,3)		see below
52	Granada 414	kr foot	Almeria	c.430	BICS 25 (1978) 82		see below
53	Melbourne D1/ 1976	bell-kr		York Reverse group	see below	Fig.13t	22F,7
54	Louvre K253	bell-kr		Painter of Rodin 966 (McPhee)	see below		22F,8; 25F,7
55*	Bologna PU289	bell-kr					
56*	ex Rome market	cal-kr		b.g.	(B)		17F,10

The mark extends over only half the foot on 11. 31 is probably Naples 2419. 53 and 54 are published by McPhee, *Art Bulletin of Victoria* 1976 41-4; 53 is *ARV* 1450,6 and is also illustrated in *Christie 30/4/1975* 54. There are additional marks on: 5, a number of probable unit strokes; 51, *rho pi* on one side of the foot, ┌┤┤ on the other; 52, Phoenician graffito discussed, with bibliography in *BICS* l.c. The decoration of 30 is A, symposium (two men and a youth); B, two komasts.

 iv) A single line across the whole foot, often broken into three constituent parts

57*	Taranto 20931	col-kr	Convers-ano	Florence painter	(ARV 543,39); (B)		
58	Dublin UCD-143	bell-kr		b.g., 450-40	(Hope Heirlooms 12)		17F,9
59	Ragusa 26556	bell-kr	Kamarina	b.g., c.440	(G & R 21 (1974) 149)	Fig.6c	
60*	Syracuse 30296	bell-kr	Kamarina	b.g., c.440			
61*	Florence 75748	stam		Polygnotos	(ARV 1028,8)		
62	London E447	stam		Midas painter	(ARV 1035,3); Stamnos fig. 17		
63*	Syracuse 23912	hy	Kamarina	Manner of Peleus painter	(ARV 1041,11); G & R l.c. 151,9	Fig.6b	
63a*	Naples 3089	stam	S. Agata	Group of Polygnotos	(ARV 1050,4)		19B,17
64	Basel	hy		Group of Polygnotos (Schmidt)	AK 15 (1972) 136		6D,20
65	Munich 2394	bell-kr	S. Italy	Kleophon painter	ARV 1145,28; Hackl p.68		☰
65a*	Agrigento C2034	col-kr		Painter of Louvre Centauromachy	(ARV 1089,23)		22F,9
66	Naples 116116	col-kr		Painter of London E488	ARV 1120,1		19F,11; 22F,3; 23F,2; 24F,3
67	Vienna 641	col-kr		Late mannerist	ARV 1120,8		
68	Rhodes	hy	Rhodes?	c.430	BSA 70 (1975) 158,72		
69*	Milan A1869	col-kr	Spina	c.425			
70*	Bologna 320	bell-kr	Bologna	440-420			
71*	Harrow 65	col-kr		Duomo painter	(ARV 1118,18)	Fig.13q	
72*	Cracow Univ. 103	bell-kr	Naples	Dinos painter	(ARV 1154,32); (B)	Fig.6d	
73*	Bonn inv.76a	pel		Manner of Dinos p.	(ARV 1157,22); (B)		
74	Louvre G496	bell-kr		Pothos painter	ARV 1190,24; Hackl p.69		14F,3
75	Vienna 873	bell-kr		Pothos painter	CVA 3 22		
76	Vienna 732	bell-kr		Pothos painter	CVA 3 22		see below
77*	London E486	col-kr	Nola	Painter of Munich 2335	(ARV 1166,88)	Fig.10d	17E,41; 19F,17
78*	Florence 81948	hy	Populonia	Meidias painter	(ARV 1312,1)	Fig.13l	21F,13
79	Dublin 1880.509	bell-kr		420-10		Fig.13d	14F,12
80*	Ferrara T583B	bell-kr	Spina	late fifth century			graffito
81*	Palermo	hy	Chiusi	Nikias painter	(ARV 1334,29); (B)		see below

82	Vienna 1034	bell-kr	Lokri?	Nikias painter	*CVA* 3 24	
83	Vienna 538	bell-kr		c.400	Hackl p.69	
84	Vienna 892	bell-kr		Telos painter	*CVA* 3 26; Hackl p.69	1F,5; 22F,1
85	Vienna 955	bell-kr		related to p. of Oxford Grypomachy (Eichler)	*CVA* 3 27	see below

I do not know the precise form of the mark on 74, 83, 84 and 85 but place the last three here on the strength of *CVA* 3 24 'Fuss innen durch Strich zweigeteilt'. 82 and 83 may be identical. 76 has *phi* and six strokes on one side of the foot, five strokes on the other. Beazley gives several further lines in his sketch of 81. 85 also has *lambda alpha* (?) and ΓΙΙΙ . Hackl has J232, not J239 for 65.

SECTION D

Type 1D AⱺTI

All vases are BF. The cross-bar of the *alpha* slopes up to the right, even when retrograde (23 not known).

 i) AⱺI

1*	Munich 1703	hy	Vulci	Euphiletos painter	(*ABV* 324,26)	Pl. 11a-b'	2D,1
2	Copenhagen 111	hy		Euphiletos painter	*ABV* 324,29; H301		3D,1
3	Würzburg 312	hy	Vulci	Euphiletos painter	*ABV* 324,35; H300		
4	Erlangen M349	hy	Vulci	Euphiletos painter	(*ABV* 324,36); H299		
5	Vatican 418	hy	Vulci	Madrid painter	*ABV* 329,1; H303	Pl. 20	8D,18
6	Boston 60.790	n-a	Vulci	Group of Würzburg 199	*CVA* 1 34		
7	Vatican 423	hy	Vulci	related to Antimenes painter	*ABV* 281,6; H304		2D,2
8	Leiden PC2	hy	Vulci	520	*CVA* 1 pl.52,1; H302		
9	ex Rome, Hercle	n-a	Vulci	520-10	*St.Etr.* 34 (1966) 320		

The old number of 3 is U128, not U120, as Hackl.

 ii) AⱺTI

10	Cab.Med. 231	n-a		530-25	*CVA* 1 31; H297		
11	Würzburg 186	n-a	Vulci	Antimenes painter	*ABV* 271,77; H291	retrograde	
12	Tarquinia RC2450	n-a	Tarquinia	Antimenes painter	(*ABV* 271,80); *St.Etr.* 36 (1968) 242		
13	Berlin 1896	hy	Vulci	Manner of Antimenes p.	(*ABV* 277,11)		
14	Florence 3845	n-a		Eye-siren group	(*Paral* 125,7bis); H292		13A,5
15*	Tarquinia RC1804	n-a	Tarquinia	525	(*CVA* 2 pl.32,4)	Fig.6e	
16	Tarquinia 641	n-a	Tarquinia	520	H295; *St.Etr.* ibid 237	retrograde	
17	Munich 1562	n-a	Vulci	515	*CVA* 8 26; H290		
18	Munich 1488	n-a	Vulci	520-10	*CVA* 8 13; H289		
19	Gotha 31	n-a	Tarquinia	510	*CVA* 1 43	retrograde Λ	
20	Boston 80.160	n-a		510	*CVA* 1 35; H296		
21	Tarquinia 640	n-a	Tarquinia	510-500	H294; *St.Etr.* ibid 237		
22	Villa Giulia 20861	cup	Cerveteri		*NSc* 1937 385,17		
23	Orvieto, Faina 16	n-a	Orvieto?		H298		

There is no final *alpha* on 10, as reported by Hackl; see *CVA* l.c.

Type 2D ΓI

This is to a certain extent an arbitrary selection, largely of earlier vases; elsewhere the mark is certainly numerical. See the commentary.

BF, dipinto

1*	Munich 1703	hy	Vulci	Euphiletos painter	(*ABV* 324,26)	Pl. 11a-b	1D,1
2	Vatican 423	hy	Vulci	related to Antimenes p.	*ABV* 281,6		1D,7

graffito

3*	Munich 1502a	foot		of lekythos?		
4*	Tarquinia 668	n-a	Tarquinia	520-10		Fig.6g
5*	Louvre Cp12268	col-kr		P. of Louvre Cp12268	(*Paral* 155,2)	
6	Geneva Ill	n-a		tradition of Diosphos p. (who?)	*CVA* 2 pl.54,4-5; (*ABV* 482,7)	
7	ex Paris market	sky			*Vente* 1903 66	

RF

8	Vatican G71	hy	Vulci	Euthymides	*ARV* 28,14
9	New York 21. 88.2	hy		recalls Dikaios painter	*ARV* 34,14

10 Munich 2314 Panath Vulci Triptolemos painter ARV 362,14

1 is very faint; there are certainly four verticals and I am inclined to think a horizontal, forming the *pi*.

Type 3D ∧|

i) BF, dipinto

1	Copenhagen 111	hy		Euphiletos painter	ABV 324,29	¦	∧	1D,2	
2*	Munich 1697	hy	Vulci	Euphiletos painter	(ABV 324,31)	¦	∧		
3	Munich SL458	n-a	Vulci	Manner of Lysippides painter	CVA 7 62		20A,19		
4	Würzburg 185	n-a	Vulci	Antimenes painter	ABV 270,55; H11	¦	∧		
5	Würzburg 306	hy	Vulci	Antimenes painter	ABV 267,14	∧		∧⌐	
6*	London B301	hy	Vulci	Alkmene painter	(ABV 282,2)	∧			14A,1
7	Würzburg 191	n-a		Eye-siren group	(ABV 286,6); H12		¦∧		
8*	London B195	type A Vulci		Rycroft painter	(ABV 335,2)		20E,1		
9*	V.G. 50514 (M494)	n-a		Manner of Acheloos p.	(ABV 386,9)	⁼	∧		

Comment is needed on most of these marks. The readings of 1, 3 and 6 are secure. 2 and 4 may be either as 1 or 6. On 7 Langlotz read a retrograde *nu* to the right, but I saw no third stroke and so revert to Hackl's reading. 8 and 9 are even fainter marks; by both I have the note 'at least', and for 9 that means in a vertical as well as a horizontal direction, since the remains may only be the lower parts of the original letters. Therefore the inclusion of 8 and 9 here must be regarded with considerable reserve.

ii) Graffito

BF

10	Ferrara 163	oen	Spina	Class of London B495	CVA 2 14	
11	Ferrara 1302	oen	Spina	Class of London B495	CVA 2 15	
12	Ferrara 16279	oen	Spina	Class of London B495	CVA 2 14	
13	Ferrara 16276	oen	Spina	500–475	CVA 2 13	⊛

iii) Various ∧| and |∧

BF

14	Mus. Etruscum 229 patterned	hy	Vulci				
15	Naples RC2	col-kr	Cumae	c.500	H572	Fig.6f	16B,30; 1F,14; 7F,4

RF

16	Vatican 16554	hy	Vulci	Syleus painter	ARV 252,47; Hackl p.69	18E,10
17	Louvre G491	bell-kr		Polygnotos	ARV 1029,26	16B,32; 20F,3
18	vacat					
19*	ex Feuardent b.g.	pel		Manner of Sabouroff p.	(ARV 851,1?); (B)	17E,38
20	Villa Giulia	cup	Cerveteri c.450		NSc 1937 424,77	retrograde

14 may well be a misread mark of type 2F.

iv) Some instances of ↳| (or |↰)

BF

21	Louvre CA4716	hy		Leagros gr., Antiope painter ?	RA 1972 137; H418	13E,26

RF

22	Würzburg 533	hy	Vulci	Eucharides painter	ARV 229,43	see below
23	ex Rome market	stam		Hermonax	(ARV 484,20); Stamnos fig. 15	9E,112

21 is also mentioned, with a misleading interpretation, in REG 1973 361. 23 has a strange collection of marks, none of which belongs to any clearly established mercantile group. There are other marks on 22 also, and the ↳| is closely preceded by a *nu*, suggesting that the intended reading may be NV.

Type 4D

	BF, dipinto						
1	Villa Giulia	type B Cerveteri 540			*BSA* 68 (1973) 187	Pl. 21	8 strokes
2*	Oxford	hy		550–525			
3	Villa Giulia	type B Cerveteri c.540			*BSA* ibid	Pl. 22	

Only the lower parts, including the feet of the figures in the scene, are preserved of 2. 3 is certainly not Etruscan, as stated earlier, *BSA* l.c., but probably Attic in spite of the lack of incision. 1 and 3 have in addition the graffito **A∫**.

Type 5D H P

i) In ligature, stemless *rho*

	BF, dipinto					
1*	Taranto 20121	n–a	Taranto	550		
	dipinto and graffito					
2	Aachen, Ludwig 18	type B		Amasis painter	*Paral* 65, lower	see below
	graffito					
3	Würzburg 249	type B		Painter of Berlin 1686	*ABV* 296,10	after **III**
4	Louvre F26	type B		Amasis painter	*ABV* 150,5	
5*	Trieste 1802	n–a		520–10		Fig.6j

The graffito of 2 is preceded by four strokes. Another vase by the Amasis painter may be added; it has H followed by five strokes, and another mark:

6	New York 06. 1021.69	type B		Amasis painter	*CVA* 3 5

ii) In ligature, stemmed *rho*

	BF, dipinto					
7*	V.G. 50541 (M457)	n–a		Lydan	(*ABV* 116,16)	retrograde, navel
8*	Where?	n–a			(B)	15E,10
	graffito					
9	ex Paris market	oen	Apulia	c.530	*Vente* 1903 47	
10	Rome, private	oen		c.530	*Arch.Cl.* 21 (1969) 85	
11*	New York, Noble	hy	Capua?	Leagros group	(*ABV* 695,83bis)	Fig.6k
12	Villa Giulia 47798	col-kr	Cerveteri	Leagros group	*ML* 42 1010; (*ABV* 376,224)	
13*	Palermo 1889	lek	Gela	Haimon painter	(*ABL* 241,3)	
14	Orvieto	foot	Orvieto		*Annali* 1877 pl. L, 11	
	RF, dipinto					
15	Syracuse	pel	Akrai	c.425	*NSc* 1915 210	
	graffito					
16*	Ferrara T697	oen	Spina	P. of Louvre G456	(*ARV* 826,33) ; (B)	
17	Leningrad St.1938	pel	Pantikap-aion?			

The loop of the *rho* on 7 cannot be said to be certain; the mark is very faint.

iii) Not in ligature, stemmed *rho*

	BF					
18	Taranto?	cup	Monte Sannace	Leafless group (Scarfi)	*ML* 45 310-2	**IΔ**
	RF					
19	Rhodes 12454	pel	Kamiros	Erichthonios painter	*BSA* 70 (1975) 158,76	**XI**
20	Marseilles	cup	Camargue		*GGA* 1933 i–ii 9–10	

iv) Not in ligature, tailed *rho*

BF
21*	Louvre Cp10512	n-a	Tyrrhenian group (Bothmer)		Fig.6h
22*	Louvre Cp10701	n-a	Tyrrhenian group (Bothmer)		Fig.6i and Pl. 8 traces

The lower part of 21 is very worn. The attribution of 22 is mentioned in *Amazons* 7,15.

i) A doubtful candidate for ii

BF
23	Compiègne 1040	lek	Vulci	510	*CVA* 9

Type 6D ⊓ and the like

i) ⊓

BF, dipinto
1*	Salerno, Caudium cup T459		Caudium	525		

dipinto and graffito
2*	Basel 1921.328	n-a		530-25		3E,44

graffito
3	Munich 2238	cup	Vulci	530	Hackl p.60; (*Amazons* pl.26,4)	s.1.1,48
4	Würzburg 205	n-a	Vulci	Three-line group	*Paral* 141	
5	Berlin 1848	n-a	Vulci	530-25	(*ABV* 671,2 below)	

RF
6	Leningrad P29	n-a		Kleophrades painter	(*ARV* 184,19)	E

b.g.
7	Adria (21,25)	cup	Adria	500-475		Pl. 25

There are other dipinto traces on 2. The first stroke of the *pi* is short on 3; on 4 and 5 it is unusually long. There is a second graffito on 7.

ii) ⊓

BF
8	Leningrad St.271	type B		Antimenean (Gorbunova)	
9	Munich 1541	n-a	Vulci	510-500	(*AV* pl.177)
10	Villa Giulia 20841	n-a	Cerveteri	490	*ML* 42 284; *PdP* 30 (1975) 365

RF
11	Bologna 252	col-kr	Bologna	Pig painter	(*ARV* 564,22)	
12	Naples 3031	n-a	Nola	470		
13*	Chiusi 1850	col-kr	Chiusi	Cleveland painter	(*ARV* 517,9)	Fig.6l

undetermined
14	Adria (21,26)	cup foot	Adria	c.450		2B,47
15	Adria (21,27)	lek or oen	Adria			7D,20

For 8 and 10 see *PdP* l.c., where others of sub-groups i and ii are mentioned.

iii) ⊓ , very small

RF
16	Louvre G240	oen	Vulci	Dutuit painter	*ARV* 307,10

iv) ⊓

BF
17	Naples Stg.111	lek		c.500, white ground

RF

18	London E570	mug	Nola	P. of Louvre CA1964	(*ARV* 787,4); *BMC*	twice	ϟ⋀
19	Florence 4021	pel		P. of Florence 4021	*ARV* 873,1	navel, with ≡	
20	Basel	hy		Group of Polygnotos (Schmidt)	*AK* 15 (1972) 136		18C,64

I have not traced 17 in Naples and cannot therefore judge Heydemann's remark that it may not be ancient; although the accompanying numerals cause difficulties (see the commentary), Heydemann condemns marks without due reason elsewhere in his catalogue. One of the versions on 18 is small and 19 is very small. I omit Gotha (*CVA* 2 12), RF hydria of c.450; Beazley's notes give a mark of this type, but the *CVA* reading is correct and not very close to the type.

Type 7D ϟ| and ϟ|

The number of apparent *betas* included here is justified on the grounds of their close relationship with vases displaying unligatured ϟ|.

 i) ϟ|, alone

BF, dipinto

1	Hannover 1966.85	hy		500	*CVA* 1 28	retrograde

graffito

2*	London B295	n-a	Agrigento	BMN painter	(*ABV* 226,1)	
3	Taranto 4596	vol-kr	Taranto	Golvol group	(*ABV* 195,2); *ASMG* 8 (1967) 51-2	
4*	Gela	kr foot	Gela	c.525		Fig.7a
5	Brussels R232	Panath		520-10	*CVA* 1 5	
6	Louvre F282	Panath		520-15	*CVA* 5 4	
7*	Villa Giulia 15730	n-a	Nepi	near Acheloos painter	(*ABV* 373,181)	retrograde
8	Louvre F246	foot		alien foot	*CVA* 4 27	*sigma* retrograde

RF

9	Boston 01.8019	psyk	Orvieto	Phintias	(*ARV* 24,11); CB ii 6	
10	Naples 3174	n-a	Nola	510-500		navel
11	Warsaw 142348	hy		P. of the Yale lekythos	*ARV* 658,18	
12*	Tarquinia 706	pel	Tarquinia	Late mannerist	(*ARV* 1121,12)	Fig.6t
13*	where?	type C			(B)	

The *iota* of 1 is stunted; it could be a blotted *omicron*. 5 has the letters in quasi-ligature.

 ii) As i, in company with other marks, mostly numerical

BF

14*	V.G. 50617 (M490)	n-a	Vulci	520-10		Fig.6u

RF

15*	London E512	oen	Vulci	Pan painter	(*ARV* 557,125)	Fig.6n
16	Swiss, private	Nolan		Hermonax (Cahn)	*MM Sonderliste N* 3	Fig.6p
17*	Florence PD574	col-kr		Painter of London E489	(*ARV* 546,11)	Fig.6r
18*	Tarquinia 707	pel	Tarquinia	Late mannerist	(*ARV* 1111,2)	Fig.6m
19	Munich 2363	pel	Capua	Painter of Munich 2363	*ARV* 853,1	

undetermined

20	Adria (21,27)	lek or oen	Adria			6D,15

16 is also published in *Art Antique, Collections Privées de Suisse Romande* 216.

 iii) With a cross over the whole foot and ϟ| in one of the segments

BF

21*	Louvre F235	n-a		near p. of Munich 1519 *ABV* 395,8

·

iv) ⳤ| in ligature (except 22 and 27)

BF, dipinto

22	London B197	type A	Kamiros	Painter of Berlin 1686	*BSA* 70 (1975) 153,52	

RF

23	New York 41. 162.17	Nolan	Nola	Berlin painter	*ARV* 202,80	
24	London E313	Nolan	Nola	Berlin painter	(*ARV* 202,87); *BMC*	
25*	Naples 126053	Nolan	Capua	Berlin painter	(*ARV* 202,88)	Fig.7s
26*	St. Louis 57.55	n-a		Berlin painter	(*ARV* 203,104);(B)	
27	Naples 3116	Nolan	Nola	Manner of Berlin p.	(*ARV* 215,5)	
28	London E574	lek	Sicily	Manner of Berlin p.	(*ARV* 216,19)	9E,49
29	Boston 10.185	bell-kr	Cumae	Pan painter	*ARV* 550,1	
30	Oxford 1884.714	pel	Serignano	Geras painter	*ARV* 286,21	
31	Altenburg 297	oen	Nola	Imitative of Hermonax	*ARV* 494	
32	London E292	n-a	Nola	Charmides painter	(*ARV* 653,5); *BMC*	

All the vases by the Berlin painter are late.

v) ⳤ| , not in ligature, accompanied by numerals

RF

33	Madrid 11117	hy		Berlin painter	*ARV* 209,167	
34*	Gela 8736	lek	Gela	Berlin painter	(*ARV* 211,207bis)	Fig.6q
35	London E287	Panath	Nola	Manner of Berlin p.	(*ARV* 214,1)	
36	New York 41. 162.19	lek		Hermonax	*ARV* 490,115	

See also on Eretrian in the commentary (p. 238).

Type 8D X

i) Dipinto

BF

1	Bochum S480	hy		Polos painter	*Paral* 20		
2*	London 1897. 7-27.2	n-a		Painter of London B76	(*ABV* 86,8)		
3	ex Swiss market	hy		near p. of London B76 (Cahn)	*Auktion* 51 118		
4	Munich 1447	n-a	Vulci	near p. of Acropolis 606	*CVA* 7 30; H3		
5	Munich 1430	n-a	Vulci	Tyrrhenian group	see below; H5		
6	Florence 3774	n-a		Tyrrhenian group	(*ABV* 103,116); H6		
6a	Florence 3770	n-a		near p. of Vatican 309	(*ABV* 122,1); H4	navel	
7*	Tarquinia RC7370	type B	Tarquinia	550-540		navel	
8*	Cerveteri MA 429,6	type B	Cerveteri	550-540		navel	
9	Munich 1373	type B	Vulci	Painter of Munich 1379	*ABV* 303,2; H1	twice	
10	Munich 1374	type B	Vulci	Painter of Munich 1379	*ABV* 303,3; H2	twice	
11	Munich 1403	type B	Vulci	St. Audries painter	*ABV* 313,2	with ‖	
12	Munich 1385	type B	Vulci	close to Swing painter	*ABV* 310		
13*	Tarquinia RC7903	n-a	Tarquinia	520-10, b.g.		navel	𝖠𝖠
14*	Locri T594	Panath	Lokri	520-10		navel	
15*	Munich 1506	n-a	Vulci	Leagros group	(*ABV* 375,208)	glaze	
16	Castle Ashby	n-a		Leagros group	*CVA* 8		
17*	Naples Stg.150	n-a		Manner of Acheloos p.	(*ABV* 385,1)	glaze	
18	Vatican 418	hy	Vulci	Madrid painter	*ABV* 329,1; H303		1D,5

RF

19*	Villa Giulia 48239	pel	Cerveteri	Triptolemos painter	(*ARV* 366,22)

5 is not considered an ancient dipinto in *CVA* 7 22. For 15 see the note on 21A,4.

ii) Graffito

BF
20* Jena 178 amphora Veii Sophilos (ABV 39,7) repeated V
21 Louvre E849 n-a Tyrrhenian group (ABV 98,41)
22 Vatican G46 oen Vulci 550-40
23* Florence 3798 type B 540 navel traces
24* Chicago 1889.13 pyxis 530-25
25* Louvre Cp10717 n-a 525 across
 whole foot

26 Altenburg 212 n-a Cerveteri Antimenes painter ABV 272,92
27 London B318 hy Vulci Manner of Antimenes p. ABV 277,9
28 Erlangen M61 n-a Vulci Manner of Antimenes p. CVA Munich 8 80
29 Munich 1513 n-a Vulci Group of Toronto 305 CVA 8 82
30* Vatican 394 n-a Vulci Group of Toronto 305 (ABV 282,5)
31 New York 41.85 type B Group of Toronto 305 CVA 3 16
32 Kassel T675 pel Cerveteri Leagros group CVA 1 45
33 V.G. 50432 oen Painter of Sèvres 100 ABV 584,5
 (M450)
34 London 1901. n-a Rhodes Class of Edinburgh BSA 70 (1975)
 7-11.1 p.'s doubleens 153,56
35* V.G. 50647 n-a P. of Villa Giulia (ABV 590,2)
 (M483) M482
36 Würzburg 224 n-a 510
37 Villa Giulia n-a 510
 M490
38 Louvre F160 oen near p. of Louvre F161 ABV 450,1 navel
39 Cab.Med. 223b n-a Group of Munich 1501 Paral 153,10
40 Syracuse 21139 lek Gela Gela painter ML 17 402;
 ABL 208,59
41 Conservatori 68 oen 500 CVA 1 15
42 Würzburg 221 n-a Vulci Group of Würzburg 221 ABV 401,1
43* Naples Sp.253 oen Suessola c.490
44 Leningrad St.158 oen
45* Naples RC232 lek Cumae (B)
46* Tarquinia n-a Tarquinia
 foot
47 Mus. Etruscum amphora Vulci
 297
48* where? type B (B)
 RF
49 Louvre G1 type A Vulci Andokides painter ARV 3,2
50 Cab.Med. 510 plate Vulci Epiktetos ARV 78,96
51 Louvre G204 Nolan Vulci Berlin painter ARV 202,90;
 see below
52 Vienna 688 col-kr Class of Cab.Med.390 ARV 255,2
53 Toledo 61,26 cup Triptolemos painter CVA 1 40
54 Würzburg 518 stam Vulci P. of the Yale ARV 657,2 13B,28
 lekythos
55* Dresden 314 Nolan Polygnotos (ARV 1031,46); (B)
56* Chicago 1889.27 cup Cerveteri Penthesilea painter (ARV 884,77) s.1.1,50
57 Brussels R330 cup Vulci Painter of Bologna 417 ARV 911,62
58 Villa Giulia col-kr Falerii Nausicaa painter ARV 1109,27
 3583
59 Berlin 2590 sky Nola Painter of Bonn 92A ARV 1303,1
60* Leipsic T64 oen Painter of Leipsic T64 (ARV 1214,1); (B)
61* Vatican oen Painter of Leipsic T64 (ARV 1214,2); (B)
62* Chicago 1916. lid c.450? (of a stamnos)
 410A
 b.g.
63 New York psyk 510-500 BMM 1960-1 155 also under
 60.11.6 lid
64 Adria (20,22) cup Adria 450-400 (stemless)
 foot
65 Adria (20,21) sky? Adria 450-400

I am not sure whether 20 is dipinto or graffito. The foot of 21 has now been removed. 32 has a
small additional stroke. 49 is shaped like a sidelong obelus. 51 is only given by Hoppin o.c.
i 65. 20 is illustrated in W. Müller, *Keramik des Altertums* (Jena) fig 13.

iii) With one (or more) strokes

BF
66*	Bari 2954	cup	Taranto	C painter	(*ABV* 53,38 or 47)	Fig.7c
67	Louvre F208	type A		525-20	*CVA* 3 14	Fig.6s
68	Louvre F50	hy		Manner of Antimenes p.	*ABV* 277,8	Fig.7b
69*	Florence 71004	n-a		520-15		X navel, **IIII** foot
70*	Salerno	n-a	Fratte	520		
71	Vienna 3598	type A	Cerveteri	Rycroft painter	*ABV* 335,4	**XIIII**
72*	Würzburg 255	type B		Manner of Acheloos p.	(*ABV* 386,10)	**XII**
73*	Basel BS412	Panath		Eucharides p. (who?)		**XII** 33A,23

RF
74	New York 10.210.19	hy	Falerii?	Berlin painter	*ARV* 209,169	
75	ex Swiss market	pel		Pan painter	(*ARV* 554,84); *Auktion* 40 101	
76	Naples 3169	n-a	Nola	Group of Naples 3169	(*ARV* 514,1)	
77	Vatican G72	cup	Vulci	Comacchio painter	*ARV* 955,1	
78	London o.c. 936	askos				

72 may be modern. My readings of 67 and 68 differ from those of Pottier. I have only seen 70 through the glass and cannot be sure of the reading.

iv) Various others

BF
79	Petit Palais 304	type A	Vulci	525	*CVA* pl.48,5	with **k**
80	Louvre F300	hy		Leagros group	*ABV* 360,4	17E,5
81	Cab.Med. Delepierre 28	hy		Leagros group	(*ABV* 365,62)	17E,28
82	Louvre F212	type B		Leagros group, Painter S	*ABV* 368,103	Fig.11e 2F,33
83	Louvre F381	n-a		500	*ABV* 483,6	

83 is probably incomplete; the foot is broken. For further examples of crosses over the whole foot see types 26A and 7D,21.

Type 9D

i) BF

1	Würzburg 319	hy		Psiax	*ABV* 293,10; H100	
2	Oxford 1965.115	n-a		Antimenes painter	*CVA* 3 3	with **III**
3	Louvre F232	n-a	Vulci	related to Antimenes painter	*ABV* 281,10	
4	Munich 1690	hy	Vulci	related to Antimenes painter	(*ABV* 280,1); H99	
5	Munich 1560	n-a	Vulci	Long-nose painter	*CVA* 8 34; H98	with **IIII**
6	London B501	oen	Vulci	Class of Vatican G47	(*ABV* 530,16);H102	
7*	Vatican, Astarita 563	oen		520		
8*	Vatican, Astarita	n-a		520		
9	Munich 1484	n-a	Vulci	520-10	*CVA* 8 74	with **IIII**
10	Dublin 1880.1108	n-a		520-10	*G & R* 21 (1974) 151,6	with **IIII**
11	Munich 1718	hy		515	H101	
12*	Chiusi 1812	type A	Chiusi	Chiusi painter	(*ABV* 368,97)	Fig.7d
13	Tübingen 2451 (D9)	n-a		Leagros group (Watzinger)	*CVA* 2 51	With **IIII**
14	V.G. 50428 (M475)	n-a	Cerveteri	510		With **II**
15*	Cambridge Cl. Arch. 475	n-a		c.510 (doubleen)		
16*	Copenhagen Th. 31	oen		Altenburg class	(*ABV* 422,4)	
17*	Leipsic	?			(B)	with **K**
18	Erlangen	cup			H103	A

| 19 | Villa Giulia 20792 | oen foot? | Cerveteri | | *NSc* 1937 428,40 | |

ii) ⊟ RF

| 20 | Louvre G62 | type C | | P. of the Munich amphora | *ARV* 245,2 | 18E,6 |
| 21 | Leningrad P27 | type C | | P. of the Munich amphora | (*ARV* 245,3) | 18E,7 |

Reference should be made to the publications for the full texts of the two.

SECTION E

Type 1E $H

BF, dipinto

1	Brussels R289	type B		Group E	ABV 133,3		
2*	Toronto 300	type B Tarquinia	Group E	(ABV 134,14)		2E,1	
3*	London B160	type B		Group E	(ABV 134,15)	Pl. 18	2E,2
4*	Vatican 348	type B Vulci		Group E	(ABV 134,16)		2E,3
5	Munich 1397	type B Vulci		Group E	ABV 134,20; H29		
6*	Tarquinia RC7170	type B Tarquinia	Group E	(ABV 134,24)		2E,4	
7*	Boulogne 420	type B		Group E	(ABV 134,29)		
8	Tarquinia 617	type B Tarquinia	Group E	(Paral 56,36bis); H30		2E,5	
9	Munich 1396	type B Vulci		Group E	ABV 135,39; H28		33A,3
10*	Munich 1382	type B Vulci		Group E	(ABV 135,47)		
11	Boston 1970.8	type B		P. of Vatican mourner	(CVA 1 4-5); Auktion 40 68		

All the marks are on the navel save the *sigma* of 3 and 4. 1, 5, 7, 9 and 10 have additional dipinto marks; at least in the case of 5 and 9 the red of these marks is a different shade. The full extent of most of these additional marks cannot now be ascertained. 3 must be set apart; it has clear remains of a four-bar *sigma*, while the traces on the navel may or may not be of an *eta*. Albizzati noted only a graffito on 4. Both the dipinto and graffito of 8 are faultily recorded in *St.Etr.* 36 (1968) 236. Lullies noted red traces on 10 (*CVA* 1 16).

Type 2E ⟨glyph⟩ and the like

BF, usually lightly incised

1	Toronto 300	type B Tarquinia	Group E	ABV 134,11		1E,2	
2*	London B160	type B		Group E	(ABV 134,15)		1E,3
3*	Vatican 348	type B Vulci		Group E	(ABV 134,16)		1E,4
4*	Tarquinia RC7170	type B Tarquinia	Group E	(ABV 134,24)	Fig.7g	1E,6	
5	Tarquinia 617	type B Tarquinia	Group E	(Paral 56,36bis)	Fig.7f	1E,8	
6*	Munich 1806	oen	Vulci	510-500		Fig.7e	
7*	Munich 1808	oen	Vulci	late sixth century			
8	Villa Giulia	oen	Cerveteri c.510	see below			

Although dipinto and graffito overlap on 4 it is not possible to say which was applied first. The mark on 7 is the same as the upper part of that on 6. 8 is published in *Quad.V.G.* 1, which has no page numbers, on the 'olpe page' right, centre.

Type 3E E P

i) ⟨glyph⟩

BF, dipinto

1	Vienna 3604	n-a	Cerveteri	Painter N	ABV 221,41; H33
2	Vatican 362	n-a	Cerveteri	Painter N	ABV 218,12; H34
3	Louvre F101	n-a	Cerveteri?	Painter N	ABV 217,5; H35
4	Louvre F102	n-a	Cerveteri?	Painter N	ABV 216,4; H36
5	Louvre F104	n-a		Painter N	ABV 222,58 (q.v.); H37
6	Louvre F106	n-a		Painter N	ABV 218,13; H38
7	Louvre F107	n-a	Cerveteri?	Painter N	ABV 221,39; H39
8	Louvre F109	n-a	Cerveteri?	Painter N	ABV 221,45; H40
9	Louvre F111	n-a	Cerveteri?	Painter N	ABV 219,27; H41
10	Louvre F112	n-a	Cerveteri?	Painter N	ABV 219,28; H42
11	Louvre F113	n-a	Cerveteri?	Painter N	ABV 220,32; H43
12	Oxford 1885.654	n-a	Cerveteri	Painter N	CVA 3 18
13	Aachen, Ludwig 21	n-a		Painter N	Paral 105,43bis
14	Villa Giulia 20863	n-a	Cerveteri	Painter N	Paral 104,14
15*	V.G. 50558 (M462)	n-a		Painter N	(ABV 221,37)
16*	Villa Giulia	n-a	Cerveteri	Painter N	see below

16a*	Athens, Kanell- opoulos unnum	n-a	Italy	Painter N	(*AAA* 9 (1976) 146)		
17*	Trieste S306	type B		Swing painter	(*Paral* 134,21[6])		
18	Würzburg 259	type B		Swing painter	*ABV* 306,35		
19	London B182	type B	Vulci	Swing painter	(*ABV* 306,42)		
20*	Brussels R318	n-a		Swing painter	(*ABV* 308,72)		
21	Würzburg 256	type B	Vulci	535-25			

The following have single dots or small circles in the loop of the *rho* and between the horizontals of the *epsilon*: 5, 7, 9, 13 and 15. 4 and 16 are poorly preserved. On 2, 3 and 15 the loop of the *rho* rejoins the vertical between the lower hastae of the *epsilon*, not at the base, as elsewhere. 16 is probably *ABV* 221,51: A and B, fight; on neck, winged female; on handles, satyr.

ii) Ligatured, with tailed *rho* and a mark of type 4E

BF dipinto
22*	Munich 1544	n-a	Vulci	510-500	(*CVA Oxford* 3 8)	Fig.7i	4E,7
	graffito						
23	Oxford, Miss.	n-a	Cerveteri	Antimenean	*AJA* 60 (1956) 5-6		4E,4
24	Munich	n-a		Antimenes p.(Robinson)	*AJA* ibid; H317		4E,5
25	Oxford 1960.450	n-a		510-500	*CVA* 3 8		4E,6

iii) As ii, alone or with other marks

BF, dipinto and graffito
26*	Chiusi P543	n-a	Chiusi	520-10		Pl. 16	
	graffito						
27	New York 41.162.193	n-a	Vulci	520-10	*CVA* 4 37; H315		
28	Florence 3872	n-a		515-10	H319	Fig.7n	
29	Berkeley 8.3852	n-a	Vulci	Leagros group	*ABV* 375,202; H202		A x)
30	London B220	n-a	Vulci	Group of London B250	(*ABV* 340,1); H314	twice	A
31	Naples RC231	n-a	Cumae	510		Fig.7l	
32	Boulogne 574	n-a		510-500	see below	Fig.7j	
33*	Palermo 2379	n-a		510-500	(Brommer 130,4)		
34	Vatican G23	n-a	Vulci	Group of Vatican G23	*ABV* 406,1		
35*	Detroit 63.18	n-a					
36*	ex London market	oen		500-490 (white ground)	(*Christie 16/3/1977* Fig.7t 202)		
37	Orvieto	foot	Orvieto?		H318		

In all cases save 34 the loop of the *rho* is rounded. 32 is *Catalogue of the Beugnot Collection* no 39.

iv) As i, graffito

RF
38	London E405	pel		Hermonax	(*ARV* 486,46)		
39	Syracuse 24552	lek	Gela	Hermonax	*ARV* 490,120		
40*	Basel, Käppeli D8	lek		Providence painter	(*Paral* 400,73bis)		
41*	Syracuse 17250	Nolan	Gela	Briseis painter	(*ARV* 410,57)	Fig.3z	6B,7
42	Syracuse 21196	Nolan	Gela	Oionokles painter	*ARV* 649,43; *ML* 17 456		6B,8
43	New York 41.162.69	col-kr		Nausicaa painter	*ARV* 1108,23		

v) An 'internal' ligature, ⨌

BF
44*	Basel 1921.328	n-a		530-25			6D,2
45	Cab.Med. 229	n-a		Three-line group	*ABV* 320,1	Fig.7h	
46	ex Swiss market	n-a		520-10	*Auktion* 51 129		
47*	Ferrara inv. 1236	oen	Spina	Workshop of Athena painter IV	(*ABV* 529,65)	Fig.7v	9E,87

Possibly related:

48	Leningrad St.43	oen					10B,14
	RF						
49*	Bologna PU284	col-kr		Florence painter	(*ARV* 542,35)	Fig.7k	18C,5

vi) E P , unligatured

BF
50	*Munich 1592	n-a	Vulci	Red-line painter	(*ABV* 602,33)	
51	Mannheim Cg 218	n-a		near Edinburgh p. (Greifenhagen)	*CVA* 28	
52	Chicago 1889.10	mast-oid		500-480	(*ABV* 649,242)	
53	Laon 37894	lek		Diosphos painter	*Paral* 249,15bis	

RF
54*	Naples 126056	oen		Geras painter	(*ARV* 287,32)	Fig.7u	4F,4
55	Florence 4020	Nolan	Chiusi	Painter of Munich 2332	*ARV* 1192,3		

53 is perhaps rather *epsilon-delta*.

vii) Various others

BF
56	Cambridge 54	hy		510	*CVA* 1 23	
57	New York 46.92	n-a		510	*CVA* 4 39	
58	*Munich 1666	n-a	Vulci			
59	Mus. Etruscum 1710	amphora	Vulci			2F,48

RF
60	Berlin 2588	sky	Tarquinia Penelope painter	(*ARV* 1300,1); *Bull* 1876 206	

See the commentary for 60. It is difficult to believe in the authenticity of the strange collection of marks on the body of the following:

 Naples 3487 oen

Type 4E

i) Alone

BF, dipinto
1	*Munich 1398 graffito	type B	Vulci	Painter of Munich 1393	*ABV* 303,4
2	Tarquinia 595	oen	Tarquinia	520-10	*St.Etr.* 36 (1968) 236
3	Munich 1813	oen	Vulci	Group of Munich 1812	(*Paral* 180,2)

ii) With a mark of type 3E,ii

BF
4	Oxford, Miss.	n-a	Cerveteri	Antimenean	*AJA* 60 (1956) 5-6		3E,23
5	Munich	n-a		Antimenes p.(Robinson)	*AJA* ibid; H317		3E,24
6	Oxford 1960.540	n-a		510-500	*CVA* 3 8		3E,25
7	Munich 1544	n-a	Vulci	510-500		Fig.7i	3E,22

Throughout, the cross-bar of the *alpha* slopes up to the right to a greater or lesser degree.

Type 5E

i) Accompanied by a mark of type 6E

BF
1	Berlin 1845	n-a	Vulci	Leagros gr., Group of Würzburg 210	*ABV* 370,136; H508
2	Würzburg 210	n-a	Vulci	Leagros gr., Group of Würzburg 210	*ABV* 373,178; H508
3	London B306	hy	Vulci	Leagros gr., Antiope group I	(*ABV* 365,68);H515
4	London B328	hy	Vulci	Leagros gr., Group of London B328	(*ABV* 363,42);H517
5*	Munich, Haniel 1	hy		Leagros group	(*Paral* 165,46bis)

6	Munich 1524	n-a	Vulci	Leagros group	(ABV 372,168);H505 twice		
7	Munich 1549	n-a		Acheloos painter	(ABV 383,12); H506 Fig.7q		
8	*Munich 1532	n-a	Vulci				
9	Mus. Etruscum 313	amphora	Vulci				
10	Mus. Etruscum 1706	amphora	Vulci				

ii) Without a mark of type 6E

BF

11	Munich 1566	n-a	Vulci	Related to Antimenes painter	CVA 8 66; H507		
12	Würzburg 318	hy	Vulci	Leagros group, Simos group	ABV 364,55;H514	X	
13	London B309	hy	Vulci	Leagros group, Simos group	(ABV 364,66);H516		
14	Munich 1715	hy	Vulci	Leagros group	(ABV 366,74);H512		
15	Altenburg 209	oen		Leagros group	Paral 167,246bis		
16	Würzburg 310	hy	Vulci	510	H513		
17	Munich 1702	hy	Vulci	510-505	H519		
18	Würzburg 331	col-kr	Vulci	500	H520		

iii) With various marks

BF

19*	New York, Herrmann	hy		520-10	(Kende Sale 6/10/1951 91)		see below
20	Berlin 1904	hy	Vulci	Leagros group, Simos group	(ABV 364,54);H518		9F,26
21	Leiden PC33	hy	Vulci	Leagros group, Simos group	CVA 1 pl.52,4	Pl. 19	11E,48
22*	Louvre F302	hy		Leagros group	(Paral 165,74bis)	Fig.7m	17E,14

The mark is clearly embedded in the complex on 21; it was cut after, and upside down to the mark of type 11E, which had been erased by several horizontal and one diagonal stroke. 22 is not correctly given in CVA 6 54. There are several additional letters on 19, separate from our mark; they are apparently Greek and perhaps include ΛΗ.

iv) Other shapes lacking the 'probe'

BF

23	Gotha 29	oen	Cerveteri	510-500	CVA 1 47		
24	Florence 3820	oen		510-500	H521		
25	Florence 3821	oen		510-500	H522		18B,4
26	Conservatori	n-a		500	RM 38-9 (1923-4) 84		

RF

| 27 | Munich 2422 | hy | Vulci | Phintias | ARV 1620; H557 | navel | 2F,35 |

On 23 the top part of the upper loop is placed on the opposite side of the vertical. On 24-26 the lower part of the upper loop is omitted. On 27 the two lines on the other side of the vertical do not splay out from the centre but spring independently from the mid-point of each loop.

Type 6E ⌐|

i) Alone

BF

1	Louvre F236	n-a		510-500	CVA 4 26; H523

RF

| 2 | New York 15.27 | col-kr | Naples | Agrigento painter | ARV 574,9 |

ii) With a mark of type 5E

BF

3-12 = 5E,1-10

The mark of type 6E on 5E,1, 4, 5, 9 and 10 is retrograde. My reading of 5E,7 emends that of Jahn;
the *pi* has the additional stroke, though much of it is lost. We must doubt whether 9 lacks the add-
itional stroke as published. 5E,2 and 10 have two additional short lines independent of the rest.
There is no fixed or even general relationship between the two marks on the vases of these types.

 iii) With a mark of type 7E

 BF

13-14 = 7E,1-2

Type 7E

	BF					
1	V.G. 50631	n-a		Red-line painter	*ABV* 373,171	6E,13
	(M488)					
2	Cataloghi	n-a			H524	6E,14
	Campana 496					

Type 8E

 i) Dipinto, BF

1	Würzburg 234	n-a		Painter of Würzburg	*ABV* 591,3; H14	15E,4
				234		
2	Munich	n-a			H13	15E,5

Langlotz' publication of 1 demonstrates Hackl's doubts about the identity of the accompanying sign as
ႥᎬ. I assume that 2 was similar; the vase appears to be no longer extant.

 ii) Graffito, alone or with its constant companion ⌝ or ✓ or a similar mark; some have
 other isolated marks.

	BF					
3	London B218	n-a	Vulci	Manner of Antimenes	(*ABV* 277,15);H132	Fig.7r
				painter		
4	Vatican 431	hy		Rycroft painter	*ABV* 337,29	33A,22
5	Basel BS409	n-a		Rycroft painter	*Paral* 149,16bis	with X,
						navel
6	Louvre F301	hy	Vulci	Leagros group,	*ABV* 361,20; H122	Fig.7p
				Painter A		
7	Munich 1712	hy	Vulci	Leagros group,	(*ABV* 362,34);H120	traces
				Antiope group		
8	Munich 1547	n-a	Vulci	Acheloos painter	(*ABV* 385,3); H142	
9*	Karlsruhe 61/24	n-a		Leagros group, Chiusi	(*Paral* 171,8)	
				painter		
10	Leiden PC3	n-a	Vulci	Leagros group	*CVA* 1 pl 52,12;H128	
11	Leiden PC49	n-a	Vulci	Leagros group	*CVA* 1 pl 53,1	
12*	ex London market	n-a		Leagros group	*Sotheby 4/12/1973*	
				(Johnston)	144	
13	Munich 1644	n-a	Vulci	Red-line painter	(*ABV* 604,69); H131	
14	Erlangen M443	oen	Vulci	Red-line painter	(*ABV* 604,76);	
					Munich J1190	
15	*Munich 1601	n-a	Vulci	Manner of Red-line	(*ABV* 606,11);H129	
				painter		
16	Erlangen M31	n-a	Vulci	520	*CVA Munich* 8 37;	
					H126	
17	Vatican G24	n-a	Vulci	510-500		
18	Turin 4114	n-a	Vulci	500	*CVA* 2 7	
19	New York	n-a		500	*CVA* 4 46	
	69.233.2					
20*	Boulogne	cup		c.500		
21	Oslo MAA 8673	n-a		500-490	*CVA* 1 19	
22	Berlin 1864	n-a			H127	
23	*Munich 1518	n-a			H130	
24	Leningrad	type B			H133	
	St.80					
25	Munich 'foot 8'	foot			H134	
26	Munich 'foot 25'	foot			H135	

27	Mus. Etruscum	n-a		Vulci			

27 Mus. Etruscum n-a Vulci
 1701
 RF
28* Basel BS437 hy 510
29 Munich 2614 cup Vulci Ambrosios painter (ARV 173,2)

Only 8 is wholly unaccompanied. 10, 11 and 14 do not seem to have the usual 'dumb-bell' cross-bar; the same may be true of 9. There is an erroneous reference to Jannsen no. 45 (= PC3) in the *CVA* publication of 11. 12 is very worn; the basic mark can be read, but the accompanying lines are not clear. There are further marks on 29, at least one of them Etruscan.

 iii) With a normal *alpha*

 BF
30 Louvre F257 n-a 510-500 *CVA* 5 33
 RF
31 Leningrad P21 hy Euthymides (ARV 28,15)
32 London E160 hy Vulci Nikoxenos painter (ARV 222,19)

32 must remain a doubtful case; parts of the complex recall the ↲ (not present on the other two), and the rest may involve the main mark and an *alpha* partly superimposed, but close scrutiny has not led me to resolve the issue.

 iv) With glaze A P

 BF
33 Munich 1710 hy Vulci Leagros group, (ABV 360,7) Fig.8d 9E,6
 Painter A
34 Mainz inv. 74 Panath Vulci 500-490 *Paral* 318 9E,8
 b.g.
35 Würzburg 322 hy c.500 FA ;9E,9

See also 44.

 v) With a mark of type 13E,ii (and no ↲)

 BF
36 Louvre F286 hy Priam painter *ABV* 333,28; H139 13E,19
37 Florence 3866 hy 510 *CVA* 5 13; H123 13E,22

 vi) With a circular mark (no ↲)

 BF
38 Würzburg 351 oen Painter of Würzburg *ABV* 436,1; H145 15B,17
 351
39 Würzburg 352 oen Painter of Würzburg *ABV* 436,2; H146
 351

38 appears to have a circular mark incorporated in the 'dumb-bell' as well.

 vii) With M E

 BF
40 Louvre F299 hy Leagros group, *ABV* 362,29; H140 10E,24
 Painter Ä
41 Florence 3867 hy Leagros group, *CVA* 5 14; H123 10E,29
 Painter A
42 London B325 hy Vulci Leagros gr., Group of *G & R* 21 (1974) Pl. 23a-b 10E,28
 Vatican 424 151,10
 RF
43 Berlin 2175 hy Painter of Munich (ARV 246,11);H138 10E,31
 amphora

The two marks are upside down to each other on 40-42; the relationship on 43 is not known to me. Pottier reports an X on 40, but I did not see it. As well as the graffito ME on 42 there is a red *mu* and remains of a second letter consistent with an *epsilon*.

 viii) With a mark of type 11E,i (44,45) and type 11E,iii also (46)

 BF
44 Munich 1709 hy Vulci Leagros group, (ABV 361,14);H137 9E,7;
 Painter A 11E,35

45	Compiègne 1056	hy	Vulci	Leagros gr., Group of Vatican 424	ABV 364,53			11E,36
46	London B326	hy	Vulci	Leagros gr., Group of Vatican 424	(ABV 362,28)			11E,43
46a*	ex London market	hy		Leagros group (Johnston)	(Sotheby 4/12/78 199)			11E,42a

ix) With ME and a mark of type 11E,i or 11E,iii, or both

	BF							
47	London B314	hy	Vulci	Leagros group, Painter A	(ABV 360,2); H125	Pl. 34		10E,23; 11E,40
48	London B322	hy	Vulci	Leagros group, Painter A	(ABV 362,32);H141	Fig.8b		10E,25; 11E,37
49	London B323	hy	Vulci	Leagros group, Painter A	(ABV 362,33)			10E,26; 11E,41
50	Munich 1708	hy	Vulci	Leagros gr., Group of Vatican 424	(ABV 360,5); H136	Fig.8a		10E,27; 11E,38
51	Madrid 10904	hy		Leagros gr., Group of Vatican 424	ABV 363,41			10E,14; 11E,39
52	Vatican 424	hy	Vulci	Leagros gr., Group of Vatican 424	ABV 363,43			10E,15; 11E,44

48 and 50 are alike in having the ▲ cut over the *epsilon* of the ME. On 51, assuming that the *CVA* reading is incomplete, the ▲ stands separately. The ME on 49 is incised in the same place as the ↲ ; the two lower hastae of the *epsilon* do not join the vertical.

Of the last three sub-groups only 41, 47 and 49 have ↲.

x) With various other marks; all have ↲ or V

	BF						
53*	Florence 76167	n-a	Vulci	540		Fig.8c	16E,1
54	Compiègne 988	n-a	Vulci	Group of Compiègne 988	ABV 285,4		1B,2
55	Cambridge 51	n-a	Vulci	Painter of Cambridge 51	ABV 340,1; H143	Fig.2k	20A,11
56	Munich 1713	hy	Vulci	520-10	H119; (AV pl 142)	Fig.1k	5A,11
57	Leningrad St.282	hy		Priam painter (Gorbunova)	H124		10F,2

The exact reading of the last part of 55 is not clear owing to surface dirt and the slight depth of the incision; it would appear to be a variant of ↲ . I take the last part of 57 in Stephani's facsimile to be ↲ also.

xi) ↲ alone

	BF					
58	London B239	n-a	Vulci	Leagros group	(ABV 371,147)	
59*	V.G. 50619 (M497)	n-a		Leagros group	(ABV 374,193)	
60	Gela, Navarra 1	lek	Gela	Leagros group?	ZPE 17 (1975) 155; (CVA 3 pl 1,1-2)	
61	Leiden PC55	n-a	Vulci	doubleen	CVA 1 pl 53,7; (H227)	
62*	ex Northwick Park	n-a		recalls Troilos painter	(ABV 400); (B)	

61 does not belong to type 21A, where Hackl placed it; it seems to have the circular mark of vi.

Type 9E A P, etc.

i) Dipinto, red, unligatured

	BF					
1	Louvre E824	type B		Painter of Louvre E824	Paral 54,1	
2*	Villa Giulia M468	type B		Painter of Louvre E824	(Paral 54,2)	
3*	Louvre Cp10635	type B		Painter of Louvre E824	(CVA 11 pl 128,1)	Pl. 24
4*	Jena	hy?		Early	(B)	

Villard notes, and I accept the similarity of 1-3 (*CVA Louvre* 11 109); the foot of 3 has been added since the publication of the *CVA* volume. The cross-bar slopes up to the right on 1-3, down on 4.

 ii) Dipinto, red, **API**

BF
5* Louvre E803 hy Painter of Vatican 309 (*ABV* 120,1) Fig.8j

 iii) Dipinto, glaze, unligatured; with other marks

BF
6* Munich 1710 hy Vulci Leagros group, (*ABV* 360,7) Fig.8d 8E,33
 Painter A
7 Munich 1709 hy Vulci Leagros group, (*ABV* 361,14); H45 8E,44;
 Painter A 11E,35
8 Mainz inv. 74 Panath Vulci 500-490 *Paral* 318 8E,34
 b.g.
9 Würzburg 322 hy c.500 H47 8E,35,q.v.
 undetermined
10 Louvre G166 foot c.500, from a krater? *RA* 1972 244 9E,85

The letters are squat and the *rho* has a short stem, if any.

 iv) In ligature, stemless *rho*

BF, dipinto
11* Boulogne 417 hy Manner of Lysippides (*ABV* 260,32)
 painter

graffito
12 Munich 1472 n-a Fringe of Group E *CVA* 7 54
13 Munich 1440 n-a Affecter Mommsen no 91;
 CVA 7 38; H334
14 Omaha 1953.255 hy Affecter Mommsen no 89
15 Madrid 10919 hy Affecter Mommsen no 90;
 AJA 80 (1976) 43
16 Orvieto 240 type B Orvieto Affecter Mommsen no 95
17 Orvieto 594 n-a Orvieto Affecter Mommsen no 96
18 Orvieto, n-a Orvieto Affecter Mommsen no 97;H335
 Faina 63
19 Copenhagen type B Orvieto Affecter Mommsen no 100
 NyC 2692
19a Petit Palais 312 hy Ready painter *ABV* 130,3
20 London B193 type A Andokides/Lysippides (*ARV* 4,8); H346 twice
 painter
21 Munich 2301 type A Vulci Andokides/Lysippides *ARV* 4,9; H344
 painter
22 Bologna 151 type A Bologna Andokides/Lysippides (*ARV* 4,10); H348 Fig.8e
 painter
23 Louvre F204 type A Vulci Andokides/Lysippides *ARV* 4,11; H345
 painter
24 Zurich 7 n-a Tarquinia Lysippides painter *CVA* 1 21
25 Louvre F59 n-a Manner of Lysippides *ABV* 259,15; H337
 painter
26 Würzburg 192 n-a Vulci Manner of Lysippides *ABV* 259,23; H336
 painter
27 Florence 3790 hy Orvieto Manner of Lysippides *CVA* 5 12; H340
 painter
28 Munich 1688 hy Manner of Lysippides (*ABV* 260,33); H353 8F,4
 painter
29 New York n-a Manner of Lysippides *CVA* 4 34
 23.160.60 painter
30 Louvre F298 hy Vulci Nikesippos group *ABV* 264,1
31 ex Swiss market n-a Toulouse painter *Paral* 141,1
32 Compiègne 1034 hy 530-20 *CVA* 5
33* Bern market hy 525 Fig.8n
34 Würzburg 309 hy Vulci Antimenes painter *ABV* 268,28; H339
35 Naples 2486 n-a 525-0 H338 Fig.8f traces
36 Copenhagen 100 n-a 520 *CVA* 3 86
37 Cab.Med.AVH3389 n-a 520 *CVA* 1 29
38 Cincinnati, oen akin to Class of *Auktion* 16 102;
 Boulter Vatican G47 (*Paral* 186)
39* ex London market type B 520-515 *Sotheby* 9/12/1974 Fig.8k
 228

40	Dublin 1921.93	n-a		520-15		Fig.8l
41	Vulci	n-a	Vulci	510	*Arch.Cl*. 23 (1971) 113	
42	Leningrad St.112	type B		Leagros gr., Group of Würzburg 210	H342	
42a*	Taranto 107101	lek	Taranto	510-500		small OI
43	Syracuse 21925	n-a	Gela	500	*ML* 17 469	with I
44	Villa Giulia	cup	Cerveteri	early fifth century	*NSc* 1937 426,91	
45	Orvieto, Faina 85	hy	Orvieto		H341	
46	Mus. Etruscum 1432	stam?	Vulci		H343	

RF

47*	Louvre Cp11072	n-a		Euthymides	(*ARV* 27,7)	Fig.8g
48	London E256	type A	Vulci	recalls Bowdoin-eye p.	(*ARV* 168)	s.1.2,1
49	London E574	lek	Sicily	Berlin painter	(*ARV* 216,19)	7D,28
50*	London E579	lek	Gela	Pan painter	(*ARV* 557,117); (B)	
51	Leningrad P61	pel		Argos painter	(*ARV* 288,11)	
52	Cambridge 166	n-a	Nola?	Perseus painter	*ARV* 581,6	

undetermined

53	Louvre G43	stam		alien foot	(*ARV* 20,2); H351	16E,12
54	Adria (21,4)	cup foot	Adria		H366	

b.g.

55	Adria (21,3)	bowl	Adria		H350	

Throughout, the shape remains much the same; the cross-bar slopes up to the right except on 37, 44, 47-51, 54 and 55. On 19 the cross-bar forms an arc. 16 is incompletely preserved. I assume that the top of 37 has been worn away, as is the case with 25. I give Gorbunova's attribution of 42. Von Bothmer suggests that 46 is a neck-amphora by the Affecter (*AJA* 80 (1976) 43). The *rho* on 49 is not certain; it would have had an angled, not rounded loop. 51 has an additional mark, perhaps an *alpha* (but upside down to the ligature). To be compared with 28 is:

56	Orvieto	foot	Orvieto?		H349; *Annali* 1877 pl L,8	8F,5

Perhaps belonging here:

57	ex Swiss market	n-a		circle of Lysippides p. (Cahn)	*MM Sonderliste P* 99	

The graffito is described as 'Monogram ΔΛ '.

v) Similar but retrograde

BF

58	Munich 1729	hy	Vulci	Manner of Acheloos p.	(*ABV* 386,16); H355 Fig.1i	3A,1
59	Würzburg 323	hy	Vulci	Near Acheloos painter	*ABV* 387	3A,2
60	Hamburg 1917.471	n-a		Leagros group	*CVA* 1 28	AI

RF

61	Munich 2420	hy	Vulci	Pezzino group	*ARV* 1621; H356	

On 58 and 59 the cross-bar slopes down, and 60 and 61 up to the right. 60 may not belong here; the loop of the '*rho*' is not complete. 40 would perhaps be more at home in this sub-group.

vi) Quasi-ligatured

BF

62	Oxford 1910.804	n-a		Leagros group	*CVA* 3 9	Pl. 9	19B,7

vii) Unligatured, stemless *rho*

BF

63	Madrid 682	n-a		late	*CVA* 1 7	ADXI

viii) Ligatured, stemmed *rho*

RF

64	Bologna 153	type A	Bologna	470-60	H584	Fig.8h	6A,6; 12F,1
65	Leningrad St.1784	Nolan		Polygnotos	(*ARV* 1031,43); H368		

66*	Munich 7518	lek		Phiale painter	(ARV 1021,109);(B)		see below
67	Princeton 29.203	col-kr		Hephaistos painter	(ARV 1115,27); see below		1OE,21; 24F,4

The cross-bar of 64 slopes down to the right. 66 also has **BΛΙΙ**, but I have not included it in either type 6B or 7D. For 67 I give the reading of H.R.W. Smith, *The Origins of Chalcidian Ware* 110 n.60; Amyx, *Hesperia* 27 (1958) 198 prefers a ligature of *alpha* and *pi*.

ix) Similar, with added **Ι**

	BF						
68*	Gela, Navarra 49	lek	Gela	520-10			Fig.8i
69	Syracuse 21942	lek	Gela	Phanyllis painter	(ABL 199,9); ML 17 479		
70	Naples 2447	hy	Capua?	510-490	H365		**Ι** to left
71	Berlin 2081	cup-sky	Nola	Manner of Haimon painter	(ABV 567,635)		11B,22
72	Taranto 20328	cup-sky	Taranto	P. of Elaious I (Lo Porto)	ASMG 8 (1967) 61		1OE,10
73*	Naples Sp.2142 b.g.	cup	Suessola	c.480		Fig.8w	
73a	Ferrara 13	bowl	Spina	425-400	St.Etr. 46(1978) 305		1F,17
	undetermined						
74	Adria (21,5)	stem-less?	Adria		H367	Pl. 14	

On 72 a *pi* follows the mark of type 1OE; on 71 *pi iota* comes between the marks of type 11B and 9E; 74 also has *pi iota*, and it is certainly not from a hydria, as Hackl suggests. 73 should perhaps be in sub-group xiii. In all cases if the cross-bar slopes at all it is down to the right.

x) Similar, but the addition is **Ι**

	RF					
75	Naples 3105	oen	Ruvo	near Kleophrades painter	(ARV 193,2); H365	
76	Louvre G242	oen		near Kleophrades painter	(ARV 193,1); H365a Fig.8s	

On both the cross-bar slopes up to the right.

xi) What may be termed an 'internal' ligature

	BF						
77	Leiden PC1	hy	Vulci	Painter of London B343	CVA 1 pl 52,3		21E,59
	RF						
78	Vienna 3725	pel	Cerveteri	Berlin painter	ARV 204,104		
79*	Florence 3985	pel	Vulci?	Berlin painter	(ARV 204,110)	Fig.8t	
80	Amsterdam 1313	pel	Naples	Nikoxenos painter	ARV 221,12		
81*	Florence	hy		Nikoxenos painter	(ARV 222,21)	Fig.8m	16E,6
82	Leningrad P23	hy		Nikoxenos painter	(ARV 222,22)		21E,60
83	Leningrad P25	hy		Nikoxenos painter	(ARV 222,23)		21E,61
84*	Vatican 16548	hy	Vulci	Carpenter painter	(ARV 179,3)	Fig.51	8C,2

It is not easy to define the mark on 79, but this form of the ligature seems to have been intended; similarly, the lower part of the loop on 83 is elusive. The following seems to be a variant:

	undetermined					
85	Louvre G166	foot		c.500 (from a krater?)	RA 1972 244	9E,10

xii) Ligatured, tailed *rho*, some with *iota*

	BF						
86	Vatican 413	pel	Cerveteri	510-500	H354	retrograde	
87*	Ferrara inv.1236	oen	Spina	Workshop of Athena painter, IV	(ABV 529,65)	Fig.7v	3E,47
	RF						
88	Louvre G186	stam		Berlin painter	ARV 207,140	navel	
89	Castle Ashby 25	stam		Berlin painter	(ARV 207,141);H358; CVA 29		
90	Munich 2406	stam	Vulci	Berlin painter	ARV 1633; H359	retrograde	
91	London E468	vol-kr		Berlin painter	(ARV 206,132);H361	unligatured	

92	Oxford 1927.4502	hy		Berlin painter	ARV 210,172	
93*	Boulogne 449	hy		Berlin painter	(ARV 210,175)	Fig.9f
94*	Detroit 24.13	stam		Tyszkiewicz painter	(ARV 291,28)	
95	Oxford 1916.68	stam		Polygnotos	ARV 1028,6;	18C,14
					Stamnos fig. 16	
96	Palermo b.g.	?	Lipara		*Lipara* ii pl n,5	
97*	Syracuse 45978	n-a	Gela	c.475		
98	Gela G87	sky	Gela	450-430	CVA 2 pl 40,3-4	Ꭿ⇩⇧⇧

All except 88 and 91 have a simple ligature; despite minor differences I am loth to disassociate
88 from the rest. The cross-bar slopes up to the right on 87-90, 93 and 96, down on 92. The full
reading of 94 may be of sub-group xiii. 89 is incompletely given in *CVA*.

xiii) As viii, but with an additional vertical stroke below the cross-bar

BF

99*	London market (Ede 5038)	oen		c.500		Fig.8r	
100*	London B625	oen	Nola	Athena painter's workshop	(ABV 531,12)	Fig.8v	
101	Munich 1464	Panath	Vulci	Group of Vatican G23	(ABV 406); H575	Fig.8p	19F,1

RF

102*	Copenhagen NyC 2659	pel		Tyszkiewicz painter	(ARV 293,50)	Fig.8q	5F,2; 19F,5
103	Rouen inv.359	stam	Vulci	Syriskos or Copenhagen painter.	(ARV 259,2)	Fig.8u	s.1.1,41
104	New York 56.171.50	stam		Syriskos or Copenhagen painter.	(ARV 259); *Stamnos* fig. 14		
105*	Munich 2408	stam	Vulci	Copenhagen painter	(ARV 257,8)	Fig.8x	
106	Oxford 1965.127	stam		Copenhagen painter	(ARV 258,21); *Stamnos* fig. 14		
107	Brooklyn 1903.8	stam	Capua	Copenhagen painter	(ARV 258,22)	Pl. 13	
108	London E163	hy	Vulci	Copenhagen painter	(ARV 258,26)		1F,10; 21F,1

The mark is on the navel of 101, 102 and 108. On 99, 101, 104 and 108 the added stroke continues to
the apex of the *alpha*, half-way on 100. 103, 104, 105 and 106 have an additional vertical beside the
ligature, detached on 104 and 106, but connected to the main mark by a horizontal at the top on 103
and possibly 105 (this part is obscured by accretion). According to von Bothmer (*Gnomon* 39 (1967)
817-8) 103 also has H; the mark on its handle is recorded by Philippart, *Ant.Cl.* 1 (1932) 246. The
added vertical on 107 can be descried in the photograph, though not given by Philippaki fig. 14.

xiv) Various other ligatured forms

BF

109	London B178	type B	Vulci	Eucharides painter	(ABV 396,27)		

RF

110*	Ferrara	col-kr	Spina	Flying-angel painter	(ARV 281,31 or 32); (B)	Fig.9a	
111	Naples 3033	n-a		Aegistheus painter	(ARV 506,24)		
112	ex Rome market	stam		Hermonax	(ARV 484,20); *Stamnos* fig. 15		3D,23
113	Louvre G230	pel		Altamura painter	ARV 594,52	Fig.9e	
114	New York 41.162.87	hy	Nola	440-30	CVA *Gallatin* 14		
115*	Naples Spinelli	pel foot	Suessola	later fifth century		Fig.8y	
116	Leningrad St.2022 undetermined	pel					
117*	Vatican, Astarita 624	oen foot?					A

This is a completely mixed bag and reference should be made to the publications to ascertain the nature
of each mark. All seem to be ligatures of *alpha* and *rho* plus another letter, save 117, which has the
loop of the *rho* extended to form the cross-bar of the *alpha* (as 19). A more monumental ligature
deserves special mention:

RF

118	London E467	cal-kr	Altamura	Niobid painter	(ARV 601,23)	8F,6

xv) Various unligatured forms

BF

119	Gela, Navarra 38	lek	Gela	Phanyllis painter	*ZPE* 17 (1975) 155; (*CVA* 3 pl 6,1)	Fig.9b	
120	Geneva I36	n-a		Phanyllis painter	(*ABL* 200,35); *CVA* 2 pl 54,1-3	A D Γ	
121	Capua 154	n-a	Capua	500	*ABV* 482,3		
RF							
122*	Dunedin E59.3	n-a		Akin to Charmides painter	(*Paral* 403)	A P I	
123	Madrid 11121	n-a		Follower of Douris	*ARV* 805,81	A P	
124	Ruvo 767	sky	Ruvo	c.450?		Fig.9c	8F,7; 13F,11

The cross-bar slopes down to the right on 122 and 123, up on 124.

Type 10E M E

i) In ligature, alone or with other, isolated marks

BF, dipinto

1	Orvieto	foot	Orvieto		*Annali* 1877 pl L,30		
graffito							
2	Cab.Med. 207	type B	Vulci	Painter of Berlin 1686	*ABV* 296,6	↳	
3	Berlin 1693	type B	Nola	Swing painter	(*ABV* 305,25);H207		
4	Tarquinia RC1886	n-a	Tarquinia	540-30	H209	navel	
5*	Aberdeen 688	type B		late sixth century			
6*	ex Basel market	oen		510-500			
7	Taranto 4415	lek	Taranto	c.510	*ABL* 54		
8	Geneva 12048	lek		Capodimonte group	*CVA* 2 pl 73,14-16; (*Paral* 214,9)		
9	Taranto 4592	lek	Taranto	Group of Athens 581 (Lo Porto)	*ASMG* 8 (1967) 57		
10	Taranto 20328	cup-sky	Taranto	P. of Elaious I (Lo Porto)	*ASMG* ibid 61		9E,72
RF							
11*	Athens 1690	Nolan	Corinth	related to Charmides p.	(*ARV* 654,2); (B)		
b.g.							
12	Adolfseck 197	cup	Italy	later fifth century			

ii) In ligature, with a mark of type 8E or 11E, or both

BF

13	London B327	hy	Vulci	Leagros group, Painter A	(*ABV* 363,38);H166		11E,42
14	Madrid 10904	hy	Vulci	Leagros gr., Gr. of Vatican 424	*ABV* 363,41		8E,51; 11E,39
15	Vatican 424	hy	Vulci	Leagros gr., Gr. of Vatican 424	*ABV* 363,43		8E,52; 11E,44

iii) Not in ligature, mostly alone

BF, dipinto

16	Geneva 15053	col-kr			*CVA* 2 pl 59	retrograde				
graffito										
17*	V.G. 50754 (M435)	hy		535-30						
18	Bochum S497	lek		530						
19	London B201	type A	Vulci	Euphiletos painter	(*ABV* 323,22)					
20	Geneva MF151	Panath			*CVA* 2 pl 56,1-3	after				
RF										
21	Princeton 29.203	col-kr		Hephaistos painter	(*ARV* 1115,27)		9E,67 (q.v.); 24F,4			
undetermined										
22	Adria (20,11)	cup foot	Adria							

22 is broken to the right and so may be incomplete.

iv) As iii, accompanied by a mark of type 8E or 11E, or both, or 1A

BF, glaze dipinto

23*	London B314	hy	Vulci	Leagros group, Painter A	(ABV 360,2)	Pl. 34	8E,47; 11E,40

graffito

24	Louvre F299	hy		Leagros group, Painter A	ABV 362,29;H211		8E,40
25	London B322	hy.	Vulci	Leagros group, Painter A	(ABV 362,32);H141	Fig.8b	8E,48; 11E,37
26	London B323	hy	Vulci	Leagros group, Painter A	(ABV 362,33);H163		8E,49; 11E,41
27	Munich 1708	hy	Vulci	Leagros gr., Gr. of Vatican 424	(ABV 360,5); H136	Fig.8a	8E,50; 11E,38
28*	London B325	hy	Vulci	Leagros gr., Gr. of Vatican 424	G & R 21 (1974) 151,10	Pl. 23a-b	8E,42
29	Florence 3867	hy		Leagros group	CVA 5 14; H212		8E,41
30	ex Rome, Hercle	hy	Vulci	Leagros group (Johnston)	St.Etr. 34 (1966) 321		1A,4

RF

31	Berlin 2175	hy		P. of Munich amphora	(ARV 246,11);H213	8E,43

The presence of a red dipinto on 28 is noted under type 8E,vii, and overincisions of type 11E marks on those of type 10E under type 8E,viii.

v) Quasi-ligatured

BF

32	Leningrad St.85	n-a	Vulci	Princeton painter	(Paral 130,1bis); H208

RF

33	Trondhjem 807	sky	Aeschines painter	CVA Norway 1 34

Type 11E

i) Alone

BF

1	Hillsborough 4004	Panath		520	Raubitschek 4		
2*	Harrow 24	Panath		515		Fig.9d	
3	Vienna 3600	n-a		Leagros group	(Paral 166, 125bis); H183		
4*	V.G. 50450 (M495)	n-a		Leagros group	(ABV 371,140)	Fig.9i	
5	Munich 1707	hy	Vulci	510	H178		traces
6	Aachen, Ludwig 26	Panath		510-500			
7	Providence 22.212	n-a		500	CVA 20		
8*	Copenhagen Th. 57	oen		Guide-line class	(ABV 442,2); (B)		

Beazley has a wrong number for 8 in ABV; I assume that 57 is the correct one.

ii) With minor additional marks, **X** or **ㄱ** , or both

BF

9*	Tarquinia 647	n-a	Tarquinia	Group of Vatican 347	(ABV 139,8)	Fig.9h	
10	V.G. 50734 (M477)	n-a		Painter of Würzburg 229	ABV 131,5		
11	Munich 1522	n-a	Vulci	near Group of Toronto 305	CVA 8 79; H181	both	traces
12	Berlin 1865	n-a		520-10	(AV pl 63); H184	both	
13	London B280	n-a	Vulci	Class of Toronto 315	(ABV 589,1)	see below	
14*	Portland 35.137	n-a		late sixth century	(ex Forman 292)	Fig.9g	

15*	London V & A 4815.1901	n-a	Vulci	Dot-band class	(ABV 484,15)	see below
	Six's technique					
16	Warsaw 142333	hy		Sappho painter	ARV 300	**X**

On 13 the ∧ has become joined to a downward extension of the left diagonal of the main mark, so that it resembles the basic mark of the remaining sub-groups, albeit lacking the second short stroke (but see 19 and 27). 15 has a small *zeta* to the side of the main mark and a *nu* on the opposite side of the foot.

iii) △ , alone or with minor additions

	BF						
17*	Basel Z361	oen		520-10			
18	Turin 4102	n-a	Vulci	510-500	CVA 2 6		
19	Leiden PC17	oen	Vulci	Keyside class	CVA 2 29; H170	see below	ЗΔ
20	Hannover 1963.47	n-a		500	CVA 1 26		
21	Leiden PC13	n-a	Vulci	500-490	CVA 1 pl 53,3; H161		**B**
22	Munich	n-a			H158		
23	Berlin 1869	n-a			H159		
24	Munich 'foot 4'	foot			H171		↑
25	*Munich 1789	oen	Vulci		H168	on handle s.l. 1,38	
26	*Munich 1820 b.g.	oen	Vulci		H169	see below s.l. 1,39	
27	Karlsruhe B301	hy	Vulci	c.510	CVA 1 42	see below	

For the attribution of 18 see von Bothmer, *AJA* 74 (1970) 114. 19 and 27 have only one short stroke, as 13, but the ↑ is much more tidily attached to the deltoid than on 13. 26 has the mark on the handle, as 25, with a trifling variation; it also has an underfoot mark which, as given, appears to be a careless version of the main mark.

iv) With a mark of type 12E, and others

	BF					
28	Leningrad St.149	oen		early fifth century	H167	12E,30
29	Vatican 434	oen		Keyside class	ABV 426,16	12E,31

The two would seem to have the same collection of marks, though 29 has the second ▲↑∧ on the handle.

v) With **B↑**

	BF						
30	*Munich 1565	n-a	Vulci	c.525	H157		14E,7
31	London B288	n-a	Vulci	Painter of London B288	(ABV 593,1)		14E,8
32*	Vatican 403	n-a		Painter of London B288	(ABV 593,5)	Fig.9k	14E,9
33*	Vatican 404	n-a		Painter of London B288	(ABV 593,6)		14E,10
34*	Copenhagen Th. 36	n-a		510-490			14E,11

The vertical of 31 is askew, but it is an insignificant variation.

vi) As i, with a mark of type 8E

	BF					
35	Munich 1709	hy	Vulci	Leagros group, Painter A	(ABV 361,14);H177	8E,44; 9E,7
36	Compiègne 1056	hy	Vulci	Leagros gr., Gr. of Vatican 424	ABV 364,53	8E,45

vii) As vi, with **ME** also, in ligature on 39

| | BF | | | | | | |
| 37 | London B322 | hy | Vulci | Leagros group,
Painter A | (ABV 362,32);H164 | Fig.8b | 8E,48;
10E,25 |

| 38 | Munich 1708 | hy | Vulci | Leagros gr., Gr. of Vatican 424 | (ABV 360,5) | Fig.8a | 8E,50; 1OE,27 |
| 39 | Madrid 10904 | hy | | Leagros gr., Gr. of Vatican 424 | ABV 363,41 | | 8E,51; 1OE,14 |

viii) As iii, with marks of type 8E and 1OE

BF
| 40 | London B314 | hy | Vulci | Leagros group, Painter A | (ABV 360,2); H164 | Pl. 34 | 8E,47; 1OE,23 |
| 41 | London B323 | hy | Vulci | Leagros group, Painter A | (ABV 362,33);H163 | | 8E,49; 1OE,26 |

ix) Both simple (i) and extended (iii) versions, with marks of type 8E or 1OE, or both

BF
42	London B327	hy	Vulci	Leagros group, Painter A	(ABV 363,38);H166		1OE,13
42a*	ex London market	hy		Leagros group (Johnston)	(Sotheby 4/12/78 199)		8E,46a
43	London B326	hy	Vulci	Leagros gr., Gr. of Vatican 424	(ABV 362,28);H162		8E,46
44	Vatican 424	hy	Vulci	Leagros gr., Gr. of Vatican 424	ABV 363,43; H165		8E,52; 1OE,15

On 42a there is only one, not two added strokes to the mark of type 11E,iii.

x) With a mark of type 13E

BF
45	Munich 1486	n-a	Vulci	Circle of Antimenes painter	CVA 8 86; H156	Fig.9l	13E,23
46	Louvre F255	n-a		510-500	CVA 4 28		13E,24
47	Castle Ashby	n-a		510-500	CVA 7		13E,25

xi) Erased and replaced by a mark of type 5E

BF
| 48 | Leiden PC33 | hy | Vulci | Leagros group, Simos group | CVA 1 pl 52,4 | Pl. 19 | 5E,21 |

Type 12E

i) Alone, or not immediately associated with other marks

BF
1	Louvre F229	n-a		510	CVA 4 24		
1a*	London market, Christie	col-kr		c.510	(Christie 31/5/79 320)		
2	Berkeley 8.3380	Panath	Capua	Painter of Oxford 218b	ABV 339,2		
3*	London B490	oen	Nola	Painter of Vatican G49	(ABV 536,32)		traces
4	Tarquinia RC1626	hy	Tarquinia	Painter of Vatican G49	(Paral 268,44); H186		
5	Gotha 44	oen	Cerveteri	Painter of Vatican G49	CVA 1 49		
6	Utrecht 117	oen		P. of Sèvres 100 (Vos)	Talanta 1 (1969)11		
7*	Basel Z362	oen		c.500			
8	Louvre F264	n-a		505-500	CVA 5 34; H187	Fig.9j	
9	Villa Giulia 47552	oen	Cerveteri	late sixth century	ML 42 997		
10*	Rouen inv. 539	oen		late sixth century?	(Ant.Cl. 1 (1932) 244)		
11*	Cerveteri 67158	pel	Cerveteri	500-490			
12*	Milan, Lerici BL290	oen	Cerveteri	500-480			
13*	Salerno 1124 (or 6?)	lek	Fratte	Diosphos painter	(ABV 510,16); see below		

14	Louvre F251	n-a		490-80	*ABV* 401,1	크ⴰ
15	Leningrad St.119	oen			H184	
16	Leningrad St.133	oen			H185	
17	Villa Giulia 45589	pel	Cerveteri		*NSc* 1937 413,6	
18	Florence	foot			H191	
19	Mus. Etruscum 1462	amphora	Vulci			크ⴰ

RF

20	Louvre G174	bell-kr		Berlin painter	*ARV* 205,123	
21	Leningrad P36	col-kr		Myson	(*Paral* 510)	
22	Munich 2315	Panath	Vulci	Painter of Palermo 1108	*ARV* 299,2; H189	
23*	Boulogne 196	Panath		Providence painter	(*ARV* 638,51)	

13 is in Six's technique.

ii) With EV크

RF

| 24 | Providence 15.005 | n-a | Vulci | Providence painter | *ARV* 635,1 | 9B,23 |
| 25 | Vatican 16572 | n-a | Vulci | Providence painter | *ARV* 635,2 | 9B,24 |

iii) With Ionic numerals

BF

26	ex Swiss market	oen		Painter of Vatican G49	*ASV MM* no 17; (*Paral* 267 bottom)	IB
27	Copenhagen NyC 2673	oen		Workshop of Athena p.	(*ABV* 526,1); *Vente 1910* 186	IB
28	Berlin 1937	oen	Vulci	Sèvres class	(*ABV* 525,5)	L
29	Villa Giulia	oen foot?	Cerveteri		*NSc* 1937 413,7	H

The identity of 27 with the auction vase seems highly likely; it was bought in Paris in 1920.

iv) As 28, but with further marks (for which see type 11E,iv)

BF

| 30 | Leningrad St.149 | oen | | early fifth century | H188 | 11E,28 |
| 31 | Vatican 434 | oen | | Keyside class | *ABV* 426,16 | 11E,29 |

Type 13E Ⱶ

i) Alone

BF

1*	Taranto 4404	lek	Taranto	Phanyllis painter	(*ABL* 199,13)	
2	Toronto 302	n-a		Long-nose painter	*ABV* 327,3	
3	V.G. 50622 (M484)	n-a		Group of Würzburg 199	*ABV* 288,14	
4	Würzburg 196	n-a	Vulci	Rycroft painter	*ABV* 336,19;H153	
5	London B259	n-a	Vulci	Priam painter	(*ABV* 331,12);H151	
6	London B345	hy	Vulci	Priam painter	(*ABV* 332,20)	
7*	Boulogne 406	hy		Priam painter	(*ABV* 332,21)	Fig.9r
8	Munich 1721	hy	Vulci	Priam painter	(*ABV* 332,24);H147	
9	Toledo 61.23	hy		Priam painter	*CVA* 1 40	
10	London B329	hy	Vulci	Priam painter (A.D.)	(*ABV* 334,1)	
11	Würzburg 316	hy	Vulci	Priam painter (A.D.)	*ABV* 334,2	
12*	London B317	hy	Vulci	Priam painter (A.D.)	(*ABV* 335,7)	
13	Cab.Med. 257	hy		Leagros gr., Antiope group I	*ABV* 363,47	
14	Louvre F270	n-a		510	*CVA* 5 35	

15	Naples Stg.10	hy		510		CVA 1 16; H152	Fig.9q
16	ex Wandel	?				(B)	
	RF						
17	London E514	oen	Vulci	Berlin painter		(ARV 210,185)	

5, 9, 10, 12, 13 and 15-17 have two appended strokes, the rest, as far as I have ascertained, one; it is not easy to judge whether 3 has one or two. The single stroke on 8 is tilted to a position similar to that of type 2F, though the angle is scarcely as acute; the near lack of marks with the stroke in such a 'half-way' position makes it easy to distinguish between the two types. Hackl has the wrong number for 15 and both Heydemann and CVA have defective readings. The Priam and A.D. painters are conflated in Paral 147.

ii) With V, or V and a mark of type 8E

	BF					
18	London B332	hy	Vulci	Priam painter	(ABV 333,27)	
19	Louvre F286	hy		Priam painter	ABV 333,28; H150	8E,36
20	Oxford 1965.108	hy		Priam painter	CVA 3 25	
21*	Vatican, Astarita 733	hy		Priam painter	(Paral 147,30)	
22	Florence 3866	hy		510-500	CVA 5 13; H149	8E,37

iii) With a mark of type 11E,i or iii

	BF					
23	Munich 1486	n-a	Vulci	Circle of Antimenes painter	CVA 8 86; H156	11E,45
24	Louvre F255	n-a		510-05	CVA 4 28	11E,46
25	Castle Ashby	n-a		510-500	CVA 7	11E,47

iv) With various marks

	BF					
26	Louvre CA4716	hy		Leagros group, Antiope painter?	RA 1972 137	3D,21
27	where?	n-a	Vulci		Bull.Inst. 1883 165	

v) A mark that may be related

	BF					
28	Munich 1903	lek	Vulci	Workshop of Athena p. (Johnston)	H154	Fig.9m
29	Munich 1904	lek	Vulci	Workshop of Athena p. (Johnston)	H155; (Micali pl 99,13)	

Type 14E

i) Alone

	BF					
1	Hamburg 1913.390	n-a		Red-line painter	CVA 1 31	
2	Villa Giulia	oen	Cerveteri		NSc 1937 429,118	
3	*Munich 1779	oen	Vulci		H176	

ii) With a mark of type 2F

	BF					
4	Compiègne 974	n-a	Vulci	520-10	CVA 5	2F,56
5	Munich 1501	n-a	Vulci	Group of Munich 1501	(ABV 341,1); H173	2F,57
6	London B250	n-a	Vulci	Group of Munich 1501	(ABV 341,2); H174	2F,58

iii) With a mark of type 11E

	BF						
7	Munich 1565	n-a		c.525	H172	11E,30	
8	London B288	n-a	Vulci	Painter of London B288	(ABV 593,1); H176	11E,31	
9*	Vatican 403	n-a		Painter of London B288	(ABV 593,5)	Fig.9k	11E,32
10*	Vatican 404	n-a		Painter of London B288	(ABV 593,6)	11E,33	
11*	Copenhagen Th. 36	n-a		510-490		11E,34	

iv) Marks similar in appearance

BF
| 12 | Turin 4106 | n-a | Vulci | Group of Würzburg 199 | CVA 2 5 |
| | | | | (Lo Porto) | |

undetermined
13*	Tarquinia 73/	cup	Gravisca	525-500	
	12316	foot			
14	Adria (21,21)	cup	Adria	c.450	
		foot			

13 seems to be from a Chalcidising cup; the shape of the mark is virtually as the main version. For H175 see 15B,18.

Type 15E ⱯE

i) Alone, dipinto

BF
1	Vatican 347	type B Cerveteri Painter of Vatican 347	ABV 138,1; H23
2	Vatican 353	type B Cerveteri Painter of Vatican 347	ABV 138,2; H24
3	Vatican	type B	H25

I found no third example of the mark in the Vatican and must make 3 a doubtful entry; dittography occurs elsewhere in Hackl's catalogue.

ii) Dipinto, with a mark of type 8E

BF
4	Würzburg 234	n-a	Painter of Würzburg	ABV 591,3; H14	8E,1
			234		
5	Munich	n-a		H13	8E,2

iii) Graffito

BF
6	Aachen, Ludwig	type B	Amasis painter	Paral 65, upper	retrograde
	19				
7	Louvre G520	type B	550-525	CVA 5 6	Fig.9n
		foot?			
RF					
8	Copenhagen 126	cal-kr	Troilos painter	ARV 297,11	Fig.9x

iv) Longer abbreviations

BF
| 9* | Louvre E804 | hy | Lydos | (ABV 108,13) | Fig.9p and Pl. 12 |
| 10* | where? | n-a | | (B) | 5D,8 |

Beazley gives the reading Ǝ⊤ƎⱯ ⊢Ꝑ for 10.

Type 16E Ⱶ

BF
1*	Florence 76167	n-a	Vulci	540		Fig.8c	8E,53
2	Oxford 1965.118	type A		Rycroft painter	CVA 3 21		17E,24
3	Worcester 1956.	type A		Rycroft painter	Paral 148,5bis		
	83						
4	Madrid 10914	n-a		Rycroft painter	ABV 336,18		
5	Yale 106	n-a		520-10			
RF							
6*	Florence	hy		Nikoxenos painter	(ARV 222,21)	Fig.8m	9E,81
7	Boston 13.119	lek	Gela	Early mannerist	ARV 588,73		
8	Gela 635	Nolan	Gela	460	ML 17 420; G & R	with ‖	
					21 (1974) 149		
9	Syracuse 30664	Nolan	Gela	475-450, b.g.	G & R ibid	Fig.10z	

10	Munich 7524 (2335a)	n-a	Capua?	Providence painter	*ARV* 637,34		ᚷ
11	Florence 4015 undetermined	hy		450-40		Fig.5p	11C,3
12	Louvre G43	stam		alien foot	(*ARV* 20,2); H431		9E,53

2-4 are not cut the same way up in relation to the foot of the vase. Very close to 6 and 12 are 21E,60 and 61, with a vestigial extra stroke to the mark.

Type 17E Λ E

i) Not in ligature, mostly alone

	BF						
1*	Tarquinia RC1876	n-a		Tarquinia 530		Fig.10a, on neck	
2*	Leningrad inv. 2067	hy		Leagros group, Painter S	(*Paral* 160)		
3	Boston 63.473	hy		Leagros group, Antiope group	*Paral* 164,31bis; *CVA* 2 25		
4	Cab.Med. 256	hy	Vulci	Leagros group, near Antiope group	*ABV* 363,44	see below	
5	Louvre F300	hy		Leagros group	*ABV* 360,4	see below	7D,80
6	Berlin 1907	hy	Vulci	Leagros group	(*ABV* 360,8); H427		
7*	Louvre CA2992	hy		Leagros group	(*ABV* 360,10)		
8	Munich 1719	hy	Vulci	Leagros group	(*ABV* 361,13);H425		
9	Vatican 416	hy	Cerveteri	Leagros group	*ABV* 365,65		
10	Munich 1714	hy	Vulci	Leagros group	(*ABV* 365,66);H426		
11	Vatican 417 b.g.	hy	Vulci	Acheloos painter	*ABV* 384,26		
12	Würzburg 139	cup		Ionic?	H428		
	RF						
13*	Bari 3196	hy		Group of Polygnotos	(*ARV* 1061,155)	retrograde	18C,17

The reading of 5 is not that of Pottier, who was misled by later scratchings under which the original mark lurks. As is stated in *CVA*, 4 is incomplete, though the *CVA* reading of what remains is inexact.

ii) As i, with other marks

	BF						
14	Louvre F302	hy		Leagros group	Paral 165,74bis	Fig.7m	5E,22
15	Mus. Etruscum 82	amphora	Vulci				32A,16
	RF						
16	Louvre G178	hy	Vulci	imitation of Berlin painter.	*ARV* 218,3	Fig.9w	10F,23; 26F,7
17	Mus. Etruscum 1198	amphora	Vulci	near Berlin painter? (Amyx)	*Hesperia* 27 (1958) pl 54d		10F,24; 26F,8
18	New York 07.286.78	type B	Agrigen-to?	Eucharides painter	*ARV* 227,9	with numerals	14F,11
19*	Würzburg 509	type C		Syleus painter	(*ARV* 249,5)	Fig.10b	18E,8; 19E,1
20	Louvre G232 b.g.	pel	Chiusi?	Syleus painter	*ARV* 250,24		18E,9
21	Adolfseck 198	lekanis		425-400	*CVA* 1 45	with numerals	

The reading I give for 14 is not as Pottier's. 20 also has Etruscan *tha*.

iii) In ligature

	BF, dipinto						
22*	Cerveteri, magazzini	n-a	Cerveteri	570		navel	
23*	Villa Giulia 50757	hy		540		navel	
24	Oxford 1965.118 graffito	type A		Rycroft painter	*CVA* 3 21		16E,2
25	Munich 1449	n-a	Vulci	570-60	*CVA* 7 31	s.1.1,21	

26	Louvre F228	n-a		Antimenes painter	ABV 269,46		
27*	Louvre F297	hy		near Priam painter	(ABV 333,1)	navel	
28*	Cab.Med. Delepierre 28	hy	Vulci	Leagros group	(ABV 365,62)		8D,81
29	Florence 3858	hy		510-500	CVA 5 19; H430	twice	
30	Louvre E734	hy		510	H429	Fig.9s	
31*	Louvre F327	oen		Group of Vatican G50	(Paral 190,7)		
32*	Syracuse 19912	oen	Gela	500-490			
33	Orvieto	foot	Orvieto		Annali 1877 pl L,9		
34	Orvieto, Faina	amphora	Orvieto?		CII app. 628c		

RF

35	Leningrad P39	col-kr		Berlin painter	(ARV 207,134);H432		⋀\
36	London E352	pel	Kamiros	Early mannerist	(ARV 586,53); BMC		
37*	Ragusa 29915	pel	Kamarina	Hasselmann painter	(ARV 1136,17)	with ‖‖	
38*	ex Feuardent b.g.	pel		Manner of Sabouroff p.	(ARV 851,1?); (B)		3D,19
39	London o.c. 1217	n-a	S. Italy	450-25			

The horizontal hastae of the *epsilon* on 27 slope upward somewhat. There is a further graffito on 36 unconnected with this mark. The published description of 34 is 'V and VE in ligature'; this may suggest a mark of type 21E, or a retrograde ligature, as perhaps the following:

iv)

BF

40	Tarquinia RC1750	oen	Tarquinia	Altenburg class	(ABV 423,9); NSc 1930 160	Fig.9t

RF

41*	London E486	col-kr Nola		Painter of Munich 2335	(ARV 1166,88)	Fig.10d	18C,77; 19F,17
42	Cab.Med. 377	n-a		Westreenen painter	ARV 1006,4		s.1.2,34
43*	ex Ruesch	Nolan			(B)		

v) As iii, but perhaps in close association with accompanying marks

RF

44	Louvre G200	n-a		Cleveland painter	ARV 517,10; H432a Fig.10h

It is not easy to decide the intended meaning of the other marks; all of the horizontal strokes could be queried, though a proportion of them should be intentional. I can offer no satisfactory text.

vi) In ligature, the letters joined at the base only

BF

45	Munich 1485	n-a	Vulci	related to Lysippides painter	CVA 8 24; Hackl pl 2	21E,63

RF

46	Bologna 177	stam	Bologna	Agrigento painter	(ARV 577,53); H206	
47	Bologna 203	col-kr	Bologna	Florence painter	(ARV 541,9); H204	
48	Bologna 210	col-kr	Bologna	Painter of London E489	(ARV 546,3); H205	
49*	Ferrara T770	bell-kr	Spina	c.420	(B)	18C,40

46-48 are on the navel. Hackl has an erroneous reading for them, but his comment on p.64 suggests that this may be the result of a misprint. The graffito on 45 is similar to type 21E, but differs enough to warrant separate treatment.

See also 9F,iv for further examples of the mark, unligatured.

Type 18E E M

i) Alone

BF

1	Brussels, Mignot 8	n-a		520-10	
2	Brussels R315	oen		Painter of Vatican G49	ABV 528,41
3	Würzburg 201	n-a	Vulci	490	

RF

4*	Berlin 3154	pel		P. of the Munich amphora	(ARV 245,4); (B)
5*	Hague 2026	type C		Tyszkiewicz painter	(ARV 292,32); (B)

ii) With K and a ?pictogram

RF

6	Louvre G62	type C		P. of the Munich amphora	ARV 245,2		V⟩ ; 9D,20
7	Leningrad P27	type C		P. of the Munich amphora	(ARV 245,3)		9D,21

iii) With ΛΙ or ΛE

RF

8*	Würzburg 509	type C		Syleus painter	(ARV 249,5)	Fig.10b	17E,19; 19E,1
9	Louvre G232	pel	Chiusi?	Syleus painter	ARV 250,24		17E,20
10	Vatican 16554	hy	Vulci	Syleus painter	ARV 252,47		3D,16

iv) With other marks

RF

11	Stockholm 1963.1	type B	Tyszkiewicz painter	ARV 1643,33bis	Fig.10c	19E,2; 10F,18
12*	Palermo 2378	stam	Syleus painter	(ARV 251,34)	Fig.10k	5F,3
13*	Naples 127930	col-kr	470-60		Fig.10g	9F,52

Type 19E K P O

i) With EM and other marks

RF

1*	Würzburg 509	type C	Syleus painter	(ARV 249,5)	Fig.10b	17E,19; 18E,8
2	Stockholm 1963.1	type B	Tyszkiewicz painter	ARV 1643,33bis	Fig.10c	18E,11; 10F,18

ii) Other

RF

3	New York 06.1021.151	type A	Syracuse painter	ARV 519,16	k

Type 20E ΓE

i) Alone

BF

1	London B195	type A	Vulci	Rycroft painter	(ABV 335,2)	3D,8
2	Leningrad St.19	hy		Near p. of Würzburg 173	(Paral 145)	
3	Vatican 385	n-a	Vulci	Leagros group	ABV 374,195	
4	Dublin 1921.94	n-a		Leagros group (von Bothmer)		Fig.9v
5	London B184	type B	Vulci	520-10	(CVA 3 pl 33,3)	
6	Los Angeles 50.8.22 undetermined	n-a		510-500	Hesperia 24 (1955) 12	
7	Adria (20,28)	cup foot	Adria			
8	Adria (20,29)	cup foot	Adria			

ii) With K

BF

9	London B279	n-a	Vulci	Red-line painter	(ABV 601,5)	
10	*Munich 1640	n-a	Vulci	Red-line painter	(ABV 603,60)	
11	Vulci	n-a	Vulci	Red-line painter (Riccioni?)	Quad.V.G. 3 31	
12	Leningrad St.120	type B		Near Red-line painter (Gorbunova)		K twice

| 13 | New York
41.162.212 | n-a | | | 500 | | | *CVA* 4 32 | |

Jahn's reading of 10 lacks the horizontal. The reading of 11 is not fully clear from the photograph. It seems to be as 12 but with added strokes on the *kappas* (if such they be), making them like asterisks, and two unit strokes at the end. 13 also has a slightly asteroid *kappa*, plus five unit strokes.

 iii) Possibly related

	BF					
14	Paris, Rodin 232	oen		Near Athena painter	*ABV* 530,85	
	RF					
15	Vatican 16571	type B	Vulci	Achilles painter	(*ARV* 987,1)	Fig.9u

15 has been published in various forms; I hope my version will settle the issue.

Type 21E

This mark assumes a variety of contorted shapes which I have attempted to sort into sub-groups.

 i) ⋀⋔ The lowest hasta of the *epsilon* is not one with the stroke of the '*lambda*'

	BF						
1	Naples Stg. 160	n-a		Antimenes painter	(*ABV* 271,68)	Fig.10f	
2	London B244	n-a	Vulci	Antimenes painter	(*ABV* 271,74);H440		traces
3	London B247	n-a	Vulci	Antimenes painter	(*ABV* 271,81);H441		
4*	Villa Giulia 15731	n-a	Nepi	Antimenes painter	(*ABV* 272,98)		
5	London B262	n-a	Vulci	Medea group	(*ABV* 321,3); H442	Pl. 32a-b	21E,64
6	New York 61.11.16	n-a		Medea group	*CVA* 4 28		
7*	Florence 76360	n-a	Tarquinia	520-10		Fig.10j	
8	Frankfort VF 289	n-a		related to Leagros group	*CVA* 1 30		
9	Kassel T698	col-kr		Hischylos, potter	*CVA* 1 46		
10	Louvre F269	n-a		510	*CVA* 5 36		
11	Tarquinia 652	n-a	Tarquinia	510-500	*St.Etr.* 36 (1968) 238	Fig.10e	
	RF						
12	Louvre G52	hy		520-15	*CVA* 6 40	Fig.10l	

1 is complete, *pace* Beazley, *JHS* 47 (1927) 89. My interpretation of 11 is different from that offered in *St.Etr.* l.c.; the extra stroke does not join the vertical and is probably a later addition; heavy wheel marks on the foot obscure the issue.

 ii) ⋀⋔ The line in question is continuous. Also examples where the nature of the line is
 unknown to me (= *)

	BF						
13	Leiden PC63	hy	Vulci	Antimenes painter	*CVA* 1 pl 52,5		
14	Norwich?	hy		Antimenes painter	(*ABV* 268,23); *JHS* l.c. 89		* **T**
15*	Villa Giulia 15537	n-a		Antimenes painter	(*ABV* 269,47)	Fig.10i	
16	Dunedin E48.231	n-a		Antimenes painter	*CVA* 1 9		*
17	Vatican 392	n-a	Vulci	Antimenes painter	*ABV* 272,89		
18	Los Angeles 50.8.1	n-a		Antimenes painter	(*ABV* 273,108); *Hesperia* 24 (1955) 23		*
19	Berlin 1842	n-a		Antimenes painter	(*ABV* 273,110); *JHS* l.c. 88		*
20	Cambridge 53	n-a	Vulci	Antimenes painter	*ABV* 273,114;H444		
21	London B226	n-a	Vulci	Antimenes painter	(*ABV* 273,116);H438		traces
22	London B266	n-a	Vulci	Antimenes painter	(*ABV* 273,118);H443		
23*	Cab.Med. Delepierre 29	n-a		Antimenes painter (who?)			
24*	Boulogne 1	n-a		Manner of Antimenes p.	(*ABV* 278,38)	Fig.10n	
25	London B315	hy		near Antimenes painter	(*Amazons* 62);H447	Fig.10v	
26	London B237	n-a		Eye-siren group	(*ABV* 286,3) H439		traces
27	San Francisco 1814	n-a		Group of Würzburg 199	*ABV* 287,3		

28*	Cologny, Bodmer	n-a		Group of Würzburg 199	(*Paral* 126,3bis)		
29	Leningrad St.121	n-a		Antimenean	H445		
30	Boston 97.205	n-a		near Antimenean Group	*CVA* 1 31		
31*	Windsor, HM the Queen	n-a		525		Fig.10p	
32*	London, V & A 4796.1901	n-a	Vulci	525			
33	V.G. 50414 (M479)	n-a		520		Fig.10m	X
34	Leiden PC40	n-a	Vulci	520	*CVA* 1 pl 52,9		
35*	Boulogne 572	n-a		520-15		Fig.10r	
36*	Vatican 390	n-a		510		Fig.10q	
37	Würzburg 182	n-a		Long-nose painter	*ABV* 327,4; H436		
38	Würzburg 203	n-a	Vulci	Long-nose painter	*ABV* 328,6; H437		
39	Leiden PC51	n-a	Vulci	Leagros group (Vos)	*CVA* 1 pl 52,11		
40	Copenhagen inv. 2	pel	Capua?	Red-line painter	*ABV* 604,71		
41	Berlin 1843	n-a		Edinburgh painter	(*ABL* 220,85);H433		
42	*Munich 1570	n-a	Vulci		H434		*
43	*Munich 1628	n-a			H435		*

For the lid published in *CVA* with 15 see 11B,6. 36 is not easy to discern on the vase.

iii) Close to i, but accompanied by AB in ligature

BF

44*	Florence 4148	n-a		510		Fig.10s	22E,7
45*	Tarquinia RC7450	n-a	Tarquinia	510-500		Fig.10w	22E,8
46	Louvre F21			alien foot			22E,9

iv) As ii, but the shape of the *epsilon* sacrificed to that of the '*lambda*'(an exaggerated form of 35)

BF

47	Vatican 400	n-a	Vulci	500	

The vase bears this number, rather than Albizzati's 399.

v) As i, but the '*lambda*' not clearly defined

BF

48	Berkeley 8.3377	n-a	Capua	500-490	*ABV* 481,2

vi) ⋀⊬

BF

49	Cambridge 52	n-a	Vulci	Related to Lysippides painter	*ABV* 263,5		
50*	Boulogne 418	n-a		Leagros group, near Acheloos painter	(*ABV* 373,177)	Fig.10aa	traces
51	Vatican 396	n-a	Vulci	Leagros gr., recalls Acheloos painter	*ABV* 375,206	Fig.10u	
52	Naples Stg.141	n-a		Leagros gr., recalls Acheloos painter	*ABV* 375,209		
53*	Bologna PU196	n-a		Leagros gr., recalls Antiope painter	(*ABV* 371,146)		traces
54*	Capesthorne Hall	hy		Leagros group	(*ABV* 365,64)		see below
55*	Boulogne 419	n-a		Leagros group	(*ABV* 375,215)		
56*	ex London market	n-a			*Sotheby* 1/7/1969 102	Fig.10t	

On 49 the *epsilon* is attached in a different manner from the rest of the sub-group. There is a further graffito on 54 for which I have no full reading.

vii) A mark similar to vi is found on a vase stylistically associated with another bearing a mark closer to type 20E. I put them together here because the resemblance to type 20E is not quite close enough to demand its inclusion there, and also to illustrate the complex ties which seem to hold together a number of these *lambda-epsilon* marks.

	BF						
57	Copenhagen 114	n-a	Vulci	Group of Copenhagen 114	*ABV* 394,1		
58	Würzburg 213	n-a	Vulci	Group of Copenhagen 114	*ABV* 395,6		

viii) As ii, but with only a vestigial first stroke to the '*lambda*'

	BF						
59	Leiden PC1	hy	Vulci	Painter of London B343	*CVA* 1 pl 52,3		9E,77
	RF						
60	Leningrad P23	hy		Nikoxenos painter	(*ARV* 222,22)		9E,82
61	Leningrad P25	hy		Nikoxenos painter	(*ARV* 222,23)		9E,83

See also 16E,6-12.

ix) Dipinto

	BF						
62*	ex London market	type B		c.520	(*Sotheby 9/7/1973* 168)		
63	Munich 1485	n-a	Vulci	related to Lysippides painter	*CVA* 8 24; Hackl pl 2		17E,45
64*	London B262	n-a	Vulci	Medea group	(*ABV* 321,3)	Pl. 32a-b	21E,5

62 is worn, but I am confident of the reading; the shape is as of i. 63 is nearer to type 16E, while 64 is perhaps closer to 49 than any other; I add 'perhaps' since the mark is ill-preserved. After 62 it is the best preserved of this set of dipinti (including 2, 21 and 26), but even so I am not confident of the reading; of the rest the best one can say is that they all have v-shaped marks which form only part of the original. 64 seems to have had a further dipinto in the vicinity of its graffito; a v-shaped fragment is all that can be read.

Type 22E

i) Alone

	BF						
1	Bonn inv. 44	type B		510	H216; *AA* 1935 427-8, 449		
2	Naples 2539	hy		510-490	H217; *CVA* 1 18	with ❙	Etruscan marks
3	Gela, Navarra 125/B	lek	Gela	Edinburgh painter	*CVA* 3 8		
4*	Taranto 52160	lek	Taranto	Edinburgh painter		Fig.10y	
5*	Tarquinia Gr.II 18353	cup foot	Gravisca	late sixth century			
6	*Munich 1895	lek			H215		

The 'Boeotian' shape of the *alpha* on 1 is to be noted. On 3 the cross-bar slopes down to the right. 4 may not be complete; there are traces of a further letter, but the foot is broken.

ii) With a mark of type 21E,iii

	BF						
7*	Florence 4148	n-a		510		Fig.10s	21E,44
8*	Tarquinia RC7450	n-a	Tarquinia	510-500		Fig.10w	21E,45
9	Louvre F21			alien foot			21E,46

The reading of 9, the clearest of the trio, must be **AB** in ligature; 7 and 8 should be regarded as basically similar despite the difficulties involved. The mark of type 21E is lightly incised on both 7 and 8, but it is possible to see the protruding central hasta of the *epsilon* on both.

iii) The exact form unknown

	BF						
10	Havana, Lagunillas	n-a		Leagran?	ex Forman 290		

The catalogue mentions a 'monogram graffito composed of the letters ABI'.

Type 23E Λ A

i) Not in ligature

BF

1*	New York, Noble	n-a		Euphiletos painter	(*ABV* 323,21)	
2	Ullern, Oslo	oen	Rome?	510-500	*CVA Norway* 1 20	
3*	Louvre AM1388	cup foot				
	RF					
4	Brussels R235	pel	Capua	Late mannerist	*ARV* 1121,11	other graffiti

On 1 and 2 the cross-bar of the *alpha* slopes up to the right, on 4 down; on 3 it is horizontal.

ii) With a mark of type 5A

BF

5	Louvre F258bis	n-a		505	*PdP* 27 (1972) 418 fig. 3	5A,16
6	Würzburg 217	n-a	Vulci	Group of Munich 1501	*Paral* 153	5A,17
6a*	Athens, Kanell- opoulos 2499	hy	Italy	520	(*AAA* 9,2 (1976) cover)	26F,17a

iii) Accompanied by various marks

BF

7	Naples 2712	n-a		520-10	*PdP* l.c. fig. 2		26F,19
8	Louvre F240	n-a	Vulci	Leagros group	*ABV* 370,129; *PdP* l.c. 419		24E,4
9*	Chicago 1889.15	hy	Cerveteri	510	(*ABV* 673)	Fig.10x	24E,5
10	Cambridge Cl. Arch. 472	col-kr		510	*PdP* l.c. 417		21A,62

8 also has a single stroke on the opposite side of the foot and 9 apparently an X; otherwise the two marks are strikingly similar. It is highly likely that Naples 2533 (26F,18, Fig.13k) belongs here; for a discussion of the reading see *PdP* l.c. 418 n.2. 6a forms part of the cover motif.

iv) Ligatured, the two letters joined at the base only

BF

11*	Tarquinia 627	Panath	Tarquinia	Euphiletos painter	(*Paral* 142,12bis)	Fig.10cc	E
12	Oxford 218a	Panath		related to painter of Oxford 218b	*CVA* 3 16		
13	Louvre F325	oen		Dot-ivy group	*ABV* 448,2; H214		E
14	Sèvres 57	n-a		Dot-band class	*ABV* 484,13		
15	New York X21.4	n-a		late sixth century	*CVA* 4 56		
15a*	Newcastle Univ. 105	n-a		520-500, black-glazed		Pl. 27	
16	Ferrara 16388	col-kr	Spina	Mikra Karaburun group	*CVA* 2 5		
	RF						
17	Oxford 1891.689	Nolan	Gela	Kleophrades painter	*ARV* 184,20		
18	Copenhagen inv. 122	cup	Vulci	Boot painter	*ARV* 822,28		E

Hackl and Pottier have an incomplete reading of 13; its shape is close to 11. The cross-bar slopes up to the right on 12, 15, 17 and 18, down on 14 and 15a.

v) Ligatured, with a common vertical

BF

19	London B257	n-a	Vulci	very late	(*CVA* 4 pl 63,3)	twice
20	London B275	n-a	Vulci	very late	(*CVA* 4 pl 68,1)	
	RF					
21	Basel, Bolla	stam		Dokimasia painter	*AK Beiheft* 9 100	

A version of 21 is also given by C. Isler-Kerenyi, *Stamnoi* 64.

vi) The exact form unknown

RF

22	ex Barone		krater		*CIG* 8346h

Type 24E Γ V

BF, dipinto

1	Hannover 1936. 107	type B		P. of Würzburg 243 (Follmann)	CVA 1 20	retrograde	

graffito

2	Munich 1414	type A	Vulci	Leagros group	ABV 367,87		
3	London B158	type B	Vulci	Leagros group	(ABV 368,105)	Fig.10bb	
4	Louvre F240	n-a	Vulci	Leagros group	ABV 370,129		23E,8
5	New York 26.60.29	type B		Acheloos painter	CVA 3 18		
6*	Chicago 1889.15	hy	Cerveteri	510	(ABV 673)	Fig.10x	23E,9
7	Vatican 386	n-a	Vulci	Painter of London B272	Paral 153,11		
8	Bologna 73	oen	Bologna	Workshop of Athena painter	(ABV 527,28)	with E	

b.g.

9	Würzburg 163	lekanis	Arezzo	525–500			s.1.4,38

RF

10*	Villa Giulia	pel	Viterbo area	Euphronios	(ARV 15,11)	before ‖	

The present fragmentary state of 2 makes inspection difficult; the letter given as a sidelong *epsilon* in *CVA* 1 32 is possibly a *pi*, since the central vertical does not connect with the horizontal. 3 is not as published in the old catalogue. The foot of 7 is dirty; my reading is not secure, but that of Albizzati is erroneous. I take 9 to be Attic, with Sparkes and Talcott, *Agora* xii 166, n.16.

SECTION F

Type 1F ΛΗΚΥΘΙΑ etc

i) LEKVΘΙΔΕS

	RF					
1*	Basel, Borowski V67.33	col-kr		Göttingen p. (who?)		9B,9
2	Syracuse 21834	pel	Gela	Syracuse painter	*Paral* 383,32	13B,5
3	Riehen, Granacher	hy		Syracuse painter	*Paral* 383,35	13B,6

1 has LEKV directly followed by acrophonic numerals, probably for 64, but the exact form of the sign for fifty is unclear.

ii) ΛΗΚΥΘΙΑ See also 14F,15

	RF					
4*	Budapest 50.154	hy		Class of London E195	(*ARV* 1077,3)	Pl. 15
5	Vienna 892	bell-kr		Telos painter	*CVA* 3 26	18C,84; 22F,1

4 is probably an ex Preyss vase mentioned by Beazley (MS) as having this mark.

iii) ΛΑΚΥΘΙΑ

	RF					
6	Gela 9240	pel	Vassall-aggi	420	*ZPE* 12 (1973) 295-9	Fig.12d 19F,2

A possible abbreviation, defectively inscribed, appears on a BF column-krater, Villa Giulia 50624, treated fully in *PdP* 30 (1975) 362-5.

iv) ΛΕΚΥ

	BF					
7	Tarquinia RC5165	type B	Tarquinia	Rycroft painter	(*ABV* 336,8); H570	Fig.12a 2B,39
	RF					
8	Bologna 162	pel	Bologna	Leningrad painter	(*ARV* 570,64);H571	

v) ΛΗΚΥ . See type 2F,vii A and B and viii.

vi) ΛΗΚ

	BF					
9	Chicago University	pel		Eucharides painter	*ABV* 396,23	7F,3; 19F,4
	RF					
10	London E163	hy	Vulci	Copenhagen painter	(*ARV* 258,26);H569	9E,108; 21F,1

vii) Λ Η, not in ligature. See also 2F v and vii C

	BF, dipinto					
11	Hannover 1967. 11	type B		540, Boeotian? (Follmann)	*CVA* 1 18	
	graffito					
12	London B261	n-a		Leagros group	(*ABV* 373,176);H567	2F,24
13	San Francisco 243.24874	type A	Vulci	Leagros group, Antiope painter	*CVA* 31	

I cannot discern the form of 13 from the photograph in *CVA*, nor do Smith's comments in the text clarify matters. I assume that Λ Η is the basis of the mark.

viii) ΛEKA

patterned
14 Naples RC2 col-kr Cumae c.500 Fig.6f 16B,30;
 3D,15;
 7F,4

ix) ΛHKA

RF
15 Naples RC132 col-kr Cumae Painter of Naples RC132 (ARV 233,1) Fig.12b 7F,6
16* Naples 3163 Nolan Nola Sabouroff painter (ARV 824,124) Fig.12q

Heydemann's reading of 15 is incomplete since there is a cross-bar to the *eta*.

x) ÆK

b.g.
17 Ferrara 13 bowl Spina 425-400 *St.Etr.* 46 (1978) 9E,73a
 305

Type 2F ΛΛ

i) Alone

BF
1 Boston 1970.69 n-a 520-10 *CVA* 1 31
2 Compiègne 1015 oen Vulci Dot-ivy group *ABV* 447,21
3* London 1926. n-a Leagros group (*ABV* 375,211)
 6-28.7
4 Berlin 1900 hy Vulci Acheloos painter (*ABV* 385,27);H418
5* Berlin 1851 n-a Vulci Acheloos painter (*ABV* 383,1); (B)
6 Tarquinia 635 n-a Tarquinia 510-500 H399 Fig.11a

1 seems later than the 525-20 suggested in *CVA*.

ii) With ⟩

BF
7 Berkeley 8.3376 n-a Group of Berkeley *ABV* 391,2 retrograde
 8.3376
RF
8 ex Swiss market hy 510-500 *Auktion* 14 74

I take the 'archaic *sigma*' mentioned in the catalogue on 8 as ⟩.

iii) Twice

BF
9 Louvre F213 type B Leagros group, *ABV* 369,110
 Antiope group I
10 Louvre F260 n-a 510 *CVA* 5 34 Fig.11c

There must be a strong likelihood that this mark appears on a hydria once on the Swiss market
attributed to the Leagros group (*Paral* 164,25bis); the catalogue gives HH .

iv) With a mark of type 3F

BF
11 Dunedin E48.66 hy Vulci Leagros group, near *CVA* 1 12 retrograde 9F,25
 Painter S
12 Naples Stg.148 n-a Leagros group, gr. of (*ABV* 371,141);H402
 Würzburg 210
13 Toronto 306 n-a Leagros group, gr. of *ABV* 373,180
 Würzburg 210
14 Stockholm n-a Leagros group, gr. of *Paral* 163,197
 1962.7 Würzburg 210
15 Cab.Med. 255 hy Vulci Leagros group (*ABV* 361,18)
16 Berlin 1908 hy Vulci Leagros group (*ABV* 365,70); H419 X
17 Louvre F263 n-a Leagros group *ABV* 375,205; H403

18	Dublin 1921.96	n-a		Leagros group (Johnston)		Fig.11b	
19*	London B252	n-a		510	(*CVA* 4 pl 62,2)		traces
20	Munich 1579	n-a	Vulci	510-500	H392		

The *CVA* reading of 15 is incomplete. H400 must be H402 repeated. A photograph of 12 is published in *Medelhausmuseet Bulletin* 3 (1965) fig.22.

v) As iv, with the main mark repeated

BF
21	Würzburg 214	n-a	Vulci	Leagros group, gr. of Würzburg 210	*ABV* 373,178; H393		
22	London B222	n-a	Vulci	Leagros group	(*ABV* 370,126);H395		✓
23*	Boulogne 98	n-a		Leagros group	(*ABV* 371,151)		
24	London B261	n-a		Leagros group	(*ABV* 373,176);H396		/ ;1F,12

21 is not as published by Langlotz. The repeated mark on 24 is not in ligature.

vi) As iv, with ⟨

BF
25	Louvre F256	n-a	Vulci	Leagros group	*ABV* 371,152; H397		/
26	San Simeon 9503	n-a		510-505	*Vente* 1910 150		

vii) As iv, with abbreviated vase names and Ionic numerals. Differences in the composition of the basic marks ('countermarks' attached to the ⋀ᐟ, ⋀ᐟ repeated, no mark of type 3F) are listed in the commentary. The divisions of the sub-group are arranged according to variations in the vase-name part of the graffito; v = vase name, n = Ionic numeral, and : represents the normal form of punctuation as exemplified in the figures. All are BF save 34-37 and 50.

A v : n : ⋀H . In all cases v is ⋀HKV

27	London B310	hy	Vulci	Leagros group, Painter S	(*ABV* 361,12); H415	
28	Toledo 69.371	hy		Leagros group, Painter S	*CVA* 1 40	traces
29	Munich 1717	hy	Vulci	Leagros group	(*ABV* 362,36); H411 and pl 2,561	
30	Oxford 1948.236	hy	Vulci	Leagros group	*CVA* 3 24	Fig.11g

B v : ⋀H : n . v is ⋀V

31	Würzburg 321	hy		Leagros group, Painter S?	*ABV* 364,50; H412	

C v: n . v is XV

32	Louvre F211	type B		Leagros group, Painter S	*ABV* 368,104;H406	Fig.11d
33	Louvre F212	type B		Leagros group, Painter S	*ABV* 368,103;H407	Fig.11e 8D,82
34	Munich 2421	hy	Vulci	Phintias	*ARV* 1620; H421	see below
35	Munich 2422	hy	Vulci	Phintias	*ARV* 1620; H422	5E,27
36	London E159	hy	Vulci	Phintias	(*ARV* 24,9); H424	
37	Louvre G41	hy	Vulci	Pioneer group	(*ARV* 33,8); H423	Fig.11f

v is ⋀H

38*	Detroit 64.148	hy	Vulci	Leagros group, near Painter S	(*Paral* 164,11bis)	Fig.11l
39	Cambridge 56	hy	Vulci	Leagros group, near Painter S	*ABV* 364,52; H416	
40	Munich 1711	hy	Vulci	Leagros group	(*ABV* 360,3); H410	Fig.11k
41	Leningrad St.77	type B		Leagros group (Gorbunova)	H401; (*Soov.Gosud* 38 (1974) 37)	
42*	Copenhagen Th. 56	hy		Leagros group	(*ABV* 363,40)	Fig.11i

v is ΛV

43	London B313	hy	Vulci	Leagros group, Painter S	(*ABV* 360,1); H413 Fig.11j
44	Stockholm 1968.123	hy		Leagros group, Red-line painter	(*ABV* 361,21); see below
45	Munich 1716	hy	Vulci	Leagros group	(ABV 362,25);H409
46	Berlin 1902	hy		Leagros group	(ABV 363,37);H417

v is APV

| 47* | London B225 | n-a | | Leagros group | (*ABV* 371,144) | Pl. 28 |
| 48 | Mus.Etruscum 1710 | amphora | Vulci | | | Fig.11m 3E,59 |

v is KVΛ or KVΛΦA (49)

| 49 | London B196 | type A Vulci | | Leagros group, Painter S | (*ABV* 366,84);H405 |
| 50 | Munich 2309 | type A Vulci | | Euthymides | ARV 27,4; H408 |

v is OⱵV

| 51 | London B320 | hy | Vulci | Leagros group, Painter S | (*ABV* 364,49);H414 Fig.11h 14F,13 |

D 51 also has an example of the formula v : n : n , where v is XVTPI. In another case it is ΛHKV :

| 52 | Munich 1413 | type A Vulci | | Leagros group, Painter S | ABV 366,85; H404 |

E One piece which seems to belong here but omits v

| 53 | where? | | amphora Bolsena | | NSc 1886 151 |

32 lacks punctuation. The following are not correctly, or fully published elsewhere: 36 (the ⋀⋀ is repeated), 37 (the *zeta*, though fragmentary, is a certain reading), 51 and 47 (the parallel with 48, which is not the same vase according to the description in *Museum Etruscum*, is striking, since only on 47 does the punctuation slope up to the right, and a misreading of such punctuation must have caused the odd three-bar *sigma* in the *Museum Etruscum* facsimile; the tailed *rho* there is a puzzle - it is likely to have been an accidental scratch). Only the shoulder of 29 now survives and we must be content with Hackl's copy; we should note however that it differs from Jahn's (731), who gives an additional ⸋⸋ . 34 and 55 also have Etruscan *me*, clearly in a second hand. 29 is the only retrograde ligature in the sub-group. There are a number of extra lines on 44, which is published in *Medelhausmuseet Bulletin* 11 (1976) 32.

viii) As i, with ΛHKV in letters of the same size

BF
| 54 | Munich 1543 | n-a | Vulci | 510-500 | H391 |

RF
| 55 | Munich 2423 | hy | Vulci | Hypsis | ARV 1621; H420 |

On all the RF vases in this type the lettering is of approximately the same size throughout; on the BF pieces the lettering of the formulae is regularly smaller than that of the main marks.

ix) As i, with a mark of type 14E

BF
56	Compiègne 974	n-a	Vulci	c.510	*CVA* 5	14E,4
57	Munich 1501	n-a	Vulci	Group of Munich 1501	(*ABV* 341,1); H389	14E,5
58	London B250	n-a	Vulci	Group of Munich 1501	(*ABV* 341,2); H394	14E,6

x) I know no more about the following than Hackl gives:

BF
| 59 | Florence | n-a | Chiusi | | H398 |

I omit Munich 1575 (H390) from my list as the true reading makes it a doubtful candidate (*CVA* 8 10).

Type 3F ⚨ alone

For accompanied marks see type 2F *passim*

	BF			
1	Cab.Med.	amphora		*CVA* 2 56
		lid		
2*	Louvre	amphora		
		lid		
3*	Louvre	amphora		
		lid		
4*	London 1966.	amphora		
	4-28.5	lid		
5	Mus. Etruscum	amphora	Vulci	
	1692			

All the marks on lids are on the underside and of some size. 1 was erroneously associated with Cab.Med. 252 (21A,14).

Type 4F ΑΡVΣΤΗΡ

For further examples of **ΑΡV** see 2F, 47-48.

1) Abbreviations

| | BF | | | | | | |
| --- | -------------- | ------------- | -------------------- | ------------------ | -------- | ------ |
| 1 | Toronto 250 | *Panath | Eucharides painter | *ABV* 395,2 | | |
| 2 | Leiden PC7 | *Panath Vulci | Near p. of Berlin 1833 | *CVA* 1 pl 53,10; | | |
| | | | | H549 | | |
| 3 | Munich | foot | | H550 and pl 2 | | |
| | | of | | | | |
| | | Panath | | | | |
| 4* | Naples 126056 | oen | Geras painter | (*ARV* 287,32) | Fig.7u | 3E,54 |

The position of the various parts of 1 on the foot can be envisaged from a comparison with 2 and 3.

ii) The word in full

	RF				
5	Edinburgh	hy	Polygnotos	*G & R* 21 (1974)	3B,2a;
	1877.29			151,12	18C,14a;
					21F,4

The surface of 5 is much worn and it is difficult to establish a precise text, especially in the final line; see on 3B,2a.

Type 5F ΚV

See type 2F,vii C. Add the following:

	RF						
1	Villa Giulia	pel	Falerii	Tyszkiewicz painter	(*ARV* 293,49);	Fig.12h	9F,48
	1129				*CIE* 8291		
2*	Copenhagen NyC	pel		Tyszkiewicz painter	(*ARV* 293,50)	Fig.8q	8E,102;
	2659						19F,5
3*	Palermo 2378	stam		Syleus painter	(*ARV* 251,34)	Fig.10k	18E,12
4	Adolfseck 74	col-kr		Pig painter	*ARV* 564,16		10F,15;
							13F,2
5	Naples 3232	hy	Nola	Polygnotos	(*ARV* 1032,61)		
6	Ruvo 323	owl	Ruvo	c.450?	ΚVΔΔIIII		
		sky					

Type 6F ΛV

See type 2F,vii B and C. Add the following:

	RF					
1	Berlin 2188	stam	Vulci	Hephaisteion painter	ARV 298,1	2B,14; 22F,4
2	Naples 2847	bell-kr	S. Agata	Erbach painter	AJA 82 (1978) 225	23F,7; 18C,49; 26F,14

1 has the full name λύδια . 2 may or may not be an abbreviation of this, see AJA l.c.

Type 7F ΧV

See also type 2F,vii C. As with some of the succeeding marks, there are examples which do not have any vase-name connotation; sub-groups i and ii are perhaps such.

i) BF, dipinto

1	Rhodes 12397	cup	Kamiros	530-20	BSA 70 (1975) 153,63	retrograde
2	Istanbul 1938	cup	Rhodes	520	BSA ibid 49	

ii) Graffito

	BF						
3	Chicago, University patterned	pel		Eucharides painter	ABV 396,23	1F,9; 19F,4	
4	Naples RC2	col-kr	Cumae	c.500	H572	Fig.6f	16B,30; 3D,15; 1F,14
5*	Vatican	col-kr		c.500		Fig.12e	
	RF						
6	Naples RC132	col-kr	Cumae	P. of Naples RC132	(ARV 233,1)	Fig.12b	1F,15

5 is not fully preserved but the remains strongly suggest a reading as on 4 and 6. The bottom left-hand stroke of the second letter on 4 and 6 seems to be an accidental prolongation.

iii) Full vase names

	RF					
7	Aachen, Ludwig 36	stam		Copenhagen painter	Paral 351,20	15F,1
8	ex Swiss market	stam		Tyszkiewicz painter	(ARV 291,23); Stamnos fig. 15	26F,4

See the commentary on type 15F for the reading and interpretation of 7. H559 is 2F,9; the reading in the Cataloghi Campana misleads.

Type 8F ΠΟΙ

i) Alone or nearly so

	RF					
1	Chantilly	n-a	Nola	Aison	(ARV 1176,25); AK 10 (1967) 143	after ⟨
2	Basel BS407	oen		Eretria painter	Paral 469,12bis; AK ibid	
3	London E229	hy	Cyrenaica	Painter of London E230	ARV 1481,1; Hackl p.72	

ii) With a mark of type 9E

	BF					
4	Munich 1688	hy	Vulci	Manner of Lysippides painter	(ABV 260,33); Hackl ibid Hackl ibid	9E,28
						9E,56

| 5 | Orvieto
RF | foot | Orvieto | | | | |
|---|---|---|---|---|---|---|
| 6 | London E467 | col-kr | Altamura | Niobid painter | (ARV 601,23);
Hackl ibid | | 9E,118 |
| 7 | Ruvo 767 | sky | Ruvo | c.450 | | Fig.9c | 9E,124;
13F,11 |

Hackl doubted whether the foot of 4 belongs; I saw no reason to doubt it and so assume that 5 is also from a BF vase.

iii) Associated with a ΔPAX mark

	RF					
8	London 1921. 7-10.2	hy		Group of Polygnotos	ARV 1060,138; see below	2B,28; 21F,7
9	Leningrad St.1206	hy		Group of Polygnotos	(ARV 1060,141)	21F,8

See Beazley, *JHS* 51 (1931) 123 and *AK* l.c. for the full text and discussion.

iv) Others

	RF					
10	Louvre G436	Nolan	Nola	Phiale painter	ARV 1015,1; H612 and p.72	16B,31; 11F,16
11	Newcastle, Univ. 199	oen		Bull painter	(*Paral* 483,12ter); *Arch.Rep.* 1969-70 60	
12	Ampurias	foot	Ampurias	c.400?, small open vase	see below Fig.12t	
13	Chersonesos	sky	Cherson- esos		*VDI* 1976 3 137-8	
14	Histria V.8731	sky	Histria	400-350	*St.Class.* 7 (1965) 284	
15	once Tartu	cup		c.400	*AK* l.c.	
16	Naples?	cup			*CIG* 8345i	14F,21

All save 10 have assured numerals accompanying the mark; see the publications for details. 15 is illustrated in Malmberg and Felzberg, *Antichniya vazi i terrakotti* pl.4. I prefer the reading ΠΟΙ to ΠΔΙ on 14 because the ordering of the numerals would be unusual, especially with ΔΠΙ on the same foot, although the letter seems nearer a *delta* than an *omicron*. 12 is published, in a manner, by A. E. Prescott, *XIV Congreso Nacional di Arqueologia* 832. 13 is also published in *Graffiti Antichnoyo Chersonesa* no 1403.

Type 9F N V

i) Alone

	BF						
1*	Bologna PU195	n-a		Group of Würzburg 199	(ABV 288,10)	Fig.12g	
2	New York X 21.17	n-a		Red-line painter	CVA 4 57		
3	Naples 2752	pel	Nola	Theseus painter	H472; ABV 519,11	part on navel	
	RF						
4	Harvard 1927.148	Nolan		Alkimachos painter	ARV 529,7		
5	Naples 3180	Nolan	Nola	Alkimachos painter	(ARV 530,16);H473		
6	Madrid 11101	Nolan		Alkimachos painter	ARV 530,18		
7	London E285	n-a		Alkimachos painter	(ARV 530,25);H474		
8	Brussels A3093	stam	Capua	Deepdene painter	ARV 499,14		
9	Naples 3034	pel	Nola	Deepdene painter	(ARV 500,33);H477		
10	Louvre G428	hy		Painter of the Yale oenochoe	ARV 503,19; H482a		
11	London E567	oen	Nola	Manner of Bowdoin p.	(ARV 1666,31bis); H481		
12	ex London market	col-kr		Orchard painter	ARV 525,33		
13	New York 06.1021.192	hy	Campania	Chicago painter	ARV 630,32		
14	London E519	oen	Nola	Amphitrite painter	(ARV 833,39);H480		
15	Göttingen	pel	Nola	Comacchio painter	(ARV 957,36);H475; = Berlin 2168		

16	Naples 3190	pel		Comacchio painter	(*ARV* 957,40);H478	
17*	Bologna PU280	pel		Comacchio painter	(*ARV* 957,41)	navel
18*	Edinburgh 1872.23.11	hy		Villa Giulia painter	(*ARV* 623,65)	Fig.12r
19	Boston 90.157	Nolan	Nola	Painter of London E342	(*ARV* 667,19); see below	
20	ex Hope 96	Nolan		c.460		
21	Vatican 17908	pel		c.440	H479	
22	Florence b.g.	cal-kr			H484	
23	Berlin 2552	cup				
24*	Copenhagen Th.275	oen		fourth century		

The reading of 1 is made difficult by a thick strip of plaster between the two verticals of what I consider to be a *nu*. 19 is mentioned by E. Robinson, *Catalogue of Greek, Etruscan and Roman Vases* (1893) 155. The *upsilon* of 24 is developed, with a stem and curving branches.

ii) In immediate association with numerals

BF, dipinto

25	Dunedin E48.66	hy		Leagros group, near Painter S	*CVA* 1 12	III	.2F,11
26	Berlin 1904	hy	Vulci	Leagros group, Simos group	(*ABV* 364,54)	III	5E,20
27	Munich 1417	type A	Vulci	Leagros group, Simos group	*ABV* 367,86	III	
28	Liverpool 56.19.6	Panath		Leagros group	(*ABV* 369,115); *G & R* 21 (1974) 151,7	I	

graffito

29	London B493	oen		Manner of Red-line painter	(*ABV* 606,18)	ΛΛΛΓ	
30	New York 06.1021.82	n-a	Capua?	P. of Manchester satyr	*CVA* 4 57	Λ	
31*	Munich 1512	n-a		515-505		Fig.12f	
32*	Würzburg	n-a		510-500		Γ	
32a*	Palermo 1947	n-a		500-490		Fig.12i	

RF

33	Naples 3172	stam	Nola	Painter of Würzburg 517	(*ARV* 305,3); H483	IIII and III
34	Munich 2405	stam	Vulci	Painter of Würzburg 517	*ARV* 1644	IIII and III
35	Leningrad P43	stam		Triptolemos painter	(*ARV* 361,8)	Λ and III
36*	Palermo 1495	pel	Chiusi	Myson	(*ARV* 239,15); (B)	II and Λ
37	Aleria 1953	col-kr	Aleria	Villa Giulia painter (Jehasse)		IIII

undetermined

38	Washington	cup foot		c.500-480	Furtwängler, *Kleine Schriften* ii 494	Π

The dipinti are in small neat letters with firm lines. There is a further dipinto on 25 which I am unable to read; the cross-bar of the *nu* is in a position half-way between that of an *eta* and a *nu* – see the commentary for my reasons for taking it as a *nu*. There is another mark on 33, for which see Heydemann or *Stamnos* fig. 15. The two central strokes of the group of four on 34 do not join, though the facsimiles in *CVA* and *Stamnos* suggest that they do. There is a further graffito on 38.

iii) With KA

RF

39	Biel, private collection	pel		490	*Auktion* 22 160	11F,13
40	Leningrad P102	pel		Agrigento painter	(*ARV* 578,73)	11F,15

A further mark on 40 seems to be Etruscan *al*.

iv) With Λ E

RF

41*	Basel, Borowski V71.243	col-kr		c.480-70		26F,10
42	Cambridge 1935.2	stam		Deepdene painter	(ARV 499,16); *Stamnos* fig. 14	
43	Warsaw 142310	pel	Nola	Deepdene painter	ARV 500,32	
44	Oxford 1929.779	stam		Chicago painter	ARV 628,7	
45	New York 06.1021.190	hy	Campania	Chicago painter	ARV 630,33	
46	Vienna 772	n-a		imitation of Altamura painter	ARV 597	

v) With various marks

RF

47	London E443	stam	Vulci	Tyszkiewicz painter	(ARV 292,29)	Fig.12j	
48	Villa Giulia 1129	pel	Falerii	Tyszkiewicz painter	(ARV 293,49); CIE 8281	Fig.12h	5F,1
49	Leningrad P87	hy	Vulci	Pan painter	(ARV 555,95);H482	HE I I	
50	Naples 3030	pel	Capua	Deepdene painter	(ARV 500,31);H476	O	
51	New York 06.1021.149	col-kr		Orchard painter	ARV 523,2		13F,3
52*	Naples 127930	col-kr		470-60		Fig.10g	18E,13

There is also an Etruscan graffito on 49

vi) The N V is clear on the following, but the rest is hard to read

RF

53	Villa Giulia	cup	Cerveteri 450-425?		NSc 1937 391

Type 10F ON, NO and ΓΡΟ

i) ON, in association with numerals only

BF

1	Warsaw 142451	cup		c.510	(CVA Goluchow 16) Pl. 7	11B,11	
2	Leningrad St.282	hy		Priam p. (Gorbunova)		8E,57	
3	Naples 3360	n-a		c.500			
4	Naples Sp.91	cup	Suessola	c.490	Bull.Inst. 1879 156 Fig.12n		
5	London market (Ede)	sky			Pottery from Athens Fig.12m (1976) no 11		
6	Aleria 1921	sky	Aleria	c.475	BICS 25 (1978) 80-1		

RF

7*	Tarquinia RC992	col-kr	Tarquinia	Painter of the Munich amphora	(ARV 246,7)	Fig.12k

The other marks on 1 and 2 are not obviously closely related to the ON set. 3 was considered false by Heydemann, but I cannot imagine his reasons and do not feel the need to argue for authenticity. The text of 7 is not full since the ends of the unit strokes lie under accreted matter which I failed to remove.

ii) ON alone

RF

8	Greenwich, Bareiss 15	n-a		Berlin painter	Paral 342,51		
9*	Capua 217	n-a	Capua	Berlin painter	(ARV 200,52)		
10	Vatican 16513	type A	Cerveteri	Troilos painter	ARV 296,1		
11*	Cerveteri, magazzini	pel	Cerveteri	490		s.1.2,13 q.v.	
12*	Munich 7514	lek		480			
13*	Cambridge 1952.6	pel		Tyszkiewicz painter	(ARV 293,54)	s.1.2,12	
14	Naples RC151	col-kr	Cumae	460-50		navel	

It is possible to read all these marks as NO , but in view of some of the accompanied marks below at least 8-10 and 13 must be taken as ON.

iii) ON with KO

RF

15	New York 06.1021.152	col-kr		Pig painter	ARV 564,15		13F,1
16	Adolfseck 74	col-kr		Pig Painter	ARV 564,16		5F,3; 13F,2

iv) ON with ГРO, ГРOalone (20) and with other marks (18)

RF

17	Utrecht inv.11	hy		Tyszkiewicz painter	ARV 294,61		26F,9
18	Stockholm 1963.1	type B		Tyszkiewicz painter	ARV 1643,33bis	Fig.10c	18E,11; 19E,2
19	Leningrad P60	pel		Tyszkiewicz painter	(Peredolskaya)		
20	Bologna 190	col-kr Bologna		Orchard painter	(ARV 524,27)		

v) ON with TI , numerals and other marks

RF

21*	Louvre CA2981	type A Vulci		Berlin painter	(ARV 196,2)	Fig.12p	26F,6
22*	Oxford 1930.169	n-a		Berlin painter	(ARV 198,20)	Fig.12L	
23	Louvre G178	hy	Vulci	imitation of Berlin p.	ARV 218,3	Fig.9w	17E,16; 26F,7
24	Mus. Etruscum 1198	amphora Vulci		near Berlin p.? (Amyx)	Hesperia 27 (1958) pl 54d		17E,17; 26F,8
25	Copenhagen 126	cal-kr		Troilos painter	ARV 297,11	Fig.9x	15E,8; 17F,1; 26F,5

ON is repeated on the opposite side of the foot of 21; Bloesch, AK 4 (1961) 50 and 55, states his belief that the foot belongs to the vase, against the opinion of Beazley (ARV 1633); I saw no reason to reject the pairing. 22 has no TI. The second nu on the navel of 23 is odd, but a poor thing, given too much prominence in the CVA photograph by a trick of the light; the other nu was probably cut as soon as the shortcomings of this one were noticed. We obtain a good idea of the appearance of 24 by comparing it with 21 and 23.

vi) NO seems the best reading

RF

26	Bologna 250	col-kr Bologna	Manner of Syracuse p.	(ARV 527,3)

The letters are very obscure, but Pellegrini's reading seems assured.

Type 11F KA and KAI

In a few cases it is not easy to distinguish between the two.

i) KA

BF

1	Vatican 352	type B Vulci		Group E	ABV 134,30		
2	Compiègne 983	n-a	Vulci	Antimenes painter	ABV 272,102		
3	Compiègne 977	n-a	Vulci	Manner of Antimenes p.	ABV 277,19		
4	London B215	n-a	Vulci	Eye-siren group	(ABV 286,1)		s.1.1,15
5	Louvre F380	n-a		515-500	Pottier	navel	
6	Munich 1554	n-a	Vulci	510-500			
7	Los Angeles 50.8.20	n-a		510-500	Hesperia 24 (1955) 23		

b.g.

8	Naples 659	lekanis Nola					s.1.4,39
9	Ruvo 514	bowl	Ruvo	fifth century?	AZ 1869 81		
10	Ruvo 519	bowl	Ruvo	fifth century?	ibid		

undetermined

11	Adria (21,28)	cup foot	Adria		H470		7B,10

The mark is in ligature on 6. On 1, 3-5 and 7 at least the cross-bar of the alpha slopes down to the right; on 2 and 6 it is horizontal.

ii) Retrograde, with additional strokes on the *kappa*

	RF					
12	Louvre G68	cup		Thalia painter	*ARV* 113; Pottier	

iii) K A (or K A I) with other marks

	RF						
13	Biel, private	pel		490	*Auktion* 22 160	9F,39	
14	Naples 3048	pel	Nola	Syriskos painter	(*ARV* 262,33); H452 K A I Γ		
15	Leningrad P102	pel		Agrigento painter	(*ARV* 578,73)	9F,40	
16	Louvre G436	Nolan	Nola	Phiale painter	*ARV* 1051,1; H612	16B,31; 8F,10	
17	Harvard 1942.209	Nolan	Nola	Group of Polygnotos	(*ARV* 1059,125)	25F,2 q.v.	
18	Harvard 1959.187	Nolan		Group of Polygnotos	(*ARV* 1059,126)	Fig.2y	2B,30 q.v.
19*	Jena 447	pel		Washing painter	(*ARV* 1129,117);(B) see below		
20	Naples Stg.270	Nolan	Capua	Painter of Munich 2335	(*ARV* 1161,1)	2B,31	

On 19 the mark is incised above three *deltas*, which in turn are over six unit strokes, two per *delta*. Heydemann's reading of 20 is far too heavy. The cross-bars are mostly horizontal.

iv) K A I alone

	BF					
21	Villa Giulia M625	cup		540-30		
22*	Louvre F139	cup		Group of courting cups (*Paral* 82,10)		
23	Adria (22,9)	oen	Adria	c.500?	H453	
	RF					
24	Karlsruhe B3134	head vase		Sabouroff group	*ARV* 1545,25	retrograde
	b.g					
25	Karlsruhe B594 undetermined	oen		c.450	*CVA* 1 44	
26	Adria (22,7)	stemless?	Adria		H454	retrograde
27	Adria (22,8)	cup foot	Adria		H454	retrograde

On 21 and 25 the cross-bar slopes down to the right, on 24, 26 and 27 up. On 26 and 27 the left stroke of the *alpha* is curved. On 24 the final two letters are joined at the base.

v) K A P

	b.g.				
28	Berlin 2621	kantharos	sessile form		strokes

vi) K A in ligature

	b.g.				
29*	Palermo 2057	lek	Sicily?	c.475	Fig.12s

Type 12F K A Δ I

	RF						
1	Bologna 153	type A	Bologna	470-60	H584	Fig.8h	6A,6; 9E,64
2	Oxford 276	Nolan	Nola	Phiale painter	*ARV* 1016,28; H585		

An illustration of the possible expansion of the abbreviation:

	RF				
3	London E429	pel	390-70	H586; *BMC*	

Note the scribal error in the omission of the *rho* in μίκροι. Another vase perhaps belongs here:

b.g.
4 ex Barone sky? c.450 H587

See also 26F,21.

Type 13F KO

i) On column-kraters in association with numerals or vase names

RF
1	New York 06.1021.152	col-kr		Pig painter	*ARV* 564,15	10F,15
2	Adolfseck 74	col-kr		Pig painter	*ARV* 564,16	5F,3; 10F,16
3	New York 06.1021.149	col-kr		Orchard painter	*ARV* 523,2	9F,51
4	Cleveland 24.533	col-kr		Naples painter	*CVA* 1 20	

ii) ΔKOI

BF
| 5 | Oxford 1925.140 | type B | | 540–535 | *CVA* 3 final fig. | |
| 6 | Boston 01.8127 | Panath | | Mastos painter | *CVA* 1 41 | |

iii) Various others; 8 and 9 have *koppa* for *kappa*

BF, dipinto
7	London B260 graffito·	n-a	Vulci	550–40	(*CVA* 4 pl 64,2)	Pl. 6	24B,11
8	Louvre E623	col-kr		Ptoon painter	*Paral* 31 1	s.1.1,2	
9	Dublin UCD-114	cup		c.500		Fig.13a	
10*	Taranto 52349	lek	Taranto	490–80	(*ABV* 540,28?)		

RF
| 11 | Ruvo 767 | owl sky | Ruvo | c.450? | | Fig.9c | 9E,124; 8F,7 |

undetermined
| 12 | ex Barone | ? | Nola | | *CIG* 8346f | | |

Type 14F ΚΡΑΤΕΡΕΣ, ΒΑΘΕΑ, ΟΞVΒΑΦΑ, ΓΕΛΛΙΝΙΑ

These names occur together in five well-known price graffiti and I keep them together here under one
type. The most convenient collection of facsimiles of the five is *Hesperia* 27 (1958) pl 52, with
Amyx's comments on pp 289-292.

RF
1	Vienna 869	bell-kr	Kadmos painter	*CVA* 3 20	18C,43; 26F,2
2	Louvre G503	bell-kr	Kadmos painter	*ARV* 1185,18	12B,10; 18C,42; 26F,3
3	Louvre G496	bell-kr	Pothos painter	*ARV* 1190,24	18C,74
4	London E504	bell-kr	Pothos painter	(*ARV* 1190,25)	18C,45
5	Philadelphia 5682	bell-kr	Dinos painter	*ARV* 1154,37	

1 is defectively published as *CIG* 8345d. The price graffito and abbreviation on 4 do not impinge on
one another as closely as the facsimile may suggest.

ii) ΚΡΑΤHΡΕΣ,

RF
| 6 | Salerno, Caudium T227 | bell-kr | Caudium | c.400 | *AJA* 82 (1978)224-5 | 18C,48; 23F,2 |

iii) ΚΡΑ (and ΚΡΗ - 9)

	BF					
7	Vatican 356	type B	Vulci	540		retrograde
8	Bologna 44	n-a	Bologna	525-500	Zannoni pl 59,7	
	RF					
9*	Brooklyn 1903.9	col-kr	Capua?	Walters painter	ARV 278,3	Fig.13b 17F,2

See also 26F,21.

iv) KRA

	BF					
10	Boston 13.65	n-a		Uprooter class	ABV 589,2	Fig.13r
	RF					
11	New York 07.286.78	type B	Agrigento	Eucharides painter	ARV 227,9	17E,18

11 lacks the *alpha*. It is unlikely that any of the entries in sub-group iii and iv are vase-name abbreviations, since they are not on kraters and are not directly associated with numerals. See 17 below for a further certain vase-name mark.

v) BAΘEA.

	RF					
12	Dublin 1880.509	bell-kr		420-10		Fig.13d 18C,79

vi) OΞ (14) and OΞV (13)

	BF					
13	London B320	hy	Vulci	Leagros group, Painter S	(ABV 364,49)	Fig.11h 2F,51
	RF					
14	Newark, N.J. 68.11	col-kr		500	Auktion 34 150	Fig.13s

vii) OΞVBAΦA.

	RF					
15	Naples 151600	pel	Naples	Nikias painter (Johannowsky)	AJA 82 (1978) 222f	Fig.12c 18C,47; 19F,3; 26F,12
16	Cab.Med. 932	bell-kr		P. of Würzburg 523 (Corbett)	AJA 45 (1941) 597	
17	Oxford 1956.310	bell-kr	Al Mina	early fourth century?	AJA 61 (1957) 8	
18	ex S. Giorgio	bell-kr			H599	
	b.g.					
19	Thessalonike	plate	Olynthos	400-350	Olynthus iv 255	

Only the foot of 17 survives; the *beta* is clearer than Beazley's copy suggests; there is also a KPA abbreviation with numerals. See Hackl for the publication of 18.

vii) ΓΕΛ

	RF				
20	Vatican 17848	stam		Achilles painter	ARV 992,68; Stamnos fig. 14
21	Naples?	cup			CIG 8345i 8F,16

Type 15F KVA

The first two preserve a complete vase name, the third has the above abbreviation, possibly of the same name, *kyathe(i)a*, though the information about it is too scanty to be sure.

	RF				
1	Aachen, Ludwig 36	stam		Copenhagen painter	Paral 351,20 7F,7

| 2 | Copenhagen 123 | stam | Vulci | Danae painter | *ARV* 1075,1; H582 | | large *delta* |

| 3 | undetermined where? | 'amphor-iskos' | Vulci | | H583; *CIG* 8345f | |

See the commentary for the reading of 1. The fourth letter of 2 appears to be incised over a *kappa*.

Type 16F IXΘVAI

b.g.

1	Munich 6498	lekanis	Cumae	c.450	H601a and pl 3		3B,4
2	ex Pourtales	lekanis			H600 and pl 3		3B,5
3	ex Betti	cup			H602	with numerals	

3 appears to lack the final *iota*.

Type 17F ΣKV

RF

1	Copenhagen 126	cal-kr		Troilos painter	*ARV* 297,11	Fig.9x	15E,8; 1OF,25; 26F,5
2*	Brooklyn 1903.9	col-kr	Capua?	Walters painter	*ARV* 278,3	Fig.13b	14F,9
3	Louvre G430	n-a		Polygnotos	*ARV* 1031,40;H589a		
4	London E170	hy	Capua	Coghill painter	(*ARV* 1040,2);H591	Fig.13h	18C,20; 21F,5
5	Berlin inv.4498	n-a		Epimedes painter	(*ARV* 1044,3);H589		
6	Arkansas Univ. 57.24.21	pel	Gela?	Biscoe painter	(*ARV* 1063,1); *AJA* 75 (1971) 89	with ⧽	
7	Munich 2321	n-a		P. of Munich 2321	*ARV* 1681; H588		
8	London E497	bell-kr	S. Italy	P. of London E497	(*ARV* 1079,1); H590		

b.g.

| 9 | Dublin UCD-143 | bell-kr | | 450-440 | (*Hope Heirlooms* 12) | | 18C,58 |
| 10* | ex Rome market | cal-kr | | | (B) | | 18C,56 |

The reading of 4 in *BMC* and Hackl must be disregarded. 1 has three-bar *sigma*. A silver mug from Stara Zagora with this mark is discussed in *BICS* 25 (1978) 79-80.

Type 18F Σ Π A

i) A vase name in full, ΣΠAΘAI

RF

| 1 | Boston 03.821 | n-a | Suessola | Kadmos painter | *Paral* 460,29 | | 12B,11 |

ii) Abbreviated

RF

2	New York GR579	n-a	Capua	Niobid painter	*ARV* 605,61		
3	London E280	n-a	Capua	Polygnotos	(*ARV* 1030,35); BMC; H500		
4	Berlin 2353	n-a	Nola	Polygnotos	(*ARV* 1031,39);H498		B

b.g.

| 5 | Berlin 2341 | Nolan | | 475-450? | H499 | | |

Extra strokes are attached to the *alpha* of 2.

Type 19F ΣTA and ΣVMMI

The two occur together on 1, and I keep them together for convenience

i) The two together

BF
1 Munich 1464 Panath Vulci Group of Vatican G23 (*ABV* 406,6); H575 9E,101

ii) ΣTAMNIA and ΣTAMNOI

RF
2 Gela 9240 pel Vassall- 420 *ZPE* 12 (1973)265-9 1F,6;
 aggi 23F,1
3 Naples 151600 pel Naples Nikias p. *AJA* 82 (1978) 222f Fig.12c 18C,47;
 (Johannowsky) 14F,15;
 26F,12

iii) ΣTA

BF
4 Chicago pel Eucharides p. *ABV* 396,23 1F,9;
 University 7F,3
 RF
5* Copenhagen NyC pel Tyszkiewicz painter. (*ARV* 293,50) Fig.8q 9E,102;
 2659 5F,2
6 Leningrad Nolan Hermonax (*ARV* 488,73);H574
 St.1672
7* Tarquinia RC3240 n-a Tarquinia Niobid painter (*ARV* 604,54) Fig.13f
8 Syracuse 22177 pel Gela Villa Giulia painter *ARV* 622,48; Fig.13c
 ML 17 445-6
 b.g.
9* Naples n-a 475-50 Fig.13g

The mark on 7 is mentioned in *Nuove Scoperte e Acquisizioni nell'Etruria Meridionale* 60,7. Both 7
and 9 are lightly incised on similar vases of the same period and one is tempted to call the marks
the same, but as can be seen in Fig. 13f the ligature on 7 appears to be ΣTP. I believe the marks
may still be connected and therefore that the abbreviation on 9 may be ΣTPA rather than of στάμνια
or the like. 8 is a complex mark; there is a gap after the first two letters in which an *alpha* may
have been cut; further letters follow, but not necessarily part of the same mark, or indeed themselves
belonging to a single mark.

iv) ΣVMMI and the like

RF
10 Louvre G356 col-kr Leningrad painter *ARV* 568,29 Pl. 33
11 Naples 116116 col-kr P. of London E488 *ARV* 1120,1
 18C,66;
 19F,11;
 23F,2;
 24F,3
12 Naples RC125 col-kr Cumae Hephaistos painter (*ARV* 1115,21) 18C,35

Beazley's view (*AJA* l.c.) that 10 has a *tau*, not correctly recorded in *CVA*, is borne out by Pl. 33.
I was not sure which had been cut first on 11, the line across the base or the *pi* that coincides
with it.

v) ϟV

BF
13* Broomhall n-a near Group of Toronto (*ABV* 284,6); (B) retrograde
 305
 RF
14* Syracuse 24009 col-kr Kamarina Boreas painter (*ARV* 528,26) Fig.4a 6B,14

vi) ΣV

BF
15 Cambridge 48 n-a Manner of Lysippides *ABV* 259,17 retrograde
 painter
16* Taranto 20201 sky Taranto c.500 Fig.13v
 RF
17* London E486 col-kr Nola Painter of Munich (*ARV* 1166,88) Fig.10d 18C,77;
 2335 17E,41

Type 20F T P

 i) Tailed *rho*

 BF

| 1 | Palermo | sky | Lipara | 500–490 | *Lipara* ii pl n,1 with *mu* | |

The interpretation given in the text (p.155) scarcely tallies with the facsimile.

 ii) Tailless *rho*

 RF

2	ex Swiss market	lek		Phiale painter (Cahn)	*MM Sonderliste N* 34	Fig.5w	11C,4
3	Louvre G491	bell-kr		Polygnotos	*ARV* 1029,26		16B,32; 3D,17
4	Naples RC148	bell-kr	Cumae	Group of Polygnotos	(*ARV* 1054,50)		
5	Copenhagen NyC 2694	stam	Orvieto	Christie painter	(*ARV* 1048,36); *Stamnos* fig. 17		
6	New York 06.1021.187	bell-kr		Polydektes painter	*ARV* 1069,1		16B,27
7	Copenhagen NyC 2693	stam	Orvieto	Kleophon painter	(*ARV* 1144,8); *Stamnos* fig. 17		
8	Munich 2415	stam	Vulci	Kleophon painter	*ARV* 1143,2; H493		
9	Leningrad P210	stam		Kleophon painter	(*ARV* 1143,3);H492		16B,28
10	Munich 2414	stam	Vulci	Kleophon painter	*ARV* 1143,6; H494		18C,26
11*	Cerveteri, magazzini	pel	Cerveteri	440–430		Fig.13i	
12	Florence b.g.	stam			H495		
13	ex Barone	plate	Nola		*CIG* 83461		16B,29

T P is followed by an *iota* on 2, 4, 6 and 13. The *CVA* reading of 3 is defective. A *tau* does appear on 10, contrary to the *CVA* reading, but as often in this type is very faint. 8 is of interest in having both a rounded and an angled loop to the *rho*, the former inside the latter. At least 8 and 10 are on the navel.

Type 21F V Δ P I

A variety of abbreviations are represented here

 RF

1	London E163	hy	Vulci	Copenhagen painter	(*ARV* 258,26);H576		9E,108; 1F,10
2	Warsaw 142290	hy		Leningrad painter	(*ARV* 571,76)	Pl. 26	
3	where?	hy		c.470	H576a		
4	Edinburgh 1877.29	hy		Polygnotos	(*ARV* 1032,59); *G & R* 21 (1974) 151,12		3B,2a; 17C,14a; 4F,5
5	London E170	hy	Capua	Coghill painter	(*ARV* 1040,2)	Fig.13h	18C,20; 17F,4
6	Vienna 1152	hy		Close to Christie p.	*CVA* 3 39; H577		18C,23
7	London 1921. 7-10.2	hy		Group of Polygnotos	*ARV* 1060,138		2B,29; 8F,8 q.v.
8	Leningrad St.1206	hy		Group of Polygnotos	(*ARV* 1060,141); H578		8F,9 q.v.
9	New York 25.28	hy	Capua	Nausikaa painter	*ARV* 1110,41	with *pi*	
10	Ragusa 22950	foot	Kamarina	c.450	H581		
11	London E183	hy	Nola	P. of London E183	(*ARV* 1191,1);H568		
12	Brussels R2509	hy		P. of Munich 2335	*ARV* 1166,102);H580		
13*	Florence 81948	hy	Populonia	Meidias painter	(*ARV* 1312,1)	Fig.13l	18C,78
14*	Würzburg 536	hy		Manner of Meidias p.	(*ARV* 1321,7)	Fig.13u	
15	London F90	hy	Nola	400–375	*JHS* 80 (1960) 59; H579		

5 and 11 are the most radically different abbreviations, with HV , approached by 14 with VΔ . It is instructive to note that the *CVA* reading of 2 is AΔP ; as can be seen from Pl. 26 a wheel mark has been taken as the cross-bar of an unintended *alpha*. See on type 4F for the reading of 4. Amyx,

Hesperia 27 (1958) 296 n.33 comments on the shape and date of 10; I saw no reason for rejecting it as the foot of a hydria in two degrees. Hackl took 11 as a ∧H abbreviation, but there can be little doubt that HV was the intended form (very lightly incised) from consideration of the ground-line (H taller than V) and the slightly curving strokes of the *upsilon*. See the commentary for the interpretation of 13. I read two drachma signs on 10, not three as Orsi.

The following may belong here:

RF
16 Gotha hy Capua c.450 *CVA* 2 12 VH

I have excluded it from type 6D, q.v.

Type 22F Other complete vase names

RF

i) OINOXOAI

1 Vienna 892 bell- Telos painter *CVA* 3 26; H600 18C,84;
 kr 1F,5
2 Varna II.1449 bell- Odessos Painter of Ferrara (*ARV* 1694,4bis);
 kr T463 *BIAB* 27 (1964)112

ii) KΩΘΩNIA

3 Naples 116116 col-kr Painter of London E488 *ARV* 1120,1 18C,66;
 19F,11;
 23F,2;
 24F,3

iii) ΛEΓAΣTIΔEΣ

4 Berlin 2188 stam Vulci Hephaisteion painter *ARV* 298,1; H592 2B,14;
 6F,1

iv) ΣKAΦIΔEΣ

5 Ancona 3264 col-kr Numana Agrigento painter (*ARV* 576,37); 26F,11
 AJA 45 (1941) 597
6 Dublin 1880.507 col-kr Meleager painter (*ARV* 1411,38) Fig.13j 18C,46;
 24F,6

v) TPVBΛIA

7 Melbourne bell- York-reverse group (*ARV* 1450,6); see Fig.13t 18C,53
 D1/1976 kr below
8 Louvre K253 bell- Painter of Rodin 966 see below 18C,54;
 kr (McPhee) 25F,7

vi) XOEΣ

9* Agrigento C2034 col-kr Painter of Louvre (*ARV* 1089,23) Fig.13e 18C,65a
 Centauromachy
10 Ferrara 8095 oen Spina c.400 see below OINO

All these are either accompanied by numerals or other vase names, save 9, and so are in some sense commercial. For other simple vase names, such as H603 and 604, reference should be made to the Greek index, though not all such marks have found a place in my text. For the numerals accompanying 7 and 8 reference should be made to the publication cited under type 18C, as well as Fig. 13t . 9 lies under a layer of incrustation; the letters are clear, however, and I do not believe that there are any more, at least on this part of the foot. 10 is published in L. Massei, *Gli askoi a figure rosse nei corredi funerari delle necropoli di Spina* 285-6.

Type 23F ΕΝΘΗΜΑΤΑ, associated marks and possible abbreviations thereof

i) Complete words

RF

1	Gela 9240	pel	Vassall-aggi	420	*ZPE* 12 (1973) 265-9	1F,6; 19F,2
2	Naples 116116	col-kr		P. of London E488	*ARV* 1120,1	18C,66; 19F,11; 22F,3; 24F,3
3	Salerno, Caudium T227	bell-kr	Caudium	c.400	*AJA* 82 (1978) 224	18C,48; 14F,6

ii) ΕΝ

BF

4	Castle Ashby	n-a		Amasis painter	(*ABV* 152,23); *CVA* 5	13A,4
5	Tarquinia RC1803	n-a	Tarquinia	Leagros group	(*ABV* 372,170); *PdP* 27 (1972) 423	21A,90
6	New York 91.1.463	n-a		510	*CVA* 4 43	
7	Naples 2847	bell-kr	S. Agata	Erbach painter	*AJA* 82 (1978) 225	18C,49; 6F,2; 26F,14

Type 24F Adjectives derived from place names

RF

i) Corinth

1	Berlin inv.2928	col-kr	Rhodes	recalls Chicago p.	*BSA* 70 (1975) 159,86		
2	Brunswick, Maine 13.8	col-kr	Gela	Group of Polygnotos	see below	Fig.13m	
3	Naples 116116	col-kr		P. of London E488	*ARV* 1120,1		18C,66; 19F,11; 22F,3; 23F,2
4	Princeton 29.203	col-kr		Hephaistos painter	(*ARV* 1115,27)		9E,67 q.v.; 10E,18
5	Madrid 11045	col-kr		Suessola painter	(*ARV* 1345,8); *AJA* 31 (1927) 351		
6	Dublin 1880.507	col-kr		Meleager painter	(*ARV* 1411,38)	Fig.13j	18C,46; 22F,6

There are varying forms and abbreviations of the adjective. Beazley's reported attribution of 2 is mentioned in *Hesperia* 27 (1958) 198. The reading of 6 is not established in detail; the foot was repaired in antiquity and more recently, and is worn in parts.

ii) Miletos

7	where?	foot		c.420, from bell-kr	*RM* 46 (1937) 150

iii) An unidentifiable place name may lie behind the ΕΜΓΟΡ of the following:

8	London E227	hy	Cyrenaica	390-80	*CVA* 6 pl 93,2; Hackl p.69

Type 25F Other adjectives etc.

All these are in connection with numerals. Reference should be made to Hackl's facsimiles where applicable. 3 is assumed to be RF.

i) ΓΛΑV

RF
1 Berlin 2599 owl H594
 sky

ii) ΜΑΚΡΑ

RF
2 Harvard 1942.2(Nolan Nola Group of Polygnotos (*ARV* 1059,125); 11F,17
 H605

It is published by H. Immerwahr, *Acta of the Congress of Epigraphical Studies in Cambridge, 1967* 58;
he gives three strokes on the other side of the foot.

iii) ΜΕΓΑΛΑΙ

RF
3 ex Barone cup H606

iv) ΜΕΛΑΝΑ

b.g., dipinto
4 Naples? sky Suessola *Bull.Inst.* 1878 Fig.13w
 149

v) ΜVΡΤΩΤΑΙ

RF
5 Oxford 1965.121 stam Dokimasia painter (*ARV* 414,34); 2B,15
 Stamnos fig. 13

vi) ΟΙΝΙ...

RF
6 Aleria 1768 col-kr Aleria Leningrad painter (*Paral* 391,23bis) 19B,3

vii) ΓΑΧΕΑ

RF
7 Louvre K253 bell- Painter of Rodin 966 18C,54
 kr (McPhee) q.v.;
 22F,8

viii) ΛΕΙΑ and ΡΑΒΔΩΤΑ

b.g.
8 where? oen Cyrenaica H607; *RA* 1875 ii
 115

Type 26F ΤΙΜΗ etc.

i) ΤΙΜΗ

RF
1 Göttingen pel H608; ex Berlin 2361

ii) ΤΙΜΕ

RF
2 Vienna 869 bell- Kadmos painter *CVA* 3 20 18C,43;
 kr 14F.1
3 Louvre G503 bell- Kadmos painter ARV 1185,18 12B,1o;
 kr 18C,42;
 14F,2

iii) ΤΙΜΑ?

RF
4 ex Swiss market stam Tyszkiewicz painter (*ARV* 291,23); 7F,8
 Stamnos fig. 13

iv) T| with the drachma sign or numerals

RF

5	Copenhagen 126	cal-kr		Troilos painter	*ARV* 297,11	Fig.9x	15E,8; 1OF,25; 17F,1
6*	Louvre CA 2981	type A	Vulci	Berlin painter	(*ARV* 196,2)	Fig.12p	1OF,21
7	Louvre G178	hy	Vulci	imitation of Berlin p.	*ARV* 218,3	Fig.9w	17E,16; 1OF,23
8	Mus. Etruscum 1198	amphora	Vulci	near Berlin p.? (Amyx)	*Hesperia* 27 (1958) pl 54d		17E,17; 1OF,24
9	Utrecht inv.11	hy		Tyszkiewicz painter	*ARV* 294,61		1OF,17
10*	Basel, Borowski V71.243	col-kr		480-70			9F,41
11	Ancona 3264	col-kr	Numana	Agrigento painter	(*ARV* 576,37); *AJA* 45 (1941) 597		22F,5
12	Naples 151600	pel	Naples	Nikias painter (Johannowsky)	*AJA* 82 (1978) 222 f		18C,47; 14F,15; 19F,3
13	Naples 2847	bell-kr	S. Agata	Erbach painter	*AJA* ibid		18C,49; 6F,2; 23F,7

b.g.

14	Berlin 2734	cup	Asia Minor		H609		

10 has no numerals following. See on the other types for details of the readings.

v) T| alone

BF

15*	Tarquinia RC1822	n-a	Tarquinia	530-25		(*CVA* 1 pl 14,1)
16*	Tarquinia	n-a	Tarquinia	530		
17*	London market	n-a		510-500		(*Sotheby* 26/2/1973 143)

16 has: A, Herakles and Kyknos; B, two rampant lions; a dolphin frieze below. There is also a pair of short-horizontal lines somewhat apart from the T| . 17 is of special shape.

vi) Others

BF

17a*	Athens, Kanell-opoulos 2499	hy	Italy	520		(*AAA* 9,2 (1976) cover)		23E,6a
18	Naples 2533	n-a		515-10			Fig.13k	
19	Naples 2712	n-a		520-10		*PdP* 27 (1972) 418 fig. 2		23E,7

RF

20	Syracuse 22833	bell-kr	Kamarina	Curti painter	(*ARV* 1042,4); *ML* 14 829

See *PdP* l.c. for the reading of 18. The true reading of 20 may be simple T| with a mark of type 18C; therefore I do not include it in iv, but do not feel entitled to include it in type 18C; I have not seen the vase.

vii) In Cypriot syllabic script

RF

21	New York 22.139.11	bell-kr		Cassel painter	*ARV* 1083,5

See also Masson, *Inscriptions Chypriotes Syllabiques* no 350.

MARKS ON CORINTHIAN VASES

All marks are red dipinti unless otherwise stated. The order of entries is based on that in *Necrocorinthia*, while the attributions are those of J. Benson, *Die Geschichte der Korinthischen Vasen* with some of Amyx's alterations and additions, *AJA* 73 (1969) 119ff.

Protocorinthian I know of no marks on Protocorinthian vases; an A is reported by Johansen, *Les Vases Sicyoniens* 20 on an EPC oenochoe, London 1859.2-16.38, but it is the initial of the previous owner, Auldjo.

Transitional

1	Basel Z196	oen	P. of Vatican C73 (Amyx)			traces and graffito ᕘ
2	Louvre Cp10475	oen	P. of Vatican C73 (Amyx)	*CVA* 13 pl 58		graffito ⋏

Early Corinthian

3	Berlin 1112	oen	Nola		*NC* 733 (MC, Benson)	T
4	Louvre E570	kr	Cerveteri			glaze Pl. 2
5	Louvre E635	kr	Cerveteri		*NC* 780	traces
6	Louvre E633	kr	Cerveteri		*NC* 780a (MC, Benson)	ᴗ

For 1 and 3-6 see also *BSA* 68 (1973) 188.

Middle Corinthian

7	Crotone CR512	aryb	Croton		*BSA* 70 (1975) 148 n.6	⌐
8	Syracuse 7496	aryb	Megara Hyblaea		*BSA* ibid	⏀
9*	Palermo 1631	aryb	Gela?			Ŧ?
10	Rhodes 5175	aryb	Ialysos		*BSA* l.c. 147,1	stripe
11	London A1513	plate			*NC* 1033	X
12*	Paestum	plate	Paestum			Ŧ
13	London 1867. 5-8.892	pyx		P. of ring-handled pyxides	*BSA* 68 (1973) 187	Pl. 37
14	Berlin 1109	pyx	Tarquinia			Ŧ
15	Berlin 1111	pyx	Nola			ᴐ
16*	Gela	pyx	Gela			traces
17*	London o.c.316	pyx				Pl. 38
18*	London o.c.317	pyx				ᖴ
19*	London o.c.309	pyx				⟨
20*	London o.c.310	pyx				⟨
21*	Palermo 1755	pyx			*NC* 900A?	traces
22*	Palermo 1735	pyx				traces
23*	Louvre	oen foot				graffito ⋆
24*	Vatican 16350	oen				at least Y
25*	Cab.Med. 90	oen	Cerveteri	Manner of P. of Louvre E565		traces
26*	Ragusa	oen	Kamarina			at least �haiH
27	Berlin 1114	oen	Nola	Dodwell painter? (Payne)	*NC* 1092	ɲ
28	London 1865. 12-14.4	oen	Kamiros		*NC* 1093	ɲ
29	Munich 237	oen		Scale pattern painter	*NC* 1100	graffito H
30	Munich 238	oen		Scale pattern painter	*NC* 1101	graffito H
31	Rhodes 12567	oen	Kamiros	Ampersand painter	*BSA* 70 (1975)147,4	ƁV
32	Rhodes 12096	oen	Kamiros		*BSA* l.c. 147,2	⊗
33	Louvre ED216	oen			*BSA* 68 (1973) 187	X
34*	Vulci TP 4	oen	Vulci			at least ⥾
35*	Palermo 1714	oen				traces
36	Berlin 1115	oen	Nola			X
37*	Boulogne 368	oen				X?
38	Karlsruhe B2589	oen	Civita-vecchia		*CVA* 1 51	ᴎ
39	Dublin 1886.387	oen				traces
40	Berlin 1129	oen	Nola	Kalinderu group	*NC* 1125	H
41	Princeton 57.5	oen		Dodwellian (Amyx)	*Rec.Art Mus.* 15 8-10	�╫

42	London 1928. 1-17.36	hy		Dodwell painter	*NC* 1150	�haE
43*	Louvre E632	kr	Cerveteri		*NC* 1178	traces
44	Berlin 1147	kr	Cerveteri	Memnon painter	*NC* 1170	⊕
45*	Louvre E634	kr	Cerveteri	Memnon painter	*NC* 1182	ⴓ
46*	Louvre E630	kr	Cerveteri	Detroit painter	*NC* 1180	Pl. 36a-b
47	Louvre Cpl0479	kr		Detroit painter	*BSA* 68 (1973) 186	⟨VMI
48*	New York 27.116	kr		Detroit p. (Amyx, *AJA* l.c.)		at least FPA
49	ex Swiss market	kr		Detroit painter (ibid)	*Auktion* 22 112	F
50*	London B43	kr				ꟻ
51*	Louvre E569	kr				at least ⌐L
52	Louvre E616	kr	Cerveteri		*BSA* 68 (1973) 188	traces
53	Louvre E618	kr			*BSA* ibid	⊕
54*	Bari, Palese 12	kr	Apulia			X

Middle or Late Corinthian

55	Louvre ED223	pyx			*BSA* l.c. 187	F
56*	Syracuse	pyx	Akrai			Pl. 35a-b
57*	Louvre S3941	oen				traces and graffito A
58*	Chiusi 1805	oen	Chiusi			A navel
59	Gela 20324	hy	Gela		*BSA* 68 (1973) 187	ꓶ
60	Palermo	sky foot	Selinus		*ML* 32 pl 86,11	ꓺꟼO

Late Corinthian

61	Cambridge Cl.Arch.NA188	ary	Naukratis	late quatrefoil	*BSA* 70 (1975) 148 n.6	И
62*	Bari 2890	pyx	Taranto			X
63	Berlin 987	pyx	Nola	floral	*NC* 1321	black MO
64*	Louvre·E367	pyx		floral	*NC* 1322	Φ?
65*	Milan A174	pyx		floral		⊥
66*	Taranto 20766	pyx	Taranto	floral		Pl. 40a-b
67*	Taranto 112575	pyx	Taranto	floral		⌐ᴅ
68*	Palermo 1674	pyx		floral		large ⊕
69*	Gela	pyx	Gela	floral		traces
70*	Syracuse 5994	pyx	Syracuse	floral		Aᶜₒ
71*	Syracuse 38079	pyx	Grammich-ele	floral		L
72*	Louvre El. 99	pyx	Elaious			∧?
73*	Palermo 1659	pyx	Selinus			stripe
74*	Agrigento S2278	kothon	Agrigento		Montelusa tomb 2	traces
75*	Naples 80245 (H351)	lek		P. of slim sphinxes	*NC* 1363	⌐
76*	Oxford 1928.11	lek		Manner of p. of slim sphinxes		⊕
77	London B27	lek	Nola		*NC* 1366	BV
78*	London o.c. 377	lek				F
79*	London o.c. 378	lek				traces
80	Karlsruhe B198	lek			*CVA* 1 52	BᴠV
81*	Taranto 20742	lek	Taranto	glazed		graffito ⌐
82*	Syracuse 2215	lek	Leontini		*NC* 1362a	∎
83*	Syracuse 45723	lek	Syracuse			A
84*	Bari 3194	oen	Metapon-to?		*NC* 1402	traces
85*	Louvre N iii 2352	oen	Rhodes?	glazed		∆A
86*	Gela 204	oen	Gela	glazed		traces
87	ex Swiss market	oen		P. of slim sphinxes	*NC* 1385; Ars.A.A. iv 126	black ᛋ
88	Zurich 6	oen	Tarquinia	P. of slim sphinxes	*CVA* 1 15	glaze ᛋ
89	ex Geneva, Hirsch	oen			*NC* 1386	ᛋ
90	Louvre E646	type B	Cerveteri	White horse group	*NC* 1423	⌐V
91*	Naples Stg.137	type B		White horse group	*NC* 1424	traces
92*	Naples 80256	type B		Tydeus painter	*NC* 1429	Ʞ
93*	V.G. 50537 (M328)	type B		Andromeda painter	*NC* 1433	ⴕₒ
94*	Naples H336	type B		Manner of Damos p.		X
95*	Conservatori 80	type B			(*CVA* 1 pl 5,5-6)	traces

96*	Louvre E652	type B				traces
97*	Louvre E653	type B				at least A
98*	Louvre S3933	type B				traces
99	Florence 3766	n-a		Tydeus painter?	NC 1436	A
100	London B36	n-a		Andromeda painter?	NC 1438	
101	Syracuse 52165	n-a	Syracuse		NSc 1951 308	X
102*	Louvre E642	hy	Cerveteri	Damos painter	NC 1447	traces
103	Louvre E622	kr	Cerveteri	Tydeus painter	NC 1480	Γ
104	Louvre E621	kr	Cerveteri	Tydeus painter	NC 1481	Π
105	Villa Giulia 46197	kr	Cerveteri	Detroit painter	NSc 1937 432	
106	Basel, loan	kr		Athana painter	AK 11 (1968) 82	℉
107*	Louvre E637	kr	Cerveteri			traces

Most of these marks are on the navel; for exceptions see *BSA* 68 (1973) 188. Where the mark is unpublished I have not bothered to bracket the *NC* number. An attribution of 29 is cited in *AJA* 73 (1969) 116, and for 30 see ibid. 116 n.21.

MARKS ON LACONIAN VASES

Dipinto

1	Villa Giulia 47995	col-kr	Cerveteri			ML 42. 534	AD
2*	Gela, Navarra 25	col-kr	Gela	c.530			traces
3	Limoges 81.00	col-kr				CVA 4	X
4*	Louvre E687	col-kr					Γ
5	Rhodes	hy	Ialysos	Hunt painter		BSA 70 (1975) 147,5	Red stripe

Graffito

6	London o.c.225	col-kr				4Λ
7	Ferrara T499	col-kr	Spina			Shoulder
8	Villa Giulia	kr foot	Cerveteri		NSc 1937 417,29	Φ
9	Copenhagen ABc905	hy			CVA 5 172	Shoulder
10	Tocra	small oen	Tocra		Tocra 1 972	ΥΜ

For further notes on these pieces see *BSA* 70 (1975) 148, n.7 (especially for 7).

MARKS ON CHALCIDIAN VASES

R indicates catalogue numbers in Rumpf, *Chalkidische Vasen*; see ibid. 53 for most of the marks.

Dipinto

1	Brussels R220	n-a		Group of the Orvieto hydria	R41
2	Berkeley 8.3415	n-a		Group of the Orvieto hydria	R46; CVA 1 24
3	ex-Swiss market	n-a		Group of the Bonn amphora	Auktion 26 82

Graffito

4	ex-Castellani	n-a	Cerveteri	Phineus painter	R57
5	ex-Castellani	n-a	Cerveteri	Phineus painter	R58
6	Cat.Campana 449	n-a	Cerveteri	Phineus painter	R59
7	Cat.Campana 453	n-a	Cerveteri	Phineus painter	R67
8	Oxford 1965.132	n-a		Group of the Orvieto hydria	R26; Spencer-Churchill no 72
9	Orleans	n-a		Group of the Orvieto hydria	R27
10	New York 46.11.1	n-a		Polyphemos group	BMM 1946-7 132-3

Rumpf does not mention the mark on 2, and the nature of 3 is not specified in the catalogue.

MARKS ON EAST GREEK VASES

I have not attempted any chronological ordering in these lists, but rather arranged them by pro-
venance and to a certain extent vase shape. *N = Naukratis*, *T = Tocra* (both volume i, unless ii is
added).

Chiot

I give here references to published material, and add a little that is unpublished. All the
vases are chalices save 67, which is from a bowl. To my knowledge there are no marks on feet of the
early broad type, but most are from smaller chalices, which do not reliably reflect the progress
towards higher feet seen in the larger versions. Most probably belong to chalices of the period
580-550.

1-44 *N* 34-67, 362, 367, 370, 436-442. They are respectively: London 1886.4-1.739-754, un-
 traced (*N* 50), 1886.4-1.755-771, 715, 720, Oxford Gl23.4,
 London 1910.2-22.50-56. *N* 42 also has red traces.

45-67 Unpublished pieces from Naukratis.
 All save 51 are feet only, some
 fragmentary.
45* London 1886.4-1.773 red ⊕ *(47)*
46* London 1886.4-1.981 Ψ
47* London 1888.6-1.374 *(48)*
48* London 1888.6-1.375
49* London 1888.6-1.376 *(49)*
50* London 1888.6-1.384 red traces
51* London 1888.6-1.419 Pl. 41
52* London 1888.6-1.420 *(52)*
53* London 1888.6-1.428 red ⊟
54* London 1888.6-1.765 Κ
55* London 1888.6-1.766 Pl. 42
56* London 1888.6-1.767 Pl. 39
57* London 1888.6-1.768 Ⰳ
58* London 1888.6-1.769 Pl. 30 *(59)*
59* London 1888.6-1.770
60* London 1888.6-1.771 *(60)*
61* London 1888.6-1.772 Pl. 31
62* London 1888.6-1.773 Α *(64)*
63* London 1888.6-1.774 Ⱶ
64* London 1888.6-1.776 *(65)*
65* London 1910.2-22.262
66* London 1965.9-30.257 Ψ
67* London 1965.9-30.259 *(67)*

On 51-53 there are dedicatory inscriptions to Aphrodite incised around the outside of the foot, on 51
by Phortylos, on 52 by Hermogenes (*N* ii 752) and on 53 by Eukles (*N* ii 753).

68-70 *T* 783, 784 and ii 2051 The first two marked by the handle, the other under the
 foot. All red dipinti.
71-74 *Chios; Greek Emporio* 279-282 Pre-firing graffiti, the first two strengthened with
 added red.

Fikellura

Also listed in *BSA* 70 (1975) 149-50.

75	London 1949.5-16.7	n-a	Tell Defenneh	*BSA* l.c. n.12	
76	London 1910.2-22.48	n-a	Naukratis	ibid.	Ⱶ on wall
77	Bucharest	oen	Histria	ibid; *Histria* iv 187	red Δ
78	Rhodes 10614	amphoriskos	Ialysos	*BSA* l.c. 149,9	
79	Rhodes 13686	amphoriskos	Kamiros	ibid 10	
80	Rhodes 14103	amphoriskos	Kamiros	ibid 12	
81	Louvre A334	amphoriskos	Kamiros	ibid 11	graffito on shoulder
82	London 1864.10-7.1350	amphoriskos	Kamiros	ibid 13	graffito on shoulder
83	where?	amphoriskos	Kamiros	ibid 14	graffito on shoulder

Klazomenian

Also listed in *BSA* 70 (1975) 149-150. 86 is an imitation of Klazomenian ware.

84	Kiev	askos		*BSA* l.c. n.11	red ⚚ above 11 strokes
85	Vienna, loan	amphora		ibid	red ΣV
86	Rhodes 6251	amphora	Ialysos	*BSA* l.c. 149,8	

Banded amphorae

Also listed in *BSA* 70 (1975) 149-151.

87	Rhodes 1446	Ialysos	*BSA* l.c. 150,19	
88	Rhodes	Ialysos	ibid 149,18	
89	Rhodes	Ialysos	ibid 150,20	graffito on shoulder
90	Munich 460			
91	Munich 463		ibid fig.2,H	
92	Munich 467			graffito on shoulder
93	Munich 468			graffito on shoulder
94	Tarquinia RC1145	Tarquinia	*BSA* l.c. n.15	graffito on neck
95	Tarquinia RC1860	Tarquinia	*BSA* l.c. fig.2,G	
96	Tarquinia RC3440	Tarquinia	*BSA* l.c. fig.2,B	graffito on shoulder
97	ex Rome, Hercle	Vulci	*St.Etr.* 34 (1966) 318-9	
98	Louvre S3943		*BSA* l.c. fig.2,F	
99	Bonn		*AA* 1891 18; *BSA* l.c. n.15	red ⟨

A hydria of the same fabric:

100	Villa Giulia M418		*BSA* l.c. n.15	graffito on shoulder

'Samian' Lekythoi

Also listed in *BSA* 70 (1975) 150. Graffiti on shoulder unless otherwise stated.

101	Rhodes 1325	Ialysos	*BSA* l.c. 22	
102	Rhodes 1326	Ialysos	*BSA* l.c. 23	
103	Rhodes 1328	Ialysos	*BSA* l.c. 24	
104	Rhodes 6490	Ialysos	*BSA* l.c. 21	
105	Rhodes 12218	Kamiros	*BSA* l.c. 25, fig.1	
106	Rhodes 12961	Kamiros	*BSA* l.c. 26	graffito on body
107	Rhodes 13139	Kamiros	*BSA* l.c. 27	graffito on body
108	Syracuse 12648	Syracuse	*BSA* l.c. fig.2,J	graffito on neck
109	Syracuse 24670	Gela	*BSA* l.c. fig.2,K	
110	Syracuse 24691	Gela	*BSA* l.c. n.13	Pl. 44a-b under-foot dipinto
111	Syracuse	Gela	ibid	
112	Syracuse	Gela	ibid	
113	Taranto 4892	Taranto	ibid fig.2,D	
114	Taranto 20739	Taranto	ibid fig.2,E	

Rhodian

I reserve pieces which cannot with any confidence be attributed to Rhodes till the next section.

115-148 From Tocra; red unless otherwise stated

115	*T* 589	amphora	dipinto mentioned in text, but not in catalogue
116-117	*T* 601,602	amphora or oen	

118	*T* 606	kr?	
119	*T* 627	fruit-stand	
120-121	*T* 635,639	dish	
122-124	*T* 647,651-2	dish	
125-126	*T* 660,664	dish	the second said to have a dipinto, but not illustrated
127-128	*T* 670,673	dish	graffito X on 670
129	*T* ii 1985	dish	
130-132	*T* 681,684-5	banded dish	
133-136	*T* 690,693-4,698	banded dish	690 as 664 above
137-139	*T* 701,709,713	banded dish	
140-141	*T* ii 1998,2005	banded dish	
142-144	*T* 718,757,759	banded bowl	
145-147	*T* 723,736,743	rosette bowl	723 has graffito asterisk, the other two are marked in the handle zone, 743 under the foot as well.
148	*T* ii 2038	rosette bowl	
149	*T* 1272	cup	

150-165 From Istria; L = Lambrino, *Les vases archaiques d'Histria*; i and ii = *Histria* i and ii.

150	L fig. 170, B1666	fruit stand	see *T* 46, n.8
151-152	L fig. 174-5, B1965, 1660	banded dish	
153	ii 69 (pl 64)	dish	
154	L fig. 49 and p.88, B1029	cup	graffito
155	L fig. 192, B2036bis	plate	graffito
156-157	L fig. 41b,42 and 176, B1645 and 1401	bowl	
158	i 385, fig. 210	bowl	
159-161	ii 233,234,509 (pl 28 and 64)	bowl	
162-165	ii 623,624,629,632 (pl 60 and 64)	olpe	

166-175 From Naukratis; graffito, save 174

166-170	*N* 429-433	dish	= London 1910.2-22.44, unlocated and 1910.2-22.45-47
171	*N* 450 (London 1910. 2-22.63)	bowl	
172	*N* 358 (London 1886. 4-1.712)	rosette bowl	
173*	London 1922.5-8.6	plate	
174*	London 1924.12-1.339	plate	red HO[...
175	Cairo 26.146 (Edgar pl. 3)	plate	

176-179 From Tell Sukas; some of these pieces are not given a specific Rhodian label in *Sukas* ii.

176	*Sukas* ii 108, TS2603	cup	graffito
177	*Sukas* ii 108, TS4924	cup	
178	*Sukas* ii 108, TS2481	cup	
179	*Sukas* ii 247, TS2251	closed vase	

Further short, or apparently short graffiti are found elsewhere than under the foot, *Sukas* ii 233, 265, 291 and 308.

180	from Taman, *AA* 1912 331, fig. 14	fruit stand	red
181	from Lindos, *Lindos* i 975	fruit stand	E
182	from Kamiros, *BSA* 70 (1975) 148,15	plate	Florence 78994
183	from Corinth, *Corinth* vii 307	rosette bowl	A

Other East Greek

A large number of vase feet from Naukratis in London cannot be readily attributed to a source; some may be Rhodian, but I put them all under a neutral heading.

184-229 From Naukratis; all graffiti on feet, unless otherwise stated.

184-199 *N* 352-7,359-361,363-6,368-9,375 = London 1886.4-1.706-711, 713-4, unnumbered,
 716-9, 722?, 721, 727

200-210 *N* 443, 451-2, 461-5, 670-1, 673 = London 1910.2-22.57, 64-5, 72-6, untraced (670-1),
 1886.4-1.931. *N* 366 has the same mark dipinto and
 graffito; *N* 368 is a handle.

211*	London 1886.4-1.1026	glazed cup	red ⋀I	
212*	London 1886.4-1.1302	closed vase	X on navel and red traces	
213*	London 1888.6-1.414	cup	Ⱥ	
214	vacat			
215*	London 1910.2-22.252	closed vase	red traces	
216*	London 1910.2-22.259	bowl	part of two verticals	
217*	London 1922.5-8.12	small closed vase		*(217)* ⋎⋏ ⋎
218*	London 1922.5-8.13	olpe?	red M	
219*	London 1924.12-1.897	bowl		*(219)* H⟙
220*	London 1965.9-30.256	bowl	⋀	
221*	London 1965.9-30.479	bowl, slipped white		*(221)* ⋀⋀⋀
222*	London 1965.9-30.638	cup	red ⊥	
223*	London 1965.9-30.671	bowl		*(223)* ⇥
224*	London 1965.9-30.672	bowl		*(224)* ⋋⊦
225*	London 1965.9-30.674	bowl		*(225)* ⋀⟙
226*	London 1965.9-30.677	bowl	H	
227*	London 1965.9-30.678	bowl	Pl. 43	
228*	London 1965.9-30.679	small closed vase	Pl. 45	
229*	London 1965.9-30.703	cup	ⱦ	

230-239 From Tell Defenneh

 Tanis ii pl 32. These dipinti were probably on Rhodian vases, but proof is lacking.
 Hackl took them as Attic, but this is extremely unlikely.

240-242 From Xanthos

 Metzger, *Fouilles de Xanthos* iv 415-7. He does not indicate the fabric, but presumably
 they are East Greek.

243-246 From Tell Sukas

243	*Sukas* ii 346, TS1764	foot of closed vase
244	*Sukas* ii 401, TS4456	foot of closed vase
245	*Sukas* ii 407, TS601	foot of closed vase
246	*Sukas* ii 412, TS4894	foot of cup

247	*Tocra* ii 2041	rosette bowl	
248*	Syracuse 9923, from Megara Hyblaea	stemless bowl	XI
249*	London 1907.12-1. 797, from Ephesus	foot of open vase	ΣKO
249a	Nicosia, from Amathus	rosette bowl	

249a is published in E. Gjerstad and others, *Greek Geometric and Archaic Pottery found in Cyprus*, 69, 34.

Unknown provenance:

250*	Louvre N3345	foot	glaze ⋀
251	Leningrad St.266	col-kr	= 24B,4
252	Würzburg 139	cup	= 17E,12

Various pieces from Old Smyrna are published by Jeffery in *BSA* 59 (1964) 40ff. All are graffito, and while none are convincingly commercial, some may be. Most of the other inscribed vases from Naukratis are either Attic black-glazed or of various wares but marked on parts of the vase other than the foot.

SUBSIDIARY LISTS (ATTIC)

Subsidiary List 1

Vases with marks which could be regarded as of a commercial nature on parts of the body other than the foot.

a) On the lip

BF

1	Louvre Cp10655	hy		Taleides painter	*Paral* 72,6	10A,1
2	Louvre E623	col-kr		Ptoon painter	*Paral* 31,1	13F,8
3	Louvre E821	type B		horse-head	*ABV* 17,21; Hackl p.59	
4	New York 51.11.3	type B Attica?		Lydos	*CVA* 3 1	s.l. 3,1
5*	Basel, loan	type B		Swing painter (who?)		H
6	Cab.Med. 252	stam		Beaune painter	*ABV* 344,1	21A,14
7	Villa Giulia 74967	Panath		near Mastos painter (Riccioni)	see below	HI
8	Naples 112847	hy		Priam painter	*ABV* 333,29	
9	Louvre F276	*Panath		Group of Kleophrades painter	*ABV* 405,3	XXXI

RF

10	ex Swiss market	lek		Nikon painter (Cahn)	*Auktion* 51 161	H twice
11	London E263	type B	Vulci	Niobid painter	(*ARV* 604,53)	XXII::I inside

7 is published in *Nuove Scoperte e Acquisizioni nell'Etruria Meridionale* 214,5.

b) On neck

BF

12	Syracuse 11889	type B	Megara Hyblaea	575-550	*ZPE* 17 (1975) 153,2	Fig.14a
13	Munich 1761	oen	Vulci	Class of Vatican G47	(*ABV* 430,22); Hackl p.60	
14	Aachen, Ludwig 14	hy		560		N
15	London B215	n-a	Vulci	Eye-siren group	(*ABV* 286,1)	K inside 11F,4
16*	Cerveteri, recupero 1961.21	oen	Cerveteri	520-10		Λ Λ under foot
17	Rhodes	lek	Ialysos		*ASA* 6-7 (1923-4) 318	AP

RF

18	Cleveland 24.197	col-kr		500	*CVA* 1 18	19A,3
19	Leningrad P103	pel		Agrigento p. (Peredolskaya)		

c) On the shoulder

BF

20	Munich 1449	n-a	Vulci	570-60	*CVA* 7 31	17E,25
21	Jerusalem 74.9.8	hy		550	*Sotheby 3/12/1973* 129	⊗A
22*	Tarquinia RC2363	type B	Tarquinia	550-30, b.g.		
23*	Tarquinia RC1876	n-a	Tarquinia	530		Fig.10a, 17E,1
24	Harvard 2214	lek		530	*CVA* 29	
25	New York 56.171.4	*Panath		Painter of Boulogne 441?	*CVA* 3 33	
26	Berlin 1982	lek	Smyrna	late	Hackl p.60	
27	Naples RC184	*Panath	Cumae	Achilles painter	(*ABV* 409,3); Hackl p.60	OO IIIIII
28*	Naples 3415	*Panath		c.450	see below	

RF

29	Riehen, Gsell	stam		450	*Auktion* 16 120	

28 has an + at the top right of the panel on B. 23 belongs to section b.

d) On the belly

BF

30	Würzburg 169	n-a		Lydan (Trendall)	see below	K 15A,5
31	Sydney 13	n-a		Lydan (Trendall)	*JHS* 71 (1951) 179	K
32	Munich 1736	col-kr	Agrigen-to?	Painter of Munich 1736	(*ABV* 265,2;); Hackl p.59	see below
33	London B29	lek		540	*ABL* 59	9B,26

RF

34	Boston 33.56	vol-kr	Niobid painter	*ARV* 600,12	N under glaze
35	Mannheim Cg204	lek	425-375	*CVA* 37	

30 and 31 are taken to be Euboean by von Bothmer, *AJA* 80 (1976) 43. 32 has ⋈ upside down, near the base.

e) On the handle

BF

36*	Basel BS455	lek		540		Fig.13x
37	Vatican 434	oen		Keyside class	(*ABV* 426,16)	11E,29; 12E,31
38	*Munich 1789	oen	Vulci		H168	11E,25
39	*Munich 1820	oen	Vulci		H169	11E,26

RF

40	Berlin 2159	type A	Vulci	Andokides painter	(*ARV* 3,1); see below	1B,11
41	Rouen 359	stam	Vulci	Copenhagen painter?	(*ARV* 259,2)	9E,103 q.v.
42	Ferrara T436	vol-kr	Spina	Painter of Bologna 228	(*ARV* 511,2); *NSc* 1927 186	
43	London E375	pel	Vulci	Aegistheus painter	(*ARV* 506,20); *BMC*	Fig.13p
44	London E471	col-kr	Apulia	470	*BMC*	
45	Cambridge 1890.4	askos	Cyprus	c.400	*CVA* 2 38	18B,14
46*	Naples	lek		(B)		H
47*	where?	oen		(B)		ΕVΣ

40 has a pentagram on its handle as well as under its recently restored lid; see Knauer, *Die Berliner Andokides-Vase* 22.

f) On the inner or outer wall of cups

BF

48	Munich 2238	cup	Vulci	540	Hackl p.60	6D,3
49	Amsterdam 684	cup		520-10	*Paral* 82	inside bowl

RF

50*	Chicago 1889.27	cup	Cerveteri	Penthesilea painter	(*ARV* 884,77)	8D,56
51	Villa Giulia	cup	Cerveteri	450-425	*NSc* 1937 391	

g) On the side or top of foot

BF

52	London B449	cup	Rhodes	Haimon painter	(*ABV* 561,536);*BMC*

RF

53	Oxford 1920.105	Nolan		Syriskos painter	*ARV* 261,24

Subsidiary List 2

Red-figured vases with dipinti

Red

1	London E256	type A	Vulci	recalls Bowdoin-eye p.	(*ARV* 168)	O on navel 9E,48
2*	Villa Giulia 47836	n-a	Cerveteri	Kleophrades painter	(*ARV* 184,18)	14B,22 q.v.
3*	Louvre G235	pel		Kleophrades painter	(*ARV* 184,25)	⋀
4*	V.G. 50384 (M669)	hy		Kleophrades painter	(*ARV* 189,75)	traces

5*	V.G. 50471 (M653)	n-a	Cerveteri	Harrow painter	(*ARV* 272,1)		traces	
6*	Sarasota	n-a		Harrow painter	(*ARV* 272,9);	(B)	14B,23	
7*	Naples 126062	n-a		Harrow painter	(*ARV* 273,16)		13B,20	
8*	Villa Giulia 48238	pel	Cerveteri	Matsch painter	(*ARV* 284,1)		traces	
9*	V.G. 50462 (M660)	n-a		Matsch painter	(*ARV* 284,3)		traces	
9a*	Villa Giulia 14215	n-a		Near Matsch painter	(*ARV* 284)		HΛ	
10*	Florence 76985	pel	Chiusi	Flying-angel painter	(*ARV* 280,17)		traces	
11*	Louvre G237	pel		Tyszkiewicz painter	(*ARV* 293,52)		A ?, navel	
12*	Cambridge 1952.6	pel	Chiusi	Tyszkiewicz painter	(*ARV* 293,54)		traces	10F,13
13*	Cerveteri, magazzini	pel	Cerveteri	490			one stroke	10F,11
14*	Villa Giulia 48239	pel	Cerveteri	Triptolemos painter	(*ARV* 366,22)		8D,19	
15	Vatican 16526	stam	Vulci	Hermonax	(*ARV* 484,21)		2B,2 q.v.	
16*	Syracuse 34430	col-kr	Syracuse	Painter of London E489	(*ARV* 547,26)		traces	
17	ex Swiss market	lek		Circle of Phiale painter	*Auktion* 34 170		14B,24	
18*	Vatican 17915	n-a		P. of Louvre Centauromachy	(*ARV* 1093,91); see below		traces	
19*	Louvre G353	col-kr		Orestes painter	(*ARV* 1113,9); see below		traces	
20*	Cab.Med. 852	askos		Curtius painter	(*ARV* 935,74); (B); see below			16B,4
21	Syracuse	pel	Akrai	c.425	*NSc* 1915,210		5D,15	
22	Compiègne 1090	cup	Vulci	Wedding painter	*ARV* 922,1		lines and dots	
23*	ex Segredakis?	amphora			(B)		Γ	

Glaze

24*	Munich 2300	type A	Vulci	early bilingual	(*ARV* 11,1)	see below	
25*	Vatican 16547	hy	Vulci	Eucharides painter	(*ARV* 229,38)	A , navel	
26	London E261	type B	Vulci	Diogenes painter	(*ARV* 248,2); *BMC*; H66	21A,26	
27	Villa Giulia 20845	stam	Cerveteri	Birth of Athena painter	*ARV* 495,6	2B,3	
28	Villa Giulia 20846	pel	Cerveteri	Birth of Athena painter	*ARV* 495,2	2B,4 q.v.	
29	Villa Giulia 20847	pel	Cerveteri	Birth of Athena painter	*ARV* 495,3	2B,5 q.v.	
30	London E410	pel	Vulci	Birth of Athena painter	(*ARV* 494,1)	2B,6	
31	Swiss private collection	pel		Birth of Athena painter	*ARV* 495,4	2B,7 q.v.	
32	ex Swiss market	pel		Birth of Athena painter	*Paral* 380,5bis	2B,8 q.v.	
33*	Oxford 1965.128	oen		450	*Spencer-Churchill* no 78		
34	Cab.Med. 377	n-a		Westreenen painter	*ARV* 1006,4		17E,42
35*	Louvre CA1944	bell-kr	Boeotia?	c.400		HNO	
36	Adria (22,14)	sky	Adria			13A,10	

Medium unknown

37	Würzburg 518	stam	Vulci	Painter of the Yale lekythos	(*ARV* 657,2)	13B,21 q.v.	
38*	Ferrara T797	oen	Spina	Painter of Ferrara T797	(*ARV* 1216,1 or 2); (B)	A	

Mingazzini omits the attribution of 9 in his catalogue. The scenes on 13 are: A, boy with hoop, draped male, B, dancers. The marks on 18-20 are mentioned in *BSA* 70 (1975) 159 n.36. There are glaze splashes on 24, but nothing that can surely be taken as an intentional mark. My assumption that M is the dipinto mark on 37 and X graffito (see Philippaki 55) may be mistaken. In view of the abrasive nature of the earth around Comacchio I imagine that 38 must be subsidiary glaze.

A further black mark is thought to be modern: German private collection, bell-kr, c.390, W. Hornbostel, *Kunst der Antike* 349, no. 299, dipinto E.

Subsidiary List 3

Attic figured vases (other than pyxides) with a Greek provenance, bearing marks.

BF

1	New York 51.11.3	type B	Attica?	Lydos	*CVA* 3 1	s.1.1,4
2*	Belfast (1318)	cup	Boeotia?	late sixth century	= 17B,6	Fig.4u
3	Bartenstein	hy	Melos	Painter of Vatican G49	*AA* 1909 31-2; *ABV* 536,43	
4	Tübingen 717 (D61)	oen	Attica	Painter of Vatican G49	*ABV* 535,5	2B,50
5	Amsterdam 3303	sky	Greece	c.500	*ABV* 581,15	2B,46
6	Copenhagen 92	lek	Seriphos	Cock group	*ABV* 471,3	
7	St.Louis WU3279	lek	Corinth?	Athena painter (who?)		KN
8*	Agora P24530	lek	Athens	510-490		ϟΛVNE
9	Corinth CP2143	lek	Corinth	Manner of Haimon p. (Eliot)	*Hesperia* 37 (1968) 358	

RF

10	Oxford, Miss.	pel	Athens	Myson	*ARV* 238,7	21A,102
11	Agora P5009	mug	Athens	early fifth century	*Agora* xxi 33, F46	
12*	Argos C7777	lek	Argos	470	(*BCH* 91 (1967) 826)	K
13*	Athens 1690	Nolan	Corinth	near Charmides painter	(*ARV* 654,2); (B)	10E,11
14	Compiègne 1037	lek	Athens	Klügmann painter	*ARV* 1200,34	
15	Thessalonike	n-a	Stryme	Peleus p. (Bakalakis)	*Anaskaphi Strymis* 67	IΛII
16	Agora P23242	oen	Athens	450-40	*Agora* xxi M12	⅏ on neck
17	New York 06.1021.174	sky	Athens	Polion	*ARV* 1172,21	
18	Athens	kr foot	Perachora	fifth century	*Perachora* ii 400, 148	
19*	Louvre CA1944	bell-kr	Boeotia?	late fifth century		s.1.2,35
20	Thessalonike 1623	pel		near Group of Vienna 888	*ARV* 1358,1	ΣΙΚΕΛΙΚΑ

Subsidiary List 4

Pyxides and related lidded vases with marks under lid and foot.

a) Type D pyxides. The marks pre-firing save for 2, 11 (part), 16, 23 (name), 28 and 30 (20 unknown to me).

RF

1	Munich 2726		c.420	*CVA* 2 30	◁	
2	London E771	Naukratis	late fifth century	*BMC*	AT	4B,14
3	London F141	Nola	c.400	*BMC*	⫣	
4	Thessalonike	Olynthos	c.400	*Olynthus* v 201	ϟℙ	
5*	Oxford 1964.325		early fourth century		Fig.14y	
6*	London, Wellcome 223.1946		early fourth century		Fig.14z	
6a*	Edinburgh 1956.477		early fourth century		Fig.14aa	
7	Warsaw 142352	Marion	fourth century	*CVA Goluchow* 28	Y	
8	Berlin inv.4517	Piraeus	fourth century	*CVA* 3 31	E	
9	Baltimore 48.82 b.g.		fourth century?	(*Agora* xii 178)	N⊥	
10	Rhodes 12036	Ialysos	475-450	*BSA* 70 (1975) 160,89	EC	
11	Vienna 3718		450-425	*CVA* 1 40	M Γ	
12	Vienna 1971	Greece?	425-400	*CVA* 1 40	ΦA	
13*	Nicosia C751	Marion?	late fifth century		Fig.14bb	
14	Rhodes 13789	Kamiros	late fifth century	*BSA* l.c. 161,98	⋔Γ	
15	Oxford 334		early fourth century	(*CVA* 1 10)	Fig.14cc	
16	Thasos	Thasos	fourth century	*BCH* 97 (1973) 571	⅗	
17	Athens, Agora P5711	Athens	fourth century	*Agora* xii 1315	KI	
18	Athens, Agora P19428	Athens	fourth century	ibid		

19	Athens, Agora P23140	Athens	fourth century	ibid	
20	Kerameikos inv.1009	Athens		(Agora xii 178)	
21*	London 1842. 7-28.1054*	Athens			Fig.14dd
22	once Princeton			(Agora xii 178)	PT
23	Berlin inv. 31547			(Agora xii 178)	N

Box only preserved:

24	Athens, Agora P24795	Athens	425-400	Agora xii 1310	Λ
25	Villa Giulia	Cerveteri		NSc 1937 425,83	H

Lid only preserved:

RF

26	Athens, Agora	Athens	c.400	Hesperia suppl. x 34,131	T twice
27*	Athens, Agora P777	Athens			black ξ
28	Thessalonike	Olynthos	c.400	Olynthus v 204	E
29	Thessalonike	Olynthos	c.400	Olynthus v 205	ΛΑ
30	Thessalonike	Olynthos	c.400	Olynthus v 206	ΡΊ·

b.g.

31*	Athens, Agora P22824	Athens			Δ
32*	Athens, Agora P23549	Athens			Γ

Marked under lid only?

33*	Tübingen		b.g.	(B)	B

With different marks under lid and box (see also 15):

34	Copenhagen inv. 953	Chalkis	Gaurion, potter	ARV 1360,1	
35	Cab.Med 865	Nola		de Ridder	

On 23 there is also the inscription of a later owner, ?Euxenidas.

b) Type C pyxides

36	New York 06.1021.120
37	Boston 22.824

Mentioned in Agora xii 178.

c) Lekanides

38	Würzburg 163	Arezzo	525-500		
39	Naples 659				11F,8
40	Athens, Agora P19313	Athens	440-400	Hesperia 20 (1951) 220	

38 has a mark under the foot and repeated on top of the disc knob; it is also 24E,9. I assume that one of the marks given by Heydemann for 39 is under the foot, the other under the lid. Only the bowl of 40 is preserved; it has pre-firing Α .

d) Casserole

41	Sèvres 2043		Apulian?	JHS 56 (1936) 253; (CVA 44)	glaze H

The precise shape of four more vases, from the Athenian Akropolis, is not clear; ADelt 1 (1915) parat. 41. Add the batch and price notation under the lid of a RF type D pyxis lid from Apamea (p. 20).

Subsidiary List 5

Black-figure vases with traces of red dipinti. I give only basic details; as most of the marks are
unpublished I give brackets only where the mark is overlooked in a recent publication.

1	Aachen 16	type B	horse-head
2	Agrigento R145	col-kr	510-500
2a	Agrigento C2038	col-kr	*Paral* 47
3	Amsterdam 3374	n-a	= 14A,8
4	Berkeley 8.5699	n-a	*Cal.St.Class. Arch.* 2 (1969)279
5	Bologna 7	type B	510-500
6	Boulogne 13	n-a	*Paral* 157 9[7]
7	Boulogne 418	n-a	= 21E,50
8	Brussels R232	Panath	= 7D,5
8a	Capua 144	col-kr	*ABV* 686
9	Cambridge 47	n-a	*ABV* 314,1
10	Cerveteri 47457	hy	*Paral* 172
11	Cerveteri recupero 1961.20	oen	c.510
12	Dublin 1921.92	type B	c.510
13	Dublin 1921.95	n-a	540
14	Erlangen (J1189)	n-a	c.500
15	Florence 3844	n-a	*ABV* 278,35
16	Harrow 27	n-a	515
17	London B151	type B	*BSA* 70 (1975) 153
18	London B156	type B	ibid.
19	London B205	type A	*ABV* 136,55
20	London B252	n-a	= 2F,19
21	London B263	n-a	*BSA* ibid
22	London B324	hy	*ABV* 361,24
23	London B472	oen	
24	London B516	oen	*BSA* ibid
25	Münster 565	hy	*Paral* 164,31ter
26	Munich 1393	type B	*ABV* 303,1
27	Munich 1402	type B	540
28	Munich 1431	n-a	560
29	Munich 1432	n-a	(*CVA* 7 18)
30	Munich 1439	n-a	*CVA* 7 40
31	Munich 1441	n-a	(*CVA* 7 41)
32	Munich 1473	n-a	= 32A,2
33	Munich 1552	n-a	= 21A,84
34	Munich 1699	hy	*ABV* 324,34
35	Munich 1707	hy	= 11E,5
36	Munich 1712	hy	= 8E,7
37	Munich 1728	hy	*ABV* 397,30
38	Munich 8772	n-a	(*CVA* 7 32)
39	Naples 2473	n-a	*Paral* 142,2
40	Naples 2486	n-a	= 9E,35
41	Naples 2503	type B	*ABV* 305,26
42	Naples 2748	n-a	525
43	Naples 2777	hy	*ABV* 276,3
44	New York 06.1021.68	type A	*CVA* 3 29
45	New York 53.11.1	Panath	*CVA* 4 13
46	Oxford 1911.256	type B	*CVA* 3 last fig.
47	Oxford 1960.741	n-a	not Attic, *BSA* 68 (1973) 276
47a	Palermo 1919	col-kr	540-30
48	Louvre E655	col-kr	550-40
49	Louvre E823	type B	s.1.6,5
50	Louvre E827	n-a	550
51	Louvre E829	n-a	c.560, b.g.
52	Louvre E831	n-a	*ABV* 103,108
53	Louvre E833	n-a	*ABV* 99,57
54	Louvre E835	n-a	*ABV* 101,82
55	Louvre E838	n-a	*ABV* 102,106
56	Louvre E840	n-a	*ABV* 99,52
57	Louvre E845	n-a	*ABV* 102,93
58	Louvre E860	n-a	*ABV* 103,111
59	Louvre E867	n-a	*ABV* 103,113
60	Louvre F39	hy	*ABV* 174,5
61	Louvre F48	hy	540-30
62	Louvre F130	cup	*ABV* 262,49
63	Louvre F206	type A	*ABV* 145,12
64	Louvre F209	type A	*ABV* 335,6
65	Louvre F214	type B	520
66	Louvre F218bis	n-a	*ABV* 308,80
67	Louvre F223	n-a	520
68	Louvre F226	n-a	*ABV* 308,66
68a	Louvre F227	n-a	*ABV* 309,86
69	Louvre F234bis	type B	520-10
70	Louvre F249	n-a	*ABV* 372,166
71	Louvre F265	n-a	*ABV* 375,217
72	Louvre F286	hy	= 8E,36
73	Louvre F289	hy	520-10
74	Louvre F294	hy	= 7A,1
75	Louvre F295	hy	= 16B,6
76	Louvre F303	hy	510-500
77	Louvre F394	n-a	*Paral* 300
78	Louvre Cp121	hy	?Eretrian, see p
79	Louvre Cp10612	n-a	530
80	Louvre Cp10622	type B	575-65
81	Louvre Cp10695	n-a	530
82	Louvre Cp10700	n-a	*Paral* 42
83	Louvre Cp10701	n-a	= 5D,22
84	Louvre Cp12267	col-kr	*Paral* 154,2
85	Louvre Cp12277	col-kr	*Paral* 155
86	Louvre Cp12281	col-kr	520-10
87	Louvre CA2252	n-a	540-30
88	Louvre CA3327	type B	*Paral* 8
89	Cab.Med. 258	oen	*ABV* 229
90	Villa Giulia 3549	col-kr	520-10
91	Villa Giulia 8340	amphora foot?	
92	Villa Giulia 24994	n-a	= 14B,5
93	Villa Giulia 25000	n-a	*ABV* 590,7
94	Villa Giulia 47231	type B	*ABV* 323,24
95	V.G. 50493(M456)	n-a	*ABV* 121,16
96	V.G. 50706(M432)	hy	550-40
97	Villa Giulia M464	type B	540-30
98	Villa Giulia	type A	= 2B,18
99	Conservatori 55	n-a	= 14A,3
100	Conservatori 212	col-kr	*Paral* 16,2
101	Vatican 310	n-a	*ABV* 91,5
102	Vatican 431	hy	= 8E,4
103	Milan, Lerici MA 154/5	hy	570-60
104	Milan, Lerici MA 248/5	oen	520
105	Rhodes 15439	oen	*BSA* l.c. 152
106	Rhodes 15444	hy	*BSA* ibid
107	Salerno (Fratte)	col-kr	520-500
108	Syracuse 21951	hy	*ABV* 337,26
109	Taranto 20119	n-a	570-65
110	Taranto 20238	n-a	c.570
111	Taranto 20851	oen	c.575
112	Taranto 52210	lek	*CVA* pl 14,1-2
113	Taranto 52256	lek	c.510
113a	Taranto 127164	vol-kr	fragmentary, c.520
114	Tarquinia 605	n-a	37A,9
115	Tarquinia 618	type B	*ABV* 125,33
116	Tarquinia 626	type B	= 16B,5

117	Tarquinia 637	sky		*ABV* 621,99
118	Tarquinia 639	n-a		*Paral* 134,7bis
119	Tarquinia 644	n-pel		530-20
120	Tarquinia RC975	n-a		515
121	Tarquinia RC985	type B		530
122	Tarquinia RC2421	type B		*ABV* 306,45
123	Tarquinia RC3029	n-a		*ABV* 331,10
124	Tarquinia RC5564	n-a		*ABV* 84,1
125	Tarquinia RC5652	n-a		525-20
126	Tarquinia RC8650	n-a		c.540, b.g.

127	Tarquinia	n-a	520-10
128	Toledo 69.371	hy	= 2F,28
128a	Trieste S405	hy	*ABV* 350
129	Würzburg 241	type B	*ABV* 169,5
130	Würzburg 263	type A	*ABV* 142,6
131	Sotheby 1/7/1969	hy	510
	101		

23 was omitted from the list of BF vases from Rhodes with marks, *BSA* l.c. 127 has: A, Herakles and Geryon; B, frontal chariot (Brommer 59, 18).

Subsidiary List 6

Vases marked with a plain *alpha*, before c.490 BC

BF

1*	Louvre E825	n-a		570-60	see 8B,4	
2	Rome, Guglielmi	type B	Vulci	Amasis painter	*JHS* 51 (1931) 258	glaze
3	Louvre E859	n-a		c.550	*CVA* 1 pl 6,6 and 13	
4	Aachen, Ludwig 17	type B		c.550		red
5*	Louvre E823	type B		550-40		s.1.5,49
6	Munich 1377	type B	Vulci	Manner of Princeton painter	*ABV* 302,3	red
7	Munich 2154	cup		540		
8	Brussels R231	Panath		540-30	*CVA* 1 5	
9	Villa Giulia 933	n-a	Falerii	Euphiletos painter	*ABV* 323,17	
10*	Geneva MF240	cup		Group of Courting cups	*CVA* 2 pl 65,1-3	
11	Vienna 3597	type B		550-525	Masner 224	
12*	Tarquinia 677	n-a	Tarquinia	Long-nose painter	(*Paral* 145,6bis)	
13	Boston 89.256	type B		525	*CVA* 1 7	
14	London B308	hy	Vulci	Lerici group	see below	
15	Villa Giulia	hy	Cerveteri	Lerici group	see below	
16	Toronto 920. 68.71	n-a		Related to Antimenes painter	*ABV* 281,8	
17	Tarquinia RC1077	n-a	Tarquinia	520-10	*St.Etr.* 36 (1968) 241	
18	Tarquinia RC2464	n-a	Tarquinia	520-10	ibid 242	
19	Villa Giulia 914	sky	Falerii	520	*CVA* 3 25	
20	Munich SL459	Panath		Leagros group, group of Würzburg 210	*ABV* 369,121	
21	New York 06.1021.50	hy	Capua	Manner of Red-line p.	*ABV* 605,6	
22	Matera	lek	Pisticci	490-80	*ML* 48 168	
23	Geneva 20608	oen			*CVA* 2 pl 69,6-7	
24	London B525	oen		early fifth century		
25	Munich 1648	n-a	Vulci			
26*	Jena 179	n-a		(ovoid)	(B)	
27*	Leipsic	hy			(B)	red

RF

28	Louvre G50	hy	Vulci	Kleophrades painter	*ARV* 188,70	
29	Berlin 4029	stam		Six's technique		

It is hardly possible to rule out an Etruscan rather than a Greek inscriber for any of these, but the following are of a more obviously Etruscan shape:

BF

30*	Villa Giulia, Cast.	n-a		550-25, b.g.		
31	Bochum S483	cup		540		
32	Orvieto inv. 2491	pyxis lid		540-30	*CVA* 1 IIIh pl 1, 3-4	
33*	Tarquinia 638	n-a	Tarquinia	530-25	(*CVA* 1 pl 2,1)	
34	Boston 76.40	n-a	Capua	Dayton painter	*CVA* 1 29	

35	Vatican G43	hy	Vulci	P. of Vatican G43	*ABV* 263,1
36	Tarquinia RC1081	n-a	Tarquinia	520-10	*St.Etr.* 36 (1968) 241
37	Castle Ashby	n-a		c.500	*CVA* 7

The attribution of 14 and 15 is only in the typescript *Paralipomena* in Oxford, but is quoted, or rather misquoted in the publication of 15, *Quad.V.G.* 1 (no page numbers).

Subsidiary List 7

Vases with *kappa*. See s.l.1,30 and 31, and also types 16B, 9D, 18E,ii and 20E,ii.

BF

1*	Civitavecchia 56199	type B		550		see below	red	
2	Vatican 415	stam	Vulci	Group of Louvre F314	(*ABV* 388,3)			32A,14
3	New York, Noble	stam		Group of Louvre F314	*Gnomon* 39 (1967) 816			
4	Swiss private collection	stam		Michigan painter (who?)	Isler-Kerenyi, *Stamnoi* 23			
5	Vannes 2157	n-a		Red-line p. (Bothmer)	*CVA* 3		with ⌐	
6	Leningrad St.152	type B					twice	
7	Leningrad St.132	type B					with ⫫⫠	

RF

8	Vienna 654	n-a		Berlin painter	*ARV* 201,67			
9	Louvre G357	col-kr		c.490	*CVA* 4 15	twice		
10	Florence 3995	stam		Hermonax	*ARV* 484,7			
11	Oxford 523	stam	Gela	Villa Giulia painter	*ARV* 621,41			
12	Louvre G210	Nolan	Capua	Oionokles painter	*ARV* 647,18	twice		
13	Berlin 2359	pel	Capua	Manner of Washing p.	(*ARV* 1134,12)			
14	Bologna 322	bell-kr	Bologna	P. of Bologna 322	(*ARV* 1170,10)			18C,38
15	Ferrara T44	col-kr	Spina	P. of Munich 2335	(*ARV* 1166,92); (B)			
16	London E433	pel	Greece	Group G	(*ARV* 1466,104)	with ⫫⫠⫠		

1 may be the vase Gerhard, *AV* pl 228,1.

COMMENTARY

SECTION A

Type 1A

The BF vases are all chronologically close and while they are not all from the same workshop, Leagran pieces dominate. The workshop connections suggest that the lack of a 'tick' on 1 and 3 may not be significant.

The basis of the mark is an *alpha;* the curvature of the left leg on 4, 6 and 7 may suggest an Etruscan origin, while the inconsistency in the slope of the cross-bar could indicate more than one hand at work. The additional lines do not point to any obvious ligature; Etruscan *lambda* is ruled out by the fact that the tick is attached half way up the leg of 4, 6 and 7, and in any case may be optional. The top stroke is also baffling.

4 occurs in a context where we might have expected a mark of type 8E. Could it then be an equivalent of that mark? 8E is also a Leagran mark. If the two are equivalent we could consider the tick as a kind of countermark, such as we sometimes find attached to marks of type 8E. Although an equivalence is possible there seems nothing to be gained from comparing the more inscrutable marks of either type. Both may be Etruscan marks based on an *alpha,* a conclusion lent some weight by the fact that 4, 5, 6 and 7 already bear a Greek graffito.

In view of their different provenances 1-3 could hardly have belonged to a single Etruscan owner. So if we take the mark as Etruscan and if it has the same significance on all the BF vases, it should be of a commercial rather than private character. The fact that 1-3, from the same workshop, ended up at different destinations serves to strengthen this hypothesis.

Type 2A

Another mark based on an *alpha* with an additional tick and a more perplexing adjunct over the *alpha.* Here the *alpha* is much more typically Etruscan, especially in the curve and breadth of the arms. As for an interpretation, one can make no more headway than with type 1A. Perhaps the only available alphabetic explanation of the loop over the *alpha* is that it is part of an Etruscan 8, the lower portion to be supplied from the *alpha;* this could give an abbreviation Fal - -, plausible but far from certain. There is no way of retaining such an interpretation if we try to link the type with 1A and 8E, where no 8 can exist. There may however be some association between the loop here and the circular marks on 8E, 38, 39 and 61.[1]

Type 3A

I repeat the suggestion Fal - -, with a little more confidence, for sub-group ii. The main objection, that the horizontal bars of the *digamma* do not point in a retrograde direction (as in sub-group i), may be trivial. 3 and 5 could be by the same hand. There is not enough evidence for us to decide whether this is purely a private owner's mark or of some commercial significance, as I suggest for type 1A.

1 and 2 form a close group in all respects; same workshop, same provenance, same set of marks. The two marks on 1 are clearly in different hands and this is probably so with 2 as well. The mark of type 9E is unusual in being retrograde and far from well formed in the case of 1. I take it as Greek; Etruscan CA is a possibility, but the shape of the *alpha* would be different from that of the mark of type 3A. The additional simple line with this mark puzzles, but a basic interpretation as Fa - - seems reasonable.

6 stands apart epigraphically, and although the workshops are related I would not take it closely with 1 and 2. Again Fa - - is the obvious explanation.

Type 4A

It is not easy to decide whether this mark is based on an *alpha,* or like types 5C, 6C, 11E and 12E has a more symbolic meaning based on a *delta.* Perhaps it is a ligature of the two letters, *delta* and *alpha.* The base line of the *delta* is not always well aligned with the struts, but one would expect this if it were the last line incised. The fact that the 'cross-bar' slopes immediately distinguishes it from the symmetrical marks of type 11E and 12E. If an *alpha* is

part of the mark we would expect some slope at the date in question, but the fact that it slopes here in either direction is a warning not to be too dogmatic in assigning any particular form of *alpha* to a given state. The same ligature of *delta* and *alpha,* with the cross-bar sloping up to the right, appears on vases found at the sanctuary of Aphaea on Aegina; the marks are better incised, probably because they were visible, and I accept Furtwängler's explanation of the ligature as an abbreviation of δαμόσιον.[1] The mark here would stand rather for a personal name.

The bulk of the type revolves, at a certain distance, around the Antimenes and Lysippides painters.

The dipinto on 10 is intriguing. We have seen that two-element punctuation nearly always, if not always, divides off numerals (p. 25); thus the *pi* here could well stand for five and it may be worth speculating that the *sigma* is an abbreviation of στάμνια or the like, for which see the commentary on type 19F.

The same abbreviation Da - - may be intended on some of the vases of sub-group ii, but they can have no connection with the BF vases and serve at best to demonstrate that two vases with the same mark need have no other connection whatsoever.

Type 5A

The type is wide-ranging and aptly illustrates the criteria used for accepting or rejecting groups of marks.

I would interpret the simpler mark as a ligature EV or EN. In most cases the top hasta of the *epsilon* slopes steeply enough for a respectable *upsilon* or *nu* to be formed in the ligature. Names beginning with these letters are common enough and so it is not surprising that we can discover several closer groups in the type, which in turn have no connection with vases bearing the unligatured versions, 9B and 23F, ii.

The vases cover a restricted chronological span but are from a range of provenances. This may encourage the idea of a very active exporter, Eu - -. However, before closely associating any two marks we should look for similarity in the shape, size and medium of the mark. In any close group there is usually a core of vases from a single workshop, and a wide spread of provenances cannot be shown to occur in any such group before the third quarter of the fifth century.

So the two glaze dipinti can be immediately set apart, and the division is confirmed by the shape and style of the vases together with the provenance of one of them. In sub-group ii, 3 is isolated by date and 4 by the size of the mark from the rest. The rest could perhaps be associated with each other, though the range of provenances is unusually large,

Similarly in sub-group iii there are superficial resemblances and distinctive features. The additional mark on 12 is of a different shape, probably a *theta,* giving the abbreviation Euth - -. It is also distinguished by shape and provenance from 10 and 11, on which the additional mark does not seem alphabetic; perhaps it is a countermark. We may note that such a mark accompanies 10B, 4 and 8E, 38 and 39, and it may not be without significance that a mark of type 8E is found on 11, though with the more regular 'double-tick' companion; perhaps the mark of type 5A is an alternative to one of the more normal accompanying marks of 8E. As the circle clearly goes with the 5A mark here it cannot be directly compared with those attached to the 8E mark on 8E, 38 and 39. Such an observation illuminates only the complexities of the relationship of type 8E with its companions.

Eut - - or Ent - - seems a suitable interpretation for the pair 13 and 14; they are close in all respects. One must doubt whether 15 is to be connected with them, but 16 and 17 may perhaps be. For further comment on them see on type 23E.

18 is probably a ligature of *epsilon* and *mu.*

Type 6A

It is not easy to judge from the details which I possess how closely the BF vases may belong together. In broad terms they are contemporary, and if the marks represent a single person the spread of provenances becomes particularly interesting. 1 and 2 suggest that the direction of the mark could vary at will.

An abbreviation of a personal name is the most obvious interpretation, but there are other words that could be considered, the one that comes immediately to mind is ἐπιθήματα, attested in a fifth century 'shopping-list' from the Athenian Agora (*Agora* xxi 10, B13). In the case of 6 the possibility of lids accompanying the batch of κάδια must be taken seriously (see further on type 12F); it is a moot point whether this could apply to the small neck-amphorae in sub-group i.

Type 7A

In the next type we find all the vases of one type by a single painter bearing the same mark; here is a pair of vases of different shapes, a small proportion of the work of the Lysippides painter whose works carry a variety of other marks.[1] The shape of the mark is so striking that there can be no doubt that the two are, or were closely connected in some way.

The mark should be Greek since we can only interpret one part of it as four-bar *sigma* or *beta,* the former rare, the latter unknown at this time in Etruria.[2] The other part of the ligature appears at first sight to be a four-bar *epsilon,* yet the bars are not all parallel, or even roughly parallel, as we would expect if this were a form of *epsilon*; see also on type 9A. No obvious alternative explanation is available, unless we think of Sel - - or Bel - -.

The pair must have formed a single order from the workshop of the Lysippides painter. Not knowing the provenance of 1 we cannot say whether this consignment was split on reaching Etruria, but this must be a strong

possibility. If they were not despatched together, the close similarity of the two suggests that they were at least inscribed consecutively.

Type 8A

This mark occurs without exception on the BF neck-amphorae of the Nikoxenos painter, and nowhere else, not even on other vases by the painter.[1] I state this making allowance for 13 which I have not seen, but which must clearly stand a good chance of being attributable to the same hand. A whole branch of one painter's (not potter's) production is being aimed at the export market. The EV is Greek, while the spread of provenances demonstrates that the vases were marked before being sent to their ultimate destination, at the latest in an Etruscan port.

The meaning of the mark is more difficult to fathom. First thoughts turn to a guarantee of quality equivalent to 'Al Lloyds'. On 4, 10, and probably 2 (I have not seen 1, 6 and 12) the second EV is separated from the rest of the mark, but this need not deter us from thinking of it as a single unit.

The double-dash punctuation of this kind appears on other vases from the Leagran workshop, always in connection with vase-names and numerals (see type 2F, vii). Is there a parallel here? EV does not promise as a vase-name, though it is possible that A stands for 'one', and the gaps on 2, 4 and 10 could have been left for a numeral notation to have been filled in. I am tempted to interpret the whole as 'a single vase for Eu - -', though far from satisfied that this is the only significance of the mark. The minimal size of the batches is the most worrying feature.

Type 9A

We seem to have here further examples of four-bar *epsilon,* but just as in type 7A, the top bar is never parallel with rest, 5 showing the discrepancy most clearly. I would conclude from 3 in particular that we have here a ligature of *tau* and *epsilon,* and further, judging from 7 that the *tau* appears to be Etruscan; certainly the ratio of the two constituent lines is most un-Greek.

3 is in a different hand from the heavy 5 and 7, and so they were not cut by a single individual, but as the possibility remains open that all the vases come from Tarquinia, it could well be that these are a single owner's mark.

Tarquinia 639, a neck-amphora of 540-530 has K and I on one side of the foot and a mark similar to this on the other; it differs in that the second bar from the bottom extends a long way to the left. Despite the discrepancy in date there must remain the possibility that the mark belongs to this type, in which case the other marks on the foot, being of Greek origin, are not to be taken closely with it. Another Tarquinia vase, RC5637, an oenochoe of 520-510, has a dipinto of type 3E, i, but with four bars to the *epsilon,* the lowest continuing across under the *rho;* perhaps it should be read the other way up as Tre - -.[1]

Type 10A

The looseness of this collection of marks is explained in part by the large number of names beginning He - -, though we may have expected to find more RF representatives. We cannot ascribe any of the marks to an Ionian hand in view of Ionic psilosis; on the other hand the closed *heta* of 3-6 does not suggest the Attic script of the later sixth century. Perhaps 3 is an owner's mark, since there is a good chance that the piece had a Greek-speaking provenance. Despite the orthograde direction of 4-6 there remains the possibility that the mark is Etruscan, where *heta* remains closed at this period.

There must have been a close connection between 5 and 6; if 4 belonged to the same close group, which is chronologically possible, the mark could not be an Etruscan owner's mark in view of the two provenances involved.

9 seems to have two isolated Greek marks, and yet has an Etruscan provenance. I treat this important problem of isolated marks above in Chapter 9. They should not be neglected for the more rewarding larger groups.

11 is another oddity with an apparent four-bar *epsilon* which I am unable fully to explain.[1]

Type 11A

The impermanence of red dipinti is nowhere as frustrating as here. Dipinti are common enough on vases by the Swing painter, but few survive in a fully recognisable form.[1] Naples 2792 (*ABV* 305, 10) certainly has an open *heta*, as the pieces here, but the other remains point rather to a mark of type 4D, i than the more complex mark here.

As all three marks are incomplete any interpretation remains hazardous. A *rho* seems vouchsafed, with the *heta,* but the additional lines defy interpretation. Therefore we cannot be sure whether the base is a *heta* or *eta.*

Type 12A

There is a possibility that the two marks may be connected despite the difference in medium. I have seen neither, but from facsimiles the reading would seem to be IH rather than the upturned HI, for which a larger range of possible interpretations would be open, most obviously the abbreviation of a personal name. If the correct reading is IH, we must consider seriously the possibility of it being an Ionic numeral for 18. No firm conclusion is possible.

Type 13A

We have here a very scattered collection of vases with little but the shape of the dipinto in common.

There are further sets of vases by the Painter of Louvre F6 in types 15A and 24A, those marks perhaps being Attic and Etruscan respectively. The most obvious explanation of the mark here is Ionic *lambda,* which would add a third nationality to the circle of the painter's business associates. Other explanations, however, are possible. 3 may be allied to 1 and 2, giving a glimpse of connections between trading routes to Campania and Magna Grecia in the early years of Attic expansion.[1]

5 - 6 present another possibility, this time numerical; see p. 30.

Glaze marks must of course have been applied before firing and so it would be of some interest to determine whether the mark on 4 represents an Attic or Ionic letter, or no letter at all. Glaze marks are rarely singletons, and it is possible that 4 is to be connected with the mark on the type B amphora by the same painter in the Guglielmi collection.[2]

Although 10 has no connection with the other vases in the type it is noticeable for being one of only two dipinti known to me on vases from Adria and Spina; they are also rare on pieces from Bologna.[3]

The glaze mark 9 may well be closely associable with similar graffito marks found on two other askoi of the mid-fifth century, London E723 and E725, from Rhodes (*BSA* 70 (1975) 159, 83 and 84). Other graffito examples of the mark are to be found on a range of BF and RF vases, none apparently connected with these dipinti.[4]

Type 14A

This abbreviation is not uncommon in Etruscan and so a number of these marks may be Etruscan.[1] However, it is difficult to isolate any that must be so; a probable case is 5 with its accompanying Etruscan signs. The accompanying *delta* on 12, if it is a letter, cannot be Etruscan. For the rest no clear decision can be made; the shape of the *alphas* helps little.

The relatively early date of 7-11 makes their retrograde direction a less persuasive indication of Etruscan origin. Pairs of vases with the same mark are no rarity in the Lydan workshop; some of the marks appear to be Greek, others could be Etruscan. The possibility that the other pair here, 2 and 3, came from the same tomb (no direct evidence) makes it more likely that their mark is Etruscan.

Without a transcription of 11 I would not be ready to guess at its significance; maybe the second letter is *upsilon* or the strokes are not close to the rest of the mark.

Type 15A

Again the problem of distinguishing Greek from Etruscan and in the same Lydan ambience. The fact that the majority of the marks are orthograde points to a Greek origin. If we could be sure that all the marks on the vases from the Lydan workshop referred to the same person, despite the variations involved, an Etruscan origin would be ruled out by the appearance of an Ionic *lambda* on 9. But it would be rash to make that equation; 9 may well be Greek, but there is no necessary connection with the dipinti 1-4.[1]

The accompanying marks on 5 and 9 are not easy to explain; that on 5 I discuss on p. 6 and conclude that it may be a mercantile mark incised on the body. Therefore the most economical explanation of the type 15A mark is that it is the abbreviation of its Etruscan owner's name (especially as it is retrograde). The graffito on 9 is inscrutable; if it is a Greek *mu* an explanation of why the vase bears two Greek marks and has a presumed Etruscan provenance is needed.

Type 16A

We have seen several marks based on an *alpha* with an added tick. This type and 6E present us with a *pi* and an additional stroke. Sub-groups can be isolated and it is pleasing to note that for each variety of the mark there is a core of related vases.

The Antimenean core of sub-group i has only emerged from recent finds and publications, but once established it has become possible to ignore the minor differences between 1-13 and think of them all as representing the same idea. The differences do tell us, however, how to interpret the mark; in all these marks the final stroke of the *pi* is long, usually as long as the first, but while it is vertical on some, on others it is more aslant, a shift that could only arise under the influence of the additional stroke. This strongly suggests a ligature of *pi* and *upsilon,* which will be Greek in view of the shape of the *pi.*

14 is not far different and the abbreviation may be the same. On 18 the third stroke of the *pi* is short enough to distinguish it from 1-14.

The basic *pi* element in sub-group iii cannot be doubted either. It is a later group with a Leagran core. However, unless one thinks of Pl - - with an Attic *lambda,* there is no obvious explanation of it as a ligature. There seems no connection with the Leagran type 24E, and it is also difficult to associate it with 6E in view of the lack of 6E's faithful companion, 5E. The additional stroke could be a form of countermark, as it seems to be in type 6E, or possibly we have a not very elegant ligature of *upsilon* and *pi,* presumably psilotic, therefore Ionian Hyp - -.

19 would seem to link up our type with 6E, introducing the countermark while retaining the 'upsilon' stroke. One cannot tell how far this is a real rather than apparent connection.

25 has a mark of the same shape as those in sub-group iii, but the added *koppa* is of some interest; there is no reason to think of it as an Ionic numeral, and it would be most unusual in an Athenian inscription of this period. More plausibly, it is a local Tarentine letter, in which case it is not without significance for the history of the Tarentine script.[1]

The numerals with 20 do not reflect the usage of the main sub-groups.

Type 17A

These marks appear to be regular commercial types with a good measure of painter grouping. *Pi-rho* and *pi-omicron* sub-groups are largely distinct, but one vase related to Group E, 4, does have *pi-rho* in contrast to the other Group E representatives here. It is difficult to assess the bearing this may have on the date of the horse-head amphorae 1-3; if they had the *pi-omicron* dipinto they would certainly be placed in the 540s, but with only a single comparandum the relationship is not so tight.[1]

18 illustrates the difficult position of isolated marks. It has no close companions, and though parallels may come to light, one has to explain the presence of these single, obviously Greek marks on vases found at Etruscan sites.

Type 18A

I assume that this mark is the abbreviation of a personal name, since no single word beginning with these letters seems to fit the context and it seems unlikely that the mark is to be split into constituent parts. It is tempting to look towards Samos and a Rhoikos, probably a later one than those known from the Heraion and Naukratis.[1]

The vases could be contemporary but they have no close stylistic connection.

Type 19A

Hackl mistakenly saw in 2 the full version of type 20A (see below). 3 probably has nothing to do with the others; it has every appearance of a Greek, possibly Athenian owner's mark, but as the provenance of the vase is unknown we cannot press any argument concerning its ancient history.

1 and 2 are likely to be connected, and I see no reason why this Simon should not have been a trader, as other individuals who used abbreviated marks. The name is of course common. I have noted that 1 presents the only letter in glaze dipinto marks which it is not easy to interpret as Attic, namely the Λ of the accompanying ΛAB;[1] we may prefer to take it as an Attic *gamma* rather than seek a script which used Λ *lambda* with three-bar *sigma* and O for the long vowel.

Type 20A

I stress the unity of this large group in the catalogue; the mark assumes a variety of forms and only a few of the most fragmented examples are doubtful members of the type.

Only four of the vases have further marks on the foot, 11, 16 (probably a repetition of the mark, dipinto), 19 (a numeral) and 28 (traces of a dipinto). Smi - - clearly had a simple marketing method.

Hackl (p. 105) suggested that this person was Simon, arguing from 19A, 1. Yet although that vase is contemporary with many in this type and the script may well be the same, I do not see how SIMON could become the clear SMI abbreviation of sub-group i. This objection I feel is insuperable, despite the single SIM, 84. Our man must be a Smikythos or Smikros (the vase-painter would be an outside candidate). The range of dates is wide from c. 540 to c. 510, but not excessive for the career of one man.

The core of the group is Antimenean. Twenty-six of the vases are from his workshop, and of those from the hand of the painter himself there are examples from early and late in his career.[1] In addition there are five Lysippidean pieces and one by Psiax. All five vases attributed in *ABV* and *Paralipomena* to the Painter of Cambridge 51 bear the mark, and it appears on the works of a number of other painters of the period 530-510. Although this period includes the early work of the Leagran school, there are no Leagran vases which definitely have the mark.

The shapes represented are typical of marked BF vases: the majority are neck-amphorae, there are thirteen hydriai, seven other amphorae, two oenochoai and a calyx-krater. The provenances are spread through Etruria, but not beyond, with the less important centres, ceramically speaking, represented by Bomarzo and Toscanella.

The script is not very diagnostic, but is most likely Attic. The three-bar *sigma* makes an Ionic origin at any rate most unlikely.[2]

Type 21A

I have treated this mark fully elsewhere and so merely summarize my argument here and treat some further points arising from it.[1]

Starting from 62, I posited that its accompanying letters, ΛA, are an abbreviation of λάκυθος or the like, and that the mark could well be in Aeginetan script. An Aeginetan ϟο points towards the Sostratos whose wealth from trading is recounted by Herodotos and whose inscribed votive anchor-stock has been found at Gravisca, the port of Tarquinia.[2]

There are very many Greek names beginning Σο or Σω, and I cannot feel confident that our abbreviation in this type (disregarding the final entries 100-104) represent a single individual. The most intractable piece is 26, which one can only place with the greatest generosity marginally before 500, and is probably to be put up to ten years later. Without it, the group can be accommodated within the period 535-505, a span similar to that of the

previous type, to which indeed this type is closely analogous. Previously I considered 28 to be an early outsider, but on reflection it is 30 which causes more concern. Mommsen has quite rightly placed it among the early works of the Affecter, in contrast to the other pieces in sub-group v which belong to his middle period;[3] she is also right in being cautious in dating the Affecter's early work, but I would not find a date in the mid-530s, even if before rather than after 535, impossible.[4] In any case 30 does stand out in its sub-group and it may be that it did not leave Athens immediately after manufacture.[5]

The type is unique in having dipinti in all four (?) substances known to have been used, red, glaze (an unusually large number), matt black and a presumably accidental 'added red', when the marker dipped his brush into the wrong pot. The glaze dipinti involve the Antimenean workshop and the Perizoma group, a large number of whose vases are so marked; the two workshops are probably chronologically distinct, but there must be a good chance that the same ϟο is intended throughout. The Antimenean dipinti here tie up with the Antimenean core among the graffiti of sub-groups vii and ix. Unlike type 20A these sub-groups also include a few Leagran pieces, suggesting that, if sub-group ix is unitary, the career of Sostratos lasted marginally longer than that of Smi - - .

I repeat here the point that the glaze dipinti were presumably applied by a person using Attic script, in contrast to the Aeginetan hand of the graffito 62, but that nonetheless there is no reason why all the marks should not refer to a single individual.

The mark is accompanied on a slightly higher percentage of vases than 20A, but as I noted in *PdP* l.c. there is no sure clue to the third letter of the abbreviation. In particular, it seems that the *phi,* said to accompany 35 in an earlier publication, does not exist.

It must be doubted whether there is any connection between 95, from Sicily and the rest of the type; there is no way of determining whether it may represent a dealer So - - - trading with Sicily or whether it is a local owner's mark. The same is to be said of 100; one suspects that the three-bar *sigma* is a false reading on a vase of the advanced fourth century.

If the reported provenance of 102 is correct it is one of the rare large figured vases from Greece with abbreviated graffiti (see subsidiary list 3). Neither epigraphically nor ceramically does it relate to the rest of the type. What is unusual is the use of four-bar *sigma,* which was not in general use in private inscriptions in Athens at the date of manufacture of the vase.[6]

101 and 104 are both associated with numerals, though there can be no further association between them. If the mark on 101 is contemporary with the manufacture of the vase, the 'arrow' *delta* becomes one of the earliest known to us (see p. 29). The interpretation is difficult; I would take the *delta* as numerical, but leave the rest unexplained.

The reading of 104 is clear; eighteen objects refer in some way to so - - (for a discussion of the numerical signs see p. 29ff). What the so - - refers to is a more difficult question. We find numerals under owl skyphoi elsewhere, once with a clear reference to $\gamma\lambda\alpha\hat{\upsilon}(\kappa\epsilon\varsigma)$ (25F, 1) but there is no way in which ΣO can be supplemented to give a suitable vase-name or adjective.[7] We must leave open the question whether reference to such a word or to a person was intended.

Type 22A

There can be little doubt that an Ionian hand inscribed 1-4 at least. The vases are perhaps contemporary with, or a little earlier than the earliest members of type 21A, although they come from a different workshop from those patronised by Sostratos. In theory it could be possible for this Ionic mark to represent Sostratos also, e.g. written by an Ionian trained slave in his employ, but I would prefer to keep the two types distinct and posit a second, Ionian, $\Sigma\omega$. . here. Another possibly Ionian trader associated with the Swing painter appeared in type 11A.

5 and 6 can scarcely refer to the same person, but whether they are connected one with the other remains a moot point.

Type 23A

The closeness of the vases in this type is immediately apparent, all are from the Affecter's middle period, yet it is far more difficult to interpret the mark. On 2 only the ends of the horizontal of the first sign are cut and on 3 it is omitted altogether; it would seem that the angle between foot and navel substituted for it. This suggests that the sign is not alphabetic (*omega* being the only possibility) despite being intimately connected with an obvious four-bar *sigma*; moreover,'$\Omega\sigma$ or '$\Omega\sigma$ is a virtually impossible beginning for a personal name. We may salvage a little by stressing the relatively frequent occurrence of tick-shapes marks and other non-alphabetic marks among commercial graffiti, and since all the vases are amphorae there remains the possibility that the Σ could stand for $\sigma\tau\acute{\alpha}\mu\nu\sigma\varsigma$ (see on type 19F).[1]

Type 24A

Here we have another small group of Lydan vases with a mark that may be Greek or Etruscan. I suggest in type 13A that this mark may be Etruscan, but that view is based solely on the thought that on 3 and 5 the head of the *tau* is canted in the Etruscan manner, which is scarcely watertight evidence for an attribution. If it is Etruscan we should probably rule out an explanation as an owner's mark in view of the two provenances involved.

For the graffito on 4 see on type 17C.

Type 25A

Disregarding the rather different 10, we have another close group of vases, rooted firmly in Group E. However, once again interpretation of the mark is difficult; it would seem that the first sign is a *upsilon* since it occurs both with and without a stem, yet the second sign corresponds to no sign in regular use in any Greek or Etruscan alphabet.[1] We may then regard it as a non-alphabetic sign, akin perhaps to the regular tick-shaped companion of type 8E (although shorter in the stem), or think of it as a letter with an additional stroke - most likely a retrograde Etruscan or Attic *lambda*. The second solution is perhaps a little clumsy, but one would expect a second letter to go with the plain *upsilon*.

Type 26A

This is a highly individual mark, yet it appears on a selection of vases which are roughly contemporary but have no other obvious connection with each other. It may serve as a reminder that marks are not necessarily the prerogative of a single workshop.

Three other marks employ the same formula of inserting letters into the angle of a large cross: Louvre F235 (7D, 21) with *sigma iota* in the top quadrant, Louvre Cp10642, type B amphora of c. 540 with the mark dipinto and an *alpha* in the lower quadrant, and ex Forman 295, a neck-amphora not since traced, with EI involved in the cross.[1]

An interpretation as the abbreviation of personal names seems best. Each name would have begun with a *chi* and the other letters will have followed. In type 26A the first letter seems to have been repeated, giving us a Ξε - - , while the other marks are of Ξι, Χα - - and Χει - - respectively. An Attic hand is indicated here and on Louvre F235 by the three-bar *sigma*, as well as by the use of χϟ for *xi*. Such a distinctive monogram was probably cut by Ξε - - himself.

Type 27A

Again one must have reservations about whether this clearly unitary mark is wholly alphabetic. An abbreviation of χϟι, partly ligatured, could be envisaged, although such a ligature is awkward; if it is acceptable it would seem to be another Attic mark. The Antimenean content is notable. Except in the case of 1 the upper part of the second sign consists of straight lines, not a loop, which serves to distinguish it from the similar sign in type 3E, ii; in that type I argue that a tailed *rho* is involved in the ligature, but here the possibility can scarcely be entertained in view of the retrograde direction (which would not allow the plausible abbreviation χρ-) and the consequent intractable collocation of letters.

Type 28A

This is another small, closely knit group with a strong Antimenean flavour. I have not been able to determine satisfactorily which way up it should be read; as I give it, it is akin to the previous type, but if turned the other way up type 34A also comes to mind. In the former case we could consider the whole a ligature of χϟι, though the *chi* is a little elusive in the ligature and as in type 27A we have one rounded loop, on 4. In the latter case, one might start to consider 'red' *chi* as part of a ligature, but even this is overspeculative.

Type 29A

I believe that this mark involves an *omega*, whatever the significance of the vertical stroke, and therefore must be Ionic.[1]

The mark strengthens the chronological link between the vases, though they come from various workshops, from which our Ionian seems to have made his choice. I have discussed 3 under type 12A; if its second mark is an abbreviated personal name we have to explain how this *omega* mark fits in as well.

Basel BS455 (s.l. 1, 36) may belong to this same commercial group.

Type 30A

It is probable that this mark embodies some pictographic idea, but its meaning must remain obscure. I have not seen 4 but the other vases seem reasonably contemporary.

Type 31A

The vases in this type also are chronologically close, as far as I have ascertained, but the provenances remarkably spread. As 4 is on the navel I am loth to connect it closely with the rest, but there remains a good chance that 1 and 2 are to be taken together; if so, this would constitute a second example of vases with similar marks found at Orvieto and Bologna, for which see p. 13.

Type 32A

There is a strong possibility that many of the marks in this type are of Etruscan origin. While it is difficult to prove this in the case of the simple asterisk, which may be considered, together with the simple cross, as one of the

most obvious non-alphabetic marks that could occur to the mind of an inscriber (and appears here on one vase with a Greek provenance), the appearance of the several constituent parts of these marks on Etruscan vases, including 10 here, and the general ductus of the marks goes some way to support the argument.

The asterisk and 'red' *chi* are commonly found on Etruscan vases;[1] I can offer no suggestion as to their interpretation when they occur together, as in sub-group ii, or of the *chi* accompanied by other marks in sub-groups iii and iv. Of sub-group iv I have only seen 19, and the accompanying mark bears only a superficial resemblance to a *digamma*.[2]

Close workshop grouping seems confined to sub-groups iii and v; this in itself may be taken as an argument against the interpretation of the marks as regular Greek commercial graffiti. The grouping of the vases in sub-group iii appears more interesting, but the connection between the two Antimenean and the two Leagran vases is weakened by the uncertainties of the readings, and we cannot say much about 16 and 17, though their decoration as described seems Antimenean.[3] One of each of the two pairs of stamnoi has one or two crosses in addition. As Vulci is the only known provenance here the mark could be that of an Etruscan owner just as much as of a trader.

21 and 22 are presumably owner's marks, the form of *chi* being Geloan. A possible, though hardly preferable interpretation would be as *psi*. The pieces could have some bearing on the date of the introduction of the 'blue' script to Gela.[4]

Type 33A

This type is composed of distinct sub-groups. It is not clear whether sub-group i itself is unitary. The dipinti are all large with the circle on the navel and the hook running on to the foot proper; the graffiti are all small. However, there are two considerations which suggest that we may ignore this difference: first, it is natural that dipinti should be larger than corresponding graffiti, and secondly a link between the two is afforded by the Lydan and Group E affinities that appear in each section.

To the dipinti here must be added those on other members of type 1E, (1, 5 and 10). There the dipinto consists of the hook with only the arc of a circle, not, I would say, part of a now worn whole circle. The mark also appears to be later than, and certainly on 3 in a different shade of red from the dipinto of type 1E. Any interpretation of sub-group i must take cognizance of this abbreviated form, which would rule out any alphabetic interpretation of the mark. The repetition of the mark on 6 - 9 supports a non-alphabetic interpretation; alphabetic marks are occasionally repeated, but rarely so regularly and never thrice. 8-9 may suggest that this is a mark used to ensure that lid and vase were kept together during transit.[1] I would hesitate to go further and think of the mark as a pictogram for a lid. The spread of provenance suggests that it is a Greek rather than Etruscan mark.

As I have not seen 12 and 13 I can say little about sub-group ii. The practice of placing the same mark dipinto and graffito on a vase was more widespread than Hackl recognised.[2] Such double marks occur most often in the period c. 530-510 when red dipinti were going out of fashion; graffiti or glaze marks were more permanent and could be written smaller - on smaller vases or in longer texts.

Sub-groups iii and vi contain pairs of related vases, but I can offer no convincing interpretations of the marks.[3] The vases in sub-group v may be connected and it is possible that the mark is a ligature of *omicron* with four-bar *sigma* or *mu*.[4] 16 and 20 may have a ligature of *omicron* with three-bar *sigma*; if so, they do not relate to type 21A, where Leagran representation is thin and which did not last down to the date of 20. The other marks of sub-group iv show no unity.

Type 34A

As can be seen from fig. 3 there are minor differences between the marks on these vases, but as there is no other mark resembling it I hazard that they are to be taken closely together.

The direction of the mark must be as I give it in fig. 3, since two of the verticals of 2 seem to have been unintentionally continued downwards; it would be most exceptional for them to have been so extended upwards. Otherwise, the loop in the mark would have suggested a ligature involving *rho,* although the shape of the loop on 1 would not be readily suggestive of a *rho*. If the mark is non-alphabetic it is unusually asymmetrical; the majority of non-alphabetic marks are at least symmetrical, even if inscrutable (37A being an exception).

The vases are not contemporary, and I doubt if they were inscribed by a single individual.

Type 35A

While I cannot solve the question of the workshop of 1 and 2, we may at least note that the more angular form of mark, found on 1, also appears on several nearly contemporary East Greek vases (see p. 236). On all four vases the mark is well preserved and the reading assured. Unless 1 and 2 come from a very backward workshop they should date from a noticeably earlier period than the other pair.

Type 36A

1 and 2 clearly belong together, but the position of 3 and 4 is not as easy to assess; 3 is contemporary, but the mark is slightly different, and the date of 4 cannot be closely ascertained.

The shape is similar to type 35A, but closer to a mark that appears on a number of East Greek vases (above). It is not impossible that the same trader marked Attic and non-Attic vases.

The most obvious interpretation is that the mark is the representation of an anchor, with stock and tines, such as we see on many vases as shield blazons.[2] We may surmise that such a mark came from the head of a seafarer, not a potter. Some other types of mark which might be thought to be related to this (2E, via the connection with Group E, 11E which could be considered a tidied up version of 36A) in no way recall an anchor and such associations may be discounted.

Type 37A

This mark is distinctive in being the only graffito type which extends over the whole foot of the vase. Its unity cannot be doubted, despite minor variations from piece to piece, the most striking being 8. No alphabetic explanation is plausible. As with type 33A there is a possibility, judging from 10, that the mark was used to ensure the pairing of vase and lid. We can scarcely suppose that all the pieces came from a single tomb at Tarquinia and therefore can reasonably rule out an explanation as an Etruscan owner's mark; also it is likely that 8 was found at Vulci.

Type 38A

There is some similarity between this and the last type, but the difference in size is immediately striking, and even in the case of 4 the shape of the mark is noticeably different. We have not entirely left Antimenean soil.

As for interpretation, there is little more to be said than for 37A; most unlikely to be alphabetic, but not a particularly obvious non-alphabetic sign.

Type 39A

Little more can be said of this type. 1-3 are clearly very closely connected, and the curvilinear motif suits the dipinto medium well. It is striking that such a distinctive mark should appear again, much later and in graffito form; since RF lekythoi are rarely found in Etruria we may consider 4 at least to be a Greek mark.

Type 40A

This is yet another non-alphabetic mark from the apparent heyday of such usages in the last quarter of the sixth century. It is of a satisfactorily pleasing shape. The significance may be the same on both vases; if so, in view of the one Campanian and the one probable Etruscan provenance, the mark is again likely to be Greek.

Type 41A

Both marks seem fully preserved and the vases could perhaps be related or at least taken together, but no interpretation of the mark is possible.

SECTION B

Type 1B

Most of the types in section B comprise vases covering a wide time range, from 550 to 450 or later. We cannot therefore regard the alphabetic marks among them as being the abbreviations of a single person's name. Not unnaturally, these abbreviations could stand for a large number of names; perhaps the available range for type 1B is more restricted than in other cases, and it is therefore instructive to note that most of the vases in sub-group i could have been made within the possible working career of one merchant.

Little can be said about 1, 9, 10 and 16 without having further details of the marks and vases. Of the rest, 3-5 clearly form a close group, and if we compare type 9E we may be tempted to associate 11-13 with this core, despite the earlier date of the RF vases; in type 9E we have glaze dipinti on Leagran vases and graffiti on bilinguals of the Andokides painter, together with a piece by Smikros. However, it is likely that a major group within type 9E originated in the Lysippidean workshop and the glaze dipinti are not necessarily connected with the Lysippidean graffiti. Here only 2 affords any sort of stylistic link between the RF and Leagran vases.[1]

1, 7 and 8 are unlikely to be connected with these two groups. I have noted the Centuripe skyphos elsewhere;[2] the shape of the mark is not as in the rest of the sub-group. We should note the early acrophonic numerals (also on 8) and in particular the early drachma sign; I cannot accept the published description of this latter mark as pre-firing. A price seems to be quoted of one drachma for five pieces (? a litra each) which is not altogether inconsistent with what other early prices we have (see p. 33) but cannot be taken as a certain interpretation.

The shape of both the vases and the mark isolates sub-group ii from the rest of the type. Since the vases are from separate tombs, it is unlikely that the mark is that of a single owner at Spina.[3] If it is a commercial mark the presence of a *kappa* points to a Greek origin, although the letter was used in the North Italian scripts; at any rate, the shape of the *alpha* does not indicate an Attic hand.

Sub-group iii consists of another close pair; it is accompanied by a variety of the additional hook or tick such as is seen with types 25A and 11E.

The retrograde examples in sub-group iv have no apparent connection with the rest. 23 may well be a local owner's mark; 24 is rather hastily cut, but does seem to be a ligature of *alpha* and *kappa* and therefore a Greek, not a local Etruscan mark.

Type 2B

As is clear from the catalogue, there are a number of abbreviations here, each of which could represent a large range of names; hence the diversity of the type.

We can still isolate a number of close groups, most notably the set of vases by the Birth of Athena painter. Glaze marks are rare on RF vases (see s.l. 2) and there is certainly no other group such as this; the red dipinto, 2, is on a vase connected with 3 by shape (Philippaki 44-5) and it is possible that the graffito 9 is a slightly later member of the same group, though 10 can scarcely belong. The script and spread of provenances indicates a Greek origin for the mark, while its interpretation may be *alpha* and Ionic *lambda* or, perhaps better, *alpha* and *mu.*

13-15 seem to form a close group within sub-group iii; 12 has a different mark, perhaps an abbreviation of *tau, alpha* and Ionic *lambda* in some order. The adjunct at the top of the mark on 13-15 suggests a *theta*, giving either 'Aλθ . . or Θaλ .; if the former, 16 could be linked with them. Philippaki (49-50) has noted the similarity of potting of 14 and 15, which are also linked by their 'price' graffiti, for which see p. 34.

The rest are a very mixed bag. I can point to no connected groups save the Adria cups and the pair of neck-amphorae from Gela, 44 and 45; even here it is likely that the marks are those of owners rather than merchants. The Polygnotan members of sub-group iv may also belong together. Otherwise there is a very wide range of provenances, vase shapes and dates. A number of the vases were found in Greek-speaking areas and could very well have local owners' inscriptions. 23 gives an idea of what the full name of one of these owners may have been.

40 and 41 are probably Etruscan marks, 40 with *al* and another letter, 41 with *la* and perhaps *an.*

Type 3B

Again a motley collection of marks and vases, although 4 and 5 must have been a close pair, related not only by their shape and this ligature but also by the further vase-name graffiti.

The shape of the *pi* is always Greek rather than Etruscan.

Naukratis i 559 (London 1910.2-22.165) should also be mentioned; it is from a large, probably Attic open vase and has the simple ligature.

Type 4B

1-7 form a definite sub-group, with 7 affording a good example of a red dipinto having the same meaning as glaze marks. Not many small neck-amphorae have marks (p. 36) and this group is the largest among them. If we assume that it is the abbreviation of a personal name, the range of possible supplements is small. It must be strongly suspected that 6 belongs to a further neck-amphora by the Red-line painter. The letters appear fully Greek, as is confirmed by their pre-firing application.

The marks on 9 and 14 are similar, presumably a ligature of ANT.

10-13 and 15 are more likely to be Etruscan owners' marks, which are frequently found on RF cups elsewhere (as are Greek owners' marks on glazed cups from Greece); the lettering bears no sure Etruscan characteristics, apart from the crossbar of the *alpha* on 11, but commercial marks are rarely found on any type of cup.

Type 5B

This sign is unusual enough to suggest an immediate link between the two intact vases, although one must not overlook the additional lines on 1. The vases of Smikros carry a variety of marks which also appear on BF pieces. In type 1B a possible link between him and the Leagros workshop was mooted; Smikros worked a little earlier than the period of full production in that workshop, but there must have been some chronological overlap between the two. This type adds a little to the evidence for commercial links also.[1]

Type 6B

While little can be gained from considering possible interpretations of this simple mark, it is satisfactory to note that it embraces one close group, comprising all the vases attributed to the Zurich painter. The lack of accompanying marks and the position on the navel serve to set them apart from the other dipinti, which are in any case later.[1]

6 remains enigmatic; the additional mark in dipinto and graffito cannot be easily explained. It resembles a drachma sign, but such an explanation would raise serious problems at this date (see on type 26F, p. 233). Superimposing the two parts one would obtain a sign of type 5E, but again the chronological gap yawns, and in any case the interpretation of type 5E would be made no easier.[2]

Sub-group iii forms a close group within a larger close group, 3E, iv; I have no satisfactory explanation why the vases should bear these two marks. It could be that 14-16 or at least 15 and 16 are to be connected with them, and the proximity of the numerals to the *beta* on 15 further suggests that the letter may stand for something other than a personal name; the three strokes may indicate a price of three obols. *Beta* is the only possible reading since the loops are rounded in the majority of cases, ruling out a ligature of *sigma* and *iota,* as in type 7D. Sub-group iv presumably comprises regular abbreviations, while 14 has a more complex ligature.

Type 7B

This is a very mixed set of pieces, as type 3B, and like that type consists of Greek marks, here because of the *delta.* It is possible that 5-7 are to be connected, as well as 10 and 11. The ligature is used at Athens to mark state property, but normally more obviously than in the case of these discreet underfoot marks.[1] I think it most unlikely that any of these pieces were smuggled out of a state reception wrapped in somebody's himation. There were plenty of citizens eligible to use the abbreviation on their own account.

I am tempted to interpret the additional mark on 6 as 'five for two drachmai and three obols' i.e. three obols each.[2] For the numerals on 9 see n. 7 on p. 240.

Type 8B

This mark seems surprisingly rare in view of the number of people whose names began with these two letters. By contrast it may appear that ΙΔ is rather frequent, a far rarer beginning for personal names; yet it is possible that 1-3 all refer to a single person, and in any case the mark may be retrograde (or even an Ionic numeral). ΔΙ may also be an acrophonic numeral and in many cases (at least in the fifth century) alphabetic and numerical usages cannot be readily distinguished. When the mark occurs entirely alone an alphabetic interpretation may be preferable; this is probably so on the two lekanides, 13 and 14; without knowing their provenance we cannot be sure whether it is an owner's or merchant's mark. 9 - 11 could form another close group.

Much more likely to be numerical is another mark that deserves a mention here, on Harrow 50, col-kr by the Cleveland painter (*ARV* 516, 5) from Vitorchiano. The mark is as given in *JHS* 17 (1897) 295, Δ┤Ι Δ(I do not think the first two signs join) and would seem to quote a price.

Type 9B

Names in Eu - - are common indeed and it is no surprise to find a wide range of vases in this type. The mark must be Greek, but the letters allow no further diagnosis; the strokes of the *epsilon* gradually become four-square and the *upsilon* changes from tailless to stemmed.

There are two obvious close groups, sub-groups ii and iii, which are abbreviations of names in Εὐσ - and Εὐξ - - respectively. Further varieties are afforded by 25, whose Ionic *gamma* could perhaps have been cut by an Athenian c.470, perhaps even at Spina, and 29.

Sub-group i consists largely of vases of two different periods; 2 is a little earlier than the other BF vases with graffiti, which are chronologically close enough to have been cut by one man, though the vases have no obvious workshop connections. Among the RF pieces 10 and 11 go together and can take 16 with them, since the Harrow painter has commercial connections with the Kleophrades painter elsewhere (see types 13B and 14B). 14 and 15 have a workshop connection and are roughly contemporary with 10, 11 and 16, but skyphoi, as 14, do not commonly have commercial graffiti; its provenance might allow a local Greek owner's inscription.

Type 10B

Apart from the pieces from Adria this type too is loosely constructed. The sign is presumably an abbreviation of *heta* and *alpha,* in a non-Ionic dialect; the form of *alpha* with cross-bar sloping up to the right is not common in Athens, but is in a sense partly necessitated by the canting of the whole *alpha* over to the left.

The additional small circle on 4 may suggest a connection with 8E, 38 and 39, and an interpretation of that mark as HA, but the chronological gap between the vases can scarcely sustain the argument. 4 may rather belong with 2 and 3, which are closely related, and perhaps 1 as well. 6 also has a perplexing accompanying mark, but it is in the same hand as the main mark.[1]

The number of vases from Adria with this mark and the inconsistency of its direction (retrograde examples at least in part later than orthograde) suggests that they were inscribed by several people, whether owners or not. I would incline to the opinion that they are commercial marks; 12 and 16 could be connected with them, as far as the chronological evidence suggests.[2]

Type 11B

This mark resembles a ligature of open *heta* and *epsilon,* but the possibility can only be entertained in sub-groups iv and v. In groups i and ii the mark must be read horizontally and the varying length of the constituent lines on some pieces also militates against the alphabetic interpretation.

Sub-group i is an obvious close group; moreover, all the pieces are from the Affecter's early and middle periods.[1] The inclusion of a lid, 6, once more prompts the thought that a, if not the only purpose of this particular mark was to keep vase and lid together.

The marks of sub-groups ii and iii vary in shape; 7 and 8 should belong together, despite the lack of an upper horizontal on 8. There is no clear connection with the Affecter's vases.

Among the 'upright' versions of the mark sub-group vi is a close group indeed; the shortness of the leftmost stroke must rule out the possibility that it is part of a *heta* in ligature. 18 has a similar mark, but the added 'comma' is lacking and there seem to be no other factors connecting it with 23 and 24. The initial vertical of 17 is also not of full length.

Type 12B

Most striking here is the late fifth century RF group. At this date crossed *theta* was no longer in use as a letter in Etruria or the Greek world, except parts of the Peloponnese with which we can hardly be concerned here; therefore the sign on 8-11 and Vienna 732, if Beazley's surmise is correct, must have a symbolic, not alphabetic meaning. We should note that the vase-name graffiti which appear on some of these and other vases by the same painters use dotted *theta.*

Even among the earliest marks of the type an Etruscan explanation can be ruled out.[1] The accompanying marks in the basically Leagran sub-group ii vary in shape, near a drachma sign on 12, a small *upsilon* on 14, and an Etruscan *tau* on 16 and 17; as the pieces must be associated, none of these individual explanations can be accepted. Again, we must have some form of countermark as I have suggested for a number of other types. The very neatness of the added mark on 18 sets it off from the rest.

In sub-group i, 5 and 6 may belong together, but 1a and 4 are somewhat apart in date (see *BSA* l.c.). The very rarity of isolated dotted *thetas* elsewhere underlines the difference, in sub-group iii, between the range of marks found on vases from Adria and those with Etruscan or South Italian provenances - whether the marks be personal or commercial.

Type 13B

This and the following type demonstrate that however simple an abbreviation may be we can still isolate close groups of commercial marks from the residue by concentrating on workshop relationships.[1] It should still be noted,

however, that there does remain a residue which cannot be pigeon-holed in any such satisfactory manner.

Here the provenances of the close groups are more varied than usual. The shape of the letter precludes an Etruscan origin and therefore 1 and 2 must have some commercial significance, while the script of the accompanying vase-name graffiti on 5 and 6 is not Geloan, again suggesting that our single letter is not a local owner's mark.[2] It is perhaps not beyond question that the same M - - is referred to in sub-groups i and ii.

It is not easy to decide whether any of the pieces in sub-group v are to be connected with the other sub-groups, or with each other. 20, 21 and 23 - 25 must have been made within a few years of each other; in addition we may bear in mind a further vase by the Tyszkiewicz painter, one by the Harrow painter and two by the Matsch painter which have only traces of dipinti (s.l. 2, 5, 8, 9 and 12), which could possibly have been this mark. Though solid evidence is lacking it is possible that a single M - - may have been responsible for the marketing of a number of vases by these three painters, who otherwise have no particularly close connections. If we were to include 21 here we would add yet another facet to the already many-sided character of the Painter of the Yale lekythos, as depicted by Philippaki 150-151.

For the accompanying marks on 28 see p. 29.

There seems to be a strong case for taking 30-32 together, even if the shape of the mark is slightly different on 31; provenance, probable contemporaneity and the size of the mark on 30 and 31 point to such a conclusion. Interpretation is not easy, nor a decision between commercial or owner's mark.

Type 14B

This type resembles the previous one, although the number of isolated marks is more restricted. While an Etruscan origin is not ruled out by mere letter shape, as in the previous type, none of the marks is as exaggeratedly archaic as the typical Etruscan *nu* of the relevant date.

The closest groups are ii and vi, but there is a strong likelihood that the bulk of sub-group i also refers to a single N - -; the Lydan core is noteworthy. A further sub-group may be found in 16, 17 and perhaps 19.

22 is a low elongated mark, and I felt that it belonged to this type rather than being a worn *mu, pace* Beazley. On the other hand, Beazley's reading of 23 is a very archaic *nu,* which could well have originally been a *mu.* As both painters are represented among the dipinti of type 13B, it is tempting to suggest a unitary reading for all the pieces by the Kleophrades, Matsch, Harrow and Tyszkiewicz painters here.

Type 15B

This is a very heterogeneous collection of vases. NI in vase-painting circles immediately suggests the workshop owner Nikosthenes, but there is no sign of his work here. Moreover, there are no two vases which one could single out and say were connected in any obvious way; even the noticeable number of early BF pieces are spread over a good period and there are no workshop links; they are no prerequisite of mercantile groups, but in the majority of cases they do occur.

There are a number of Greek-speaking provenances which would allow some of the marks to be those of local owners, but there still remains a large residue of vases.[1] There may be some mercantile significance to the mark on the later sixth century lekythoi.

The companion piece of 17, Würzburg 352, has the same accompanying mark, but no mark of our type, indicating that the NI or IN is in *some* way secondary on 17.[2]

Type 16B

1 and 2 add to our evidence for groups, albeit small ones, of glaze marks. The two vases should be closely contemporary. 3 - 15 are a mixed bag, as might be expected with such a mark; yet all of them must have some significance, since the letter is not Etruscan and those vases with an Etruscan provenance must have been purposely marked before reaching their final destination.

16 and 17 are clearly a pair, and the mark probably commercial. This must also be the case with the Polygnotan vases 18-21, 27-28 and 32-33, together with 25, 26 and 31 of about the same period. Beazley has suggested the interpretation ποικίλος for 25-6, which would plausibly connect sub-groups iii and iv on the interpretation I give in type 20F for the latter.[1] I would extend this interpretation to the simple *pi* on 18 - 21 and those on 31 and 33-6. *Pi* by itself, standing for ποικίλος may be ambiguous, but its accompanying marks in sub-groups iii-v have a strong vase-name flavour, an ambience in which personal names rarely occur. Another possible interpretation is as a numeral, five; I think this would be the right interpretation for 22, which is associated by date and workshop with other pieces bearing isolated acrophonic numerals,[2] and possibly for 32, which already has the longer abbreviation ΓOΙ. Elsewhere, however, this interpretation has little to recommend it; on 33 it would merely confuse the issue, since there is another acrophonic numeral following; perhaps the first three letters are an elliptic abbreviation of ποικίλος, though this type of abbreviation is not found elsewhere. The whole would then read 'eight decorated (kraters) for Archi - - - '. For the price quoted on 34 and 35 see p. 34.

See on type 3D for 30 and 31.

Type 17B

I include here under one heading both of Hackl's types XXXVI and LII.

The BF vases of sub-group i seem to have no interconnection (6 is presumably an owner's mark), but the RF members and sub-group ii must refer to a single Πα The dates of the vases are close, centring on the early 470s. Philippaki (36 and 151) has noted a relationship between the early Syleus painter and the Tyszkiewicz painter, while she has also connected a stamnos by the latter to the vase by the Berlin painter listed here, 7; there are indications then that this mark was applied in a workshop rather than by individual painters or their respective agents. The type C amphora by the Tyszkiewicz painter provides a link with the main artist of the group, the Flying-angel painter, who seems to have been closely attached to this workshop.

22 is probably a singleton, and lack of details of 24 prevents me from discussing the possibility of any connection between the two vases of sub-group iv. The individuality of the monogram in sub-group v suggests that its members are closely related. The nearest parallels, from the Agora, are a ligature of Παυ- - , but I would think that the shape of the added stroke favours Παυ - - here.[1] The vases are not contemporary, but could be fitted into one person's career; there are no clear workshop connections.

The foot of 4 is very worn, but I feel that the abbreviation and numerals may be in different hands; for the latter see p. 28.

Type 18B

Names beginning Φι - - are common enough, and we have here vases of widely different dates, with no assured close groups among them, to be contrasted with a group of cups from Greece with this mark.[1] The mark is most likely Greek, and 13 and 14 could have been cut locally; 10 and 11 could be taken together,[2] and the preponderance of oenochoai among the BF vases may also be significant. We may note that a companion vase of 4, Florence 3820, bears no sign of a dipinto although it has the same non-alphabetic (?) graffito as 4.

Type 19B

The various forms of this mark should be kept distinct. In sub-group i the marks are superficially similar but of increasingly smaller size; it is possible that 1 and 2 are to be connected, giving an interesting association of provenance, but even here the difference in size of the marks causes doubt. No interpretation comes readily to mind.

Beazley suggested that 5 has a ligature of *lambda* and *upsilon* (CB l.c.); the notion could be applied to other marks in sub-group ii. This mark also appears with some regularity on East Greek vases,[1] yet there can be no connection between them and any of sub-group ii, nor do there appear to be any close connections between the vases in the sub-group itself.

All other type C amphorae by the Flying-angel painter with foot preserved have a mark of type 17B; not only does 5 seem to have been marketed by somebody else, but a further note is appended. Beazley was uncertain whether the reference was to something sweet or to three lamps.[2]

The marks in sub-groups iii and iv are probably non-alphabetic. It may or may not be significant that all the vases are amphorae or varieties thereof. 7 and 9 could be connected; 14-17 certainly are, and form a close group.

Type 20B

Little can be said about the meaning of this and the following marks. Here, moreover, there is no obvious connection between the marked vases. As RF cups often bear Etruscan owners' marks, it is possible that 3 is one also, though an East Greek mark of the same shape, Chiot 11, urges caution.

Type 21B

Sub-group i includes a substantial set of small neck-amphorae by the Diosphos painter. Chronologically 6 and 7 should belong to the same close group, despite the additional marks, absent on the BF vases. While the style of the two sets are far apart the peculiarity of the mark does bring them together; we shall see a similar case in type 9E, xii and xiii of minor BF vases associated by their mark with better RF pieces.

The spread of provenances, together with the added abbreviation on 6 and 7 points to the mark being Greek; this abbreviation is not necessarily connected with the mark, but seems to be; I would assume that it is in Attic script and indicates the merchant involved in the sale of the vases.

The dipinto 1 fascinates, but I cannot interpret it.

In sub-group iii Beazley has already noted that 10 may be the same as 6 and 7 without the added abbreviation (*JHS* 30 (1910) 53) and the pair by the Syriskos painter may well be included in this relationship.[1]

Type 22B

The swastika was a decorative element on Greek vases long before it appears as a commercial mark.[1] It is a much more obvious non-alphabetic mark to employ than some we have seen, and does appear on other fabrics earlier than Attic,[2] where its appearance is perhaps rather restricted.

Although 1 and 2 rather strikingly come from the same, unusual part of the Greek world, they can have no chronological connection.[3]

3 and 4 are probably a close pair; it is not possible to say whether the mark is Greek or Etruscan, nor if the additional marks on 3 were cut by the same person; the delightful mannikin, lounging against the edge of the foot, seems to be in East Greek or Etruscan rather than Attic style.[4]

6 and 7 are obviously connected, not least by the peculiar shape of the stamnos. The Berlin painter does not have this mark elsewhere,[5] and so it is tempting to think that he painted these two vases (and how many others?) for a potter fond of experiment, who kept them in his workshop and sold them as a pair, in which case they were probably painted at least in the same year.

Type 23B

This is another non-alphabetic shape which should have come readily to mind, yet is rarely found on Attic vases.[1] The two vases here cannot be connected in any way. We should note that the mark is also used to secure the identity of lid and vase on Berlin 2159, s.l. 1, 40.

Type 24B

This is a miscellaneous collection of signs. Few of the hour-glass marks were inscribed in a vertical position; 7, 11 and the enigmatic 3E, 60 are the only assured examples. 3 is considerably canted and the exact positions of 4 and 9 are unknown to me. 8 has and 2 may have a handle attached, making it a double axe, as Rhodian 181, though the additional line is not certainly deliberate. The vase from Taranto, 9, shows that this is not necessarily an Etruscan mark and 7, with an attached 0 points in the same direction; if the A on 3 and the B1 on 6 are closely connected with our mark, they too suggest a Greek origin. The wide chronological spread does not present any close groups and demonstrates that the mark was in general currency.[1]

For 11 see on type 13F, p. 228.

12 - 16 are likely to be Etruscan marks; see further on type 4E for the figure-of-eight sign and on 3F for marked lids. It is not possible to say whether the sign is used here as a letter or merely as an identificatory mark.

Type 25B

Among the BF vases 2 and 3 seem to be closely connected. As can be seen from Fig. 5h, 2 has the appearance of a boat, with hull, separate stem and stern, mast and perhaps yard; as it sits nicely on the edge of the foot, I feel inclined to believe that this was the intention of the inscriber, not a mirage of interpretation, and we may add this pair to 36A to enhance the nautical flavour of commercial graffiti.

The mark on the RF vases is different and is not easy to interpret; 5 and 7 are members of a larger, complex group in type 17B, and it is therefore probable that our mark was inscribed on them after that of type 17B.

Type 26B

Although this mark resembles certain forms of Etruscan or Italic *mu,* they occur only later than its period of use. The mark may yet be Etruscan, but if we think of a four-stroke *mu* as being the basis of the mark it must then be Greek.[1] 5 may suggest that the difference between the two versions is insignificant; however, there are no obvious connections between any of the vases except 1 and 2.

SECTION C

Not surprisingly, the marks that appear only on RF vases are confined to somewhat out-of-the-way shapes, since in the first place many abbreviations and ligatures had already seen service in the sixth century, and secondly the proportion of RF vases with marks is far less than that of BF. Moreover, most of these types embrace close groups of vases.

Type 1C

The vases are clearly connected, but the mark cannot be satisfactorily interpreted. The common occurrence of vase-name marks on Polygnotan vases, often accompanied by a type 18C mark, encourages one to think that such a meaning may be found here, but even speculation will yield little. There is an unhelpful parallel in Rhodian 100.

Type 2C

This is likely to be a ligature of *alpha* and *gamma,* in which case it is an Ionic mark. This need not surprise us in the case of 1, for Ionic marks are common on vases of the Leagros group, from which the Athena painter emerges.[1] 2 - 4 are closely related, and as the mark appears to be Greek, it cannot be interpreted as an owner's inscription; the pieces should be fairly closely contemporary.

Type 3C

This is presumably an abbreviation of a personal name, less informative than type 1D, a longer abbreviation starting with the same letters. Having no details of 5, I am unable to say whether all the vases are contemporary.

Five vases by the Painter of the Yale oenochoe have marks to my knowledge; three here, 16B, 11 and 9F, 10. Three vases by the Orchard painter are marked: 4 here, 9F, 12 and 10F, 20 (perhaps not an integral member of that type). Both painters therefore appear in types 3C and 9F, indicating a little more than a casual relationship between them. Add Dresden 325 (p. 31).

We may note the wide range of vase shapes on which 'standard' RF graffiti appear, in contrast with the restricted number of BF shapes. The main reason is clearly the greater diversification among the larger vases made for export in the fifth century.

Type 4C

Judging from the shape of the *alpha* this may be an Etruscan rather than Greek mark. The full significance of the ligature, if such it be, escapes me, and with a small group like this no conclusions can be safely drawn about the nature or chronological spread of the mark.

Type 5C

We shall see a number of marks based, it would seem, on a *delta*; of these 5C and 6C appear only on RF vases, and 5C is involved with a more restricted range of painters than 6C. The latter cannot be viewed as a developed form of 5C, since it is regularly accompanied by a *nu,* which does not appear here.

However, we cannot be sure that a *delta* is part of the ligature, if it is a ligature. The range of provenances proves the commercial nature of the mark, and if it is based on a *delta,* it must be Greek. The quartet by the Eucharides painter form a close group somewhat earlier than 5-6, which could themselves be another close group; the different shapes and provenances, as far as they are known, underline this distinction.

Type 6C

For most purposes we can here ignore the unaccompanied form of the mark; sub-group ii seems in no way connected with the rest, at least with regard to the published descriptions of its members.

Sub-group i includes vases by a large range of Classical painters, but the Polygnotan group is conspicuous by its absence; as it is a relatively frequent user of commercial marks, it is valid to conclude that the person responsible for,

or indicated by our mark had no contact with that group, which used other outlets. The sub-group is made up from sets of two or three closely related vases, all probably of the third quarter of the fifth century, but having no obvious workshop coherence overall; a possible relationship between the Villa Giulia and Achilles painters is intriguing.

Beazley (*CVA* l.c.) suggested that the mark is a ligature of *delta* and *tau*. Such an abbreviation is difficult to elucidate, and the *nu* makes it all the more difficult; even with a more reasonable *delta iota*, the *nu* would be intractable. There is no vase with the simple graffito *nu* (type 14B) which can be associated with those here and so the two parts should be taken closely together. Perhaps we should consider whether the mark could be in some way numerical.

Type 7C

This mark is a little puzzling. I assume that 1 and 2 are two distinct entries (I have not seen 2) and that a single foot has not been exchanged. 2 and 3 are close as vases, 1 and 2 are close by provenance, though not by date (unless my judgement of 1 is somewhat astray). The basis of the mark would seem to be a non-Faliscan *delta*. Perhaps the sign has some significance such as types 5C, 6C or 3F. The remains of the dipinto on 1 may just be reconciled with a shape similar to the graffito, though the equation must remain uncertain.

Type 8C

There can be little doubt that this is a ligature of *zeta* and *epsilon* (long or short), despite the relative scarceness of names beginning with those letters.

Philippaki (p. 39) has pointed to a connection between 3 and 4 as vases; here again we have a group based on workshop or potter rather than painter, a situation opposed to that which prevailed in the sixth century, emphasizing the trend away from painter or potter/painter dominated workshops to establishments where several painters of varied experience could find occasional employment.

2 complicates the issue; it is a vase within the broader circle of the Berlin painter, but seemingly from earlier in his career, unlike 3 and 4. Its other mark is also typical of the early Berlin painter. Our mark therefore is a little embarrassing, for if it is another personal abbreviation, how does it fit into the history of the vase? Perhaps it refers to the same Ze - - - as 1, who may or may not have later marked 3 and 4 as well.

Type 9C

Sub-group i seems best taken as Ek - - - , though Ke - - - cannot be ruled out. There is no proven connection between the first pair, probably by the same hand (*BSA* l.c.), and 3. See also *JHS* 98 (1978) 218, and add another black-glazed piece from Marion, *JHS* 12 (1891) 196.

An interpretation of sub-group ii as Eu - - - may be acceptable; there is no connection with any of the mostly earlier pieces in type 9B. 5 and 6 are clearly related, while 4 cannot be chronologically far removed; there are some coincidences of marks on vases by the Achilles painter and those of the Polygnotan group (16B, 13C), but they do not extend to smaller vases. The lack of known provenances is regrettable. Those of sub-group iii are of more interest, and it may be that the two vases were sent to Sicily by the same Ke - - - , even if he constructed his monogram differently on the two feet.

Type 10C

Clearly a closely related pair, with a ligature of *epsilon* and *mu,* or more likely *sigma*. As we do not know the provenances it is idle to speculate on whether it is an owner's or merchant's mark.

Type 11C

This type poses several problems despite its innocuous appearance. It may be best to take its members severally. 3 appears to stand apart from the rest in its presumably non-Sicilian provenance; it is also accompanied by a further abbreviation. 1 is followed by an indubitable drachma sign, which suggests that the mark may have some vase-name force; the most obvious interpretation, a ligature of *kappa* and *alpha*, points towards κάδος or a derivative, but this is not a word we find elsewhere associated with lekythoi (p. 228) and in any case a drachma appears a high price for such a piece (but see p. 34). While 2 has the same provenance, and is a vase termed κάδος in antiquity, no price is quoted, or batch number, and moreover there is an alternative reading Ⱥ, given in *AZ* 1872 53; if I prefer Beazley's reading, I cannot be sure of it.[1] 4 is another lekythos, may well have a Sicilian provenance, judging from the full name inscribed on it,[2] and is accompanied by numerals and further graffiti, seemingly all in one hand; the Ionic script perhaps suggests Athens rather than Sicily as the place where the graffiti were cut,[3] even if referring to a Sicilian. It is tempting to link up the numeral, 15, with the graffito TPI, perhaps fifteen pieces for three drachmae, though other possibilities are open. In such a fluid state of affairs it may not be irrelevant to suggest a possible interpretation of our mark as a ligature of ΛΑΚ(VΘOI). At any rate, the association with numerals and other graffiti on three of the vases persuades me that it is probably not a simple personal abbreviation, even if it has more than one meaning here. 11F, 29 may well be connected with some of these pieces.

Type 12C

I have listed most of these pieces in *BSA* 68 (1973) 189, where I doubt the likelihood that the mark is an abbreviation of Kleophrades' name, - at least that is, of the potter Kleophrades, since it is likely that the mark is still a ligature of *kappa* and Ionic *lambda,* with a further countermark of some kind; the slight variations among the examples appear trivial. The Geras painter is indeed a follower of the Kleophrades *painter,* but rather later in his career than the period when he was painting for Kleophrades the potter; also 1, 2 and 6 are from completely unrelated workshops, although we may assume that the mark has the same significance. In fact few other marks, at least on RF vases, are found on the products of as many distinct shops.

Type 13C

This mark could be either a personal or a vase-name abbreviation. The latter is suggested by the fact that vase-names do frequently appear on Polygnotan vases, although supplements for this abbreviation are hard to find: we may resort to the σκοίκιον attested as some kind of receptacle at Cyrene in the fourth century, or rather nearer home, at the same period, the Boeotian version, σκόφος.[1] The script is Greek, but closer we cannot go.

We may also note that a vase-name interpretation is preferable in one other type where both Achillean and Polygnotan vases are represented, 16B.

Type 14C

Judging from the comments of Hoppin and Hackl these marks are probably Etruscan; the exact shape of *alpha* and *tau* would decide the point. Certainly the retrograde script would be unusual at Athens at this date.

Etruscan marks, mostly abbreviated, and unligatured, are more common on RF cups than on any other kind of Greek vase. We can appreciate that they were prized more highly - and in a more individual manner - than other shapes and were used and transported more than the rest, many of which were placed directly in the tomb; therefore it was necessary to be able to identify them as possessions of living imbibers.[1]

Type 15C

On most of these vases the *epsilon* has a distinctly archaic appearance, and several seem best read retrograde.[1] While it is not impossible that a Greek mark could be so inscribed in the mid-fifth century (see 18C, 65a especially), an Etruscan origin may be preferable, though clearly not referring to a single owner. 3 and 5 seem particularly closely connected by the repetition of the mark in a similar quasi-ligatured form.

Type 16C

With 1B and 5B this type affords a little evidence to connect Smikros with the Leagros group. The mark resembles type 7E, which has strong Leagran connections. Yet the resemblance may not be close; there is no mark here of type 5E, such as accompanies many of 6E and both vases of type 7E, and the one mark of 7E which I have seen is much more curvilinear, though the difference is not as much as Philippaki's facsimiles of our marks suggests. This pair is also a little earlier than the Leagran 5E and 6E, which would make 16C a precursor of what otherwise seems the basic shape, 6E, if a connection were upheld.

An alphabetic interpretation seems most unlikely.

Type 17C

Contrary to what we may have expected with so distinctive a mark, there is little apparent unity to the type, with a range of shapes, painters and dates. The range of dates would just allow a single point of reference, but there would be no other link between any of the pieces.

A rather roughly cut graffito on Louvre E810 (24A, 4) could perhaps be a much earlier instance of the use of the shape.

The mark has every appearance of being a non-alphabetic sign used purely for the purpose of recognition. The range of provenances suggests that it is not an Etruscan owner's mark.

Type 18C

This type stands very much by itself; it should have found a home in section E perhaps, but as it is confined to RF vases and has no special relationship with any *one* other mark I have placed it here.

For the development of the mark, from triple to single lines, see *BSA* 70 (1975) 160. The fact that three of the four varieties of the mark appear on vases by the Florence painter demonstrates its rapid simplification and the lack of significance in the variations, especially between sub-groups iii and iv.

The marks were applied very early in the life of the vase; this is indicated by the very wide distribution of the vases (note especially 52), by the general alignment of the later marks with regard to the already cut lines and, where this did not happen, by the evidence of other marks being incised over a mark of type 18C (22, 47, 66?); on 7 one of the lines has been utilised as the basis of a monogram (= 9C, 8). I also feel that some of the marks may have been incised before firing, though I cannot convincingly substantiate the claim.

I assume that the mark indicates that the vase has been reserved, either ordered or even sold. It was clearly a recognised general practice, starting before 450 and continuing beyond 400, too long for it to be a single man's habit. Many of the pieces are prestige products, from a range of workshops, the Boreas/Florence group, the Phiale painter, the Polygnotan group and the Dinos, Pothos, Kadmos and Nikias painters.

The accompanying marks cover the whole range of contemporary usage; well over a half are vase names, adjectives or numerals, with some further *dubia* (17, 40, 41, 44), while most of the rest appear to be regular personal abbreviations.

SECTION D

Type 1D

This is an intriguing mark which I include in section D because it is accompanied on at least three occasions by dipinto numerals; there need be no close association between the two, but it would be unwise to ignore the coincidence. Marks of four letters are rarities and we must attempt to wrest as much information as we can from it.

The mark has been published as Etruscan, but the only explanation of it that has been offered is that it is the abbreviation of a Greek word, Ἄτθις, in some oblique case.[1] It can scarcely be Etruscan; judging from the range of provenances and the rarity of this collocation of letters elsewhere in Etruscan inscriptions one would have to take it as the mark of a single individual applied in one of the Etrurian ports.[2] The proportion of retrograde examples is not as high as one would expect in Etruscan at this date, nor are the letter forms typical; the *alpha* only approaches the Etruscan form once, on 18, which is a wretchedly cut letter; the left upright never has any substantial curve and although the cross-bar slopes in the typical Etruscan direction, it does not do so as exaggeratedly as for example in the slightly later Pyrgi plaques (*CIE* II 6314-5). The latter also have *theta* without any internal mark, and there seems little evidence for the use of cartwheel *theta* in Etruria in the last quarter of the sixth century.[3] In most Greek states, however, it was still in regular use, as was a certain amount of retrograde writing. The *tau* presents no fully developed Etruscan form, such as on 3E, 26 and 32, but we should not perhaps expect it always at this date.[4]

Epigraphy then suggests a non-Attic Greek origin. The varieties of spelling show that the mark is a unit and that there may be dialectal alternatives in spelling. I am unable to think of any root other than Ἄτθι-, although the word is rarely attested otherwise before the Hellenistic period.[5] We must then accept that the consonants could be transposed, or the *tau* entirely omitted. Parallels for such metathesis are naturally rare, since the letters seldom occur together. The analogous *pi* and *phi* in Σάπφω retain that order in Ionic dialects; the aspiration of *tau* under the influence of a nearby, but not adjacent *theta* is common in the Doric of Crete and the Peloponnese, e.g. in the well-attested θέθμος. Such aspiration would here result in the suppression of, or rather the simplified spelling with, one *theta,* such as seems to occur on some slightly later coins of Thessaly.[6]

I would hazard a guess that the mark may be Aeginetan; the form of *alpha* fits, as does the possible Doric dialect.[7] Whether the word is being used as an adjective or the root of a personal name is another question. The accompanying numerals may suggest that it is an adjective, although there could hardly have been any need at the time to identify the origin of such BF vases; the spread of shapes precludes the possibility that it is the nickname of one particular vase form. On balance a personal name may seem preferable, although it does not explain the dipinti, themselves obscure in significance, satisfactorily.[8]

Type 2D

This pair of letters could equally well be an acrophonic numeral or the abbreviation of a personal name. If the vases all came from a particular workshop the latter explanation would be preferable since it would be highly improbable for the number six to be repeated so many times. Here, however, we have only one small group, 8 and 9, which could fall into such a category. Of the rest, 6, 10 and perhaps 7 are late enough for them to be acrophonic numerals of no particular interest, while 3, 4 and 5 are unremarkable. The form of 1 and 2 clearly indicates a numeral, seven, though one must have doubts about the shape, or reading, of the *pi* on both; 2 cannot be thought of as a simple *pi,* and the type with equally long verticals, which may be present on 1, is unexpected at this date; certainly I consider its suggested presence on type 10F, 17 unusual enough to merit emendation.

Type 3D

The dipinti are unfortunately a poorly preserved lot; it would be best to ignore 8 and 9 as primary evidence, noting that 8 is not the same as the dipinto on 17E, 24, by the same painter, and that 9 may or may not be a dipinto of type 21E, vi. I have considered the possibility that the other dipinti may be the remains of a mark of type 21E, but except in the case of 1, which I have not seen, I am satisfied that it is unlikely.

The amount of painter grouping encourages me to think that the dipinti are connected, and in addition, 1 has a mark of type 1D, which elsewhere is accompanied by dipinti of type 2D. A numerical interpretation seems necessary, obligatory for 5 at least. The pair of dots which certainly occurs twice and probably is used four times could be punctuation, though apparently superfluous, or it could have a numerical significance. We must also include

in our considerations three marks with simple Λ, two dipinti, 13A, 5-6, one accompanied by a mark of type 1D, and 1D, 19; 6 has a *'lambda'* preceded by six dots, which would be even more otiose if taken as punctuation. I discuss the numeral system involved at greater length above, p. 31, but I stress the problem of the presumed fractions involved in the dots or dashes here. The matter is complicated by the fact that on 7 they appear *between* two other elements, not at the end. They can scarcely represent fractions of vases, nor single units, if, as I argue, the Λ is to be interpreted as five, in view of the *six* dots on 13A, 6. Possibilities remaining are indications of capacity or price; see further p. 31. It is regrettable that although we can elucidate the numeral system involved and part of its history, the meaning of the mark escapes us.

Sub-group ii is a typically isolated set of marks from Spina. The vases come from three tombs and so the marks are not likely to have been an owner's abbreviation.

My first draft of sub-group iii included a number of pieces which turned out to belong to type 2F; the published versions of Würzburg 214 and 321 and Louvre F213 are misleading in this respect, while Lullies reading of Munich 2421 (*CVA* 5 17, as FR ii 66) gives IΛ for the Ionic numeral IΔ. There is little to say on 14 and 19 - 23; on 21 and 22 the mark could be taken as retrograde Etruscan *pi iota,* conceivably numerical.

15-18 are more problematic. The letters ΛI have a separate existence on 16 and 18, although the reading of 18 is not assured and 16 may be an inscriber's error (see on type 18E). As *pi* is a frequent Polygnotan mark the ΛI on 17 could also stand by itself. 15 is a much older piece and one hesitates to interpret the ΠΛI in the same way; yet ΠΛI is not an easy abbreviation to complete, despite the superficial resemblance between bricks (*plinthoi*) and clay vases, and if 15 is taken closely with 17 the ΠΛI cannot be interpreted as referring to one and the same *person.*

I conclude that the meaning of the *pi* in type 16B, at any rate on the Polygnotan vases, is ποικίλος, and that its other companions, K and TPI, have a vase-name significance of some kind. Is the same true of ΛI? In the case of the non-Polygnotan 16, it is to be equated with ΛE (p. 217), probably an abbreviation of λήκυθος or the like. If the equation is extended to the other ΛI here, we may assume that the *iota* in all cases is a conscious etacism.[1] Problems remain: such etacism does not occur on the two vases closely related to 16, 18E, 8 and 9; the ΛI could hardly refer to the inscribed vases, as the K does and the TPI may well do (see p. 231); the abbreviation of the supposed vase-name on 18 would be curious. However, some such explanation does seem preferable, especially in a Polygnotan context.

Type 4D

My discussion of 1 and 3 in *BSA* 68 (1973) 187-8 was based on an identification of 3 as an Etruscan vase. A re-examination in 1978 convinces me that it is Attic, or a peripheral imitation of Attic, with no incision in the panels. The vases remain unpublished; nor was 2 included in *CVA* 3 since so little of its figured scene is preserved.

One difficulty should not be overlooked. The addition of a third example may lead us to doubt the interpretation that in each case we are dealing with a measurement of eight (what?), especially as the *eta* is repeated; one can only point to the eight strokes painted on 1 as confirmation of this interpretation. Although 2 can hardly come from the same tomb as 1 and 3, it is approximately contemporary. Repetition of eight in this way is perhaps less likely to indicate an accompanying batch (batches are rarely so consistent in size, though 16 does appear more than once in the much later 8F) than price or capacity. Price is a doubtful possibility in the years around 540, and eight units are not easily interpreted, especially as 2 seems a smaller vase than 1 and 3. See p. 207 for further possible candidates for marks of capacity.

It remains to be seen whether other vases from the tomb may have the ϟA mark found on 1 and 3; I assume that it refers to an Etruscan owner.

Type 5D

It is unlikely that this mark is to be interpreted as a vase-name or similar abbreviation when it is accompanied by numerals, and therefore it constitutes an exception to the general 'rule' that numerals do not occur directly dependent on personal abbreviations.[1]

There are only a few marks with numerals, confined to a short period; among them dipinto and graffito forms are closely related, and the numerals must have been inscribed at the same time as the monogram. There is no good reason to think that the IΔ on 18 may be an Ionic numeral, nor that 7 refers to the same person as 2 - 4; 6 presumably does so refer, for the numerals, together with the painter link, favour the same interpretation for all four. 1 could perhaps be related to 2 - 4, yet one would like a closer painter association, or numeral strokes, before connecting the piece with others of presumed Etruscan provenance. 9 and 10 are probably a close pair, but the illustration of 9 is not good enough for a proper judgement on their style.

The obvious interpretation is a ligature of *eta* and *rho,* presumably Ionic; but it is possible to consider *heta-rho,* with a medial long or short *epsilon* suppressed; such a combination is not unknown in Attica before the introduction of Ionic letters, and in ligature such a suppression is even more likely.[2] In this respect, 13 could possibly be a local Geloan mark. Many of the later marks could be in Ionic script yet of Attic origin, but the bulk of the type is too early for such an explanation to be acceptable. The open (h)eta would be expected in Athens or Ionia during the third quarter of the sixth century.

Sub-group iv causes some concern. The lettering seems much later than the date of manufacture. True, on 21 the mark is worn, but there is no absolute guarantee that this wear is ancient, considering the friable nature of the clay of Tyrrhenian vases (witness the many scoured bases leaving only the faintest traces, or less?, of dipinti). While, it is unlikely that the wear occurred after the interment of the vase, the possibility cannot be excluded. I have not therefore included the pair in the list of early tailed *rhos* given on p. 209; 10 and 17 there (the Argive pin and Syracuse steps) could be as early as these vases, but in both these areas closed *heta* was in use. We may therefore choose between two interpretations: first that the marks were cut at a date when the script was more developed (Jeffery's argument with regard to the Argos pin); the difficulty here is that Tyrrhenian vases were made primarily for the Etruscan market and one presumes that these two were direct exports to Etruria, where the form of script exhibited was not adopted for several centuries.[3] Secondly, one can consider that the marks were cut by somebody who would have used open (h)eta at the time, c. 560, therefore an Athenian or Ionian, despite the fact that tailed *rho* does not otherwise appear at Athens till c. 530 and in Ionia before 550, where it is never common. So on balance, I regard the marks as being in a contemporary Ionic script, though they are hardly reliable evidence for the introduction of tailed *rho* there.

Type 6D

I have discussed the earlier members of this type in *PdP* l.c., where I distinguish between those that have a numerical force, 8-10, and sub-group i, where the mark is more likely to be a regular personal abbreviation. The repetition of the sign on 3 and its appearance on another cup, 1, supports the latter interpretation, since at this date acrophonic numerals appear to have been in their infancy. The shape of 1 is not quite as that of the others, where a ligature of ΓΑ may be suspected.

Inscriptions on stone yield very few exact parallels to our marks in their signs for fifty, but this interpretation is needed for some of the graffiti.[1] On 8 and 10 it is indicated by the following 'arrow' *delta* - a common numerical variant (p. 29) - and *iota*, or rather unit stroke. I noted, *PdP* l.c., the troubling difference in date between the two vases; perhaps 8 is later than is indicated, but certainly the marks could not have been applied in some Etruscan destination after the date of manufacture. Such dating discrepancies are rarely found, and it may be that 8 should be placed nearer 500. The interpretation of the mark depends on our view of the first sign; the only obstacle to taking it as standing for fifty is the equal length of the legs of the *pi*, a rarity at this date.[2] Perhaps this may persuade some to see a ligature of *pi* and, say, Ionic *lambda*, followed by a numeral, eleven, rather than a bald numeral, sixty-one. On 13 the sign seems closely associated with the *sigma*, with the *alpha* some way apart; we may possibly consider '50 summikta' (see type 19F).

I discuss sub-group iv briefly in *AK* l.c.; 16, 18 and 19 are miniature marks indeed, though there is little to be said about their interpretation; the repetition of the mark on 18 points to a non-numerical meaning, and the accompanying marks on both 18 and 19 are noteworthy - they could be wholly or partly numerical; πο (ικίλος) might be considered. Much the same applies to 17 also; I cannot determine whether the *beta* is to be taken closely with the rest of the mark, but the numerals give the appearance of being related to the kind that occur with type 10F. The 'bracket' that divides our sign from the 'arrow' *delta* is as of that type and may perhaps represent fifty, as I suggest it does there. In that case a similar interpretation for our mark seems ruled out and an alphabetic interpretation may be considered.

Type 7D

We may think that the fairly consistent progression from three- to four-bar *sigma*, together with the occasional accompanying numeral at all periods should indicate a common meaning for most of these marks; while there may be some truth in the former point, the marks with numerals have a curious diversity.

The BF vases of sub-groups i and ii are not closely linked by date or style, but not so spread as to make it impossible that the marks refer to one person. The strokes on 14 and probably the X as well are not in the same hand, and so all these marks probably do have a personal significance, and names in ΣΙ are not lacking, Simon for example, of type 19A. 3 and 4 are probably connected and the provenance of 2 tempts one to associate it with them. The retrograde direction of 7 points rather to an Etruscan hand. Of the RF pieces, 9 and 10 belong with the BF vases and little can be said of 11 - 13.

15 - 19 are difficult to interpret. On 19 there appear to be punctuation dots before the ʃΙΙΙΙ and on 18 the ʃΙ comes after another element. This may suggest that some slightly complex information is being offered, the ʃ perhaps standing for στάμνος or the like and part of the rest quoting a price, the remainder a batch; or στάτηρ, or some combination of some of these elements. The three-bar *sigma* at a date after 450, together with the retrograde direction may suggest that an Etruscan interpretation has to be sought.[1]

15 and 17 are closely related as vases and bear the same Etruscan inscription in addition to our mark; the parts relevant here, however, are completely different, and 15 resembles 16 rather, with its very light incision, contrasted with the heavy work of 17. The *gamma* of 17 is strongly Etruscan, even if the X, if it is a *tau*, is more exaggerated than in the other graffito on the foot. It may read *Cest - -,* but the form of *epsilon* (ΙΙ) seems too advanced for the date of the vase.[2] We may note that as it is a column-krater the interpretation of the *sigma* as στάμνος is in any case not readily acceptable; the oenochoe 15 also makes such an interpretation difficult, but it does seem that on 15 and 16, as on 18 and 19, something beginning with a *sigma* (Greek or Etruscan) is being listed.

The RF examples with four-bar *sigma* are more straightforward; the nucleus is formed of vases by or near the Berlin painter, all of which, except 33, are placed late in his career by Beazley. They therefore connect more closely with the pieces by the Pan and Charmides painters and Hermonax; indeed, the date span 485-455 probably embraces all the RF pieces. The uncontracted form of the mark on 27, 33 and 36 ensures the interpretation of the rest as Si - - .[3]

As with the three-bar variety, the evidence for its use in direct association with numerals is not as impressive as appears. The extra marks on 33 may not be numerals, although the reading may be faulty; an X may follow the ΣI directly, indicating a name in Sich - or perhaps Sil - -. The main body of strokes and dashes on 35 is in a different hand, and the rest is at least separate from the ΣI. Only on 34 and 36 which have identical marks is the numerical connection probable, though no single interpretation can be urged.

Overall, some marks are Etruscan, a few are connected with numerals, though Σ rather than ΣI may be the binding factor in most cases. Otherwise I would attach a personal meaning to most of the ΣI marks. Among the Greek marks there is something of a progression from three- to four-bar *sigma*; this may be purely coincidental, but there is the possibility that it reflects the development of what might be termed a 'commercial' Attic script.

Type 8D

As X can mark any spot, I consider it pointless to speculate on the origins of most of these marks. The fact that it was used for so many early dipinti indicates that the purpose of marks was simply to set apart one vase from the rest, although this should not obscure the fact that other types of mark were used as early and that X was in use till much later.

Among the number of small close groups, we may note in particular the two glaze and one red example on Leagran vases, 15 - 17.

For the graffiti, I am not entirely happy about the authenticity of some of the more deeply incised examples, such as 49 and 80; X could well be a more modern dealer's or owner's mark; the Roman numerals cut on London B178 are a different matter.[1] 34 is very faint, scarcely a commercial mark. 26 - 31 are a clear Antimenean close group and 60 and 61 are also connected, but otherwise the spread ranges evenly over the greater part of BF and RF production.

XI could well be the abbreviation of a personal name on 74 - 78, and the unit strokes are not directly linked with the X on 69. Of the rest, 11, 66 - 68 and 70 - 73, we can do nothing with 67, while 68 is the most obviously numerical; if the vase were a wine amphora an acceptable explanation would be 'six choes and three kotylai', but the vase is not even a figured amphora, but a hydria, and the inscription is under the foot, not an easy place to inscribe a full vase (but see on type 4F). Parallel marks, without the X, are on two vases by the Swing painter, London B185 (*ABV* 304, 4) with the same numerals, and Vatican 349, with six strokes but no dots (*ABV* 305, 14), as on the neck-amphora of the Botkin Class, *Auktion* 51, 123;[2] though earlier than our vase, I would consider that the meaning of the marks is the same and may relate to some use of the vases as containers, despite the difficulties noted above. Such an explanation is unlikely for 11 and not convincing for 71; four measures in regular use (presumably choes) would merely wet the bottom of the vase. In most of these cases we cannot discount the possibility of the numerals being Etruscan, but 66, from Taranto, prevents us from interpreting them all as such. See further p. 31.

Type 9D

H. R. W. Smith (*CVA San Francisco* 1 26-7) suggested that this mark is a pictogram for 'lekythos', an equivalent for the ligature of type 2F as he interpreted it. One may have reservations, since the shape of 9 damages the idea that the 'cap' represents the foot of a lekythos, but we cannot expect great accuracy (nor assume it was intended), and failing other possibilities we may at least inspect the consequences.

The presence of an associated numeral on six occasions strongly suggests some kind of vase-name interpretation. Further support may be offered by the RF pieces, 20 and 21, although they are not closely related to the rest. 18E, 8 and 9, which have the same EM mark as 20 and 21, also have ΛE; are the letters substituted for the pictogram? It certainly seems that the pictogram represents a vase name, but on the RF pieces it resembles rather a kylix, reinforced by the *kappa* perhaps, which is also found on the vases, while a fuller abbreviation, KV, without a pictogram, is found on 18E, 12.[1] The vases are moreover stylistically related.

Most of the BF vases are earlier than the Leagran members of type 2F, though 12 and 13 at least show that the two overlap. The size of the batches is small, comparable to those of the ΛH in type 2F, vii C (q.v.). Although there is little direct evidence to suggest that the mark is Greek apart from the *kappa* on 17, the analogy with both the RF vases and type 2F should convince us that it is. We may note that it appears relatively frequently on oenochoai and small neck-amphorae, unlike 2F, although the earlier members of the type are all full-size vases.

SECTION E

Type 1E

There is no good reason for treating these letters separately, but together they do cause some epigraphic anxiety. The mark should be read this way up (otherwise on 10 the top bar of the *sigma* would be extremely short); it could then be taken as orthograde or retrograde, but it would then be curious that the *sigma* is always orthograde if the mark were intended to be read retrograde. We might take the first letter as Corinthian *iota*, but the open *heta* would be out of place in mid sixth century Corinthian script. We therefore are obliged to read the mark as *sigma-eta*, despite the fact that the combination of three-bar *sigma* and open *eta* at this period is extremely unusual; no well-attested script uses them concomitantly. 3 perhaps eases the situation with its clear four-bar *sigma*; the painter and the graffito suggest that the dipinto should be *sigma-eta*, in which case both three- and four-bar forms may have been in the repertoire of the inscriber.

There are a few Rhodian inscriptions with three-bar *sigma*, rather more than from Ionia;[1] in these scripts open *eta* would be normal by c. 540. It would not be rare in the Cyclades, but the only island which regularly uses three-bar *sigma*, Naxos, employs *eta* only for vowels other than original *ē* which precludes a large proportion of the names available, such as Semon and its derivatives.

It would be rash to think of the inscriber as coming from an Ionian city whose script is as yet little known; Rhodes, perhaps Ialysos, may have a stronger claim, or it could be argued that metics in Athens were responsible for this apparently hybrid script.

The dipinti of type 33A (or marks akin) were painted after our mark, but unfortunately it is not possible to decide whether the graffiti of type 2E were applied before or after the type 1E dipinti; if before, the graffito would be proved Greek.

There is no need to stress the unity of the type, one of the earliest substantial close groups of Attic vases.

Type 2E

The type falls into two distinct groups 1-5 and the rest. There is a temptation to take it as Etruscan, a peculiar mark, akin perhaps to the later 8E; or it could be considered a forerunner of the Greek 11E. The short verticals at the end of the horizontal appear an integral part of the mark, yet do not appear in type 11E; they do occur in type 8E, but there there is no central vertical. Type 36A is not far different and includes vases close to ours. All four types mentioned are largely inscrutable. Many of the marks, especially 6 and 8, are untidily cut. For a possible meaning or use of the mark see on type 3F.

Type 3E

The standard dipinto on the Nikosthenic amphorae by Painter N has been noticed before, but it should be observed that a mark of type 21A also appears on several of his products. Examples of both types were found in one tomb at Cerveteri, where the great majority of these vases have been found.[1] One might think that the Nikosthenics were snapped up by the dealers for Cerveteri, close by what must have been a major port for the intake of Etruscan goods, Pyrgi.[2] This does not however explain the fact that many masterpieces of vase-painting, some of which must surely have been recognised by the Etruscans as such, were found at other Etruscan sites. There is a strong suggestion that Nikosthenes was working for specific orders from Cerveteri, otherwise his work would have reached a number of other Etruscan cemeteries.[3] 19 demonstrates that the merchant whose mark we have here was involved not only with Cerveteri, and 17 - 21 are important in showing that the mark is no potters' signature, firstly because the mark can in no way refer to Nikosthenes, and then because of the lack of any stylistic link between the two painters, despite their contemporaneity. The added dots on some of the dipinti may merely be an affectation.

There has been disagreement over the interpretation of sub-groups ii and iii, which I have outlined *apud CVA Oxford* 3, 8. Is the *epsilon* in ligature with a three-bar *sigma* or a *rho*?[4] It matters little whether an Er - - or a Se - - was responsible for their export, but the issue of the tailed *rho* deserves closer scrutiny.

Robinson thought 24 too early for a tailed *rho* to be considered, though an error in his article confuses the matter.[5] Yet a simple ligature of *epsilon* and *sigma* cannot be entertained; on all the vases save 34 the top part of the

'sigma' is too curved for a plain *sigma* to be read. For 34 Beazley suggested a ligature of *epsilon, kappa* and *pi* (?), which may be acceptable for this piece, but again can hardly stand for the rest. I note in *CVA Oxford* l.c. that the dipinto 22 has a form of *rho* in the ligature which is much closer to early tailed *rhos,* with a full loop and short tail, than the *rho* found in the graffito ligatures; the dipinto is much worn, but even if the 'tail' is a washed out streak, there can be no doubt that a ligature of *epsilon* and (tailless) *rho* was intended, and since the accompanying mark is the same as on some of the other vases concerned, there is good reason for seeing a similar ligature in the graffiti. As a vase 22 is later than some of the others, but the discovery of the slightly earlier 26 with its very clear reading can only reinforce this argument.

It remains to find a script in which tailed *rho* was in use throughout the last quarter of the century. I list early examples known to me.[6]

Ionia

1. Columns of temple of Artemis at Ephesus, dedicated by Croesus; *LSAG* Ionia 54. 550-540.
2. Vase fragments, *Naukratis* ii 777; from a slipped dish of the late animal frieze style. The published reading omits the tail of the second *rho* and gives more of the first than is preserved. c. 550.
3. London 1888.6-1.452, sherd of a Chiot chalice from Naukratis, with part of an undeciphered dedication. The tail of the *rho* seems intentional. c. 575-50.

Black Sea

4. Graffito on rim of oenochoe from Pantikapaion; *VDI* 1974 4, 56-7 and pl. 1. 575-550.
5. Graffito on sherd from Histria; *Histria* ii no 765. The vase is of c. 560.
6. Bronze fragment, dedication to Artemis Ephesia at Pantikapaion; *VDI* l.c. 59 and pl. 2. c. 550?
7. Fragments of an East Greek bowl, from Berezan; *VDI* 1971 1, 65. The suggested date of the first half of the sixth century seems too high for the shape of the *alpha* and *mu,* though 550-525 is certainly not early.

Further examples are mentioned by Vinogradov l.c. under 7. Besides being the earliest these are the only examples of tailed *rho* in Ionia and the Black Sea area known to me, though three fifth century inscriptions may be mentioned in this context:

Bronze from Dodona, perhaps in Ionic script; Carapanos 40 n. 3.
Berlin inv. 2452, vase from Rhodes; *IG* XII 1 728, *JdI* 1 (1886) 153.
Bronze hydria from Lebedos, *LSAG* 340. Rhodian? The *rho* is orthograde in the retrograde inscription.

Delphi[7]

8. Fragment of base of dedication of Rhodopis; *LSAG* Phokis 7. c. 530?
9. Names painted on the frieze of the Siphnian treasury; *LSAG* Phokis 9. 525-500.

Argos

10. Bronze pin from the Heraion; *LSAG* Argos 14 and p. 140. 550-25?
11 and 12. Two other dedications there; *LSAG* Argos 11 and 12. 550-25.
13. Inscribed sherd, Argos C70/271; BCH 96 (1972) 176 fig 28. Not the latest sixth century.

Attica

14. Name inscribed on a gem from Brauron; Richter, *Engraved Gems of the Greeks and Etruscans* no 124. 540-30.[8]
15. Grave stele set up by Opsios; *ADelt* 20 (1965) pl 51. c. 520.
16. Grave stele; Richter, *Archaic Gravestones of Attica* no 75. c. 520.

Elsewhere

17. Syracuse. Inscription on steps of temple of Apollo; Guarducci, *Epigrafia Greca* i 343. c. 550?[9]
18. Selinus? Palermo, Fondazione Mormino, Lakonian krater inscribed on lip with owner's name and patronymic; unpublished. 525-500?
19. Metapontum. Graffito on vase; Guarducci l.c. in note 6. c. 550?
20. Delos. Graffito on vase; *LSAG* Central Aegean 43b. The vase to be dated c. 550, but the tail of the *rho* may be accidental.
21. Rhegion? Names painted on Chalcidian vases; Rumpf, *Chalkidische Vasen* no 2, 4, 6, 9, 12, 17 and 19. 540-25, save 17 which is later.
22. Where? Graffito on lekythos, s.l. 1, 24. c. 530.

It is difficult from this evidence to form an idea of the spread of use of the letter. 14, 18 and 22 are of uncertain scripts, but we see that Argos and some of the Black Sea colonies were early users, that it remains in regular use at

Argos and is soon taken up by the painters of Chalcidian vases and that sporadic early uses are found in a number of other areas. In some of these the lunate *delta* was established and so there was some need to distinguish it from *rho* in less careful writing. In East Greece there was no such need, but we should note that on 7 the exaggerated version of the *alpha* could certainly be mistaken for a *rho* were it not tailed. Such exaggerated *alphas* are a phenomenon of the period c. 550-500. [10] In sum, it appears likely that there was no single origin for the form, but a possible case for Delphian influence could be made in a number of areas.

The letter appears rather later in Attica than elsewhere. The earliest occurrence in an informal inscription that I have noted is on Agora P23372, a storage amphora with an *alpha-rho* dipinto, datable to the period 520-480. No other Agora graffito with the letter has a footing in the sixth century, although the letter does appear frequently enough in vase inscriptions of the end of the century. [11]

The interpretation of the mark in question as *epsilon-rho* can be upheld simply in terms of whether the letter was in use at the time, and is preferable to any other, as I have demonstrated above; but the script employed cannot be pinned down - was the name aspirated or not? He may have come from Ionia, the Cyclades, Athens or even Rhegion (presumably not Argos or Phokis).

Even if the tail is discounted the shape of the *rho* is different from that in sub-group i (save on 22). The form with a small loop is not the commonest at this period. Similarly noticeable are the mature *alphas* on 29 and 20 with high, horizontal cross-bar, akin to those in type 8A. The main accompanying mark, sub-group ii, is Etruscan (see type 4E) and the accompanying signs on 26, 27, 29 and 32 are also Etruscan, with some reservations about 29. [12] We may note the presence of both Antimenean and Leagran vases.

38 - 42 are a close group of RF vases; the extra stroke on 38, hardly in the right place for a tail, can be disregarded. As the provenance of all the pieces may be Gela we cannot rule out that this is an owner's mark; alternatively, it may be commercial and the B on 41 and 42 an owner's mark. [13]

The ligature of sub-group v may be compared with the similarly formed 9E, xi. 44 - 45 may be closely connected. Few of the remaining pieces are in any way remarkable. 60 is perhaps the most interesting; one can hardly think of it as Etruscan with its Greek *alpha,* tailed *rho* and orthograde direction, but it would be very odd Greek. [14] 47 seems to have some connection with its fellows in type 8E, but not with its companions here. 56 is a most odd abbreviation, perhaps of more than one word.

Type 4E

The figure-of-eight sign was introduced into the Etruscan script in the sixth century, replacing the earlier form of notation using two letters, *digamma* and *heta.* [1]

The dipinto is fully curvilinear, while the graffiti show the difficulty of inscribing two circles. [3]

The abbreviation Fa - - is common in Etruscan; it is probably to be taken as a personal name. [4] As it appears with type 3E four times and only three times by itself, it is likely to be a commercial rather than owner's mark, especially with two provenances allegedly involved. As type 3E is so often accompanied by an Etruscan graffito, I am tempted to think the association more than casual or accidental; at any rate the dipinto 1 would be in an unusual medium for an Etruscan owner's mark; it was presumably applied after firing and not in Athens, unless one suggests (?improbably) that the Etruscan in question placed orders in person in Athens. 1 is in addition much earlier than the rest; the *CVA* photograph shows a break and the join of foot and body is not particularly pleasing, but this could have been an original feature. If the foot does belong, the sign would be among the earliest 8 known.

Type 5E and 6E

I discuss these marks together, since it is clear that they are closely related and appear mostly in company. Interpretation is difficult, as so often with gregarious marks on Leagran vases. The only published suggestion here is Hackl's guess (p. 68) that 5E is a ligature of *beta* and *upsilon.*

The Antiope/Acheloos branch of the Leagros group is much involved, as in type 17E; also the Simos group has four members in type 5E, one of which is accompanied not by 6E but by a dipinto of type 9F. This suggests that 5E may be a personal monogram since it is unlikely, though not impossible, that two vase-name marks should appear, especially in graffito and dipinto form, on a single foot.

Most intriguing is the mark of type 11E erased on 21. We can see that on a vase of the Simos group a mark of type 5E and perhaps 6E also was to be expected; a 'wrong' mark of type 11E was applied and then erased as far as possible. This does not explain how a mark of type 11E came to be cut on the vase, instead of on work from Painter A or the group of Vatican 424; it is most instructive that it was so cut, but a complete explanation (or rather a single one) is scarcely to be expected. In particular we should note that this example puts type 5E relatively late in the history of the vase, since 11E in turn is incised over a mark of type 10E in a number of instances.

The network of marks on vases of the Antiope group as a whole demonstrates a certain commercial unity, yet the lack of complete uniformity and the fact that a smaller percentage of its vases bears marks than in the rest of the Leagros group points forward to an absence of sizable close groups of marked vases among the painters who carried on the tradition of this part of the group. [1]

Again we have a single Antimenean piece, 5E, 11, in a Leagran setting. The mark close to type 17E on 5E, 12 is discussed under that type; it too could have had a vase-name significance.

If 5E is the abbreviation of a personal name, 6E probably is not. The basis of the mark must be a Greek *pi,* but with a mysterious added stroke. A numerical interpretation could be considered, yet the mark occurs too regularly for a price or batch meaning to be considered, and when vases of the Leagros group do not display the Ionic numeral system, they tend to have the *'gamma'* form of five (see p. 29). The extra stroke may be of too regular occurrence to be thought of as a countermark, of the type suggested under types 8E and 2F.[2]

24 - 26 are clearly closely related, but with no sure connection with the main body of the type. The mark may be a complex ligature, but the suggestion KΛP in *CII Appendix* 40c-d is unpromising. For 27 see on 2F.

An unusual feature of both types is that they appear in various positions on the foot, both absolutely and relative to each other. 5E, 1, 2 and 22 have the mark horizontal to the edge of the foot.

6E, 2 is not connected with the rest of the type; it merely has a similar mark, interpreted by Milne *(apud* Richter and Hall 221) as ΓV or VΓ.

Type 7E

The existence of this apparently alternative form of 5E should warn us against any too obvious explanations of that type, unless we are prepared to consider it a completely misunderstood version. There seems no very good reason to connect it with type 16C, q.v. Without having identified 2, I can say nothing about the possible relationship of the vases.

Type 8E

The frequent occurrence of this mark suggests that we should be able to have some idea of its interpretation; yet it remains enigmatic. I have outlined the major problem involved in *BSA* 70 (1975) 152 - whether it is Greek or Etruscan. The shape of a number of the marks is that of an Etruscan *alpha* with an otherwise unusual horizontal cross-bar, necessitated by the extra component of the (?) ligature.[1] The diagonals can be straight, angled or curved, precluding a reading as Ionic *lambda,* or reversed as *upsilon.* I know of two other uses of the mark on non-Attic vases, Rhodian 97 *(BSA* l.c.) and a 'citola di argilla rossastra con tracce di vernice nera' from Vulci.[2] The Ionic vase may have come through the Peiraeus or rather have been marked by a trader who used the Attic market, and the slight difference in the shape of the graffito on the Vulci piece, and the uncertainty of its place of manufacture restrict its use as proof of an Etruscan origin of the mark.

More striking is the fact that all vases attributed to **Painter A** and the group of Vatican 424 bear the mark, while none of the other, clearly Greek marks which they have are so monopolistic. It is difficult to explain this situation if the mark is Etruscan; certainly no private Etruscan owner could have been so eclectic and yet so all-embracing at the same time, and if we think in terms of an Etruscan commercial graffito, we must again ask why it appears on such a selective range of vases (ignoring for the moment the question why it appears at all). The trader must have had close and well-regulated ties with the Greek merchants whose marks appear on these particular Leagran pieces and quite casual dealings with others such as those represented in sub-group x. Without these obvious difficulties one could accept that the mark must be Etruscan on palaeographical grounds, but otherwise a *non liquet* is wise.

The secondary nature of the mark is demonstrated not only by its relationship with the glaze marks of type 9E and 10E, but also by other accompanying marks. The other marks on 36, 55 and perhaps 37 are more typical of the vases by the painters concerned than the mark of type 8E:[3] it is probable that the mark of type 1B on 54 is also the primary graffito, associated with 1B, 11 - 13. In all these cases our mark is in a sense intrusive. Further the mark is often cut upside-down to the pre-existing mark of type 10E on the foot, and therefore can have no very intimate connection with it; we may also assume that our mark and its accompanying sign were cut on either side of the type 10E mark on 41.

Without being sure of its origin it is dangerous to speculate on its interpretation. The base is surely an *alpha;* the earlier examples have a form which is not typically Etruscan, but this need not indicate a non-Etruscan source since the 'typical' Etruscan form was still evolving.[4] Hackl tentatively suggested a ligature of *alpha* and *iota,* while *alpha nu* is suggested for the Vulci plate noted above. Neither possibility can be accepted for the bulk of the type. The variety in the length of the strokes at the ends of the cross-bar does not encourage the view that any particular letter is represented, but the very fact that the cross-bar is always horizontal does indicate that there was some specific purpose in this constituent part of the mark.

The regular companion of the main mark is probably a form of countermark. A similar mark can be seen on some vases of type 2F, if one takes part of the *eta* in ligature as the vertical; also here an additional stroke can be added to the basic *alpha* mark. Where only one stroke is added to the 2F ligature we have a parallel for the tick-shaped mark here and elsewhere. I suppose that the X on 5 is related. Hackl knew of no vase with the countermark standing by itself, but 58 and 59 are obvious examples.[5] It may be that the *lambda*-shaped mark of the two dipinti, 1 and 2, is also such a countermark, with the *epsilon* not to be taken with it (could it be the same mark as the graffito accompanying 53?). If one does take the *lambda* and *epsilon* together the orthograde direction does not entirely support an Etruscan origin.

Whether the roughly circular mark on 38 and 39 is a particular form of countermark also cannot be demonstrated, but the likelihood is strong.[6] 61 may present both the tick and circle form of countermarks; certainly the shape of the mark is not as in type 21A. As a vase 61 connects closely with neither 21A nor 8E.

The accompanying *alphas* on 30, 31 and perhaps 32 are clearly not countermarks. We have seen similar *alphas* in types 8A and 3E, iii; both these are Greek marks and the *alphas* do or could depend on them. Here the letters, with their Greek shape, presumably stood alone on the vases before the mark of type 8E was cut. Instances of simple *alpha* are not rare, but there are no indications that the letter occurs on any close group of vases at this period.[7]

The majority of the vases fall in the period 515-490. 53 is much earlier; perhaps the foot does not belong, although I noted no obvious discrepancy. Its accompanying mark would also be more at home later in the century. See also on 15B, 14.

Although the mark appears on the works of a greater range of BF and RF painters than is the case with most contemporary marks it has an affinity with 5E and 2F in being the hallmark, as it were, of a particular section of the Leagros group, and like other Leagran marks appears rarely on products of the Antimenean workshop, here represented only by 3 and 54.

Type 9E

This abbreviation is by far the most frequent in general terms and the large number of names beginning with Ar- or Ari- accounts for that frequency.[1] The type presents a microcosm of the history of marks as a whole: the earliest marks are red dipinti, but the rest graffito, save for a small group of glaze dipinti in the late sixth century.

The closeness of 1 - 3 and the isolation of 5 is self-apparent. The large range of marks on Lydan vases contrasts completely with the single marks found on all the vases attributed to such hacks as the Painter of Louvre E824 here and the Zurich painter (type 6B); were the latter single shipments of vases (of whatever size originally) or the surviving remnant of the production of a longer career?

The glaze dipinti are assured an origin in Athens; the neat *alpha* and stemless *rho* (save 8) are untypical of Attic monumental script at this date, but adequate parallels can be found among vase inscriptions. Possible connections of the glaze dipinti and in particular 10 with other sub-groups are discussed below.

The general upward slope of the cross-bar in sub-group iv is striking; where it does not appear the vases seem to be outside the painter and workshop groups of the rest. The consistency of the shape suggests that either they were all cut by one man or that they originate from a state where this form of *alpha* was regular. Neither this type of *alpha* nor the stemless *rho* was regular in later sixth century Athens.[2] It is unlikely that it was used to give the monogram a balanced appearance, since the examples from Adria, and other owners' marks from Athens,[3] have the form with cross-bar sloping down. I do not insist that we have here a non-Attic mark (Aeginetan, Megarian or Milesian?)[4] but would postulate a single man's hand if an Attic origin is argued.

The only substantial Lysippidean group is found in this sub-group, 20 - 30. The connection with the later work of the Affecter is also clear; all the neck-amphorae are late, with his inimitable floral on the neck.[5] Strikingly, there is only a single Antimenean representative, as also for the Leagros group, belonging to a less commercially organised branch of the group. There is a generous range of provenances, compared with the concentration of pieces from Vulci in more 'Leagran' types. The significance of the bilingual from Bologna is discussed on p. 13.

There is no indication that the unit strokes on 33 are to be taken closely with the ligature (see ch. 6, p. 30). The accompanying ΠΟΙ on 28 and 56 is discussed under type 8F; it may give a clue as to the interpretation of the unit strokes - ? decorated vases in the same batch, but other possibilities remain open.

The accompanying mark on 53 also appears on 77, and 81-83. The different shape of the ligature on these four may not indicate the same 'Ap - - as in sub-group iv, yet the association of sub-group iv with early RF and the nearly exclusive representation of early RF in xi does suggest a connection. No other mark, or varieties of a single mark, appears so frequently on such vases, and none other is found so often on both RF and BF of these years. If we are dealing with a single man using different forms of the monogram, we can say that he had a good eye for the market; the Affecter was well established as an Etruscan favourite when he began his career, and his association with the workshop of the Lysippides painter led him to blaze the trail for RF, which he followed up desultorily until he came upon the young Berlin painter and his more traditionally minded colleague, the Nikoxenos painter.[6]

Is the same man indicated by the glaze dipinti? They are unlikely to have been painted by the hand of the person to whom they refer, and so they may constitute orders for this man. It is more difficult to decide whether the graffiti 42 and 58-60 are also to be included. They are not by the same hand(s) as the bulk of sub-group iv, but still may refer to the same person; in this case we can only base our argument on the premise, supported by the general connection of the Leagros group and early RF, that not more than one 'Ap - - was in business at one time. If we accept the association we obtain a very large group of BF and RF vases.

Taking these arguments further, we may turn to sub-group xii. Here tailed *rho* appears later than in type 3E; the interpretation is secured by the unligatured 91. Its use by the Berlin painter suggests a link with the different form of the mark found in sub-group xi. It is also tempting to connect the rather Leagran 86 with the Leagran pieces found elsewhere, though the vase is a pelike and the mark retrograde. The Athena painter's vase was found in the same grave as a neck-pelike by the Berlin painter, and may then have formed part of one shipment.[7] We may note that the Berlin painter is a user of tailed *rho* in his early vase inscriptions and so may have applied some of these marks personally; however this would necessitate a different explanation of the tailless ligature of sub-group xi on his earliest vases.[8] 85 in particular points up the niceties of these possible connections with a 'Leagran' glaze dipinto and an apparent variety of the 'internal' ligature.[9]

Sub-group v has a clear Acheloan flavour and the early RF hydria is presumably to be taken closely with the rest. It cannot be fully excluded that this retrograde version is an Etruscan ligature, CA.[10]

The accompanying mark on 75 and 76 may be a *lambda,* indicating an Attic origin, or a countermark. A similar additional mark is seen on some of sub-group xiii; this is a close group since the pieces not from the hand of the Syriskos and Copenhagen painters are more or less contemporary, and two of them, 101 and 102, have vase-name marks in addition, as 108. As in sub-group xii, the Athena painter's workshop is represented. The mark may be a ligature of APTI or APXI, but it is not easy to see a consistent value in the varieties represented. It is unlikely, though, that the same man is to be seen in sub-group xii, rather an 'Αρι - - .

Another API appears on the two Dourian vases 122 and 123. The style of the type A amphora in Bologna, 64, could be said to be in the Dourian tradition and one wonders whether its ligatured form could be related to the unligatured on 122 and 123. We have seen ligatured and unligatured versions on vases by the Berlin painter in sub-group xii and the Phanyllis painter too presents both types, 69 and 119-120.

The ligature on 118 seems to be of AMBP, not apparently as on the roughly contemporary 113, which I take to be *alpha* and tailed *rho.*

On a number of pieces the abbreviation seems to be directly associated with numerals: 71 - 74, 98, 119-120 and 124. None, we may note, has an Etrurian provenance. 74 has no obvious connection with any other, and the numerals are slightly set apart. 71-73 are difficult to assess; while 71 and 72 have closely similar marks, with the numeral on 71 being six, that on 72 five, 73 has a different form of the monogram from 72 and seemingly the alternative *'gamma'* sign for five. 119 and 120 are connected by the painter; it may be doubted whether the single stroke on 119 is other than an *iota,* part of the abbreviation, but the *pi* on 120 seems more likely to be numerical than part of a different abbreviation; if it is a numeral it is quite early. 98, like 119, is from Gela, though much later; on it the sign Ѵ comes between the *alpha-rho* ligature and the indication of a batch. It is not easy to interpret this, but most likely it is a local 'red' *chi,* rather than *psi* or a non-alphabetic sign. In this case we may tentatively think of an abbreviation of χυτρίδια or the like.

On 124 the API is in close connection with numerals and associated with adjectives describing vases; if no particular supplement comes readily to mind, the general connotation of the prefix ἀρι - - is relevant enough.[11] Here and in 73a a vase-name orientated interpretation is preferable, and it may be so with 71 - 73 as well, since the numerals are directly associated with the mark and a further abbreviation is present on 71 and 72, probably of a personal name.

Finally I note that the type is included in section E largely because of the glaze dipinti, which were painted first on the feet and only later became accompanied by other marks. Apart from these and a few other accompanied or possibly vase-name marks, the type is comparable with section B types.

Type 10E

This is another type largely qualified for section B, except for a set of accompanied Leagran pieces. Commonly found as an abbreviation elsewhere, its appearances as a commercial mark are comparatively limited.

On the Leagran vases the mark occupies a position closely analogous to the glaze dipinti of type 9E. The discovery of the red 28 and in particular the glaze 23 have eased the problem of relating the two types. Presumably glaze, red and graffito ME on the Leagran vases all refer to one person; so the mark still had relevance after the firing of the vase. By contrast, we have no certain red or graffito comparanda in type 9E. Not but what, the mark did have a limited use, as it is twice obliterated by an overincised mark of type 11E (and further, 11E was replaced by a mark of 5E on 11E, 48). Both ligatured and unligatured versions are used, seemingly at random, within this close group.

No obvious close groups emerge from the remaining material. The lekythoi could be related, especially 7 and 9, although they do not come from a single tomb and so are unlikely to have been the property of one owner. 10 must be rather later; whether the mark as a whole is closely related to that on Berlin 2081 (see 9E, 71) depends on whether the reading of the monogram on the latter is faulty; their similarity in other respects suggests that the monogram may be the same.

On Berlin 2081 and 10 I suggest that the *alpha-rho* mark may be some kind of vase-name abbreviation, and so the mark of type 10E can be a personal ligature. On 21 however, there is a vase name and two other marks, of type 9E (?) and 10E. Amyx (*Hesperia* 27 (1958) 198, n. 79) suggested that the ME is an abbreviation of μεγάλοι, qualifying the KOP - explicable as Corinthian kraters. Such qualifying adjectives are very rare (see 24F, 1 for an example), and I doubt whether there is one here. Despite having the same abbreviations, or at least similar ones, Berlin 2081 and 10 provide no parallel, since in view of their size the ME can hardly indicate large vases and the numerals are dependent on the type 9E mark. Neither abbreviation is common at the time of manufacture of 21.

The additional marks on 30 should be noted. The vase belongs to the Painter A and Group of Vatican 424 branch of the Leagros group,[1] and we would expect the regular set of marks, as in sub-groups ii and iv. The first mark on the foot may be of type 11E, though I doubt it; the second may be a variant of type 8E - see on type 1A and note 2 to type 8E.

Type 11E

Under this heading I also remark on the whole set of marks on the Leagran vases involved.

There are similarities with type 8E: the mark occurs alone, but not as often as with a habitual accompanying mark, on a range of vases of the late sixth century; it occurs with other marks on vases which belong to close groups

formed by those other marks rather than this one; it occurs with a collection of other marks on vases of the Leagros group; there is some variety in the shape of the accompanying sign (though here most of the vases with variations are earlier than those with the regular sign). From these earlier pieces we may assume that the additional mark became attached to the main sign by naturalisation rather than birthright; its original shape is somewhat like an exaggerated archaic Etruscan *tau*.[1] It presents the same problem of interpretation as the cross-bar of type 8E: the varieties of detail seem to preclude a single explanation, but the feature is significant enough for one to be desirable.

A major difference between the two types is that we can be sure that 11E is Greek. The mark may occur as an Etruscan numeral for 500,[2] but that is hardly relevant here. Many of the graffiti are cut with a care not apparent in Etruscan marks, but most important is the fact that 48 was clearly incised before the Greek mark of type 5E that overlies it. The additional mark on the later vases takes the form of a *digamma,* which would be at home in Etruria; no Greek state using equilateral *delta* was also using *digamma* as a letter in this period,[3] and no straightforward explanation as a numeral seems acceptable. The *digamma* shape is only established after a period when other forms, X and tick were used, attached to or separate from the main mark (sub-group ii). Both are found on 11, and I believe that all the graffiti on the vase are in the same hand; so we cannot regard any part as a countermark added at a later stage; X as a 'regular' countermark of some kind seems to be used on 16 and 8E, 5. A further tick in addition to the regular appendage appears only on oenochoai and the unidentified foot, 24.

Since the mark is twice incised over a mark of type 10E, we may assume that it had no immediate relevance to the pottery in Athens, but like 8E and 2F had some use in a later procedure. Since 8E and 11E can appear together they are unlikely both to represent the same usage. Perhaps the deltoid mark 3F had a similar purpose to our mark, but evidence is lacking.

The origins of the main mark are unclear. 8E, 53 may be a 'rogue' example, but 9 here cannot be doubted; not only is it of the decade 540-530, but unique among the members of 8E and 11E it has a known provenance other than Vulci. The provenance of Tarquinia, the situation of the mark on the navel and the link with Group E suggest a connection with type 2E or 36A. Both types have elements in common with 8E and 11E, but lack the accompanying sign. However, the development in shape from 2E to that of 9 seems too substantial for the few years that separate the vases.

Discussion of sub-groups iv, v and x is reserved for the other types involved.

The Leagran vases of types 8E to 11E and those of type 2F share possible countermarks and perplexing deltoid signs; overincisions occur in each group and they share a large slice of the Leagros group between them with no overlap. While the individual marks in types 8E to 11E occur on a wider range of vases, together they appear on as restricted a set as type 2F.

Yet despite these resemblances it is impossible to find any similarity in the meaning of the marks. The core of type 2F, sub-group vii, is concerned with accompanying batches of various types of vase. There is no indication of numerals or vase-names being involved in types 8E - 11E, and the only variations are minor compared with those of 2F, vii. None of type 2F could be considered Etruscan, while here there are strong Etruscan claims for 8E. Here a personal monogram was cut or painted first, of type 9E or 10E, and then after some time the marks of type 8E and 11E were applied. In type 2F there is no certain personal abbreviation; the only candidate, 3F, was cut at a late stage of proceedings. 8E or 11E may perhaps be personal abbreviations to match 3F, but the possibility must be considered remote in the case of 11E with its optional appendage and its repetition on 42 - 44.

If we cannot reconstruct the mercantile history of this set of marks as tidily as we can that of type 2F, we can at least see that they were marketed with some degree of organisation. The elements involved were in existence before the advent of the Leagran workshop, unlike 2F, and no use seems to have been made of batch marketing.

Parallels elsewhere for the mark show that it had a wide currency. There are Bronze Age pot-marks of a similar shape,[4] two Attic pieces from Naukratis and one from Abydos,[5] and a mark on the shoulder of a hydria, possibly East Greek, more likely local, from Bologna.[6] On none of these is there any trace of an accompanying sign.

Type 12E

This type is placed here because of its general resemblance to 11E and the particular appearance of both marks on 30 and 31. One of the striking features of the type is the large number of oenochoai, far more than in type 11E, where there is still a noticeable number. 30 and 31 are among the latest vases in type 11E, and along with 11E, 25 and 26 have an additional independent tick-shaped mark, as well as repeating the main mark, not simply as on some of the Leagran pieces, but complete with the *'digamma'* attachment - on three occasions at least on the handle. On 30 and 31 the two marks with their respective satellites could be regarded as equivalent: both are deltoid marks associated with a *digamma*, of advanced shape in the case of 12E.

Is 12E merely a later version of 11E? It is just as Greek as 11E in view of the neat incision, the range of provenance (note especially 13) and the accompanying Ionic numerals on some of the pieces. The most obvious numerals are on 26 and 27, both mentioning batches of twelve, and I suggest that the *digamma* on 28, 30 and 31 is also numerical, batches half the size of those noted on 26 and 27.[1]

If 11E and 12E are equivalent we would expect some note of the batch size with the mark of type 11E on 30 and 31. This could only be in the attached *'digamma',* making batches of six a regular feature of type 11E. An obvious drawback is this very regularity; the only possible variant is the *zeta* on 11E, 15. Also we saw that the accompanying mark *develops* into this shape from an irregular tick.

Therefore the apparent identity on 30 and 31 is misleading. So might be the further *digamma* on 8, 14 and 19; here it is part of the Etruscan abbreviation FE, apart and in a different hand from the rest of the graffito: it would be interesting to know if the same person is denoted in each case since 8 and 14 are not closely contemporary.

Jongkees-Vos (l.c. on 6) has suggested that the mark is a ligature of *delta* and *eta*; I would add 'possibly' and 'or *lambda* and *eta*'. The association with numerals and its appearance with EVƎ in sub-group ii points away from it being the abbreviation of a personal name; it could indicate a vase-name or the like, and *lambda-eta* will be shown to be an excellent candidate (type 2F). Yet I am loth to reject all connection with type 11E; here only a non-alphabetic interpretation can secure any kind of equivalence. Perhaps the two marks are ideograms, akin to 9D.[2]

The prevalence of oinochoai is accounted for by the fact that the type is basically late BF, when fewer large vases were being produced. There is no other mark so devoted to late BF. The Painter of Vatican G49 is prominent, but much comes from outside his workshop and so we cannot judge the relationship of the RF pieces with his work. Virtually at either end of almost any scale are 13, a slight lekythos in Six's technique from Fratte, and 20, an exquisite and early bell-krater from Etruria.[3]

Type 13E

This is very much a one-painter mark. It appears on twelve of the thirty-four large vases of the conflated Priam/ AD painter which have feet and of which I have knowledge. The rest belong to a range of contemporary BF painters, save 1, 28 and 29, which are slightly different in form and 17 which is later.

The basis of the mark must be a Greek *(h)eta.*[1] Corinth 105 has a similar mark dipinto, but I argue that its basis may be a *zeta,* and it is too much earlier than our type to have any direct connection with it. On 22 the mark seems to have been cut before the accompanying mark of type 8E.

The additional stroke(s) seems to have been cut at the same time as the *(h)eta,* and so is integral to it, not any true countermark.[2] On two sherds from the Agora where there is one added stroke we can think of a ligature of *eta* and *gamma,*[3] but two additional strokes make it difficult to accept a purely alphabetic explanation. There is no sure connection with type 2F or any of the other *lambda-epsilon* marks to follow.

Like the strokes the V-shaped sign found in sub-group ii also seems to have been cut at the same time as the main mark; at any rate, the mark of type 8E on 22 has very ragged edges while all the rest is in broad but clean lines, somewhat untypical of the other, often untidy marks of the type. The V therefore emphasises some point connected with the incision of the main mark. It may not be coincidence that all the vases in the sub-group are hydriai; it is certainly possible that the sign is a *upsilon,* standing for unaspirated, presumably Ionic, ὑδρίη.

An Ionic origin is further suggested by the four-bar *sigma* on 27, though we cannot say how closely it is connected with the main mark. Only on this vase do we have a mark that can be definitely taken as a personal monogram; none of the selection of marks on 26 promises in this direction, though they seem to lack any relation with any other mark at all.

Type 14E

Another unusual, and inscrutable mark. Even its orientation can only be secured by analogy with type 11E, with which it is five times associated. On the same analogy we can consider that the added 'tick' has the same force as in type 11E and 2F.[1]

It may be thought that the mark is constituted of closed *(h)eta* and *lambda* - giving a complete equivalence of the two marks in sub-group ii. Yet there are weighty objections. The *'lambda'* is more likely to be some kind of counter-mark, as in type 11E, than an undeveloped Ionic *lambda,* or, by upturning, an Attic or Etruscan *lambda*; on 3 and 7 it scarcely resembles a *lambda* at all, and the closed *(h)eta* standing by itself on 11E, 21 suggests that it was dispensable, just as the addition to type 11E. We would also have to explain why a closed *(h)eta* appears here on vases rather later than the bulk of type 2F, at a time when the closed form was becoming something of a rarity.[2] The variation in 12 and perhaps 2 also point away from this explanation; a *(h)eta* with two cross-bars does occur occasionally in Euboean inscriptions, but is rare enough to make its presence on 12 unlikely.[3] If there is any kind of equivalence between the two marks on vases of sub-group iii, an alphabetic explanation is unlikely.

13 is similar to the rest and may have been cut at Gravisca, but whether by a Greek or Etruscan cannot be fully ascertained.

To ponder whether the variations found on 12 in any way form a bridge between types 14E and 2F; the pieces in sub-group ii are not integral members of 2F.

14 is probably ΛEV with a non-Attic *lambda.*[4]

Type 15E

I have discussed 4 and 5 under type 8E. Langlotz's facsimile of 4 does not encourage the view that the two letters belong together.

For the rest we face the question of whether the *lambda* is Greek or Etruscan. Certainly Greek on 8; see on type 10F. The rest of the type is early enough for retrograde versions to be Greek as much as Etruscan.[1] A similar situation arose with 14A, where both orthograde and retrograde versions appear on Lydan vases, as here. The dipinti are perhaps more likely to be Attic.

9 is a curious mark; there is no obvious reason to doubt its authenticity, but the collocation of letters is highly unusual. No single word begins λεξε, save for parts of the rare aorist of λέγω, hardly a promising area. The reading cannot be doubted and the letters are too close-set to split the mark into constituent parts. The only explanations open are to condemn the mark or to think in terms of a hybrid script with blue *xi* and Attic *lambda,* such as just possibly an Ionian Lydos may have adopted for his personal use. I cannot trace 10 which may throw further light on this question; Beazley read *tau,* but there can be no doubt of the *xi* on 9.

Type 16E

This is the first of a number of marks, apart from the obvious 15E, which can be interpreted as *lambda-epsilon.* I defer general discussion of the origin and significance of these marks until types 21E and 1F.[1]

I suggest such an interpretation for some of this type because of 2; here we have graffito and dipinto marks which I would take to be equivalent (*CVA Oxford* l.c.) on the grounds that on several vases of type 21E we find similar repetition of graffito and dipinti, not always, as far as can be judged, in identical form. 2 should take the other pieces by the Rycroft painter with it. 5 and 6 could go with them. I have noted under type 8E that the foot of 1 may not belong; the mark is smaller than in the rest of this type, but it may well belong to the same period, perhaps as much as twenty years later than its apparent date. A further connection with type 21E is afforded by 6, since two kalpides by the same painter have a variety of type 21E (21E, 60 and 61). An unusual feature shared by the kalpides (with the BF 21E, 59) and 6 and 12 here is the second monogram; it would seem that this AP mark is more typical of the vases concerned than the *lambda-epsilon* graffito and should be taken as a personal monogram.

In other instances a ligature of TE may be preferable, as for example the close pair 8 and 9, perhaps with 7. Although the mark is not very close to the presumed price graffiti on the same foot a direct association cannot be ruled out.

Type 17E

This is one of the more unequivocable *lambda-epsilon* marks. Epigraphically there is little to compel the reading of the first letter as *lambda,* but it is at least disentangled from any complex ligature. The mark must be Greek, not Etruscan.

The early examples are a mixed, but interesting bunch, 1, 22, 23 and 25. We may note that the foot of 1 is lost; possibly the same mark was cut under it. Nonetheless it may be significant that a similar mark appears on the neck or shoulder of two decorated vases (1 and 25). There is no sure evidence whether the first letter should be regarded as Ionic *lambda* or Attic *gamma* and it is not easy to assess whether the mark may have any vase-name significance such as may be seen in some later members of the type. Much the same must be said of 12, and without knowing the provenance of 13 one should not speculate about the meaning and direction of the mark.

The bulk of sub-group i and some of ii is centred on the Leagros group, specifically the Antiope group. It should be noted that 2 is the only vase attributed to Painter S which does not bear a mark of type 2F, vii. The provenance of 9 is also noteworthy, a rare exception to the Leagran commercial monopoly of Vulci. I doubt whether there is any significance in the fact that all the Leagran vases concerned here are hydriai.[1]

It has been suggested that the mark is equivalent to type 2F; we shall see in type 1F that the spelling of vase names in *le* - - varies between *epsilon* and *eta,* and so on these grounds the interpretation could be accepted; but there is one substantial difference: 17E is rarely, and then only later, accompanied by numerals, while 2F often includes tallies of vases. I consider this a strong argument against a vase-name interpretation of 17E.[2]

Three of the vases in sub-group ii are in some way Leagran, 14, 15 and 18. 14 also has a mark typical of the Simos group, though Beazley puts it on the fringes of the group. Our uncertainty over the interpretation of the accompanying mark (5E) does not help the interpretation of 17E, but at least the four-bar *sigma* cut in the shelter of the first letter confirms its identity as Ionic *lambda.* The second mark on 15 is typical of the Painter of Louvre F314; there is no means of knowing whether the vase is his rather than late Antimenean, but the *lambda-epsilon* points in the former direction.[3] While the Eucharides painter is a late member of the Leagran workshop and therefore 18 may have a similar connotation, I have reservations. The painter shows no commercial connections with the Group elsewhere, and on 18 we find a direct association with numerals, the sole occurrence in this type before c.450.[4] I would follow Milne in taking the ΛE as an abbreviation of a vase name and the KR of a personal name. An early parallel for *lambda-epsilon* as a vase name is 15E, 8, though there the *lambda* is Attic. In each case the attached numbers are large, suggestive of the ΛHKV of type 2F, vii. 16 and 17 are accompanied by type 10F marks, as is 15E, 8; the contrasting *lambdas,* Ionic and Attic, pose a problem which I attempt to explain below (p. 227). It emerges that the ΛE on 16 and 17 cannot with any certainty be connected with the Leagran examples. For 19 and 20 see on types 9D and 18E.

Some of the ligatured marks of sub-group iii bear a closer relationship with other *lambda-epsilon* types: 26 is by the painter who dominates type 21E and 24 seems closely linked with the mark of type 16E on the same foot. 28 on the other hand affords an important link with the non-ligatured version of the mark.[5]

29 and 30 are a closely related pair with no clear connection with the rest of the sub-group, and the later examples attest the sporadic use of the mark in the fifth century. They show no coherence compared with a set from Bologna, 46 - 48, which can be taken separately in view of the special form of the ligature and the position of the mark on the navel. 49 is so much later than them that we cannot assume a connection, though the provenance may

tempt us. 45 is of similar shape, but closely bound up with type 21E by date, workshop and accompanying dipinto.

We have already noted the appearance of ligatured and unligatured versions of a mark appearing on vases of the Berlin painter (p. 207 and 212) and I suspect that 35 is to be taken with 16 and 17.[6]

21 is clearly separate from the rest of the type. A batch of twelve ΛΕ is noted; I assume that they were of the same shape as the marked vase and that the abbreviation stands for λεκάνιδες; the significance of the final *(h)eta* is unclear. Some of the other marks in the type may also refer to lekanides, but there is no direct evidence for the interpretation.

Type 18E

With this type we enter a very tangled web, involving not only the previous 17E and following 19E, but also types 9F and 10F. We shall see that the latter pair have much in common, even if only 10F is satisfactorily explicable. 18E can stand alone or in company, as those types, but unlike them it does not admit numerals into its presence; we must first examine the company that it does keep to see how intricate the relationship of these types is.

The Syleus sequence and Tyszkiewicz painter predominate. Each is represented among the unaccompanied marks in sub-group i, and (via 12) in type 5F; but otherwise they go their own way. The combinations in sub-groups ii and iii are confined to Sylean vases, but we should note one Sylean vase, 10F, 7, which must have some connection with the members of 10F from the workshop of the Berlin painter which also have ΛΕ. 8, as well as having a mark of type 17E, has one of type 19E, which affords further links with the other types in question. 11, by the Tyszkiewicz painter, has the same mark, and also ⌐ Ρ Ο, which appears on some of his other vases (10F, 17 and 19) in association with ΟΝ. It seems therefore that a number of these marks are alternatives, though any, save 18E, can stand by itself. To round off this picture, 13 is accompanied by a mark of type 9F, serving to underline the similarities between types 9F and 10F.

This is not an easy web to disentangle. Epigraphically, 9 appears more archaic than the rest, though this must indicate a different, not earlier hand, since 8-10 and 12 must be put closely together, probably in the 480s. 6 and 7 are earlier, and we have noted, under type 9D, that there is a probable equivalence between their pictogram and the ΚV on 12, while the ΛΕ, ΛΙ and ΛΕΚΙ on 8-10 here may be alternatives; they are so close as vases that I suspect the three versions reflect a single notion. Certainly the ΛΙ seems to be an alternative form of ΛΕ, although the ΚΙ on 10 is more perplexing; possibilities are λέκ(υθος) 1, λεκίθια or the like, λε(κύθια) ΚΙ (parallel to the *kappa* on 6-7).[1] I do not think that the ΚΙ or *kappa* on 6-7 are likely to be personal abbreviations. The *kappa* is rather the initial of κύλιξ.

Nothing can be gleaned from the shape of the marked vases to suggest an interpretation of ΕΜ. Without 13, two possibilities could be entertained, that it is a personal abbreviation, otherwise lacking here, or that it is an introductory mark along the lines of 9F and 10F; 13 throws doubt on both, and points to ΕΜ being an abbreviation of a vase name, as most non-numerical accompaniers of 9F. I would suggest ἐμ(βάφια) as a possibility, an alternative form of ὀξύβαφα (see type 14F) with an acceptable pedigree.[2] Section E may not therefore be the best home for the mark.

Type 19E

The final sentence above must be repeated here. Indeed the interpretation κρώσσοι has already been put forward for 19E. In each case the mark is a little apart from the rest of the graffito, though in 1 and 2 at least the whole is cut by a single hand. The mark therefore could be a personal abbreviation, but the vase-name ambience of its companions, and the related pieces as outlined in the previous types, point rather to a vase-name interpretation of some kind.

Since all the vases are one-piece amphorae, it may be thought that the ΚΔΟ, being the only element common to all, should refer to the inscribed vases; Milne's κρώσσοι could provide such an explanation.[1] It could also be suggested that the Κ on 18E, 6-7 may be related, though that is a far more speculative jump.[2]

Type 20E

The mark is included here more because of the connection of some of the pieces *qua* vases with others among the *lambda-epsilon* types than through any strong conviction that many of the graffiti here should be so interpreted. 1, 3 and 4 are by painters with *lambda-epsilon* marks elsewhere, but the shape of the mark is not easy to square with a *lambda*. There may be a superficial resemblance to type 21E, but our mark is always cut upright, not canted as regularly with 21E. A ligature of *pi* and *epsilon* seems a more reasonable interpretation, especially where the spine of the *epsilon* is shorter than the first stroke of the ligature, as 1 and 12, and the Adria pieces, on which the unusual length of the second hasta of the *epsilon* must be a quirk of the inscriber. Where the verticals are of the same length one cannot rule out the possibility of an Ionic *gamma* being involved, and 11 has a shape that would just allow thoughts of Ionic *lambda*; however 9 - 13 are clearly a close group which must be given a single interpretation, and *pi epsilon* is preferable.

The accompanying marks in sub-group ii are not easy to interpret; the *kappa* can be repeated or turned into a form of asterisk, and also unit strokes can accompany it. A vase-name interpretation seems likely and we recall the *kappa* on 9D, 16, 19 and 20; here κάδια could be entertained (p. 228), although this does not explain the asterisk form. *Kappa* by itself is not a common mark.[1]

15 stands by itself, as it does as a vase; a ligature of *epsilon* and *pi* (retrograde) seems acceptable.[2]

Type 21E

Beazley first noted the Antimenean character of this mark;[1] twenty-three of the thirty attributed vases in sub-groups i and ii come from his workshop, while three are Leagran in the broadest sense. The two varieties of mark in these sub-groups are chronologically parallel and appear on the same range of vases. The form i shows that the mark was conceived of two different parts and helps us to gauge where the break between the two letters comes and what shape the *'lambda'* part originally had. The mark has always been termed a ligature of *lambda* and *epsilon,* though there has been no agreement on the type of *lambda* represented.[2] This crux I turn to later.

We should note two features of sub-groups i and ii compared with iii. In the latter the *epsilon* stands vertical to the edge of the foot, but in i and ii the inscriber could not make up his mind; the nature of the ligature clearly made it impossible for both parts to be neatly aligned and so he placed the whole mark askew. Secondly, i and ii are very rarely accompanied; in this sense there are not section E material, but are included because of apparent relationships between a number of *lambda-epsilon* marks and because two sub-groups, iii and viii, do have companion marks.[3]

10 provides the nearest parallel to the rather anomalous 57, and also has the projecting central hasta of the *epsilon* found on 44 - 46 and 50 - 56, but which only recurs elsewhere in sub-groups i and ii on 25.[4]

Sub-group iii presents its own peculiarities. It is not possible to assess whether 44 or the foot 46 may have come from Tarquinia, as 45.[5] As well as having a vertical alignment for the *epsilon* and a projecting central hasta, 44 and 45 have additional lightly incised lines; they do not appear on 46 however, and we may assume that they are not basic to the significance of the mark. The two complete vases are slight work of the late sixth century, later than most of sub-groups i and ii, but roughly contemporary with the core of sub-group vi. Here we also find the projecting hasta, but a radical difference is the alignment of the *epsilon* facing down, horizontal to the rim. The variation in shape is accentuated by the dissimilarity in the vases; sub-group vi is a Leagran stronghold.

Although the shape of the mark in sub-group vi indicates a separate close group within the type, the meaning of the mark may not be different. 58 is a broadly Leagran vase; the mark is slightly different from sub-group vi, but scarcely enough to remove it wholly from that close group.[6] 57 has a shape of its own, similar perhaps to type 20E, but bending in the middle, not as squarely cut as most of type 20E. On the one hand its association as a vase with 58 suggests a reading *lambda-epsilon,* on the other is its mark so different from type 20E that it should be given a separate interpretation (*pi epsilon*?), especially since it would stand alone as a *lambda-epsilon* mark if we interpret the bulk of type 20E in some other way?

An association with type 16E is afforded by sub-group viii. The *epsilon* is roughly vertical to the edge of the foot and the first stroke of the *'lambda'* is much shorter than elsewhere in this type. 16E, 6 and 12 are closely connected with this sub-group by shape of mark and painter (6) and in particular by the presence of an *alpha-rho* ligature. Nor should we overlook the fact that 57 and 58 are from a workshop very closely allied to the Nikoxenos painter, all within the Leagran ambit. Is it pure coincidence that there is a nexus of similar marks on these vases, or should we consider them varieties within one genus? The latter seems to be the most promising line to follow.

Apart from the two main sub-groups, i and ii, the varieties are confined largely to vases from single workshops, though one shop may use more than one variety. This applies to some other *'lambda-epsilon'* types; the whole of 18E, i, with some obviously unconnected exceptions, is attributed to the Leagros group; similarly with 20E, ii. We can guess the Rycroft painter's place of work by observing his connection with the RF part of the Leagran workshop in type 16E and with the BF in type 20E.[7] His ligatured dipinto, 17E, 24, is paralleled in the Leagran graffito 17E, 28. The Antimenean circle is not represented by any unligatured form of 17E, and only one ligatured one, and so a direct link between 17E and 21E, i and ii is not available; I suggest some indirect ones above.

Only one of the dipinti in the type, 62, can be said to have the same shape as the primary graffito form, i. 63 approaches type 16E, but differs in having a broken, not continuous line across the top; if the offset here were greater the mark would be very close to 49 and 64. 49 and 63 are related as vases, the only Lysippidean pieces in the type, and seem to demonstrate further the idiosyncrasies developed by users of the mark. The *graffito* of 63 is of yet another shape, be it remembered.

With these interconnections in mind, what can we make of the interpretation of the mark? A number of the varieties are late: 16E (assuming a late date for 1), most of 17E, i and ii, and iv - vi, 20E, and 21E, iii - v with most of vi - viii. The great majority of the marks before 520-515 are of type 21E, i and ii, with the dipinti of ix, and the very early examples of 18E, i and ii. I noted that 21E, i is the prior form, simplified to ii. What is the letter that is combined with the *epsilon*? It was cut before the *epsilon,* since the latter extends into or beyond the angle of foot and navel on 1 and 7; from this we may conclude that the first letter was to be read with its angle facing upward.[8] This would rule out Ionic *lambda,* but is Attic *lambda* preferable? Can the wide-angled V with approximately equal sides be so interpreted?[9] The most natural ligature of the two letters would be ⋌E, perhaps simplified to 16E, but that form is later.[10] It is not easy to explain the form that the ligature takes if Attic *lambda* is intended; one can cast around for other explanations,[11] but they do not account for the varieties and interconnections which we have isolated; when taken as a whole, these marks can only be considered as having a *lambda,* of whatever kind, in their ligature. Some marks may involve a *pi, tau* or *gamma,* but the bulk are incorporated in the interlocking framework that emerges. The most securely interpreted mark, 18E, i, is unfortunately the least directly connected with type 21E.[12]

I take up the question of interpretation of the mark in type 1F.

Type 22E

While the presence of a *beta* in the mark ensures a Greek origin, the shape of the *alpha* in five of the marks is typically Etruscan.

3 and 4 (perhaps with 6) form an interesting close group; it is unlikely to be coincidence that two vases by the same painter have the same mark, and so the vases were probably marked before reaching their destinations, giving us an interesting commercial group outside Etruria.

On 1, 5 and 7 - 9 we find a form of *alpha* that in a Greek context would be termed Boeotian, though even there the cross-bar normally slopes in the opposite direction.[1] Since there is every likelihood that 5 was cut at Gravisca, and 8 was found at Tarquinia, there may be reason to think that all these marks were incised in Etruria, whether by a Greek or Etruscan. Curiously, no two have exactly the same mark - 5 with an extra stroke to the left and 8 with an extra cross-bar. Yet it is difficult to see how the mark could be otherwise interpreted; a *beta* is assured by the form of the loops - no *sigma* could be so made up, and the rest must be an unusual, Etruscan influenced (?) form of *alpha,* or completely non-alphabetic.[2]

Type 23E

I have argued an interpretation of this mark as an abbreviation of λάκυθος in Aeginetan script in the case of sub-groups ii and iii, in *PdP* l.c. The accompanying numerals on 5, 6, 8 and 9 suggested a vase-name interpretation and the script, plus the assumed Dorian dialect, pointed to Aegina. 1 may be associated with these if we can put any diagnostic weight on the slope of the cross-bar of the *alpha.* The fact that the accompanying numerals are acrophonic rather than Ionic warns us away from the obvious attribution of the 'Ionic' *lambda.* The size of the batches, eleven and two, if they are batches and not an early price notation, suggests the ΛΗ of type 2F, vii, rather than the ΛΗΚΥ.

The rest of the type has little unity. No mark seems to warrant a λάκυθος interpretation; such vase-name marks are usually accompanied, either by a personal abbreviation or by numerals. There is always a chance that an isolated vase-name mark when abbreviated may go unrecognised and perhaps we should not be too hasty here, though none seem at all closely linked with the λάκυθος group. 19 and 20 form an obvious pair, 22 cannot be judged; 4 is set apart and 17 is of a different shape from the rest. The cup, 3, must be disassociated from any reference to lekythoi.

There may be some commercial linking in sub-group iv, but it is hard to pinpoint. 18 can hardly be included, despite the additional *epsilon,* which recurs on two of the BF vases.

For 21 see my comments *apud AK* l.c. I prefer not to connect it with 2B, 13 - 15, with a reversal in the order of the ligature.

Type 24E

The type has a Leagran core, and numerical associations.[1] 3, 4, 6 and 10 are attended by unit strokes, and 2, I believe, by a *delta,* apparently acrophonic numerals, as in type 23E. 8 is probably not to be connected with the other BF graffiti. Usually the interpretation of marks associated with numerals is reasonably obvious, but there is no word beginning ΠΥ which would easily fit here; πύξις and πύνδαξ are possible - the former lent a little weight possibly by 9, or πύελος.[2]

SECTION F

Type 1F

Beazley has treated 2 and 3 in *Hesperia* l.c. His conclusions and those of Amyx earlier must be accepted, that they are price graffiti in acrophonic notation. The script must be Attic.[1] I would add one caveat to the simple explanation that the price is quoted for the number of lekythoi mentioned; the accompanying mark seems to be the same as on 13B, 7, where a price seems to be given as well, but this time, one assumes, for the marked vase; this explanation cannot be completely ruled out for 2 and 3.[2] The EV on 1 may have an analogous meaning.

Turning to the latest vases in the type, we have the full Ionic alphabet on 4 and 5, together with 14F, 15. This was probably inscribed by an Athenian in the late fifth century; the overincision of a graffito of type 18C on 14F, 15 by itself demonstrates that conclusion, but the spread of provenances, including Odessos, also points to an Athenian origin for the marks.

I have considered the shapes of vases indicated by these names elsewhere, and review my conclusion under type 14F.[3] The abbreviated marks in type 1F present certain problems concerning such identifications. Sub-groups vi and vii remain ambiguous, since they could be supplemented either as ΛHKV or ΛHKA; the accompanying mark of type 7F on 9 suggests that it should be taken more closely with 15.[4] Sub-group vii is in any case rather artificial; 11 is isolated in many respects, 12 all but belongs to type 2F, vii C and the reading of 13 is not secure.[5]

Assuming that leka - - and leky - - are real alternatives and not a mis-spelling of a single name, we can see that either could be given an *epsilon* or an *eta,* all the time with an Ionic *lambda.* We might hope to find some rationale behind these alternatives, but I will attempt to outline why I think that the contaminations are either very superficial or deeply rooted.

An unpromising start for a solution must be made by noting that alternative spellings appear on two closely related vases, 14 and 15; even if we were to separate the marks into two parts, ΛE or ΛH and KA, the vowel usage still has to be explained. There is no such striking instance of alternative possibilities (rather than local differences, in letter forms or pronunciation) with ΛEKV/ΛHKV, but 7 is at least contemporary with sub-group v. An alternative explanation would be that 7 is an Attic inscription with *epsilon* for the long vowel and an early use in Athens of the borrowed Ionic *lambda;* here the accompanying mark does not give any further clues, though the mark of type 3D on 14 indicates a non-Attic origin for the graffiti, seemingly in one hand.[6]

The identity of the vases cannot be fully secured. For ΛHKA and ΛEKA little alternative to λέκανις is possible, and these may well be of the shape to which we give the name.[6a] For the rest various kinds of lekythos should be meant; on 14F, 15 two particular shapes are distinguished, the forms λήκυθοι and ληκύθια being given further distinguishing adjectives. Lekythoi are among the commonest Attic imports into Sicily, the provenance of 2 and 6; the vases mentioned on the latter may be presumed to be squat lekythoi,[7] though 2, presumably with 1 and 3, can only refer to the lesser patterned and glazed standard lekythoi being produced in the first half of the century (also suggested by the diminutive form). To anticipate later conclusions, the batches of over thirty ΛHKV found on the Leagran vases of 2F, vii could also be lesser vases, but they are hard to discern among the quantities of larger vases from the tombs at Vulci. In the same sub-group of 2F we find much smaller batches of ΛH, probably indicating finer pieces, possibly from the Leagran workshop itself (but see p. 222 below); the longer abbreviation, ΛHKV, stands for the longer word, the diminutive.[8]

We must consider now the interpretation of the other *lambda-epsilon* marks. The possible interrelationships of types 16E to 21E I have already discussed in type 21E; on epigraphical grounds I thought that there is a strong possibility that much of the material in those types is interconnected. Yet there are reasons why it seems better to interpret some of them as personal abbreviations, others as vase names, and it is no easy matter to find the dividing line.

Certain graffiti are obviously vase-name abbreviations: 9F, iv and 17E, 21 must be such and there are strong grounds for adding 18E, 8-10. I argue that 17E, 18 has a vase-name mark, and 1F, 9 is by the same painter. 10F, 23-24 should have a vase-name connotation in their ΛE, compared with 10F, 25 which has an obvious one, with Attic *lambda.*

These are RF vases, not connected with the BF series, which is less closely implicated. There, only 21E, 44 is a *lambda-epsilon* mark closely followed by a numerical mark; 17E, 14 is accompanied by a mark of type 5E, which

seems to have vase-name company elsewhere, most clearly in combination with type 9F; is it coincidence that 17E and 9F are a regular pairing in later years? If 17E, 14 is taken as a vase-name mark the whole Leagran group of marks in type 17E must go with it. The argument might be backed up by suggesting that ΛE on 17E, 1 should be equivalent to Ħ, since the vase is the only one by Painter S without a Ħ mark.[9]

However, the vast majority of *lambda-epsilon* marks are unaccompanied; the isolated type 17E marks on Leagran vases are in strong contrast to those of type 2F, or even the type 8E-12E complex. Therefore I would be loth to interpret all *lambda-epsilon* marks as being of some vase-name import.[10] The links that connect types 16E and 21E with 17E may seem tenuous, but if we place a dividing line here, we end up with vase-name marks of type 17E which are just as unaccompanied as the presumed personal abbreviations of types 16E and 21E. On the other hand we could try to separate sections within type 17E, only the later members of which appear with any numerical company; here we would have to ignore the record of the Rycroft painter - marks of type 16E and 21E on the Oxford vase and a clear reference to a vase-name on 1F, 7.

The question has, I think, to be left open. If all or most *lambda-epsilon* marks are taken as vase-name abbreviations, they show none of the normal symptoms of such marks, and 17E in particular belies the Leagran penchant for lengthy collections of graffiti around vase-name marks in the broadest sense. The prevalence of *lambda-epsilon* marks on later sixth century black-figure could lead to interesting conclusions about the nature of the export trade if again they were all interpreted as having some vase-name significance.

Type 2F

While one section of the Leagros group was using the perplexing sign 8E with a collection of accompanying marks, and another section has the pairing 5E and 6E, a further part is equally faithful to this mark.

As sub-group vii is clearly the most important, I begin there. Most of the members have the basic signs of sub-group iv, together with a formula of v: n character, in smaller and usually neater lettering.[1] The interpretation of the formula as consisting of vase names and numerals scarcely requires proof; the Ionic numerals secure their own identity, and in five cases (28, 30, 32, 41 and 43) individual tally strokes add up to the total given by the Ionic numerals.[2]

If we recognise that a formulaic procedure is being used and that the same meaning must underlie all its varieties, the interpretation of the rest as a vase name must follow. Some of the varieties could be explained as units of capacity for example, but terms such as XVTPI and in particular KVΛIΘA can only be taken as vase names.[3]

From the evidence of overincisions we can establish the order in which the several marks were cut. On 28, 38, 40, 43 and 46 the deltoid mark of type 3F has been formed with the help of a *lambda* in the vase name already inscribed; possibly a *delta* in the numeral of 45 is similarly treated. Further, the Ħ is incised over the final tally strokes of 30 and 43, completely obliterating one of them.

Assuming therefore that the v: n formula was not cut before the unit tally had produced the total figure, one has the sequence: tally, v: n, deltoid, with the Ħ certainly after the first and presumably after the second; judging from the hands it should be contemporary with the deltoid. The v: n was cut shortly after the tally, since in most cases it was not necessary to make a tally (at least on the vase), implying that the relevant process was carried out at much the same time.

The *lambda-eta* interpretation of the main mark can be substantiated by another overincision, again on 30, where the large ligature at the head of the tally has been cut over an earlier, smaller sign of the same shape. It seems probable to me that this smaller ligature was cut first on the foot and that the tally was incised after it; 29 provides a parallel for the small sign at the head of a tally (though caution is necessary in view of the possibly incomplete reading). The connection of small mark and tally necessarily involves a connection between the small mark and the v of the formula, and therefore the interpretation of the ligature as *lambda-eta* is secure.[4]

It may seem an easy step from here to equating the significance of the smaller and larger ligatures, but it is precisely here that the major problem of this type lies. In the cases we have been considering the tally is of ΛHKV and the possibility has been suggested that these ΛHKV are somehow also represented by or equivalent to both the small ligature and the large ligature; but what then are we to assume when the tally is introduced by other abbreviations such as ΛV? Can we equate the large ligature with these tallied vases? It is possible that 30 may provide a clue towards answering this crux. As on 29, just mentioned, we do not have the simple formula v: n here, but an additional ΛH not in ligature. If we equate *this* ΛH with our small ligature and not with the v in the formula, our difficulty disappears, or is at least shifted; we merely have to understand a 'suppressed' ΛH in the remaining v: n formulae.

Amyx and Jongkees regarded this added ΛH as a price notation.[5] I cannot accept that the price chosen for these batches (not of the same size, though within a close range) should be such a confusing number of obols, unresolved into drachmai (or staters). On 31, rather than thinking in terms of the ΛH being the numeral and Λ a price, I would assume that we have a slightly confusing order of entries, the ΛV being the type of vase tallied, the Λ the tally and the ΛH having the same significance as on 27-30. If we adopt the suggestion that the ΛHKV and ΛH are equivalent on the latter, not only would one be superfluous but ΛV would become equivalent to ΛH on 31. The size of batches of ΛHKV and ΛH also militate against explaining one as some kind of gloss on the other. The ΛH are five (41), six (38 and 42) and seven (39 and 40), while the ΛHKV are twenty-nine (29), thirty (28 and 30) and thirty-four (27).[6]

So the ΛH on 27-30 is not to be equated with the ΛHKV on the same feet, nor does it fit well with the ΛH on 38-42. It must have some independent significance; Smith suggested something along these lines in *CVA San*

Francisco 26-7, noting the relationship of the large Ѫ with ΛH on 41 and with ΛHKV on 54-5; as we have seen, the large sign is related to a far greater range of abbreviations than these two and the argument Smith advanced is not, I believe, as formally cogent as that presented here.[7] In sum, as long as we suppose a link between the large Ѫ and the v: n formulae - a link that is all but proved by 30 - we should seek it in the ΛH that is added to some of the formulae and can be understood in the rest.

The identity of this 'ΛH quality' imbued in these vases is a difficult matter. From our conclusion above it would seem to have a general application to all the varieties in the formula, but at the same time seems itself to be enumerable on 27-30. It is difficult to reconcile any vase-name word in λη - with varieties such as OΞV and KVΛ. One might suggest, on the evidence of 1F, 14 and 15 especially, that the λέκανις group of words could be included under the heading of 'vases in λη-', with an alternative spelling, but even so we cannot think of them as cover terms for OΞV and KVΛ without misgivings. The suggestion reported by Webster of λῆψις may be preferable, though I would prefer a form with more verbal content; however it does not fit our reading of the history of 30 as well as a vase-name abbreviation.[8]

As with the Leagran series 8E-11E, we have been able to reconstruct the sequence of inscribing through over-incisions, though there is little apparent similarity in the significance of the respective marks. What applies to sub-group vii must also be assumed for the other sub-groups, and so the deltoids on the vases without v:n formulae were also cut at a comparatively late stage in their commercial life.

In a number of cases the large Ѫ has one or more additional strokes, confined save in one case to vases of sub-group vii.[9] This may suggest that they may be countermarks in some way relevant to the formulae, despite overincisions that may have obliterated them, but this apparent concentration on sub-group vii is tempered if we take the isolated strokes on 22, 24 and 25 as similar countermarks unattached to the ligature. The stylistic difference between the vases of sub-group vii and much of the rest of the type is such that we may consider marginal differences in the manner of marketing also - by several traders or by one over a period of years.

It is reasonable to assume that the counting of the tallied vases was done in the Kerameikos and that the later marks were not intended to serve a purpose wholly in the same area; I mention traders for this reason. At the very least the ligature and deltoid must refer to the fact that the vases were to be collected by a certain person. The smaller size of the marks first inscribed is more appropriate to transactions taking place in a workshop, but the larger letters were meant to be seen at a glance, for ready reference; the enlargement of the ligature on 30 supports this contention. The tallied vases presumably were of some relevance to the trader concerned, and the obvious conclusion is that he exported them with the master-vase.[10]

Most of the vase names are discussed separately in the ensuing types, where similar abbreviations elsewhere are listed. Two abbreviated vase names do not recur elsewhere, OΞV and APV, but I take both of them to represent full names that we do find, albeit a good many years later. Ἀρύστηρ occurs once as a vase name, 4F, 5; here there are some alternative supplements that might be considered, in particular ἀρύβαλλος and its derivatives, although it seems that the Athenians at least did not avail themselves of this term during the classical period.[11] For OΞV there is little alternative to ὀξύβαφον, or some very similar word; we shall see that at the end of the fifth century this represented any small bowl (p. 229) and so there is every likelihood that the word had a similar meaning a hundred years earlier.

In all there are well over four hundred vases, of about the same period, listed in our tallies; if we could trace them we would have a much clearer idea of the process with which we are dealing; Smith suggested that an exhaustive (or -ing?) study of the material might show whether a Ѫ vase was usually given away with the master vase; we have already seen that the Ѫ ligature does not indicate a single vase and that we are looking for many more. As we have no details of the grave groups in which these vases were found we cannot be confident in affirming, or (more important) denying that the tallied vases accompanied the master vase from pottery to tomb. We do in fact have full details about one tomb, that at Bolsena in which 53 was found, but regrettably we cannot now reconstruct its contents; the vases were subsequently dispersed and I have not been able to trace the amphora which bears the apparently imperfectly recorded graffiti.[12]

As the tallies were recorded at Athens it may be unreasonable to expect that the batches reached a single destination, let alone a single tomb, together. We can have little idea what smaller vases, whether figured or glazed, may have been available to accompany the main hydria or amphora; it seems unlikely that lekythoi painted by members of the Leagros group are to be found among the tallied vases, but this may be a dangerous argumentum e (quasi) silentio.[12a] Many of the batches give the impression that they comprise what was available at the time when the master-vase was removed from the workshop; round numbers are infrequent and there is little consistency in batch size; however the fact that the sizes seem to have a restricted range does suggest that considerations of packaging may have determined the maximum size or weight of a particular batch.[13]

Vases are the last thing, archaeologically speaking, to vanish into thin air, but I fear that we must treat the accompanying vases in this belief. We may speculate that they ended up in Sicily, which apparently imported many more smaller Attic vases, or on the waste heaps of the Prince Lucien of Canino. At any rate, the fact that small vases rarely carry marks does encourage us to believe that they regularly were exported under the aegis of a larger master-vase.

Two further notions about the marketing of such vases seem untenable: first that extra vases were tied into the sale of a master-vase;[14] in view of the size, numerically, of some of the accompanying batches I find this a difficult idea. Secondly it has been mooted that the satellite vases may have constituted regular services of table ware; this suggestion cannot stand against the considerable variety of the batches.

The dipinti that appear on 11, 19 and 28 should not be overlooked, however ill-preserved; in the first case there may be a link with other branches of the Leagros group (see on type 9F) and the dipinto on 28 may well indicate yet a further stage in its marketing. The apparent three-bar *sigma* on 7, 8, 9, 25, 26 and 28 must also be mentioned; there are no *sigmas* preserved in the formulae to compare with them, but the four-bar type must surely be expected. I would suggest that the mark is a countermark along the lines of the tick, but am not happy that it should so closely resemble an Attic letter form.

The deltoid mark is discussed below; it does not appear on a few of the vases in sub-group vii, 32, 33, 49 and all the RF pieces, though one of the latter, 35, does have a different monogram on the navel.[15] There are other factors which distinguish the RF vases, principally the fact that all the letters are of the same size, but also the different form of punctuation. Such differences support the conclusion that these RF vases are earlier, if only slightly, than the bulk of the Leagran BF production. [16] A link is provided by 8, itself later than the other RF vases here.

Sub-group ix is treated under type 13E.

Type 3F

Previous interpretations of this type have seen some kind of price notation, either δ(ράχμαι) ΗΗ or ΔII (obols); I have stated my objections elsewhere, but not fully.[1] I find it difficult to accept in either case the arrangement of the mark with units added *beneath* the initial sign, rather than beside it; the acrophonic system of the second alternative is out of keeping with the Ionic numerals of the tallies, and the ductus of the marks is often unpromising if we attempt to wrest drachma signs from the 'tail'. More damning to this idea is the discovery of the sign on the lids 1-4; one cannot accept that a price (for what?) was so inscribed. Attempts to see a price in this mark must be abandonned. The marked lids suggest that the mark was used to secure the association of vase and lid during transit, yet there are two objections: first the fact that many of the vases marked are hydriai, never provided with a lid, and secondly the fact that so many Leagran amphorae have or had the same mark under lid and foot, which would scarcely help the trader in maintaining the correct pairing in any one case.[2] We may then think that the mark is a normal personal abbreviation, used by a Δεξ - - perhaps to indicate his property; for we have found no mark of this type elsewhere on the vases concerned. If this is the right explanation I would have expected to find more examples of the mark standing by itself than the dubious 5; moreover the ligature suggested is no more plausible than the numerical interpretations, perhaps less so, since the two cross-strokes are regularly completely without relationship to the bottom stroke of the *delta*.[3]

There is an analogous situation in respect of types 1E and 2E; for 2E in one particular form does not appear unaccompanied by a 1E mark. Unfortunately we were unable to determine the sequence in which they were applied to the vases, but I suggest that the dipinto 1E was painted in the workshop, in this case to identify some trader involved, and that the 2E mark was cut later to indicate perhaps some significant sub-group. The other vases of type 1E with further dipinti may have constituted another such sub-group. A mark of type 2E could also have served to secure the association of vase with lid, though we have no lid to prove the point; we do have them however with the graffito version of the dipinto accompanying the other 1E vases, 33A, 8 and 9. 33A and 2E appear to be non-alphabetic marks, and so 3F could well be the same.

There may be other marks of this species, primarily used to associate lid and vase, but also with some independent significance, as demonstrated by the hydriai of type 2F - much later of course than 2E and 33A. The lids 37A, 10 and 11B, 6 bring those types to mind and 36A may be another candidate. The purpose of these marks must be distinguished from those on pyxides which are relevant to the firing process (see p. 38).

Type 4F

1-3 form a very special group, while 4, 5 and 2F, 47 and 48 seem to refer to a type of vase, written out in full on 5. There would seem to be two possible shapes that could be called ἀρυστηρ, the skyphos or kyathos. Etymologically a dipper vase, such as the kyathos, is the more acceptable, but finds do not support the equation for 5 at least; the kyathos is a rare shape after 490 (see p. 229). Hesychius (A7561) equates aryster with kotyle; this probably refers primarily to the liquid measure, but there seems no good reason why the Ionic aryster measure should not also refer to a vase shape, just as the kotyle.[1] I have no strong feeling that the same type of object is meant in all these graffiti; the large oenochoe 4 may itself be thought of as an aryster, and we should not rule out the possibility of metal ladles accompanying batches of pots, however incongruous their relationship with the hydria 5 may appear.[2]

Turning to 1 - 3, I stress immediately the rarity of underfoot marks on prize Panathenaic amphorae; some examples with marks on the shoulder, all probably numerical, are included in subsidiary list 1, but only 1 - 3, Boulogne 441 and Cab. Med. 244 (fig 13n) have underfoot marks.[3] Also striking is the stylistic relationship between 1, 2 and Cab. Med. 244, close enough to suggest that they were all awarded at one Panathenaia, and to a single victor, since they are all horse-race pieces; however, Boulogne 441 is stylistically a little apart and has a wrestling scene.

The vases were not inscribed before being awarded; their isolation among so many uninscribed vases and the Ionic script prove the point. The graffiti must refer to a second-hand transaction. The key to its nature lies in the *koppa* on 1, 2 and Boulogne 441.[4] The following *beta* and *epsilon* in two cases exclude the possibility of a straight abbreviation, and all but prove that these are Ionic numerals. If they are, we can read the partly missing central letters on 3 as *koppa* (or *pi*) *delta*, which would give us figures of 90, 92, 94 (or 84) and 95.

Such figures cannot refer to the price of the vases and/or contents; drachmai would be out of the question, and even obols would be very expensive, even if it were likely that they should be cited unconverted into drachmai (staters or whatever).[5] It is highly improbable that batches of vases are to be understood in view of the fact that these are not regular export transactions, and in consideration of a further interpretation that seems far more plausible.

Herodotus ii 168 says that the ἀρύστηρ is the Ionic equivalent of the Attic kotyle measure, and earlier a fragment of Alcaeus (Diehl 70, 9) hints at the same meaning. If we associate the ΑΡΥΣΤΗ etc. with the numerals on 1-3 we have notations of some size being measured, presumably oil, probably the prize oil itself.[6]

90, 92, 94 and 95 kotylai give us figures of 7½ to nearly 8 choes of oil (or from 7 if we read *pi* on 3). These amounts remind us of the amphora sizes suggested by the Agora graffiti, what Lang terms 'ordinary' amphorae.[7] Such figures do not however correspond with the capacity of Panathenaic amphorae, notionally twelve choes or 144 kotylai.[8] Underneath the heavy layer of concretion on the foot of Cab. Med. 244 there is a series of twelve *deltas* followed by three unit strokes, and at some distance another mark consisting of 'red' *chi* and *iota*. 123 is a sum of kotylai falling between the two sizes of amphorae just mentioned. The use of acrophonic numerals distinguishes the mark from 1-3, but it remains closely connected by the style of the vases and the very presence of an underfoot graffito. It is not inconceivable, from available evidence, that both numeral systems could have been used at this period in a single establishment, but I would prefer to think of two different men selling off the prize oil in these vases. There are discrepancies here and the overall picture remains blurred. In part at least the marks indicate an Ionian merchant using a local term, ἀρύστηρ, seemingly refilling or adjusting the contents of the vases to the capacity of the commercial amphora size to which he was accustomed. One vase however received over ten choes, possibly filling it.[9] 1 - 3 were inscribed after being filled, when their contents were known, but Cab. Med 244 if we take due regard of the lack of signs for fifty and one hundred,[10] seems to have been marked with a running tally, however difficult a procedure.

An alternative explanation could be that the ΑΡΥ here is a larger measure, such that about 90 filled a Panathenaic amphora.[11] This removes the embarrassment of having vases only two-thirds full, but on the other hand introduces an additional, unattested standard and contradicts Herodotus. Of course if Cab. Med. 244 is to be in any way closely related to 1 - 3 such an explanation cannot stand.

Further clues may lie in the third portion of each graffito, but I can make nothing meaningful of them, apart from their probable numerical character; the *digamma* on 1 can hardly be explained otherwise.

A question that remains is whether these vases were shipped to Etruria full, or rather two-thirds full of oil. If they were not, we must posit a third stage of their career in some Ionic ambience, before they reached their final resting place.

Of the other vases in the immediately related stylistic group neither London B133 (*ABV* 395, 1) nor New York 56.171.3 (ibid 3) has a mark.

Type 5F

4 and the two vases of type 2F, vii have a longer graffito, preserving the *lambda* and therefore indicating that we have the word κύλιξ, although 4 and 2F, 49 are not easily interpreted. The latter has a clear ΚΥΛΙΦΑ, which must be either an abbreviation of an otherwise unattested derivative of κύλιξ, a mis-spelling or a *koppa*. In the last two cases the intention would have been ΚΥΛΙΚΑ, presumably an accusative singular or another unattested derivative; mis-spelling with a *phi* is odd and the use of a *koppa* before *alpha* perverse in view of the *kappa* before *upsilon* at the start of the word. The first alternative is preferable.[1] The apparent dative form on 4 is also strange; splitting the mark up helps little, though the 'iotas' could perhaps be regarded as punctuation, giving the reading 'twenty kylikes'; yet such single line punctuation is very rare (p. 25) and the Ionic numeral would also be out of place.

3 is linked to 1-2 through type 18E; the size of the batch, 40, is worthy of note. The mark on the navel is not easy to interpret, especially as there seems to be chipping and accidental scratching in the upper part.

1 and 2 are intimately linked as vases and in the structure of the graffiti, though 1 lacks the monogram, while the similarity of use of types 9F and 10F provides a further link between 1 and 4. 1 is the only vase from Falerii known to me to have a vase-name mark.

6 raises the question of the identity of the ΚΥ or ΚΥΛ. It is rare that small vases have vase-name marks which refer to a shape other than themselves; the batch marketing system did not use small vases as master-vases accompanied by pieces of different shape. There is also ample evidence to suggest that, as on 6, the skyphos was regularly termed κύλιξ throughout the Greek world:[2]

Athens: *Hesperia* 36 (1967) 187-9; 425-400?
Kea: *Hesperia* 33 (1964) 333-4; c. 480.
Olympia: unpublished local glaux skyphos; 450-400.
Olbia Pontica: *Sov. Arch.* 28 (1958) 84-5, cup-kotyle; c. 425.
Nymphaion: Tolstoi 129; sixth century.
Crimea: *CVA Zurich* 1 46; c. 375.
Al Mina: *AE* 1953-4 i 205-6; 400-350. κόλιξ.

In fact the only other term for skyphos that seems to have been used on the vases themselves is γλαὖξ.[3] This is ample evidence to show that the batch on 5 was of vases of the same shape as the inscribed example. Elsewhere in the type the mark could refer to cups or skyphoi.

Type 6F

2 I have fully discussed in *AJA* 82 (1978) 225, where I suggest that ΛV probably indicates λύχνοι, and that a price for two batches of them is given; the small lacuna prevents full proof of this interpretation.

1 has given rise to considerable debate, and I have mentioned it elsewhere myself.[1] The two problems concerning it are the identity of the λύδια and the interpretation of the Ionic numerals. It may be thought acceptable that the ΛV of type 2F are to be given the same interpretation in view of this Ionic connection, despite the considerably later date of 1. The shape that we term *lydion* was in decline by the end of the sixth century and seemingly extinct by the time of 1. It also seems unlikely that the large size of the batches could refer to the relatively rare *lydion*.[2] There is no other shape which obviously derives from Lydia, or which may have been thought to so derive by Ionian Greeks. It is unlikely, I think, that we shall discover the solution.

Regarding the price interpretations put forward, Greenwalte has noted the difficulty that the price per unit for the larger *lydia* of 1 would be less than for the ΛV of 2F, 31, 7/20 against 6/7 of a unit (l.c. 133). I have tried to show that the 2F vase does not have a price graffito, and I do not believe that 1 has one either, although there is no evidence here on a par with that available in the case of 2F. I assume that the batch was for some reason split; it is probably coincidence that the ΛV of 2 were also quoted in two sets, each with a price, but the reasons for the split may have been similar.

Type 7F

Sub-group i I have discussed in *BSA* 70 (1975) 156, concluding that they are commercial marks, abbreviations of χύτρα or a similar word.

Sub-group ii need not be a monogram of *chi* and *upsilon*; it is important in linking the vases and therefore the other marks which they bear, and in giving a good dating peg for the chequered kraters.

7 has the only complete vase name in the type. The end of the word, ριδες is clear enough and so sense was obviously intended; the first three letter must then be read κυθ, the lack of a dot to the *theta* providing the only anxiety. However the lack here facilitates the reading of the second word (see on type 15F). The result then is not only a full word, but an excellent example of the metathesis of aspiration to be expected in Ionic dialect here and in other words of the same root.[1] The question arises why such a transposition is not found with the χυτρι of 2F, 51 nor in the χυ of 2F, 32-37; for these marks are in full Ionic script. The very hasty incision of 7 is in sharp contrast to the disciplined graffiti of type 2F, and so we may be dealing with more and less 'broad' Ionians; see further on type 15F.

The interpretation of 8 is not easy; acrophonic numerals are used and so the initial *alpha* cannot be numerical, nor is it feasible to take it as the article. It looks therefore as if ἀτιμα must be seen as one word, which for the purposes of the trader could only mean 'cheap', not the normal meaning when related to objects, 'worthless'.[2] The price and identity of the vases cannot be established without knowing which of the accompanying numbers refers to the batch and which to the price. As both 7 and 8 are stamnoi there is a possibility that the vase name refers to the inscribed vases, although the χύτρον group of words does have a much wider range of application.[3] Therefore I tentatively suggest that we have 'two stamnoi for ten obols', although I would not use this example as secure evidence for prices in the early fifth century.

Type 8F

I have little to add to earlier treatments of this mark, an abbreviation of ποικίλος, 'decorated'.[1] It must be thought likely that 4 and 5 should be so interpreted, despite being so much earlier than the rest of the type. The gap is in a sense filled by the reference to decorated Athenian vases in Pindar *Nemean* x 36.[2] The type can also be expanded by the inclusion of a number of Polygnotan and later vases in type 16B, q.v. I doubt whether any member of type 17A can be brought in as well; Πο is not a natural abbreviation of ποικίλος.

Recent finds and publications have vastly increased the range of destinations to which vases marked as decorated, with their accompanying batches, were sent. Of particular note is the size of the batch on 12; one wonders how frequently such large batches of figured vases were despatched from the Peiraeus; it is unfortunate that neither date nor shape of the piece can be satisfactorily assessed.[3] The purpose of putting such a mark on the vase is not clear; it seems most natural to assume that the rest of the vase would not be visible to the shipper or purchaser and so the nature of the piece was noted underneath - we have one example of the more self-effacing μέλανα in 25F, 4. As more black-glazed vases were produced in the fifth century, so it became more useful to single out exceptions. Shefton suggests that 11 was inscribed before firing, which may prompt the thought that the purpose was at least in part to distinguish glazed and figured pieces before firing, but all the examples which I have seen are definitely post-firing and I believe refer to transactions in Athens or the Peiraeus before shipping, as the wide range of provenances indicates.

For the initial *sigma* on 1 see on type 19F.

Type 9F

This is one of the most consistent of vase-name types, yet its interpretation is the most elusive. It is in use over a lengthy period, with a slight gap between the latest BF and earliest RF members.

The proof of its vase-name nature is the company it keeps; it can occur alone or with numerals, but also with vase-name marks, most clearly the KO of 51 and KV of 48, but also sub-group iii, for which see type 11F. There and on 51 the accompanying vase names refer to the inscribed vases, but this cannot be the case with 48, nor does the variety of shape of the vases in sub-group iv encourage such an interpretation there. The lack of numerals in sub-group iv reminds one of the unaccompanied marks of type 17E.

There is no persuasive supplement for the abbreviation, whether noun or descriptive adjective. Virtually all words beginning with these letters are from the roots $\nu\upsilon\kappa\bar{\tau}$,. $\nu\upsilon\mu\phi$- or $\nu\upsilon\sigma\sigma$- , none of which seem relevant, though Webster bravely suggested $\nu\upsilon\mu\phi\iota\upsilon\iota$.[1] I would more tamely suggest that we are at least dealing with a colloquialism, perhaps unattested in any other form. The apparent aspirate on 49 indicates a non-Ionic origin, as do the acrophonic numerals; in this case the Ionic *lambda* of sub-group iv must be taken as an Attic borrowing. For the interpretation of the ΛE see the next type, where it appears in similar circumstances.

It may be that prices are quoted on 47, 49 and 50; the 0 on 50 suggests an obol, the three short horizontals following a single stroke on 47 are reminiscent of 10F, 25, where the horizontal line indicates a quarter-obol, and one could at least hazard that the HE on 49 stands for $\eta\mu\iota\sigma\upsilon$. To what these prices refer is not clear. The behaviour of some of the numerals elsewhere is curious; 33, 34, 35 and perhaps 36 have two groups of numerals. Although there is no obvious explanation, here again a quotation of prices cannot be ruled out. The NV may in fact be dispensable; Leiden K94/1.10 (*CVA* 1 pl 54, 3) is closely related to 29 as a vase and has similar acrophonic numerals, without NV, and by the same hand as 30 is Manchester IIIh 48 (*ABV* 591, 2) with three *deltas* and a *gamma* (see also p. 29). A related small neck-amphora, 32a, has either ΛΛ followed by *nu* or NV followed by an inverted Λ; the inversion of the *'gamma'* five on 10F, 6 and 25 may favour the latter alternative. On the Leagran vases it is likely that if the numerals had exceeded four the acrophonic system would have been evidenced, though the association of 25 with a type 2F mark and the Ionic *sigma* on the related 17E, 14 cause anxiety in this respect. It should be noted that, with the reading of 1 uncertain, the Leagros workshop in its broadest sense may embrace all the BF pieces here. The workshop grouping of the RF vases is also clear; the Chicago and Deepdene painters have both simple and accompanied versions.

Type 10F

This type was at the root of the dispute between Amyx and Jongkees on the subject of vase prices; while I agree with most of Amyx's conclusions, a further review of the material has suggested some new interpretations.

As with 9F the mark occurs alone, with numerals only, or with vase-name abbreviations. There are also parallels in detail; the vases with numerals only include lesser BF pieces, while the better BF vase, here 2, has a smaller tally and is accompanied, as on 9F, 26, by a further graffito apparently of no vase-name significance.[1] Further similarities are that the same painter displays both simple and accompanied forms, and that there are possible instances of split tallies (3, 4, 5). The painter groups tend to be closer than in 9F.

Our inability to interpret NV suitably does not help us with 10F, but the ramifications of the type are more complex, and eventually do suggest a plausible supplement. While three painters have the simple mark, none share any additional mark (not unlike type 19E). The added mark on the Pig painter's vases in sub-group iii is most easily explained; for the KO see type 13F and for the rest type 5F. Here the KO clearly refers to the inscribed vases, but it is very unlikely that this is the case with the other accompanied marks.

The accompanied piece by the Troilos painter, 25, will be the corner-stone of my interpretation. The ON element, as 10 demonstrates, can have an independent existence; to its right on 25 Amyx read 'le- 40' with a punctuation mark between; such an interpretation of the bracket sign is possible, but in view of the small size of a similar bracket on 23 and its position on 3, I prefer an interpretation as a numeral, fifty, while not denying that a similar sign is used as punctuation elsewhere.[2] The Attic *lambda* here is of double significance; it makes the quantity of the following *epsilon* variable, allowing a number of supplements, and together with the three-bar *sigma* to the left makes the bulk of the mark definitely Attic. Since the ON fits neatly between the two, we can assume that it was cut first and therefore of probable Attic origin as well. The O therefore is also of uncertain quantity, and the abbreviation may still stand for $\dot{\omega}\nu\dot{\epsilon}\omega\mu\alpha\iota$ as Jongkees suggested. Amyx' objection was that it clashed with the *omega* that appeared in Jongkees $\delta\dot{\omega}\sigma\omega$; the sequence of letters so interpreted appears on three vases (22, 23 and 24) and is not easy to interpret. The letters are surely Ionic, but Jongkees ignored the *xi* that stands at their head; I assume that they were inscribed after the Attic ON and vase-name marks, and that they form some kind of self-sufficient type.

Returning to 25, the vase-name on the left is $\mathsf{\gamma KV}$ - see type 19F - and the final part reads '17 TI 12' followed by three horizontal lines. The letter following the *delta* is a *'gamma'* five cut upside down as on 6 (see *BICS* l.c.). The last sign is clearly not a *xi,* and would have 14F, 17 as the only parallel among graffiti as a punctuation mark; I take it as a notation of fractions and return to it below.

The Tyszkiewicz painter presents simple ON, simple ON and ΠPO and the latter with numerals. The tail on the *rho* of 17 is a further indication of an Attic origin for the marks. 19 rules out of court Jongkees interpretation of ΠPO as 'in return for', unless one can view it as a blank sales ticket, a counsel of despair. Jongkees further noted that on 17 two forms of *pi* were used 'to prevent misunderstanding'. The first *pi* looks very odd; the shape is unusual and

we would expect the *'gamma'* five as on 21, 23-25, did not the lack of a sign for five in the second numeral suggest that we should expect none at all. I suggest, without having seen the mark, that the true reading is ONTI IIII , with the *iota* placed close to the *tau* to prevent confusion with the following unit strokes. Again, I return to the interpretation of 17 below.

It is 21 that provides sufficient evidence to support the readings suggested above. Its mark is very similar to that on the navel of 23, my reading of which shows the *tau* more clearly than in previous publications. This encourages the belief that we have here an independent unit, itself containing ON, which can be used by itself; 24 supports this view with a clear *tau* and a *'gamma'* standing by itself. The TI and *'gamma'* five bring 25 close to 21-24, though the differing *lambdas,* Attic and Ionic cause problems that I must take up below.

The isolation of TI and *'gamma'* components helps us to interpret the rest. TI immediately suggests τιμή or the like; the following numerals do not support the notion that it is a personal abbreviation, and an advertisement or record of price is what we might expect. If this interpretation is correct, it follows that ON must be a general noun or adjective, capable of standing by itself, or in loose connection with vase names (25), or directly with an expression of price. Some form of ὠνέομαι would fill this role well; ὤνιος and ὠνητός are well attested classical words for 'for sale'.[3] At any rate, there is no other word in ὸν -, ὼν - - or οὐν - which could be considered likely. The adjectival form avoids Amyx' well founded objection that Jongkees was proposing a buyer's not a seller's advertisement. The explanation does put the vases on the open market, as it were - 'for sale, not already ordered'; were they available only to foreign buyers or exporters, as the lack of such marks on vases remaining in Attica suggests, or is it pure accident that so far no such graffiti have been found on RF vases from Athens and the rest of central Greece?

Another question is to what do the prices refer? Prima facie there seems little objection to taking them with the marked vases, giving seven obols for a type A amphora or hydria (21, 23), five for an amphora (24) and four for another hydria (17). Such prices square with those gleaned from 14F, 1-6, 15, but seem low compared with the two to three drachmai of the hydriai 21F, 7-8. The test of such a price interpretation must lie with 25; here the price quoted clearly does not refer to the marked vase but to a batch of seventeen ϟΚV (though the ON may still refer to the master vase, as it does on 10 by the same painter). If one assumes that the price is in obols, rather than drachmai, as Jongkees, one has seventeen vases for twelve obols and three parts. While later the smallest fraction of the obol was the chalkous, an eighth, we have nothing smaller than the quarter preserved from early Attic issues, which gives us here the tidy sum of seventeen for fifty-one quarters, or three-quarters each.[4] It is this exact figure which convinces me that prices are quoted in the numerals introduced by TI within type 10F. Where TI does not occur we must be far more circumspect; 7 may have cost nine obols, but three obols for 22 seems too little. These numbers are more likely to refer to batches.

Further batch numbers can be found on vases in the type: those on the BF vases in sub-group i and more on the RF vases we have been discussing - 57 on 17, 77 on 23 and 90 on 25, interpreting the bracket as fifty. On the latter the number is firmly attached to the ΛΕ label, and the size of the batch recalls the λεκύθιδες of 1F, 1 - 3. On 17 Jongkees interpreted the mark as a single unit, but we have ample evidence now that ON and ΠPO can exist without numerals; also 18, by the same painter, has ΠPO in company with other probable vase-name marks. In sum, ΠPO would seem best taken as a vase name too and πρόχους seems a suitable identification, though the numbers on 17 are considerable for what was probably not a particularly small vase.[5] We must recognise that on 17 the price quoted may not be for the master vase but for this batch of prochoi, though the resulting figure seems extremely low.

The 77 noted on 23 could well be thought of as le(kythides) similar to those accompanying 25; we have seen that the Ionic letters preceding it do not belong to, and were cut later than, the ON TI mark on the navel at least, but what of the ΛΕ cut on the opposite side of the foot, and on the navel of 24? Could this not introduce and describe the batch, as the ΛΕ on 25? The different *lambdas* are an embarrassment. A possible explanation is that the ΛΕ was cut at the same time as the ΞΔΩ, still perhaps referring to the batch already noted on the vase; any view accepted here will have some reflection on the other *lambda-epsilon* marks; for example, the tailed *rho* on 17 suggests an Attic hand, but its associations via the Tyszkiewicz painter in type 19E with EMΛE marks again bring us against the Attic/Ionic problem. Certainly Attic *gamma* can scarcely be entertained; perhaps we should think of more or less Ionically influenced Athenians, or a wider range of possible 'nationalities'.

The figures on the BF vases in sub-group i probably refer to the marked vases and accompanying batches of the same shape; they are all small vases (3 is a very small amphora). I am not sure however of the interpretation of the two sets of numerals on 3, 4 and 5; a price may be quoted, but there seems no correlation between the two sets of figures on 4 and 5, which are roughly similar as vases. We may merely note that such sets of figures must have confused the traders involved were there not some generally known conventions giving a key to their interpretation.[6]

It may be significant that the final stroke of the *nu* on 10 and 13 ends in a spiky tuft. Note that a normal *pi* appears in the numeral on 26, the one vase on which the read NO seems assured.

Type 11F

The majority of entries in this type probably have no vase-name significance; personal names in Kα- are common enough for such an abbreviation to occur. We may assume that the Antimenean pieces were handled by a single dealer, perhaps 5 - 7 by another.

13 causes the compounding here of KA and KAI. The accompanying NV shows that the following letters are a vase-name abbreviation, supported by the evidence of the other members of sub-group iii. One could interpret the

whole as NV *ka(dia)* and an Ionic numeral, but, judging from the published facsimile, the last sign does not accommodate itself well to an Ionic numeral and that system does not appear elsewhere with NV marks. 14 provides a possible parallel, with a stroke following the KA and an enigmatic sign, perhaps an Ionic *gamma,* but with an excessively long horizontal. One may think of καινός as a possible supplement, but assuming that the vast majority of vases were exported straight from the workshop, the adjective would have little force. See the next type for discussion of the rest of sub-group iii.

The shape of the *alpha* on the pieces from Adria suggest a local origin for those marks; *kappa* and retrograde script are also at home in the area.[1] 21, 22 and 25 are more likely Greek, though of doubtful significance; personal names in Καυ- - are extremely rare.[2] The *CVA* text equates 24 and 25, but there are clear differences in the direction of the script and the shape of the *alpha;* 24 has similarities with the Adria graffiti and indeed similar vases are found at Spina (*ARV* 1545, 21).[3]

For 28 see ch. 8, n. 13.

Type 12F

There has been little doubt that the vase name involved here refers to an amphora or similar container, but two fairly recently discovered pieces of evidence have considerably clarified fifth century Attic usage of the word, a plain ware deep cooking pot from the Kerameikos and a fine type A amphora, *Ars. A. A.* iv 131, on which is the jingle καλὸς ὁ κάδος.[1] The abbreviations, or full word, here show that we are rather looking for a diminutive form, κάδισκος or perhaps κάδιον. This causes something of a problem with 1 since it is a much larger piece than the Swiss market amphora cited above - as well as being among the latest type A amphorae, for which four companions might be unexpected.[2] We should note that the ΕΠΙ is rather squashed in below the rest, when the whole of the rest of the foot was available. It is improbable that this is another personal abbreviation, after the *alpha-rho* ligature, and from its position it should have some relevance to the numerals; it may be complete in itself, 'in addition', though more likely, as suggested on p.186, is the supplement ἐπιθήματα, 'lids', in which case the ΚΑΔΙ are more likely to have been larger amphorae, as the marked vase.

2 and 3, with the vase-name entries in type 11F are all Nolan amphorae or pelikai, and those members of type 16B with ΚΠ, interpreted as καδ(-) ποικιλ(-), are of the same shapes. The large number of known pelikai by the Washing painter should allay any anxiety over the large size of the batch listed on 11F, 19.

4 must be an uncertain member of the type; Hackl took the *rho* as a miscut *iota,* a dangerous assumption. καδ(ίσκοι) ρα(βδωτοί) could be suggested, though the reference would not be to the inscribed vase, as far as can be ascertained.

Type 13F

There can be little doubt that on the kraters 1 - 4 the abbreviation stands for κορινθιουργης or the like (see type 24F); on 1 and 2 the graffito reads 'for sale, a krater (?with a kylix)'; on 4 'four kraters' is clear, and the following *kappa* and stroke may be similar in meaning to the ΚΙ on 2, though the length of the stroke does not immediately suggest an *iota.* The large size of the batch on 3 may indicate a large back-log of winter's work by the fairly prolific Orchard painter, ready to be shipped by the first boat of a new season. Note that the fuller inscriptions of type 24F appear on the later vases.

8, from the Campana collection, is from Etruria and so the mark can be no dedicatory inscription. It may be significant that it comes from the most Corinthianising workshop at Athens. Could it be that we have here a very early use of the term κορίνθιος?

The significance of the abbreviation KOI on 11 and 12 could lie in κοῖλος or a derivative;[1] in that case we would have perhaps three vase-name abbreviations on 11, the mysterious ΑΠΙ, the more explicable ΠΟΙ and KOI.

Sub-group ii admits of no ready interpretation; a κοῖλος word preceded by a numeral is a possibility, though any form of numeral would be of unusual interest at this date. 'Andokides' cannot, I think, be resurrected from it.

The reading of 7 cannot be doubted, ΚΟΞ. The mark must be Greek, with *kappa* and *omicron;* the use of the hour-glass in a vertical position should be distinguished from its occasional horizontal appearances, with or without other letters, or even from other vertical but lone examples (see type 24B). The sign cannot be isolated from the preceding two letters; it may be a letter, a numeral or a punctuation mark, and the latter is hardly likely, though the sign is so used in Crete (*LSAG* 308-9). The sign is probably an alphabetic letter even if used numerically; such a usage may be attested on the amphora handle *Naukratis* i 397B - conceivably a Knidian equivalent of the Ionic *xi* on ibid. 389, 396 and perhaps 388. It could hardly be a plain *xi* on 7, nor is Sikyonian *epsilon* much better. The same could be said about the letter on two other Attic vases, 24B, 7 (where *xi* is a possibility) and an SOS amphora from Porto Cheli, for which no suitable interpretation has yet been found.[2] For it and 7 an explanation nearer home than Knidos is probably to be sought.

10 is of no great value in assessing the use or lack of *koppa* in Taras (see also p. 188).

Type 14F

Amyx discussed 1 - 5 fully in *Hesperia* 27 (1958) 289 ff, and I have added further material and comment in *AJA* 82 (1978) 222ff. Here I summarise, the results reached, reserving comment on the prices involved to p. 33ff.

1 - 6 were inscribed at Athens. Batches of vases are noted, some kraters with large quantities of small vases; 15 adds significant variation with its στάμνοι and accompanying lekythoi of two types, smaller lekythia and 'proper'-δίκαιοι - lekythoi, probably late descendants of the traditional Attic type. It is possible that where no price is quoted in these lengthy lists that one obol was charged for the number of pieces listed; it is also probable that the price was reckoned at so many per drachma for the smaller vases. There seems to have been some physical limitation on the size of the batch; ἐνθήματα on 6 is equivalent to the sum of the accompanying vases of various shapes on 1 - 5, implying a 'package' of a managable size, possibly conditioned by the circumstances of transportation. On several other vases where a single numeral appears we may have an even more abbreviated version of this notation.[1] Campania was clearly the main outlet for these 'packages'.

Although 12 belongs to the same period its mark is more idiosyncratic; the 'standard' price for ten βαθέα would be 3½ obols, which is difficult to wrest from the numerals on 12.

Beazley rightly left the price quotation on 17 unallotted; the seven obols cited can refer neither to the six kraters nor forty oxybapha at the rates mentioned in the other lists. Either a large form of oxybaphon is indicated or the price could refer to a total of accompanying vases as the ἐνθήματα of 16. Robinson, when publishing 19, suggested that the inscribed vase, a fish-plate, was meant by ὀξύβαφον; in general terms our graffiti dispose of this idea because of the low prices; also as a measure the oxybaphon is only a quarter of a kotyle, egg-cup size.[2] Then in Aristophanes, Aves 361, such vases are worn monocle-fashion by Peisthetairos and Euelpides to ward off the birds' attacks - fish-plates would be stretching Aristophanic licence; Cratinus apud Athenaeus xi 494c also implies a bowl of small size. 13 and 14 indicate that the name was current in the late sixth century, when the fish-plate was unknown and there was no recognisable precursor of it. Most likely what is meant is the common small handleless bowl; they were well enough known at Olynthos (Olynthus v pl. 176), and fit the description of the use of ὀξύβαφα in the game of kottabos given by Athenaeus.[3] It could be that the central bowl of the fishplate, which presumably served the same purpose as the small bowl, gave its name to the whole plate.[4]

πελλίνια cannot be easily identified; the root word πέλλα was a large receptacle.[5] It is unfortunate that we know little of 21, since it is likely that the vases listed were of the same shape as the inscribed piece. Even when decorated (ΠΟΙ on 21) they would have been among the lesser pieces of the potter's repertoire, judging from the price given on 4. The relevance of 20 is dubious.

In sub-groups iii and iv presumably only 9 refers to kraters; the strongly Ionic eta is noteworthy, as is the very use of κρήτηρ rather than Κορίνθιος which is otherwise used at this period. For 11 see p. 216. 10 is of some interest since it has been mooted that the Uprooter class is of Italian origin; it can only be said that if this is the case the lettering of 10 cannot be termed Etruscan, whether in the kappa, tailed rho or non-Etruscan shape of the alpha.[6] It may of course have travelled from Etruria to a Greek-spelling area, but it is without a known provenance.

Type 15F

Though some latitude of interpretation may remain, I think that 1 is to be read KVAΘEIA; the theta is undotted as in the other word on the foot (see p. 225) and the last two letters are probable (see the photograph in Ars. A. A.). The epsilon remains difficult to extract, if intended, but if sense were intended, which it seems reasonable to suppose, KVAΘ can only be supplemented in two ways, supposing a word in the nominative plural to accompany κύθριδες, namely κυάθεα or κυάθεια.[1]

An unskilled hand is at work here as the untidy scrawl attests. The undotted theta is Etruscan, but I do not think that we have here an Etruscan trying out his Greek by copying out a similar original; yet the oddity of the lacking dot is strange, and it cannot be that both it and the Ionic metathesis of the aspirate are mistakes.

The vase we call a kyathos had gone out of production by c. 480; therefore the vases mentioned on 1 and 2 cannot be of that type. Richter and Milne reject the possibility that a metal ladle could be meant, without, it seems, realising that the pottery kyathos was defunct.[2] Certainly a metal ladle would not be out of place with a pottery stamnos, although we cannot rule out the possibility of the term being applied to an oenochoe. The κύθριδες of 1 are presumably to be found in the marked stamnos and some companions.

Ionian writers use both κύαθος and ἀρύστηρ to refer to ladles or something very similar.[3] Both can be measures, the aryster larger than the kyathos.[4] Etymologically the aryster should primarily be a dipper, but on the one piece where the full name appears, 4F, 5, such a meaning cannot be applied, again for chronological reasons, if a pottery vase is meant. The APV of 2F, 47 and 48 could well, however, be our kyathoi, since the marked vases belong to their period of production, and surely the Ionian who cut 2F, 47 and 48 called our kyathos either κύαθος or ἀρύστηρ.

Type 16F

As 3 may well be a lidless lekanis it seems best to refer this name to the inscribed vases.[1] Panofka, AZ 1847 24, complains of not finding ἰχθύα in the lexica, and Liddell and Scott offer 'a pot, perhaps for pickled fish'; we have more obvious reasons for terming another shape 'fish-plate'. The lekanis is not primarily a vessel for kitchen storage; we must assume that fish were often served in them, the lid being used to retain the heat, not a consideration that one normally associates with Mediterranean cuisine.

Judging from the tailed rho we may say that the graffiti were cut in Athens. Amyx felt unhappy about the use of ΔR to signify drachmai in Jongkees' and Hackl's intepretation, but we are here in the period before the normal

drachma sign became universal. There seems little objectionable about Jongkees' price of two obols apiece for the vases listed on 1; this is not excessive for a complicated vase such as the lidded lekanis. Amyx sought another interpretation, not an easy task, since another personal name would be unlikely and another vase-name obscure (ΔR?). Both 2 and 3 seem to quote a price, though the published readings are unsatisfactory.

The different form of numerical *delta,* the *pi* with longer second vertical and the stemmed *upsilon* of 1 indicate a slightly later date; its light incision is typical of graffiti later than c. 475, but the tailed *rho*, if Attic, should be earlier than 440.[2]

Type 17F

While I have argued that 1 is an Attic mark (p. 226) and the presence of a *heta* in the accompanying graffito on 4 also points to an Athenian hand, the fully Ionic KPH on 2, the prevalence of four-bar *sigma* and the lack of an aspirate in many of the Polygnotan 'hydria' graffiti (type 21F) associable with 3 - 6, suggest rather that this mark is usually Ionic. It is possible that we have a largely mixed type with 1 and 2 being the more distinctive forerunners.

Identifying the ΣKV is not easy. The skyphos comes first to mind, but inscribed skyphoi from Attica are termed either kylix or glaux (p. 224); σκύφος appears far more rarely actually on vases.[1] Points that Richter and Milne advance for identifying our and the ancient skyphos are the propensity of the Boeotians for it, the occasional knotted handles and its association with Herakles.[2] True, we should look for a deep cup, but in all the above details the kantharos is just as good a candidate; Simonides' 'eared skyphos' is far better seen as a kantharos.[3] The inscribed kantharoi from Boeotia are called *kotylos.*[4]

There is little in type 17F to assist. The price of the seventeen ჂKV accompanying 1 may seem high at ¾ obol each if we think of plain skyphoi, but either figured skyphoi or glazed kantharoi could be accepted. The silver mug from Stara Zagora adds a further candidate, the type 8 oenochoe, or mug, which was in production throughout the period in question.

For the additional *sigma* on 6 see on type 19F.

Type 18F

Before 1 was published it would have been foolish to suggest that the abbreviation ΣΠΑ was a vase name σπάθη. Amyx, *Hesperia* 27 (1958) 299, expressed doubts whether a vase was meant, but there seems no alternative.[1] The graffito belongs to the same circle as 14F, 1 - 5 (cf. the punctuation and *theta*), and there clay vases are clearly listed. The price of one drachma per piece is considerable, comparable to that of the pelike, 14F, 15; when we note that all the vases in the type are neck-amphorae it seems extremely likely that the name refers to the inscribed vases.[2] The slim classical neck-amphora is called μακρά on 25F, 2 and the word σπάθη has exactly the same connotation. A possible parallel is 9D; that pictogram also has some resemblance to a short sword or dagger, though there the reference seems more likely to be to lekythoi than to the marked vases. The chronological gap between 9D and this type would allow for development of usage along the lines suggested.

Beazley and Milne were rightly puzzled by the extra strokes on the *alpha* of 2. If it is a ligature there can be no reference to σπάθαι, unless the mark is split up, and the letters seem too close-set for that. Yet there is no obvious ligature available; the suggested σπαδ, σπαρ and σπαυ are unconvincing, as are the parallels cited with Louvre G65 (3A, 6 and 5B, 3) and Louvre F188 bis (2B, 27).

1 may be Attic in view of its closeness to 14F, 1-5. The *beta* on 4 is inscrutable; it can hardly be an Ionic numeral at this date.

Type 19F

I note in the catalogue that 7 and 9 may have a different abbreviation and are not to be taken as vase-name marks.

The association of ΣTA with a vase name and an adjective applicable to vases on 1, 4 and 5 requires that ΣTA itself should be given a similar interpretation, and 2 and 3 clearly point to the direction in which we should look.[1] All the vases concerned are pelikai or amphorae, and we may contrast 5 with London E163, which has the same central monogram, but the clearly self-referent HV instead of ΣTA. So both amphora and pelike could be termed στάμνος, as well as κάδος or the like. I further suggest in *AJA* 82 (1978) 226 that the abbreviation Σ can be used (as K) in this context; a remarkable number of plain *sigma* graffiti of the fifth century are found on vases of these two shapes.[2] Some further form of στάμνος may lurk behind 8, but the incompleteness of the foot and the apparent overcutting of a further mark complicate the reading.[3]

I have little to add to Beazley's remarks on σύμμικτα in *AJA* 31 (1927) 350-1. The full sentence on 11 must be taken as the expanded version of the more succinct message on 10 and 12 (where we can also understand κορίνθιοι), although longer marks tend to appear later in the century (12 being an exception). On the force of the ἔνεστι see *AJA* l.c.

The shorter graffiti of sub-groups v-vi are a mixed bag. 13 and 15 are likely to be abbreviations of Etruscan *suthina* - 'grave goods'.[4] The relevant part of 14 may be a local owner's mark, and while the same may be true of 16, we should note that the three-bar *sigma* persists at least until 450 on Tarentine coinage;[5] ΣVΔ is a rare collocation, but it would be speculative to split the mark up into components. 17 is more likely a vase-name abbreviation, since

there is another mark on the vase which seems to be a personal abbreviation; it could be an abbreviation of σύμμικτα.

4 is almost certainly Ionic, 1 very probably so; 2 is Geloan or Akragantine and 16 is unlikely to be Tarantine. The rest are late enough for the four-bar *sigma* to be taken as Attic.

Type 20F

Milne concluded that some price or content was indicated by this mark, though noting that the close stylistic links between the vases might rather suggest a personal name.[1] There are enough Polygnotan groups of vase-name marks to override the latter observation, but the large size of some of the marks and the fact that at least two of them are on the navel is not typical of vase-name marks.

The ΔΠ in close proximity to the mark on 2 and the *pi* preceding it on others support a vase-name interpretation. I suspect that the *pi* is an abbreviation of ποικίλος, as in certain elements of type 16B.[2] 21F, 8 could therefore present a fuller version of ΠΤΡΙ, ποι (κίλη) τρίδραχ (μος). Certainly there seems no reason why *pi* should have been set in front of a personal name (though 13F, ii gives us pause), and it is not possible to isolate the constituent parts of the mark completely from each other.

There are difficulties in assuming the supplement τρίδραχμ (. . .) for all the type, especially for 2; here the vase, although fine, cannot measure up to the large pieces of the rest of the type, and if we take the TPI closely with the numeral, the resulting fifteen for three drachmai seems rather low. The Phiale painter does have commercial links with the Polygnotos group elsewhere (especially in type 16B) and so the meaning of TPI on 2 is likely to be the same as in the rest of sub-group ii. 11 is not a very spectacular piece, and one would be chary of giving it such a high price tag. If the marks refer to the inscribed vases, which seems likely in view of the general lack of batch figures, a word of broad significance, or at least application, is needed. If τρίδραχμ (. . .), why do we have no contemporary δί(δραχμ . . .)?

The interrelationship of the pieces by painter, provenance and *pi* is intricate.

Type 21F

Discussion of the interpretation of the name is not here necessary, though we may note that 10 was thought to be the foot of a krater.[1] The prominence of the Polygnotan group once again encourages us to believe that more inscrutable marks on other Polygnotan vases have a vase-name significance.

The nationality of the inscribers (chronology must allow more than one) poses problems. 5 and 11 are aspirated and so unlikely to be Ionian, but they cannot easily be separated from the contemporary unaspirated examples; 1 seems fully Ionic, though not so closely connected with the rest of the type.[2] Quite possibly both Athenian and Ionian hands are to be seen here, though presumably at work in Athens (or the Peiraeus), judging from the appearance of batch marks on some pieces and the non-Greek provenances of others.

The restricted size of the batches, maximum of five, reflects the extra care that the potter in particular had to put into the hydria. The prices are discussed further on p. 35. There seems little to be gained from investigating the use of nominative or accusative forms, but we may note the various misspellings on 10 and 12.

13 is not too easy to interpret; the first part may read VΔP II or VP ΔII, while the following letter seems to be a deliberate *mu*, reminiscent of the much earlier 13B, 5-7. It is a pity that we cannot obtain a price for this fine vase from the inscription; if two hydriai are mentioned, it is likely that the other piece by the Meidias painter from the same tomb was its companion; it has no graffito.

Type 22F

The identification of the oenochoe is well enough established for discussion of the vases mentioned on 1 and 2 to be superfluous. It is perhaps curious that it does not appear earlier as a vase-name mark. The precise reading of 2 is not easy.[1]

Much recent debate seems to have established the type 8 oenochoe or mug as at least one of the shapes termed κώθων.[2] The inscribed mug from Isthmia is the main evidence, but 3 too is worth considering, since few of the other candidates put forward were being produced when 3 was potted, c. 425, while mugs, whether decorated, glazed or with impressed ornament, were being made in good numbers.[3]

Theopompus (*apud* Athenaeus 485c) tells us that the *lepaste* was a larger vase than the *kothon* and was used for drinking, and Athenaeus' other material also points to a large drinking vessel, though his philological explanations are at least dubious.[4] As we have a diminutive form on 4 the reference to size may be useless to us in securing an identification. Vases of a shape akin to a limpet which we may consider are the mastos, mastoid cup and perhaps the Hermogenean skyphos, but none of these were being made by the time of 4.[5]

Beazley remarks fully on 5 in *AJA* l.c. The TI is probably to be taken as τιμή, as on the earlier Attic graffiti of type 10F. The strokes following TI should be the price, with the batch notation in the other numeral. The price of one skaphis would then be 1½ obols or less (the plural indicating a batch of at least two), or one obol if the numerals following the ligature denote the batch size.

Literary references to the *skaphis,* despite the diminutive form, indicate a large vase: Odyssey ix 223 makes it a pail for whey and Aristophanes fr. 417 includes it in a baker's equipment along with kneading troughs and serving trays; it can also describe a small boat.[6] Yet not only the low price on 5, but also the size of the batches on both 5 and

6 point here to a smaller vase; the fifteen *skaphides* with four kraters on 6 suggest something just a little larger than the pieces normally dispatched with sets of kraters.

Tryblia are discussed by McPhee l.c. They are small bowls used by Peisthetairos in the Birds for the same purpose as oxybapha, see p. 229. The scholia on the passage give the metrological information that the tryblion equals four oxybapha, which is not wholly out of keeping with the numbers of the two types of vase accompanying the master kraters.

It is perhaps not surprising to find the word χοῦς in a commercial context as on 9 and 10; on a chous oenochoe of c. 375 in Bochum the word is cut alone.[7] Rather more curious is the form χόε found on 9; the letters show through the accretion well enough and this does seem to be the full reading. I assume it may be the dual. Also unusual is the retrograde direction, made clear by the ductus of the *epsilon,* at a date after the middle of the fifth century. We may assume that the kraters 9 and 10 were accompanied by vases of the shape we term chous; the vase has of course a particular significance at Athens, but nonetheless good numbers of them were exported.[8] I assume that the first letter of line 1 of 10 is a badly cut *omicron* and that two types of vase are listed, ordinary οἰνο(χόαι) as well as χόες; the form οἰνοχοες must be viewed with suspicion.

Type 23F

1-3 and 7 are fully discussed in *AJA* l.c. The word denotes the batch of smaller vases accompanying a set of master vases - here mostly kraters, and can be seen as a shorthand method of listing such sets as are found on 14F, 1-5 and 15. While 3 and 7 are later than the vases of type 14F, 1 and 2 show that this form of description of pieces associated with the sale of larger vases goes back to a rather earlier period. How early depends on our attitude to 4-6. Though they are far earlier than the RF vases, we have already noted that the vase names found on vases of the Leagros group are more drastically abbreviated than in the later fifth century and so we could expect a similar treatment if ἐνθήματα or the like were a sixth century concept. 5 has a personal mark already, one which is rarely accompanied elsewhere, and also comes from the Leagros group. If we can accept that EN stands for ἐνθήματα here, there are two reasons why we could take the usage back to the period of 4: it too has a second, personal abbreviation, and a kindred mark, ΣVM for σύμμικτα, appears on a rather earlier Corinthian vase (Corinthian 47). On the other hand, while personal names in ’Εν - are not common, we could also think of a supplement along the lines of ’Ενπεδόκλης.

Type 24F

The use of the word κορίνθιος or the like to describe the column-krater is well established, and we have seen that there are grounds for explaining some of the KO abbreviations of type 13F similarly.[1]

Mingazzini identified the bell-krater as μιλήσιος, or as on 7 μιλησιούργος and Jacobsthal cited the kraters of East Greek manufacture found on Rhodes as supporting evidence.[2] The neuter plural form of 7 is a little unexpected - we must understand a general word such as ἀγγεῖα; the matter of gender recurs in type 25F, and it is instructive to note here that a neuter can refer to kraters.

Despite the varied spelling 6 and 7 are probably both Attic. The form -οργος is regular in Ionic, -ουργος more usual in Attica, but the spelling of the secondary diphthong with a simple *omicron* is always possible.[3] The confused use of *omega* on 3 and 5 suggests that the writers were not familiar with the letter, probably Athenian. The spelling of the nominative plural of ē stems in -εις is general, but the spelling of the neuter plural in -η, as on 7, is rare in Ionic.[4]

I have discounted earlier suggestions that a price is quoted on 1 in *BSA* 70 (1975) 160, where I also mention the ten-obol price quoted on 2; the latter is taken up on p. 35 together with the related pieces, 18C, 59 and 63. The longer part of the graffito on 2 seems unitary, even though the middle appears crowded. Amyx took the first word as dative and as a non-Attic name unparalleled elsewhere; while the reading which has been supplied to me by the museum does not perhaps fully support this interpretation, it does not throw up any other possibility; certainly we have a full name in association with a quotation of a batch of vases.[5] If it reflects standard commercial practice, we may conclude that batches of vases were regularly set aside for middlemen coming from the other end of the trade route.

The interpretation of the second part of the mark also is not quite clear. The reference to column-kraters is obvious, but the final part obscure; as it stands πή(λινα) seems the only reasonable interpretation, but perhaps 'emendation' is the best solution, either ΘΙΓΗ, giving an unusual abbreviation of κορωθούργη, or ΓΙΙ (I think not ΓΗ). 16B, 32 (also Polygnotan) is similarly constructed, with 'eight decorated kraters for Archi - - '.

A difficulty arises when we try to place in sequence the two graffiti on the foot. The A introduces, it appears, the price for the inscribed vase only, yet the second mark quotes a larger batch; logically the second mark would have to have been inscribed first, with the second being cut perhaps on arrival in a Sicilian port, presumably quoting local currency. I consider this question in chapter 7, but note here that there is little evidence elsewhere to suggest that prices noted underneath vase feet were anything other than those asked or paid during transactions at Athens. So the simple interpretation of 2 is probably misleading.

The size of the batches is noteworthy in some cases, considering the bulkiness of the column-krater.

Type 25F

Longperier, publishing 8, was not ready to accept that the vases mentioned were of the same shape as the inscribed piece since the graffito is neuter and οἰνοχόη feminine. The argument was over-precise; we have just seen that a neuter can be used of kraters and can accept a similar case here.[1] The fact that the inscribed vase is fluted (ῥαβδωτόν) confirms the conclusion. The adjectives on 8 are simply interpreted, and the word on 4 is also clear in intent; its rarity in graffiti, contrasted with the increasing output of wholly glazed vases during the fifth century is accounted for by its self-depreciating nature; when a distinction had to be made between a batch of decorated vases and one of glazed pieces it was normally the former that was given the ΠΟΙ tag. 4 also is neuter plural with no obvious noun available (possibly 7 too). A price is apparent also, a drachma for six pieces, rather high for such a simple vase.[2]

1 is readily interpreted. It is likely that the Athenians, like ourselves, were not too scrupulous in reserving the term *glaux* either for all skyphoi with owls on them, or all skyphoi of type B; see Johnson, *Studies Presented to David Robinson* ii 95ff. It is unfortunate that the central part of the graffito does not yield sense, having apparently both regular and 'arrow' *delta*; is there a price concealed?[3] In his dating of the piece Johnson repeated Hackl's observation that acrophonic numerals do not occur before 480. While the premise is incorrect (see p. 28), the Ionic script does point to the second quarter of the fifth century; the acrophonic numerals are not likely to have been cut by an Ionian and so the mark should be Attic; we do not know what name an Ionian may have applied to the typically Athenian owl skyphos.

Longperier considered μακρά on 2 to be a suitable epithet for lekythoi, but there can be little doubt that the word refers to the inscribed vase, and the description is apt for the slim classical Nolan amphora; see also on type 18F.[4]

ΠΑΧΕΑ on 7 presumably refers to a batch accompanying the marked krater, along with the τρύβλια mentioned on the same foot. A range of heavy walled glazed vases were being produced at Athens at this period from salt-cellars upward, and the term seems very appropriate.[5]

The μεγάλαι on 4 might reasonably be thought to refer to a batch of large cups of which 4 was one. However, the publication explicitly states that 4 was a small cup, and the second part of the graffito remains to be explained. Several interpretations are open, though Hackl's idea that ΠΟΔ could be high-footed stands can hardly be right; more promising is his second suggestion that ΠΟΔ is to be taken with μεγάλαι and indicates high-stemmed cups. A misreading is possible; certainly ΠΟΙ is a tempting emendation, whether or not followed by a numerical *delta*. Perhaps also the relatively high value of the μεγάλαι could be reconciled with 'kleine Schale'.

I have hazarded that OINI on 6 refers to some type of vase, but have no further suggestions to make.[6]

5 remains; Beazley thought that the reference might be to a myrton-shaped vase, but there is no obvious candidate.[7] Myrtle decoration on the vases in question is a more likely approach, though Beazley, without quoting examples, states that such ornament occurs earlier and later than 5, but not at the same period. On smaller vases myrtle appears most often on members of the St. Valentin class, later than 5,[8] but similar decoration does appear on the owl skyphos, which was certainly in production at this time; the branches depicted on them were surely intended to be olive, but since the inscriber of the mark was an Ionian it might just be possible to pardon him for wrongly describing Athena's attribute. Not but what the most distinctive feature of the type is the owl and it would be odd that the vase should be named by anybody after the mistaken identity of a secondary feature. Apart from the owl skyphos there seems no good candidate for μυρτῶται.

Type 26F

For comment on many of these entries reference should be made to the other types involved, notably 7F, 10F and 14F. There can be no doubt that a price is being quoted for the marked vase plus others on 2 - 3 and the drachma signs and other indications point to the same interpretation of 1, 5 - 9 and 12 - 14; the prices on these may be for the marked vase (6 - 8, probably 9, 12) or others (5, ?11, 13) with 14 uncertain and some doubt over 1.[1] The drachma sign does not appear on the earlier pieces, but it was probably not fully established everywhere before c. 450; the earliest uses known to me are on vases from Sicily, and we may even consider that the sign originated there, since there were flourishing coinages on the island from the later sixth century onward.[2] The half-obol sign also appears first on a vase from Sicily, 16E, 9, probably a little earlier than 13B, 7; 1 here is its only other secure appearance in commercial marks. 5 has the horizontal stroke for the division of an obol (p. 227).

10 stands a little apart with TI ending the mark; the accompanying NVΛE has numerical company elsewhere, but further speculation would be out of place.

None of the members of sub-groups v and vi, making due allowance for the reported additional strokes on 20, have any good credentials for being interpreted as τιμή. Personal names in Τι . . . are common and we can readily accept a few such abbreviations here. 15 and 16 are probably a close pair, and 18 and 19 another, whatever the intended reading of the second part of 18; I have attributed the latter pair to an Aeginetan hand, akin to, possibly the same as that which cut the curving *lambdas* of 23E, 5, 6 and 10.[3] The addition of 17a tends to confirm my interpretation of 18.

MARKS ON VASES OF OTHER FABRICS

Corinthian

Several aspects of these marks are discussed, in general and detail, in *BSA* 68 (1973) 185-9 and 70 (1975) 148-9 and are merely recapitulated here.

1 and 2 stand by themselves and are the earliest marks known to me on fully decorated vases. The next pieces are at least twenty years later; none of 3 - 6 can be said to have a secure footing in the seventh century.[1] It is therefore unfortunate that the dipinto on 1 is so poorly preserved; we can say nothing of its meaning, script or origin and can only argue rather tamely by later analogy that it was applied at Corinth. The graffito is probably of a different shape and so to be disassociated from it; the script is not Corinthian, though it fits the alphabets of many other areas. The mark is commonly found elsewhere as an abbreviation of ἱερόν, but although we do not know the provenance of 1 it would be surprising for a dedicated or cult vessel to survive in such good condition.[2] Rather, it is the abbreviation of a personal name, of a non-Corinthian, possibly Etruscan owner; the more enigmatic mark 2 could have been closely associated with it, in view of the painter link.

The following series of marks covers the whole of the first half of the sixth century, apparently terminating with the red-ground style's demise although graffiti are found on later glazed vases from Corinth and Perachora.

Marks are generally found on 'prestige' shapes, as at Athens. These include the lekythos and convex-sided pyxis. There are a few lesser pieces, the plates 11-12, a skyphos 60, a kothon 74, and a mean aryballos 61.[3]

The range of provenances of marked vases is far wider than for Attic. A proportion are from Cerveteri,[4] two from Tarquinia, one from Civitavecchia and one from Vulci; six from Nola contrast with the scant record of marks on early Attic vases from the site. The rest are scattered throughout S. Italy and Sicily, with Rhodes, Elaious and Naukratis also represented.

The letter forms of many of the marks strongly suggest that the dipinti are of Corinthian origin with few exceptions.[5] It would be perverse to place elsewhere the *beta* of 27-28, the *epsilon* of 17, 31, 77 and 80, the *digamma* of 18, 45, 46, 48-50, 55,78, 92, 100 and 106, the *iota* of 66, the *xi* of 14 and the *san* of 63. A number of more difficult pieces are discussed in *BSA* 68 (1973) 187; 47 is clearly in Ionic script, but the apparent open *(h)eta* or straight *iota* on 13, 40 and 41 may be a false interpretation. 19 and 20 have �508, which is perhaps more likely to be *sigma* than the initial of a Corinthian name in *iota,* but the latter possibility can by no means be ruled out. The ductus of the marks on 65 and 105 suggests that their basis is a *zeta* rather than *(h)eta.* In sum, only 47 and perhaps the group around 13 and 41 are likely to be non-Corinthian. Where there is inequivocal evidence the marks are seen to be painted over the glaze rings on the underside of the foot, and so we cannot argue that any marks were painted at Corinth before the vases were fired (*BSA* ibid.).

There are no large groups of vases bearing the same mark. The range of marks is wide, but most are simple, of one or two letters; non-alphabetic marks are very much in the minority. The commonest marks are X (sometimes no doubt alphabetic *chi*) and *digamma;* instances of the former are spread throughout the MC and LC periods with no apparent grouping. The *digammas* too cover the ceramographic spectrum though it is possible that the two kraters 49 and 50 were marked for the same man.

Further small groups of marks may suggest that contemporary Attic and Corinthian practice was not too far apart.[6] The graffiti 29 and 30 are on closely related vases, but are not likely to be Corinthian; 19 and 20 can be taken together, also 87 - 89 (despite the different pigments) and 103 and 104 by the Tydeus painter. 27 and 28 may be close, though I have not seen the former. 45 and 46 belong to the same group and although they are not closely related within it the peculiarity of the mark must give them commercial unity; the mark is presumably a ligature (rare at Corinth) of *digamma* and *rho,* which prompts the thought that 48 should also be taken with them, while the painter link invites us to consider including some of the simple *digamma* marks in the same grouping. Fρα . . . may have been a major exporter from Corinth.[7] 40 and 41 also belong together, but the other vase with a similar mark, 13, stands outside their group; much the same applies to the BV marks: 76 and 81 are probably related but have no connection with the earlier 17 and 31.

Particularly noteworthy is the relationship of marks and provenance. 27 and 28, related as vases and by their mark, are from Nola and Kamiros respectively. 31, from Rhodes is connected by its mark at least with 72 from Nola.

Such a spread of provenances is a significant argument for the application of marks at source, not so much at Corinth, where the Corinthian script constitutes even stronger proof, but by way of analogy at Athens.

It is not easy to calculate the proportion of Corinthian vases bearing marks. Limiting a survey to the larger vases in Payne's catalogue, *NC* 1090-1199 and 1361-1485, and excluding those pieces which I have not examined or have not been fully published, as well as those with restored feet, we find marks on about 15% of MC vases and 24% of LC. Because of the impermanence of dipinti it is difficult to assess how close these figures may be to the original figure. A trivial percentage of smaller vases carry marks.

The nearly exclusive use of dipinti at Corinth is reflected at Athens in the same period. By the time marks start appearing with any regularity at Athens, c. 570, the practice of dipinto marking was well established at Corinth; it is possible that this was a further aspect of pottery production that migrated from Corinth during these years.[8] From preserved material, the range of the use of marks was more limited at Athens, both as regards the shapes marked and their destinations, though by the LC period Corinth too was looking more fixedly towards Etruria. There is no evidence that in this respect personnel accompanied the idea to Athens;[9] some marks, in their respective scripts, appear in both places, but they are common abbreviations, Φι-, Ευ- and Σο-, and there are no close chronological links; it is most unlikely that the same people are involved.

Laconian

As at Corinth and Athens, cups are not marked, and so a large proportion of Laconian production is excluded from discussion. We do find a few marks on kraters, which are the next largest group of exported vases.[1] They are few however, and even accounting for possible lost dipinti the proportion of marked vases must have been much lower than in Late Corinthian, the main period of production of the kraters. The rarity of graffiti on vases from Laconia itself may reflect a low level of literacy,[2] but exported vases can scarcely be used to support that conclusion since there is no good evidence to suggest that Laconians handled Laconian vases. Alphabetically, the marks are not helpful; the basis of 6 may be a non-Laconian *delta* and the *sigma* of 7 is puzzling - the mark may have been cut locally at Spina by a Greek.[3] 10 could be a Laconian mark, but would be an extraordinary collection of letters; better to take it as *chi san,* naming an owner X - -, in which case a local origin is to be adopted.[4] The mark on 9 is numerical and very unlikely to be Laconian; there is no clear picture as to what the numerals signify.

Chalcidian

Approximately one in eight of the larger vases seems to have been marked, a somewhat lower proportion than for the earlier Corinthian.[1]

The shape of the marks gives little away; this is unfortunate if we may have hoped that the marks could have given some clue as to the place of manufacture of the ware. There is no apparent connection with Attic or Corinthian, though the '*alpha*' mark on 4-7 is found on a number of East Greek bowls.[2] Could the shippers have been Ionian? Rumpf's interpretation for 8 and 9, *delta zeta,* seems implausible; there may be a parallel in the incomplete East Greek 29 (Chiot).

The appearance of groups of vases connected by painter and mark reflects contemporary Attic marking; Chalcidian vases had as much of a vogue as Attic in Etruria. The high ratio of graffiti to dipinti is also in keeping with the Attic record of the second half of the century.

Could vases have been so marked if they were made at Rhegion? Later Italian vases are rarely marked (p. 238) but they were made mainly for local consumption. There is no obvious reason why the Rhegines could not have adopted Attic 'marketing-methods'; the makers of the vases could copy much from Corinth and Athens, why not the marks as well?[3] Mainland Greeks may have been more aware of such transactions, but their *arcana* could well have been known anywhere in the Greek world, and especially in the key port of Rhegion.

East Greek

Marks appear mainly on smaller vases of East Greek manufacture, and two groups stand out, Chiot chalices and Rhodian bowls and related shapes.[1] In contrast with Attic and Corinthian practice, we do not find marks on vases exported to Etruria (which are in any case fewer), except rarely on banded amphorae and 'Samian' leythoi. Also few pieces that remained in the homeland of East Greece bear marks (71-4, 78-83, 86-88, 101-107, 181-182); as with other fabrics, this argues in favour of a commercial interpretation of the majority of the marks. It is possible that a few pieces are to be dated before 600, thus constituting the earliest examples of trademarks, along with Corinthian 1 and 2.[2]

Fikellura and Klazomenian

Although these fabrics are contemporary with later Corinthian and much Attic black-figure, trademarks were not regularly applied to them. The one caveat is that the survival rate of Klazomenian feet is not high, as a perusal of *CVA British Museum* 8 will demonstrate.

Cook considered 75 to be a dedicatory mark, but I think it unlikely;[3] there is nothing in the history of the piece to suggest it was ever temple property. More probably it is a commercial mark, especially as it is dipinto; there are contemporary parallels in Attic (type 4D) though the *rho* is of a different shape. This may suggest that 4D marks are Ionic rather than Attic with suppressed *epsilon.* The *xi* of 76 would be out of place on Rhodes, but there is no

way of deciding between alternative explanations - manufacture elsewhere, marking by an Ionian trader at Kamiros or at Naukratis. For 78-83 see *BSA* l.c.

84 has a rare and early numerical mark, though the use of unit strokes is not revealing. 85 is suitably Ionic; it would be dangerous to suggest the supplement ΣV(MMIKTA).

Chiot

The marks on vases from Tocra and Emporio are set apart by their technique - dipinti in the handle zone and graffiti strengthened by red - from the Naukratis material. The 'epigraphic' use of red exactly overlapping a graffito is not common, occurring on two other East Greek vases, 75 and 196, and 13A, 3.[4] One is tempted to take the latter as Ionic *lambda* purely on these grounds of technique.

No coherent system of marketing seems to emerge from such differences. Even within the Naukratis material there is a wide spread of isolated marks, though a few do recur to form small groups. The general use of graffiti on the Chiot vases from Naukratis is also noteworthy; in the first half of the sixth century Attic and Corinthian pieces with graffito trademarks are rare, and there are only a few on Rhodian vases; dipinti on Chian amphorae also seem commoner at sites other than Naukratis.[5] I can see no single reason why graffiti should so predominate on the Naukratis chalices; possibly the habit of incising dedications on these and other vases at the shrines in the settlement influenced the choice, though at the same time it is equally possible that the use of dipinti elsewhere may have been stimulated by the equally popular Chiot habit of dedicating chalices with painted bespoke inscriptions.

We may make a distinction between the trade to Tocra or the Black Sea and that to Naukratis, where some of the traders may well have taken up temporary residence. Perhaps many of the vases found in the waste pits of the sanctuaries could have been used by these traders before being dedicated and the marks on them could be their own identificatory marks. The marks on the later black-glazed vases from Naukratis have a strongly private appearance, akin to the owners' marks from the Athenian Agora. There is however one substantial objection to this interpretation of the graffiti: there is no correspondence between them and the name of the dedicator on those vases where both mark and dedication are preserved.[6] While such material is very limited, we can also note that there is no correlation at all between the names of those dedicators we know and the abbreviations beneath any of the severed feet except for ΔA on N441, who could possibly have been the Damon who dedicated many pieces at the sanctuary of Aphaea on Aegina.[7] Even if only a small proportion of the fragments with dedications were originally united with feet with graffiti, the discrepancy between the two would be striking; even with non-alphabetic marks it would be legitimate to ask why a man who could write his own dedication did not use an abbreviated owner's mark.

If this argument is accepted the marks must refer to somebody or some transaction that took place before the dedicator took possession of the vase. Similar marks occasionally appear on Rhodian and other East Greek vases, suggesting that some traders had a wide range of vases to offer; this would weaken the notion that many of the Chiot vases were actually made in Naukratis - perhaps being marked by the potter before being sold over the counter.[8] The question would be highlighted if a bespoke vase should be connected with a graffito-bearing foot, since the mark would not refer to the dedicator, yet the vase must have been dedicated immediately after being handed over by the merchant. In that case it would be pertinent to ask why a mark was necessary when the name of the dedicator gave the piece a destination, but here purely hypothetical arguments take over.[9] If no convincing explanation of the Naukratis marks comes out of these considerations, they may at least show that the history of the chalices may not have been as simple as would appear.

The alphabet of the marks, where diagnostic, is Ionic, but our present knowledge of the Ionic scripts does not allow us to say whether they were cut by Chians or others. A number of marks are *psi*-shaped; if alphabetic, they may have indicated an Ionian Ps - -, but Rhodians with names in Ch - - would have been more plentiful.

Disregarding single letters, X in particular, the following marks recur on other fabrics:

29A. Chiot 37. An Ionic origin for this mark on Attic vases was apparent and as all of them are relatively early it is not impossible that the same man marked the Chiot vase.

34A. Chiot 51 is the only parallel on a non-Attic vase and as that mark is incomplete I would not stress any connection.

36A. Chiot 24 and 35; it also appears on a piece from Tocra (Rhodian 142) and may have a relative in Corinthian 56. All the Attic vases are fairly early and so the use of the mark may have been derived from Ionia.

9B. Rhodian 178.

11B. The mark as in sub-groups i-iii may be a derivative or alternative form of a common East Greek mark, Chiot 39, Rhodian 123, 128, 152, 157 and 168, East Greek 227 and perhaps 240;[10] it also appears on the wall of a Corinthian skyphos from Naukratis, London 1886.4-1.1337. The marks vary in detail but I would accept a connection between them, although no one explanation seems to cover all varieties; it is unlikely to be alphabetic.[11] Here the graffiti from Naukratis are connected with dipinti from elsewhere. Together with examples of type 19B the mark illustrates some East Greek *koine* of motifs used by an 'international' trading fraternity.

19B. This is the most common mark on East Greek vases: Chiot 34, 56 and 61, Rhodian 131, 132 and 153 (perhaps 95) and East Greek 197, 198, 250 and perhaps 205.[12] The length of the struts of the V varies, but it is likely that all the marks belong together; Beazley suggested the interpretation ΛV (p. 198); it is an attractive

suggestion but we should note that if we adopt it for the similar marks that appear on Chalcidian vases (4-7 and 10) the inscriber was using a non-Chalcidian *lambda*. [13] It is unlikely that the Chalcidian marks, or the Attic ones, refer to the same person as on the East Greek vases; [14] once again, however, graffiti at Naukratis match up with dipinti on East Greek material from other sites.

20B. Chiot 11 seems the only parallel.

23B. Chiot 36; it appears on some other East Greek vases: on the shoulder of a plain oenochoe, *Histria* ii 316, on the neck of a Chian amphora, Boardman, *The Greeks Overseas* 147, and a shoulder fragment from Al Mina, Oxford 1956.574. A thoroughly mixed collection, as in Attic. [15]

24B, i. Akin to this mark are Chiot 59 and Rhodian 180 and 182. They have stems, making them double-axes rather than hour-glasses; presumably the mark has a pictographic origin. There is perhaps enough material here to suggest that the sign belonged to the general East Greek repertoire. The hour-glass version appears on 251 and on an amphora handle, *Naukratis* i 397b. The provenance and the fact that most marks on Rhodian vases outside Naukratis are dipinti suggests that 182 is an owner's mark.

23E. East Greek 58, 190 (?) and on the wall of a vase, *Naukratis* i 397a. The mark is almost certainly a ligature of *lambda* and *alpha*, and although it is hardly possible to date the pieces securely they must be among the earliest commercial marks in ligature (see p. 2). There is probably no direct connection with the Attic marks.

3F. Chiot 31 is not an exact parallel but demonstrates that Attic vases hold no monopoly of enigmatic *delta*-based marks; if 3F is not alphabetic Chiot 31 could have a similar meaning, especially as we have seen that 3F was cut by an Ionic hand.

Parallels for two other types are found on pieces not in the catalogue:

22B. Rhodian 159 could be considered, but looks more like a whirligig. It is also found on the outside of the rim of an East Greek bowl from Naukratis, London 1922.5-8.14, on Corinthian 87-89 and stamped on the neck of Massiliote wine amphorae (*Gallia* 16 (1958) 426).

11E. *Naukratis* i 412 (London 1910.2-22.28) and an Attic glazed sherd ibid. 569 (1910.2-22.174). They do not appear related to the main type and give little help in its interpretation. [16]

Rhodian

A good proportion of the output of larger vases in the Wild Goat style dates to before 600, but even so the comparative lack of marks on amphorae, oenochoai etc. is striking. It seems that a practice opposite to that at Corinth and Athens was adopted, and it would be interesting to know why it is that smaller Rhodian vases tend to be marked; perhaps they were thought to be the mainstay of the trade. It would appear that vases sent to Italy were not marked, while new material from eastern and Black Sea sites is always being added. As elsewhere at this period most marks are simple; ligatures appear, but are not always readily recognisable (e.g. Rhodian 116 and 117).

The script of the marks gives precious little away; for example, the closed *eta* of 147, 162 and 164 might seem rather more at home on Rhodes than in Ionia, but the sign also appears on Chiot vases, presumably of much the same date. The position of 146 and 147 in the handle zone is as Chiot 68 and 69, and we have already noticed a certain overlap in the repertoire of signs used between Chiot and Rhodian (probably with other East Greek states). Some single letter marks appear at more than one site, *eta* at Tocra and Histria, X and *gamma* or *lambda* at Tocra and Tell Defenneh; a simple loop appears at these two places also (119 and 237). 234 has a perfect Corinthian *beta*, which is parallelled on *Naukratis* i 443 (E. Greek? kylix foot); it would be devious to explain this as anything other than a Corinthian, or possibly Byzantine *beta*, since no other user of that form of letter seems a better candidate, and none appears in Herodotos' list of incumbents at Naukratis (ii 178). There are some marked Corinthian sherds from Naukratis, and so our B - - would not be wholly isolated. [17]

There is enough in common between the Tocra and Histria material to prove a common source for the dipinti, a source that we may assume to have been Rhodes (whether applied by Rhodians or Ionian traders). The material from Tell Sukas seems to fit this pattern, as does that from Tell Defenneh; that being so there can be no doubt that the system was well known at Naukratis, despite the preponderance of graffiti there.

I have discussed the marks on banded amphorae and 'Samian' lekythoi in *BSA* l.c. Marks are only found on the amphorae from Etruria, but there is no mark that must be Etruscan and some that are certainly Greek, 98 and 100; 95 provides the sole but striking link with other East Greek material. 97 is particularly puzzling with its mark of type 8E, which I discuss under that type. The *lambda epsilon* mark on 91 has no obvious connection with those of type 17E or any other, but we cannot rule out the possibility that it has a similar significance. [18]

As often with semi-decorated or plain vases both the banded amphorae and 'Samian' lekythoi are regularly marked on the shoulder; in the latter case southern Italy is the only source of exported material with marks. [19] It is unlikely that these marks had the same purpose as those on larger plain vases, or indeed as the bulk of those on decorated ware; yet only 108 gives the appearance of an owner's mark, similar to those on the pieces from Rhodes. The dipinto 110 is of particular interest; two other marks on East Greek vases have a mark akin to type 2F, both graffito on the wall of the vase: *Naukratis* i 419 (London 1910.2-22.34) and *Tocra* 859. None of these is likely to have a close connection with the Leagran core of type 2F, and none are of precisely the same form, the last two perhaps being a ligature of *eta* and *gamma*, the dipinto possibly non-Ionic *heta upsilon*, while remaining an unusual example, exported to the West, of a 'regular' form of dipinto mark on an East Greek vase.

Other East Greek

A number of these pieces have been already discussed above and little can be said of the rest. I assume that 186 preserves the beginning of a name in Doric dialect, proving perhaps Rhodian activity at Naukratis. 196 besides being a rare example of superimposed graffito and dipinto may be an early example of the 'internal' ligature, type 9E, xi. The provenance of 249 is of interest, but the mark is presumably an owner's inscription.

Eretrian

There is as yet no consensus over attributions of later BF vases to Eretrian workshops. Several marked vases have been so attributed in recent years:

New York 68.11.40	hy	c. 540	*MMJ* 2 (1969) 31		
Würzburg 458	type B	540-30	*MMJ* ibid		
Louvre Cp121	hy	c. 550	*CVA* 17 53	Fig 14w	traces
Louvre Cp11031	hy	550-40	*CVA* 17 54		
Louvre CA6141	hy	525-15		⊕	navel

All marks dipinto save part of Cp121. None of the dipinti can be closely paralleled (in most cases cannot be paralleled at all) on Attic BF. The alphabet used is distinct in the three-bar *sigma* of New York 68.11.40, which could equally well be Eretrian, Aeginetan, Attic or Etruscan; the ductus of the graffito on Cp121 does bring to mind Boeotia in the slightly diagonal final stroke of the *pi* and angled *alpha;* assuming that the vase was found in Etruria, it would seem that it was marked by a non-Athenian Greek before reaching its destination. The wagon-wheel on CA6141 is a panhellenic possession, but does not reappear as a dipinto elsewhere; contrast the anchor mark, 36A.

The marks then lend little support to stylistic arguments, whether backed up or not by clay analysis.[1] Yet this entry by itself may serve to remind us that there may well have been Euboean traders marking either their own or Attic vases.

Boeotian

I would take as owner's marks all those graffiti on kantharoi and other glazed vases from Boeotia itself which bear graffiti, usually not under the foot, but often abbreviated. The figured vase Würzburg 649 can be similarly treated.[1]

Etruscan

A very large number of Etruscan vases bear graffiti, but none of these are of immediate concern to us here, being mainly owner's marks - whether alive or dead. Similarly Etruscan owner's marks are regularly found on imported Greek vases. There are over and above these several Etruscan marks on Greek vases which are worthy of attention; some have a commercial significance and are noted sporadically elsewhere.[1] Others are dipinto and may be either owner's or commercial marks; e.g. 4E, 1 and Berlin 1877 with retrograde CA. To my knowledge red dipinti are rare on Etruscan vases however; a dipinto occurs under an Italocorinthian olpe from Cerveteri, *ML* 42 585, of the first quarter of the sixth century; the sign is not easy to interpret, apparently a ligature involving tailed *rho,* though in an Etruscan context neither of those possibilities bears close scrutiny.[2]

South Italian

A red dipinto cross or cartwheel is often found under the feet of later fourth century Apulian or Gnathia ware vases, largely oenochoai and pelikai; it has no obvious commercial significance, since other varieties are lacking.[1] Otherwise marks appear rarely and sporadically in South Italy and are almost entirely confined to small vases; an exception is a Lucanian oenochoe in Malibu with a glaze dipinto name, probably of the buyer.[2] A small group of pyxides have a distinguishing mark, but the remaining material seems largely inconsequential, mostly no doubt abbreviated owner's inscriptions.[3]

NOTES TO THE CATALOGUE

TYPE 2A

1. I have not seen 2 and so cannot judge whether the vases are closely contemporary; they seem to be earlier than those of type 1A.

TYPE 4A

1. Fürtwängler, *Aegina* 465-7, nos. 367-9, 373 and 375; see also *AAA* 9 (1976) 88. The two letters are ligatured in the full word, δαμόσιον, cut on a vase from Corinth, *Hesperia* 40 (1971) 41, 33. A similar mark on a glazed vase from Chersonesos is interpreted in the same manner by Solomonik, *Graffiti Antichnoyo Chersonesa* no 532.

TYPE 7A

1. See types 20A and 9E for examples.
2. For the four-bar *sigma* in Etruria see more recently Colonna, *MEFR* 82 (1970) 668-9 and Cristofani, *Ann. Scuol. Norm. Pisa* 38 (1969) 105-7.

TYPE 8A

1. I have not seen *ABV* 392, 11 (Tarquinia RC2801).

TYPE 9A

1. For the sake of completeness I mention some other candidates for four-bar *epsilon*: 10A, 11 - see the following note; Cab. Med. 232 is published as having such a letter, but there are in fact only three bars; an apparent example is published under the foot of a type A amphora by the Swing painter in a Swiss collection, Niemeyer, *Weltkunst aus Privatbesitz* (Köln, 1968) A16. An Etruscan example, *NSc* 1937 435, 106, from Cerveteri.

TYPE 10A

1. It is the most assured example of four-bar *epsilon* that I have found among trademarks. So many of the possible candidates were found at Tarquinia that a local usage may be considered; for the most part, however, I am not convinced that we are dealing with simple *epsilon*. The four-bar form does appear sporadically in Greece (*LSAG* 266-7) and Jeffery is as loth to accept a Geloan fashion as I am a Tarquinian.

TYPE 11A

1. 3E, 17-20 are the best preserved. Traces only can be read on s.l. 5, 41, 66, 68, 68a, 118 and 122; a little more survives on Boston 00.331 (*CVA* 1 25).

TYPE 13A

1. See further Ch. 4, p. 15 for marks on vases from Taranto.
2. See Ch. 2, p. 4.
3. For the vase from Spina see s.l. 2, 38. Bologna 5 may have red traces, 7 certainly has; Bologna 48, col-kr of 520-510 by the Painter of Bologna 48 has red KD, see Hackl p. 63.
4. BF: 8D, 20; s.l. 1, 16; Würzburg 212, n-a, Leagros group (*ABV* 371, 150) - incomplete?; Munich 1761, oen, Class of Vatican G47 (*ABV* 460, 22); Naples 2475, n-a, late sixth century; Castle Ashby, Panath, 510-500 (*CVA* 9 - ?Λ); Tarquinia RC1816, amphora lid. RF: London E37, cup, Epiktetos (*ARV* 72, 17); Oxford 1927.4065, cup, Oltos (*ARV* 62, 77); Louvre G58, psykter, Smikros (*ARV* 21, 6); Compiègne 1036, lek, Berlin painter (*ARV* 212, 213); Berlin inv. 3189, pel, 500-475, from Tarquinia; unnumbered cups in the Vatican by the Pythokles and Euaion painters, from Cerveteri and Vulci respectively; London E102, cup, Eretria painter (*ARV* 1253, 70); London market (*Coins and Antiquities cat.* 58, AN767), askos, from Kamiros (once van Branteghem 151); Milan A1806, bell-kr, c. 380, from Spina (*CVA* pl 10); Gotha, bell-kr, (B).

TYPE 14A

1. Fowler and Wolfe 369-374. We may note here the graffito under Harrow 110, a black-glazed stemless cup of the late fifth century; it bears the common Etruscan *larta*, but the first *alpha* is of a completely different shape and somewhat larger size than the other, suggesting that it was already on the foot and was employed by the Etruscan inscriber (Fig. 14v).

TYPE 15A

1. For further remarks on 1-3, 5 and 9 see Ch. 11, p. 65.

TYPE 16A

1. *LSAG* 183 and 280. It is unfortunate that we cannot assess the significance of the letter. *Kappa* is used before *omicron* on 13F, 10 from Taranto. See also the mason's mark, Weuillumier, *Tarente* 242 n. 2.

TYPE 17A

1. The date given by Lullies for the Munich vases (*CVA* 1 8) is implicitly contested by Beazley, *ABV* 16. They are among the latest vases of the series, but the shape does not seem later than 550; Bothmer dates a slightly more elaborate but otherwise similar piece to 560-40 (*CVA Metropolitan Museum* 3 2).

TYPE 18A

1. For references to the two see *LSAG* 328; the Naukratis vase is certainly far earlier than the vases of type 18A.

TYPE 19A

1. *PdP* 27 (1972) 421 n. 12.

TYPE 20A

1. E.g. Munich 1514 is early, Naples Stg. 186 late.
2. See p. 9 for parallels to the mark from Athens. It appears once with a dipinto of type 3D which could perhaps be Aeginetan (p. 204); a further Aeginetan connection may be afforded by a graffito on a coin of about 500, but not closely datable, one of a hoard of Aeginetan staters found in Elis, *Chiron* 5 (1975) 15. The letters also appear retrograde at the start of the orthograde owner's inscription on a Laconian krater from Selinus?, p. 209 no. 18. On three-bar *sigma* in Ionia see *BICS* 21 (1974) 97-8.

TYPE 21A

1. *PdP* 27 (1972) 416-23. The self-confessed thinness of parts of my argument has been crisply restated by M. Guarducci, *Epigrafia Greca* 3 25 n. 1. Cf. Hopper, *Trade and Industry in Classical Greece* 210 n. 109 (under-rating Gravisca).

2. Sostratos' stele, Torelli, *PdP* 26 (1971) 55-60; the interpretation as an anchor stock, Gianfrotta, *PdP* 30 (1975) 311ff. The marble of some of the Gravisca pieces has been identified as Hymettan, *Int.J.Naut.Arch.* 6 (1977) 287, perhaps a further pointer to connect Sostratos with trade from Attica.

3. Mommsen, *Die Affecter* 69-71.

4. Ibid. 79-81. The late period of the painter can be reasonably well fixed not only by his amphora painted by a Lysippidean painter, but also by the commercial connections with the Andokides and Lysippides painters revealed in type 9E; this stage of his career must fall in the 520s or a little later, but it is by no means easy to project backwards to its beginning.

5. It is more difficult to distinguish the stages in the career of Painter N, but it would seem that the type embraces both early and later pieces; 41, 43 and 47 are early and 42 and 44 later, if we judge from the shape of the amphorae (cf. *RA* 1966 24).

6. See M. Lang, *Agora* xxi 3-4 etc.

7. Eichler's suggestion that it is an abbreviation of σκύφοι (*CVA Vienna* 1 36) is scarcely acceptable, nor his interpretation of the numerals as a price. Other owl skyphoi with numerals are 7B, 9, 5F, 5 and New York 41.162.127 (*CVA Gallatin* 105); in every case the numeral may be a multiple of six.

TYPE 23A

1. One further vase has a more recognisable *omega* followed by a four-bar *sigma*, Tarquinia RC7045, a black-glazed type B amphora of c. 540; it also bears other graffiti which seem to be casual doodles.

TYPE 25A

1. I would rule out the possibility of Etruscan *su*, standing for *suthina* = grave goods; see on type 19F.

TYPE 26A

1. We can add a similar mark on a silver phiale of the fifth century, *Silver for the Gods* (The Toledo Museum of Art, 1978) 25 no. 2, where one quadrant of the cross includes ΣA (rather than *mu alpha* as given in the catalogue).

TYPE 29A

1. A similar mark is found under a Chian chalice from Naukratis, Chiot 35.

TYPE 32A

1. For Ψ see for example *NSc* 1937 412, 3; ✗ is more sporadic in its appearances.

2. An Etruscan origin for the Uprooter class is suggested by H. R. W. Smith, *Gnomon* 30 (1958) 364, and D. von Bothmer, *AJA* 80 (1976) 434; however, see p. 229 on 14F, l0.

3. Philippaki, 9-10, connects 11 and 13 by shape. 14 is a carelessly incised *kappa*, not a cross or asterisk; this associates it with s.l. 7, 3. Philippaki's suggestion that 14 is similar to the mark on Compiègne 1068 is not valid; I include the latter as 12C, 3.

4. For a recent appraisal of the question of 'red' and 'blue' scripts is Sicily see Manni Piraino, *Himera* i 353-5.

TYPE 33A

1. See on type 3F, where I deal further with the question of lids.

2. For a list see Ch. 9, n.4.

3. A similar mark to that of sub-group iii appears on some archaic staters, possibly of Mylasa, Kraay and Hirmer, *Greek Coins* no. 625; the sign there is presumably derived from the ankh or symbol of sovereignty seen on many coins of Cyprus (e.g. ibid nos. 676-7). Coins do not provide us with contemporary parallels for our marks otherwise.

4. Parallels for *omicron mu* are rare: MO appears in large neat letters on a red-figured column-krater in a German private collection, attributed to the Nikoxenos painter (*ARV* 1636; *Münzen und Medaillen, Sonderliste N* 5; W. Hornbostel, *Kunst der Antike* 300), and OM is found on Ferrara 16385 (T17D), n-a of 500-490 (*CVA* 2 4).

TYPE 36A

1. The anchor blazon is common on BF vases; a range of examples may be found in *CVA Leiden* 1 and an early occurrence is on London B156, type B amphora of c. 540. For actual examples of anchor stocks belonging to the sixth and fifth centuries see Gianfrotta, *Int.J.Naut.Arch.* l.c. above Type 21A, n.2. A graffito similar to 3 is on a black-glazed foot of the later fourth century, *Tarsus* iii 1434.

TYPE 1B

1. The Antimenean piece, 2, is rather out of context in such associations, in particular since it is accompanied by a mark of type 8E.

2. *ZPE* l.c. in catalogue.

3. For some thoughts on this question see *BSA* 70 (1975) 146-7, 164-7.

TYPE 5B

1. It is perhaps possible that the mark may be Etruscan, an awkwardly inscribed CA, written orthograde, although the crisply incised A does not look typically Etruscan.

TYPE 6B

1. The possibility that we may have here a Corinthian E should be mentioned, though the lack of any obvious Corinthian lettering on Attic vases does not encourage such an interpretation.

2. For the sake of completeness I add one further graffito involving a *beta*, on Hamburg 1917.476, hydria by the Rycroft painter (*CVA* 1 36). Here too the accompanying mark resembles a drachma sign; the same remarks apply as to 6, although the piece is closer in time to type 5E and the relationship of the two parts of the graffito is different.

TYPE 7B

1. For the Athens graffiti see M. Lang, *Agora* xxi 51-2, and *AAA* 9 (1977) 87-9.

2. For a similar interpretation see Hackl 75 (with further possibilities) and compare other prices discussed above p. 33.

TYPE 10B

1. It can scarcely be alphabetic; perhaps a countermark or a retrograde' *'gamma'* five. Another black-figure lekythos in Palermo, 1929, from Agrigento (*ABL* 50, no. 2212), may have a similar ligature; the foot is encrusted, but the *alpha* is clear and the initial vertical, though no traces of the horizontal of a *heta* can be discerned.
2. See further *BICS* 25 (1978) 84 n. 9 and p. 13 above. Retrograde marks would be unusual at Athens at the apparent date of after 500.

TYPE 11B

1. See p. 44 and 240, n.4. The early date brings them a little closer to the parallels on East Greek vases (see p. 236) but the shape of the mark is not very close - only on the much later 11 is there a striking resemblance.

TYPE 12B

1. Crossed *theta* was virtually extinct in Etruria by 525; see further on type 1D. As a curiosity we may note that this mark was interpreted as a numeral, 1010, by De Feis, *Origine dei numeri Etruschi.*

TYPE 13B

1. Other single letter close groups can be found in types 13A, 24A, 6B, 12B, 16B, and 8D; see also *kappa*, discussed on p. 228 (s.l. 7). There are also some small groups of Corinthian and East Greek vases. While other single letters do recur on Attic vases I have isolated no close groups among them, e.g. the list of *alpha* marks, s.l. 6.
2. Although the letter and numeral parts of the graffito need not have been cut at the same time there is no reason to assume that they were not. For the numeral on 7 see *AJA* 82 (1978) 223 n. 11 (though with reference to Fig 4bb rather than the facsimile given there).

TYPE 15B

1. I thought that the black mark on 6 was not glaze, and so could have been applied at Gela. I was not sure that NI was the full reading on 5; there was no obvious trace to suggest that the dipinto was the same as the graffito, but the possibility remains strong. I cannot comment on the additional letters on 3 without having seen the piece.
2. The marks on 14 might at first sight appear close to those on Würzburg 352 (8E, 39); but, assuming the reading is correct, the first sign bears only a superficial resemblance to 8E, and the vase is far earlier than that type, even the problematic 8E, 53.

TYPE 16B

1. Beazley, *AK* 10 (1967) 143. The *kappa* he interprets as some form of κάδος, or the like, referring to the marked vase (see on type 11F); KAΓOI on 31 would then be a slightly expanded version of KΓ.
2. See Type 14F, n. 1, below.

TYPE 17B

1. M. Lang, *Agora* xxi F27 and F30 (P6173 and P13462 respectively). The accompanying mark on 26 may be a complex ligature of ΓANK, linking it with one reading given for 29.

TYPE 18B

1. For this group of cups see Ch. 3, p. 8.
2. I would not draw any sweeping chronological conclusions from the possible pairing. For the relationship of the Pan painter and Myson see Follmann, *Der Panmaler* 70-72; she dates the London vase 480-470.

TYPE 19B

1. See p. 236-7. The mark also appears on three pieces from Gravisca: 73/2429, Attic kylix foot, 73/12082, foot of large non-Attic vase, and 73/17330, foot of non-Attic kylix.
2. Neither possibility can be paralleled at this period, but either would add something to our knowledge of the export trade. The ductus perhaps favours taking the letters as a single word, although Ionic numerals are still found at this date (p. 27); for lamps see on type 6F.

TYPE 21B

1. Although Beazley originally took the foot of 10 to be its own; see *JHS* 30 (1910) 48 and 53, and *ARV* 183, 10. For the career of the Syriskos painter see also Robertson, *MJbBK* 27 (1976) 42-3.

TYPE 22B

1. It appears on Early Geometric vases (Coldstream, *Greek Geometric Pottery* pl 1, j), if we do not go back to Middle Helladic (Furumark, *The Mycenaean Pottery* 228). It is also the underfoot decoration on a Protocorinthian conical oenochoe from Isthmia.
2. See p. 237 for East Greek and other examples. Add s.l. 3, 16 from the Agora, with the mark on the neck.
3. *BSA* 70 (1975) 157 n. 28.
4. The style of another such graffito is similar, Furtwängler, *Aegina* 467 no 403; different the Thasos charicature, *BCH* 90 (1966) 952 fig 16.
5. The relationship of the graffiti is already noted by von Bothmer, *Gnomon* 39 (1967) 817. At a pinch we may regard the mark as a ligature of three-bar *sigma* and *iota,* which does appear, in a different form, on later works of the Berlin painter (see on type 7D).

TYPE 23B

1. See p. 237 with n. 15 for other examples.

TYPE 24B

1. For examples outside Etruria see, e.g., *Naukratis* i no 397b and ΚΩΚΑΛΟΣ 13 (1967) 20 (Segesta); a world-wide survey is attempted by Buonamici, *Epigrafia Etrusca* 151ff; the examples from Este given ibid. 150 are in fact X incised between guidelines, and the piece referred to on 153 must be my 11, since Bologna 111 has no such mark. As the sign is rather rare in Etruscan, a Greek origin for the examples here can be accepted with some degree of confidence. Both figure-of-eight and double-axe are found used as mason's marks on walls at Bolsena, of the fourth or third century (R. Bloch, *Recherches archéologiques en Territoire Volsinien* pl 26 and plan H).

TYPE 26B

1. A similar mark appears on a bowl of the mid sixth century from Smyrna, *BSA* 59 (1964) 41 no 46. Similar, but not identical signs are used for *mu* especially in later Campanian inscriptions.

TYPE 2C

1. Another vase by the Athena painter has a mark very similar to a *sampi*, which would be of clear Ionian origin, Cambridge 1937.8 (see p. 23). I would not care to interpret the mark further.

TYPE 11C

1. Otherwise the alignment of the mark on the foot serves to distinguish it from possible defective examples of type 1A. It is also found on the base of a fluted glaze bowl from Halieis.

2. Sakon is not a common name and is largely confined to the west; see Gallavotti, *Helikon* 15-16 (1975-6) 104 and Manni Piraino, *ΚΩΚΑΛΟΣ* 10-11 (1964-5) 482-3. We should not however forget the Attic potter Sakonides (*ABV* 170-2).

3. At this date, c. 440, the *omega* would be a little precocious, though far from impossible, in a Sicilian inscription; there is none on a coin persuasively earlier than c. 425. See *LSAG* 267 with n. 4.

TYPE 13C

1. σκοίκιον, *Riv. Fil.* 6 (1928) 263, 1.139; σκόφος, *Rev. Phil.* 40 (1966) 71, lines 8 and 72.

TYPE 14C

1. Cups were repaired more often and more elaborately than other shapes, indicating their value; see for example, *FR* i 114 and *St. Etr.* 30 (1962) 59.

TYPE 15C

1. An assured retrograde example is on Milan A1498, the foot of a glazed bowl of the fifth century, seemingly of Italian manufacture. Yet the letters are rare in Etruscan at the beginning of a word; all examples listed in Fowler and Wolfe belong to the two words χeritnal and χest.., but we may add χeχan inscribed on two earlier pelikai by the Syleus painter (*ARV* 1639).

TYPE 17C

1. 1 is probably from Campania or Sicily; it was acquired from the Pantalis-Lefèvre collection, other pieces in which bear the seal of the King of Sicily.

TYPE 1D

1. As Etruscan in *St. Etr.* 36 (1968) 242; 'greche?' in *St. Etr.* 34 (1966) 320. Ἄτθις suggested by Nogara, *NSc* 1937 451.

2. A similar sequence of letters is found to my knowledge only in the Tabulae Iguvinae 1b 12.

3. I follow the generally accepted dating of the Pyrgi plaques. The lead plaque from Santa Marinella, *CIE* 6310, of about the same date has a dotted *theta*, as a vase from Tarquinia from a context of c. 500 (*NSc* 1930 162), and Florence 3852 (*CII* 40m) of about the same date; earlier, a BF eye-cup from Foiana, *TLE* 673, seems to have both forms. The graffiti with crossed *theta* published in *BSR* 1969 9-10 appear to be dated too late in the late sixth century; however, the Etruscan mark on 3E, 27 certainly includes crossed *theta* and must be the latest example of the form in Etruria. See further Cristofani, *Aufstieg und Niedergang* I 2 480-1, where *CIE* 5000 of 530 is described as 'veramente eccezionale' in its crossed version.

4. Although in this fairly large group of inscriptions it would be surprising not to find some more typically Etruscan examples of *tau.*

5. For the history of the word see Jacoby, *Atthis* 79-81. The fact that it and its derivatives are found only in poetry, except in the specialised usage to describe the chronicles of Attica, is not harmful to my interpretation. It is a commonplace that poetic vocabulary was taken up by prose writers, and moreover, if the mark is Aeginetan, possibilities of local vocabulary must be considered; Doric greatly influenced tragic usage and at Athens the word is first found in Euripides.

6. Buck, *The Greek Dialects* section 65. Some Thessalian coins have the legend ΦΕΘΑ for Φeτθά(λων), *AA* 1970 89 and n. 17. Similar renderings are not unknown in Attica, e.g. ΘΕΘΙ**ϟ** on the BF prothesis plaque, Louvre MNB905 (*BSA* 50 (1955) 62, 28).

7. The type of *alpha* is regular on Aegina, though far from rare in other areas. It is noticeably frequent around the Black Sea; *LSAG* pl 72, 61 from Borysthenes is a graffito with an even more exaggerated 'Boeotian' *alpha* and crossed *theta*. The prevalence of this form in the area can hardly be due to Milesian influence; there is little among archaic Ionian inscriptions and the graffiti from Naukratis to suggest that it was used with any regularity there. Aeginetan or Megarian example may have started the fashion, either through the Megarian colonies in the North or Aeginetan traders in the area. The graffito in *LSAG* may even be a Megarian mark, though not, I think, mercantile. See also Ch. 4, n. 41.

8. The lifespan of the mark will allow it to be a personal abbreviation. If it is an Aeginetan mark, we may ponder whether it went out of use at the same period as the deterioration of relations between Athens and Aegina c. 505. The date may fit the evidence of this type, but perhaps not that of all possible Aeginetan marks (20A?, 9E, iv, 23E?).

TYPE 3D

1. There is no adequate survey of the phenomenon in the archaic and classical periods. It is evident on one of the slates of the fifth (?) century excavated in the Academy (*SEG* xix 37) and in the IMI for εἶμι in a dedicatory inscription from Olympia of c. 480 (*Ol. Ber.* 1 78).

TYPE 5D

1. For a discussion of this 'rule' see Ch. 1, p. 3 above. This type has more exceptions than others; see in addition the guttus cited on p. 9 under type 5D and an absorbing graffito on the neck of a fifth century Thasian wine amphora from Nymphaeum, Brashinsky, *VDI* 1978 2, 135ff; Brashinsky's suggestion of an abbreviation of ῥητός is vitiated by the fact that the mark is so obviously an abbreviation of *eta-rho.*

2. The examples cited by Kretschmer, *Griechischen Vaseninschriften* § 77 are mostly later than this period, when the growing use of *eta* for ē at Athens added to the confusion; for some earlier examples see G. Neumann, *AA* 1977 40.

3. For open *heta* in Etruria see below Type 13E n. 1, and for tailed *rho* Type 3E, p. 209.

TYPE 6D

1. ᴎ appears in an inscription from Rhamnous datable to the 440s, EM 12863 (*AE* 1934-5 128ff), and later in the accounts of the Other Gods for 429-8 (*IG* 1 219 in majuscule = *IG*² 310, l.246).
2. It certainly indicates that this is Greek, underlined perhaps by its repeated appearance at Adria - 14 has uprights of equal length. ᴎ and ᴘ need not necessarily be distinguished: ᴘ seems numerical here and on the vase cited under 1F, iii, while ᴎ appears on stone and is generally more common; see Tod, *BSA* 18 (1911-12) 98ff *passim.*

TYPE 7D

1. With an eye on 17 we might think of taking 18 as Etruscan *pesi,* but I know of no parallel to this letter sequence.
2. *Cest - -* is amply attested in Etruscan, see Fowler and Wolfe 290; however, such a use of II for E is excessively premature, since the next usages do not seem earlier than the later fourth century. Double i may be preferable.
3. For the use of both plain and ligatured abbreviations on vases by the Berlin painter see types 9E and 17E (as *BSA* 70 (1975) 160 n. 39 and 164 n. 49). It is perhaps not always as easy to distinguish between types 6B and 7D as may appear from my treatment of them. For the date of 31 I follow A. Lezzi-Hafter, *Der Shuwalow-Maler* 39 n. 162, placing it in the second quarter of the century, rather than the 450-440 suggested by Bielefeld in *CVA.* A local owner's mark of this type is found at Gela, along with another piece with the full name, Sibyllos (*RM* 63 (1956) 151-2).

TYPE 8D

1. I take it as modern, as perhaps the ligature that precedes it - at any rate I do not include it in type 9E.
2. See also Ch. 6, p. 30 where further examples are cited.

TYPE 9D

1. While 18E, 12 strongly suggests that the pictogram is of a kylix, there is no a priori reason for thinking that the same type of vase is the point of reference on all the vases concerned; there could still be an equivalence between ΛE and the pictogram, although κ(ύδος) must be counted an outside possibility.

TYPE 1E

1. For three-bar *sigma* in Ionia see *BICS* 21 (1974) 97-8; on one sherd from Naukratis cited there, London 1924.12-1.1025, it is found alongside open *eta.* For Rhodes see *LSAG* 346.

TYPE 3E

1. 'The usual red dipinto' is mentioned by Beazley, *ABV* 222,56; the foot which he notes is probably that now attached to 14. The two vases from the one tomb are to be found in *ML* 42 246-8. One fragment of a Nikosthenic comes from the Akropolis (*ABV* no 50) and one from Palestrina (no 55), but see *AK* l.c. below 51 n. 54. The example in Cambridge (*Paral* 105, 7bis) is said to be from Orvieto; there is a faint ˅-shaped mark in the cone of the foot, but it may be the result of stress during firing, *Arch. Rep.* 1965-6 46. Athens, Kanellopoulos 2527 has a probably Etruscan graffito, ?*alpha.*
2. It is reasonable to assume that the great majority of imports into Etruria were distributed from ports near the main centres. The excavations at Gravisca, the port of Tarquinia, seem amply to confirm this assumption (see Torelli, *PdP* 32 (1977) 398ff), although the graffiti on the vases from the sanctuary, mainly smaller pieces - cups etc. - have only tenuous links with those on other imported vases from the necropoleis of Tarquinia; they will be published by the present author. We may note also that 17B, 2 is said to be from Montalto di Castro, the *scala* of Vulci.
3. See M. Verzar, *AK* 16 (1973) 51-2 for the popularity of the particular shape of amphora at Cerveteri. We can have little idea of whether any broadly political considerations (hostilities etc.) may have affected the issue.
4. Earlier comment by H. R. W. Smith, *CVA University of California* 31, D. M. Robinson, *AJA* 60 (1956) 5-6, Beazley, *RG* no 23 and also Hackl p. 66.
5. *AJA* l.c., where the vase is erroneously given to Exekias or his manner.
6. The question has also been reviewed recently, and cursorily, by M. Guarducci, *Akten VI Kongr.Gr.Lat.Ep.* 382-3; she includes many examples as early which are of disputed, if not clearly later date, and the presence of a tail on the *rho* of the Rome graffito at the core of her note is doubted by Happ, *Glotta* 48 (1970) 216-7. I do not include examples later than c. 510 in my list, thus excluding, for example, the early coinage of Syracuse and Taras. The tailed *rho* on the Late Corinthian krater, Louvre E638 (*NC* 1474) is wrongly reported by Payne; see Arena, *Le Iscrizione Corinzie su Vasi* no 78.
7. For the inscription on the wall base of the Corinthian treasury at Delphi see Bousquet, *BCH* 95 (1970) 669-73; he dates it to the fifth century.
8. The date seems earlier than that given by Richter. It is frustrating (and perplexing) that the name has no final *sigma*; we would expect a four-bar version in the Cyclades. The definitive publication should elucidate the precise form of *rho.*
9. Guarducci's 'early sixth century' seems epigraphically premature, though 550 should be the latest possible date. The dating of the temple is as contested as that of the inscription (which is not absolutely necessarily of the same date); a seventh century date has been mooted - see *Arch. Rep.* 1976-7 64.
10. For examples later in the period see *LSAG* 66 (Attica) and Fig 14h (Naukratis).
11. It appears in the decade 520-10, e.g. in equal numbers with tailless examples on the calyx-krater of Euphronios now in New York (*AA* 1976 495ff, Abb. 9, 12 and 13), as on the BF amphora of the Leagros group, Munich 1417 (*ABV* 367, 86); other early RF pieces, *ARV* 8, bottom, and 34, 9; also in the signature of Prokles, *ABV* 350 and Oxford MS of *Paral* 39.
12. Perhaps it is a Greek ligature of *kappa* and stemless *rho*; cf. East Greek 228, Würzburg 458 (Eretrian?, see p. 238) and Gela, Navarra 11 (*CVA* 3 6). For 27 see Type 1D n. 3.
13. In Gela such a mark would be a ligature of *delta* and *epsilon* (*LSAG* 262).
14. There is nothing in the use of the hour-glass sign to facilitate its interpretation here. Furtwängler does not mention the mark in his catalogue, perhaps because he doubted its authenticity. Even if genuine, it must be mere coincidence that it contains the two elements of 22-25 put together.

TYPE 4E

1. M. Cristofani, *Aufstieg und Niedergang* I 2, 470 and 473. In North Italy 8 is normal at Adria and Spina, though the earlier form is also found; the latter is regular at Este. See ibid. 483 and Pellegrini, *La Lingua Venetica* i 19.
3. One is tempted to suggest that a Greek would have painted the sign with straight lines, but the curvilinear 8 has been found in at least one dipinto in Greece, as on assembly mark on the Geloan treasury at Olympia, *Olympia* ii 194. There is no suggestion

that 8 or its angular equivalent was ever confused with the hour-glass or double-axe sign.

4. It is found sixteen times according to Fowler and Wolfe 151.

TYPE 5E and 6E

1. For remarks on the Antiope group see Smith, *CVA San Francisco* 27-30 and Ronne-Linders, *Medelhavsmuseet Bulletin* 3 (1963) 54ff.

2. A possible explanation that has the merit of taking 6E as a unit is that it represents a form of *beta* used at Byzantion; in this case the interpretation of 5E as *beta-upsilon* would be attractive, being a transliteration of 6E. The shape of the letter is closer to a *pi* than the later attested Byzantine form (*LSAG* 132-3), but a more weighty objection is that it is difficult to see a *upsilon* in the ligature of 5E, with its frequently very long 'probe'; also we have to take into account the alternative version, 7E. The simple *pi* on some Leagran pieces (16B) may be related.

TYPE 8E

1. This form of *alpha* is particularly noticeable on 3, 6, 17, 30, 38, 39 and 57.

2. *St.Etr.* 25 (1957) 526. The facsimile does not present a mark of quite the same shape as on type 8E vases, but there is a close similarity. The fabric of the piece is not surely established, but is probably local; to judge from the photograph there is no regular Greek vase shape akin. An Etruscan origin for our type would be inevitable if we accept as an alternative to it the complex mark on 10E, 30, or the FA on 35.

3. 37 is close to, if not by, the Priam painter.

4. The Etruscan graffiti on two Nikosthenic amphorae, Villa Giulia 20847 and 20863 (*NSc* 1937, 383, 12 and 13) nicely demonstrate the contemporaneity of earlier and more 'Etruscan' forms c. 530. The Pyrgi plaques (*CIE* 6314-5) of c. 500 have *alphas* with slightly curving to well bent left struts.

5. It is not easy to assess how closely 60-62 may be taken with them; see *ZPE* l.c. The double tick mark is also found on a Chiot amphora neck of this period, *Samothrace* 4 ii 228; a mark similar to 61 is found dipinto on an Etruscan amphora of the sixth century, *Cahiers Subaquatiques* 3 (1974) 15 pl. 2, 1.

6. See further on types 5A and 10B.

7. The only close group seems to be of two hydriai of the Lerici group; see subsidiary list 6.

TYPE 9E

1. There are 64 pages of names in Ar- - in Kirchner, *PA*; 3.5% of my slips prepared for the *Lexicon of Greek Personal Names* are devoted to such names.

2. While the size of vase inscriptions virtually demands stemless *rho,* this is not the case with larger graffiti. The loops on the Adria pieces, 54, 55 and 74, are not as full as the rest. An examination of any body of material from Athens will yield examples of \wedge, but they will be completely outnumbered by \wedge.

3. For example, Agora P19166, cited on p. 9, has \wp·

4. Aegina and Megara are consistent users of \wedge; see Type 1D n. 7.

5. See Type 21A n. 4.

6. It is merely a nice coincidence that the Amsterdam fragment of 81 is figured on the same plate in *CVA* as 82; the history of the two is not parallel.

7. See *Scavi di Spina* i pll. 191-2 for the ensemble from tomb 867; also Robertson, *Gnomon* 39 (1967) 823.

8. The very early cup from the Agora has many tailed *rhos,* but this belongs to the period of the internal ligature, not sub-group xiii; see also Robertson, *JHS* 92 (1972) 181.

9. See my comments in *Greece and Rome* 21 (1974) 145.

10. Though I would not suggest that this explanation can be extended to many of the other examples. A mark as sub-group iv does appear on Etruscan bucchero vases from ambivalent contexts, a foot from the Greek sanctuary at Graviscas and bowls found at Lattes in southern France (J. Arnal, R. Majurel and H. Prades, *Le Port de Lattara* 133-4 - interpreted is Iberian).

11. ἅριστα or the like is a possibility, though whether such a word would be used on undistinguished vases like 72 and 73 is a moot point; a derivative is found apparently as a vase name on an important graffito of the mid-fourth century from the Kerameikos. I doubt whether in any of the marks here we have a miscut APV (see type 4F).

TYPE 10E

1. The vase is unquestionably Leagran; it bears none of the hallmarks of the Antiope group and, from the photograph, seems more carefully painted than the work of Painter S. The hanging palmettes below the main scene are typical of Painter A and the Group of Vatican 424. Munich 1708 is very similar in shape and decoration.

TYPE 11E

1. It may be worth reiterating that there seems to be no clear connection with the otherwise similar 32A, iii, which is largely later than the pieces here.

2. On the gem in the Bibliothèque Nationale, Buonamici, *Epigrafia Etrusca* 244-5; cf. Graham, *Phoenix* 23 (1969) 353.

3. Or rather no Greek state that could have realistically been involved in the export of these vases; a state in the NE Peloponnese, perhaps even Corinth, would be theoretically possible. Nonetheless the adaptation of the shape of the original accompanying mark to that of a *digamma* does suggest that the change was influenced by some regular alphabetic practice of the inscriber(s).

4. Kea: Caskey, *Kadmos* 9 (1970) 109- 110 5, 'simplified form of L56 or L57'. Cyprus: *CVA* 2 35, fig 7/7; Stubbings, *Mycenaean Pottery from the Levant* 48, A32. Most of these signs must have had a syllabic value.

5. Naukratis: see p. 237; Abydos: K. Herbert, *Greek and Latin Inscriptions in the Brooklyn Museum* no 4, black-glazed bowl of c. 425.

6. Zannoni, *Gli Scavi della Certosa di Bologna* pl 71, A-C.

Type 12E

1. A *digamma* stands by itself on an oenochoe by the Edinburgh painter in the Noble collection (*Paral* 218). For an assured use of *digamma* as a numeral at this period see 2F, 42 (fig 11i).

2. We may rule out of court the suggestion of De Feis (*op. cit.* Type 12B n. 1) that it stands for 5000; for this part of his Etruscan numeral system he had no evidence other than these marks. Also note in passing the use of a similar sign in the Cypro-Minoan syllabary (*SCE* 3 604).

3. The vases by the Providence painter are apart from the rest, including his only two large neck-amphorae; his relationship with the Berlin painter (Philippaki 150) is faintly echoed in 20. If the parallel with type 11E holds, the marks were probably not applied in the pottery, and so such evidence for workshop connections cannot be pressed too closely

TYPE 13E

1. The form with one added stroke can only be based on a Greek *(h)eta*. The Etruscan *heta* did not become open till late in the fifth century; an oddity are two apparent examples of the late seventh century, *TLE* 41 and 42 (see *MEFR* 1970 671) from Cerveteri, and another early instance, if genuine, is on a scarab in Florence of c. 450, Zazoff, *Etruskische Skarabaen* 91 166.
2. The added strokes on 22 are cut in exactly the same manner as the cross-bar.
3. See p. 10 . The same ligature may occur in some East Greek marks, see p. 237.

TYPE 14E

1. See especially 11E, 13, 19 and 27 and 2F, 22.
2. Why should an old-fashioned transliteration of the mark be needed at this date?
3. See *LSAG* 79 and Lazzarini, *Rend.Linc.* 1968 153-6.
4. The associated three-bar *sigmas* may cause some difficulty; either they were not cut at the same time as our mark with Ionic *lambda*, or the two letters coexisted in an alphabet used perhaps at Adria, possibly derived from Attic or Aeginetan - see Colonna, *Riv.Stor.Ant.* 4 (1974) 1ff, esp. 9-16.

TYPE 15E

1. The exact date of 7 is unknown, but it could well be as early as 6, c. 540, when a retrograde inscription would be no surprise in any Greek state.

TYPE 16E

1. For such an interpretation see Smith, *CVA San Francisco* 26 (mainly concerned with *lambda-eta* marks), and Hackl p. 67.

TYPE 17E

1. E. Vermeule rightly discards the pleasing idea that the abbreviation stands for Λέαγρος in her publication of 3. It is hard to think that the vases of the Leagros group, above all others, were anything other than direct exports to Etruria. On this topic see further p. 40-41.
2. *Contra* Smith l.c. Type 16E n. 1. See also p. 220-1.
3. Alternatively, we could read the second mark as of type 11E and connect the piece with Hannover 1963.47 (11E, 20), whose second mark is *delta-epsilon* (misread as *lambda* on 15?).
4. Milne in Richter and Hall 221. The use of ||||| for five also occurs on 10F, 17, whose marks are related to those on 16 and 17; there the numerals accompany a presumed Attic script. Judging from the size of the batches we can surmise that the ΛΕ here were smaller vases than the ΛΗ of 1F, vii C. If the reported provenance of 18 is correct, any of the graffiti could have been cut in Sicily.
5. It could be that 34 is of type 21E; the reported V-shaped sign also appears on 21E, 20. This V has a more acute angle than that sometimes found with type 13E.
6. The other mark on 35 may be numerical, although the two are not closely related on the foot. For the exaggerated 'arrow' *delta* see Ch. 6 p. 29. Similarly, the strokes on 37 may not be dependent on our mark; they may indicate a price for the vase.

TYPE 18E

1. For the length of the vowel see the commentary on type 1F. The lack of numerals elsewhere with these marks makes the first possibility unlikely. Milne suggests that an EM mark may appear on New York GR580, a pelike by the Argos painter (*ARV* 289, 14); one could go further and posit EMΛE followed by a numerical 'arrow' *delta*, but such a reading is uncertain and should not be used as evidence for the argument here. Note, however, a potter connection between the Syleus and Argos painters in the Class of Cab.Med. 390 (*ARV* 254).
2. The word is known from Hipponax fr. 146 (West), Hdt. ii 62 and as a measure equivalent to an ὀξύβαφον, Hp. *Loc. Hom.* 13.

TYPE 19E

1. Milne in Richter and Hall 222. Much must depend on whether the second mark on 3 may or may not also refer to the marked vase as κάδος.
2. One might consider the merits of a word in κροτο-, 'rattling' with reference to kylikes of that variety (*AJA* 78 (1974) 429-30).

TYPE 20E

1. See subsidiary list 7.
2. Elsewhere in the type I do not think that the letters can be taken in this order, though it may be tempting to associate the Red-line painter here with his workshop's products in type 6A, ΕΓΙ.

TYPE 21E

1. *JHS* 47 (1927) 88.
2. Hackl p. 67 favoured Ionic *lambda*, Beazley l.c. was non-commital and Smith, *CVA California* 26, calls it Attic rather than Ionic.
3. The accompanying marks in sub-groups i and ii amount to four dipinti, one certainly, the rest most probably of a shape related to the graffito, and three very minor graffiti, an X a *tau* and a V-shaped mark.
4. However, the direction of 10 differs from that of 50-56, and the two component parts do not meet at such a sharp angle.
5. Few Louvre vases definitely come from Tarquinia; see *ML* 36 287. We cannot be sure that the Campana collection, from which 41 comes, did not include pieces from Tarquinia. It is interesting to note that 11, from Tarquinia, (though not 7) may also have a slight additional stroke; I do not give it in Fig. 10e, since wheel-marks complicate the reading.
6. One cannot determine the exact orientation of the mark from Langlotz' facsimile, but the *epsilon* does not seem quite horizontal.
7. The vases by the Rycroft painter are from both early and late phases of his career, as also the pair in type 8E, another type with strong Leagran associations. Other marks on the painter's work are less informative: Vienna 3598 (8D, 71); New York 06.1021.67, various rough graffiti; Louvre F209, an obscure large graffito and red traces; Tarquinia RC5165 is more interesting - 1F, 7 and 2B, 39 (a similar ligature on the Priam painter's type B amphora from Cerveteri (2B,18)); Würzburg 196 has another speciality of the Priam painter (13E, 4); Oxford 1911.256 and Syracuse 21951 have red traces; Munich 1577 has a possibly Etruscan graffito; Hamburg 1917.476 is mentioned in type 6B, n. 2 and Copenhagen, Thorvaldsen 74 is 20A, 85. The order here based largely on that in *ABV* and *Paralipomena.*
8. If we read it the other way up, we should have to conclude that the *epsilon* was inscribed retrograde and from the bottom up, a most unlikely procedure.

9. In sub-group ii the length of the sides is unequal, but the angle well over 60°, often more than a right angle. 24 has the most acute angle (Fig. 10n). It is possible that the ligature was first used in a dipinto form, which might explain its more free structure and spread over the foot, though not the angle.

10. Even here the angle is rarely much less than right. The form found on the Worcester vase (16E, 3) is nearest the theoretical ideal, but it is later than the other two vases by the painter in the type and the incision could well have been influenced by the curve of the foot.

11. E.g. a three-bar *sigma*, with the *epsilon* attached to the lowest bar, or even a four-bar version with the *epsilon* tucked into the lowest angle. *Sigma* cannot be introduced into any of the other '*lambda-epsilon*' marks. It is possible that 21E, vi is a more complex ligature.

12. In viii, the latest group, together with 16E, 6 and 12, there seems to be some confusion over the meaning of the graffito, with respectively a vestigial stroke to the *lambda* and none at all. Is this in memory of an original mark? Without the vestigial stroke one may have considered the interpretation *tau-epsilon* for all five marks, though even then we would have to ignore the apparent connections provided by the Rycroft painter's work between the various types.

TYPE 22E

1. *LSAG* 89; it also appears rarely in Euboean (ibid. 79).
2. An attempt may be made to see a Corinthian *epsilon*, and so to equate the two marks - still ignoring the extra lines. There is no evidence for Corinthian trade from Athens at this period elsewhere, despite the friendly relations between the two states. The form of *alpha* is more typically Greek on a bowl from Spina, *St.Etr.* 46 (1978) 304, 23. Note also an unligatured version on Villa Giulia 14217, column-krater by the Agrigento painter (*ARV* 574, 11), Fig 14d.

TYPE 24E

1. See further *PdP* 27 (1972) 418-9. Add the observation by Beazley that 3 is near the Acheloos painter.
2. Πύξις is not attested at this period, see Richter and Milne, *Shapes and Names* 20; for πύελος see Liddell and Scott s.v. Some black-glazed vases have abbreviations πυα or πυρ, see *BSA* 70 (1975) 164.

TYPE 1F

1. Euboean is an outside possibility but the triangular *delta* is such a rarity there that we can virtually discount it; see *LSAG* 79.
2. *AJA* 82 (1978) 223, n. 11. The *mu* may have filled the same role as the *beta* on 6B, 15 or the EV on 1.
3. See also *AJA* l.c. 223.
4. There is a slight gap in the centre of the mark, suggesting that it may consist of two abbreviated words and therefore should be entered in sub-group vii and type 11F.
5. For 11 see *BSA* 70 (1975) 151 n. 14. The graffito of Ληθᾶος at Gravisca is mentioned by Torelli, *PdP* 32 (1977) 407.
6. The presence of acrophonic numerals suggests a non-Ionic origin for 17E, 18 and 10F, 25 at least; the question is finely balanced. It may be that some of these marks were cut by a hand that was neither Attic nor Ionic; confusion of *epsilon* and *eta* is a hallmark of some of the Aegean islands - a good example is ΤΗΝΔΗ on the skyphos from Kea, *Hesperia* 33 (1964) pl. 64a. An apprentice of Cycladic origin may have painted the names on an earlier Attic BF amphora, Louvre E732 (*LSAG* Central Aegean 44).
6a. 17E, 21 goes some way to supporting this argument, but 1F, 17 should also be considered; one of the vase names on the foot, ΛΕΚ and ΑΡΙ, should refer to the marked vase, and we may assume that it is the first one. In that case, λέκ(ανις) can be used of the handleless bowl.
7. A proportion of the material from Vassallaggi is now fully published in *NSc* 1971 suppl., esp. 216-9, where squat lekythoi of the period are amply represented.
8. Vulci has not produced large numbers of lekythoi (or aryballoi); see Gerhard, *Annali* 1831 125 and Haspels, *ABL* 128-9 with n. 2. I would hazard that Leningrad P91, Nolan amphora by the Alkimachos painter (*ARV* 530, 26) bears some kind of 1F mark.
9. Such a conclusion once more gives rise to the possibility of alternative spellings of the word here abbreviated, sometimes *epsilon*, sometimes *eta*. The *sigma* on 17E, 14 may be alphabetically helpful, but I cannot interpret its significance.
10. There are eight examples where a second Greek mark of an apparent personal nature accompanies a *lambda-epsilon* mark (p. 41): 9E, 53, 77 and 81-3 and 22E, 7-9. It would constitute special pleading to interpret all the *lambda-epsilon* marks on them as vase-name abbreviations merely to avoid having two personal marks on the one foot; the vast majority of the respective *lambda-epsilon* types of which they are somewhat late members are unaccompanied.

TYPE 2F

1. While the lettering of the formulae is usually neat, the large signs can be elegant, but are often in thick uneven strokes.
2. On 29 the tally strokes do not amount to the total inscribed, whether because of mathematical error or because the inscriber felt no need to complete the tally we cannot say. For the apparent lack of one tally stroke on 30 and 43 see below. On 32 a horizontal line is used for ten, see Ch. 6, p. 31.
3. The latter form is discussed under type 5F.
4. On 44 there are further large letters, possibly ΛV retrograde, echoing the ΛV of the formula, but the retrograde direction does not inspire confidence that this is the correct interpretation. Scheffer's discussion of the type in *Medelhavsmuseet Bulletin* l.c. is of interest and fairly sets out the important questions.
5. See Amyx, *Hesperia* 27 (1958) 293-4, and also *Greece and Rome* 21 (1974) 147.
6. I have pointed out in *Greece and Rome* l.c. that it seems best to take the figures on 52 together, a single batch of twenty-seven, split for some reason into two parts; the total size is close to that of other batches of ΛΗ. A price seems very out of place here.
7. The evidence of 41 adduced by Smith is ambiguous. Stephani's facsimile makes the ligature seem large, but the whole is much compressed; the accompanying five strokes suggest that it should be classed with 28-30. 54 and 55 are not closely connected with the main group for various obvious reasons; they are examples of what ⋀ can be interpreted as, not what it must be interpreted as.
8. Edwards *apud* Webster, *Potter and Patron in Classical Athens* 279 n.1. We have seen the confusion of spelling of the words concerned in type 1F. However, the total lack of ΛE in this type would then be a little surprising. It is worth noting here the neck of a probably Chian amphora from the Kerameikos on which ΛΗ is painted (see Ch. 3 p. 10). It probably does not stand for a personal name or numeral, but it is equally difficult to suggest any interpretation based on the contents or the like. An Ionic sixth century use of λήκυθος is attested on an East Greek banded jug from Histria, *Mat.Cerc.Arch.* 9 (1970) 214-5.
9. One stroke is found added to a single ⋀ on 15, 38, 39, 40, 42, 43 and 51; one stroke on each of two ⋀ on 46; one stroke on only one of two ⋀ on 27, 28, 29, 36, 44, 45 and perhaps 48; two strokes on one ⋀ and one on the second on 30. There is little to recommend Smith's idea that the strokes were added to mark the *lambda* as Ionic (*CVA* 26-7).

10. The tallied vases were presumably tied to the master vase in a way similar to that of the ἐνθήματα discussed under type 23F, despite the gap of nearly a century between the two groups of graffiti.

11. The Attic usage for the shape appears to have been λήκυθος; see *Hesperia* 24 (1955) 161-2 and *Arch. Class.* 25-6 (1973-4) 360. The variants of ἀρύβαλλος can be found in Hesychius A7547-9, 7561 and 7565.

12. The cup, *NSc* 1886 152 b, is now Oxford 231, obtained from the van Branthegem collection, which does not appear to have included the amphora. The tomb contained two cups and two lekythoi, and as the tallied vases seem to have been only three there is the possibility that they all reached Bolsena together.

12a. Just over a third of the 44 lekythoi attributed to the Leagros group in *ABV* and *Paralipomena* have known provenances; seven are from Italy and Sicily, but none from Etruria.

13. The fact that there are few round numbers among the batches does suggest that there was some limiting factor of this kind - either what could be fitted conveniently into a sort of package, or what was available at the time in the workshop.

14. As suggested by Amyx, *An Amphora with a Price Inscription* 197 n. 117.

15. There are similarities with the type 3F mark, but I feel that any attempt to interpret it as a numeral or price mark are doomed to the same failure.

16. See Bloesch, *JHS* 71 (1951) 36. He exaggerates the chronological gap in his remarks on the Lea-hydriai; I would have thought that there was a maximum of five years between the groups.

TYPE 3F

1. *Greece and Rome* 21 (1974) 147-8.

2. The lids concerned are all close in size, but not, I think, interchangeable, judging from the few that are preserved.

3. There can be no objection to reading a far more regular ligature of this shape as ΔΕΕ, but none of our marks are so regular.

TYPE 4F

1. For vases inscribed κότυλος see M. L. Lazzerini, *Arch. Class.* 25-6 (1973-4) 357-9.

2. Non-pottery companions of export orders are not clearly observable except the silver mug, *BICS* 25 (1978) 79 and p. 230.

3. The latter is no longer extant and I know the mark only from Beazley's notes; he gives ϙΒ. I assume that the Munich foot belonged to a prize vase and that Hackl took it to be from a non-prize amphora merely because it had a graffito. The lack of marks on prize vases is already noted by G. von Brauchitsch, *Die Panathenäischen Preisamphoren* 161.

4. The *CVA* reading of 2 does not give as much of the *koppa* as Hackl's pl. 2, but in any case enough remains to secure the interpretation.

5. The limit on small numbers cited unconverted into drachmai or any other larger denomination seems to be eighteen; see Amyx, *An Amphora with a Price Inscription* 190, and also p. 227. Perhaps here a price in obols for the oil would not be out of the question (cf. Amyx, *Hesperia* 27 (1958) 179 n. 30), yet the *koppa* on 1 is closely adjacent to the ΑΡVΣ.

6. The scholia on Pindar *Nem.* x 37 strongly suggest that the winners were allowed to sell the oil, though it is disturbing that they can term the vases hydriai or kalpides; see M. Tiberios, *ADelt.* 29 (1974) A 150-1. In my argument I assume that the figures quoted on Boulogne 441 and Cab. Med. 244 are also of *arysteres.*

7. Lang, *Hesperia* 25 (1956) 1ff, esp. no. 2.

8. No large number of Panathenaics have been measured (Peters, *Panathenäische Preisamphoren* 12); see *Agora* x 59 n. 9 and some capacities cited in *CVA Metropolitan Museum* 3.

9. Cab. Med. 244 is not noticeably smaller than other prize vases, with a height of 0.67 m., but without tests it is dangerous to predict capacity and I do not do so here. The Toronto vase (0.64) is smaller than that in Leiden (0.66).

10. No acrophonic *system* at this period could have dispensed with signs for both figures; see further Ch. 6, p. 27ff.

11. We have no deep knowledge of archaic liquid measures and I would be loth to add a new standard so capriciously.

TYPE 5F

1. I am not completely satisfied that *koppa* can be ruled out; this particular form of the letter is attested in a Samian inscription of the mid sixth century, G. Dunst, *AM* 87 (1972) 147-8.

2. This material is also listed, without details of the Olympia piece, in *Agora* xii 6. See also Brommer, *AA* 1967 546.

3. 25F, 1. It is also found on a foot from Ampurias, with the *alpha* and *upsilon* in ligature, A. E. Prescott, *XIV Congreso Nacional di Arqueología* 831 (regrettably faulty) and simply on a chous handle, Agora P26866; either of these could be an abbreviation of the name Glaukias or the like.

TYPE 6F

1. Starting with the entertaining version in *AZ* 1846 371 and ending with C. Greenwalte, *Cal. St. Class. Ant.* 5 (1972) 132-3; my own comments in *AJA* 82 (1978) 225.

2. For bibliography and dating of the lydion see Greenwalte l.c. 141-2 n. 50 and *CVA Munich* 6 44; also Hayes, *Tocra* i 65, n. 4 and *Kerameikos* ix 58.

TYPE 7F

1. The MSS at Herodotus v 88 do not have the transposition; it does occur in an inscription from Lemnos in κύθρᾳς (*ASA* n.s. 3-4 (1941-3) 104 no. 22). A similar transposition occurs in an Attic vase inscription of the same period as the graffiti, *CVA Norway* 24 (ΕΚΘΩΡ).

2. Liddell and Scott cite only Xen. *Vect.* 4, 10, where the word is not entirely devoid of dishonourable intentions. Τίμιος is pressed into service to describe vases in a lacuna in a graffito, *Sov. Arch.* 1971, 2, 232-8, but the supplement is in no way warranted. On 8 the ΑV in the second line is not easily deciphered.

3. Amyx, *An Amphora with a Price Inscription* 191. In the plural χύτραι is used to denote the pot market.

TYPE 8F

1. Beazley, *AK* 10 (1967) 142-3 and Shefton, *Arch. Rep.* 1969-70 60-1.

2. One should not be misled by the description of 5 in *Annali* 1877 149 as 'molto simile' to 6; in fact it is far closer to 4, and the shared mark of type 9E, iv, strongly suggests that the Orvieto foot belongs to a Lysippidean vase.

3. I am grateful to A. E. Prescott for sending me a rubbing and notes. The diameter of the foot (navel only) is 4.2 cm.

TYPE 9F

1. T. B. L. Webster, *Potter and Patron in Classical Athens* 279; his argument is seriously weakened by the fact that many vase shapes other than the stamnos are represented in the type.

TYPE 10F

1. The mark is not otherwise attested on the Priam painter's work, in contrast to the regular Leagran accompanier of 9F, 26.
2. For the sign see Ch. 6, p. 30; where used as punctuation the bracket is larger than the lettering. One piece on which a distinction cannot readily be made is 6D, 17.
3. ὤνιος is the more common, ὠνητός seemingly a more high-flown word. We can at any rate discard ὄνος, the suggestion of H. Hoffmann, *AK* 4 (1962) 25 n. 46.
4. The smallest fraction of the Athenian Wappenmünzen is the quarter-obol (Seltman, *Athens, Its History and Coinage* 157 and 166); fractions of the early owls, being struck at the time of manufacture of the vase, are rare, but again the quarter-obol is the smallest. Elsewhere we find prices quoted for batches which give very awkward fractions for single units; in these cases I argue that the vases were priced at so many per drachma (see p. 229). However, nowhere else does a price for a *batch* appear with a fraction smaller than half an obol (see on 26F, 1).
5. An oenochoe from Pantikapaion calls itself a *prochous* (*VDI* 1974, 4, 56ff) and the word is borrowed in Etruscan for similar vases (*Arch.Class.* 25-6 (1973-4) 142-3). Unpublished sherds of the fourth century from Heraklea Minoa in Agrigento museum preserve the beginning and end of the lines of a list of vases with prices; one vase-name begins ΠΡΟ and the line ends with a drachma sign.
6. Especially so if the two sets of numerals were close in size. The drachma sign may well have been invented to obviate such confusion.

TYPE 11F

1. For K see Lejeune, *Latomus* 25 (1966) 17 n. 51. For a more obviously Etruscan inscription containing the relevant letters see *St.Etr.* 26 (1958) 121-2 fig. 9. *Cai* is of course a common Etruscan abbreviation.
2. Καίρμμος is probably the most likely, attested in the fourth century, Bechtel 510. See also Burrows and Ure, *JHS* 29 (1909) 341.
3. The fact that the last stroke is attached to the *alpha* may indicate that a ligature of KAN was intended, perhaps a case of mistaken identity of the vase as a kantharos; however, the shape of the *alpha* does not encourage a Greek explanation.

TYPE 12F

1. Kerameikos vase, *Kerameikos* ix 192. The jingle is more successful than the frequent ἡ κύλιξ καλή, and calls to mind the word-play ΔΙΚ/ΜΙΚ used to distinguish different forms of lekythos in the later fifth century (14F, 15).
2. The latest type A amphorae listed in *ARV* are: Hermonax 28, Syracuse painter 16, Agrigento painter 64 and Painter of the Berlin hydria 9 and 10.

TYPE 13F

1. On 12 we could take the *iota gamma* as an Ionic numeral, but since KOI must be a single unit on 11 it would seem best to read it on 12 as well, with an acrophonic numeral for five. ΚΟΙΛΕΙΗ is the glaze inscription on a South Italian acorn lekythos, Toronto 959.17.85 (CB iii 80).
2. See *BSA* 73 (1978) 111 and 70 (1975) 155.

TYPE 14F

1. Although it is more likely that these bare numbers refer to the number of large vases, usually kraters, in the batch. Examples: ΓΙΙ| on 18C, 85; ΓΙΙ on 18C, 51 (with ΡΓ on the other side of the foot) and 53; ΓΙ on Ferrara T612 (unpublished mark; *ARV* 1411, 32, Meleager painter); IIII on 18C, 65 and 71 (Fig. 13q) and 22F, 2; IIIIII and IIIII on 18C, 76.
2. Liddell and Scott s.v. ὀξύβαφον II. Although Athenaeus cannot be taken as good evidence, he consistently refers to the oxybaphon as a small drinking vessel, using the word κύλιξ; drinking is not implied by the etymology of the word, and at 667a even Athenaeus draws a distinction between kylix and oxybaphon.
3. For a full treatment of the shape see *Agora* xii 132-8.
4. One doubts whether a very small vase can be meant on 13, since the batch size is far smaller than those of other vases associated with type 2F.
5. Athenaeus 495c-e gives a range of meanings; at Iliad xvi 641 a large bowl or pail is indicated.
6. The suggestion was made originally by H. R. W. Smith in *Gnomon* 30 (1958) 364 and is repeated by von Bothmer, *AJA* 80 (1976) 435. One piece from another class of disputed origin, the Hyblaea class, has an intriguing, if isolated graffito (Fig 14c; New York, Noble, *Paral* 108, 4).

TYPE 15F

1. We cannot tell which word was cut first; if κυάθεια, then the spelling of κύθριδες may have been influenced by it; if κύθριδες, the *theta*, corrected from a *upsilon*, could have been copied without a dot in the second word.
2. *Shapes and Names of Athenian Vases* 31. κύαθος is a word of Ionian origin first attested in Anakreon 43, 5 (Diehl). For the terminal date of production see M. Eismann, *Archaeology* 28 (1975) 77.
3. 'Αρύστηρ: Alcaeus 70, 9 (Diehl); κύαθος, see above n. 2. In both passages a process of drawing off liquid is probably described.
4. 'Αρύστηρ in Herodotus ii 168, κύαθος in Galen 19, 753.

TYPE 16F

1. Hackl, p. 74, and Amyx, *Hesperia* 27 (1958) 299 n. 47, considered this possibility.
2. For examples of late tailed *rho* in Attic inscriptions see R. Meiggs, *JHS* 86 (1966) 93; also *Hesperia* 37 (1968) 127 and *CVA Robinson* 3 pl. 12, 3 (probably earlier than Robinson suggests). The form would be acceptable at Cumae, the provenance of 1, but it would be unwise to consider that all these marks were cut there.

TYPE 17F

1. Lazzarini, *Arch. Class.* 25-6 (1973-4) 355, a kylix from the Gela area; the word appears in an intriguing but fragmentary graffito from Adria, G. Colonna, *Riv. Stor. Ant.* 4 (1974) 7 pl 2.
2. These various attributes are listed by Athenaeus 500a-b; see also E. Simon, *AK* 6 (1964) 7-8.
3. Though the adjective was regularly used for 'handled' whatever the position of those handles.
4. Lazzarini l.c. 357-8.

TYPE 18F

1. It has been suggested that some sort of dip-stick may be meant (Amyx, *Hesperia* 27 (1958) 299), and we have noted on p. 229 that metal ladles may have accompanied stamnoi; however, such considerations cannot weigh heavily against the interpretation offered below.

2. Σπαθεῖον is used much later of 'carrot'-shaped storage amphorae, V. Grace, Agora Picture Books 6, final pages.

TYPE 19F

1. I discuss 2 and 3 more fully in the articles cited in the catalogue.

2. Seven out of twelve RF vases with *sigma* graffito by itself or as an apparent independent unit are on amphorae or pelikai: 8F, 1, 17F, 6, Munich 2333, Nolan (*ARV* 1194, 1), Cab.Med. 376, Nolan (*ARV* 1194, 1), Berne 12214, pelike (*AJA* 82 (1978) 226), Leningrad P103, pelike (*Paral* 513) and Oxford 1884.714, pelike (but see 7D,30). The other five are: Bologna black-glazed oenochoe, 475-50 (unpublished); Edinburgh 1881.44.28 (unpublished; Philippaki pl 15, 4); Villa Giulia, oenochoe (*ARV* 308, 1; the graffito inexactly described in Helbig, Fuhrer⁴ 3 601); 13B, 22 and 6D, 18 (both mugs). We should hardly expect such a simple graffito always to have one point of reference (with skyphos, stater etc. also available), but this percentage seems high. See also on 6D, 13, p. 206, and 4A, 10 p. 186, as well as *AJA* 82 (1978) 226 n. 28.

3. I have not been able to discern the original reading of this 'palimpsest'; the initial *sigma tau* is clear enough, but after a break there appear several ill-adjusted letters and marks. An original στάμνιδες is attractive, but not justified by the physical remains.

4. A number of Attic vases with this word graffito in full are discussed by M. Pandolfini, *St.Etr.* 40 (1972) 465-8. For examples from Spina see p. 14.

5. The change of the *sigma* in the legend from three- to four-bar occurs some way into the main oekist series (Vlasto 13). New hoard evidence to be published by C. M. Kraay would put these coins in the 440s or even later.

TYPE 20F

1. Milne in Richter and Hall 224, no. 133.

2. 13 appears somewhat out of keeping, and I would consider the *CIG* reading unreliable.

TYPE 21F

1. It is difficult to think why Orsi took it to be from a krater. For some curiosities of early uses of ὑδρία see p. 62, n. 2.

2. The *heta* of 5 is cut rather like a *nu*, which could also account for the reading *nu* reported on 3; the different *sigma* could also be a mis-reading. Lack of the aspirate, probably under the influence of encroaching Ionic usage, is found in ὑδρία in the early fourth century temple inventory from Thespiai, *Rev.Phil.* 40 (1966) 72. It is possible that the mark HIII on 21B. 12 can be interpreted as h(ydriai) 3, or h(ydria) 3 (obols).

TYPE 22F

1. A photograph kindly supplied by Professor Fol shows a group of four lines distinct from the OINOXOAI = 11, and also *three* other longer lines of type 18C character.

2. Most relevant bibliography is assembled in *Agora* xii 1 and 70. I see no reason why the graffito on the Isthmia mug should not refer to the inscribed vase. See also Lazzerini l.c. 365ff. It is only fair to add that it is perfectly possible to drink out of a Corinthian 'kothon'.

3. See *Agora* xii l.c. and Sparkes, *AK* 11 (1968) 8-9.

4. Athenaeus 485a. Amyx, *An Amphora with a Price Inscription* 191, thinks of a shallow vase; this is not necessary and does not fit the sense of the Theopompus fragment.

5. Except for a few mastoid type grooved vases by Sotades, *ARV* 773 and Shefton, *Ann.Arch.Arab.Syr.* 21 (1971) 109. For the mastos see Greifenhagen, *Festschrift Frank Brommer* 133ff.

6. For σκάφη see Sparkes, *BABesch* 51 (1976) 50 n. 24.

7. Unnumbered, N. Kunisch, *Antiken der Sammlung Julius C. und Margot Funcke* 126-7.

8. There is a noticeable number from Spina, the provenance of 10, but I know of few from Sicily; the lists in van Hoorn, *Choes and Anthesteria* 59 ff are useful, if a little dated. The amount of material increases substantially if we extend the range of χοῦς to cover the related type 2 oenochoe.

TYPE 24F

1. See Beazley, *AJA* 31 (1927) 351 and Amyx, *Hesperia* 27 (1958) 198.

2. Mingazzini l.c. in catalogue; Jacobsthal, *Metropolitan Museum Studies* 5 (1934) 117.

3. - ουργος, Buck, *The Greek Dialects* § 44, 4; - οργος (or rather - ωργος) in Ionic, Bechtel iii § 47, 2.

4. Buck o.c. § 42, 1 and 111, 3; Bechtel iii p. 54.

5. It could perhaps be argued that it may be an unattested noun or adjective, but 'unattested' shows the weakness of any such case. We may note another full dative, standing by itself, under Naples 86046, a pelike recalling Aison, from Cumae (*ARV* 1178) with ΗΓΗΣΑΡΧΩΙ in Ionic script.

TYPE 25F

1. The noun in question could be a general term such as ἀγγεῖα (Hackl p. 75) or perhaps κυάθεια could be considered as a candidate for describing oenochoai.

2. There is always a possibility that a bald statement of price may refer to a mixed lot (see Amyx, *Hesperia* 27 (1958) 299) and so upset our calculations. Yet it should be noted that no figures, batch size or price, accompany references to σύμμικτα elsewhere.

3. There is more obviously a price cited somewhere in the graffito on another skyphos, dating after 450, Würzburg 610 (not 614 as Langlotz); as Langlotz' facsimile is inexact I give a corrected version in Fig. 14q. A price of a drachma for twenty-six pieces may be given, but this ignores part of the mark (see also Ch. 7, p. 34).

4. The noun to be understood is probably κάδια; the three unit strokes on the vase may be the price, three obols, but we cannot be sure. The idea of slimness as well as height in the use of μακρός is clear from its application to trees, columns and the like.

5. For discussion of heavy-walled glazed vases see *Agora* xii 111-2.

6. *BICS* 25 (1978) 80.

7. *AJA* 31 (1927) 349.

8. See Johnson and Howard, *AJA* 58 (1954) 191-208.

TYPE 26F

1. Here I follow Amyx, *Hesperia* 27 (1958) 299. It is definitely odd that on 1 a price of sixteen and a half obols is asked for thirty-two pieces.
2. Though in the Chalcidian colonies the drachma would be one third more valuable than in the colonies that were minting precisely on the Attic standard (5.7 against 4.3 gr.). We may hope that more local evidence (or a convincing lack of it) will eventually suggest whether the sign originated in the West or the mainland. See also *Megara Hyblaea* i 318 n.1, for a further example that *may* be datable to before 483; Megara had no coinage of her own and it is a puzzle where the vase was marked.
3. *PdP* l.c. in catalogue.

CORINTHIAN

1. See *BSA* 68 (1973)188. A dating rather lower than mine for the Iole krater, 5, is proposed by T. Bakir, *Der Kolonettenkrater in Korinth und Athen zwischen 625 und 550 v. Chr.* 37ff.
2. For a similar graffito see on s.l. 1, 4, p. 6.
3. The humility of this last piece is a further peculiarity of the material from Naukratis. A partly preserved foot of a large vase from Naukratis, London 1886.4-1.1303, with a dipinto *mu* on the navel may be Corinthian.
4. We may assume that a large proportion of the pieces in the Louvre are from Cerveteri, but proof is lacking.
5. For the Corinthian alphabet see *LSAG* 114-6 and Guarducci, *Epigrafia Greca* i 170-2.
6. There are few large groups of marks on Attic vases before the end of the Late Corinthian period; see p. 2.
7. Initial F*ρ* at Corinth at this period is not unexpected; see Thumb-Kieckers 2 i § 126, 9.
8. In both places marks at this period are usually alphabetic; there are a few ligatured marks on Corinthian vases, and so Attic potters or traders could have picked up that idea from Corinth. In both places too there are a number of 'long' marks (Corinthian 47 and 48; Athens, *BSA* 70 (1975) 157 n. 21). Accidents of survival make it dangerous to be too specific about influences and habits in such matters.
9. For relationships between the Corinthian and Athenian Kerameikos in this period see in particular Kleinbauer, *AJA* 68 (1964) 355-70.

LACONIAN

1. For lists of Laconian kraters see Shefton, *Perachora* ii 384 n. 3 and Addenda 540; of course many further sites have yielded examples more recently.
2. Graffiti cannot be said to be common on pottery from Laconia. None of the dipinti and graffiti in the largest body of material, dedications to Athena, Zeus/Agamemnon and Alexandra/Kassandra, seems earlier than c. 475 (*BSA* 30 (1929-30) 241ff); also later the graffiti *BSA* 55 (1960) 272 and 297. There are few archaic examples among the other graffiti excavated by the British School. Noteworthy, but still later, are the notation of capacity on a body sherd (p. 60), a fragmentary measuring jar with glaze△AMO[. .(*BSA* 30(1929-30) 242 fig. 1, 23) and a later fifth century sherd from the Akropolis with μέτριος/ἐγὸ/ Ἀλκ[; the vase itself may be speaking (cf the mug, *Ergon* 1970 69, fig. 73), or could it be a plea of sincerity by a modest Spartan? Modest Spartan literacy is also argued by Cartledge, *JHS* 98 (1978) 25ff.
3. Perhaps by an Aeginetan or Athenian; see Ch. 4, p. 13 (Adria).
4. Though there are difficulties. The Ѱ would be either 'red' *chi* or 'Theran' *xi*; in the latter case the *san* would be pleonastic. 'Red' *chi* is not attested elsewhere in Cyrenaica and the Theran *xi* does not occur before the fifth century; yet a Tocran origin still seems preferable to a Laconian. The mark is not included in the survey of archaic Cyrenaic inscriptions by C. Dobias-Lalou, *Rev.Phil.* 44 (1970) 228-256.

CHALCIDIAN

1. Rumpf lists about seventy intact amphorae and hydriai; the total has of course since risen substantially.
2. See on type 19B and also *BSA* 70 (1975) 151 n. 16. Bothmer noted the similarity of the mark to my type 19B in his publication of 10. If its graffito is to be interpreted in the same way as the dipinti on 4-7 an interpretation as *lambda* (non-Chalcidian) *upsilon* would be attractive.
3. If a Lokrian could specifically order a large Attic BF amphora with Eleusinian scenes (*ABV* 147, 6; *JHS* 95 (1975) pl 1a), there seems no reason why a Rhegine could not have similarly close contacts with the Athenian Kerameikos.

EAST GREEK

1. I have found no marks on any large vase of the Wild Goat style, excepting the very debased 115, unless 116-8, 179 and 243-5 originally belonged to such vases.
2. 163 is dated by the excavators to the late seventh century level.
3. *BSA* 34 (1933-4) 91 n.3.
4. 75 is peculiar in having the red outlined by graffito strokes, rather than simply overlying an ordinary graffito. A similar technique is found on a sixth century tombstone from Memphis, K. Herbert, *Greek and Latin Inscriptions in the Brooklyn Museum* no 1 (with a wholly misleading reference to the sherd from the sanctuary of Artemis Orthia, *LSAG* 198, 2).
5. Graffiti are often found on Chian amphorae, whatever the provenance. The impression that Naukratis has produced fewer dipinti than other sites rests largely on the statement of Lambrino, *Les vases archaïques d'Histria* 115 'sur presque tous les autres fragments on distingue encore des traces de peinture rouge posée après la cuisson'.
6. 51-53, see the catalogue. Two of the marks are non-alphabetic, but the dipinto on 53 is apparently a closed *eta*, not the initial of the dedicator, Eukles, although he does use the form in his inscription (*Naukratis* ii 64, 753).
7. Cook and Woodhead, *BSA* 47 (1952) 159ff; two further joint dedications should be added, both probably by Aristophanes and his partner: Aegina 604 (Furtwängler, *Aegina* 245, 14) which has the initial *alpha* preserved as well as the end of the plural verb, and a kantharos sherd in University College London, from Naukratis, again with an *alpha*, and the final letters (of Aphrodite's name) overlapping it below. A large proportion of the bespoke vases are kantharoi rather than chalices, while the marked feet are chalices only.
8. The argument is put by Boardman, *BSA* 51 (1956) 55ff. Since then vases of the Grand Style have been found at Pitane and Erythrai; they were presumably made on Chios.
9. There are fragments of apparently plain chalices of 'bespoke' type with graffiti on the wall, London 1924.12-1.648, 665 and 698, but none of the marks are alphabetic and on none of them is a glaze inscription preserved. On 1924.12-1.662 the preserved snatch of a graffito reads].χως[.
10. I include 152 although Lambrino does not give the top line; it seems to be present in the photograph.
11. Psilosis in Ionic dialect would rule out an interpretation as HE for the fullest form of the mark. A similar sign appears on

Mycenaean vases (Stubbings, *Mycenaean Pottery from the Levant* 46-50, A 1-5 and B 1-2). Perhaps it is a pictogram, representing a trident (or a bident) or a vase shape, but this is difficult to accept in the case of 152 and the Attic varieties.

12. See also *BSA* 70 (1975) 151 n. 16.

13. There is a circular mark associated with the Chalcidian marks which is not readily interpreted. Certainly we cannot take the sign as simple *alpha* since the broken cross-bar does not appear before the late fourth century, see *Agora* xii 1317. The interpretation ΛV is suggested for different reasons as the explanation of similar marks on some later fourth century pieces, *Himera* ii 680, 42.

14. Although this does not mean that the Attic and Chalcidian marks do not belong to a similar Ionic tradition; the interpretation *lambda-upsilon* would be preferable to Attic *gamma-upsilon*, a much rarer word beginning.

15. A selection of further examples: shoulder of Attic SOS amphora from Pithekoussai, *BSA* 73 (1978) 130 Fig. 7D; Attic black-glazed sherd, *Naukratis* i 691 (London 1886.4-1.949); shoulder of glazed oenochoe, *Ol.Forsch.* v 156, no 67; bronze rhyton from the Samian Heraion, *AM* 87 (1972) 144; Berlin 2581, glazed skyphos from Nola.

16. The ordering of the graffiti in *Naukratis* i pl 34 suggests that Gardner interpreted 569 as *delta-iota;* 412 could conceivably be numerical.

17. Corinthian 61 and the foot mentioned above, Corinthian n.3.

18. Another isolated Ionic example of the mark is 252; here the reading can only be *lambda-epsilon,* but as the piece is a cup the mark is unlikely to signify a vase name, which may be the explanation of some of the marks in type 17E.

19. Discounting an obviously Etruscan graffito, *St.Etr.* 34 (1966) 319 and pl. 42, c-d (Vulci).

ERETRIAN

1. Certainly the analysis of Louvre Cp11031 (*CVA* 17 66) demonstrates that it is not made of normal Attic clay (low Mg, Cr and Ni).

BOEOTIAN

1. For similar arguments see Burrows and Ure, *JHS* 29 (1909) 338-42; I do not include in this category the common HI and KAB abbreviations on vases dedicated at the Kabirion sanctuary. For a further probable owner's mark see Reading 56.8.8 (p. 6). Follmann attributes Hannover 1967.11, a type B amphora of c.540 to a Boeotian school (*CVA* 1 18 and *BSA* 70 (1975) 151 n. 14); its dipinto admits of various interpretations.

ETRUSCAN

1. See in particular on types 1A, 2A, 3A, 4E, 8E and 14E. For an Etruscan graffito clearly denoting a batch of Attic vases for distribution see p. 62, n. 20, and add Florence 4007, p. 31.

2. Another red dipinto on an Etruscan vase is found on a sixth century olla from Cerveteri, *St.Etr.* 42 (1974) 259, and add the storage amphora, type 8E, n. 5.

SOUTH ITALIAN

1. I have made no thorough tally of these marks, but see *BSA* 70 (1975) 159 n. 36; add *CVA Cracow* pl 16, 2 (Apulian oenochoe), Milan A1856 (Apulian pelike: owl; palmette), London, Wellcome (unnumbered Gnathia oenochoe), Trieste S444 (Apulian askos), Trieste S587 (glazed guttus askos with moulded frontal female head), Trieste S448 (Gnathia oenochoe) - all these with a red cross, and an Apulian pelike seen in the Florence market (Ponte Vecchio). Apulian oenochoai in Taranto reserves.

2. *South Italian Vases* (An Exhibition at the J. Paul Getty Museum) 1; A. D. Trendall, *Lucanian, Campanian and Sicilian Red-figured Vases, supplement* 2 317b ; *Studies in Honour of A. D. Trendall* 71ff.

3. Pyxides: Beazley, *JHS* 56 (1936) 253. Puzzling glaze dipinti, *alpha* and *phi,* appear under two of the lids of the composite lebes gamikos from Paestum, *Dialoghi di Archeologia 8* (1974-5) 258-60; cf. Trieste S482, an Apulian lekanis lid with rough glaze *alpha.* Miscellaneous graffiti: Mayer, *Apulien* 306 (five examples); *Lupiae* 87, Apulian plate; *CVA Robinson* 3 pl 33, 6, glazed casserole; Dublin 1917.55, Apulian stemless cup, graffito *pi*; London market (Ede), Apulian lekanis, pre-firing (?) Λ graffito on Gnathia pyxis foot from Lilybaeum, *NSc* 1971 698.

MUSEUM INDEX

Most references are to catalogue numbers, a minority to page numbers.
EG = East Greek; s.l. = Subsidiary list.

I The main body of the index includes vases of known present (or recent) location.

II There follow sections for vases once in particular collections, vases once in the antiquities' market, vases in private
collections whose precise location is unknown to me, and various *incerta.*

Under each heading there may be up to four sub-headings, **A** to **D**:

 A for non-Attic vases
 B for Attic black-figure (with glazed pieces earlier than c. 500)
 C for Attic red-figure (with later glazed pieces)
 D for uncertain pieces

The lists only include vases mentioned for their graffiti or dipinti. Material listed in Chapter 3 for comparative purposes
is not entered individually in the Index.

I

Aachen, Ludwig
The numbers in R. Lullies,
Griechische Kunstwerke,
Sammlung Ludwig, Aachen
B
14 s.l. 1, 14
16 s.l. 5, 1
17 s.l. 6, 4
18 5D, 2
19 15E, 6
21 3E, 13
26 11E, 6
C
36 7F, 7; 15F, 1
Aberdeen, University
B
683 16A, 9
684 38A, 2
688 10E, 5
689 16B, 2
Adolfseck, Schloss
Fassanerie
B
3 21A, 74
4 21A, 6
C
42 17A, 15
74 5F,4; 10F, 15; 13F, 2
197 10E, 12
198 17E, 21
Adria, Museo Civico

Except for the third and
fourth entries the numbers
are of the entries in the
plates of Schoene.
I place most entries under D,
although the majority are
of black-glazed vases of the
fifth century.
B
22,9 11F,23
C
22,14 (B452) 13A, 10
D
Ce 30 p. 2.
Ce 69 p. 13
19,19 p. 13
20,1 9B,19
20,3 12B,20
20,5 12B,19
20,11 10E,22
20,19 14B,28
20,21 8D,65
20,22 8D,64
20,28 20E,7
20,29 20E,8
20,30 2B,52
20,31 2B,36
20,32 2B,37
20,33 4B,16
20,34 2B,38
21,1 2B,42

21,2 3B,8
21,3 9E,55
21,4 9E,54
21,5 9E,74
21,8 9B,18
21,10 5A,15
21,11 5A,9
21,12 p.13
21,14 10B,10
21,15 10B,11
21,16 10B,9
21,17 10B,17
21,18 10B,19
21,19 10B,18
21,20 11B,20
21,21 14E,14
21,22 13B,28
21,24 16A,20
21,25 6D,7
21,26 2B,47; 6D,14
21,27 6D,15; 7D,20
21,28 7B,10; 11F,11
22,3 6C,13
22,7 11F,26
22,8 11F,27

Agrigento, Museo Nazionale
A
S2278 Cor 74
B
C2038 s.l. 5,2a

R136 p. 39
R145 s.l. 5,2
C
C1539 9C,8; 18C,7
C2034 18C,65a; 22F, 9

Aleria
Numbers of the catalogue
in J. and L. Jehasse, *Le*
Necropole préromaine d'Aléria
(*Gallia* suppl. 25)
B
1921 10F,6
C
1768 19B,3; 25F,6
1903 10B,16
1953 9F,37
1954 7B,7
2100 11B,27
Altenburg, Staatliche
Lindenau Museum
B
209 5E,15
212 8D,26
C
279 p.25
284 19B,11
285 2C,4
297 7D,31
Ampurias, Museo Mono-
grafico

C
– 8F,12
– p. 60 (2 pieces)
Amsterdam, Allard Pierson
Museum
B
684 s.l. 1,49
3303 2B,46; s.l. 3,5
3374 14A,8; s.l. 5,3
C
1313 9E,80
8212 18C,27
Ancona, Museo Nazionale
C
3264 22F,4; 26F,11
Apamea, see Hama
Argos, Archaeological
Museum
C
C7777 s.l. 3,12
Arlesheim, Schweizer
C
– 2F,8
Athens, Agora Museum
See pp. 8-10, 18, 28-29 and
subsidiary lists 3 and 4
C
P26866 p. 247
Athens, Kanellopoulos
Museum
B
2499 23E,7a (p.70)
2527 p. 243
– 3E,16a (p.70)
Athens, Kerameikos Museum
See pp. 8-10 and subsidiary
list 4
Athens, National Museum
For material from the
Akropolis see pp. 8-10
B
561 p. 59
C
1690 10E,11; s.l. 3,13
– s.l. 3,18
Baltimore, Walters Art
Gallery
B
48.2127 11A,3
C
48,82 s.l. 4,9
Bareiss, see Greenwich
Bari, Museo Archeologico
A
2890 Cor 62
3194 Cor 84
Palese 12 Cor 54
B
2954 8D,66
3083 p. 60
C
1397 18C,15
2799 p.16
3196 18C,17; 17E,13
6251 18C,34
Bartenstein, Roese
B
– s.l. 3, 3
Basel, Antikenmuseum
Including material on loan
from various owners
A
Z196 Cor 1
loan Cor 106
B
BS409 8E,5
BS412 33A, 3; 8D,73
BS455 s.l. 1,36

Z361 11E,17
Z362 12E,7
Z363 4B,5
Z365 8C,1
1921.328 6D,2; 3E,44
1921.356 11B, 8
1945.95 20A,47
loan s.l. 2,5
C
BS404 p. 63
BS407 8F,2
BS437 8E,28
BS451 9B,13
Z348 7B,5
Bolla 23E,21
Kappeli D8 3E,40
Wilhelm 21B,7
– 6D,20; 18C,64
Basel, Borowski
C
V67.33 1F,1; 9B,9
V71.243 9F,41; 26F,10
Beaune
B
– 21A,12
Belfast, Ulster Museum
In brackets the catalogue
numbers in Johnston, *PRIA*
73 (1973) C 473 ff.
B
(1313) 20A,9
(1318) 17B,6; s.l. 3,2
C
58.13 (1326) 9C,7
Berkeley, University of
California
A
8.3415 Chalc. 2
B
8.3376 2F,7
8.3377 21E,48
8.3380 12E,2
8.3851 p. 39
8.3852 3E,29
8.5699 s.l. 5,4
Berlin
As my knowledge of the
present whereabouts of
many of these pieces is
incomplete, I have not been
able to draw up separate
lists for the Antiken-
museum and the Pergamon-
museum. Unless otherwise
noted the numbers are those
of Furtwängler's catalogue,
where most of the graffiti
not subsequently published
in *CVA* are to be found.
A
987 Cor 63
1109 Cor 14
1111 Cor 15
1112 Cor 3
1114 Cor 27
1115 Cor 36
1129 Cor 40
1147 Cor 44
B
1693 10E,3
1713 25B,1
1714 25B,2
1808 21A,68
1835 p. 39
1837 21B,2
1840 32A,10
1842 21E,19
1843 21E,41

1844 8A,2
1845 5E,1; 6E,3
1848 6D,5
1851 2F,5
1857 p. 39
1861 13B,14
1862 21A,78
1864 8E,22
1865 11E,12
1867 24B,4
1869 11E,23
1877 p. 238
1880 13B,17
1891 28A,1
1892 20A,77
1893 20A,52
1894 20A,69
1895 21A,48
1896 1D,13
1900 2F,4
1902 2F,46
1903 16A,24
1904 5E,21;9F,26
1907 17E,6
1908 2F,16
1935 21A, 79
1937 12E, 28
1982 s.l. 1,26
2081 11B,22; 9E,71
4029 s.l. 6,29
C
2159 1B,11; s.l. 1,40
2164 21B,10
2168 see Göttingen
2175 8E,43; 10E,31
2188 2B,14; 6F,1; 22F,4
2274 15B,20
2332 16B,25
2341 18F,5
2345 16B,21
2353 18F,4
2359 s.l. 7,13
2361 see Göttingen
2478 16C,3
2521 3B,2
2552 9F,23
2588 3E,60
2590 8D,59
2599 25F,1
2621 11F,28
2734 26F,14
3154 18E,4
inv. 2928 24F,1
inv. 3189 p. 239
inv. 4498 17F,5
inv. 4517 s.l. 4,8
inv. 31547 s.l. 4,23
1962.82 12E,32a (p. 70)
Berne, Historisches Museum
C
12214 p. 249
Biel, private collection
B
– p. 23
C
– 9F,39; 11F,13
Binghamton, University Art
Gallery
B
1968.124 21A,34
Birmingham, City Museums
and Art Gallery
B
1611.85 26B,5
Bochum, Ruhr Universität
B
S480 8D,1
S483 s.l. 6,31

S497 10E,18
C
S522 p. 29
– p. 232
Bologna, Museo Civico
Numbers cited as in Beazley
B
5 p. 59; 239
7 s.l. 5,5; p. 59; 239
17 31A,2
20 12B,7
39 13B,1
44 14F,8
48 p. 239
52 17A,18
59 13B,2
73 24E,8
75 1B,6
111 p. 241
151 9E,22
PU189 21A,30
PU195 9F,1
PU196 21E,53
C
153 6A,6; 9E,64; 12F,1
162 1F,8
174 p. 14
176 p. 39
177 17E,46
190 10F,20
198 p. 14
199 5A,18
203 17E,47
206 p. 14
210 17E,48
244 14B,26; 18C,8
250 10F,26
252 6D,11
320 18C,70
322 18C,38; s.l. 7,14
PU280 9F,17
PU284 18C,5; 3E,49
PU289 18C,55
PU318 p. 29
– p.14; 249
– p.14
Bonn, Akademisches
Kunstmuseum
A
– EG 99
B
11 15B, 1
38 21A,11
39 20A,14
42 33A,9
44 22E,1
C
75 p.70
76A 18C,73
Boston, Museum of Fine
Arts
B
76.40 s.l. 6,34
80.160 1D,20
89.256 s.l. 6,13
89.258 26B,4
89.562 p. 70
97.205 21E,30
99.516 21A,33
99.517 11B,5
99.522 12A,2; 29A,3
00.331 p. 239
01.8035 31A,1
01.8127 13F,6
13.65 14F,10
22.404 20A,62
23.210 20A,71
25.220 20A,49

28.46 9E,29a (p. 70)
60.790 1D,6
61.195 8E,56a;10F,1a (p.70)
62.1185 8E,9a (p. 70)
63.473 17E,3
1970.8 1E,11
1970.69 2F,1
C
90.157 9F,19
95.32 14C,1
95.35 14C,2
98.882 19B,5
00.346 10A,10
01.18 p. 31
01.8019 7D,9
01.8079 33A,20
03.821 12B, 11; 18F,1
06.2447 16C,6
10.185 7D,29
13.82 14C,3
13.191 32A,21
13.197 32A,22
13.199 16E,7
22.824 s.l. 4,37
33.56 s.l. 1, 34
— p. 40
Boulogne, Musée des Beaux
Arts
A
68 Cor 37
B
1 21E,24
13 14B, 29; s.l. 5,6
21 9A,3
69 20A,73
85 14B,30
88 14B,3
95 21A,50
98 2F,23
406 13E,7
417 9E,11
418 21E,50; s.l. 5,7
419 21E,55
420 1E,7
422 37A,3
441 p. 223-4
564 20A,80
572 21E,35
574 3E,32
575 20A,16; 15B,5
— 8E,20
C
196 12E,23
443 9E,93
667 9B,30
Bristol, City Museum
B
H801 18A,3
H802 10B,4
The Brooklyn Museum
B
09.5 6A,3
C
1903.8 9E,107
1903.9 14F,9; 17F,2
Broomhall, Elgin
B
— 19F, 13
Brunswick, Herzog A. Ulrich
Museum
C
— 16B,35
Brunswick, Maine, Bowdoin
College Art Gallery
C
13.8 24F,2
Brussels, Musées Royaux
A

R220 Chalc. 1
B
A200 8A,7
R231 s.l. 6,8
R232 7D,5; s.l. 5,8
R235 23E,4
R278 20A,8
R289 1E,1
R291 20A,31
R300 16A,7
R310 20A,84
R315 18E,2
R318 3E,20
R346 1A,8
R389 21A,41
C
A134 1C,1
A717 16C,1
A3093 9F,8
R235 23E,3; p. 66
R307 10B,15
R330 8D,57
R2509 21F,12
Brussels, Abbé Mignot
B
8 18E,1
9 9A,2
Bucharest
A
— EG 77
varia EG 150-165
C
V.8731 8F,14
Budapest, Musée des Beaux
Arts
C
50.154 1F,4
Cab.Med. see Paris,
Bibliothèque Nationale
Cairo, Egyptian Museum
A
26.146 EG 175
Cambridge, Fitzwilliam
Museum
Where applicable I give the
numbers in Gardner's cata-
logue
B
47 s.l. 5,9
48 19F,15
51 20A,11; 8E,55
52 21E,49
53 21E,20
54 3E,56
56 2F,39
59 14B,7
1937.8 p.23; 242
1952.2 21A,65
1962.3 p. 243
C
166 9E,52
1890.4 18B,14; s.l. 1,45
1928.8 18C,25
1935.2 9F,42
1937.25 9B,28
1937.26 2B,28
1952.6 10F,13; s.l. 2,12
1955.9 16B,17
Cambridge, Museum of
Classical Archaeology
A
NA188 Cor 61
B
472 21A,62; 23E,10
475 9D,15
Cambridge, Mass., Fried-
lander
B

— 21A,69
Cambridge, Mass, see
Harvard
Capesthorne Hall, Bromley-
Davenport
B
— 21E,64
Capetown, South Africa
Museum
B
HW1 20A,87
Capua, Museo Campano
B
144 s.l. 5,8a
145 1A,1
149 11B,17
153 9B,21
154 9E,121
C
209 2C,3
217 10F,9
Castle Ashby, Marquess of
Northampton
B
— 13A,4; 23F,4
— 8D,16
— 11E,47; 13E,25
— s.l. 6,37
— p. 239
C
25 9E,89
199 6C,10
Cerveteri, Museo Nazionale
Cerite
B
47457 s.l. 5,10
67158 12E,11
M.A. 429,6 8D,8
M.A. 561 23A,5
recupero 1961.20 s.l. 5,11
recupero 1961.21 s.l. 1,16
Cerveteri, magazzini
B
— 17E,22
C
— 10F,11; s.l. 2,13
— 20F,11
Chantilly, Musée Condé
C
— 8F,1
Chersonesos
C
— 8F,13
Chicago, The Art Institute
B
1889.10 3E,52
1889.13 8D,24
1889.15 23E,9; 24E,5
C
1889.27 8D,56; s.l. 1,50
1911.456 18C,8a
1916.410A 8D,62
Chicago, University
B
— 1F,9; 7F,3; 19F,4
Chios, Archaeological
Museum
A
— EG 71-74
Chiusi, Museo Etrusco
A
1805 Cor 58
B
1794 21A,55a
1806 17A,11
1812 9D,12
P543 3E,26
C
1850 6D,13

D
— 9E,98a (p.70)
Christchurch, University of
Canterbury
B
42 36A,1
43 36A,2
Cincinnati, Boulter
B
— 9E,38
Civitacastellana, Antiquario
B
814 7C,1
C
5386 15C,8
5427 18C,32a
Civitavecchia, Museo
Municipale
B
56199 s.l. 7,1
Cleveland, Ohio, Museum
of Art
C
24.197 19A,3; s.l. 1,18
24.533 13F,4
Cologny, Bodmer Foundation
B
— 21E,28
Compiègne, Musée Vivenel
B
974 14E,4; 2F,56
975 20A,46
977 11F,3
979 21A,36
981 22A,3
983 11F,2
988 1B,2; 8E,54
1009 18B,9
1015 2F,2
1032 2C,1
1034 9E,34
1040 5D,23
1050 25A,1
1055 20A,17
1056 8E,45; 11E,36
C
1036 p. 239
1037 s.l. 3,14
1068 12C,3
1090 s.l. 2,22
Copenhagen, National
Museum
A
ABc905 Lac 9
B
92 s.l. 3,6
100 9E,36
111 1D,2; 3D,1
114 21E,57
inv. 2 21E,40
inv. 4759 20A,21
C
123 15F,2
126 15E,8; 10F,25; 17F,1;
 26F,5
148 24B,7; p. 31
149 12C,4
inv. 5 16B,11
inv.122 23E,18
inv. 953 s.l. 4,34
inv. 3882 2B,26
Copenhagen, Ny Carlsberg
Glyptotek (NyC)
B
2653 20A,33
2673 17E,27
2692 9E,19
3385 14B,15

C
2659 9E,102; 5F,2; 19F,5
2693 20F,7
2694 20F,5
**Copenhagen, Thorvaldsen
Museum (Thorv.)**
B
31 9D,16
36 11E,34; 14E,11
56 2F,42
57 11E,8
62 33A,19
72 20A,67
74 20A,86
C
275 9F,24
**Corinth, Archaeological
Museum**
See p. 8ff.
B
CP2143 s.l. 3,9
**Cracow, Archaeological
Museum**
C
3598 4A,15
Cracow, National Museum
B
836 21A,70
1083 14A,4; 21A,71
1253 21B,3
Cracow, University
C
inv. 103 18C,72
Crotone, Museo Archeologico
A
CR512 Cor 7
Detroit, Institute of Arts
B
24.127 12A,1
63.18 3E,35
64.148 2F,38
C
24.13 9E,94
Dresden, Albertinum
C
293 p. 70
314 8D,55
325 p. 31
Dublin, National Museum
In brackets the catalogue
numbers in A.W. Johnston,
PRIA 73 (1973) C 341ff.
A
1886.387 (297) Cor 9
1917.55 (1137) p.251
B
1880.1108 (330) 9D,10
1917.36 (339) 16A,18
1921.91 (329) 21A,52
1921.92 (326) s.l. 5,12
1921.93 (332) 9E,40
1921.94 (333) 20E,4
1921.95 (328) s.l. 5,13
1921.96 (334) 2F,18
1921.97 (327) p. 64
C
1880.507 (427) 18C,46; 22F,6;
 24F,6
1880.509 (431) 18C,79; 14F,12
1920.316 (419) 9B,17
Dublin, University College
Bracketed numbers as above
B
UCD-101 (958) 21A,63
UCD-114 (972) 13F,9
C
UCD-143 (1147) 18C,58;
 17

Dunedin, Otago Museum
B
E48.66 2F,11; 9F,25
E48.231 21E, 16
C
E59.3 9E,122
F54.80 13B,9
**Durham, N.C., Duke
University**
C
— 39A,4
Edinburgh, Royal Scottish
Museum
C
1872.23.10 16B,16
1872.23.11 9F,19
1877.29 3B,2a; 18C,14a;
 4F,5; 21F,4
1881.44.28 p. 249
1953.22 18C,30a
1956.477 s.l. 4,6a
Erlangen, University
B
M6 20A,12
M8 (or 8) 22A,2
M31 8E,16
M35 30A,1
M61 8D,28
M80 38A,1
M349 1D,4
M443 8E,14
M930 17A,3
I385 23A,1
I635 20A,89
ex Munich J1189 s.l. 5,14
— 9D,18
Fayetteville, University of
Arkansas
C
57.24.21 17F,6
Ferrara, Museo Nazionale
I give inventory or tomb
numbers according to the
usage of the respective
publications (mostly *CVA*
and *Scavi di Spina*); inven-
tory numbers are given for
marks cited in the article
St.Etr. 46 (1978) 287ff,
although they are not cited
in the text above.
A
T499 Lac 7
B
inv. 150 p. 13
 156 p. 13
 157 p. 13
 163 3D,10
 180 p. 13
 1236 9E,87; 3E,47
 1302 3D,11
 12208 p. 13
 16271 p. 13
 16273 p. 13
 16276 3D,13
 16279 3D,12
 16290 1B,18
 16291 1B,19
 16346 p. 13
 16347 (T16D) p. 13
 16351 2B,48
 16385 p. 240
 16388 23E,16
C
inv. 13 9E,73a; 1F,17
inv. 20 p. 14
 22 p. 14
 27 p. 14

 61 p. 14
 72 p. 14
 8095 22F,10
 22073 8B,15
 22087 p. 13
 22117 p. 14
T44 s.l. 7,15
T119B 25F,10
T266 p. 59
T281 9B,25
T411 p. 39; 59
T436 s.l. 1,42
T456 p. 59
T583B 18C,80
T597 16B,36
T604 p. 59
T612 p. 14; 248
T697 5D,16
T709 p. 59
T770 18C,40; 17E,49
T797 s.l. 2,38
T912 18C,6
T1210 p. 65
— 9E, 110
— p. 59
Florence, Museo Archeologico
A
3766 Cor 99
78994 EG 182
B
3770 8D,6a
3774 8D,6
3790 9E,27
3798 8D,23
3820 5E,24
3821 18B,4; 5E,25
3826 10B,1
3830 14A,11
3838 18B,3; 26B,3
3839 21A,7; 34A,1
3844 s.l. 5,15
3845 13A,5; 1D,14
3856 20A,38
3857 12B,14
3858 17E,29
3861 p. 63
3862 11B,2
3863 21A,32
3866 8E,37; 13E,22
3867 8E,41; 10E,29
3872 3E,28
4148 21E,44; 22E,7
70995 p. 66
70998 20A,37; p. 66
71004 8D,69
72732 17B,23
76167 8E,53; 16E,1
76360 21E,7
92167 33A,8
'1841' 12E,18
— 3A,3
— 5A,14
— 20A,4
— 21A,27
— 4B,6
— 19B,4
— 2F,59
C
3935 p. 61
3985 9E,79
3995 s.l. 7,10
4007 p. 31
4010 19B,14
4015 11C,3
4020 3E,55
4021 6D,19
4025 3C,4
73140 18C,9

 75748 18C,61
 76895 s.l. 2,10
 81947 p. 231
 81948 18C,78; 21F,13
PD538 17B,20; 25B,7
PD574 7D,17
— 2B,41
— 9E,81; 16E,6
— 9F,22
— 20F,12
Frankfort, Museum für
Kunsthandwerk
B
WM 03 2A,1
C
— 8B,12
Frankfort, Museum für Vor-
und Frühgeschichte
B
289 21E,8
344 11B,12
C
425 p. 37
— p. 64
Gela, Museo Nazionale
Numbers partly in the
series of the Syracuse
museum
A
204 Cor 86
20324 Cor 59
Navarra 25 Lac 2
— Cor 16
— Cor 69
— EG 112a (p. 70)
B
Navarra 1 8E,60
Navarra 11 p.2; 16; 28; 243
Navarra 38 9E,119
Navarra 49 9E,68
Navarra 116 21A,95
Navarra 125/B 22E,3
— 7B,2
— 7D,4
C
635 16E,8
640 13B,31
8736 6D,31
9240 1F,16; 19F,2
9255 p. 60
10597 p. 2; 29; 37; 60
27305 1B,17
G87 9E,98
Navarra 68 11B,23
Navarra 116/B 6B,16
Navarra 15B,12
Geneva, Musée d'art et
d'histoire
B
5761 p. 30
12048 10E,8
15053 10E,16
20608 s.l. 6,23
Ill 2D,6
I36 9E,120
MF151 10E,20
MF153 12B,1
MF240 s.l. 6,10
Genoa, Museo Civico
B
1169 24B,15
Gerona, Museo Arqueologico
Provincial
B
— p. 29
Glasgow, Art Galleries and
Museums
C

1883.32a 15C,2
Göttingen, University
C
ex Berlin 2168 9F,15
ex Berlin 2361 26F,1
Gotha, University
B
28 20A,36
29 5E,23
31 1D,19
32 8A,3
44 12E,5
C
— p. 239
— 21F,16
Granada, Museo Provincial
C
414 18C,52
Greenich, Conn., Bareiss
B
20 13B,12
21 21A,35
— 21A,13
C
15 10F,8
The Hague, Gemeente
Museum
C
2026 18E,5
Halle, University
C
inv. 256 12B,18
— p. 28
Hama
C
— p. 20
Hamburg, Museum für
Kunst und Gewerbe
B
1913.390 14E,1
1917.471 9E,60
1917.472 17B,25
1917.476 p. 240
1917.477 21A,87
1917.987 9B,5
Hannover, Kestner Museum
A
1967.11 p. 251
B
752 20A,32
1936.107 24E,2
1962.78 17B,2
1963.47 11E,20
1964.9 19A,1
1965.30 27A,1
1966.85 7D,1
1967.11 1F,11

Harrow-on-the-Hill, Harrow
School
B
24 11E,2
26 16A,3
27 s.l. 5,16
C
50 p. 24; 195
65 18C,71
100 p. 61
110 p. 239
Harvard, Fogg Museum
B
2214 s.l. 1,24
60.315 19B,9
C
1927.148 9F,4
1942.209 11F,17; 25F,2
1959.187 2B,30; 11F,18

Havana, Lagunillas?
B
— 22E,10
Hearst, see Hillsborough and
San Simeon
Hillsborough, Hearst
The numbers in I. Raubit-
schek, *The Hearst Hillsbor-
ough Vases* are quoted in the
catalogue.
B
4004 11E,1
5517 38A,3
5528 28A,4
Histria see Bucharest
Istanbul, Archaeological
Museum
A
— EG 240-242
B
1938 7F,2
— 22B,1
Jena, University
B
178 8D,20
179 s.l. 6,26
184 21A,3
189 p. 31
— 9E,4
C
355 15C,6
447 11F,19
Jerusalem, Israel Museum
B
74.9.8 s.l. 1,21
Karlsruhe, Badische Landes-
museum
A
B198 Cor 80
B2589 Cor 38
B
B31 18B,5
B301 11E,27
61.24 8E,9
C
B594 11F,25
B3134 11F,24
Kassel, Hessisches Landes-
museum
B
T674a 17A,9
T675 8D,32
T698 21E,9
C
T682 21B,9
Kiev
A
— EG 84
Küsnacht, Hirschmann
B
G9 20A,34
Laon, Musée Municipal
B
37894 3E,53
37971 21B,8
C
371023 26B,8
Lausanne, private
B
— 22A,1
Legon, University of Ghana
B
— 8A,12
Leiden, Rijksmuseum van
Oudheden
B
PC1 9E,77; 21E,9

PC2 1D,8
PC3 8E,10
PC7 4F,2
PC13 11E,21
PC17 11E,19
PC29 20A,25
PC33 5E,21; 11E,48
PC40 21E,34
PC43a 32A,11
PC48 20A,48
PC49 9E,11
PC51 21E,39
PC52 1A,3
PC55 8E,61
PC63 21E,13
K94/1.10 p. 29; 226
1954 /12.1 24A,2
Leipsic, University
B
— 9D,17
— s.l. 6,27
C
T64 8D,60
Leningrad, Hermitage
Museum
Much of the red-figure
material is published by
Peredolskaya, *Krasnofigurnye
Atticheskie Vazy,* abbreviated
as P. All but two of the rest
are published in Stephani's
catalogue (St.).
A
St.266 24B,4; EG 251
B
St.19 20E,2
St.21 17B,24
St.35 9B,1
St.43 10B,14
St.62 1B,9
St.73 2B,22
St.74 21B,5
St.77 2F,41
St.80 8E,24
St.85 10E,32
St.112 9E,42
St.119 12E,15
St.120 20E,12
St.121 21E,29
St.132 s.l. 7,7
St.133 12E,16
St.136 12B,16
St.140 12B,17
St.149 11E,28; 12E,30
St.152 s.l. 7,6
St.158 8D,44
St.271 6D,8
St.282 8E,57; 10F,2
inv. 2067 17E,2
— 5A,7
C
St.1206 8F,9; 21F,8
St.1217 3B,7
St.1491 p.16; 60
St.1538 9F,43
St.1672 19F,6
St.1681 12C,7
St.1694 16B,24
St.1784 9E,65
St.1807 p. 18
St.1863 33A,21
St.1938 5D,17
St.2022 9E,116
St.2168 3C,5
St.2173 p.18; 60; 65
St.2193 21A,100
P20 1B,13

P21 8E,31
P23 9E,82; 21E,60
P25 9E,83; 21E,61
P27 9D,21; 18E,7
P29 6D,6
P32 7C,3
P35 18B,10
P36 12E,21
P39 17E,35
P43 9F,35
P51 17B,13
P52 17B,8
P59 17B,17
P60 10F,19
P61 9E,51
P87 9F,49
P91 p. 246
P102 9F,40; 11F,15
P103 s.l. 1,19; p. 249
P125 18B,12
P201 6C,9
P210 16B, 28; 20F,9
P211 15B,16
P216 13B,8
P229 9B,29
Limoges, Musée Adrien
Dubouche
A
81.00 Lac 3
Liverpool, Free Public
Museums
B
56.19.6 9F,28
1977-114-10 20A,37a (p.70)
1977-114-13 5A,10a; 8E,55a
(p. 70)
Locri, Museo Archeologico
B
T594 8D,14
London, British Museum
The readings of the old
catalogue (o.c.) of 1851-70
are consistently more
accurate than those of the
'new' catalogue of 1893-6
and *CVA;* the latter are
particularly unreliable. I
bracket o.c. numbers in the
following lists where later
numbers are in more general
use.
A
A1513 Cor 11
B27 Cor 100
B43 Cor 50
o.c.225 Lac 6
o.c.309 Cor 19
o.c.310 Cor 20
o.c.316 Cor 17
o.c.317 Cor 18
o.c.377 Cor 78
o.c.378 Cor 79
1864.10-7.1350 EG 82
1865.12-14.4 Cor 28
1867.5-8.892 Cor 13
1886.4-1.706-711 EG 184-
189
1886.4-1.712 EG 172
1886.4-1.713-4 EG 190-
191
1886.4-1.715 EG 35
1886.4-1.716-719 EG 193-196
1886.4-1.720 EG 36
1886.4-1.721 EG 198
1886.4-1.722? EG 197
1886.4-1.727 EG 199
1886.4-1.739-771 EG 1-16

and 18-34
1886.4-1.773 EG 45
1886.4-1.931 EG 210
1886.4-1.981 EG 46
1886.4-1.1026 EG 211
1886.4-1.1302 EG 212
1886.4-1.1303 p. 250
1886.4-1.1337 p. 236
1888.6-1.374-376 EG 47-49
1888.6-1.384 EG 50
1888.6-1.414 EG 213
1888.6-1.419 EG 51
1888.6-1.420 EG 52
1888.6-1.428 EG 53
1888.6-1.765-774 EG 54-63
1888.6-1.776 EG 64
1907.12-1.797 EG 249
1910.2-22.28 p. 237
1910.2-22.34 p. 237
1910.2-22.44 EG 160
1910.2-22.45-47 EG 162-164
1910.2-22.48 EG 76
1910.2-22.50-56 EG 38-44
1910.2-22.57 EG 200
1910.2-22.63 EG 171
1910.2-22.64-65 EG 201-202
1910.2-22.72-76 EG 203-207
1910.2-22.252 EG 215
1910.2-22.259 EG 216
1910.2-22.262 EG 65
1922.5-8.6 EG 173
1922.5-8.12 EG 217
1922.5-8.13 EG 218
1922.5-8.14 p. 237
1924.12-1.339 EG 174
1924.12-1.897 EG 219
1928.1-17.36 Cor 42
1949.5-16.7 EG 75
1965.9-30.256 EG 220
1965.9-30.257 EG 66
1965.9-30.259 EG 67
1965.9-30.479 EG 221
1965.9-30.638 EG 222
1965.9-30.671-672 EG 223-224
1965.9-30.674 EG 225
1965.9-30.677-679 EG 226-228
1965.9-30.703 EG 229
— EG 192

B
B29 (627) 9B,26; s.l. 1,33
B31 15B,4
B50 (445) 14A,7
B144 (573**) p. 22
B150 24A,2
B151 s.l. 5, 7
B152 (566) 11B,3
B153 (565) p. 64
B158 (586) 24E,3
B156 s.l. 5,8
B160 1E,3; 2E,2
B163 (580) 17A,10
B174 33A,6
B178 (574) 9E,109; p.207
B179 (583) 17B,26
B180 (596) 21A,94
B181 (597) 12B,2
B182 (579) 3E,19
B184 (590) 20E,5
B185 (585) p.30; 207
B193 (608) 9E,20
B195 (599) 3D,8; 20E,1
B196 (603) 2F,49
B197 7D,22

B198 (604) p. 39
B201 (600) 10E,19
B205 (607) s.l. 5,19
B211 7A,2
B212 (552) 15A,10
B214 (549) 25B,1
B215 (509) 11F,4; s.l.1,15
B218 (544) 8E,3
B219 (543) 17B,27
B220 (546) 3E,30
B222 (542) 2F,22
B223 (535) p. 39
B224 (532) 26A,1
B225 2F,47
B226 (538) 21E,21
B227 (537) 20A,13
B228 (536) 22B,5
B229 (539) 18A,2
B230 (541) 21A,81a
B232 (545) 21A,72
B233 2B,45
B234 (533) 4A,1
B235 (524) 24B,2
B237 (524*) 21E,26
B238 (530) 1A,7; 8A,10
B239 (553) 8E,58
B240 (550**) 20A, 55
B244 (510) 21E,2
B247 (514) 21E,3
B249 11E,16
B250 (531) 14E,6; 2F,58
B251 (511) 32A,3
B252 2F,19; s.l. 5,20
B257 (519) 23E,19
B259 (520) 13E,5
B260 (508) 24B,11; 13F,7
B261 (550*) 1F,12; 2F,24
B262 (517) 21E,5 and 64
B264 (525) 20A,41
B266 (526) 21E,22
B272 (529) 1A,2
B275 (555) 23E,20
B279 (503) 20E,9
B280 (504) 11E,13
B282 15B,15
B288 (490) 11E,31; 14E,8
B295 7D,2
B296 21A,47
B300 (447*) 20A,60
B301 14A,1; 3D,6
B302 (447) 20A,81
B303 (467) 21A,76
B306 (487) 5E,3; 6E,5
B308 (449) s.l. 6,14
B309 (464) 5E,13
B310 (463) 2F,27
B312 20A,26
B313 (452) 2F,43
B314 (462) 8E,47; 10E,23; 11E,40
B315 (630) 21E,25
B317 13E,12
B318 (456) 8D,27
B320 (459) 2F,51; 14F,13
B322 (471) 8E,48; 10E,25; 11E,37
B323 (472) 8E,49; 10E,26; 11E,41
B324 (474) s.l. 5,22
B325 (469) 8E,42; 10E,28
B326 (473) 8E,46; 11E,43
B327 (465) 10E,13; 11E,42
B328 (466) 5E,4; 6E,6
B329 (481) 13E,10
B332 (480) 13E,18
B336 (478) 21E,49
B338 (482) 16A,22
B340 (461) p. 63

B345 (484) 13E,6
B362 (561) 11A,6
B449 s.l. 1,52
B467 (662) 12B,15
B472 s.l. 5,23
B475 (640) 5A,6
B489 (648*) p. 29
B490 12E,3
B493 (646*) 9F,29
B501 (654) 9D,6
B516 s.l. 5,24
B518 (653) 21B,1
B523 (655) 15B,10
B525 s.l. 6,24
B625 9E,100
B697 9C,1
B698 9C,2
o.c.639 13A,8
1863.4-30.3 22B,1
1863.7-28.443 15A,6
1897.7-27.2 8D,2
1899.2-18.67 18B,6
1901.7-11.1 8D,34
1910.2-22.248 9B,20
1911.4-12.1 1B,20
1926.6-28.7 2F,3
1928.1-17.1 10B,2
1951.1-21.2 13A,2
1966.4-28.5 3F,4
C
E37 (828) p. 239
E44 (822) 20B,3
E62 (850) p. 70
E102 (818) p. 239
E142 16B,14
E159 (720) 2F,36
E160 (718) 8E,32
E163 (717) 9E,108; 1F,10; 21F,1
E168 (757) 21B,11
E170 18C,20; 17F,4; 21F,5
E177 (741) 2B,9
E179 p. 69
E183 21F,11
E195 (738) 6C,7
E201 (729) 3B,6
E227 (C1) 24F,8
E229 (C58) 8F,3
E256 (791) 9E,48; s.l. 2,1
E261 21A,26; s.l. 2,26
E263 (807) s.l. 1,11
E274 (796) 20B,4
E278(806) 5C,4
E279 (796*) 5C,3
E280 18F,3
E285 (912) 9F,7
E287 (871) 7D,35
E292 7D,32
E313 7D,24
E319 (863) p. 15
E331 (869) 13C,1
E352 17E,36
E375 s.l. 1,43
E380 (742) 16B,26
E405 (929) 3E,38
E410 (741*) 2B,6; s.l. 2,30
E429 12F,3
E433 s.l. 7,16
E438 16C,2
E440 (785) 11B,25
E443 (788*) 9F,47
E444 (783) 8C,3
E446 3C,2
E447 18C,62
E453 (740) 18C,19
E458 (786) p. 36
E467 (1265) 9E,118; 8F,6
E468 (786*) 9E,91

E471 s.l. 1,44
E473 (1266) 18B,11
E486 18C,77; 17E,41; 19F, 17
E497 (1278) 17F,8
E504 (1282) 14F,4; 18C,45
E512 (870) 7D,15
E514 (855) 13E,17
E519 9F,14
E567 (890) 9F,11
E570 6D,18
E574 (751) 7D,28; 9E,49
E579 9E,50
E723 p. 188
E725 p. 188
E728 13A,9
E771 4B,14; s.l. 4,2
F54 p. 16; 65
F90 21F,15
F141 (933) s.l. 4,3
G39 p. 21
o.c. 936 8D,78
o.c. 1217 17E,39
o.c. 1233 21A,103
o.c. C100 4A,16
1842.7-28.1054* s.l. 4,21
1859.2-11.71 p. 29
1863.7-28.451 p. 17
1864.10-7.1704 p. 28
1866.4-15.19 p. 21; 28
1898.7-15.1 1C,2; 18C,21
1921.7-10.2 2B,29; 8F,8; 21F,7
1929.5-13.2 1A,9
1965.8-16.12 p. 59
1965.9-30.579 p. 20; 29
1965.9-30.876 p. 20
MS cat. 1927 p. 30
MS cat. 1929 p. 30
D
1910.2-22.165 p. 195
1910.2-22.174 p. 237
1965.9-30.747 p. 61
London, Embirikos
C
— 13B,25
London, Victoria and
Albert Museum (V & A)
B
4796.1901 21E,32
4815.1901 11E,15
C
— 8B,14
London, Wellcome Trust
A
— p. 251
B
R223/1946 s.l. 4,6
Los Angeles, County
Museum
B
50.8.1 21E,18
50.8.2 21A,15
50.8.19 16A,13
50.8.20 11F,7
50.8.22 20E,6
C
50.8.35 15C,3
Madrid, Museo Arqueologico
There are differences in readings between CVA and Leroux's catalogue; the former seem more reliable.
B
682 9E,63
10903 15A,8
10904 8E,51; 10E,14; 11E, 39

10914 16E,4
10919 9E,15
C
11010 1B,15
11045 24F,5
11075 12B,9
11101 9F,6
11113 10C,2
11117 6D,30
11121 9E,123
Mainz, University
B
73 8A,8
74 8E,34; 9E,8
Malibu, J. Paul Getty
Museum
A
— p. 238
C
73.AE.23 p. 29; 99
— 9B,10
— 16B,34
Malmaison
B
297 21A,43
298 21A,44
The Manchester Museum
B
IIIh 48 p. 29; 226
IIIh 50 20A,20
Mannheim, Reiss-museum
B
Cg 40 4B,4
Cg 218 3E,57
C
Cg 11 p. 15
Cg 204 s.l. 1,35
Maplewood, Noble, see
New York
Marseilles, Musée Borély
B
— 2B,23
C
— 5D,20
Matera, Museo Nazionale
D. Ridola
B
— s.l. 6,22
Melbourne, Monash
University
C
— 19B,6a
Melbourne, National Gallery
C
D1/1976 18C,53; 22F,7
Milan, Museo Archeologico
Including material on perma-
nent loan from the excavations
of the Lerici Foundation at
Cerveteri
A
A174 Cor 65
A1498 p. 242
A1856 p. 251
B
A126 p. 63
Lerici B 116/1 9B,3
Lerici BL290 12E,12
Lerici MA 154/5 s.l. 5,103
Lerici MA 284/5 s.l. 5,104
Lerici 21A,20
C
A1605 12B,8
A1805 p. 63
A1806 p. 14; 65; 239
A1814 18C,36
A1869 18C,69

Milan, Museo Teatrale alla
Scala
C
416 17B,16
Miletus
D
— p. 62
Moscow, Pushkin Museum
C
1089 p. 65
Mount Holyoke College, see
South Hadley
Münster, University,
Archaeological Museum
B
565 s.l. 5,25
Munich, Antikensammlungen
A good number of readings
can only be found in Jahn's
catalogue. * in the catalogue
marks a vase lost in the war.
A
237, J964 Cor 29
238, J966 Cor 30
460 EG 90
463 EG 91
467 EG 92
468 EG 93
B
1361, J739 17A,1
1362, J741 17A,2
1367, J481 15A,1
1368, J637 15A,2
1373, J93 8D,9
1374, J696 8D,10
1377, J606 s.l. 6,6
1381, J589 17A,4
1382, J645 1E,10
1383, J75 29A,1
1384, J1081 33A,1
1385, J729 8D,12
1393, J316 s.l. 5,26
1396, J1114 33A,3; 1E,9
1397, J1079 1E,5
1398, J1138 4E,1
1400, J610 17A,5
1402, J1080 s.l. 5,27
1403, J1203 8D,11
1410, J328 39A,1
1411, J330 39A,2
1413, J693 2F,52
1414, J7 24E,2
1415, J380 33A,16
1416, J379 2B,40
1417, J3 9F,27
1430, J150 8D,5
1431 s.l. 5,28
1432, J175 s.l. 5,29
1439, J82 s.l. 5,30; p.64
1440, J79 9E,13
1441, J77 s.l. 5,31; p.64
1445, J396 24A,5
1446, J918 14A,9; 24A,3
1447, J916 8D,13
1449, J1154 17E,25; s.l. 1,20
1461, J495 32A,5
1464, J496 9E,101; 19F,1
1471, J474 17A,6
1472 9E,12
1473, J1153 32A,2; s.l. 5,32
1480, J622 16A,6
1480A 16A,11
1484, J1181 9D,9
1485, J719 17E,45; 21E,63
1486, J315 11E,45; 13E,23
1488, J309 1D,18
1490, J641 24B,12

1492, J571 20A,54
1501, J168 14E,5; 2F,57
1502, J639 20A,3
1502A 2D,3
1503, J473 20A,78
1505, J533 4A,11
1506, J1259 8D,15
1509, J327 20A,64
1512, J97 9F,31
1513, J1342 8D,29
1514, J525 20A,5
1518, J644 8E,23
1519, J651 1B,3
1522, J1179 11E,11
1524, J450 5E,6; 6E,8
1527, J397 1A,6; 8A,5
1530, J1265 21A,5
1532, J182 5E,8; 6E,10
1534, J1196 21A,89
1535, J180 4A,12
1537, J317 20A,56
1540, J684 20A,65
1541, J584 6D,9
1542, J653 30A,4
1543, J501 2F,54
1544, J1250 3E,22; 4E,7
1545, J101 20A,50
1546, J1187 8A,11
1547, J434 8E,8
1548, J313 16A,5
1549, J728 5E,7; 6E,9
1550, J1263 17B,28
1552, J623 21A,84; s.l. 5,33
1553, J718 10A,9; 6B,9
1554, J643 11F,6
1557, J1344 4A,10
1560, J694 9D,5
1562, J1325 1D,17
1564, J425 1B,4
1565, J621 11E,30;14E,7
1566, J1219 5E,11
1567, J567 10B,3
1570, J443 21E,42
1575, J499 p. 69
1577, J620 p. 245
1579, J545 2F,20
1592, J364 3E,50
1593, J482 4B,2
1597, J494 4B,1
1601, J529 8E,15
1607, J1248 4B,3
1617, J1288 21A,21
1624, J1221 17B,30
1628, J722 21E,43
1629, J689 1B,10
1633, J1362 21A,96
1640, J607 20E,10
1644, J654 8E,13
1645, J650 32A,18
1646, J648 32A,20
1648, J1254 s.l. 6,25
1664, J1214 21A,101
1666, J1290 3E,58
1681, J1276 18B,1
1686, J484 19A,2
1687, J1289 20A,79
1688, J1215 9E,28; 8F,4
1689, J492 21A,75
1690, J116 9D,4
1695, J445 21A,51
1697, J44 3D,2
1699, J649 s.l. 5,34
1700, J65 p. 63
1701, J427 10A,4
1702, J60 7E,17
1703, J164 1D,1; 2D,1
1706, J87 33A,11

1707, J132 11E,5; s.l. 5,35
1708, J114 8E,50; 10E,27;
 11E.38
1709, J48 8E,44; 9E,7; 11E,
 35
1710, J430 8E,33; 9E,6
1711, J128 2F,40
1712, J409 8E,7; s.l. 5,36
1713, J62 5A,11; 8E,56
1714, J46 17E,10
1715, J120 5E,14
1716, J118 2F,45
1717, J731 2F,29
1718, J112 9D,11
1719, J407 17E,8
1721, J1147 13E,8
1722, J136 21A,73
1725, J1329 21A,61
1728, J477 s.l. 5,37
1729, J287 3A,1; 9E,58
1736, J750 s.l. 1,32
1744, J1120 16B,7
1761, J1107 s.l. 1,13: p.239
1772, J85 15B,18
1779, J398 14E,3
1789, J426 11E,25; s.l. 1,38
1791, J1192 33A,5
1805, J1124 8B,6
1806, J422 2E,6
1808, J1145 2E,7
1813, J1149 4E,3
1820, J1355 11E,26; s.l.1,39
1895, J288 22E,6
1903, J149 13E,28
1904, J157 13E,29
2030, J1317 21A,66
2078, J186 21A,67
2148, J26 32A,8
2154, J23 s.l. 6,7
2238, J418 6D,3; s.l. 1,48
2301, J388 9E,21
2418, J56 21A,77
8518 = 1480A
8772 s.l. 5,38; p. 64
J1259 21A,4
SL458 20A,10; 3D,3
SL459 s.l. 6,20; p.39
'foot 4' 11E,24
'foot 8' 8E,25
'foot 22' 4F,3
'foot 25' 8E,26
Hanniel 1 5E,5; 6E,7
— 3E,24; 4E,5
— 8E,2; 15E,5
— 11E,22
C
2300, J375 s.l. 2,24
2307, J378 31A,4
2309, J410 2F,50
2314, J1185 2D,10
2315, J51 12E,22
2321, J249 17F,7
2322, J420 1B,24
2333, J261 13B,26; p.249
2335A (7524) 16E,10
2343, J1181 19B,10
2346, J293 2B,49
2363, J511 7D,19
2371, J303 4A,13
2379 7B,6
2394, J239 18C,65
2405, J352 9F,34
2406, J421 9E,90
2407, J415 9B,16
2408, J343 9E,105
2410, J354 18C,29
2414, J296 18C,26; 20F,10

2415, J382 20F,8
2420, J377 9E,61
2421, J6 2F,34
2422, J50 5E,27; 2F,35
2423, J4 2F,55
2427, J347 21B,6
2476, J365 22B,8
2614, J1096 8E,29
2726 s.l. 4,1
6498 3B,4; 16F,1
7514 10F,12
7518 9E,66
8738 22B,7
Naples, Museo Nazionale
I quote the numbers in
Heydemann's catalogue
without an introductory H;
they are not readily con-
fused with the much longer
inventory numbers.
A
328, 80256 Cor 92
336 Cor 94
351, 80245 Cor 75
Stg. 137 Cor 91
B
2447 9E,70
2466 13B,13
2473 s.l. 5,39
2475 p. 239
2486 9E,35; s.l. 5,40
2498 33A,7
2501 20A,53
2503 s.l. 5,41
2505 20A,75
2533 26F,18
2539 22E,2
2712 23E,7; 26F,19
2714 24A,1
2734 13A,1
2748 s.l. 5,42
2752 9F,3
2777 s.l. 5,43
2787 32A,19; 11B,9
2792 p. 187
3360 10F,3
3415 s.l. 1,28
112847 s.l. 1,8
126050 20A,76
127875 15A,4
RC184 s.l. 1,27
RC192 13B,15
RC199 40A,1
RC204 20B,1
RC219 41A,1
RC220 5A,10
RC229 14B,19
RC231 3E,31
RC232 8D,45
Sp.91 10F,4
Sp.253 8D,43
Sp.257 p.59
Sp.296 p.59
Sp.2142 9E,73
Spinelli 31A,3
Stg.10 13E,15
Stg.30 21A,55
Stg.111 6D,17
Stg.118 9B,4
Stg.141 21E,52
Stg.148 2F,12
Stg.150 8D,17
Stg.160 21E,1
Stg.175 32A,12
Stg.186 20A,29
Santangelo p.64
C
659 11F,8; s.l. 4,39

967 3B,3
2847 18C,49; 6F,2; 23F,7;
 26F,13
3030 9F,50
3031 6D,12
3033 9E,111
3034 9F,9
3048 11F,14
3089 19B,17;18C,63a
3093 6C,3
3097 4C,1
3105 9E,75
3116 7D,27
3163 1F,16
3172 9F,33
3174 7D,10
3180 9F,5
3183 16B,18
3190 9F,16
3211 13C,2; 18C,16
3232 5F,5
3245 18C,50
3373 10B,7
3487 3E,52
3500 6C,11
4862 p.15
86046 p.249
116116 18C,66; 19F,11;
 22F,3; 23F,2; 24F,3
126053 7D,25
126055 6C,4
126056 3E,54; 4F,4
126062 13B,20; s.l. 2,7
127930 9F,52; 18E,13
151600 18C,47; 14F,15; 19F,
 3; 23F,3
'1346' 18C,31
RC2 16B,30; 3D,15; 1F,14;
 7F,4
RC125 18C,35;19F,12
RC132 1F,15; 7F,6
RC148 20F,4
RC151 10F,14
RC171 14A,6
RC245 18B,15
Sp.353 p.28; 38; 59
Sp.453 p.59-60
Sp.2081 18C,41
Sp.2086 p.30; 60
Spinelli 9E,115
Stg.249 5C,1
Stg.253 p.63
Stg.270 2B,31; 11F,20
— 8B,13
— 10B,12
— 24B,10
— 9C,3
— 18C,30
— 19F,9
— s.l. 1,47
Newark, N.J., The Newark
Museum
C
68.11 14F,14
Newcastle-upon-Tyne,
University, The Greek
Museum
C
105 23E,15A
199 8F,11
Newhaven, Yale University
B
106 16E,5
New York, Metropolitan
Museum
A
27.116 Cor 48
46.11.1 Chalc 10

68.11.40 p. 238
B
96.18.51 32A,13
98.8.14 39A,3
98.8.15 4B,7
06.1021.29 17B,1
06.1021.50 s.l. 6,21
06.1021.59 6A,2
06.1021.67 p.245
06.1021.68 s.l. 5,44
06.1021.69 5D,6
06.1021.82 9F,30
06.1021.88 41A,2
23.160.60 9E,29
26.60.20 p.23
26.60.29 24E,5
41.162.190 16A,8
41.162.193 3E,29
41.162.212 20E,13
41.85 8D,31
49.11.1 2B,1
46.92 3E,57
51.11.3 s.l.1,4 and 3.1
53.11.1 s.l. 5,45
56.171.4 s.l. 1,25
56.171.10 p.4
56.171.13 p.34
56.171.18 17A,8
56.171.20 20A,83
56.171.27 20A,7
60.11.6 8D,63
61.11.16 21E,6
69.233.2 8E,19
1974.11.1 24B,3
X21.4 23E,15
X21.17 9F,2
C
06.1021.116 19B,16
06.1021.120 s.l.4,36
06.1021.149 9F,51; 13F,3
06.1021.151 19E,3
06.1021.152 10F,15; 13F,1
06.1021.174 s.l. 3,17; p.37
06.1021.187 16B,27; 20F,6
06.1021.190 9F,45
06.1021.192 9F,13
07.286.78 17E,18; 14F,11
08.258.21 p. 29
08.258 58 11B,26
10.210.19 8D,74
15.27 6E,2
17.230.13 9C,4
18.74.1 2C,2
21.88.2 2D,9
21.88.3 18C,32
22.139.11 26F,21
25.28 21F,9
29.131.4 11B,18
41.162.17 7D,23
41.162.19 7D,36
41.162.69 3E,43
41.162.87 9E,114
41.162.127 p.29; 38; 249
41.162.137 16B,23
56.171.50 9E,104
GR 579 18F,2
GR580 p. 29; 245
GR585 9B,14
GR597 10B,8
New York, Blos
B
— 23A,4
New York, von Bothmer
B
— 6A,5
New York, Hermann
B
— 5E,19

New York, Noble
B
— 21A,2
— 5D,11
— 23E,1
— s.l. 7, 3
— p. 244
— p. 248
C
— 6B,15
— 7B,4
Nicosia, Cyprus Museum
A
C950 p. 19
B
C650 (Myres 1554) 14B,18
C
C532 p. 19
C535 p. 20
C462 p. 20
C558 p. 20
C574 p. 20
C592 p. 61
C594 p. 20
C654 16B,9
C688 p. 20; 29
C751 s.l. 4,13
C807 p. 61
C869 p. 61
C883 p. 19
C969 p. 19
1950.vii-31/4 p.19
1961.ii-2/8 p. 20
Myres 1901 p. 61
Norwich, Castle Museum
B
— 21E,14
Omaha, Josllyn Art Museum
B
1953.255 9E,14
Orleans, Musée Historique
A
— Chalc 9
Orvieto, Museo Civico
For much of the material I
have been able to obtain
little more information
than was available to
Hackl - also for the Faina
collection. L numbers refer
to Annali dell'Instituto 1877
pl. L.
B
240 9E,16
273 19B,1
299 33A,4
594 9E,17
inv. 2491 s.l. 6,32
L8 9E,56; 8F,5
L9 17E,33
L11 6D,13
L15 21A,98
L17 33A,12
L18 33A,13
L21 20A,57
L22 20A,58
L30 10E,1
— 3E,37
— p. 5
C
1044 8C,4
— 4B,13
— 10F,7a (p. 70)
Orvieto, Museo Faina
B
16 1D,23
45 14B,1
50 21A,93

63 9E,18
70 4A,2
79 10B,13
80 21A,23
85 9E,45
124 8A,1
— 15B,3
— 17E,4
C
23 1B,16
103 4B,11
Oslo, Museum of Applied
Arts
B
8673 8E,21
Oxford, Ashmolean
Museum
A
123.4 EG 37
1928.11 Cor 76
1956.574 p. 237
1960.741 s.l. 5,47
1965.132 Chalc 8
B
208 (1885.665) 23B,1
209 (1879.163) 13B,16
210 (1879.162) 22A,5
210a 2B,44
215 (1885.654) 3E,12
218a 23E,12
222 (1879.161) 18A,1
237 (1879.152) 5A,12
249 15B,11
250 (1890.27) 5A,1
509 21A,31
569 (1910.804) 19B,7;
 9E,62
1911.256 s.l. 5,46
1925.140 13F,5
1948.236 2F,30
1960.540 3E,25; 4E,6
1965.104 20A,70
1965.108 13E,20
1965.115 9D,2
1965.118 16E,2; 17E,24
1965.119 9B,2
1965.135 17A,7
— 4D,2
C
273 (1891.689) 23E,17
276 12F,2
283 (1884.714) 7D,30,
 p. 249
292 (1885.659) 3C,1
296 16C,5
304 (1879.166) 16B,13
334 s.l. 4, 5
523 s.l. 7,11
524 6C,1
1891.323 7B,3
1914.733 9C,5
1916.68 18C,14; 9E,95
1918.28 2B,17
1920.105 s.l. 1,53
1927.4065 p. 239
1927.4502 9E,92
1929.779 9F,44
1930.169 10F,22
1937.983 18C,37
1956.310 14F,17
1956.467 p.20
1956.468 p. 20
1956.482 p. 29
1956.498 p. 20; 29
1956.500 p. 20
1956.503 p. 20
1960.1289 p. 65
1964.325 s.l. 4,5

1965.121 2B,15; 25F,5
1965.127 9E,106
1965.128 s.l. 2,33
1966.853 19B,6
Paestum, Museo Nazionale
A
— Cor 12
Palermo, Museo Nazionale
A
1631 Cor 9
1659 Cor 73
1674 Cor 68
1714 Cor 35
1735 Cor 22
1755 Cor 21
— Cor 60
B
1820 p.2: 64
1825 15B,19
1889 5D,13
1891 p. 29
1895 2B,20
1902 16A,17
1908 17B,4
1917 19B,13
1919 s.l. 5,47a
1926 10B,6
1929 p. 241
1947 9F,32a
2379 3E,33
— 20F,1
C
1495 9F,36
2057 11F,29
2378 18E,12; 5F,3
V745 11C,2
— 2B,34
— 15B,21
— 18B,13
— 18C,81
— 9E,96
Palermo, Fondazione
Mormino
B
304 15B,8
Paris, Musée du Louvre
Most marks that are not in
CVA or Pottier, *Vases
antiques du Louvre* are
unpublished.
A
A334 EG 81
E367 Cor 64
E569 Cor 51
E570 Cor 4
E616 Cor 52
E618 Cor 53
E621 Cor 104
E622 Cor 103
E630 Cor 46
E632 Cor 43
E633 Cor 6
E634 Cor 45
E635 Cor 5
E637 Cor 107
E641 Cor 102
E646 Cor 90
E652 Cor 96
E653 Cor 97
E687 Lac 4
ED216 Cor 33
ED223 Cor 55
N3345 EG 250
N iii 2352 Cor 85
S3933 Cor 98
S3941 Cor 57
S3943 EG 98
Cp121 p. 238; s.l. 5,78

Cp10475 Cor 2
Cp10479 Cor 47
Cp11031 p. 238
CA6141 p. 238
El. 99 Cor 72
- Cor 23
B
E623 13F,8; s.l. 1,2
E655 s.l. 5,48
E678 33A,5
E707 35A,1
E708 35A,2
E734 17E,30
E803 9E,5
E804 15E,9
E810 24A,4; p. 202
E821 s.l. 1,3
E823 s.l. 5,49; s.l. 6,5
E824 9E,1
E825 8B,4; s.l. 6,1
E827 s.l. 5,50
E829 s.l. 5,51
E830 13B,10
E831 s.l. 5,52
E833 s.l. 5,53
E835 s.l. 5,54
E838 s.l. 5,55
E840 s.l. 5,56
E845 s.l. 5,57
E849 8D,21
E858 6B,6
E859 s.l. 6,2
E860 s.l. 5,58
E867 s.l. 5,59
E868 15A,9
F1 11B,7
F3 10A,7
F9 17A,14
F20 11B,1
F21 21E,46; 22E,9
F26 5D,4
F27 p.64
F31 8B,2
F32 25A,8
F39 s.l. 5,60
F45 6B,3
F48 8B,3; s l. 5,61
F50 8D,68
F52 27A,2
F54 p. 63
F55 25A,5
F56 20A,66
F59 9E,25
F60 8B,1
F72 21A,28
F99 29A,2
F100 21A,39
F101 3E,3
F102 3E,4
F104 3E,5
F106 3E,6
F107 3E,7
F108 21A,40
F109 3E,8
F111 3E,9
F112 3E,10
F113 3E,11
F130 s.l. 5,62
F139 11F,22
F160 8D,38
F201 33A,10
F202 20A,6
F203 1B,12
F204 9E,23
F205 7B,1
F206 s.l. 5,64; p. 64
F208 8D,67
F209 s.l. 5,64

F211 2F,32
F212 8D,82; 2F,33
F213 2F,9
F214 s.l. 5,65
F218bis. s.l. 5,66
F219 20A,30
F220 33A,17
F221 11B,21
F222 4A,4
F223 s.l. 5,67
F226 s.l. 5,68
F227 s.l. 5,68a
F228 17E,26
F229 12E,1
F232 9D,3
F233 6B,5
F234 20A,88
F234bis s.l. 5,69
F235 7D,21
F236 6E,1
F239 14B,10
F240 23E,8; 24E,4
F242 21A,83; 16B,8
F244 18B,2
F246 7D,8
F247 8A,4
F248 25A,10; 12B,6
F249 s.l. 5,70
F250 16A,23
F251 12E,14
F253 p. 39
F255 11E,46; 13E,24
F256 2F,25
F257 8E,30
F258bis 5A,16; 23E,5
F259 5B,1
F260 2F,10
F263 2F,17
F264 12E,8
F265 s.l. 5,71
F269 21E,10
F270 13E,14
F276 s.l. 1,9
F282 7D,6
F283 21A,22
F286 8E,36; 13E,19;
 s.l. 5,72
F289 s.l. 5,73
F292 21A, 85
F294 7A,1; s.l. 5,74
F295 16B,6; s.l. 5,75
F297 17E,27
F298 9E,30
F299 8E,40; 10E,24
F300 8D,81; 17E,5
F301 8E,6
F302 5E,22; 17E,14
F303 s.l. 5,76
F325 23E,13
F327 17E,31
F328 12B,5
F333 13B,3
F338 33A,24
F344 13B,4; 16B,3
F348 1B,21
F356 9B,8
F358 34A,4
F380 11F,5
F381 8D,83
F383 12B,12
F386 21B,4
F394 s.l. 5,77
F397 21A,24
F405 3A,5
AM1008 16A,16
AM1388 23E,3
Cp966 37A,10
Cp10352 6B,12

Cp10512 5D,21
Cp10599 32A,6; 14B,13
Cp10609 27A,4
Cp10612 s.l. 5,79
Cp10622 s.l. 5,80
Cp10635 9E,3
Cp10642 p.191
Cp10655 10A,1; s.l. 1,1
Cp10694 34A,3
Cp10695 s.l. 5,81
Cp10700 s.l. 5,82
Cp10701 5D,22; s.l. 5,83
Cp10710 5A,13
Cp10717 8D,25
Cp12263 24B,2
Cp12267 s.l. 5,84
Cp12268 2D,5
Cp12277 s.l. 5,85
Cp12279 26A,4
Cp12281 s.l. 5,86
CA2252 s.l. 5,87
CA2992 17E,7
CA3327 s.l. 5,88
CA4702 37A,7
CA4716 3D,21; 13E,26
— 20A,42
— 21A,38
— 36A,4
— 5B,3
— 3F,2
— 3F,3
C
G1 8D,49
G41 2F,37
G43 9E,53; 16E,12
G44 2B,12
G46 2B,24
G50 s.l. 6,28
G52 21E,12
G53 13B,23
G55 9B,11
G58 p.36; 239
G62 9D,20; 18E,6
G65 3A,6; 5B,2
G68 11F,12
G124 4B,11
G137 4C,2
G138 2B,51
G142 11B,13
G166 9E,10 and 85; p. 70
G174 12E,20
G178 17E,16; 10F,23; 26F,7
G179 16B,10
G180 11B,24
G182bis p.61
G186 9E,88
G188 p.61
G188bis 2B,7
G192 22B,6
G200 17E,44
G201 12C,1
G202 5C,2
G204 8D,51
G210 s.l. 7,12
G212 17B, 12
G220 17B,15
G223 17B,18
G230 9E,113
G231 4A,14
G232 17E,20; 18E,9
G235 s.l. 2,3
G237 s.l. 2,11
G240 6D,16
G242 9E,76
G247 11B,14
G331 17C,4
G347 p.60
G353 s.l. 2,19

G354 9B,12
G356 19F,10
G357 s.l. 7,9
G368 3C,3
G413 5C,6
G415 15C,5; 18C,28
G417 18C,24
G420 14B,20; 18C,10
G428 9F,10
G430 17F,3
G436 16B,31; 8F,10; 11F, 16
G491 16B,32; 3D,17; 20F, 3
G496 18C,74; 14F,3
G503 12B,10; 18C,42; 14F,2; 26F, 3
G519 3B,9
G520 15E,7
G522 p. 65
G548 15C,9
K253 18C,54; 22F,8; 25F, 7
K343 18C,33
M7 p.20
Cp10751 18C,4
Cp11072 9E,47
CA1944 s.l. 2,34; s.l. 3,19
CA2582 17C,1
CA2981 10F,21; 26F,6
Campana p.70
Paris, Bibliothèque Nationale, Cabinet des Médailles (Cab. Med.)
A
90 Cor 25
B
207 10E,2
215 20A,10
223b 8D,39
229 3E,45
231 1D,10
232 1A,5
244 p.28; 223-4
251 24B,16
252 21A,14; s.l. 1,6
254 20A,61
255 2F,15
256 17E,4
257 13E,13
258 s.l. 5,89
AVH3389 9E,37
— 3F,1
Delepierre 28 8D,81; 17E, 28
Delepierre 29 21E,23
C
376 p. 249
377 17E,42; s.l. 2,34
390 17B,19; 25B,5
393 p. 31
447 6C,6
510 8D,50
852 16B,4; s.l. 2,20
865 s.l. 4,35
932 14F,16
Paris, Petit Palais
B
304 8D,79
312 9E,19a
C
307 17B,9
Paris, Musée Rodin
B
TC863 20E,14
C
TC1052 7B,8
Paris, Nearchos

B
— 1B,1; 6B,4
Parma, Museo Nazionale
B
C1 23A,3
Perugia, Museo Archeologico Nazionale
C
81 18C,17a
123 24B,8
Philadelphia, University of Pennsylvania
C
5682 14F,5
Portland, Art Museum
B
35.137 11E,14
Princeton University, Art Museum
A
57.5 Cor 41
C
29.203 9E,67; 10E,21; 24F, 4
Providence, Rhode Island, School of Design
B
22.212 11E,7
23,303 21A,42
C
15.005 9B,23; 12E,24
Ragusa, Museo Archeologico
A
— Cor 26
C
22950 21F,10
23004 p.2; 28; 37; 60
26556 18C,59
29915 17E,37
— p. 28; 60
Reading, University
A
56.8.8 p. 6
Reggio, Museo Nazionale
D
1463c p. 60
Rhodes, Archaeological Museum
A
1325 EG 101
1326 EG 102
1328 EG 103
1446 EG 87
5175 Cor 10
6251 EG 86
6490 EG 104
10614 EG 78
12096 Cor 32
12218 EG 105
12567 Cor 31
12961 EG 106
13139 EG 107
13686 EG 79
14103 EG 80
— EG 88
— EG 89
— Lac 5
B
10604 12B,4
10616 12B,1a
12200 p. 36
12397 7F,1
13064 2B,11
13467 8B,2
15439 s.l. 5,105
15444 s.l. 5,106
— s.l. 1,17
C

10790 13B,29
12036 s.l. 4,10
12153 p. 13
12454 5D,19
13789 s.l. 4,14
— 18C,68
Richmond, Virginia Museum of Art
B
— 25A,7
Riehen, Granacher
C
— 13B,6; 1F,3
Riehen, Gsell
C
— s.l. 1,29
Riehen, Kuhn
C
— 13B,22
Rome, Museo del Palazzo dei Conservatori
A
80 Cor 95
B
15 14A,2; 16A,15
31 33A,18
47 14A,10
55 14A,3; s.l. 5,99
77 14B,4
89 3A,4
212 s.l. 5,100
68 8D,41
— 22B,9
— 5E,26
Rome, Vatican, Museo Gregoriano Etrusco
For the BF vases Albizzati's catalogue is reliable; a few marks are omitted and some of the photographs are misleading. For the RF, the primary source is *Museum Gregorianum* ii, whose readings are uneven, though generally better than those in alternative sources. Albizzati's numbers first where applicable. G = Raccolta Guglielmi
A
16350 Cor 24
B
310, 17646 s.l. 5,10
314, 17649 15A,3
338, 16595 19B,12
344, p. 59
345, 16442 32A,4
347, 16441 15E,1
348, 16443 1E,4; 2E,3
349, 17700 p. 207
352, 17701 11F,1
353, 17829 15E,2
354, 17806 25A,9
356, 16597 14F,7
357, 17699 4A,3
359, 17691 3B,1
362, 16519 3E,2
378, 17059 16A,12
382, 17693 20A,23
383, 17702 9A,6
385, 16447 20E,3
386, 17737 24E,7
387, 16590 30A,3
388, 16588 20A,40
390, 17694 21E,36
391, 17703 20A,60
392, 17710 21E,17
394, 17705 8D,30

396, 17865 21E,51
398 (or 399), 17706 1B,5
399 (or 400), 17712 21E,47
403, 17741 11E,42; 14E,9
404, 17778 11E,33; 14E,
 10
413, 16518 9E,86
414, 17752 21A,17
415, 17714 32A,14; s.l.7,2
416, 16450 17E,9
417, 16449 17E,11
418, 16451 1D,5; 8D,18
420 20A,24
421, 17758 32A,15
422, 17720 16A,21
423, 17779 1D,7; 2D,2
424, 17718 8E,52; 10E,15;
 11E,44
430, 17728 9B,6
431, 17715 33A,22; 8E,4;
 s.l.5.102
434, 17740 11E,29; 12E,
 31; s.l.1.37
— 15E,3
G16 20A,45
G17 20A,63
G20 9B,7
G22 24B,13
G23 3E,34
G24 8E,17
G25 21A,92
G34 24B,14
G43 s.l. 6,35
G46 8D,22
G49 33A,14
Astarita 45 36A,3
Astarita 563 9D,7
Astarita 624 9E,117
Astarita 733 13E,21
Astarita 9D,8
C
9098 18C,51
15531 18C,18
16513 10F,10
16526 2B,2; s.l. 2,15
16547 s.l. 2,5
16548 8C,2; 9E,84
16554 3D,16; 18E,10
16566 6B,13; 17C,2
16568 p. 109
16571 20E,15
16572 9B,24; 12E,25
16586 18C,11
17841 17B,7
17848 14F,20
17852 2B,13
17855 12C,6
17908 9F,21
17909 15C,1
17915 s.l. 2,18
G71 2D,8
G72 8D,77
— 8D,61
— 7F,5
— p. 239
— p. 239
Rome, Museo Nazionale di
Villa Giulia (V.G.)
Mingazzini has published
catalogues of the Castellani
collection, but omits the
dipinti and a number of
graffiti. Vases from Falerii
and some other sites (many
now at Civitacastellana, q.v.)
are published in CVA; as far
as I have been able to deter-

mine the marks are not well
published therein. The marks
on vases from Cerveteri are
found most readily in NSc
1937 383-5 and 433-5; many
are also given in ML 42, but
I only refer to the latter when
the vase is illustrated or there
is some difficulty over the
reading. Cerv.= from Cerveteri.
Cast. = Castellani.
A
22145 p. 238
46197 Cor 105
47995 Lac 1
50537, M328 Cor 93
M418 EG 100
Cerv. Lac 8
Cerv. p. 251; Etruscan n.2.
B
762 p. 39
914 s.l. 6,19
933 s.l. 6, 9
3549 s.l. 5, 90
8340 s.l. 5, 91
15535 9A, 1
15537 21E, 15
15537 (lid) 11B,6
15730 7D,7
15731 21E,4
20747 21A,45
20792 9D,19
20841 6D,10
20842 2B,21
20861 1D,22
20863 3E,14
24994 14B,5; s.l. 5,92
25000 s.l. 5,93
45589 12E,17
45750 6C,12
47231 s.l. 5,94
47552 12E,9
47798 5D,12
47934 24B,3
50387, M489 14B,12
50409, M502 40A,2
50414, M479 21E,33
50428, M475 9D,14
50432, M530 8D, 33
50434, M480 21A,80
50450, M495 11E,4
50487, M469 5A,3
50490, M459 33A,2
50493, M456 s.l. 5,95
50495, M531 27A,5
50499, M476 21A,1
50514, M494 3D,9
50527, M466 14B,2
50541, M457 5D,7
50558, M462 3E,15
50617, M490 7D,14
50619, M497 8E,59
50622, M484 13E,3
50624, M450 p. 25; 27; 36
50631, M488 6E,13; 7E,1
50647, M483 8D,35
50683, M430 14B,6
50697, M436 6B,2
50706, M432 s.l. 5,96
50734, M477 11E,10
50735, M463 35A,3
50747, M499 2A,3
50754, M435 10E,17
50757, M437 17E,23
M464 s.l. 5,97
M468 9E,2
M490 8D,37

M496 21A,18
M500 27A,3
M625 11F,21
Cast. 18B,8
Cast. s.l. 6, 30
Cerv. 16A,26
Cerv. 21A,26
Cerv. 21A,46
Cerv. 21A,60
Cerv. 21A,99
Cerv. 22A, 7
Cerv. 2B,18; s.l. 5,98
Cerv. 4D,1
Cerv. 4D,3
Cerv. 2E,8
Cerv. 3E,16
Cerv. 9E,44
Cerv. 12E,29
Cerv. 14E, 2
Cerv. s.l. 6,15
C
983 6C,2
1129 5F,1; 9F,48
1342 7C,2
3583 8D,58
14215 s.l. 2,9a
14217 p.246
15708 23B,2
20845 2B,3; s.l. 2,27
20846 2B,4; s.l. 2,28
20847 2B,5; s.l. 2,29
46940 12C, 8
47121 14B,27
47836 14B,22; s.l. 2,2
48238 s.l. 2,8
48239 8D,19; s.l. 2,14
48897 9B,31
50384, M669 s.l. 2,4
50431, M695 9C,6
50444, M701 15C,10
50462, M660 s.l. 2,9
50471, M653 s.l. 2,5
50646, M682 2B,16
Cerv. 4B,15
Cerv. 17B,10
Cerv. 17B,11
Cerv. 17C,7
Cerv. 3D,20
Cerv. 9F,53
Cerv. s.l. 1,51
Cerv. s.l. 4,25
Cerv. p. 249
— 14A,5
— 15C,7
— 24E,10
Rome, Guglielmi
B
— s.l. 6,2; p. 4
Rouen, Musée d'Antiquités
B
inv. 539 12E,10
— 13B, 19
C
inv. 359 9E,103; s.l. 1,41
inv. 538 22A,6
Ruvo, Museo Jatta
C
323 5F,6
514 11F,9
519 11F,10
537 p.16; 38
767 9E,124; 8F,7; 13F,11
812 p.16
892 p.38
St. Louis, City Art Museum
B
WU3279 s.l. 3,7

C
57.55 7D,26
WU 3271 p. 70
St. Louis, Mylonas
B
— 17B, 29
Salamis, Cyprus
B
5341 p. 19
Salerno, Museo Provinciale
B
1124 12E,13
1152 19B,2
142. (sic) p. 60
1658 p.60
— 8D,70
— s.l. 5,107; p. 60
Salerno, Soprintendenza alle
antichità
B
Caudium T459 6D,1
C
Caudium T227 18C,48;
 14F,6; 23F,3
Salonica, see Thessalonike
San Francisco, M.H. Young
Memorial Museum
B
1814 21E,27
243.24874 1F,13
San Simeon, see Hillsborough
and part II of this index
Sarasota, John and Mabel
Ringling Museum of Arts
C
— 14B,23; s.l. 2,6
Sèvres, Musée Ceramique
B
57 23E,14
C
2043 s.l. 4,41
South Hadley, Mount Holy-
oke College
C
1929 BS II.4 16B,19
Stockholm, National Museum
B
1962.7 2F,14
1968.123 2F,44
C
1963.1 18E,11; 19E,2;
 10F,18
— 13B,24
Sydney University,
Nicholson Museum
B
13 s.l. 1,31
Syracuse, Museo Nazionale
A
2215 Cor 82
5994 Cor 70
7496 Cor 8
9923 EG 248
12648 EG 108
24670 EG 109
24691 EG 110
38079 Cor 71
45723 Cor 83
52165 Cor 101
— Cor 56
— EG 111
— EG 112
B
7731 2B,43
11889 s.l. 1,12
18418 p. 60
19867 p. 17

19912 17E,32
20958 15B,6
21054 p.16
21139 8D,40
21925 9E,43
21926 14B,14
21942 9E,69
21951 s.l. 5,108; p.245
21953 p. 16; 22
21957 p. 16
23257 1B,23
52263 1B,7
— 10B,5
C
17250 6B,7; 3E,41
19867 p. 17
20966 11C,1
21138 32A,7
21150 p. 58
21186 1A,10
21196 6B,8; 3E,42
21834 13B,5; 1F,2
22785? 18C,1
22833 26F,20
22886 2B,32; 18C,3
23912 18C,63
24009 6B,14; 19F,14
24552 3E,39
26564 18C,2
30296 18C,60
30664 16E,9
33503 13B,30
34430 s.l. 2,16
42527 2B,33
45978 9E,97
53237 p. 17
— 5D,15; s.l. 2,21
— 16B,33; 18C,22
— p. 60

Taranto, Museo Nazionale
A
4892 EG 113
20739 EG 114
20742 Cor 81
20766 Cor 66
112575 Cor 67
B
4320 p. 60
4360 4B,9
4404 13E,1
4415 10E,7
4592 10E,9
4596 7D,3
11809 p. 60
20119 s.l. 5,109
20121 5D,1
20198 1B,8
20201 19F,16
20238 s.l. 5,110
20256 13A,3
20328 9E,72; 10E,10
20336 p. 36
20347 24B,9
20348 16A,25
20851 s.l. 5,111
51663 p. 60; 63
52127 p. 15; 22
52160 22E,4
52210 s.l. 5,112
52256 s.l. 5,113
52349 13F,10
107101 9E,42a
127164 s.l.5,113a
— 5D,18
C
4544 p. 16; 60
4550 11B,19

4625 p. 60
20931 18C,57
52235 p. 37; 60
52318 p. 60
106912 p. 60
Tarquinia, Museo Nazionale
Tarquiniense
Some marks have been
published by M. Pandolfini,
St.Etr. 36 (1968) 235ff.
Gr. = Gravisca
A
RC1145 EG 94
RC1860 EG 95
RC3440 EG 96
B
576 p. 63
595 4E,2
605 37A,9; s.l. 5,114
617 1E,8; 2E,5
618 s.l. 5,115
622 35A,4
624 15B,2
626 16B,5; s.l. 5,116
627 23E,11
630 37A,5
635 2F,6
636 4A,7
637 s.l. 5,117; p. 37
638 s.l. 6,33
639 s.l. 5,118; p. 187
640 1D,21
641 1D,16
642 9A,4
644 s.l. 5,119
646 20A,51
647 11E,9
649 4A,5
652 21E,11
656 15A,7
657 21A,29
661 9A,7
662 37A,1
664 20A,2
668 2D,4
670 9A,5
673 21A,8
675 21A,64
676 34A,2
677 s.l. 6,12
678 10A,5
679 22B,3
680 16B,1
RC975 s.l. 5,120
RC976 37A,2
RC985 s.l. 5,121
RC1077 s.l. 6,13
RC1081 s.l. 6,36
RC1082 10A,6
RC1330 12B,3
RC1626 12E,4
RC1635 15A,4
RC1748 32A,1
RC1750 17E,40
RC1803 21A,90; 23F,5
RC1804 1D,15
RC1816 (sic) 16A,1
RC1816 (sic) p. 239
RC1822 (or 4) 25F,15
RC1871 5A,4
RC1876 17E,1; s.l. 1,23
RC1886 10E,4
RC1983 16A,10
RC2363 s.l. 1,22
RC2406 21A,9
RC2421 s.l. 5,122
RC2449 11A,2

RC2450 1D,12
RC2464 s.l. 6,18
RC3015 37A,6
RC3029 s.l. 5,123
RC3030 10A,2
RC3222 20A,74
RC3300 21A,54
RC3302 22B,4
RC3455 20A,22
RC3870 5A,5
RC5164 21A,82
RC5165 2B,39; 1F,7
RC5564 s.l. 5,124
RC5577 16A,2
RC5637 p.187
RC5652 s.l. 5,125
RC5660 21A,24a
RC5994 21A,19
RC6147 17B,3
RC6847 21A,37
RC6975 21A,56
RC6991 37A,4
RC7045 p.23;240
RC7170 1E,6; 2E,4
RC7370 8D,7
RC7450 21E,45; 22E,8
RC7480 16A,19
RC7903 8D,13
RC8650 s.l. 5,126
Gr. II 18353 22E,5
Gr. II 21804 2B,35
Gr. 73/12316 14E,13
— 8D,46
— 26F,16
— s.l. 5,127
C
682 9B,15
706 7D,12
707 7D,18
RC992 10F,7
RC3240 19F,7
RC4197 p. 39
Gr. 72/20095 p. 62
— 15C, 4
D
Gr. 73/2429 p. 241
Gr. 73/12082 p. 241
Gr. 73/17330 p. 241
Thasos, Archaeological
Museum
C
— s.l. 4,16
Thessalonike, Archaeological
Museum
C
1633 s.l. 3,20
— 14F,19
— s.l. 3,15
— s.l. 4,4
— s.l. 4,28
— s.l. 4,29
— s.l. 4,30
Tocra
Numbers as in *Tocra* i and
ii
A
589 EG 115
601-2 EG 116-7
606 EG 118
627 EG 119
635 EG 120
639 EG 121
647 EG 122
651 EG 123
652 EG 124
660 EG 125
664 EG 126

670 EG 127
673 EG 128
681 EG 130
684 EG 131
685 EG 132
690 EG 133
693 EG 134
694 EG 135
698 EG 136
701 EG 137
709 EG 138
713 EG 139
718 EG 142
723 EG 145
736 EG 146
743 EG 147
757 EG 143
759 EG 144
783 EG 68
784 EG 69
972 Lac 10
1272 EG 149
1985 EG 129
1998 EG 140
2005 EG 141
2038 EG 148
2041 EG 247
2051 EG 70
Toledo, Ohio, Museum of
Art
B
23.3123 19B,7
55,225 20A,28
56,70 28A,2
61.23 13E,9
69.371 2F,28
C
56.58 25B,6
61.26 8D,53
Toronto, Royal Ontario
Museum
The numbers in the catalogue
of Robinson, Harcum and Iliffe
first.
B
296 (919.5.133) 20A,68
300 (919.5.176) 1E,2; 2E,1
302 (920.68.72) 13E,2
304 (919.5.14) 10A,11
306 2F,13
309 (920.68.71) s.l. 6,16
322 (916.3.16) 11A,3
350 (919.5.148) 4F,1
633 26A,3
Trieste, Museo Civico
A
S444 p. 251
S448 p. 251
S482 p. 251
S587 p. 251
B
S306 3E,17
S405 s.l. 5,128a
1406 26A,5
1802 5D,5
C
S423 21B,12
Trondhjem, Nordenfjeldske
Kunstindustrimuseum
C
807 10E,33
Tübingen, University
In brackets the numbers in
Watzinger's catalogue
B
717 (D61) 2B,50; s.l. 3,4
2451 (D9) 9D,13

C
1343 (E105) 13B,27; 18C,39
– s.l. 4,33
Turin, Museo di Antichità
B
4101 20A,85
4102 11E,18
4106 14E,12
4114 8E,18
C
4126 6B,10; 24B,6
Ullastret, Museo Monografico
C
– p. 60; 66
Ullern, Oslo
B
– 23E,2
Utrecht, University
B
117 12E,6
C
inv. 11 10F,17; 26F,9
Vannes, Société Polymathique
B
2157 s.l. 7,5
Varna, Regional Museum of
History
C
II.1449 22F,2
II.1450 p. 18
Verona, Museo Civico
B
18 Ce 17B,5
V.G. see Rome, Villa Giulia
Vienna, Kunsthistorisches
Museum
Marks on vases in the 3000
series are published by
K. Masner, *Die Sammlung
antiker Vasen und Terra-
cotten im K. K. Osterreiches
Museum* His catalogue
numbers are either given in
the catalogue or to be found
in Beazley's indices.
A
loan EG 85
B
3597 s.l. 6,11
3598 8D,71
3600 11E,3
3601 14B,11
3602 2A,1
3604 3E,1
– 17B,22
C
538 18C,83
589 21A,104
608 6C,8
641 18C,67
654 s.l. 7,8
688 8D,52
696 15B,13
732 18C,76
772 9F,46
869 18C,42; 14F,1; 26F,2
873 18C,75
892 18C,84; 1F,5; 22F,1
895 17A,16
955 18C,85
1034 18C,82
1065 16B,22; 18C,44
1073 9B,27
1152 18C,23; 21F,6
1971 s.l. 4,12
3691 14B,25
3698 4B,10

3718 s.l. 4,11
3724 17B,14
3725 9E,78
3729 5C,5
– 14B,21
Vulci, Antiquario
A
TP 4 Cor 34
B
64217 4B,8
– 9E,41
– 20E,11
Waiblingen, Oppenländer
C
– 16B,20
Warsaw, National Museum
B
142322 9B,22
142451 11B,11; 10F,1
142452 21A,81
147864 26B,6
C
142290 21F,2
142310 9F,43
142332 26B,7
142333 11E,16
142337 6C,5
142348 7D,11
142352 s.l. 4,7
142465 18C,12
Washington, National
Museum
D
– 9F,38
Windsor Castle, H.M. The
Queen
B
– 20A,72
– 21E,31
Worcester, Mass., Art
Museum
B
– 16E,3
Würzburg, University,
Martin von Wagner-
Museum
A
139 EG 252; 17E,12
458 p. 238
649 p. 238
B
163 24E,9; s.l. 4,38
169 15A,5; s.l. 1,30
173 20A,1
179 4A,9
180 4A,8
182 21E,37
185 3D,4
186 1D,11
188 20A,82
189 20A,39
190 21A,59
191 3D,7
192 9E,26
196 13E,4
197 30A,2
198 11B,10
200 20A,44
201 18E,3
203 21E,38
205 6D,4
207 12B,13
208 20A,18
210 5E,2; 7E,4
211 8A,9
212 p. 39; 239
213 21E,58

214 2F,21
217 5A,17; 23E,6
218 26A,2
219 37A,8
220 20A,43
221 8D,42
224 8D,36
225 6A,1
234 8E,1; 15E,4
240 13B,11
241 s.l. 5,129; p. 64
242 1B,22
244 25A,4
245 25A,3
248 17A,13
249 5D,3
251 25A,6
255 8D,72
256 3E,21
257 11B,15
259 3E,18
263 s.l. 5,130
304 21A,53
306 3D,5
307 21A,58
309 9E,34
310 5E,16
312 1D,3
313 21A,88
314 38A,4
316 13E,11
318 5E,12
319 9D,1
320 21A,57
321 2F,31
322 8E,35; 9E,9
323 3A,2; 9E,59
328 21A,16
331 5E,18
339 20A,27
351 15B,17; 8E,38
352 8E,39
382 p. 69
– 9F,32
C
509 17E,19; 18E,8; 19E,1
518 13B,21; 8D,54; s.l. 2,37
533 3D,22
536 21F,14
610 p. 34; 61
Yale, see Newhaven
Zurich, Eidgenössische
Technische, Hochschule
A
6 Cor 88
B
7 9E,24
8 20A,35
9 6B, 1
11 10A,8
C
418 8B,9
Zurich, Roš
B
– 25A,2
II Vases whose present
whereabouts are unknown
(or not precisely known)
a) once in private collec-
tions
Barone
C
– 23E,22
– 12F,4
– 25F,3
D
– 16B,29; 20F,13

– 13F,12
Betti
C
– 16F,3
Campana
Numbers in the *Cataloghi
Campana*
A
449 Chalc 6
453 Chalc 7
B
469 21A,97
496 6E,14; 7E,2
Canino
Numbers in *Musée
Etrusque*
B
82 32A,16; 17E,15
83 20B,2
84 32A,17
172 24E,5
229 3D,14
247 32A,9
297 8D,47
313 5E,9; 6E,11
332 20A,15
1432 9E,46
1462 12E,19
1692 3F,5
1700 5A,19
1701 8E,27
1706 5E,10; 6E,12
1710 3E,59; 2F,48
C
1198 17E,17; 10F,24;
26F,8
Czartoryski, Goluchow
C
28 16B,12
34 8B,11
Forman
B
295 p. 191
Hall, Tynemouth
B
– 33A,25
Hearst, San Simeon
Some of these pieces are
probably still at San
Simeon
B
9503 2F,26
9907 8A,6
C
– 10C,1
Hirsch, Geneva
A
– Cor 89
Holford
B
– 5A,8
Hope, Deepdene
C
96 9F,20
Peek
B
– 15B,7
Pourtales
C
– 3B,5; 16F,2
Principio S. Giorgio
C
– 14F,18
Robinson, Oxford, Miss.
B
– 15B,9
– 3E,23; 4E,4

C
– 21A,102; 8B,8; s.l. 3,10
– 12C,2
Rome, Società Hercle
A
– EG 97
B
– 1A,4; 10E,30
– 8A,13
– 14B,9
– 1D,9
Rothschild, Paris
B
– 21A,86
– p. 39
Ruesch
C
– 17E,43
Spencer-Churchill,
Northwick Park
B
– 8E,62
Talcott, Princeton
C
– s.l. 4,22
Tartu, University
C
– 8F,15
Wandel
B
– 13E,16
b) once on the market (in
some cases currently so)
Basel, Münzen und Medaillen
Numbers as in the *Auktion*
and *Sonderliste* catalogues.
A
22,112 Cor 49
26.82 Chalc 3
B
14,74 2F,8
16,104 14A,12
18,96 9E,31
40,66 28A,3
51,118 8D,3
51,129 3E,46
51,123 p. 30; 207
Sond. P99 9E,57
ASVMM 12 14B,17

ASVMM 17 12E,26
– 11B,4
– 12E,26
C
34,166 2B,8; s.l. 2,32
34,170 14B,24; s.l. 2,17
40,101 8D,75
51,161 s.l. 1,10
Sond. N4 1B,15
Sond. N34 11C,4; 20F,2
Sond. N76 2B,25
– 17A,17
Bern
B
– 9E,33
Florence
A
– p. 251
Geneva, Galerie Faustus
B
– 21A,91
Geneva
C
– 7F,8; 26F,4
Hamburg, Neuendorf
B
– 33A,3a (p.70)
London, Coins and
Antiquities
C
cat. 54 AN574 13B,7
cat. 58 AN767 p. 239
London, Christie
B
30/4/1975 60 17A,12
16/3/1977 202 3E,36
– 18B,7
– 12E,1a
C
19/4/1921 189,3 16B,15
31/5/1979 320 12E,1a
London, Ede
A
– p. 251
B
5038 9E,99
– 10F,5
London, Sotheby
B

1/7/1969 99 5A,2
1/7/1969 100 24B,1
1/7/1969 101 s.l. 5,131
1/7/1969 102 21E,56
26/2/1973 143 26F,17
9/7/1973 168 21E,62
3/12/1973 144 8E,12
3/12/1973 228 9E,39
4/12/1978 133,2 20A,75a
 (p. 70)
4/12/1978 199 8E,46a; 11E,
 42a
10/7/79 300 21A,10
C
26/11/1968 124 6B,11
3/12/1973 155 12C,5
– 19B,15
– 9F,12
Lucerne
Ars Antiqua auction
numbers
A
iv 126 Cor 87
B
ii 139 14B,16
iii 96 p. 151
Paris, Feuardent
C
– 3D,19; 17E,38
Paris, Hôtel Drouot
B
27/5/1887 90 13B,18
11/5/1903 47 5D,9
11/5/1903 55 6A,4
11/5/1903 58 p. 59
11/5/1903 66 2D,7
C
28/5/1887 147 p. 61
28/5/1887 405 p. 61
Paris, Segregakis
C
– 8B,7
– s.l. 2,23
Rome, Castellani
A
– Chalc 4
– Chalc 5
Rome, Pollak
C
– 18C,13

Rome
C
– 2B,10
– 8B,10
– 18C,56; 17F,10
– 3D,23; 9E,112
c) in unspecified private
collections
Berlin
B
– 4A,6
England
C
– 7D,66
Germany
B
– 14B,8
– 15B,14
C
– p. 240
Rome
B
– 5D,10
Switzerland
B
– p. 239
C
– 2B,7; s.l. 2,31
– 7D,16
– s.l. 7,4
– p. 63
d) others
B
Bull.Inst. 1883 165 13E,27
NSc 1886 151 2F,53
RM 1 (1886) 22 21A,25
RM 8 (1893) 336 33A, 25a
– 5D,8; 15E,10
– 8D,48
C
Bull.Inst. 1878 149 25F,4
Bull.Nap. 1847 22 7B,9
CIG 8345i 8F,16; 14F,21
Passeri pl. 273 21F,3
RA 1875 ii 115 24F,8
RM 46 (1937) 150 24F,7
– 7D,13
– s.l. 1,47
D
CIG 8345f 15F,3

INDEX OF GREEK AND ETRUSCAN WORDS

Index of Greek and Etruscan words including more significant abbreviations. The references are sometimes to words transliterated into Roman script in the text.

ἀγγεῖον 232
ἄριστος 244
ἀρύβαλλος 222
ἀρύστηρ 25, 62, 222-4, 229
Ἀρχι... 40, 41, 49
Ἀτθίς 204
ἄτιμος 25, 225
Ἀχήνατος 41, 49, 232

βαθέα 33, 229

ΓΑΝΝΑΣ 61
γλαῦξ 32, 190, 224, 230, 233

δα(ē)μόσιον 186
Δεῖγμα 49, 52
δίδραχμος 231
δίκαιος 229
δοῦλος 65
δώσω 226

ἐμί 61, 242
ἐμβάφιον 32, 217
ἔμπορος (-ιον) 20, 61
ἔνεστι 230
ἐνθήματα 25, 33-4, 229, 232, 247
ἔνο 25
ἐπιθήματα 186, 228

Ἡήσαρχος 249
ἡμικοτύλη 30

θεθμός 204

ἱερός (-όν) 90, 234
Ἱκέτης 41

ἰχθύα 25, 32-3, 62, 229

κάδιον, κάδισκος, κάδος 32, 201,
 217, 228, 230, 241, 249
Και... 228
καινός 228
Καίριμος 248
καλός 40-1, 45, 248
καρχήσιον 63
κοιλείη 248
κοῖλος 228
κόλιξ 224
Κορίνθιος 213, 228, 230, 232
κότυλος (-η) 62, 230, 247
κρητήρ 229
κροτο... 245
κρωσσός 217
κύαθος(-ειον) 25, 32, 229
κύλιξ 32, 217, 224, 230, 248
κύλιφα 221, 224
κώθων 32, 231

Λέαγρος 41, 45, 245
λεῖος 32
λεκανίς 217, 220, 222
λεκυ... 220
λεπαστή 231
Ληθᾶος 246
ληκυ... 24, 48, 216, 219-222
λήκυθος (-ιον etc.) 32, 35, 189,
 205, 207, 217, 219, 220, 229
λῆψίς 222
λύδίον 225
λύχνος 225

μακρός 32

μέγας 32
μέλας 32
MEMNEO 61
μέτριως 62, 250
Μιλήσιος 232
Μνησι... 49
μυρτώτη 32, 233

νέος 59
Νίκων 41
νυ... 226

Ξάνθιππος 59

οἰνι ... 233
οἰνοχόη 232-3
ὄνος 248
ὀξίς 32-3
ὀξύβαφον 17, 28, 32-3, 35, 217,
 221, 229, 232

παχέα 32, 233
πελλίνιον 32-3, 229
πλίνθος 205
ποικίλος 32, 35, 50, 66, 197, 205-
 6, 212, 225, 228, 231, 233
ποικιλάζω 58
προ... 226-7
πρόχους 227, 248
πύελος 219
πύνδαξ 219
πυξίς 219

ῥαβδωτός 32, 228, 233
ῥητός 242

Σάκων 242
Σάπφω 204
Σικελικά 180
σκάφη (-ίς) 33, 231-2
σκόφος 202
σκοίκιον 202
σκυ... 227, 230
σκύφος 230, 240
σπάθειον 249
σπάθη 25, 32, 230
στάμνος (-ιον) 32, 62, 186, 190,
 206, 229, 230
στατήρ 206
σύμμικτος 27, 206, 229, 230

TETTA 61
τιμή 34, 227, 231, 233
τίμιος 247
τρι... 201, 205, 231
τρίδραχμος 231
τριτήμορον 34
τρύβλιον 32, 232

ὑδριά 24, 62, 215, 231

χοῦς 31-2, 62, 232
χύτρη (-ιον etc.) 32, 62, 213, 225,
 229
ὠνέομαι 226-7
ὠνητός etc. 30, 227

cest ... 206
culixna 31
larta 239
suthina 230, 240
xexan 242

INDEX OF ANCIENT AUTHORS CITED

Index of ancient authors cited

Alcaeus 70 (Diehl) 224, 248
Anacreon 43 (Diehl) 248
Aristophanes, *Aves* 361 229, 232
 Ranae 1236 34
 fr. 417 231
Athenaeus 485a 249

485c 231
494c 229
495a-c 248
500a-b 248
667a 248
Cratinus, see Athenaeus 494c

Galen 19, 753 248
Herodotus ii 62 245
 ii 168 224, 248
 ii 178 237
 v 88 247
Hesychius A7547ff 247

A7561 223
Hippocrates, *Loc.Hom.* 13 245
Hipponax fr. 146 245
Pindar, *Nemean* x 36-7 225, 247
Thucydides i 103 62
Xenophon, *Vect.* 4, 10 247

GENERAL INDEX

Usually a reference to the notes is not included where the key word is clearly signposted in the text.
References to the Catalogue are restricted to a few instances where the matter concerned is not an
integral part of the Catalogue such as vase-painters and dipinti.
For provenance see also Appendix 1, p. 54-5.
See also the Greek index where there are included references to words which are transcribed into Roman script
in the text.

Abdera 10. 57
Abusir 61
Abydos (Egypt) 61, 214, 244
Achilles painter 47, 64, 201-2
AD painter see Priam painter
Adria 2, 13, 24, 37, 41, 51, 63, 64, 194, 196, 212, 217, 228, 243-5, 248
Aegina, Aphaea sanctuary, inscriptions 2, 8—9, 28, 186, 236, 241, 250
 script 13, 18, 23, 26, 30, 51, 52, 60, 189-90, 204, 219, 233, 245
Aeolic dialect 60
Affecter 12, 44, 46, 64, 132, 190, 196, 212
Agrigento (Akragas) 14, 16-17, 28, 60, 231, 241
Agrigento painter 17, 47, 246, 248
Aleria 15, 17
Alexandria 63
Alicante 60
Alkimachos painter 47, 246
Almeria 18
Al Mina 9, 20, 29, 237
alpha 3, 13, 18-19, 42, 44, 185-6, 194, 196, 204, 210-2, 219, 228, 238-9, 241, 251
Altamura 16
Amasis painter 4, 44
amphora, horse-head amphora 44, 189
 neck-amphora 15, 28-9, 32-6, 45, 54, 59-60, 63-5, 186-7, 190, 194-5, 198, 207, 230, 233, 244
 Panathenaic 6, 27-9, 35-6, 40, 50, 223-4
 SOS 1-2, 18, 28, 49-50, 58, 228, 251
 storage amphorae 1-2, 5, 9-10, 18, 21, 210, 236-7, 242, 244, 246, 249, 251
 other 22, 33-4, 36, 46, 50, 54, 58, 62-3, 198, 217, 224, 227-8, 237-8
Ampurias 10, 17-18, 60-1, 247
anchor 48, 189, 193, 240
Andokides painter 13, 45, 56, 64, 194, 240 see also Lysippides painter
ankh 57, 240
Antibes 17
Antimenes painter and group 12, 24, 36, 39, 45-6, 56, 59, 186, 188-193, 207, 210, 212, 218, 227
Apamea 20
Apollonia Pontica 18, 60
Apulia 15 see various sites, especially Taranto
aramaic inscription 1
Arezzo 12
Argos 2, 10, 209
Argos painter 245
Aristophanes of Chios 250
aryballos 38, 234
askos 9, 19-21, 33-4, 38, 54, 61, 188, 239
aspiration 13, 18, 25, 34, 187, 215, 226, 231, 250 see also heta
Athena painter 23, 45, 200, 212-3, 242

Athens 5, 24, 27-30, 34-5, 40-1, 43, 49-51, 59, 63-5, 195, 209-10, 212, 229, 235, 242
 Agora 2, 5, 8-10, 18, 22-3, 28-30, 58-9, 61-4, 210, 240
 Akropolis 2, 8-10, 35, 58, 61
 Kerameikos 5, 8-10, 18, 23-4, 43, 48, 50, 52, 62-3, 222, 227, 246
Attic script 6, 17, 19, 23-6, 28, 30, 34, 49, 52, 189-191, 198, 207, 220, 226, 230, 245
 vases passim
Balaklava 62
Basilicata 16
batches of vases 17-21, 28-30, 34-5, 37-8, 42, 48-51, 205, 214 217, 219, 221-2, 225, 227-9, 231-3, 246-8
Berezan 63
Berlin painter 23, 37, 45-6, 56, 198-9, 201, 207, 212-3, 217, 244
beta 3, 22, 41, 186, 195, 219, 234, 237, 240, 244
Birth of Athena painter 46, 194
black-figure vases passim
black-glazed vases 8-10, 13-14, 16, 18-21, 30, 33-5, 38, 50, 59, 61-4, 225, 233-4, 236, 238-40, 242, 244, 246, 251
Black Sea colonies 18, 29, 209, 236-7, 242 see also individual sites
body of vase, marks on 5-7
Boeotia 8-9, 238
 dialect and script 202, 238
 vases 230, 238
Bologna 12-14, 41, 51, 191, 212-4, 216, 239
bolsal 10, 18, 28, 33-4
Bolsena 12, 222, 241, 247
Bomarzo 189
Botkin class 207
bowl 8-10, 14, 19-21, 30, 61, 229, 235-7, 242, 246
branding 57
bracket sign 25, 29, 206, 226
Briseis painter 15, 46
bronze vases 57
Byzantium 244

Cab. Med. 390, class of 245
caduceus 58
Callatis 60
Campania 14-17, 49, 51, 65, 193, 229 see also individual sites
capacity of vases 6, 18, 28-30, 50, 57, 60, 205, 207, 223-4, 250
Capua 14-15, 17, 59, 62
Carpenter painter 45
casserole 228
Caudium 14-15
Centuripe 16, 37, 194
Cepi 65
Cerveteri 12, 40, 208, 234, 238, 245, 251 see also Pyrgi
Chalcidian vases 38, 209, 235, 237
Charmides painter 46, 207
Chersonesos 18, 29, 60, 63, 239

chi 17, 23, 30, 191-2, 213, 224, 234-5
Chicago painter 47, 226
Chios 57, 236
 vases 1-2, 28, 235-7, 240, 244, 246
Chiusi 12
chous 30, 37, 207, 224, 232
Christie painter 16, 60 see also Polygnotos group
cinnabar 58
clay 35, 63
 analysis 238
Cleveland painter 195
coins 28, 49, 51, 57, 66, 240
 Aegina 239
 Athens 34, 50, 248
 Cyprus 63, 240
 Posidonia 23
 Sicily 233, 250
 Taras 249
 Thessaly 204
Comacchio painter 47
Copenhagen painter 45, 213
Corcyra 28
Corinth 2, 8-10, 49-51, 57, 234-5, 239
 script 22, 51, 65, 234-5, 237, 240, 246
 vases 1-2, 4, 14-16, 19, 24, 27, 38, 49-50, 58, 61, 232, 234-6, 243, 249
Corsica see Aleria
countermarks 23, 42, 50, 185-6, 188, 196, 211, 213-5, 222-3
Crabtree, Joseph 268
Crete 58, 62
Crotone 15, 57
Cumae 14-15, 29, 37, 47, 248-9
cup 5-6, 8-10, 13, 15, 17, 27-30, 32, 37-8, 51, 54, 60, 62-3, 70 195, 198, 202, 219, 2? 233, 235, 239, 241, 248
cutting-compasses 5
cursive lettering 5, 57, 62
Cycladic script 26, 208, 246
Cypriot syllabic script 19-20
Cyprus 2, 19-20, 31, 34, 63 see also individual sites
Cyrenaica 20 see also individual sites

Daphnai see Tell Defenneh
Deepdene painter 226
Delos 2, 9-10, 209
Delphi 2, 209
delta 16-18, 20, 22, 27-30, 62, 185-6, 190, 200-1, 210, 223-4, 233
digamma 60, 63, 185, 214, 224, 234, 244
dinos 40
Dinos painter 203
Diolkos 2, 51
Diosphos painter 45, 198
diphthongs 25, 232
dipinto, glaze 4-6, 23, 26, 40, 42, 44-6, 48-9, 52, 186, 188-90, 194-5 197, 207, 212-3, 238, 251
 red 1-2, 4-5, 7, 13, 15-17, 19-20, 23-4, 29, 31, 36-40, 42, 44, 46, 56-60, 62-4, 105, 187, 190, 192, 194, 197, 204,

207-8, 210, 215, 218, 223, 234-8, 243-6, 250-1
 other 4-5, 190, 241
Dokimasia painter 46
Doric dialect 25, 30, 33, 204, 219, 238
Douris 14, 61, 213
drachma sign 18-20, 24, 30, 34-5, 61-3, 194-5, 201, 223, 229-30, 233, 240, 248
dual 232
East Greek vases 18-20, 28, 62, 99, 198, 235-8, 246
Edinburgh painter 60, 244
Egnatia 16
Elaious 19, 234
Eleusis 9-10
emporium 49, 51-2
Endoios 65
Ephesus 61
epsilon 10, 25, 63, 187, 196, 202, 206, 217-8, 220, 234, 239
erasure of marks see overincision
Eretrian vases 6, 238
eta 2, 10, 15, 17, 22, 63, 187, 205, 208, 215, 220, 229, 237, 250 see also heta
etacism 25, 205
Ethiop painter 31
Etruria 6, 12-15, 17, 19, 36-7, 39-41, 48, 50-2, 189, 192, 235, 237, 240 see also individual sites
Etruscan script and letter-forms 5, 11, 14, 22-4, 26, 30, 37, 39-40, 46, 48, 59, 185, 187-8, 190, 192, 194-7, 199, 202, 204-6, 210-1, 213, 215, 219, 229, 240, 243, 245, 248
 trademarks 5, 41, 49, 185, 210, 238
 vases 39, 49, 65, 192, 238
Euboean script 31, 51, 215, 246
Eucharides painter 45, 200, 216
Euhesperides (Benghazi) 20, 29
Euphiletos painter 12, 46
Euphronios 44-5, 56, 64, 70, 243
Euthymides 45, 56, 64
Exekias 40, 44, 59

F see digamma
Falerii 12, 201, 224
fish-plate 229
Florence painter 202
Flying-angel painter 46, 103
François vase 62
Fratte 15, 37, 215

gamma 14, 23, 189
 Attic 23
 Ionic 2, 23, 38, 196
Gaulish sigillata 52, 63
Gela 3, 15-17, 22-3, 30-1, 36-7, 40, 57-8, 62, 192, 194, 197, 205, 210, 213, 231, 239, 241, 243, 248
gems see seals
Geometric vases 1, 58, 241
Geras painter 46, 202
glaze dipinti see dipinti
graffito passim esp. 5-6
Gravisca 27, 40, 51, 62, 65, 215, 241, 244
Greece 8-11, 18, 40-1 see also individual sites
Group E 44, 56, 189, 191-2, 214
Group G 60, 65
guttus 33, 63

Halieis 242
Harrow painter 46, 196-7
Heloros 60
Hephaisteion painter 46
Heraklea Minoa 62, 248

Hermokopidai 35
Hermonax 37, 46, 48, 207, 248
heta 14, 16-17, 20, 22, 26, 30, 39, 60, 196, 205, 230, 234
 closed 22, 31, 187, 206, 215
 see also eta
Himera 57, 60-1, 63, 251
Histria 14, 60, 70, 237, 246
horse-head amphora see amphora
Hyblaea class 248
hydria 30, 32-6, 50, 54, 57, 60, 62, 207, 215-6, 223, 227, 231, 238
Hypsis 45

Iberian script 17-18
Ionia 19, 51, 209
Ionic script (see also individual letters) 2, 13, 15, 18, 20, 22-3, 25-7, 30, 48, 51-2, 61, 190-1, 200, 205-6, 208, 215, 220, 223, 225, 230-1, 234-7, 242, 246, 249
 dialect 25, 225, 232, 249
iota 1, 228, 234
Ischia 15 see also Pithekoussai
Isthmia 6, 231, 241
Isthmus 51

Kadmos painter 18, 56, 203
Kamarina 16-17, 28, 40, 60
Kamiros 5, 23, 28, 236, 239
kalos see Greek index
kantharos 38, 62-3, 230, 238, 248, 250
kappa 49, 59, 194, 216-7, 240
Kephisophon 34
Kerameikos see Athens
Kition 65
Klazomenian vases 235-6
Kleophon painter 56
Kleophrades 48, 202
 painter 45, 48, 56, 196-7,
Knidos 228
koppa 6, 15, 23, 57, 188, 223-4, 228, 247
kothon 231, 234
kotyle 33, 207, 223-4
krater (all types) 9, 14, 16, 18, 20, 30, 32-6, 42, 50-1, 54, 59-60, 63, 65-6, 189, 206, 215, 225, 228-9, 232, 235, 239
Kroton see Crotone
kyathos 33, 37, 65, 223, 229
kylix see cup

labels 64
Labraunda 19
ladles 48, 229
Laconian vases 19, 28, 38, 51, 209, 235, 239 see also Spartan inscriptions
lambda 3, 60-1, 191, 215-221, 237
 Attic 15-16, 22-3, 48, 188, 216, 218, 226-7
 Ionic 2, 11, 13-14, 16-17, 23, 26, 30-1, 48, 188, 194-5, 202, 205, 216, 227, 236
La Monedière 29
lamps 13, 198
Larissa, Aeolis 19
Lattes 244
Leagros 64
Leagros group 16, 23-5, 36, 39, 41, 44-6, 48-9, 56, 64, 185, 187-90, 194, 196, 207, 210-14, 216, 218-9, 221-2, 226, 232, 243-4
Lechaion 27, 51
lefthandedness 61
lekanis 21, 28, 32, 38, 54, 217, 229
lekythos 13, 15-17, 29, 32-5, 37, 54, 60, 142, 197, 201, 207, 213, 220-2, 229, 240, 247
Leningrad painter 47

Leontini 20
Lerici group 244
lid 5-6, 54, 59, 186, 192-3, 196, 199, 223, 228, 239, 251
ligatures passim, esp. 2-3, 10, 20, 24, 57-8, 60-1, 70, 185-6, 188, 191, 198, 200-1, 206, 209, 213, 216, 230, 234, 237, 239, 243
Lindos 9, 29
Lipara 3, 16-17
litra 194
Lokri Epizephyrii 15, 250
Long-nose painter 46
Lydia 225
lydion 225
Lydos and his workshop 44, 48, 65, 188, 190, 192, 197, 212, 215-6
Lysippides painter 12, 44-6, 186, 194, 212, 218

Madrid painter 46
Magna Graecia see individual areas and sites
Majorca see wreck
Malea 51
Mannerists 47
Marion 9, 19-20, 201
masons' marks 57
Massilia 17, 58, 237
mastos 37, 231, 249
Matsch painter 197
Megara 242
Megara Hyblaea 16-17, 23, 250
Meidias painter 65, 231
Meleager painter 14, 65-6
Metapontum 15, 65, 209
metathesis 25, 204, 225, 229
metics 49, 52, 66, 208
Miletus 19, 62
miltos 4, 59
Mnesiades 64
Montalto di Castro 243
mu 3, 39, 57, 59, 197, 199
Munich 1501, group of 46
Mycenaean vases, marks on 1, 19, 66, 251
myrtle 233
Myson 25

Naples 15
Narce 12
Naukratis 2, 20, 29, 51, 59, 61-2, 65, 189, 195, 209, 214, 228, 234, 236-8, 241, 243-4, 250-1
navel of foot, marks on 7, 231
Nepi 12
Nikias painter 65, 203
Nikosthenes 12, 41, 44, 197, 208 see also Painter N
Nikoxenos painter 45, 187, 212, 218, 240
Niobid painter 31, 47
Nola 14-15, 19, 37, 234, 251
nu 41, 197, 249
Numana 16
numerals passim, esp. 3, 15-18, 25ff, 39, 41, 49-50, 52, 57, 60, 62, 195, 204-7, 211, 213, 216, 228, 235-6, 245, 248
 acrophonic 6, 9, 13-14, 16, 19-21, 27ff, 190, 194, 197, 201, 219-20, 224-6, 233, 240
 Chalcidian 31, 62
 Etruscan 31, 62, 214, 244
 Ionic 6, 23, 27, 29, 34, 57, 59, 187, 205, 214, 221, 223, 225, 228, 230
 Roman 31, 62, 207
Nymphaion 242

obol 16, 30, 33-5, 50, 63, 221, 224, 226-7, 233, 248

Odessos 220
oenochoe 8-10, 13, 32-3, 36-7, 54, 60, 198, 206-7, 214-5, 223, 230-1, 238, 248-9
oil 50, 224
Oionokles painter 46
Olbia Pontica 60
Olympia 2, 5-6, 9-10, 57, 242-3, 251
Olynthos 2, 8-9, 18, 31, 60, 229
omega 14, 17, 23, 25, 61-2, 190-1, 226, 232, 240, 242
omicron 61
Orchard painter 31, 200, 228
Orpheus painter 60
Orvieto 12-13, 15, 191
overincision 34, 40, 42, 48, 64, 210, 213-4, 220-1, 230
owl skyphos see skyphos

Paestum see Posidonia
Painter of Berlin 1686 64
 Cambridge 51 46, 189
 Florence stamnoi 15, 61
 Half-palmettes 13
 Louvre E824 212
 Louvre F6 188
 Louvre F314 216
 Munich 1519 45
 Oxford Grypomachy 65
 Vatican G49 215
 Yale lekythos 46, 197
 Yale oenochoe 200
Painter N 46, 56, 208, 240 see also Nikosthenes
painters, output of 35, 50, 212
Palestrina 243
Panathenaia 223 see also amphora, Panathenaic
Pan painter 37, 44, 46, 64, 207
Pantikapaion 60, 248
Peiraeus 49, 52, 61, 225
pelike 32-5, 54, 60, 70, 212, 228, 230, 238, 242, 249
Perizoma group 190
Persephone painter 58
personal names passim, esp. 40-1, 43, 49, 195, 232, 243
Perugia 12
Pescia Romana 66
Phanyllis painter 213
Phaselis decree 213
phi 1, 190, 224
Phiale painter 47, 64, 203, 231
Phintias 45
Phoenician script 17-18
Phrynos painter 64
pi 28-30, 49, 186, 188, 195, 197, 204-5, 211, 226, 231, 238
pictogram 2, 191-2, 207, 215, 217, 230, 251
Pig painter 47, 226
Pioneer group 40, 45 see also individual painters
Pithekoussai 1-2, 28, 51, 251
pithos 9, 60
Poggia Sommavilla 62
Polos painter 19
Polygnotos and his group 17, 39, 43, 47, 56, 59, 194, 197, 200-3, 205, 225, 231-2
Populonia 12, 64
Posidonia 15, 23, 57, 99, 251
Pothos painter 203
potters 35, 42, 45, 48, 50, 63-4, 187, 199
pre-firing graffiti 5, 202, 225
Priam painter 46, 56, 60, 215, 245
prices 16-20, 33-5, 37, 49-50, 52-3, 60-1, 63, 70, 194-5, 201, 220-1, 223, 225-7, 229-33, 245, 249-50 see also obol, drachma sign
Princeton painter 56
Prokles 243
Providence painter 45

psi 30, 236
Psiax 2, 64
psilosis see aspiration, heta
psykter 36, 239
punctuation 24-5, 29, 187, 204, 206, 224, 226
Pyrgi 204, 208, 242, 244
pyxis 10, 19-20, 22, 30, 37-8, 59, 180-1, 234, 238

Ras Shamra 57
red dipinti see dipinto
red-figure vases, late 35, 47, 65, 196
 connections with black-figure 45, 198
 workshops 46-7, 51, 196-8, 201-2, 244-5
red lead 58
Red-line painter 29, 59-60, 195, 245
red ochre 4, 58
repairs to vases 65, 242
repetition of marks 39, 40, 64, 189, 192, 205-6, 214, 216
retrograde marks 24, 31, 40, 63, 185, 188, 194-6, 202, 212, 228, 232, 239, 241
Rhamnous 243
Rhegion 16, 31, 209-10, 235
Rhitsona 2
rho 6, 13, 16, 18, 23, 30, 206, 208-10, 212-3, 226, 229-30, 248
Rhodes 2, 13, 19, 36-7, 40-1, 49, 51-2, 188, 208-9, 234, 237 see also Kamiros, Lindos
 vases 1, 38, 232, 235-7
Rhoikos 189
Rome 243
Ruvo 3, 16, 28
Rycroft painter 46, 216, 218, 221, 240, 245-6

St. Blaise 57
St. Valentin vases 233
Sakonides 242
'Samian' ware see Gaulish sigillata
Samos 30, 49, 51, 57, 62, 66, 187, 247, 251
sampi 23, 38, 61, 242
san 23, 61, 234-5
S. Agata de' Goti 15
Santa Marinella 242
Satrianum 29
seals and sealings 2, 58
secondhand trade 6, 40-1, 190, 206
Segesta 60, 65, 241
Selinus 16, 209, 239
services of vases 48, 222
Seuthopolis 60
shield blazon 65, 193, 240
ship 65, 199 see also wreck
Sicily 3, 15-17, 22, 27-8, 34, 38, 40, 49, 51, 190, 201, 220, 233, 245, 249 see also individual sites
Sicyon 40
sigma 2, 5, 13-18, 20, 23, 26, 30, 39, 49, 59, 62, 186, 189-90, 192, 206-8, 216, 223, 225, 230-1, 235, 238-9, 243, 245-6, 249
silver vases 57, 62, 65, 230, 240, 247
Simon 41, 49, 189, 206
Six's technique 215
skyphos 8-10, 14-16, 25, 29, 33-5, 37, 54, 61, 63, 194, 196, 223-4, 230, 236
 owl skyphos 16, 32, 34, 63, 190, 233, 240, 249
Skythes 61
slaves 49-50, 65
Smikros 45, 48, 64, 189, 195
Smyrna 1, 19, 242
Solon 28, 49
SOS amphora, see amphora
Sostratos of Aegina 44, 49, 189

South Italian vases 70, 238, 248, 251
Sparta, inscriptions 2, 5-6, 18, 61, 250
Spina 13-14, 22, 37, 45, 51, 65-6, 194, 205, 235, 240, 246
stamnos 6, 32, 46, 48, 54, 61, 199, 225, 229, 247
Stara Zagora 57, 230
stone inscriptions, early 58
Suessola 14-15, 28, 37
Suessola painter 65-6
swastika 1, 8, 198-9
Swing painter 22, 30, 44, 187, 190, 207, 239
Sybaris 57, 62
Syleus painter 46, 61, 198, 217, 242, 245
Syracuse 16-17, 24, 28, 57, 62, 209
Syracuse painter 20, 248
Syriskos painter 45, 198, 213, 241

Taman 18
Taranto (Taras) 14-16, 23-4, 28, 31, 37, 40, 57, 65, 188, 199, 207, 228, 230
Tarquinia 12, 14, 66, 187, 189, 193, 214, 218-9, 234, 239-40, 242-3, 245 see also Gravisca
Tarsus 240
tau 190, 204
Taucheira see Tocra
Tell Defenneh 2, 20, 237
Tell Sukas 237
Thasos 9, 29, 241
Themistokles 49
Thespiai 249
Thessaly see coins
theta 13, 18, 22, 28, 38, 70, 194, 196, 204, 225, 229, 242
Tocra 2, 20, 236-7
Toscanella 189
Toscanos 18
traders, implicit passim, esp. 1-2, 22, 33, 40-2, 43ff, 48-53, 190, 194, 222, 227, 232, 234, 236
Troilos painter 226
Troy 19
Tydeus painter 234
Tyrrhenian group 44, 56, 206
Tyszkiewicz painter 45-6, 56, 197, 217, 226-7

Ullastret 60, 66
Uprooter class 229, 240
upsilon 191, 196, 215

Valenzano 16
vase names 3, 20, 25, 32ff, 36, 41, 43, 46-7, 50, 190, 197, 202, 205, 210, 213, 217, 220ff see also individual shapes
Vassallaggi 246
Vatican G23, group of 45
Veii 12
Vergina 62
Vico Equense 15
Villa Giulia painter 47, 201
Vitorchiano 195
Vix krater 57
Vulci 12, 14, 18, 23, 28, 37, 192-3, 211, 220, 234, 247

Washing painter 60, 228
wheel symbol 238
wreck, Kyrenia 20
 Majorca 18, 51
 Porticello 66

X, large graffito 191
Xanthos 10, 19, 29
xi 17, 23, 216, 226, 228, 234-5, 250

York-reverse group 65

zeta 201, 214, 234
Zurich painter 195

FIGURES & PLATES

Figures

The reproductions are at 2 : 1 except where stated.

Dipinti are given as faithfully as possible, though it is impossible to render advanced stages of wear. Dipinti are shaded, damage to the foot is cross-hatched and breaks in the foot indicated by dotted lines.

After the catalogue or other reference in the captions an E, J or N is often added. The letters indicate the orientation of the mark on the foot: E = the edge of the foot is below the mark as given; J = the join of foot and navel is below the mark as given; N = the mark is on the navel. Where no such indication is given the position of the mark is clear either from the figure or the catalogue, or I do not have the information available.

In a number of instances part or all of a mark of type 18C is omitted from the facsimile, and a few other marks are not completely given; note in particular Fig. 8b, 8u, 12p and 13f.

The marks are taken from my own rubbings except in the following cases, where the rubbings have been supplied by the relevant museum or owner, unless otherwise stated: 2m (Salmon), 2r, 3b, 3y, 3aa, 4bb (Ede), 4u and 4n (Salmon), 5s, 5t, 5w (Cahn), 6d (Bernhard), 6k, 8n (Jucker), 8q, 8u, 9a (Beazley), 9c (from the Jatta collection catalogue), 9g, 9x (from *CVA*), 10c, 10x, 11i, 11l, 11m (from *Musée Etrusque*) 12m (Ede), 12r, 12t (Prescott), 13b, 13m, 13s, 13t (from the publication cited), 13w (the same), 14c, 14k, 14r.

The following are reproduced at 1:1

Fig. 3, y-cc; fig. 4, z-bb; fig. 5, w,y; fig. 7, s-u; fig. 8, u-y; fig. 9, b,d; fig. 12, q-t; fig. 13, r, s, u, v, x; fig. 14, k-dd.
Fig. 9, a,c,x, fig. 11m and fig. 13, t,w are not to scale.

FIGURE 1

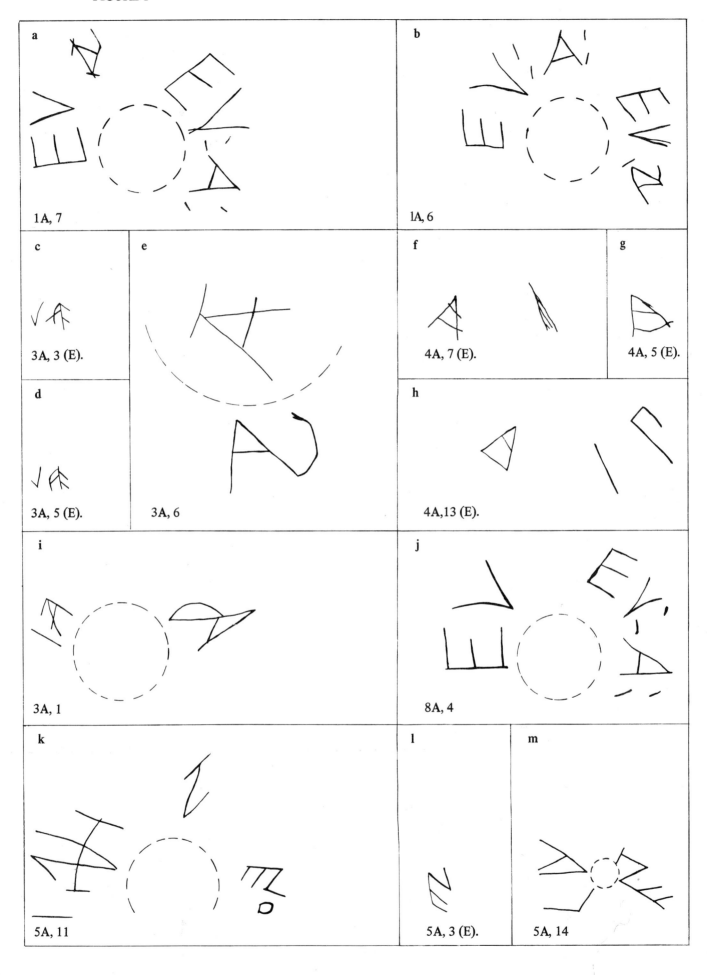

FIGURE 2

a	b	c	f	g
7A, 1 (N).	7A, 2 (N).	9A, 3 (E).	16A, 10 (J).	17a, 17 (J).

d	e	h	i
10A, 5 (E).	10A, 6 (E).	16A, 19 (E).	16A, 18 (E).

j	k	l	m
20A, 4 (J).	20A, 11 (E).	20A, 26 (E).	20A, 9 (E).

n	p	q	r
20A, 42 (E).	20A, 37 (J).	20A, 73 (E).	20A, 31 (E).

s	t	u	v
20A, 46 (J).	20A, 76 (E).	20A, 75 (E).	20A, 72 (J).

w	x	y	z
20A, 74 (E).	20A, 80 (E).	21A, 55.	21A, 52.

aa	bb	cc	dd	ee
21A, 54 (E).	21A, 37 (J).	21A, 55a (N).	21A, 38 (E).	21A, 63.

FIGURE 3

a	b	c	d
21A, 101 (E).	22A, 6 (E).	22A, 4 (J).	23A, 5 (E).

e	g	h	i
25A, 5 (E).	27A, 4 (J).	32A, 6 (E).	32A, 19.

f	j	n	p
25A, 9 (J).	34A, 2 (E).		

k	l	m		
34A, 1 (J).	34A, 3 (E).	34A, 4 (N).	32A, 12.	33A, 23.

q	r	s
36A, 3 (E).	36A, 4 (E).	2B, 12.

t	u	v	w	x
1B, 20 (J).	2B, 19 (E).	2B, 18 (E).	4B, 9 (E).	5B, 3 (E).

y	z	aa	bb	cc
2B, 30 (E).	6B, 7 (E).	6B, 15 (?).	9B, 17 (N).	9B, 30 (E).

FIGURE 4

FIGURE 5

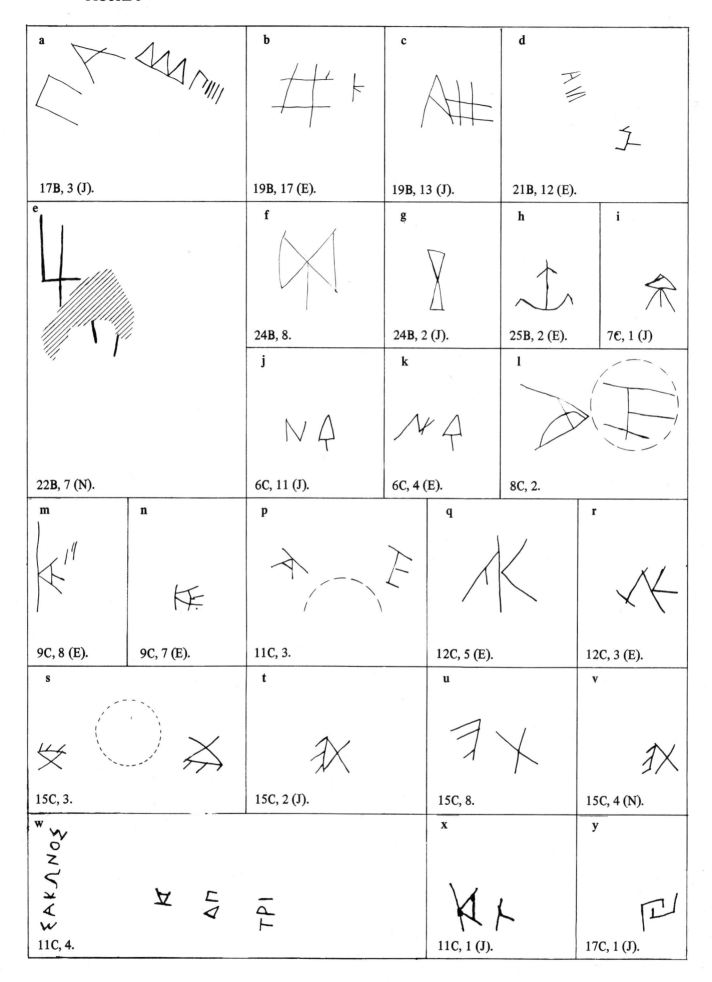

a 17B, 3 (J).

b 19B, 17 (E).

c 19B, 13 (J).

d 21B, 12 (E).

e 22B, 7 (N).

f 24B, 8.

g 24B, 2 (J).

h 25B, 2 (E).

i 7C, 1 (J)

j 6C, 11 (J).

k 6C, 4 (E).

l 8C, 2.

m 9C, 8 (E).

n 9C, 7 (E).

p 11C, 3.

q 12C, 5 (E).

r 12C, 3 (E).

s 15C, 3.

t 15C, 2 (J).

u 15C, 8.

v 15C, 4 (N).

w 11C, 4.

x 11C, 1 (J).

y 17C, 1 (J).

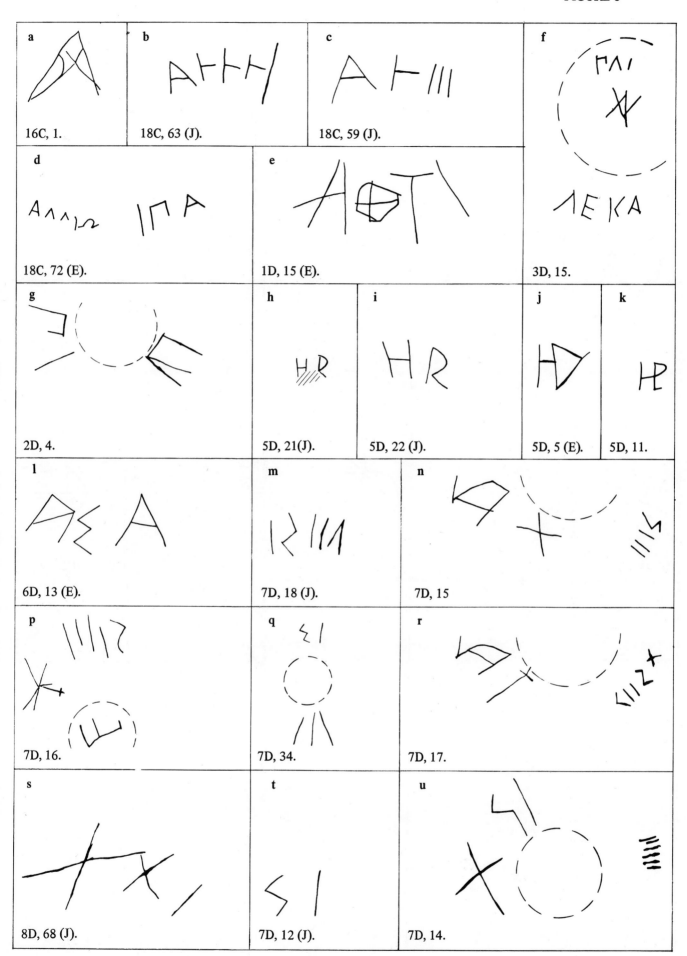

FIGURE 6

FIGURE 7

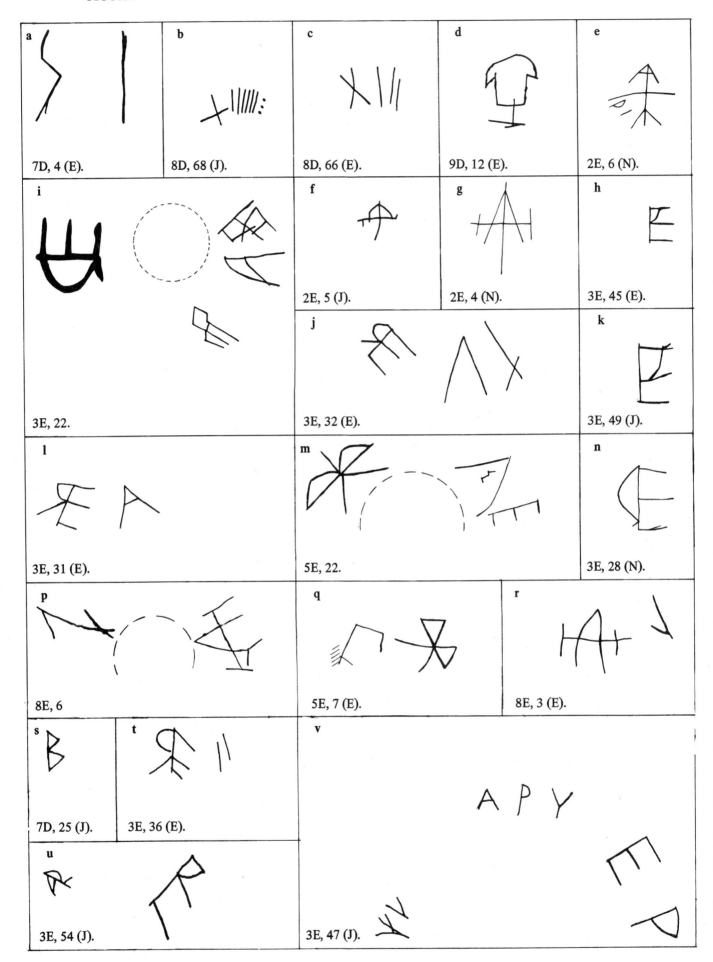

a 7D, 4 (E).

b 8D, 68 (J).

c 8D, 66 (E).

d 9D, 12 (E).

e 2E, 6 (N).

i 3E, 22.

f 2E, 5 (J).

g 2E, 4 (N).

h 3E, 45 (E).

j 3E, 32 (E).

k 3E, 49 (J).

l 3E, 31 (E).

m 5E, 22.

n 3E, 28 (N).

p 8E, 6

q 5E, 7 (E).

r 8E, 3 (E).

s 7D, 25 (J).

t 3E, 36 (E).

u 3E, 54 (J).

v 3E, 47 (J).

FIGURE 8

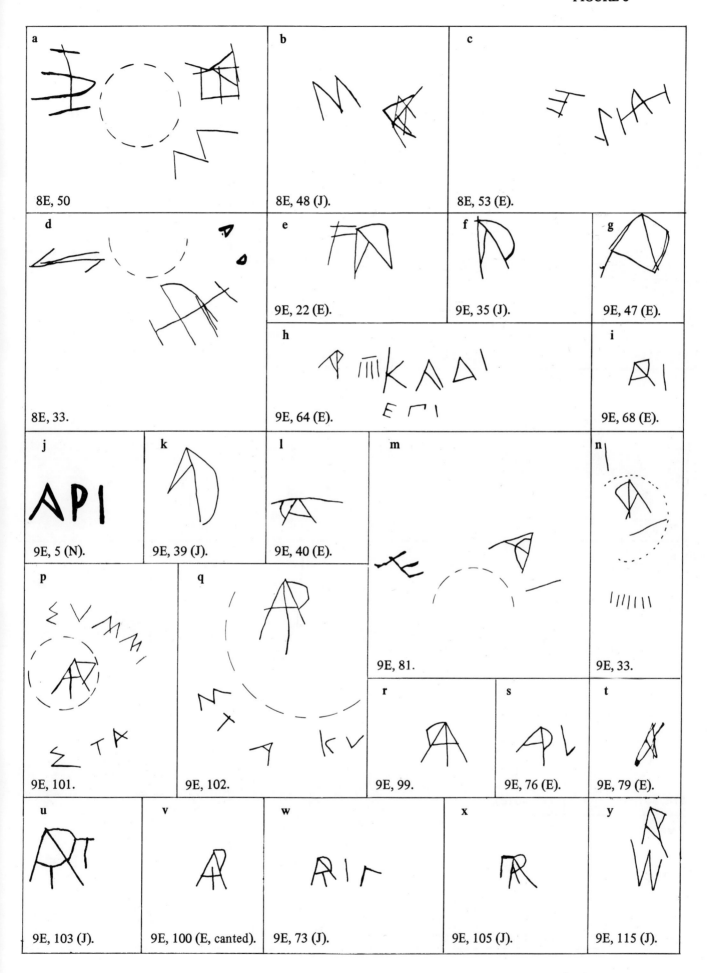

a
8E, 50

b
8E, 48 (J).

c
8E, 53 (E).

d
8E, 33.

e
9E, 22 (E).

f
9E, 35 (J).

g
9E, 47 (E).

h
9E, 64 (E).

i
9E, 68 (E).

j
9E, 5 (N).

k
9E, 39 (J).

l
9E, 40 (E).

m
9E, 81.

n
9E, 33.

p
9E, 101.

q
9E, 102.

r
9E, 99.

s
9E, 76 (E).

t
9E, 79 (E).

u
9E, 103 (J).

v
9E, 100 (E, canted).

w
9E, 73 (J).

x
9E, 105 (J).

y
9E, 115 (J).

FIGURE 9

a 9E, 110.	b 9E, 119 (J).	c 9E, 124.	d 11E, 2 (J).

e 9E, 113.	f 9E, 93 (E).	g 11E, 14 (E).	h 11E, 9 (N).	i 11E, 4 (J).

j 12E, 8.	k 11E, 32.	l 11E, 45.

m 13E, 28 (E).	n 15E, 7 (N).	p 15E, 9 (E).	q 13E, 15 (J).	r 13E, 7 (E).

s 17E, 30 (N).	t 17E, 40 (E).	w 17E, 16.	x 15E, 8.
u 20E, 15 (N).	v 20E, 4 (E).		

FIGURE 10

a 17E, 1.	**b** 17E, 19 (J).	**c** 18E, 11 (J).
d 17E, 41 (J).	**e** 21E, 11 (E).	**f** 21E, 1 (J). **g** 18E, 13 (E).
h 17E, 44 (E).	**i** 21E, 15 (E).	**j** 21E, 7. **k** 18E, 12.
l 21E, 12 (E). **m** 21E, 33 (J) 24	**n** 21E, 24 (J)	**p** 21E, 31 (E). **q** 21E, 36 (E).
r 21E, 35 (J)	**s** 21E, 44 (E).	**t** 21E, 56 (E). **u** 21E, 51 (E).
v 21E, 25 (E). **w** 21E, 45.	**x** 23E, 9.	**y** 22E, A
z 16E, 9 (E). **aa** 21E, 50 (E).	**bb** 24E, 3 (E).	**cc** 23E, 11 (E).

FIGURE 11

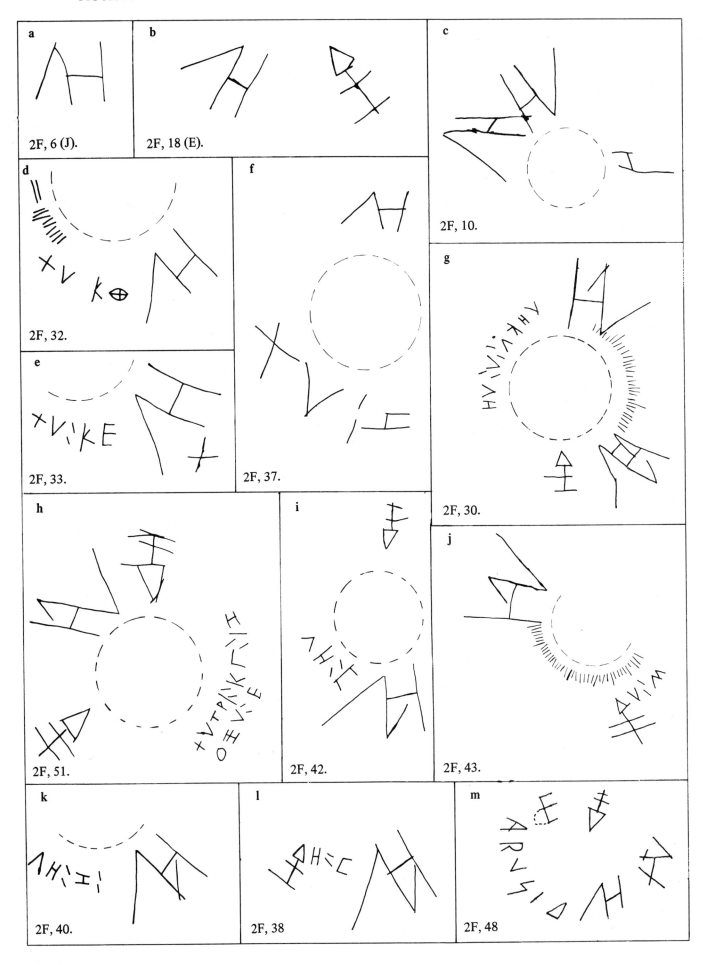

a
2F, 6 (J).

b
2F, 18 (E).

c
2F, 10.

d
2F, 32.

e
2F, 33.

f
2F, 37.

g
2F, 30.

h
2F, 51.

i
2F, 42.

j
2F, 43.

k
2F, 40.

l
2F, 38

m
2F, 48

FIGURE 12

FIGURE 13

a 13F, 9 (E).	**b** 14F, 9 (E).

c 19F, 8 (E).

d 14F, 12 (E).	**e** 22F, 9 (canted).	**f** 19F, 7 (J).	**g** 19F, 9 (E).

h 17F, 4 (E).	**i** 20F, 11 (J).	**j** 22F, 6 (J, shortened).

k 26F, 18 (E).	**l** 21F, 13 (E).	**m** 24F, 2.

n Cab. Med. 244, p. 223	**p** s.1. 1, 43.	**q** 18C, 71

r 14F, 10 (J).	**t** 22F, 7.	**u** 21F, 14 (E).	**w** 25F, 4.
s 14F, 14 (J).		**v** 19F, 16 (N).	**x** s.1. 1, 36.

FIGURE 14

a s.1. 1, 12.

b London B144, p.22 (E)

c New York, Noble, p.248

d Villa Giulia 14217, p.246 (E)

e Palermo 1820 p. 2 (J)

f Vatican 16568, p.109 (E)

g Harrow 50, p.195 (E)

h London 1965.9-30.747, p.61

i Milan A126, p.63 (E)

j Agrigento R136, p.39 (E)

k Manchester IIIh 48, p.29 (J)

l Palermo 1891, p.29 (E)

m from Euhesperides, p.29 (N)

n Nicosia C688, p.20 (N)

p Naples, Spinelli 453, p.59 (N)

q Würzburg 610, p.34 (N).

r Malibu 73. AE.23, p.99 (J)

s Naples, Spinelli 353, p.59 (N)

t Nicosia C969, p.19 (N)

u Harrow 100, p.61

v Harrow 110, p.239 (N)

w Louvre Cpl21, p.238 (E)

x Syracuse 21150, p.58 (J)

y s.1. 4, 5.

z s.1. 4, 6.

aa s.1. 4, 6a.

bb s.1. 4, 13.

cc s.1. 4, 15.

dd s. 1. 4, 21.

PLATE 1

1

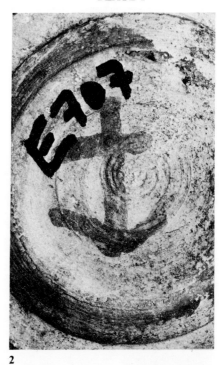

2

3

4

5

6

PLATE 2

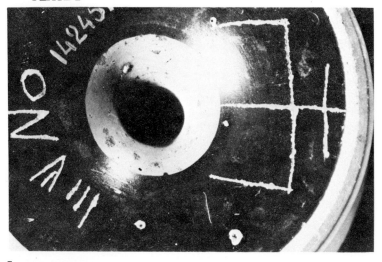

7

8

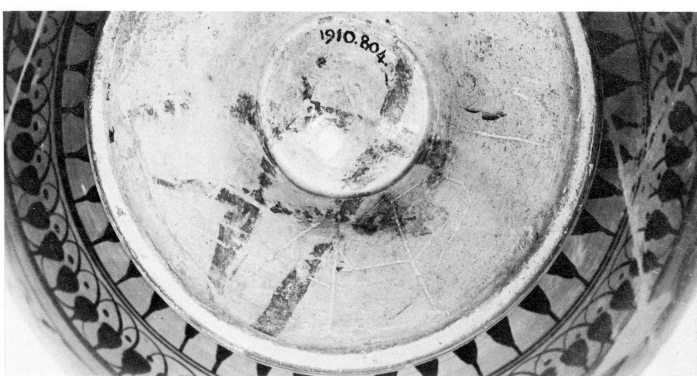

9

10a

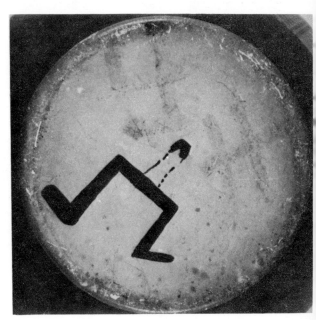

10b

PLATE 3

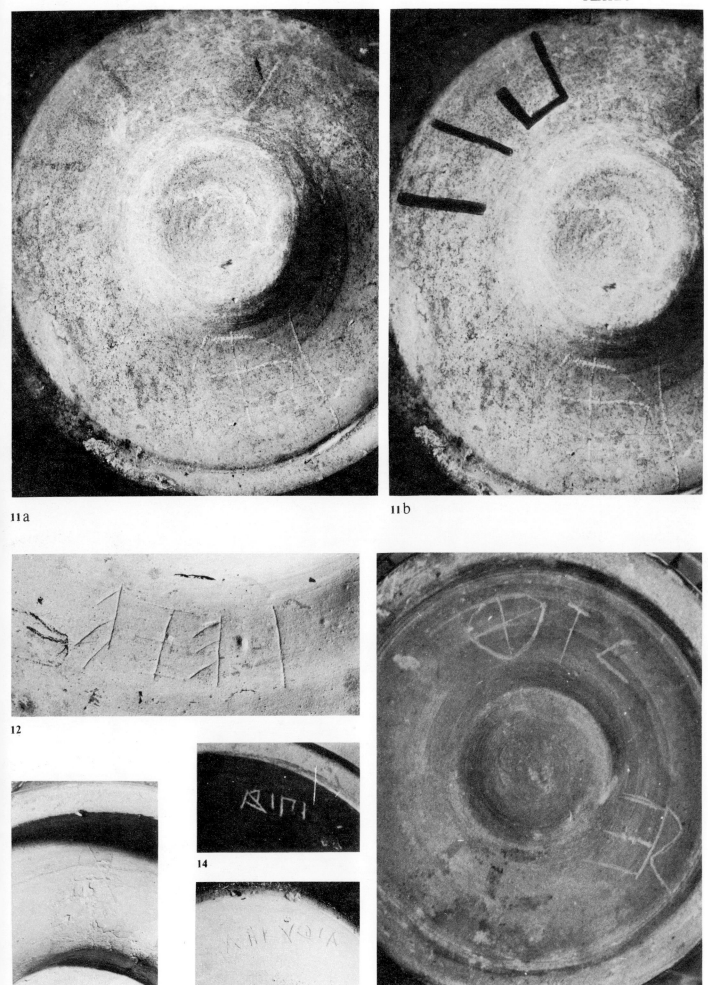

11a

11b

12

13

14

15

16

PLATE 4

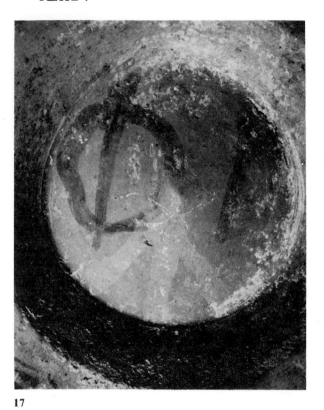

18

17

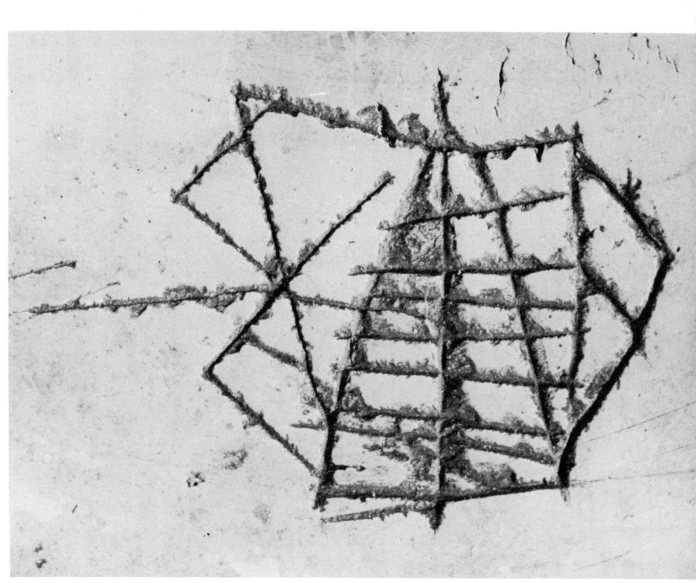

19

PLATE 5

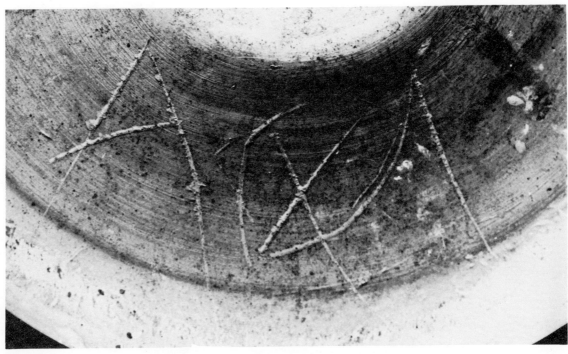

20

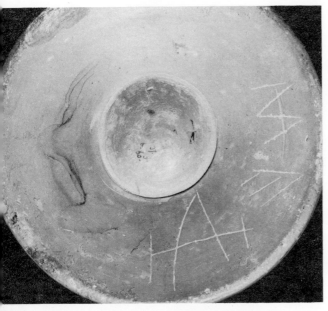

23a

21

23b

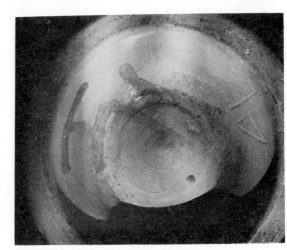

22

PLATE 6

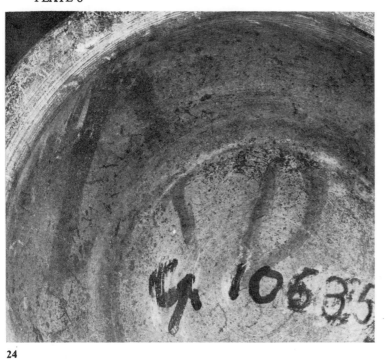

24

25

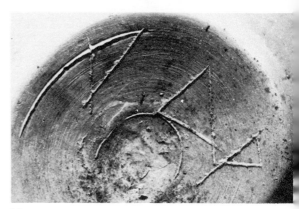

26

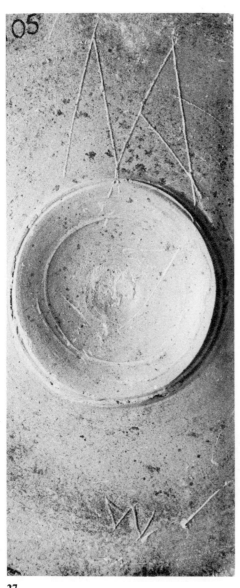

27

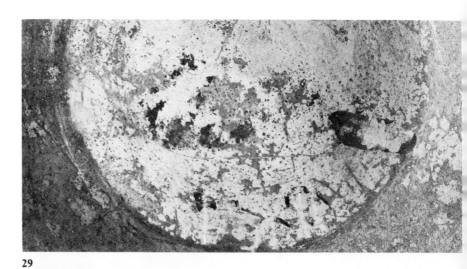

29

30

31

28

PLATE 7

32 a

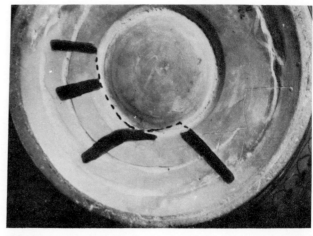

32b

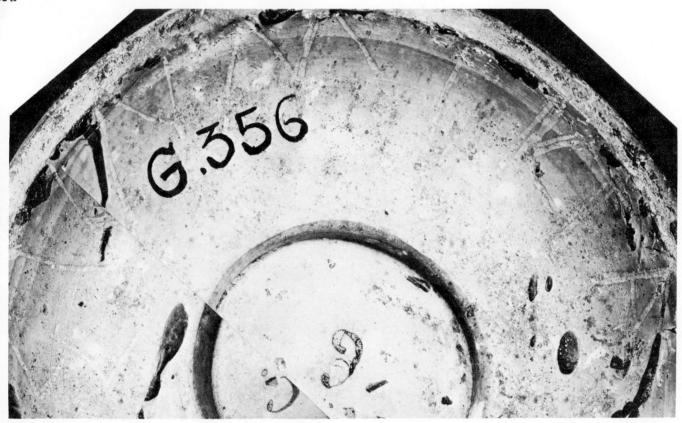

33

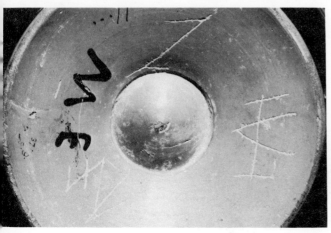

34

35 a

35 b

PLATE 8

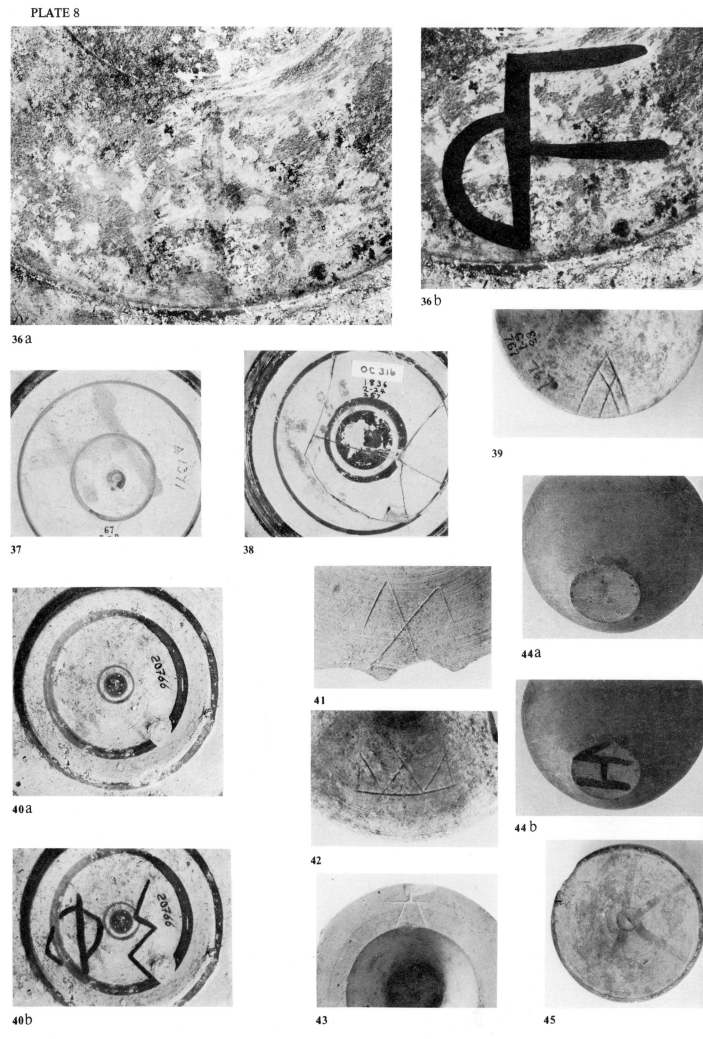

36 a

36 b

37

38

39

40 a

40 b

41

42

43

44a

44 b

45

ARIS & PHILLIPS

CLASSICAL STUDIES

N.R.E. Fisher
HYBRIS: A study in the values of Honour and Shame in Ancient Greece

A. W. Johnston
TRADEMARKS ON GREEK VASES

J. F. Lazenby
HANNIBAL'S WAR: A military history of the Second Punic War

V. Markotic (ed.)
ANCIENT EUROPE AND THE MEDITERRANEAN: Studies in honour of Hugh Hencken

C. B. Mee
RHODES IN THE BRONZE AGE

D. Proctor
THE EXPERIENCE OF THUCYDIDES

I. F. Sanders
ROMAN CRETE: An Archaeological Survey and Gazetteer of the period 69 BC - 824 AD

C. A. Trypanis (translated by W. W. Phelps)
THE HOMERIC EPICS

P. Walcot
ENVY AND THE GREEKS

Virginia Webb
ARCHAIC GREEK FAIENCE: Miniature scent bottles and related objects from East Greece 650-500BC

R. J. A. Wilson
SICILY UNDER THE ROMAN EMPIRE

CLASSICAL TEXTS

J. R. Jenkinson
PERSIUS - THE SATIRES: Text and annotated translation

R. Mayer
LUCAN - CIVIL WAR VIII: A literary commentary with text

Plato (ed. R. G. Bury)
THE SYMPOSIUM: Text with critical notes and commentary

A. H. Sommerstein
ARISTOPHANES - THE COMEDIES: Vol. I THE ACHARNIANS. Text, translation and commentary

J. Wilson
PYLOS 425 BC: Thucydides' text with a historical and topographical study of the campaign

Details and catalogues available from the publishers, Aris & Phillips Ltd,
Teddington House, Church Street, Warminster, Wilts, England.